# Museum Masters

# MUSEUM MASTERS

## Their Museums and
## Their Influence

*Edward P. Alexander*

*The American Association for State and Local History*
Nashville, Tennessee

We are grateful to the following organizations for the financial assistance that made this book possible. The Charles Ulrick and Josephine Bay Foundation, Inc., provided a grant supporting costs of publication. Research and writing were made possible by a research grant from the National Endowment for the Humanities; and additional costs were covered by funds from the sale of the Bicentennial State Histories, which were supported by the National Endowment for the Humanities.

**Library of Congress Cataloguing-in-Publication Data**

Alexander, Edward P., 1907–
  Museum masters.

  Bibliography: p.
  Includes index.
  Contents: Sir Hans Sloane and the British Museum—Charles Willson Peale and his Philadelphia Museum—Dominique Vivant Denon and the Louvre of Napoleon—[etc.]
  1. Museum techniques. 2. Museum directors—Europe—Biography. 3. Museum directors—United States—Biography. I. Title.
AM7.A5  1983      069.9′092′2 [B]       83-7086
ISBN 0-910050-68-6

Designed by Gary Gore

# Contents

# Illustrations

# Preface

This book has resulted from the Museum Studies courses I taught at the University of Delaware from 1972 to 1978. In tracing the history of museums there, I was fascinated to discover that the early concept of the museum as an encyclopedic collection of miscellaneous curiosities of interest chiefly to collectors and scholars had been transformed by several innovative museum leaders. Today the museum has become a powerful teaching medium, reaching not only the researcher and the expert but, with its exhibitions and varied interpretive and educational programs carefully designed to attract the general public and to serve—indeed, to some extent, to entertain—the whole community. No matter what the source of its financial support may be, the museum today is more and more a public cultural and educational institution.

This work was made possible through the assistance of a research grant from the National Endowment for the Humanities. Many other institutions and persons have helped me, and their contributions are detailed in the notes following each chapter. I ought to mention three libraries that have been especially useful: the Morris Library of the University of Delaware, the Reference Division of the British Library in London—formerly the British Museum Library—and the National Library of Wales in Aberystwyth.

I also found several relatives or descendants of the museum masters to be most helpful, especially the late Charles Coleman Sellers, for Charles Willson Peale; Dr. Rudolf Rimpau, for his grandfather, Wilhelm von Bode; Gunnel Hazelius Berg and her husband, Professor Gösta Berg, for her grandfather, Artur Hazelius; James M. Goode, collateral relative of George Brown Goode; Dietrich Thomas Hagenbeck, great-grandson of Carl Hagenbeck; and Rudolf von Miller, son of Oskar von Miller. Betty Bradford (Mrs. Rowland) Elzea, now of Wilmington, Delaware, was also influential in persuading me to include Sir Henry Cole as a subject. Two young women valiantly did translating for me—Patricia C. Sullivan from the German and Anne Levine from Swedish.

At the end of this journey into the past, I see an opportunity for two full biographies of great value for the art history field. One would treat Sir

Henry Cole, founder of what is today the Victoria and Albert Museum. Abundant primary source material exists for Cole, much of it in the Victoria and Albert Museum Art Library. And the breadth of Cole's reform interests would offer a chance to develop new understandings of the whole Victorian cultural era in England. The other biography would concern Dr. Wilhelm von Bode, art historian, nonpareil collector, and skilled administrator. Here the primary materials are abundant, but may be difficult to use, since several crates of his official papers are stored in the State Museums of East Berlin. Incidentally, Bode wrote a third volume of his autobiography (*Mein Lieben*) that has never been published and has been closed to readers for twenty-five years. It remains today in the State Library in West Berlin. Cole and Bode, two giant figures of their day, deserve closer investigation and analysis.

It has been pleasant to work again with the staff of the American Association for State and Local History in making this book. I early discussed the idea with Gary Gore, former Director of Publications, who has acted as designer of the volume, and he made valuable suggestions as to its scope. Betty Doak Elder, the present Director of Publications, has been most co-operative and effective in the publishing process; and Martha I. Strayhorn, the editor, has skillfully and patiently improved the text as she did for my earlier book on *Museums in Motion*.

I shall be most pleased if the new volume inspires others to explore the rich history of museums. Many important institutions and personalities are at hand, and the evolving museum profession can profit greatly from such studies.

Newark, Delaware                                    EDWARD P. ALEXANDER
April 1983

# Introduction:
# The New Museum

ET US begin by examining definitions of the word *museum*. By the eighteenth century, it had come to mean, as Dr. Samuel Johnson's *Dictionary* (1755) put it: "a Repository of learned Curiosities." Caspar F. Neickel (or Neickelius) of Hamburg in his *Museographia* (1727), written in Latin, called it a "chamber of treasures—rarities—objects of nature—of art and of reason." That kind of definition was encyclopedic, including as it did, natural and artificial (man-made) curiosities, the latter embracing also paintings, art objects, and books. Dr. Johnson's "learned Curiosities" also suggests the audience the museum was reaching: collectors, connoisseurs, scholars—the educated, wealthy elite. There was little concern for the masses, who were considered unimportant, loutish, and even revolutionary and dangerous. It is true, however, that, by that century, specialization was starting to appear. Books obviously constituted a different kind of object, and libraries began to be distinguished from museums. In the great houses of noble or wealthy collectors, paintings were often placed in a long, narrow room, lit by windows from each side and called a *gallery* (occasionally *pinacotheca*), while natural history and artificial curiosities other than paintings and sculpture were stored in a more private and secure interior room called a *cabinet, chamber,* or *closet.*[1]

Two examples of modern definitions of the word *museum* show great changes in its meaning from those of an earlier day. The American Association of Museums, for purposes of its national accreditation program, in 1970 defined a museum as "an organized and permanent nonprofit institution, essentially educational or aesthetic in purpose, with professional staff, which owns and utilizes tangible objects, cares for them and exhibits them to the public on some regular schedule." The association has since expanded that definition to include certain organizations—such as art centers, science/technology centers, and planetariums—that do not collect objects. The International Council of Museums (ICOM), which has active national committees in about seventy countries, in 1974 agreed that a museum is a "non-profitmaking, permanent institution in the service of society and of its development, and open to the public, which acquires, conserves, researches, communicates, and exhibits, for purposes of study, education, and enjoyment, material evidence of man and his environment." Notice here the idealistic aim of *service to society and its development* and the emphasis upon the public, as opposed to any elitist group, and upon study, education, and

enjoyment. Both modern definitions are greatly concerned with public exhibition and education, functions almost entirely neglected in the eighteenth-century museum.[2]

## II

This book treats twelve imaginative museum leaders who gave thought to the purposes of museums and took the institutions with which they were connected in new directions that have significance today. The study tries to understand enough of their careers and personalities and the times in which they lived to explain why they acted as they did in the museum field and to discuss the effects that their ideas and institutions have had, since their day.

Sir Hans Sloane, a leading court physician and naturalist of his time, was not a director or curator of an organized museum, but he bequeathed (at a modest price) his vast private collection to the government of England in 1753, to form the venerable British Museum. His holdings comprised about 50,000 volumes of rare books and 3,500 of manuscripts; geological materials; plants—including a herbarium of dried specimens mounted on heavy paper in 334 large volumes; zoological specimens, often preserved by taxidermy or in spirits, ranging from insects to fishes, birds, and quadrupeds; antiquities and ethnographic materials; coins and medals; paintings, drawings, and prints; and technological paraphernalia. Among its curiosities, according to Horace Walpole, a trustee under Sloane's will, were embryos, cockleshells, hippopotamuses, sharks with one ear, and spiders as big as geese. Sloane conceived of the museum as containing both books and objects, and the British Museum opened in 1759, as library and museum combined. Not until 1973 were the branches of the institution separated administratively, and—later—an agreement was reached to move the library one of these days from the present British Museum in Bloomsbury to a new location on Euston Road, several blocks away.

Sir Hans occasionally showed his treasures to royalty, to notable personages such as Voltaire or Handel, and to curious scholars like Linnaeus or Benjamin Franklin, who sought him out. Nevertheless, he favored a larger and broader audience, as is evident in his leaving his collection to the nation and asking that it be kept in or about populous London, where the most people would use it. In negotiating with Parliament about the collection, Sloane's trustees insisted that the public must "have free Access to view and peruse the same." For a time, however,

the British Museum carelessly allowed many materials to deteriorate and reserved their use mainly for visiting scholars and its own staff. It was difficult for ordinary viewers to inspect and enjoy the collection; a would-be visitor had to make two or three trips to obtain a free ticket, one had to enter past armed soldiers at the gate, the escorted tours were hurried and perfunctory, and no children were admitted.

In Philadelphia, Charles Willson Peale's privately owned and operated museum, fully opened in 1786, was very differently organized from most of its solemn European prototypes. Peale thought a natural history museum should be arranged according to the Linnean classification, so as to show God's plan and the natural laws underlying the universe, and he believed that museum visits would help make viewers lead lives of peace and happiness. Since humankind was part of the animal kingdom, a portrait gallery of Revolutionary heroes, Founding Fathers, and great naturalists could be justified to accompany the natural history and technological collections. Peale provided scientific classification and learned lectures that used museum objects, and he led a paleozoological expedition to New York State to excavate two skeletons of the mighty mammoth or mastodon. Peale also had a keen sense of humor and tried to make his museum fun to visit. He devised stimulating exhibits, including habitat settings for his birds; he showed live animals, especially snakes, and staged demonstrations of electricity and chemistry, eventually under brilliant gas lighting. Peale was never able to secure satisfactory funding for his museum, and, after his death, it ultimately failed; but he had set a pattern for American museums, with emphasis upon exciting exhibits and popular participatory educational activities.

Dominique Vivant Denon, after 1802, successfully established the Musée Napoléon at the Louvre in Paris as the most magnificent and beautiful art museum in the world, thanks mainly to the great masterpieces of painting and sculpture that he helped Napoleon to loot from the countries conquered by Bonaparte's armies. Thus the art museum became a vivid symbol of national glory and of empire. Though its special parties and civic celebrations were normally reserved for the court circle, still the masses thronged the museum on public days, while artists and students had special days reserved for them. As Napoleon's imaginative and tasteful director of fine arts, Denon also commissioned historical paintings, portraits, and monuments, and directed the state factories producing porcelains, tapestries, and carpets. He fixed the historical arrangement of old master paintings in the museum chronologically by schools and artists, rather than by color harmony or canvas size. He set

standards of exhibition and conservation that continued to be followed at the Louvre and by the rulers to whom many captured art works were returned after Waterloo.

Beginning in 1841, William Jackson Hooker brought the botanical garden fully into the modern museum movement. Both botanical and zoological gardens are forms of museums, though their collections are living rather than inanimate. Hooker transformed the Royal Botanical Gardens at Kew, just west of London, from a small botanic garden and pleasure ground—the personal domain of the royal family—into a great national public institution. Earlier "physic" gardens had, since medieval times, usually been closely linked with university medical schools, but Hooker made Kew practical instruction and delightful recreation for the general public as well as scientifically useful for both medicine and industry. He established a museum of economic botany in the garden that showed how plants were employed for food, building, medicine, cordage, and in many other ways. Kew served the British Empire well, sending out plant explorers to find useful flora that could be introduced into appropriate colonies, cultivating and improving them, and distributing them around the world. Thus, cinchona—Peruvian bark that contained quinine, a specific cure for malaria—was sent to be grown in many tropical colonies, enabling the army, civilian officials, and their families to live safely in areas where malaria was prevalent. Later, other spectacular advances occurred, as when para rubber plants were transferred from South America and sisal from Central America to Indochina, India, Africa, and elsewhere. Kew also advanced so rapidly scientifically that it became a world leader in biological research.

Henry Cole, beginning in 1852, directed the museum that later was renamed the Victoria and Albert, and Cole's influence on museums around the world was marked. He was the chief executive of the Great Exhibition of 1851, the first world's fair, an extravaganza planned by Prince Albert and Cole and staged at London's Hyde Park in the impressive iron and glass building known as the Crystal Palace. More than six million people experienced that international exposition, and, as Thomas R. Adam has observed, world's fairs "opened the way for the renaissance of the modern museum in terms of dramatic displays relevant to the social life of the community."[3] Cole's museum combined collections of "world's-fair" type pertaining to contemporary education, architecture, building materials, economic plants, food, and the like with more conventional art and much concentration on decorative arts materials. The museum provided metropolitan London with special exhibits, lectures, seminars,

night openings (using the newly invented gas-lighting), parties, and popular publications; it also served all Britain with objects from the collections lent or reproduced for local art schools (and, later, museums) and with spectacular traveling exhibitions. Cole's museum was a leader in the field of popular education, in many ways similar to modern American museums.

Ann Pamela Cunningham from South Carolina founded one of the first historic house museums in the United States, when she organized the Mount Vernon Ladies' Association of the Union in 1858, to save from destruction George Washington's plantation of Mount Vernon, situated on the Potomac River in Virginia, a few miles south of Washington, D.C. The Ladies raised $200,000 in a great public drive to purchase the plantation and managed to protect it while it occupied a perilous no man's land during the cataclysmic Civil War. They operated Mount Vernon first as a shrine, but slowly increased the authenticity of its buildings, gardens, and furnishings, as they pursued their ideal of showing the plantation as Washington knew it. A viceregent from each state (with one as regent) served as the governing board of the association. The Mount Vernon undertaking demonstrated the way talented and energetic women volunteers could conduct successfully such a project, and historic houses, many of them privately administered by volunteer boards, constitute today the most numerous type of American museum.

The museum movement began to flourish in Germany in 1872, when Wilhelm Bode joined the staff of the Prussian Royal Picture Gallery in Berlin. Enthusiastic connoisseur, thorough scholar, and ingenious administrator, Bode built a great "Museum Island" complex (actually, it was on the peninsula between the Spree and Kupfergraben rivers) in central Berlin. In 1905, he became director general of the complex and retained much influence until his death in 1929. His art museums reached the stature of those in Paris and London and could compete with the ones springing up in the prospering United States. Berlin possessed a museum of world art with not only Egyptian, classical, and European artifacts, but also Islamic, pre-Columbian, Oceanic, and Far Eastern materials. The collection overflowed the Museum Island into neighboring areas and even to the suburb of Dahlem in western Berlin.

Though Bode's greatest contributions were in the collecting field, he attracted heavy visitation with well-presented special exhibitions, experimented with period room settings, and developed scientific conservation policies. About 1894, he organized the first Friends of the Museum organization in the world; the Kaiser Friedrich Museums Verein provided

private funds that enabled him to purchase desired art works expeditiously; the Verein retained ownership of the art works, but deposited them with the Berlin Museums. World War II and the Berlin Wall have torn apart the museum center he built, but many of his collecting accomplishments are still visible today, even though divided between the museums of East and West Berlin.

Meanwhile, another important museum innovator was at work in Sweden. Artur Hazelius decided to collect, exhibit, and study the material culture of the Scandinavian folk, especially that of the agricultural, preindustrial society of the peasants. In 1873, he opened his Museum of Scandinavian Ethnography in two small pavilions in the center of Stockholm. In his exhibitions, Hazelius used historical period rooms and theatrical tableaux portraying dramatic, sentimental scenes, some of which he took to the Paris world's fair of 1878, where they created a sensation. He reorganized his indoor displays as Nordiska Museet in 1880; and then, in 1891, he opened a new open-air or outdoor section on a hillside overlooking Stockholm harbor and city. It was called *Skansen* (Redoubt), after an old fortification there. To form a typical peasant settlement, he moved in buildings, chiefly of vernacular rural architecture, from different parts of Sweden, provided them with appropriate landscape and authentic furnishings, and brought them to life with costumed guides and musicians. He also made Skansen the center for popular celebrations of national and seasonal holidays.

This first extensive open-air museum attracted enormously heavy attendance. The common people, who often had felt ill at ease in monumental museum buildings, brought their families with them to the open-air setting; the new outdoor approach combined inconspicuously the educational function of the museum with the lighthearted air of a picnic. The outdoor museum idea, whether it took shape in an actual preserved historic area or was made up of assembled buildings, settings, and furnishings, soon spread throughout the world.

The first truly modern museum executive in the United States was George Brown Goode, director of the United States National Museum of the Smithsonian Institution in Washington. Goode, like Henry Cole, received much of his museum inspiration from a world's fair, in this instance the Centennial Exhibition of American independence at Philadelphia in 1876. After it closed, some forty freight cars of exhibits came to the National Museum, and in 1881 a Victorian red-brick structure was erected to house them—the Smithsonian's present Arts and Industries Building. Goode set about organizing a new kind of museum—what he

called a National Museum of Cultural History, which would include historical, anthropological, and art objects, as well as the usual geological, botanical, and zoological specimens of natural history. Goode thought out in detail a broad museum philosophy and administrative principles, and he made many contributions in case design, use of labels and taxidermy, and in other practical and technical areas. Despite his tragic early death (in 1896, at age forty-five), Goode's holistic philosophy laid the foundations for the growth of the present Smithsonian museum megalopolis.

Carl Hagenbeck of Hamburg, a wild-animal dealer and circus supplier, was a perceptive connoisseur of animals who devised effective but humane methods of training them. Hagenbeck revolutionized the menagerie and zoo by confining animals behind deep ditches or moats, so that they could be viewed in what resembled their natural environment, rather than in cramped cages behind bars. In 1907 Hagenbeck opened his new private zoo at Stellingen, a suburb of Hamburg. The zoo was situated on a level plain, but provided with concrete mountains, pools, and other appropriate artificial terrain, the whole made beautiful by careful planting. Prehistoric animals of concrete were added in realistic natural settings. The public could observe real dolphins, seals, walruses, penguins, elephants, tigers, and many other beasts being fed and, in many cases, performing tricks. The zoo thus became a much more pleasant place for both animals and their human watchers, and the modern moated system is now used throughout the world. The zoo also has formed a refuge for endangered species, a protected place where their reproduction is encouraged.

A forceful and charismatic electrical engineer, Oskar von Miller, of Munich, transformed the industrial, technological, or science museum from a storage collection designed chiefly for scholars and experts to an active educational institution with maximum audience participation. Von Miller, who had had experience in managing early industrial fairs, founded the Deutsches Museum at Munich in 1903. He soon opened temporary exhibits in old buildings downtown, and then, in 1925, moved into a new, carefully designed structure on another Museum Island, this one in the River Isar. The museum had a large, comprehensive collection and a fine research library, but its methods of using its resources were especially impressive. They included numerous exhibits activated by the visitor, by means of push buttons or cranks; a coal mine, submarine, and many huge machines; alluring demonstrations of the processes of chemistry and physics, including electricity; the first optical planetarium; and numerous educational programs for school children, industrial trainees,

and varied adult audiences. Though the Deutsches Museum had both a distinguished collection of historical equipment and telling methods of interpreting modern technology, the latter feature was adopted by many science/technology centers that sprang up around the world. And museums in other fields used the effective exhibition and interpretive techniques of the Deutsches.

John Cotton Dana, librarian of the Newark (New Jersey) Public Library, had been a pioneer in applying the ideal of community service to the public library movement. In 1909, he founded the Newark Museum Association, to provide his library with an art, natural history, historical, and technological museum that would operate under the same public service philosophy as that of the public library. Dana considered the ordinary art museum a useless "gazing museum" and its curators out of touch with the public and its needs. He used well-conceived special exhibits to show local industrialists and their workers what was going on in German applied arts, to feature New Jersey clay products, textiles, leather, jewelry, and other manufactures, and to display inexpensive articles of good design purchased from local five-and-ten-cent and department stores. Such temporary, changing exhibits explored all parts of the community, making much of areas with immigrant and racial backgrounds. A constant stream of community and school groups came to the museum, and objects, exhibits, labels, leaflets, lantern slides, and museum staff went to the schools and to all kinds of community organizations. Branch museums were advocated for vacant store fronts. These activities were accompanied by vigorous and imaginative advertising, which Dana considered "the very life-blood of all the education a museum can give."[4]

Dana's democratizing methods enlisted the community enthusiastically behind his Newark Museum, which obtained its own building in 1926; and his articulate books, articles, addresses, and letters to the editor, all illustrating a zest for argument and controversy, spread his community service credo far and wide. Many museums today, especially smaller ones and the newer American neighborhood and minority museums, are continuing actively the movement Dana started.

The innovative contributions of these museum masters have changed the nature of the museum. No longer is it a miscellaneous collection of curiosities with little attention to the way it is viewed. No longer is it a mere storehouse, its carefully classified objects arranged much as books are, in a library. No longer is it aimed only at the cognoscenti—the learned scholars and collectors, including its own staff. Instead, its collections are

divided between those exhibited for the general public and those reserved for study and research. The popular exhibits, whether temporary or permanent, are carefully selected, with themes that tell a story, with emphasis upon functional arrangement, and with participatory activities to involve the viewers. Though study collections are often kept in storage, museum administrators strive to have them well arranged and accessible to scholars. And the museum is an active learning center, with trained guides or interpreters, skilled demonstrators, special lectures, discussions, and seminars, popularly written publications, films and soundtapes, and much hands-on participation, as well as an active outreach program that takes objects, publications, audiovisual materials, television programs, and staff members to schools and varied audiences throughout the community.

These museum masters, however, were usually deficient in one area: they failed to develop strong conservation programs for their collections. In general, they were so insistent upon making extensive use of the collections that they tended to neglect preservation practices. There were, it is true, a few exceptions. Vivant Denon at the Louvre secured skillful cleaning and rebacking of paintings. Henry Cole at the South Kensington (Victoria and Albert) Museum gave lip service to protection of the paintings and art objects he circulated throughout Britain, and his curator, J. C. Robinson, built a separate collection of sturdy materials including copies to be shipped about, so as to keep the rarer and more fragile items at home. But the development of modern concepts of conservation, largely, has come later, with heavy attendance, increasing industrial pollution, and the development of more scientific methods of controlling temperature, humidity, and lighting, and of making repairs and restorations. Indeed, professional museum workers are only now becoming aware of the crucial need for preventive conservation and of the huge backlog of objects that need treatment.

As the above summaries indicate, the industrial exhibition or world's fair has had great influence on the museum. Half of the twelve museum masters discussed (Hooker, Cole, Hazelius, Goode, Hagenbeck, and von Miller) had some experience with such exhibitions, and Cole, Goode, and von Miller had actually organized fairs, or a major part of them. The enormous crowds these popular shows attracted made show producers devise exhibits that would stand out and, in some instances, actually operate (for example, the Machinery Hall at London in 1851, the Corliss engine at Philadelphia in 1876, and the electrically driven waterfalls and lighting at Munich and Frankfurt in 1882 and 1891). The need of museums

for better exhibition techniques such as planned circulation patterns, understandable labeling, and better oral and written interpretation was clearly shown by the fairs. The general social and educational impact of these fairs was tremendous upon audiences from laboring classes, rural areas, and small towns that had never seen such wonders. Still, William Stanley Jevons was right in doubting whether those walking hurriedly past so many objects on display gained much detailed and lasting understanding from them.[5] Through the years, the museum, with its trained interpreters, lecture and discussion activities, carefully written publications, and vivid audiovisual programs, outstripped the fair that aimed only to entertain for promotional and sales purposes.

Goode clearly understood the difference between trade fairs and museums. He thought that the first stimulated commerce and manufacturing, but considered popular education as only incidental, while "Museums are *first of all* educational—industrial promotion incidental." Goode deemed museum methods a hundredfold more effective; duplicate presentations and redundant advertising displays were eliminated, a historical method of arrangement was practicable, and the best illustrations could be selected and replaced as better ones were found. No wonder that museums were becoming more popular than fairs and deserved better permanent support.[6]

### III

Though this study has given its chief attention to showing ways in which museum masters have developed the modern museum, it has produced some secondary understandings. One of them is the realization that there is no preferred corporate form of museum organization. Four of the museums served by the leaders discussed here were direct branches of a national government. Denon's Musée Napoléon, Hooker's Kew Gardens, Cole's proto-Victoria and Albert Museum, and Bode's Berlin Museums all were controlled and financed in that way. Moreover, Napoleon, Queen Victoria and Prince Albert, and Kaiser Wilhelm II took deep personal interest in the welfare of their national museums.

Four other institutions, though mainly government supported, had independent boards of trustees in direct charge of them and acting as buffers between bureaucratic government and museum administration. The British Museum, started by Sloane's bequest, for more than two hundred years had a large and cumbersome board that included three principal trustees (the Archbishop of Canterbury, the Lord Chancellor,

and the Speaker of the House of Commons), representatives of the Sloane, Harley, Cotton, and later the Knight donor families, and various governmental and social leaders. Not until 1963 were the ex officio members dropped and the board reduced to twenty-five persons, the majority appointed by the Prime Minister.[7]

Henry Cole, who believed almost fanatically in direct lines of authority, argued strongly for complete governmental control of the British Museum that would abolish its board and make its administrator responsible to a cabinet minister and ultimately to Parliament. Joseph Dalton Hooker, Sir William's son and successor as director of Kew, however, between 1870 and 1872 had a frightening encounter with his superior, the First Commissioner of Works in Gladstone's government. That affair threatened to destroy Kew's scientific integrity, though Hooker finally won a partial victory. In the 1970s, the Victoria and Albert Museum, during a period of severe governmental retrenchment, received deeper cuts than did the British Museum, with its board to fight for it; the V-and-A even lost entirely its highly valued Regional Services (formerly Circulation) Department that, since 1852, had regularly sent exhibits throughout Britain.

Nordiska Museet and Skansen were for long a single organization, supported chiefly by the Swedish government, and had a policy-making board of seven trustees that included the director. In 1963 and 1964, however, the two sections were reorganized as separate museums, each with its own seven-member board. The Swedish state continued generous support of Nordiska Museet, while Skansen was financed about 33 percent by gate receipts, 40 percent by the city of Stockholm, and 27 percent by the state. Goode's United States National Museum in Washington was part of the Smithsonian Institution, mainly sustained by the federal government, but with a considerable private endowment that went back to the original Smithson bequest of more than $500,000. Its governing board today consists of the chief justice of the United States, the vice-president, three senators, three representatives, and nine private citizens appointed by joint resolution of Congress. The Smithsonian, drawing governance and funding from both the federal government and the private sector, seems to have enjoyed more flexibility and creativity in its management than if it had been completely integrated into the governmental structure.

Dana's Newark Museum represents the compromise between local governmental and private support characteristic of many American museums. This arrangement can be traced back to the agreement of 1871 of the city of New York with the Metropolitan Museum of Art and the

American Museum of Natural History. The city was to pay the cost of erecting buildings and providing for building maintenance and security, while the two museum boards were responsible for the collections and educational programs. About one hundred museums throughout the United States have somewhat similar arrangements with their local governments. While straitened city finances in the present inflationary period have made necessary some diminution of city contributions, the system in general has worked well through the years. The Newark Museum Association was a membership organization with a board of fifty-five trustees. It owned the museum buildings and collections and acquired new accessions, but the city of Newark paid most operating expenses. In 1969, a controversy with the Newark city council threatened to cut off the city appropriation entirely, but it was restored when the state of New Jersey and Essex County assumed part of the museum's financial burden.

Von Miller's Deutsches Museum in Munich was also a membership organization with a large board or advisory council of 102 members and a powerful small executive committee (originally only three members, including the director). The museum received large grants from the German federal government, the state of Bavaria, and the city of Munich, as well as strong support from other German municipalities and industries.

Miss Cunningham's Mount Vernon Ladies' Association was entirely private and governed by a board composed of a viceregent from each state, one of the viceregents serving as regent. Thus far, the MVLA has been financed chiefly by admission fees and by contributions raised by the board. Peale's museum in Philadelphia, despite valiant efforts of its founder to obtain federal, state, or city funding, was privately run and largely dependent on admission fees for most of its life, but eventually organized—disastrously, as it turned out—as a commercial corporation in 1821. Carl Hagenbeck's Tierpark in Stellingen is most unusual, in that it has always been entirely private, has no board, and receives no tax exemption as an educational institution. Usually, a single family member has administered it, sometimes seeking advice and assistance from other family members or elsewhere. Perhaps the city of Hamburg has become more co-operative toward the zoo through the years, as its attraction for tourists has grown.

All these forms of museum organization, from actual branch of national government to purely private control and financing, can succeed, with effective leadership. The wisest arrangement today, however, seems to call for some combination of governmental and private support.

Thus, the West Berlin part of Bode's museum complex has been taken over by a governmental foundation, the Preussischer Kulturbesitz, but the Verein, or Friends, organization continues to secure backing from the private sector. The Louvre since 1897 had its Amis du Louvre organization, and there is also a thriving Skansen Association. Such bodies are especially valuable for governmentally controlled and supported museums, because they enlist financial aid from the private sector, furnish the museum administration with opportunities for quicker and more flexible action than that allowed by the usual government procedures, and they make the museum better known throughout the community it serves.

It is also instructive to observe how much these museum leaders and their institutions have depended upon the well-being and prosperity of their nations. Vivant Denon and the Louvre flourished as long as Napoleon was victorious in Europe and France was a strong world leader. The British Empire was at its height during the nineteenth century, and Sloane's British Museum, Hooker at Kew, and Cole at the developing Victoria and Albert Museum all reflected the lofty imperial stature. The rise of the German Empire after 1871 greatly benefited Bode in Berlin, Hagenbeck in Hamburg, and von Miller in Munich. Hazelius in Stockholm was aided by the sound economy and cultural nationalism of Sweden. Though the United States was too slow in its support of museums to save the Peales, conditions were more favorable at the time of the Smithson bequest, while the abundant prosperity of the country after World War II enabled the Smithsonian museum network to attain world leadership. Similarly, Miss Cunningham's Mount Vernon and Dana's Newark Museum have profited from the national growth and prosperity.

National decline and disasters also affect museums. Waterloo dealt Denon's museum at the Louvre a grievous blow from which it took years to recover. German defeat in World War II and the division of Berlin into two unfriendly governments separated by the ugly Berlin Wall have given Bode's former museums special problems. And economic inflation and downturn recently have threatened the development of museums in many countries.

Not all great museums were created or led by a single museum master, as were the dozen examined here. Some museums in the United States, for example—the Museum of Fine Arts in Boston, the Metropolitan Museum of Art in New York, the American Museum of Natural History in New York, and the Field Museum of Natural History in Chicago, to name only four—while they did not enjoy such conspicuously successful individual leadership, yet, as institutions, made important contributions to

museum history and philosophy. It may be true that today's museums, with their complex organizations and varied and specialized museum professionals, are less likely to produce this kind of individual leader and that the museum master phenomenon was especially characteristic of the museum pioneering era of the nineteenth and early twentieth centuries. There is an old argument among historians, concerning whether the development of human institutions results mainly from the efforts of great men and women, or from social forces built on small accretions of wisdom and the co-operative efforts of many persons.

In any event, the museum masters treated here have greatly advanced the cause of the museum. They have improved the excellence of museum collections, begun to provide better conservation, and they have used museum exhibitions and educational programs to reach both the general public and the research scholar. Great new museums are still constantly springing up—the Museum of Modern Art in New York, Louisiana in Denmark, or the Centre Pompidou in Paris, the Smithsonian's new branches in Washington, or the National Museum of Anthropology in Mexico City, Colonial Williamsburg in Virginia, or the Ironbridge Gorge Museum in Shropshire, the Henry Francis du Pont Winterthur Museum in Delaware, or the J. Paul Getty Museum in California, and many, many others. We are too close to the events and too lacking in the needed historical perspective to decide whether and which museum masters have been recently or are presently at work. But museums are individualistic and flexible institutions that encourage creativity and experimentation. Thus, museum masters will continue to appear, to bring the understanding and inspiration that objects can provide to larger segments of human society and to serve their communities more pervasively. For, as Sir William Flower, director of the British Museum (Natural History) observed in 1889: "What a museum really depends upon for its success and usefulness is not its building, not its cases, not even its specimens, but its curator. He and his staff are the life and soul of the institution."[8] We may argue whether the museum master should be called *curator* or *director*, but the truth of Flower's sentiment holds, in either case.

## IV

Does the present study have any value for modern members of the museum profession and for students contemplating entry into it? This emerging profession often appears so new today, when compared with the subject matter specialties with which it is inextricably bound, that the

young museum worker is tempted to regard himself or herself as an art historian, a natural scientist or a physical scientist, a historian, an anthropologist, an educator, a management specialist, or a member of some other calling recognized for a longer period and more clearly delineated. The youngster may decide that he or she just happens to work in a museum and may despise the very word *museologist*. Museum people also today too often regard themselves as highly innovative and tend to believe that the museum practices they are applying and improving have been discovered and agreed upon only recently—say, five or ten years ago, long since the time the present graybeards of the profession were in their prime.

Museums, of course, are exciting places in which to work, with many variations, great flexibility, and countless opportunities for originality and creativity. An important factor in the museum situation, however, and a real necessity for the best kind of productive output, whether in collecting, conserving, research, exhibition, or interpretation, is loyalty to the central museum concept and co-operation among the specialists involved. The goal of effective governance and enlightened management is to secure that kind of harmonious teamwork.

A strong professional tradition can help obtain better museums and museum professionals. The present study has been an eye-opener to its author. He has marveled at the ingenious ways these museum masters have devised to meet the problems encountered in carrying out their aims. He has come to see that the modern museum movement in its history of a century or two has experimented with many approaches and arrangements, and has built a strong body of experience, the successes and failures of which modern museum workers can consult in meeting present-day opportunities. There are also many inspiring role models in the story whose close acquaintance it is privilege to make. Museums are indeed learning centers, with a long and vital tradition that has produced important cultural leaders. And these museum masters may well convince modern museum workers that they constitute a stronger and better defined profession than they hitherto had realized.

## NOTES

NOTE: Source notes and a selected bibliography are provided at the end of each chapter in this book, listing works referred to in the chapter and especially pertinent to it. Many of the notes are given in shortened form, since full publication data for them appear in the

bibliography. Initial reference to book-length works listed in the bibliography consist of the author's full name, the main title of the work cited (in italics, with no subtitle), and the page numbers of the reference. First reference to journal articles listed in the bibliography consist of the author's full name, title (in quotation marks) and source of the article, and relevant page numbers. Works not listed in the chapter bibliography appear with full publication data at first mention in the chapter notes and as shortened references thereafter.

1. Alma S. Wittlin, *The Museum*, pp. 1–6; Germain Bazin, *The Museum Age*, pp. 115, 116.
2. American Association of Museums, *Professional Standards for Museum Accreditation*, p. 9; Kenneth Hudson, *Museums for the 1980s*, p.1.
3. Quoted by Hudson, *Museums for the 1980s*, p. 8
4. John Cotton Dana, *The New Museum*, p. 39.
5. William Stanley Jevons, "The Use and Abuse of Museums," in *Methods of Social Reform and Other Papers*, pp. 58–81. See also Eugene S. Ferguson, "Technical Museums and International Exhibitions," *Technology and Culture* 6 (Winter 1965): 30–46.
6. George Brown Goode to Senator Joseph Rosewell Hawley, 8 August 1889, Smithsonian Archives, unit series 54, box 3, letterbook, 1889–1892, pp. 112–128.
7. Edward Miller, *That Noble Cabinet*, pp. 48, 108, 357–358.
8. Sir William Henry Flower, *Essays on Museums and Other Subjects Connected with Natural History*, p. 12.

## SELECT BIBLIOGRAPHY

American Association of Museums. *Professional Standards for Museum Accreditation: A Handbook of the Accreditation Program of the American Association of Museums*. Edited by H. G. Swinney. Washington, D.C.: American Association of Museums, 1978. 79 pp.
Bazin, Germain. *The Museum Age*. New York: Universe Books, 1967. 302 pp.
Dana, John Cotton. *The New Museum*. Woodstock, Vermont: Elm Tree Press, 1917. 52 pp.
Flower, Sir William Henry. *Essays on Museums and Other Subjects Connected with Natural History*. London and New York: Macmillan and Company, 1898. 394 pp.
Hudson, Kenneth. *Museums for the 1980s: A Survey of World Trends*. New York: Holmes & Meier, 1977. 198 pp.
Jevons, William Stanley. "The Use and Abuse of Museums," in *Methods of Social Reform and Other Papers*, pp. 58–81. London: Macmillan and Company, 1883. Reprint. New York: Augustus M. Kelley, 1965.
Miller, Edward. *That Noble Cabinet: A History of the British Museum*. Athens, Ohio: Ohio University Press, 1974. 400 pp.
Wittlin, Alma S. *The Museum: Its History and Its Tasks in Education*. London: Routledge & Kegan Paul, 1949. 297 pp.

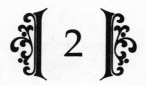

# Sir Hans Sloane
# and the British Museum:
# From Collection of Curiosities
# to National Treasure

Fig. 1. Sir Hans Sloane (1660–1753). Portrait by Sir Godfrey Kneller in the British Museum. *(Courtesy of the Trustees of the British Museum, London.)*

I

*T*HE YOUNG man was faced with a hard decision. The Duke of Albemarle was going out from England to Jamaica as governor in 1687 and wanted a doctor to accompany him and his family on the voyage. He asked his physician, Dr. Peter Barwick, to recommend someone, and Barwick sought advice from his young colleague, Dr. Hans Sloane. Then twenty-seven years old, Sloane was building a prosperous medical practice in London, had recently been elected a fellow of the Royal Society, and was about to become a fellow of the Royal College of Physicians. Would he imperil a promising medical career by volunteering to accompany Albemarle? Then, too, long sea voyages offered considerable risk, in those days, as did tropical diseases. Crusty old Dr. Thomas Sydenham, Sloane's friend and patron, told him: "No, you must not go to Jamaica: you had better drown yourself in Rosamund's pond."[1] (Rosamund's pond was a small body of water in St. James's Park and a frequent resort of suicides.)

Dr. Sloane, however, was no ordinary medical practitioner. While he made the relief of human suffering the first aim of his life, he was also an enthusiastic and dedicated student of natural science, especially botany. Thus, he sought the advice of John Ray, his close friend and correspondent and the greatest British botanist of the day. Ray cautiously backed his going in these words:

Were it not for the danger and hazard of so long a voyage, I could heartily wish such a person as yourself might travel to Jamaica, and search out and examine thoroughly the natural varieties of that island. Much light might be given to the history of the American plants, by one so well prepared for such an undertaking by a comprehensive knowledge of the European.

And in a later letter, Ray added: "We expect great things from you."[2]

Sloane soon made his decision to accompany Albemarle to Jamaica. He demanded certain stipulations, however, that illustrate shrewd business acumen. It was agreed that if

Dr. Sloane go as physician to the West Indian Fleet [of which Albemarle was the admiral], the surgeons of all the ships must be ordered to observe his directions. . . . He proposes that six hundred pounds, per annum, shall be paid to him quarterly, with a previous payment of three hundred pounds, in order to his preparation to this service; and also that if the Fleet shall be called home he shall have leave to stay in the West Indies if he pleases.[3]

These terms, which were agreed to, provided generous payment indeed.

21

Sloane carefully described the Jamaica voyage in the two large folio volumes of his *Natural History of Jamaica,* published in 1707 and 1725.[4] Seasick at the start, he recovered, to observe closely the birds, fish, and jellyfish the fleet passed and the plant life at the island stops. In Jamaica, he entered meteorological records, transcribed music played by blacks at festivals, described a sharp earthquake and his travels through the wildest parts of the island, and kept case histories of the patients he treated. Among them was the old retired buccaneer Sir Henry Morgan, lieutenant governor of the island. Morgan ignored Sloane's warnings against intemperance and carousing, and, according to Sloane, called in a black doctor, "who promised to Cure him, but he languished and his Cough augmenting died soon after."[5] When the Duke of Albemarle (also an intemperate carouser) expired in 1689, his widow wished to return home, and Sloane accompanied her. He took along a yellow snake seven feet long, a guana or iguana, and a crocodile or alligator, but they all perished on the voyage.

Sloane was an early example of the learned traveler who carefully examined the geography and history of a region, the flora and fauna, and the inhabitants with their customs and trade. He attempted to put down his observations with meticulous accuracy and was a worthy predecessor of Joseph Banks, Charles Darwin, Joseph Hooker, and other famed British scientist travelers. After his return to London, he issued a catalogue of Jamaica plants (*Catalogus Plantarium quae in Insula Jamaica . . .* )[6] in 1696 and then, later, the *Natural History.* These volumes were unusual in that Sloane described only specimens that he had actually encountered in their natural environment and tried to give a short history for each, laboriously digesting the comments of previous writers.

Sloane brought back some eight hundred plants, most of them previously unknown, either live or mounted as herbarium specimens. With customary generosity, he shared them with his botanical friends, such as John Ray; William Charleton (Courten), who had a museum of his own; Sir Arthur Rawdon of Moira in Ireland, who then sent his gardener James Harlow to Jamaica to gather shrubs and trees; and the enthusiastic and knowledgeable Duchess of Beaufort, who brought exotic plants to perfection in her garden at Badminton.

Sloane's Jamaica voyage shows two characteristics that he was to develop in his long life, both of great importance for the future welfare of museums. First of all, he had become a full-fledged collector of natural (and later artificial) curiosities, to which he would henceforth devote his energies and his rapidly increasing wealth. John Evelyn visited the collection in 1691 and reported in his diary:

I went to see Dr. Sloane's curiosities, being a universal collection of the natural productions of Jamaica, consisting of plants, fruits, corals, minerals, stones, earth, shells, animals, insects etc. collected with great judgement; several folios of dried plants, and one which had about eighty several sorts of ferns, and another of grapes; the Jamaica pepper in branch, leaves, flower, fruit etc. This collection, with his journal and other philosophical discourses and observations, is indeed very copious and extraordinary, sufficient to furnish a history of that island, to which I encouraged him.[7]

Another characteristic Sloane demonstrated was his level-headed financial sense. Not only did he make a profitable arrangement for his payment as a physician on the trip to Jamaica, but he also invested some of that money in a stock of Peruvian bark (cinchona, which contained quinine). He greatly approved of that remedy for fevers and ague (usually malaria) and prescribed it also for nervous disorders and hemorrhages. Sloane was impressed, too, by the Jamaicans' use of chocolate, and he mixed it with milk as a drink for invalids. "Sir Hans Sloane's Milk Chocolate" was sold by Nicholas Sanders and later by William White on Greek Street in Soho and "Greatly recommended by several eminent Physicians especially those of Sir Hans Sloane's acquaintance" for "its Lightness on the Stomach, & its great Use in all Consumptive Cases."[8] Sloane may have received some kind of royalty from this product. His surviving accounts for 1719 and 1724 show that he was importing sugar from Jamaica in five or six ships each year, obviously a profitable undertaking. The good doctor also made a considerable addition to his fortune in 1695, when he was married to Elizabeth Langley Rose, whom he had met in Jamaica. She was the daughter and heiress of John Langley, alderman of London, and widow of Dr. Fulk Rose, with whom Sloane had collaborated occasionally in Jamaica; she inherited one-third of the income of Rose's extensive estate. Thus, the well-organized and canny Sloane gave evidence of the entrepreneurial skill with which he was able ultimately to promise permanence for his collections through an ingenious will that resulted in the establishment of the British Museum.

## II

Hans Sloane was born on April 16, 1660, at Killyleagh, County Down, in northern Ireland. His father, Alexander, of Scottish descent, was receiver-general of taxes and trusted lieutenant of James Hamilton, Earl of Clanbrassil, and his mother, Sarah Hickes, was the daughter of the prebendary of the cathedral church of Winchester. Hans attended a classical school at Killyleagh, but was even more attracted by the plants

and wildlife on the shores of the neighboring Lake of Stangford. He wrote later that, from his youth, he had "been very much pleas'd with the Study of Plants, and other Parts of Nature, and had seen most of those Kinds of Curiosities, which were to be found either in the Fields, or in the Gardens or Cabinets of the Curious in these parts."[9] He explored uninhabited islands off the Irish coast, where the seabirds had laid their eggs "so thick that it was difficult to pass along without treading on them, while the Birds made a terrible noise over our Heads."[10]

This idyllic life was threatened when, at age sixteen, Hans began to spit up blood, probably because of tuberculosis. By placing himself on a strict regimen and barring wine and spirituous liquors, he managed to live until age ninety-three. In 1679, he felt well enough to go to London to study medicine. For the next five years, Sloane attended lectures on anatomy, medicine, chemistry, and botany, and visited physic gardens and hospitals. He studied chemistry with Nicolaus Staphorst and botany with John Watts, curator of the Physic Garden of the Society of Apothecaries in Chelsea. He also became acquainted with John Ray and with Robert Boyle, the famed chemist.

In the spring of 1683, Sloane set out for a year abroad with Tancred Robinson and another fellow student. In Paris, the young men attended the hospital of La Charité. Joseph Pitton de Tournefot taught them botany and Joseph Guichard Durverney, anatomy. Because only Catholics could receive a degree there, late in July Sloane journeyed to the University of Orange, a tiny Dutch Protestant enclave in southern France, to be examined, to "argue and maintain a disputation," and to receive the degree Doctor of Physic with the highest honors. He was described in the record of the proceedings as "of medium height, hair very short, light chestnut, face rather long and grave, marked with the small pox."[11] While his companions continued their tour to Italy, Dr. Sloane went to the University of Montpellier in the south of France, with its well-known botanical garden. He studied anatomy and medicine with Pierre Chirac and botany with Pierre Magnol, for whom the genus *Magnolia* was named. By the fall of 1684, Dr. Sloane was back in London, ready to practice medicine.

The distinguished Mr. Boyle gave Sloane a letter to Dr. Sydenham, a leading physician of the day, recommending the young doctor as a ripe scholar, good botanist, and skillful anatomist. Upon reading this, the eccentric Sydenham exploded:

That is all mighty fine, but it won't do—Anatomy, Botany—Nonsense! Sir, I know an old woman in Covent Garden who understands botany better, and as for anatomy, my butcher can dissect a joint full as well; no, young man, all this is Stuff: you must go to the bedside, it is there alone that you can learn disease.[12]

Despite such an intemperate outburst, Sydenham liked Sloane, who made it a rule to favor matter-of-fact experiment or observation over hypothesis. "The mischiefs these Hypotheses, and the Authors have done," he explained on one occasion, "by putting People from further search, out of the way, and making them wrest matters of Fact to their Fancies, have been very great."[13] Thus, many physicians refused to use Peruvian bark because it could not alter or void the humors then in vogue in medical theory, even though it was plain that quinine reduced temperature in fever. Dr. Sloane applied the usual remedies of his day—for example, bleeding, vomiting, and blistering—but he considered that "sobriety, temperance and moderation are the best and most powerful preservatives that Nature has granted to mankind."[14] He also understood something about psychosomatic medicine and in Jamaica observed: "The passions of the mind have a very great power on mankind here, especially hysterical women and hypochondriacal men."[15] As early as 1716, he advocated inoculation for smallpox and counseled Caroline, then Princess of Wales, to have her daughters so treated.

Sloane's outgoing, cheerful nature provided him with an unsurpassed bedside manner that had much to do with his success as a physician. He enjoyed people in all walks of life and was always doing them favors; he often sent John Ray and his family gifts of rich sugar, gave Dr. Richard Richardson, physician and botanist of Yorkshire, many publications in return for gifts of potted woodcocks, and remitted ten guineas to his former assistant, Dr. Johann Amman, who was professor of botany at Saint Petersburg.[16] He frequented coffeehouses and later entertained his colleagues and scientific friends almost weekly with dinner and conversation at his home

Dr. Sloane rose early to treat the poor without charge if they called before ten in the morning. He was a leader in establishing the dispensary at the Royal College of Physicians in 1687 to supply the poor with medicines at cost, a project eventually defeated by the apothecaries after a long dispute and lawsuit. Appointed physician to Christ's Hospital in 1694 at thirty pounds per year, Sloane held the post for thirty-six years, regularly returning the salary to the hospital. He also strongly supported James Oglethorpe's Georgia colony in America, settled in 1733, designed chiefly for the oppressed and the indigent of England. Sloane's patients included many members of the nobility and royalty—for example, the Duke of Bedford (one fee of forty-three pounds), the Duke of Leeds, the Duchess of Beaufort, the Duchess of Newcastle, Queen Anne, her husband Prince George of Denmark (a one-hundred-pound fee), George I, Queen Caroline, and George II. Samuel Pepys almost wished himself sick again so

that he could spend an hour or two with Sloane, and John Locke, physician as well as philosopher, consulted him about treatments. Dr. Sloane, now at the height of his career, in 1716 was made physician general of the British army and was created a baronet by George I, one of the first physicians so honored. Three years later, he was elected president of the Royal College of Physicians, a post he held for sixteen years.

Sloane's progress in the practice of medicine was accompanied by his increasing influence in the Royal Society of London, a kind of British national academy of science founded in 1660. Upon his return from Jamaica, Sloane began to take an active part in the society's affairs, becoming one of its two secretaries in 1693. In reviving the publication of its *Philosophical Transactions*, Sloane furnished papers himself and secured contributions from his numerous correspondents in Britain and Europe. Sir Isaac Newton became president of the Royal Society in 1703, and Sloane worked closely with him. Dr. John Woodward, a prominent geologist but quarrelsome and overbearing in temperament, attacked Sloane on several occasions. In 1710, he made insulting remarks while Sloane was reading a paper on bezoars, the concretions found in the stomachs of wild goats that were thought an antidote to poisons, and accused Sloane of making grimaces at him. John Arbuthnot tried to restore good feeling by gravely asking what distortions of a man's face constituted a grimace, but the altercation ended only when the society's council expelled Woodward.

When Sir Isaac died in 1727, the council unanimously elected Sloane president, and the annual general meeting of the fellows ratified that action by a majority of three to one. Sloane improved the financial status of the Royal Society by systematically collecting back dues and investing them in choice real estate in Acton. He also contributed some of his property at Chelsea to the Physic Garden of the Apothecaries for a nominal yearly rental of five pounds and for fifty different plant specimens grown in the garden to be given to the Royal Society each year for forty years. At age eighty-one, Sloane refused to seek re-election after fourteen years as president. In his long membership, just short of sixty-eight years, he succeeded in adding many papers on natural history and medicine to the society's customary nucleus of contributions on mathematics and astronomy. One of the best-known learned men of his day internationally, he was elected to academies of science in France, Prussia, Saint Petersburg, Madrid, and Göttingen.

By 1742, Sloane's life was drawing to a close. His wife had died long before, in 1724, and his stepdaughter and two daughters were safely

married. He had owned Chelsea Manor since 1712, and now, thirty years later, decided to leave his two houses, Number 3 and Number 4 at the present Bloomsbury Place, and move with his huge collections to the manor house at Chelsea.

## III

The number of collections of curiosities throughout western Europe in the sixteenth and seventeenth centuries was great. The rise of scientific interest with increasing reliance on observation as a means of explaining the world and its plants and animals gave these collections new value. In Britain, the two John Tradescants, father and son, both excellent gardeners, organized a Cabinet of Rarities in 1629 at their home in South Lambeth, outside London. Known as "Tradescant's Ark," the establishment was surrounded by a fine garden. In 1656, the younger man brought out a catalogue of the collection (*Musaeum Tradescantium*) that listed preserved birds, animals, fish, and insects; minerals and gems; fruits; carvings, turnings, and paintings; weapons; costumes; household implements; coins and medals; and plants, shrubs, and trees. Elias Ashmole, another amateur scientist and collector, secured the collection after the younger Tradescant's death, added books and coins of his own, and presented it to Oxford University in 1683. He made the university put up a special building for this Ashmolean Museum.[17]

Another well-known collection was that of William Charleton (Courten), established in London by 1684. Because of his father's financial difficulties, Charleton had given up his family name of Courten and lived abroad for a time. Sloane and he became close friends. John Evelyn described Charleton's collection in his diary in 1686:

I carried the Countess of Sunderland to see the rarities of one Mr. Charlton in the Middle Temple, who shew'd us such a collection as I had never seen in all my travels abroad, either of private gentlemen or princes. It consisted of miniatures, drawings, shells, insects, medals, natural things, animals (of which divers, I think one hundred, were kept in glasses of spirits of wine), minerals precious stones, vessels, curiosities in amber, chrystal, agate etc., all being very perfect and rare in their kind, especially his books of birds, fish, flowers and shells, drawn and miniatured to the life. . . . This gentleman's whole collection, gathered by himself travelling over most parts of Europe, is estimated at £8000.[18]

Sloane had begun to collect sporadically in Britain and France, especially dried plants, before his journey to Jamaica; but, upon his return, he started systematically to build a herbarium of dried plants

mounted on heavy paper and bound into stout tomes. Today, its 337 volumes in the Department of Botany at the British Museum (Natural History) constitute "probably the most extensive single series of botanical collections made in the seventeenth and early eighteenth centuries," of great importance historically and because of its type-specimens, especially those cited by Linnaeus.[19]

The foundation of the herbarium was eight volumes of specimens gathered by Sloane on his Jamaica trip, with others from France and Britain that he collected personally or through correspondence. Then he acquired several large collections by gift or purchase. They included one from Herman Boerhaave, famed professor of botany at Leiden, consisting of four volumes of specimens, mostly from the Leiden Garden, assembled between 1685 and 1693. Sloane secured his friend Charleton's entire miscellaneous museum by bequest in 1702, though he paid certain of Charleton's legacies totaling twenty-five hundred pounds. After Leonard Plukenet's death, Sloane in 1710 purchased his fine collection, in twenty-three volumes, of eight thousand plants, many of them from Africa, India, Japan, and China. Mary, Duchess of Beaufort, sent Sloane plants and, in 1714, left him her herbarium in twelve volumes, covering chiefly her gardens at Chelsea and Badminton; Sloane reported that she kept "an Infirmary or small green house, where she removed sickly or unthriving plants, and with proper culture by the care of an old woman under her Grace's direction brought them to greater perfection than at Hampton Court or anywhere."[20] The next year, the Reverend Adam Buddle left Sloane his choice herbarium of British plants in thirteen volumes.

One of the most important volumes in the collection was gathered by Englebert Kaempfer, chiefly in Japan; after his death in 1716, it was purchased by Sloane. Then, two years later, Sloane acquired another virtual museum, that of James Petiver, a wealthy apothecary, with a herbarium of about one hundred volumes; Sloane assumed bequests of five hundred pounds in Petiver's will and canceled a bond Petiver had given him. This collection included plants from Europe, North America, Africa, the Near East, India, and the Orient. In 1722, Sloane received North American and West Indian plants from Mark Catesby, whose collecting expedition he had helped finance; Catesby attributed "much of the success I had in this undertaking" to Sloane, "that great Naturalist and Promoter of Science."[21] About the same time, Philip Miller, well-known head of the Chelsea Physic Garden, a position for which he had been recommended by Sloane, sent him twelve volumes of plants, grown in that garden. Sloane purchased Franz Kiggelaer's collection that had been sold at auction in Holland after his death in 1723; its fourteen volumes

contained plants from India, Japan, Cape of Good Hope, North America, and the West Indies. John Bartram of Philadelphia sent two volumes of plants he had gathered in 1742 and 1743 to Sloane, who responded by bestowing upon him a copy of the *Natural History of Jamaica* and an engraved silver cup.[22]

Not only did Sloane collect widely and well. He also understood the need of a museum to put its holdings in order and provide a proper record for each specimen or object. He apologized for the delay in issuing the second volume of his *Natural History of Jamaica* that was partially due to "The putting into some kind of Order my Curiosities, numbring them, and entering their Names, and Accounts receiv'd with them, in Books, which was necessary in Order to their Preservation and Uses." Especially troublesome had been his acquisition of Petiver's collection, of which he wrote:

He had taken great Pains to gather together the Productions of Nature in England, and by his Correspondents, and Acquaintance, all over the World procured, I believe, a greater Quantity than any Man before him. He did not take equal Care to keep them, but put them into heaps, with sometimes small labels of Paper, where they were many of them injured by Dust, Insects, Rain, etc. . . . I found myself obliged to take immediate Care of all of them, and in the first place of the Animal Substances, which are most subject to Destruction . . . . I have taken as much Care as I can to bring his Collections and Papers out of the Confusion I found them in, and will take further Care that what he hath gathered together . . . shall not be lost, but preserved and published for the good of the Publick, doing right to his Memory, and my own Reputation.[23]

Sloane eventually had extensive catalogues covering his collections— thirty-eight volumes in folio and eight volumes in quarto. Though he took pride in doing much of the work himself, he had to hire others to help him. Young Johann Gaspar Scheuchzer of Zurich, who came to London in 1722, worked on the collection and lived at Sloane's house. Sloane directed his medical training and got him elected to the Royal Society, but unfortunately Scheuchzer died in 1729. He was succeeded by Cromwell Mortimer, who, after studying medicine at Leiden, lived near Sloane in 1729 and acted as his secretary and assistant. Johann Amman of Schaffhausen in Switzerland came to help with the herbarium in 1730 and then went to Saint Petersburg by 1734 as professor of botany. John Hawkins also later served Sloane as secretary, and James Empson, about 1742, became virtually curator of the holdings. Sloane left Empson a legacy, appointed him a trustee of the collection, and asked that he be paid one hundred pounds yearly until its destination should be settled.

In the second volume of his *Natural History of Jamaica* in 1725, Sir Hans

Sloane gave an inventory of his collection (below), which can be compared with a list transmitted to his executors after his death.[24]

SIR HANS SLOANE'S INVENTORY OF HIS COLLECTION

|  | 1725 | 1753 |
|---|---|---|
| Earth and salts | 536 | 1,035 |
| Bitumens, sulphurs, ambers, ambergrise | 249 | 399 |
| Metals and minerals | 1,394 | 2,725 |
| Talcs, micae etc. | 169 | 388 |
| Crystals and spars, or fluores crystallini | 1,025 | 1,864 |
| Flints, stones, and other remarkable fossils that are anomalous | 730 | 1,275 |
| Precious stones, agates, jaspers, and fine marbles | 1,394 | 2,256 |
| Corals, or such as are akin to them, as sponges and other submarine plants | 804 | 1,421 |
| Vegetables and vegetable substances, as roots, woods, fruits, seeds, gums, resins, and inspissated juices | 8,226 | 12,506 |
| Besides 200 large volumes of dried samples of plants, amongst which are such specimens as were collected by myself in Europe, the Madeira Islands, and America; also those gathered by Dr. Merret, Dr. Plukenet, Mr. Petiver, and other curious persons all over the known world | 200 | 334 |
| Insects | 3,824 | 5,439 |
| Testacea or shells and their parts, both natural, found at sea and land, and fossil | 3,753 | 5,843 |
| Echini or sea urchins, and parts of them, both natural and fossil, found at sea and land | 486 | 659 |
| Crustacea, or crabs, lobsters etc. | 263 | 363 |
| Stella Marinae | — | 173 |
| Fishes and their parts | 1,007 | 1,555 |
| Asteria, trochi, entrochi etc. | 183 | 241 |
| Birds and their parts | 568) | 1,172 |
| Eggs | 185) | |
| Quadrupeds and their parts | 1,194 | 1,886 |
| Vipers, serpents etc. | 345 | 521 |
| Humana, namely stones of the kidneys and bladder, anatomical preparations, and the like | 507 | 756 |
| Miscellaneous things, not comprehended with the foregoing, both natural and artificial | 1,169 | 2,098 |
| Things relating to the customs of ancient times or antiquities, urns, instruments, etc. | 302 | 1,125 |
| Large seals | 81 | 268 |

| | | |
|---|---|---|
| Pictures, many relating to natural history | 319 | 471 |
| Mathematical instruments | 54 | 55 |
| Large vessels, ladles, and other things made of agate, jasper, cornelian, crystals, besides many camei and seals, excisa and incisa | 441 | 542 and about 700 cameos |
| Medals, ancient, as Samaritan, Phoenician, Greek, Consular, Roman etc. and modern; and coins in all metals | 20,228 | 32,000 |
| Books in miniature or colours, with fine drawings of plants, insects, birds, fishes, quadrupeds, and all sorts of natural and artificial curiosities | 136 | 347 |
| Printed books | — | about 50,000 |
| Volumes of manuscripts, the greatest part of them relating to physic and natural history, travel etc. | 2,686 | 3,516 |

Though Sloane's greatest interest lay in medicine and natural history, he also collected some 350 "artificial curiosities" of remote and primitive peoples. The largest group came from North American Indians, including the Eskimo, but some objects were from South America, the West Indies (including nine items from Jamaica probably brought back by Sloane himself), Africa, East Indies, Lapland, and Siberia. These ethnographical artifacts were important because they established a field of collection for the British Museum that was to increase greatly with the explorations of Captain James Cook in Oceania and Australia and the rapid expansion of the British Empire. Though a majority of the articles included in Sloane's catalogue cannot be identified today and many have certainly perished, items of fascination remain such as "an Indian drum . . . from Virginia," actually typical of the Ashanti of Ghana and likely the work of a black slave.[25]

In addition to collecting and conserving his vast holdings, Sloane used them for the third traditional function of the museum—scholarly research. Even as a fledgling fellow of the Royal Society, he often had brought plants, minerals, and other objects to the weekly meetings. Once it was a calculus (4½ inches long, 5½ inches around, and weighing 3 ounces) that had passed through a woman's urethra, and, another time, a large scorpion from St. Cruz in Barbary that was ordered preserved in spirit of wine in the society's repository. His keen interest in specimens and other objects enabled him to write his books and articles, to correspond with naturalists throughout the world, and to answer many questions from the public about natural history. He welcomed scholars,

showed them about the collection, and permitted them to study it. He was quick to lend objects and especially books and herbarium sheets. Occasionally, he encountered the old dilemma of museum curators: should he lend something on which he himself was working? When Dr. William Sherard, keen botanist recently returned from serving as British consul in Smyrna, wished, about 1720, to borrow dried plants from the Plukenet and Petiver collections, Sloane was arranging them and refused the request. Eventually, however, he lent the materials, and the strained relations between the two men were smoothed.[26]

Though Sloane did not place his collection on public exhibition, he was always ready to have it shown to knowledgeable visitors. John Evelyn (1691), the German Zacharias von Uffenbach (1710), and Linnaeus's pupil, Peter Kalm (1748), wrote detailed descriptions of it. Benjamin Franklin saw it and sold Sloane an American "Purse Made of the Stone Asbestos."[27] Voltaire called upon Sloane, as did the composer George Frederick Handel, who angered his host by putting down a buttered muffin on one of Sloane's fine books. Linnaeus, then aged twenty-eight, came in 1736 with a letter of introduction from Boerhaave; he was especially interested in the herbarium and praised some of its contents, but wrote a former professor of his, "Sloane's great collection is in complete disorder."[28] By that remark, he meant that the collection was arranged empirically and not systematically as by Linnaeus's binomial nomenclature. The Prince and Princess of Wales (the parents of the future George III) visited in 1748, talked kindly to the aged Sloane, and made him especially happy when the prince "express'd the great pleasure it gave him to see so magnificent a collection in England, . . . how much it must conduce to the benefit of learning, and how great an honour will redound to Britain, to have it established for public use to the latest posterity."[29]

The Swedish Peter Kalm came twice to see the collection and talked with Sloane for two hours. Of special interest to students of museums are Kalm's descriptions of some of the installations—for example, the following:

[Insects] were now preserved in four-sided boxes, with clear glass glued on both over and under, so that one could see them quite well, but these boxes or cases were also so well stuck together that no worms or other injurious insects could get at them, and spoil them. The sides were of wood. In some both lid and bottom, were of glass, but in most only the lid. At the joins the glass was stuck or glued fast with paper. Where the bottom was of glass, the insect was gummed on to the middle of the bottom.[30]

Witty writers had considerable fun with Sloane and his collection. Alexander Pope, to whom Sloane gave two stones from the Giant's Causeway in northern Ireland for his grotto, had a line in one of his rhymes that ran: "And books for Mead and butterflies for Sloane."[31] The Duchess of Portland once wrote that she had "just come from Sir Hans Sloane's, where I have beheld many odder things than himself, though none so inconsistent."[32] Thomas Hearne did a long versified screed about rarities he was collecting for Sloane such as "The Stone whereby Goliath dy'd/Which cures the Head Ache well apply'd" or "A fig-leaf apron, 'tis the same/Which Adam wore to hide his shame," and asserted "It is my wish, it is my glory/To furnish your knick knackatory."[33] Edward Young asked

> But what in oddness can be more sublime
> Than Sloane, the foremost toyman of his time? . . .
> "Was ever year unblest as this?" he'll cry,
> "It has not brought us one new butterfly!"[34]

Most amusing of all, however, was a comic museum, set up at Don Saltero's Coffeehouse in Chelsea in 1695 by James Salter, a barber who was probably an old servant of Sloane's. Sloane apparently had lent him some objects such as Franklin's asbestos purse, but Salter had other items of his own—for example, "Pontius Pilate's Wife's Chambermaid's Sister's Hat."[35] Salter issued a mock catalogue of his collection and wrote of it in doggerel as follows:

> Monsters of all sorts are seen,
> Strange things in nature as they grew so,
> Some relicks of the Sheba Queen
> And fragments of the famed Bob Crusoe.[36]

The important point of all this interpretation—to royalty, famed visitors, scholars, and the man in the coffeehouse or on the street—was that Sloane's holdings were well known throughout the United Kingdom, and when the time came to try to transform them into a public museum, both those in power and the general public had a favorable impression of the worth of the collection.

## IV

Peter Kalm, on his visit to Chelsea Manor in 1748, noted that the eighty-eight-year-old Sir Hans "was now rather deaf, so that we were

obliged to shout loud for him to hear it. On the tongue he had a swelling so that he spoke indistinctly enough and very slowly. Sometimes a long time passed before he got out a word."[37] Sloane was occasionally pushed in a wheeled chair into his garden to take the air. He retained his interest in the Royal Society, and the naturalist George Edwards called nearly every week to tell him the latest news. Almost imperceptibly, the old collector became more and more feeble, and he died peacefully on January 11, 1753, in his ninety-third year.[38]

For long, Sloane had been pondering a plan for the future of his collection. His first will of October 9, 1739, was made before he left Bloomsbury for Chelsea. In it, he desired that the collection,

tending many ways to the manifestation of the glory of God, the confutation of atheism and its consequences, the use and improvement of physic, and other arts and sciences, and benefit of mankind, may remain together, and not be separated, and that chiefly in and about the City of London, where I have acquired most of my estates, and where they may by the great confluence of people be of most use.[39]

He instructed his executors to offer the collection for twenty thousand pounds (to be paid to his two daughters—Sarah, wife of George Stanley of Paultons in Hampshire, and Elizabeth, married to Charles, Lord Cadogan, of Oakley) to the king for the nation. If the king did not accept the collection within six months after Sloane's death, it was to be proffered, on the same terms, in turn, to the Royal Society, the University of Oxford, the College of Physicians at Edinburgh, and then to the academies of science in Paris, Saint Petersburg, Berlin, and Madrid. These institutions each would have one month to decide whether to acquire the collection. If none agreed to the terms, it was to be sold at auction. Sloane probably hoped that the threat of having his holdings leave the country would add to the likelihood of his terms being accepted by the government.

A codicil of July 10, 1749, changed the original will somewhat. The collection, now to be kept intact in his manor house at Chelsea, was to be vested in some fifty trustees (most of them noted men); also named and given controlling power were thirty visitors, including the king and the great officers of state. Additional codicils of 1750 and 1751 finally left the Chelsea manor house and lands to Sloane's two daughters. The codicils probably strengthened the chances that the collection would be accepted for the nation because of the prominence and influence of the trustees and visitors named. Including the manor house and lands with the collection,

as Sloane had once contemplated, might have led to difficulties with those who preferred a location other than Chelsea.[40]

The executors of the will were Sloane's grandsons Lord Cadogan and Hans Stanley, his nephews William Sloane and the Reverend Sloane Elsmere, rector of Chelsea, and his curator James Empson. They promptly called a meeting of the trustees on January 27, 1753, which more than thirty attended. The Earl of Macclesfield, president of the Royal Society, was made chairman and a committee appointed to draw a petition for the king. His Majesty was lukewarm about the proposal and wondered where the money was to come from, and the next trustee meeting on February 10 decided to appeal directly to Parliament.[41]

Horace Walpole wrote Sir Horace Mann about these meetings in his usual sprightly style:

> You will scarce guess how I employ my time, chiefly at present in the guardianship of embryos and cockle-shells. Sir Hans Sloane is dead and has made me one of the trustees of his museum, which is to be offered for twenty thousand pounds to the King, the Parliament, the Royal Academy of Petersburgh, Berlin, Paris, and Madrid. He valued it at fourscore thousand; and so would anyone who loves hippopotamuses, sharks with one ear, and spiders as big as geese! It is a rent-charge to keep the foetuses in spirit! You may believe that those who think money the most valuable of all curiosities, will not be purchasers. The King has excused himself, saying that he did not believe that there are twenty thousand pounds in the Treasury. We are a charming wise set, all philosophers, botanists, anti-quarians, and mathematicians . . . . [42]

Though several of the trustees were members of Parliament, that body at first was not enthusiastic about meeting Sir Hans's terms. The trustees, however, defused some of the opposition. They agreed that if the government purchased the collection, they would disband as trustees under the will and allow Parliament to appoint trustees. They insisted, however, upon certain fundamental principles from which they would not depart: that the collection be preserved intact, that it "be kept for the use and benefit of the publick, who may have free Access to view and peruse the same," and that, contrary to Sir Hans's once expressed wish, if it was "judged the most beneficial and advantageous for the publick use, to remove the Collection from the Manor house at Chelsea . . . that it be placed properly in the Cities of London or Westminister or the Suburbs thereof."[43] On March 19, the House of Commons called James Empsom, who testified that the collection was worth much more than £20,000—at least £80,000, and he had heard Sir Hans say he had expended more than £100,000 on it. Empson estimated that it might cost £400 to £500 per year to

service it, including £100 for a principal keeper, £200 for other help, £60 for coal and candles, and £20 for spirit of wine for the wet specimens.[44]

During the debate, Arthur Onslow, Speaker of the House, took the opportunity to add two other collections to the library/museum being formed—the medieval and Tudor manuscripts and state papers gathered by Sir Robert Bruce Cotton and by Robert and Edward Harley. A bill to acquire the three collections and to establish a British Museum was passed by Parliament and received the royal assent on June 7, 1753. A lottery of £300,000 was set up to finance the project, and it turned over £95,194 9s. 2d. to the trustees of the new museum. Of this sum, £20,000 went to Sloane's daughters, £10,000 to the Harley heir, £10,000 to purchase Montagu House (in Bloomsbury, at the site of the present museum building) to hold the collections, more than £10,000 for building repair and maintenance, and £44,000 to be invested in government bonds. This endowment provided only £1,320 yearly for operating expenses, but on January 15, 1759, the British Museum opened its doors to the public.[45]

When the trustees of the new museum laid down the rules for using the library and museum collections, they decided to admit not only "learned and studious men, both natives and foreigners, in their researches into the several parts of knowledge," but—since the institution was maintained at public expense—the general public, as well. The latter audience created some concern for fear that its members might insult the librarians if they tried to control or contradict them. The museum was kept open from 9:00 A.M. until 3:00 P.M. every day except Saturday and Sunday, Christmas, Easter week, and other religious holidays. Entry was by ticket only, secured by application in person to the porter well in advance, stating "names, condition, and places of abode," and called for later when approved by the principal librarian. Not more than ten tickets were issued for each hour, and parties of five were shown round each department by the under librarians or their assistants. Readers were required to order books or manuscripts a day in advance and were limited to a certain number per day from the special collections. Visitors were conducted through the unlabeled museum exhibits rapidly and without proper interpretation. The important point, however, is that the British Museum was open to both scholars and ordinary men and women, as its founder had intended.[46]

Sloane's bequest had consisted chiefly of natural history specimens (mineralogical/geological, botanical, and zoological), but his collection also contained antiquities, ethnography, pictures, coins and medals, printed books, and manuscripts. Through the years, all these classes of materials increased enormously. The natural history and ethnographic

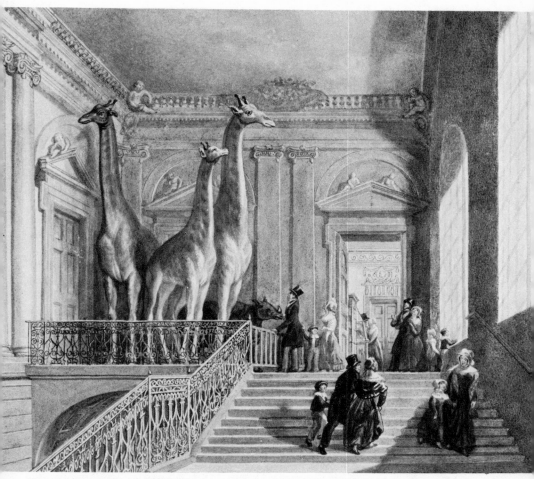

Fig. 2. The Great Stairway, Montagu House, 1847. The first home of the British Museum. Engraving by George Scharf, Sr. *(Courtesy of the Trustees of the British Museum, London.)*

holdings grew by gifts from explorers like Captain Cook, Archibald Menzies, and Sir Joseph Banks and from agents of the far-flung British Empire. Antiquities became much more important through the purchases of the classical statues of Charles Towneley and the famed Elgin Marbles, the Parthenon sculptures brought back from Athens by Thomas Bruce, Lord Elgin. Spectacular Egyptian and Mesopotamian ancient rarities were

added, such as the Rosetta Stone and other objects captured from Napoleon's hapless Egyptian expedition or the Assyrian and Babylonian monuments recovered by numerous excavations. Paintings offered fewer problems after the museum ceased collecting them in 1824, when the National Gallery was established.[47]

More vexing, however, were the stresses occasioned by the combination of a national library and a national museum under the same administration. The functions of these two cultural institutions differed greatly, and their uses were often in conflict. To begin with, a library contains rather uniform volumes that can be arranged much more readily than museum objects that vary so widely in composition, shape, and size. Books and manuscripts are used privately, one at a time. Some museum objects—for example, a series of bird skins—may receive similar study by a researcher, but many of them must be exhibited, labeled, or otherwise interpreted so as to be viewed by a large audience of varied ages and backgrounds. The British Museum's functions were tilted in favor of the library that, in general, received a disproportionate share of the limited funds, personnel, and space available. The first three departments (1756) were devoted to Printed Books, Manuscripts, and Natural and Artificial Productions. Antiquities were not added until 1807, nor Ceramics and Ethnography until 1921. The chief executive officer was the Principal Librarian until 1898, when he became the Director and Principal Librarian. The library became a true national library under the brilliant administration of Antonio Panizzi, who began supervision of Printed Works in 1831 and was the principal librarian from 1856 to 1866.[48]

After a long and sometimes bitter argument, the natural history collection was finally moved, between 1880 and 1886, to its own building in South Kensington as the British Museum (Natural History), with its own governing board and director. The exhibited part of the ethnographic collection was transferred in 1970 to Burlington Gardens and renamed the Museum of Mankind. In 1973, a new British Library was created with the British Museum Library (now the Reference Division of the British Library) as its chief component. The British Library has its own board and director general; eventually, it will move to a new location on Euston Road, several blocks away from the British Museum. When the library moves out, the present building will be devoted entirely to museum purposes, with its collection chiefly of antiquities and enthnography; the materials in the Museum of Mankind will be returned from their present temporary location.[49]

Sir Hans Sloane was acknowledged everywhere to be one of the great

men of his time. As a physician, he appears weak, to modern eyes, because the sciences of physiology, pathology, and bacteriology did not exist in his day. Yet, Sloane was on the side of scientific advance and, with keen observation, good will, and common sense, did much to combat the superstition that permeated medical practice in that age. His use of Peruvian bark and inoculation shows how progressive a physician he was. There may have been more original minds than Sloane's among the naturalists and botanists of his era, but his tireless devotion to collecting, recording, and studying natural specimens, his willingness to share his collection and knowledge with others, and his generosity and enthusiasm in backing worthwhile botanical projects are impressive.

Sir Hans Sloane's British Museum pioneered as a national museum with a wide range of library and museum functions. It bids now to end up, at least for the time being, as a national research library, a national museum of natural history, and a national museum of world and British antiquities and ethnography, the last of the three retaining the original name. The new British Museum will be unlike the art galleries that contain antiquities (for example, in Paris or New York City) or the natural history museums that include ethnography (Paris, New York City, and Washington) but will follow an independent, self-contained course, as have such museums in Berlin, Leiden, Philadelphia, and Mexico City. Throughout its long and multifaceted history, the museum that Sloane founded has been one of the great glories of the British world and has evolved to serve modern-day cultural needs and conditions ever more precisely and effectively.

## NOTES

1. There are two excellent biographies of Sloane—Gavin R. de Beer, *Sir Hans Sloane and the British Museum,* and Eric St. George Brooks, *Sir Hans Sloane: The Great Collector and His Circle.* I have used both of these sources extensively and usually quote primary sources (which I have often examined) from them because of the convenience of using them and their indexes. For this quotation, see de Beer, p. 26.
2. John Ray, *The Correspondence of,* pp. 191–192.
3. De Beer, *Sloane,* pp. 30–31.
4. Hans Sloane, *A Voyage to the Islands.*
5. De Beer, *Sloane,* pp. 41–42, 62–63.
6. Hans Sloane, *Catalogus Plantarium.*
7. De Beer, *Sloane,* pp. 193–194.
8. De Beer, *Sloane,* pp. 72–73; Brooks, *Sloane,* p. 88.

9. Sloane, *Voyage to the Islands,* 1: Preface.

10. Hans Sloane to Richard Richardson, London, November 20, 1725, in *Illustrations of the Literary History of the Eighteenth Century* . . . , by John Nichols and John Bowyer Nichols, 8 vols.: 1:283.

11. De Beer, *Sloane,* p. 20.

12. De Beer, *Sloane,* p. 25.

13. De Beer, *Sloane,* p. 71.

14. De Beer, *Sloane,* p. 82.

15. Brooks, *Sloane,* p. 61.

16. For Amman, see James Britten, *The Sloane Herbarium,* pp. 82–83.

17. David Murray, *Museums: Their History and Their Use, with a Bibliography and List of Museums in the United Kingdom,* 3 vols. (Glasgow: J. MacLeHose 1904): vol. 1; Alma S. Wittlin, *Museums: In Search of a Usable Future* (Cambridge, Mass.: MIT Press, 1970), pp. 17–22, 39–53; Silvio Bedini, "The Evolution of Science Museums," *Technology and Culture* 6 (1965): 1–29; Mea Allan, *The Tradescants: Their Plants, Gardens and Museum, 1570–1662* (London: M. Joseph, 1964).

18. Brooks, *Sloane,* pp. 177–179.

19. Britten, *Sloane Herbarium,* pp. 7–8.

20. Britten, *Sloane Herbarium,* p. 34.

21. Britten, *Sloane Herbarium,* p. 111.

22. All of these separate collections are described under their collectors in Britten, *Sloane Herbarium.*

23. Sloane, *Voyage to the Islands,* 2:i, iv-v.

24. Hans Sloane, *The Will of,* pp. 33–36; Brooks, *Sloane,* pp. 194–196. See also de Beer, *Sloane,* pp. 160–161; Edward Edwards, *Lives of the Founders of the British Museum,* pp. 297, 303.

25. H. J. Braunholtz, *Sir Hans Sloane and Ethnography,* esp. pp. 19–21, 27, 35.

26. Thomas Birch, *The History of the Royal Society of London* 4:460–461, 548; de Beer, *Sloane,* p. 59; Brooks, *Sloane,* pp. 182–184; Britten, *Sloane Herbarium,* pp. 176–177.

27. Brooks, *Sloane,* p. 192.

28. Britten, *Sloane Herbarium,* p. 11.

29. De Beer, *Sloane,* p. 134.

30. De Beer, *Sloane,* p. 130

31. De Beer, *Sloane,* pp. 125, 129; Brooks, *Sloane,* pp. 189–190.

32. De Beer, *Sloane,* p. 125.

33. De Beer, *Sloane,* pp. 126–127.

34. Brooks, *Sloane,* pp. 190–191.

35. De Beer, *Sloane,* pp. 127–128.

36. Brooks, *Sloane,* pp. 209–210; Edward Miller, *That Noble Cabinet,* p. 26.

37. De Beer, *Sloane,* p. 137.

38. Brooks, *Sloane,* pp. 21–211, 213–214; De Beer, *Sloane,* p. 139.

39. Sloane, *Will,* p. 3; Sir E. Maunde Thompson, "The Creation of the British Museum," *Cornhill Magazine* 92, p. 643; de Beer, *Sloane,* p. 138.

40. Sloane, *Will;* Hans Sloane, *Authentic Copies of the Codicils Belonging to the . . . Will . . . of Hans Sloane;* Sir William Jardine, *The Natural History of the Pachydermes,* pp. 83–92; Thompson, "Creation of the British Museum," pp. 643–644; de Beer, *Sloane,* pp. 138–139; Brooks, *Sloane,* pp. 218–221; Edwards, *Founders of the British Museum,* pp. 296–300.

41. Miller, *That Noble Cabinet,* p. 42.

42. February 14, 1753; de Beer, *Sloane,* pp. 144–145.

43. De Beer, *Sloane*, p. 147; Miller, *That Noble Cabinet*, p. 44.

44. De Beer, *Sloane*, p. 148.

45. Miller, *That Noble Cabinet*, pp. 26–36, 44–54; de Beer, *Sloane*, pp. 148–153.

46. Miller, *That Noble Cabinet*, pp. 61–63, 68–70, 90.

47. Miller, *That Noble Cabinet*, pp. 74–76, 96–107, 113–115, 131, 191–223.

48. Miller, *That Noble Cabinet*, pp. 80–81, 134–135, 144–145, 151–166, 363, 365.

49. Miller, *That Noble Cabinet*, pp. 239–244, 355–356, 358–362; "Government Commitment: New Building at Last," British Library *News*, no. 28 (April 1978): 1–2; *Museums Bulletin* 20 (January 1981): 183.

## SELECT BIBLIOGRAPHY

Birch, Thomas. *The History of the Royal Society of London . . . , 1661–1687: A Facsimile of the London Edition of 1756–57.* 4 vols. New York and London: Johnson Reprint Corporation, 1968.

Braunholtz, Hermann Justus. *Sir Hans Sloane and Ethnography.* London: British Museum, 1970. 47 pp.

Britten, James. *The Sloane Herbarium: An Annotated List of the Horti Sicci Composing It with Biographical Accounts of the Principal Contributors . . .* Rev. ed. by J. E. Dandy. London: British Museum (Natural History), 1958. 246 pp.

Brooks, Eric St. George. *Sir Hans Sloane, the Great Collector and His Circle.* London: Batchworth Press, 1954. 234 pp.

Crook, James Mordaunt. *The British Museum.* London: Allen Lane, The Penguin Press, 1972). 251 pp.

De Beer, Gavin Rylands. *Sir Hans Sloane and the British Museum.* London: Oxford University Press, 1953. 192 pp.

Edwards, Edward. *Lives of the Founders of the British Museum; with Notices of Its Chief Augmentors and Other Benefactors, 1570–1870.* 1870. New York: Burt Franklin, 1969. 780 pp.

Jardine, Sir William. *The Natural History of the Pachydermes . . . with Memoir and Portrait of Sir Hans Sloane.* Edinburgh: W. H. Lizars, etc., 1836. 248 pp.

Miller, Edward. *That Noble Cabinet: A History of the British Museum.* Athens, Ohio: Ohio University Press, 1974. 400 pp.

Raven, Charles E. *John Ray, Naturalist: His Life and Works.* Cambridge: Cambridge University Press, 1950. 506 pp.

Ray, John. *The Correspondence of: Consisting of Selections from the Philosophical Letters Published by Dr. Derham, and the Original Letters . . . in the Collection of the British Museum . . .* Edited by Edwin Lankester. London: Ray Society, 1848. 502 pp.

———. *Further Correspondence of . . .* Edited by Robert W. T. Gunther. London: Ray Society, 1929. 332 pp.

Royal Society of London. *Philosophical Transactions, 1665–1886.* 177 vols. New York: Johnson and Kraus Reprints, 1963.

Sloane, Hans. *Catalogus Plantarium quae in Insula Jamaica . . .* Londoni: D. Brown, 1696. 232 pp.

———. "Correspondence with Richard Richardson, M.D., of North Bierley, Yorkshire," in John Nichols and John Bowyer Nichols, *Illustrations of the Literary History of the Eighteenth Century . . .* 8 vols. London: 1817–1858, 1:269–289.

_____. *A Voyage to the Islands Madera, Barbados, Nieves, S. Christophers and Jamaica with the Natural History . . . of the Last of Those Islands* . . . 2 vols. London: For the Author, 1707, 1725.

_____. *The Will of Sir Hans Sloane, Bart., Deceased.* London: John Virtuoso, 1753. 48 pp. *Authentic Copies of the Codicils . . . Which Relate to the Collection of Books and Curiosities.* London: Daniel Browne, 1753. 36 pp.

Thompson, Sir E: Maunde. "The Creation of the British Museum." *Cornhill Magazine* 92 (December 1905): 641–656.

# Charles Willson Peale
# and His Philadelphia Museum:
# The Concept
# of a Popular Museum

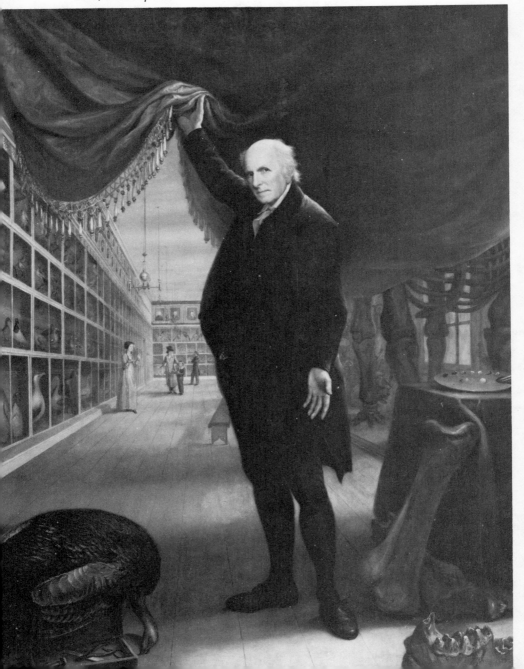

Fig. 3. *The Artist in His Museum*, 1822. Self-portrait by Charles Willson Peale (1741–1827) in the Pennsylvania Academy of the Fine Arts, Philadelphia, Joseph and Sarah Harrison Collection. *(Courtesy of the Pennsylvania Academy of the Fine Arts, Philadelphia.)*

I

ONE OF the most charming pictures of all early American art is Charles Willson Peale's self-portrait, *The Artist in His Museum.* The grand old man (aged eighty-one at the time) completed the painting in about two months of enthusiastic work in 1822. It shows Peale lifting a crimson curtain, as he invites the viewer to visit the Long Room of his Philadelphia Museum situated in the Pennsylvania State House that we now know as Independence Hall. Along one wall are cases of birds, mounted in realistic poses with carefully painted backgrounds that give them perspective and seem to make them live, for Peale had invented the habitat group so common in natural history museums today. Above the cases are double rows of portraits of American Revolutionary heroes and Founding Fathers that he hoped would keep alive the thrilling story of the birth of the Republic and inspire their viewers with fervent patriotism. In the foreground are some of the early accessions of the museum—to the left, from the Allegheny River, a paddlefish in an upright case marked "With this article the Museum commenced, June, 1784"; to the right, several mastodon bones. Behind the curtain stands an articulated skeleton of that mighty beast, the single greatest treasure of the museum and its star attraction.

Peale is not content, however, to show only the collection side of his museum. The stuffed wild turkey in the foreground (brought back by his son Titian, who accompanied the Stephen H. Long Expedition to the Upper Missouri and Rocky Mountains in 1820) is placed on a mahogany box with an open drawer containing the file, pliers, and other tools used by the taxidermist. On the green table cover to the right are the artist's palette and brushes used for both creating and retouching paintings. Thus, there is a hint of the conservation aspect of museum work. Nor is the museum's audience—its chief reason for being—forgotten. In Peale's own words,

At the further end is a figure in meditation, a man with folded arms looking at the birds, next a father instructing his son, he holding his book open before him and looking forward as attentive to what his parent says—and a Quaker lady . . . turns round and seeing the mammoth skeleton is in the action of astonishment—she is dressed in plain rich [yellow] silk and black bonnet.

The painting thus succeeds in presenting the museum in proper balance with authentic scientific specimens and realistic portraits to interpret the

45

"Great School of Nature" that includes "the animal, man," but with verve and pleasure triumphant over dullness and boredom.[1]

What manner of man was this museum proprietor? First of all, he was outgoing and humane, seldom lost his boyish enthusiasm, and lived life with romantic zest. John Adams in 1776 described him as "a tender, soft, affectionate creature," ingenious and vain, and "capable of friendship and strong family attachments and natural affections."[2] Peale was deeply interested in health and medical problems; he calculated that a man who obeyed nature's laws ought to live at least 112 years. In an *Epistle to a Friend on . . . Preserving Health, Promoting Happiness, and Prolonging the Life of Man to Its Natural Period . . .* (1803), he set down for his friend Thomas Jefferson his rules for longevity, among them "serenity of mind," no tobacco, only small amounts of spirituous liquor mixed with water, good posture, loose clothing, and sensible exercise. His *Essay to Promote Domestic Happiness* (1812) called for harmony in family life and again inveighed against strong drink.[3] Peale's energy throughout his long life was tremendous; his appealing sketch (1819) shows him astride the "fast walking machine," a forerunner of the bicycle but without pedals, the rider using his heels to propel himself except when coasting downhill. Peale astonished crowds around his museum as he sped along, his coattails and white hair streaming behind.[4]

Peale was a devoted family man, who was married first at twenty and ultimately had three wives (he was seeking a fourth shortly before his death) and eleven grown children. Seven of them were named for artists—Raphaelle, Angelica Kaufmann, Rembrandt, Rubens, Sophonisba Angusciola, and two Titian Ramsays (the first died at age eighteen in 1798)—and two for natural scientists—Charles Linnaeus and Franklin. The last one was lucky, for his father had planned to call him Aldrovand after Ulisse Aldrovandi, the Italian naturalist and museum founder, but had brought the baby for naming before a meeting of the American Philosophical Society that decided unanimously upon Franklin in honor of the society's founder and first president.[5] No better evidence of the affectionate pleasantness of Peale's domestic life exists than his conversation piece, *The Peale Family Group* (c. 1772–1809), that includes three generations of Peales, as well as the family nurse and Argus, the dog. John Adams, when he saw it, remarked that "There was a pleasant, a happy cheerfulness in their countenances and a familiarity in their air towards each other."[6] The Peales delighted in poetry, jokes, song, and instrumental music; their home, though often disorganized and noisy with pets, both usual and exotic, was a place of entertainment and inspiration,

with the children encouraged to participate and to expand their natural talents.[7]

Peale was adept with his hands, an inventive and ingenious craftsman, a tinkerer and a jack-of-all-trades. He was not afraid to tackle any kind of mechanical problem and continually sought to make improvements. For his painting, he devised a drawing machine or "painter's quadrant" to outline quickly in pencil a perspective view, and he built a telescopic sight for his gun that once gave him a black eye on the recoil.[8] For long, he worked to produce efficient eyeglasses, including bifocals, as well as more comfortable false teeth, finally casting porcelain ones with great success. He used such teeth as a lure in some of his courtships, though his family objected that it would be undignified for him to set out on a dentist's career in his old age.[9] Among dozens of Peale's inventions and ingenious devices were a wooden bridge and an improved fireplace that he patented, a portable steam bath, and various farm and milling machinery.[10] His manual dexterity constantly came in handy in developing his museum.

As a painter, Peale was not always skillful. Sometimes, especially in his early career, those he portrayed were stiffly, even clumsily posed, their faces expressionless, their eyes too small. They frequently failed to show much character; for example, *Nancy Hallam* (1771), the beautiful and glamorous young actress who inspired fervent verse in the Annapolis *Maryland Gazette*, looks at us from a face similar to that of *George Washington* (1772), portrayed as a grave and reserved colonel of the Virginia militia.[11] For all his lack of sophistication, however, Peale had an honesty and freshness of vision, an affectionate enthusiasm and gaiety that frequently came through. As James Thomas Flexner has pointed out, he succeeded more often with men than with women and with those he knew well. The olive-green background of his portraits (probably based on the green baize against which paintings were frequently hung in galleries), often embellished with appropriate landscapes, and the light greens, oranges, and pinks of his palette were charming and cheerful. Though technically not the equal of Copley or Gilbert Stuart, he was still one of the best, and certainly the most prolific, of early American artists—he painted more than a thousand portraits. He continually experimented with new ways of painting, at age seventy learning much from his son Rembrandt, who had just returned from Paris with the latest techniques used by David and others.[12]

In June 1784, Peale began to explore the idea of establishing a natural history museum. The year before, Dr. Christian Friederich Michaelis had

asked him to make full-scale drawings of bones found in Ohio of a huge mysterious creature (actually a mastodon); most of the bones belonged to Dr. John Morgan, and Peale took them home to his painting gallery, where they attracted considerable attention. Colonel Nathaniel Ramsay, his brother-in-law and respected friend, said he would have gone twenty miles to see the bones, and that they were much more interesting to him than any paintings. Peale then consulted two close friends, David Rittenhouse, astronomer and mathematician, and Robert Patterson, professor of mathematics at the University of Pennsylvania, about the desirability of forming a museum of natural history. Rittenhouse was against the idea, because he thought Peale would have a more illustrious career and make more money as an artist, but Patterson urged him to do the museum and gave him the paddlefish for his first accession.[13]

This, then, was Charles Willson Peale, the first great American museum director—warm, personable, and outgoing; creative and driving, with his daily life given over to the excitement of solving problems and making improvements. His affectionate interest in family, friends, and humankind combined with his quick eye and craft skills gave him real success as an artist and a museum man. Fortunately, five skillfully researched and sensitively written works by Charles Coleman Sellers, a direct descendant of Peale, enable us readily to follow the career of this good-hearted, talented human being and the development of the instrument for popular education that he fashioned.

## II

Charles Willson Peale was born April 15, 1741, in Queen Annes County on the Eastern Shore of Maryland, where his father, Charles, was a schoolmaster who proudly believed himself "heir in Tail to Manour of Woulton in Oxfordshire," owned by his uncle Charles Wilson, and thought he would inherit that estate one day. In 1739, he was married to Margaret Triggs in Annapolis and then moved to Chestertown to teach Greek, Latin, and other subjects in the Kent County School. He died near age forty-one, without gaining his hoped-for inheritance, and Margaret Peale, with ten-year-old Charles Willson and her four other children, returned to Annapolis, where she supported the family by her needlework.[14] Charles Willson's meager schooling included a little Latin, but before his thirteenth birthday he was apprenticed to a saddler for seven years. By January 1762, he had completed his term and set up his own shop. In that month, he was married to pretty Rachel Brewer, aged

seventeen. On returning from their honeymoon, through a cruel practical joke probably perpetrated by his former master's clerk, Peale received a letter from a supposed cousin, "Captain James Digby" of the British army, urging Peale to claim his estate in Oxfordshire, valued at two thousand pounds. Charles Willson gathered documents to verify his descent, wrote an English lawyer, and for four years lived in expectation of receiving the inheritance. Meanwhile, he pursued the saddler's craft while expanding imaginatively and vigorously into harness making, upholstery, silversmithing, and clock and watch repair.[15]

On a trip to Norfolk, Virginia, to buy leather, he saw some miserably done paintings and, on his return home, tried a few portraits himself, receiving ten pounds for a husband-and-wife pair. He visited Philadelphia to talk with two artists and to buy colors and an instruction book, *The Handmaid to the Arts*. He gave John Hesselius, the artist who lived across the Severn from Annapolis, "one of his best saddles with its complete furniture, for permission to see him paint a picture." In 1764, however, disaster struck. Peale had campaigned with a group of Sons of Liberty to defeat the court party and elect Samuel Chase to the Maryland Legislature. As part of the conservative retaliation, Peale was served with four writs by his creditors; he owed nearly nine hundred pounds and had only about three hundred pounds due him. While his friends tried to arrange for him to pay his debts gradually, Rachel and he left to visit his sister at Tuckahoe Bridge, on the Eastern Shore. There, another creditor sought him; the sheriff entered the front door as he went out the back.[16]

Peale fled down the Eastern Shore to another sister in Accomac County, Virginia. From there, he went by water to Boston, viewing paintings that inspired him in the gallery of the late John Smibert and receiving encouragement from the rapidly rising artist, John Singleton Copley. On his return to Accomac, Peale painted several successful portraits. In 1765, back in Annapolis, he made an arrangement with his creditors; some would give him four years to pay up, and the remainder accepted as surety Rachel's inheritance from her father's estate.[17]

In 1766, eleven Maryland gentlemen, led by Charles Carroll—known as the "Barrister"—John Beale Bordley, and Governor Horatio Sharpe, banded together to obtain a resident artist for their province; they subscribed eighty-three guineas to send young Peale to London to study painting for one year, hoping that he might work with Benjamin West, formerly of Philadelphia. Arrived in London, Peale purchased an elegant light-blue suit and a beaver hat, and went to call on West, who received him cordially. He served West as general assistant and had paintings

hung in at least two exhibitions of the Society of Artists. He met his uncle, the Reverend Joseph Digby, to learn that there was no Captain Digby and that his letter was a hoax; the dreamed-of Oxfordshire estate had been bequeathed to another. Peale longed for Rachel and wrote mournful poems about her absence; he thought of returning to Maryland, but the Barrister raised another forty guineas or so, to enable him to continue with West.

For a time, Peale specialized in miniatures, though Carroll urged him to do full-sized portraits, since they were more admired in Maryland. The young man worked steadily, painted a rather ridiculous full-length portrait of William Pitt in a toga, and did some sculptured busts. Though he spent little time in pleasure, there were some amusing touches; when he called on Benjamin Franklin, he espied him with a comely young woman on his knee and had to tiptoe down the hall and stomp back noisily. While he helped West get ready for his first audience with George III, Peale, always the patriot and opposed to the Townshend Acts, refused to doff his hat when the royal coach passed. Finally, after two years and one month in London, he returned to Rachel and Annapolis in June 1769.[18]

Willson Peale, as his friends often called him now, at once began to enjoy a prosperous patronage. From his home in Annapolis, he traveled throughout Maryland and to Virginia and Philadelphia painting portraits, large or miniature. These journeys, made now in a carriage instead of on horseback, were almost pure profit, for he was hospitably entertained by his sitters. In the four years after his return, he painted at least 150 pictures; by 1775, he had paid off his creditors, though he continued to have problems occasionally because of his financial carelessness. As colonial resistance to Britain increased, Peale remained a staunch patriot; he painted flags for independent militia companies at Williamsburg and Baltimore and, assisted by Rittenhouse, experimented with making gunpowder. He moved his family to Philadelphia shortly before the Declaration of Independence and was elected a lieutenant in the city militia. In December 1776, he marched with his company to Trenton. They conducted themselves well in the thick of the fighting at Princeton on January 3, 1777, with Peale in command because the captain was injured. They went on with General Washington to Morristown, Peale finding them a hayloft in which to sleep, providing a hot breakfast, and making them comfortable moccasins from two hides with the fur inside.[19]

Captain Peale (he was soon promoted) saw little further action, though he spent much time in camp at Valley Forge during the cold winter of 1777–1778. He busily painted some forty miniatures for officers to send

home and a small dashing oil of himself in uniform. A veteran is said to have remarked that Peale "fit and painted and painted and fit." In Philadelphia, he became involved in the political contest over revising Pennsylvania's radical constitution of 1776. Peale was a leader of the "Furious Whigs" against the changes proposed by the conservative "True Whigs." Yet, he always appealed to reason and tried to avoid violence. As commissioner to seize Tory property, he managed—with difficulty—peaceful eviction of the argumentative Mrs. Joseph Galloway from her home. He also opposed zealots in the militia who tried to drive out of the city suspected Tories, many of them leaders of the True Whigs.

In 1779, Peale was commissioned by the Supreme Executive Council of Pennsylvania to paint a full-length portrait of General Washington and by Congress to do another full-length painting of the departing French minister, Conrad Alexandre Gérard. That fall, Peale was elected to the Pennsylvania Legislature for a one-year term, but did not find congenial the subtleties and pretenses of political life and was not re-elected. As the French alliance began to turn the war in favor of the patriots, Peale created several amusing spectacles for his fellow Philadelphians—a two-faced, automated effigy of the traitor Benedict Arnold, prodded by the Devil, that was burned with much acclaim, and brilliantly lighted transparencies placed in windows to honor the French or to celebrate the Yorktown victory. Finally, in January, after Congress ratified the peace treaty, Peale built a gigantic, complicated triumphal arch, with transparencies to be illuminated by candles, an image of peace to descend from above, and a spectacular fireworks display. Unfortunately, someone carelessly ignited a rocket that set the whole painted fabric afire and rained exploding fireworks on the huge throng. Captain Peale was badly burned and broke a rib or two in falling from the arch.[20]

Peale's paintings of Revolutionary personages increased steadily, and probably, by 1780, he was planning to establish a gallery of the portraits. In August, he bought a neat brick house on the corner of Third and Lombard and soon began to build behind it a long, narrow, skylighted gallery, the light controlled from the inside by screens and curtains. On November 16, 1782, the gallery opened for the public, showing about thirty portraits of soldiers and statesmen, with the full-length paintings of *Washington* and *Gérard* at either end. In 1784, before he could begin his museum of natural history, Peale was distracted by another project. Philippe de Loutherbourg, an ingenious scene painter at the Drury Lane Theatre in London, in 1781 had invented the "Eidophusikon," also sometimes called "Representation of Nature" or "Moving Pictures." With a

stage or box 10 feet wide, 6 feet high, and 8 feet deep, before an audience of 130, de Loutherbourg used transparencies, reflectors, colored slides, realistic sound, and clockwork to portray changing scenes, two of the most spectacular depicting a fierce storm at sea with a shipwreck, and Satan in his city of Pandemonium, based on Milton's *Paradise Lost*.[21]

When Peale heard of de Loutherbourg's device, he spent eighteen months of unremitting labor in creating his own version. He built an extension on his portrait gallery to hold the stage and its behind-the-scenes equipment and operators; the audience was seated in the picture gallery. His "Perspective Views with Changeable Effects; or, Nature Delineated and in Motion" (soon simply called "Motion Pictures") opened in May 1785. The show—admission, three shillings ninepence (about eighty-five cents)—lasted for two hours, with five scenes. Three of them showed views of Philadelphia; another, a storm with thunder, lightning, torrential rain, and then a rainbow; and, most popular of all, Pandemonium. Later, Peale added the exciting and noisy battle between John Paul Jones's *Bonhomme Richard* and the *Serapis*. In hot weather, he provided a dozen large pasteboard fans hung from the ceiling and moved from side to side by concealed machinery. One difficulty was filling up the intervals of ten or fifteen minutes required to change scenes. The audience could, of course, examine the portraits in the gallery, but Peale provided instrumental and vocal music, selections from Milton and Shakespeare by a reader, whom Peale had to dismiss because he chose some humorous pieces with unseemly double entendre, and finally, a barrel organ that could play thirty different tunes. Even though George Washington and members of the Constitutional Convention in the summer of 1787 were impressed by Peale's Motion Pictures, the project failed to make much money; and, in 1791, it was sold to a traveling showman. By that time, Peale was deep in the development of his museum.[22]

### III

In the *Pennsylvania Packet* of July 18, 1786, Peale announced the opening of the new museum in his house at Third and Lombard. It consisted of his gallery of portraits, as well as various natural and artificial curiosities. He charged twenty-five cents admission, only half the amount that Pierre Eugène du Simitière, the Swiss miniaturist, had received from visitors to his much smaller "Curio Cabinet" or "American Museum," in the two years before his death in 1784. In his museum's first five years, Peale had to take many portrait commissions to keep it afloat, but later it could have

made him a rather rich man. By 1791, he could give up portrait-painting and devote himself entirely to the museum; for sixteen years, starting in 1795, it yielded about $3,500 yearly and at its peak, in 1816, brought in nearly twelve thousand dollars, a large sum for that day, from about fifty thousand visitors.[23]

Establishing the museum fitted Peale's deistic conception of religion, which held that God's laws and natural laws were identical, and human beings, by using their powers of reason to understand nature, could lead lives of peace and happiness. A natural history museum that presented "a world in miniature" would serve as a "School of Nature," providing its beholders with both enlightenment and "rational amusement." The museum ought to arrange in scientific order all living animals, from the lowly worm to the reasoning man; since man was an animal, a portrait gallery could be justified. Then there were the vegetable tribe, minerals, human petrifications, and aboriginal dress, arms, and utensils. Peale also kept a small menagerie in the stable and lot next to his house, and birds, small animals, snakes, and children mixed amicably indoors or out; when the creatures died, they were usually mounted for the museum. A thorough catalogue of each object or specimen was needed, as well as a library of the best writings on natural history. Peale than asked: "Can the imagination conceive anything more interesting than such a museum?—Or can there be a more agreeable spectacle to an admirer of the divine wisdom?"[24]

Although Peale was not a profound scholar or a great naturalist, his museum attracted not only the general public, but a growing body of serious students. He exchanged correspondence and specimens with museums and collectors in Paris, London, Stockholm, and other western European cities. The Reverend Nicholas Collin, Swedish immigrant naturalist and close friend, supported him solidly in the Philadelphia newspapers and helped arrange Swedish exchanges. Baron von Humboldt stopped to see Peale's museum on his way back to Germany from South America. Philadelphia scientists studied the specimens, wrote about them, and added to the collections. The Academy of Natural Sciences of Philadelphia was founded in 1812, and Peale's son—the second Titian— was admitted to membership at age eighteen. Behind all the serious study was Peale's Museum and its beguiling, inspiring founder, sometimes described by visitors as "the greatest natural wonder in the collection."[25]

Peale, then, hoped that his natural science exhibits would teach their viewers a proper religion of nature and advance public morality, just as his portrait gallery of national heroes would inspire love of country. Imbued

with these idealistic purposes, he worked day and night to build a museum, not restricted to scholars and connoisseurs, but intended for all the people. That concept was largely a new one for museums and placed great stress on their educational function. In a sense, "rational amusement," so long as it was combined with truthful exhibits and activities, was not unlike the present-day idea of museum interpretation. It could make the institution a popular, even an exciting place, in great contrast with the silent, gloomy European museums of the day. The Ashmolean at Oxford and the British Museum, the Muséum National d'Histoire Naturelle and the Conservatoire National des Arts et Métiers in Paris, or the Swedish Royal Academy of Sciences at Stockholm were elitist in outlook and did not attract large, popular audiences.[26]

In 1794, the American Philosophical Society, of which Peale was a member, gave him a ten-year lease to most of its new building on State House Square. Peale and his family lived there, and he served the Society as librarian, curator, and custodian. He also was permitted to fence off part of the State House Yard next door and place his menagerie there. He ingeniously moved his collections to Philosophical Hall by staging a six-block-long parade led by the huge American bison carried on men's shoulders and followed by panthers, tigers, and other animals, cases, and cages, many of them borne by his own and his neighbors' enthusiastic boys; he reported that he lost only one young alligator and had the glass of one case broken in the transfer. In 1802, after the Pennsylvania capital had moved from Philadelphia to Lancaster, the museum expanded into the State House itself, and at Peale's death, in 1827, it was preparing to occupy the third floor of the Philadelphia Arcade, the office building designed by John Haviland.[27]

By 1800, Peale was clear in his mind about the space needs of his museum and wrote a member of the State Senate to enlist support for the public patronage he hoped to receive. The letter contains insights into Peale's general museum philosophy and reads:

> In the first place I declare that it is only the arrangement and management of a Repository of Subjects of Natual History, etc., that can constitute its utility. For if it should be immensely rich in the numbers and value of articles, unless they are systematically arranged, and the proper modes of seeing and using them attended to, the advantage of such a store will be of little account to the public. . . .
>
> A house sufficiently large to contain all subjects proper for a museum would be a very extensive building. Such is not easily obtained, although it need not be ornamented in the least, or have lofty ceilings. Yet a great deal can be done on a

Fig. 4. Back of the State House, Philadelphia, 1799. Both the State House *(left)* and Philosophical Hall of the American Philosophical Society *(center rear)* housed Peale's Museum. This engraving, by William Birch, was given to the Philadelphia Museum of Art by Mrs. Walter C. Janney, in memory of her late husband, a former trustee of the Museum. *(Courtesy of the Philadelphia Museum of Art.)*

smaller scale. Rooms that will hold of large and small quadrupeds rather more than 200, of birds 2000, besides amphibious animals, fishes, insects, minerals and other fossils, shells and other marine productions—these, if possible, should be arranged in one suite, to shew a gradual link in the natural connecting chain. And the light ought to be from the north, as best to preserve their colors. Rooms for utensils, models, arms and clothing of various nations, a picture gallery to exhibit

many things that would communicate knowledge, which words would feebly express. A large room to deliver lectures in, and a library to contain at least a complete collection on natural history, none of which should be taken from the Museum but resorted to by all that wanted information on such subjects. Also, an allotment for botany, and some convenience for keeping a few living animals.

I will now suppose such a museum realized. Persons should be appointed to deliver courses of lectures on the several branches of natural history, having the real subjects before them. Such professors in a large city ought to get a sufficient number of pupils to reward their trouble, especially with the addition of persons who would come from other states to get the advantage of delightful and powerful instruction.

And besides these schools, a museum in perfect arrangement, with a good catalogue to give information on each subject, always open to visitors, would diffuse a beneficial taste and knowledge to those who might not be able to attend the course of lectures. The price of admission to such visitors should be proportioned to the price of provisions or labor: about as much as I have always hitherto received. And the moneys arising from the visitors should be the support of the proprietors and keepers of the museum—which mode I have ever considered the most beneficial to the public. For if a museum was free to all to view it without cost, it would be over-run and abused. On the other hand, if too difficult of access, it would lose its utility, that of giving information generally. . . .[28]

Peale's plan outlines many principles still agreed upon by museum administrators today, such as a functional building with minimum ornamentation and ceilings of moderate height; light controlled so as to prevent or reduce fading of susceptible materials; an auditorium for teaching purposes; a research library that would not circulate; a lecture program built around objects in the collection; a good catalogue; and the museum open to all visitors, with a modest admission fee designed to pay the expense of a small staff. The balance seems good for use by the scholar, the student, and the general public.

Peale, ever the enthusiastic collector, naturally stressed American specimens, though he tried to obtain materials "from every part of the Globe." His favorite class of accessions was birds; then came snakes, especially poisonous ones; next, animals—fierce, like the bear, or strange, like the giant anteater; but also flies, beetles, insects, or worms gathered from the woods or under manure piles. The spirited Peale household included dogs, cats, squirrels, mice, and snakes, while in the backyard were a bear and a five-legged cow (with six feet and two tails) that supplied the family with milk; upon its death, it became a favorite museum exhibit, mounted in the act of giving milk to a two-headed calf. The State House Yard later included a more extensive menagerie and a

few rare trees and plants; thus, the natural history museum had traces of a zoo and botanical garden. And every object had to be accurately accessioned and labeled, the natural history specimens according to the Linnean system.[29]

Peale shot birds and industriously gathered other specimens wherever he traveled; he sent Raphaelle to Georgia on a year-long collecting tour; he purchased individual specimens and whole collections; he sought and received many gifts and deposits, including materials from the Lewis and Clark Expedition, through President Jefferson and Meriwether Lewis himself; and he exchanged specimens with foreign collectors and museums. An indefatigable tinkerer and inventor, he acquired electrical and technological equipment that could be used in experiments and demonstrations at the museum; a model of a perpetual-motion machine was shown, to prove that such a concept was fallacious. Much ethnographic material came in, most of it of American Indian origin, but some brought back by ship captains engaged in the China trade or from elsewhere in the world. The numerous portraits of his own painting included a superb *Franklin* (1785), a *Lafayette* (1780–1781), *Baron von Humboldt* (1804), and every United States president through Andrew Jackson. Peale also sent Rembrandt to Paris twice, to paint distinguished French naturalists for the museum.[30]

But the greatest single accession of the Philadelphia Museum, its master exhibit of international renown, was the skeleton of the mastodon. In 1801, Peale read a newspaper account of a farmer in Ulster County, New York, who had by chance dug up an almost complete skeleton of a "mammoth," that unknown creature (*Incognitum*), a few bones of which had ignited Peale's interest in a museum. He hastened up the Hudson and persuaded John Masten, the farmer, to sell him the skeleton for two hundred dollars and, for an additional one hundred dollars, to allow him to return to dig further in the marl pit where it had been found. In great excitement, Peale went back to Philadelphia to lay out the huge bones and to discover that some of them had been damaged and others were missing, especially the underjaw and part of the head. The Philosophical Society made him a four-month, interest-free loan of five hundred dollars, so that he could organize an expedition to excavate the Masten marl pit.

With his son Rembrandt, his versatile museum assistant Jotham Fenton, and young Dr. James Woodhouse, professor of chemistry at the University of Pennsylvania, Peale returned to Ulster County. He hired twenty-five workmen for the digging and designed a giant wheel with an

endless chain of buckets to drain water from the pit; the wheel was operated by three men walking inside it, and the public flocking to the site furnished volunteers for this work. Additional bones were found, but only fragments of the mastodon's lower jaw and head were among them. The expedition examined similar sites nearby, employing a pointed iron rod designed by Rembrandt Peale to penetrate the soft earth and locate bones. After scattered finds, a substantially whole skeleton of a second mastodon was discovered, almost as good as the Masten one—and with complete underjaw. The first American scientific paleontological expedition ended in September 1801; it had lasted five months and had cost nearly two thousand dollars, a large outlay for that time. Peale recorded it in his painting, *Exhumation of the Mastodon* (1806)—not strictly accurately, since he included portraits of persons not present—friends and family members, including both his first and second wives.

Peale and his small staff took three months to articulate the two skeletons of the "mammoth" (the word then came into general American usage to designate anything of huge proportions). Peale properly thought it prehistoric and extinct, but mounted it too high at the shoulder (eleven feet) and romantically described it as "the carniverous elephant of the North," though it actually was herbiverous. George Cuvier of Peale's admired Muséum d'Histoire Naturelle identified the animal as a species separate from the elephant's ancestor, the Siberian mammoth, and named it *mastodon*. Peale showed one skeleton in Philosophical Hall at a separate charge of fifty cents (in 1802, it earned more than eighteen hundred dollars), and Charles Waterton, the English naturalist, later described it as "a national treasure" and "the most magnificent skeleton in the world." Rembrandt took his family and his brother Rubens to England with the second mastodon; he devised a farewell dinner with toasts and music at Philosophical Hall, with thirteen gentlemen seated beneath the great skeleton. The mastodon aroused some scientific interest in Britain, but failed to pay the expenses of its exhibitors.[31]

All the Peale collecting was accompanied by abundant news stories and advertisements that kept the museum before the public, and material inserted in the Philadelphia papers was copied widely throughout the country. Peale sometimes reprinted an important announcement as a small broadside and sent it to members of federal, state, and city governments, other influential leaders, and friends. In 1788, he began to publish museum accession lists in the Philadelphia news sheets, always with full credit to donors, and that practice brought a flood of gifts; some of them

Fig. 5. *Exhumation of the Mastodon*, 1801. Painted by Charles Willson Peale in 1806. In the Peale Museum, Baltimore. *(Courtesy of the Peale Museum, Baltimore, Maryland.)*

were trivial curiosities, carefully acknowledged, but not exhibited. Special events called for unusual attention: the opening of the Mammoth Room was publicized by the museum's handyman, the mulatto Moses Williams, dressed as an American Indian and riding a white horse through town, preceded by a trumpeter.

Peale's collecting continued throughout his life; as late as 1826, he

bought 150 rattlesnakes and a collection of Indian costumes. When the museum was finally sold off, about 1850, in addition to several miscellaneous groups, it contained approximately

269 portraits and paintings
1,824 birds (some lots not itemized)
250 quadrupeds
135 reptiles, lizards, and tortoises
650 fishes
363 preparations (largely anatomical) preserved in spirits
33 cases of shells (1,044 in an 1819 list)
35 cases and numerous other anthropological objects
312 volumes in the library[33]

As soon as Peale opened the museum, he had to teach himself methods of conservation. Dr. Franklin gave him the cadaver of an angora cat that had died after he brought it back from France, but cats are difficult to skin, clean, and mount, and Peale finally had to bury it. He was more successful in preparing a pair of Chinese golden pheasants that Lafayette had sent to General Washington, from the Royal Aviary in Paris; in fact the pheasants are still extant, in the Museum of Comparative Zoology at Harvard. A major problem was protecting mounted specimens from insect damage; Peale tried turpentine unsuccessfully and settled upon dipping birds and small animals in an arsenic solution and using bichloride of mercury for larger ones. Employment of these poisons was hazardous, however, and at times made Peale and Raphaelle sick. The proprietor used glass cases to protect his bird groups and small objects, but could not keep the public from fingering the specimens in his grotto, even though signs warned that they were covered with arsenic. When Peale found that stuffing large animals produced unrealistic appearances, he carved wooden underbodies to imitate the muscular play under the stretched skins, "a mode," he said, "not done in any other museum." His mountings held up well after twenty years, and he wrote proudly: "Time cannot alter them, so that if my system is pursued this Museum cannot fail of becoming in time the best Museum in the world." In 1824, Charles Waterton, on returning from South America to England, made a special trip to see the museum. He had once subdued an alligator with his bare hands, rather than spoil the skin with a weapon, and he showed Peale and Titian some new taxidermic techniques. In the area of painting, Peale always had trouble with fading pigments, and both he and his brother James occasionally revarnished and retouched pictures in the gallery.[34]

Peale perhaps made his greatest contributions to museum function in the field of exhibition. He began in his own house, in 1786, with the

construction of a grotto in the former motion-picture room. The grotto sides and the ceiling, seemingly cut out of solid rock, enclosed a mound of green turf, from which trees ascended, with a pond below. In this setting, natural specimens were arranged, the Reverend Manasseh Cutler thought, "in a most romantic and amusing manner." In holes at the foot of the mound, one saw ores and minerals; on the beach—shells, frogs, and water snakes; in the pond—fish, geese, ducks, and cranes; on the mound—partridge, bear, deer, and tiger; in a thicket—rattlers and other snakes; and the trees were loaded with birds of all sorts. The painting gallery contained a wax figure of Peale himself, brush in hand to paint a miniature, and the visitor laughed if he was fooled into thinking the model alive. Peale enjoyed a good-humored deception, and his *Staircase* painting (1795), placed above a wooden first step with life-sized figures of Raphael and Titian, to whom President Washington once bowed politely, was perhaps his most successful attempt at *trompe l'oeil*. He constantly added new and exciting exhibits—the huge American bison, a rattlesnake's fangs and poison ducts under a magnifying glass, as well as tiny insects in a wheel that passed below a microscope, a room with live snakes in cages, and outside, baboons, monkeys, and bears. By 1797, he had fashioned "waxen figures of men large as life" and appropriately clad—savages from North and South America, Siberia, and the South Seas, Chinese laborer and mandarin, and a "sooty African."

Most original of all was Peale's method of showing birds and smaller animals in natural poses in glass-fronted cases two to four feet high, with realistic, modeled foregrounds and curved, brightly painted watercolor backgrounds, many of actual scenes. These arrangements, the pioneers of the habitat groups so widely used today, were lifelike and brought out the habits and environment of the creatures shown. As Peale explained later:

> It is not customary in Europe, it is said, to paint skys and landscapes in their cases of birds and other animals, and it may have a neat and clean appearance to line them only with white paper, but on the other hand it is not only pleasing to see a sketch of a landscape, but by showing the nest, hollow, cave, or a particular view of the country from which they came, some instances of the habits may be given.

The first Titian Peale also mounted a great gray wolf, its fangs dripping blood as it devoured a lamb. Some exhibits did not follow scientific order, but were designed for fun; magic mirrors distorted a vistor's appearance into that of a giant, a dwarf, or a monster with seven heads. A speaking tube mounted in a lion's head allowed one to shout back and forth with one's friends in another room.[35]

Not much original research was done by the museum itself, though Peale arranged his displays as scientifically as limited space would allow, with a framed catalogue above the cases and continuing from room to room. Each specimen was numbered to correspond with the catalogue that followed the Linnean classification with names printed in Latin, French, and English. Palisot de Beauvois, a talented French naturalist driven out of Santo Domingo in the slave revolt in 1793, perfected this arrangement and, with Peale's help, began work on a formal catalogue, but only about forty pages were printed, covering fifty-four entries on quadrupeds from Indian skeletons to the opossum. Peale greatly admired the Muséum d'Histoire Naturelle in Paris, with its twelve professors offering lecture courses, and he decided to research and present such lectures, himself. Between 1799 and 1800 and again in the following year, he announced a course of forty lectures to be given over a four-month period, with two lectures per week. The project was unusual, in that specimens (a few of them live) were brought from their places in the museum to the lecture hall; some 122 quadrupeds and 765 birds were shown. The notes on the lectures thus comprised a virtual catalogue of the museum, and Peale combined his own observations with references to the published literature and some anecdotal, now and then humorous, material to help hold the attention of his listeners. He was careful to delete anything that might faintly shock the women who formed a majority of the audience, and he included intervals of music and poetry. The introductory lectures, held at the University of Pennsylvania, with the remainder at the museum, were printed and sent to friends and museums at home and abroad. The series was the most comprehensive attempt yet made by an American to sum up what was known of mammals and birds. Of course, many early Philadelphia scientists did research on the collections. Alexander Wilson used them extensively for his *American Ornithology*, as did Dr. John D. Godman in his *American Natural History*.[36]

Peale expected his museum to teach science in several different ways, appealing to the viewer both through language and sensory perception. Each visitor received an eight-page printed guide that amplified the framed catalogue and could observe Rubens Peale using the "great three-foot diameter single plate electrical machine" that could give viewers a moderate shock, and a new compound blowpipe to illustrate the wonders of chemistry. A little bell would call visitors to the performances that, in 1820, were given their own room with a hollow demonstration table and raked tiers of seats on three sides. Peale paid John Lowe a thousand dollars to build an organ of eight stops, arguing that harmony was a vital

part of natural history; and he allowed talented visitors to play the organ. Outside the scientific field was the physiognotrace, given to the museum by its inventor, John I. Hawkins. A visitor could use the instrument to trace his silhouette, and Moses Williams, the slave whom Peale had freed, would cut out the silhouette skillfully at a charge of eight cents; Williams made 8,800 silhouettes, in the first year the physiognotrace was displayed. Such devices gave the museum-goer an opportunity to enjoy some participatory interpretation.[37]

In the winter of 1796 and 1797, the museum began to offer interpretive features in the evening, at first lighted by whale-oil lamps, but after May 1816, by the first gaslight seen in America. (Rembrandt Peale, within a month, was illuminating his Baltimore Museum by gas.) The cheerful, lighted rooms became a kind of fashionable lounge. In 1821, Peale tried to revive the lecture program, enlisting four capable scholars in zoology, physiology, mineralogy, and comparative anatomy; lectures were open to all museum-goers, with students charged half-price and teachers with their classes entering free of charge. The lectures did not prove popular and were soon abandoned. Organ recitals and musical programs were better received. When Rubens began to manage the museum, he paid strict attention to the profits and, much to his father's sorrow and disgust, sometimes emphasized pure entertainment, rather than scholarship. In March 1820, for example, Signor Hellene, recently from Italy and touring as a one-man band who played the viola, Turkish cymbals, tenor drum, Pandean pipes, and Chinese bells, all at the same time, had to be held over by popular demand.

Peale also wanted the museum to issue publications based on its holdings, in order to increase public understanding of natural history. He had hoped to publish his and Palisot de Beauvois's catalogue in parts, with a total of three hundred to five hundred pages, but could not obtain the necessary subscribers. Peale then bought a press and, in 1824, put out the first number of *The Philadelphia Museum, or Register of Natural History and the Arts*, but again popular support failed to appear, as did a second number.[38]

Charles Willson Peale in 1810, at age sixty-nine, decided to reorganize his life. His third marriage with Hannah Moore, a kindly Quaker, was working out well, and he had achieved a long-held ambition in helping found the Pennsylvania Academy of the Fine Arts in 1805, with an art school, annual exhibits, and a promising gallery. Peale therefore turned over the management of the museum to Rubens, who was to pay him $1,000 each quarter (the museum's net income for 1808 and 1809 had

averaged $5,100). The father bought a farm in Germantown, at first called "Farm Persevere" and then "Belfield," and was soon busy inventing numerous devices for agricultural and industrial improvement. Rembrandt Peale tried to acquire a share in the museum, but Rubens and his father stood firm against him, and Rembrandt went to Baltimore to found his own museum in 1814. During Rubens's ten years of management, he was at times assisted by two other brothers—Titian as naturalist and preparator, and Franklin as engineer and demonstrator. Rubens kept the museum neat and clean, but was sometimes willing to sacrifice natural history for profitable entertainment. He replaced the framed Linnean catalogue with handsomely engrossed Bible texts, and brilliantly lighted evening openings drew heavy attendance with spectacular demonstrations of science and electricity, a magic lantern, and even crude moving pictures, while vaudeville acts such as Signor Hellene's had longer stays. When Hannah Peale died of yellow fever in 1821, Peale decided to sell Belfield and returned to the management of his museum. Rubens moved to Baltimore to take over Rembrandt's museum, and when it failed to show a profit, went on to New York to set up another one. He later sent his half-brother Linnaeus to Utica to operate a branch; but by the time the father died, February 27, 1827, the Peale museums were beginning to go downhill.[39]

## IV

Mr. Peale's Museum compared well with its contemporary rivals at home and abroad. In the United States, the early learned and historical societies—the American Philosophical (1769), Massachusetts Historical (1791), East India Marine (1799), New-York Historical (1804), and American Antiquarian (1812)—at first collected museum materials, but usually too broadly. Of these, only the New-York Historical Society and the East India Marine Society at Salem retained respectable museums, and they did not include much natural history; the others early devoted themselves to the accumulation of research libraries and to scholarly publication, placing their museum collections in other hands. But there were many museums in all parts of the country—not only in Boston, New York, and Philadelphia, but in smaller places such as New Haven, Utica, Syracuse, Niagara Falls, Pittsburgh, Charleston, Cincinnati, Lexington, St. Louis, and New Orleans. The usual exhibits were paintings, natural and artificial curiosities, and waxworks, combined often with performing arts that included demonstrations, music, drama, and vaudeville. Most American museums constituted a kind of popular theater run by unlearned men

interested in any curiosity of entertainment that would bring in admission fees. In 1834, when Titian Peale was in charge at Philadelphia, Prince Maximilian of Wied, who found nearly all American museums "calculated, not for the advantage of science, but for pecuniary gain," asserted that "Mr. Peale's collection deserves precedence above all the public museums in the United States, for its scientific arrangement, and because fewer trifling nicknacks have been admitted into it."[40]

A closer look at two of Peale's imitators will show how they were influenced by and yet differed from the Philadelphia Museum. The Library Society of Charleston in 1773 organized its museum, today the oldest in the nation, to collect materials to promote the natural history of South Carolina. It accumulated animal, vegetable, and mineral specimens, ordered an orrery from Rittenhouse, and possessed a telescope, microscope, camera obscura, hydrostatic balance, and a pair of elegant globes. Most of its holdings burned during the Revolution, but in 1824 its successor, the Literary and Philosophical Society of South Carolina, opened a museum that it hoped would become as well known as "Peale's Museum is, in Pennsylvania and Maryland." The new museum possessed eight hundred birds, including an ostrich as big as a horse; seventy beasts, with a great white bear from Greenland and a boa constrictor twenty-five feet long; two hundred fishes, the largest a twenty-foot grampus whale; the head of a New Zealand chief; an Egyptian mummy; four-inch-long shoes of a Chinese lady; and assorted curiosities. Open daily at 9:00 A.M. at twenty-five cents admission, the museum was illuminated on most evenings and occasionally featured music by a band. The society, however, failed to obtain funds for a new building, and in 1827 turned its collection over to the newly organized Medical Society of the State of South Carolina, where the materials remained for a time quiescent.[41]

New York City had a series of museums that started with John Pintard's Tammany American Museum, opened in 1791, backed by the Tammany Society and with Gardiner Baker as keeper. Its natural history collection included an American bison, an eighteen-foot yellow snake from South America, a two-headed lamb, and a smelly, noisy menagerie in a lot outside. Other attractions were waxworks, an air gun that visitors for a time could shoot for a sixpence, Indian relics, African ornaments, Chinese weapons, and a full-sized guillotine with a beheaded wax figure. In 1795, the Tammany Society gave Baker the collection, to settle arrears in his wages. He divided it in two, part shown in the New Panorama Building, with a panorama of Charleston; and he bought from Gilbert Stuart a full-length portrait of Washington, after the Lansdowne type, to

exhibit at the New City Tavern. Baker charged higher admission fees than did Peale—seventy-five cents for each of his museums or one dollar for both, and one dollar to see Washington's portrait. Unfortunately, Baker's wife became infatuated with a Frenchman, and, in 1798, Baker took her and their four children, the Washington portrait, and his costly musical automatons to Boston—where he died, of yellow fever.

In 1802, Edward Savage, a painter, acquired the collection for his "Columbian Gallery and City Museum," promised to arrange it "agreeably to the ideas of Sir Hans Sloane," and added 200 paintings and prints to its holdings. His curator, John Scudder, skilled taxidermist, in 1810 bought most of the collection and opened the New American Museum. In 1816, New York City gave Scudder, rent-free, the second floor of the old Almshouse in City Hall Park; the civic center there included other cultural institutions—the New-York Historical Society, New York Society Library, the American Academy of the Fine Arts, the Literary and Philosophical Society, and the Lyceum of Natural History. The museum's large showroom had a forest scene at one end, with 80 animals, snakes, and birds, and, in the center, 164 glass cases containing 600 specimens. When he died, at age forty-five in 1821, Scudder had filled three more great rooms. Two years later, his son John's 103-page guidebook was entitled, *A Companion to the American Museum . . . a Catalogue of upwards of Fifty Thousand Natural and Foreign Curiosities, Antiques, and Productions of the Fine Arts . . . With the Latin Names of Each Natural Curiosity.* Though Scudder advertised that his museum was unrivalled in the country in quality of displays and picturesqueness of their arrangement, the exhibits did not include a mastodon, habitat groups, or an extensive gallery of heroes and scientists.[42]

Abroad, both the British Museum and Muséum National d'Histoire Naturelle confined themselves chiefly to collection and research. The general public was grudgingly admitted, hurried through, and received little assistance in understanding the rather dowdy exhibits. Two popular museums devoted mainly to natural history did appear in London. Sir Ashton Lever (he was knighted in 1778 for his museum work) moved his collection, especially strong in birds, from his seat at Alkrington Hall, near Manchester, to Leicester Square in 1774 and opened it as the "Holophusikon." An eccentric aristocrat who liked to dress as a forester and practice archery in the garden next to the museum, he discouraged attendance by the common people and charged a high admission fee that varied between 5s. 6d. and half a guinea (about $1.25 to $2.50). In 1786, he

was forced to dispose of his holdings and held a lottery; the materials went to James Parkinson, who moved them across the Thames near Blackfriar's Bridge and finally sold them at auction in 1806.

William Bullock, a silversmith, was more successful with a museum at Sheffield—briefly, in 1795—and then at Liverpool, until he took it to London in 1809. Bullock had built for it in Piccadilly the landmark Egyptian Hall, which remained a London entertainment center until torn down in 1905. Bullock belonged to the Linnean Society and scientifically collected and mounted birds. A master showman, he created a kind of habitat group that he called the "Pantherion." The visitor entering Egyptian Hall passed through a basaltic cavern similar to Fingal's Cave and came out in an East Indian hut, from which he viewed, Bullock said, with panoramic effect, a tropical forest containing an African elephant, giraffe, lion, tiger, rhinoceros, and many other animals. The scene included a thirty-foot boa constrictor hanging from a tree and strangling a deer, and another huge python was engaged in a death struggle with a Bengal tiger. Bullock's combined botanical and zoological display somewhat resembled one of Carl Akeley's modern habitat groups, but it lacked strict authenticity, since beasts and plants from different continents were mixed. In 1819, after the British Museum and the University of Edinburgh declined to buy the collection, Bullock acted as his own auctioneer to sell it for nearly ten thousand pounds. Some of the better specimens are still extant today in British and continental museums.[43]

Peale and these foreign museums were aware of each other. Rembrandt and Rubens Peale, taking the second mastodon to Britain, were welcomed and entertained by Sir Joseph Banks, a principal trustee of the British Museum. When Rembrandt Peale went to Paris to paint portraits of French naturalists for his father's museum, he found that the name Peale opened many doors for him, and Vivant Denon, Napoleon's director general of French museums and supervisor of official art, even tried to get him to remain, to paint all imperial-ordered portraits. An English traveler to Philadelphia in 1794 compared Peale's museum with the Leverian Museum, which he thought somewhat larger. One description of Bullock's London Museum ran:

No person possessing the least desire of improving their knowledge of nature should refrain from visiting this attractive exposition; juvenile minds will there be taught a lesson beyond calculation valuable; they will read, in the great volume of creation, the work of the all-wise Providence, and the lesson will be indelibly impressed in their memories.

Not only did Bullock enunciate an underlying religious purpose similar to Peale's but he prided himself on his Linnean arrangement and his habitat-group Pantherion. Also in his auction catalogue Bullock described one black hawk as "very rare, only known in Peale's Museum."[44]

Since the Philadelphia Museum lasted so long and was so well regarded, why, then, does it not exist today? The explanation, as for so many historical questions, involves external or social forces as well as internal or personal ones. To look at the external forces first, the mix of scientific information and rational amusement found in Peale's Museum worked, for a time, but was always vulnerable from either direction. As the study of natural history grew more sophisticated and more scientific, the naturalists were distressed by what they regarded as tawdry and untasteful entertainment in the mixture. The American Philosophical Society became distrustful and less co-operative, once Peale moved his museum across the yard and Rubens took down the Linnean catalogue and turned more frequently to Signor Hellene and his ilk. The naturalists began to favor the Academy of Natural Sciences over the museum. Alexander Robinson of Baltimore, Peale's snobbish son-in-law, well illustrated the wariness of the conservative elitist for popularization or democratization—whether of science, art, or politics; Robinson was actually ashamed of Peale, accused him of being a showman, and tried to get him to give up the museum.[45]

Changing public taste for entertainment also threatened the museum. The theater, often considered immoral in early America, was becoming popular, and plays and variety acts were invading museums and replacing experiments and demonstrations. Phineas T. Barnum in New York and Moses Kimball in Boston exploited such spectacular features more successfully than did the Peale children. Barnum, though he made some scientific collections and later contributed specimens to reputable museums, was not restrained by scientific or educational canons; he could promote a fake Fiji mermaid, a Tomb Thumb, a Jenny Lind, or a Jumbo with overblown advertising and humorous hokum. He was also a tough, shrewd bargainer in financial matters. He made the Peale museums look tame and old-fashioned, as he transformed stuffed animals and small menageries into the glamorous traveling show and circus.[46] Any museum with scientific or artistic integrity could not compete with such no-holds-barred exuberance. Barnum's rise accompanied the Peales' fall. Late in 1841, Barnum outwitted a group of speculators to acquire Scudder's collection as a basis for his huge Barnum's American Museum, and

he soon added to it the remnants of Rubens Peale's New York Parthenon. In 1845, Barnum gained the Baltimore Museum and by 1850 had bid in at sheriff's sale the Philadelphia Museum's natural history holdings, jointly with Moses Kimball of the New England Museum; the two split the collection between New York and Boston.[47]

Now for the internal side of the story: Peale failed to achieve a workable organization strong and flexible enough to carry the museum through the years. He knew rather clearly what he wanted. He thought that most great European museums had been started by an individual and then taken over by a nation; he hoped that his could become a National Museum like the French natural history one. What he needed was government financial support to provide a building and expansion as the museum grew and to pay for its maintenance and that of the collection. A modest admission charge would bring in enough to support a salaried staff. Collections could be acquired by the museum workers and with gifts from the public; tax money might not be needed there—or only on rare occasions. Peale was perfectly willing to work out details within this general framework; if necessary, a loan or lottery might be used to raise building funds or an endowment, and he would be willing to take the admission receipts in lieu of set salaries for the staff and to provide enlargement of the collection.

When the new federal government moved from New York to Philadelphia in 1790, to spend ten years there before going on to the new capital in Washington, Peale asked President Washington to appoint him postmaster general, so that he could promote natural history from a cabinet vista, but Washington did not accept this unusual suggestion. In 1792, Peale announced his plan to transform his enterprise into a National Museum and appointed a Society of Inspectors or Visitors consisting of twenty-seven prominent citizens that included three cabinet members (Jefferson, Hamilton, and Edmund Randolph), Congressman James Madison, Governor Thomas Mifflin, Bishop William White, the wealthy Robert Morris and William Bingham, and other political, cultural, and scientific leaders. The group met three times and petitioned the Pennsylvania Legislature to develop a plan for assisting the museum, but the effort did not succeed, and Peale allowed the society to expire. When his close friend and correspondent Thomas Jefferson became president, Peale hoped for federal support, but Jefferson did not believe that the Constitution allowed the central government to subsidize educational and cultural organizations, or that Congress would vote money for

-museums. Baron von Humboldt later reported to Peale that President Jefferson "thought each of the States would contribute means and thus it might be a National Museum." Nothing came of that idea, nor of Joel Barlow's scheme for setting up a National University at Washington that might include a National Museum. Not until 1846 was the Smithsonian Institution chartered to use the Englishman James Smithson's surprise gift of more than a half-million dollars "for the increase and diffusion of knowledge among men," and not until the 1870s did the Smithsonian begin to establish a great national museum.[48]

Nor did Peale succeed in securing significant support from the Pennsylvania Legislature, though he showered it with petitions and letters, secured favorable newspaper comment, gave the assembly free museum tickets, and even devised an artificial hand for one rural member. In 1802, spurred by the public excitement over the mastodon, the legislature did grant Peale the whole second floor and other space in the former State House rent-free; but, eight years later, it imposed an annual rental of four hundred dollars. In 1816, the city of Philadelphia purchased the old State House and promptly raised the rent to twelve hundred dollars (later reduced to six hundred). Peale pointed out the large number of visitors attracted to the city by the museum and the value of their business to innkeepers and merchants. He threatened to take the museum to another city and investigated possibilities in New York and Washington. In retrospect, it is tragic that the museum and Philadelphia did not work out a partnership similar to that that the Metropolitan Museum of Art and the American Museum of Natural History reached with New York City in 1871, by which the city erected, owned, and maintained the buildings, and the museum boards secured, serviced, and interpreted the collections. Similar patterns of support have since become common for American municipalities and museums.[49]

Acting against government support, at least from 1795 on, was the obvious fact that the museum took in much money. Businessmen, legislators, and officials who saw the crowds thought that Peale had a good thing financially, and they did not comprehend the need for more exhibition and storage space, nor realize the cost of conservation, research, and publication. Not that Peale took real advantage of the money he received. After Peale's third marriage, at age sixty-four, in 1805, Benjamin Latrobe wrote Jefferson of him: "However, he is a boy in many respects and unfortunately, also in this: that he has saved nothing." Rubens, probably the most businesslike of Peale's children, echoed that sentiment, in hold-

ing that all the Peales were "too easy and contented," while P. T. Barnum had contempt for even Rubens's business ability. Perhaps if Peale had possessed Sir Hans Sloane's financial canniness and his adroitness at eliciting government support, the story might have been different. A truly nonprofit organization with an active board of trustees such as some of the learned societies had achieved might have brought Peale's efforts to secure government assistance greater credibility, but the easy-going Peales, father and especially sons, took for their personal use much of the income the museum generated.[50]

All attempts to secure governmental support having failed, Peale turned to a business corporation as a means of perpetuating his creation. The Philadelphia Museum Company was incorporated in 1821, comprising five hundred shares at two hundred dollars each. Peale, at first the sole stockholder, appointed a board of five trustees to manage the museum. Upon his death, the stock went to his family, and the board elected Franklin Peale manager and Titian Peale curator of the museum, which moved into the new Arcade Building in August 1827. The two young men worked well together until Franklin left for a position in the United States Mint in 1833. The board of trustees was enlarged in 1836 and more stock issued that entitled holders to free admission to the museum. Nathan Dunn, wealthy Philadelphia entrepreneur who had spent thirteen years in China and accumulated a distinguished Chinese decorative arts collection, now joined the board and took a leading part in the erection of a new building for the museum at Ninth and George (now Sansom) to house both the Peale and Dunn collections. The United States Bank lent the company the one hundred thousand dollars required. The building's main "Saloon" was 230 feet long, 70 wide, and about 50 feet in height, and the Peale collection looked impressive there. But the depression of the late 1830s made the company's position critical. In 1841, Nathan Dunn took his "Chinese World in Miniature" to London, and, two years later, the bank sold the building at sheriff's sale. The museum moved to the old Masonic Hall, and sometime in 1850 P. T. Barnum and Moses Kimball acquired the natural history collection, while the portraits were sold at auction in 1854.[51]

Little of the natural history part of Peale's Museum survives today. Many specimens were destroyed in Barnum museum fires in Philadelphia and New York. Other holdings, mainly from Moses Kimball's museum in Boston, have come down to Harvard's Museum of Comparative Zoology and Peabody Museum of Archaeology and Ethnology.

Peale's first mastodon skeleton (the one shown in Philadelphia) has found its way to a museum in Darmstadt, West Germany, where it has been mounted more scientifically. The second mastodon skeleton (shown in London and then in Baltimore) belongs to the American Museum of Natural History, New York; it has been disassembled and some of the bones lent to the present Peale Museum in Baltimore. Peale's picture gallery has fared better. It was sent in 1851 to Cincinnati, but when a drive for a building to house it failed, it returned to Philadelphia for dispersal in 1854. The city of Philadelphia purchased 106 of the portraits, and today, while Peale paintings are treasured in many museums, the greatest single collection is in the former Second United States Bank building of Philadelphia's Independence National Historical Park operated by the National Park Service.[52]

Even though Peale's Museum did not continue, it set a pattern for the American museums that succeeded it. Most European museums had been created by royal or aristocratic collectors and designed as storehouses of specimens and objects intended mainly for the delectation and use of the few, the discriminating connoisseurs and knowledgeable scholars. Though Peale did not denigrate scholarship, and the Muséum d'Histoire Naturelle and its professors remained his ideal organization, so far as research, formal teaching, and publication were concerned, from the beginning he had a very different purpose. He saw his museum as a school for the ordinary man and woman, as an institution that would promote morality and happiness for the entire public. Peale's idea fitted well the democratic stirrings of early America; he was close to his audience and depended for success upon his visitors' favorable reaction to his museum, even as expressed by their paying admission fees. But he was interested in more than their financial contributions. He was unwilling to let his ideal of inculcating moral happiness be degraded and spoiled by cheap and unworthy entertainment. He was too far ahead of his time and did not receive the federal, state, or municipal financial support that his efforts deserved, and he failed to devise a form of organization that would perpetuate his dream. Much later, the National Museum of Natural History of the Smithsonian Institution secured government support and became the kind of institution he had glimpsed, while the American Museum of Natural History in New York worked out a viable combination of private and municipal support that would have delighted Peale. And American museums of natural history and of other kinds would be known throughout the world for their devotion to the public interest and for their broad and pleasing educational and interpretive programs.

## NOTES

1. Charles Coleman Sellers, a direct descendant of Peale, discussed the main points of this chapter with me at his home in Carlisle, Pennsylvania, a few months before his death in 1980. His carefully researched and beautifully written books and articles on Peale and his museum constitute a chief source of this chapter. Charles Coleman Sellers, *Portraits and Miniatures by Charles Willson Peale*, n.s. 42, pt. 1: 160–162, 364; Charles Coleman Sellers, *Charles Willson Peale with Patron and Populace*, n.s. 59, pt. 3: 47; Charles Coleman Sellers, *Charles Willson Peale*, pp. 402–403; Charles Coleman Sellers, *Mr. Peale's Museum*, pp. ii, iv.

2. Sellers, *Peale*, p. 122; Sellers, *Mr. Peale's Museum*, p. 2; James Thomas Flexner, *America's Old Masters*, pp. 193–194.

3. Sellers, *Peale*, pp. 254, 309–310, 364–365; Sellers, *Mr. Peale's Museum*, pp. 15–16.

4. Sellers, *With Patron and Populace*, p. 42; Sellers, *Peale*, pp. 391–392; Sellers, *Mr. Peale's Museum*, pp. 236–237.

5. Sellers, *Peale*, pp. 20–23, 278, 438–439.

6. Sellers, *Peale*, p. 80; Sellers, *Portraits and Miniatures*, pp. 157–158, 289; Kenneth Silverman, *A Cultural History of the American Revolution*, pp. 169–170.

7. Sellers, *Peale*, pp. 28–29, 31–32, 246–247.

8. Sellers, *Peale*, pp. 26–28, 36–37, 89, 118; Sellers, *With Patron and Populace*, p. 8.

9. Sellers, *Peale*, pp. 386, 403–404, 427–428, 430; Flexner, *America's Old Masters*, pp. 239–240.

10. Sellers, *Peale*, pp. 280–282, 292, 377.

11. *Nancy Hallam* is at the Colonial Williamsburg Foundation, Williamsburg, Virginia, and the *Washington* at Washington and Lee University, Lexington, Virginia. Sellers, *Portraits and Miniatures*, pp. 95–96, 216–219, 352; Sellers, *Peale*, 93–95, 99–101, 452; Flexner, *America's Old Masters*, pp. 192–193; Silverman, *Cultural History*, pp. 169, 239–241.

12. Sellers, *Peale*, pp. 87–89, 179, 328, 385; Flexner, *America's Old Masters*, pp. 189–191, 221–222, 232–233, 235–236; Sellers, *With Patron and Populace*, pp. 5, 7.

13. Sellers, *Peale*, p. 204; Sellers, *With Patron and Populace*, p. 20; Sellers, *Mr. Peale's Museum*, pp. 9–12.

14. Sellers, *Peale*, pp. 3–16; Flexner, *America's Old Masters*, pp. 172–174.

15. Sellers, *Peale*, pp. 17–37; Sellers, *Mr. Peale's Museum*, pp. 52–53, 160–166, 234–235; Flexner, *America's Old Masters*, pp. 174–178.

16. Sellers, *Peale*, pp. 29–35, 38–43; Flexner, *America's Old Masters*, pp. 178–182; Silverman, *Cultural History*, pp. 19–20.

17. Sellers, *Peale*, pp. 43–49; Flexner, *America's Old Masters*, pp. 182–189; Silverman, *Cultural History*, pp. 89–90.

18. Sellers, *Peale*, pp. 49–75; Flexner, *America's Old Masters*, pp. 184–189; Silverman, *Cultural History*, pp. 99–101; Edward Miller, *That Noble Cabinet: A History of the British Museum* (Athens, O.: Ohio University Press, 1974), pp. 61–67.

19. Sellers, *Peale*, pp. 75–137; Sellers, *With Patron and Populace*, p. 14; Flexner, *America's Old Masters*, pp. 189–197; Silverman, *Cultural History*, pp. 166–171, 302–303, 316–317, 326–328, 412–413.

20. Sellers, *Peale*, pp. 75–137; Sellers, *Portraits and Miniatures*, pp. 86, 159, 226–228, 297, 355, 362; Sellers, *With Patron and Populace*, pp. 9, 16–21; Flexner, *America's Old Masters*, pp. 197–207; Silverman, *Cultural History*, pp. 350, 359–361, 368–370, 425–426.

21. Sellers, *Peale*, pp. 184–185, 190, 192, 197, 203–204; Sellers, *Mr. Peale's Museum*, p. 9;

Flexner, *America's Old Masters*, pp. 207–208; Silverman, *Cultural History*, pp. 421–422; Richard D. Altick, *The Shows of London*, pp. 119–127.

22. Sellers, *Peale*, pp. 205–211, 219; Sellers, *With Patron and Populace*, pp. 21–22; Sellers, *Mr. Peale's Museum*, pp. 13–15; Flexner, *America's Old Masters*, pp. 208–210; Silverman, *Cultural History*, pp. 452–454, 591; Altick, *Shows of London*, pp. 126–127.

23. Sellers, *Peale*, pp. 213–214, 256, 347–348; Sellers, *Mr. Peale's Museum*, pp. 195, 202; Flexner, *America's Old Masters*, pp. 213, 217. For Du Simitière's museum, see Hans Huth, "Pierre Eugène du Simitière and the Beginnings of the American Historical Museum," *Pennsylvania Magazine of History and Biography* 69 (October 1945): 315–325; Silverman, *Cultural History*, pp. 360–361, 418–419.

24. Sellers, *Peale*, pp. 215–216, 331–333; Sellers, *Mr. Peale's Museum*, pp. 22, 34–37.

25. Sellers, *Peale*, pp. 256–257, 314–317; Charles Coleman Sellers, *Charles Willson Peale: Early Life; Later Life*, 2 vols. 2: 10; Flexner, *America's Old Masters*, pp. 214, 229; Jessie Poesch, *Titian Ramsay Peale, 1799–1885:* pp. 4, 8–9, 10, 17–19.

26. Robert William Theodore Gunther, *Early Science in Oxford*, 15 vols. (Oxford: Printed for the Subscribers, 1923–1967), 1: 43–47; 3: 280–333, 346–366, 391–447; Miller, *That Noble Cabinet*, pp. 42–46, 70–71, 74, 77–79, 86–87, 92; Paul Lemoine, "National Museum of Natural History . . . Paris," *Natural History Magazine* (London) 5 (January 1935): 4–19; "Imperial Conservatory of Arts and Trades at Paris," *American Journal of Education* 21 (1870): 439–449; Sellers, *Mr. Peale's Museum*, pp. 54, 62–63; W. H. Mullens, "Some Museums of Old London: I. The Leverian Museum, II. William Bullock's London Museum," *Museums Journal* 15 (1915–1916): 120–129, 162–172; 17 (1917–1918): 51–56, 132–137, 180–187.

27. Sellers, *Peale*, pp. 214, 232, 264–265, 284, 302–303, 426; Sellers, *Mr. Peale's Museum*, pp. 76–80, 110–112, 152–153, 249, 251, 258.

28. Sellers, *Mr. Peale's Museum*, pp. 111–112.

29. Sellers, *Peale*, pp. 217, 230–274 passim, 333, 349; Sellers, *Mr. Peale's Museum*, pp. 36–37; Irwin Richman, "Charles Willson Peale and the Pennsylvania Museum," *Pennsylvania History*, pp. 257–277.

30. Sellers, *Peale*, pp. 147, 215, 227–262 passim, 314–365 passim; Sellers, *Mr. Peale's Museum*, pp. 38–44, 171–188, 191, 193, 196–197; Flexner, *America's Old Masters*, pp. 208–209; Richman, "Peale and the Pennsylvania Museum," pp. 266, 271, 272; Charles Coleman Sellers, "Peale's Museum and 'The New Museum Idea,' " pp. 25–34.

31. Sellers, *Mr. Peale's Museum*, pp. 113–147; Sellers, *Peale*, pp. 293–304, 310–311; Sellers, *With Patron and Populace*, pp. 34, 36–37; Flexner, *America's Old Masters*, pp. 222–227; Whitfield J. Bell, Jr., "A Box of Old Bones: A Note on the Identification of the Mastodon, 1766–1806," *American Philosophical Society Proceedings* 93 (1949): 169–177.

32. Sellers, *Mr. Peale's Museum*, pp. 23, 37–38, 71–72, 76–80, 110, 142.

33. Sellers, *Peale*, pp. 346, 426; Sellers, *Mr. Peale's Museum*, pp. 314–318.

34. Sellers, *Peale*, pp. 216, 241, 283, 291, 343, 407–408, 413–414; Sellers, *Mr. Peale's Museum*, pp. 24–25, 28, 34, 115, 199, 248–249; Flexner, *America's Old Masters*, pp. 213, 214; Richman, "Peale and the Pennsylvania Museum," pp. 260–262.

35. Sellers, *Peale*, pp. 219–222, 230, 262–263, 285, 337, 340–341; Sellers, *With Patron and Populace*, pp. 23, 32, 50; Sellers, *Mr. Peale's Museum*, pp. 26–29, 30–31, 36.

36. Sellers, *Peale*, pp. 279, 326, 337–339; Sellers, *Mr. Peale's Museum*, pp. 83, 100–113, 203–206, 244–245; C. W. Peale and A. M. F. J. Beauvois, *A Scientific and Descriptive Catalogue of Peale's Museum* (Philadelphia: Samuel H. Smith, 1796).

37. Sellers, *Mr. Peale's Museum*, pp. 196–200; Sellers, *Peale*, pp. 306, 335–336, 341–342; Sellers, *With Patron and Populace*, p. 35.

38. Sellers, *Peale*, pp. 279, 289, 291, 318, 341, 378–379, 394, 411.

39. Sellers, *Mr. Peale's Museum*, pp. 215–239; Sellers, *Peale*, pp. 318–322, 329, 348, 350–373, 423. Rubens established the Utica branch in 1828. Sellers, *Peale: Early and Later Life*, 2: 385–386. For the Baltimore Museum, see Eleanore McSherry Fowble, "Rembrant Peale in Baltimore," and three pieces by Wilbur H. Hunter, Jr.: "The Tribulations of a Museum Director in the 1820's," *Maryland Historical Magazine*, 49: pp. 214–222; *The Story of America's Oldest Museum Building;* and *The Peale Family and Peale's Baltimore Museum, 1814–1830*. For Peale as a farmer, see Jessie J. Poesch, "Mr. Peale's 'Persevere': Some Documentary Views," pp. 545–556.

40. Whitfield J. Bell, Jr., and Others, *A Cabinet of Curiosities;* Walter Muir Whitehill, *Independent Historical Societies: An Enquiry into Their Research and Publication Functions and Their Financial Future* (Boston: Athenaeum, 1962), pp. 6–7, 29–30; Walter Muir Whitehill, *The East India Marine Society and the Peabody Museum of Salem* (Salem: The Peabody Museum, 1949), pp. 36–45; R. W. G. Vail, *Knickerbocker Birthday: A Sesquicentennial History of the New-York Historical Society, 1804–1954* (New York: New-York Historical Society, 1954), pp. 23, 33, 52–53, 72, 93; Reuben Gold Thwaites, editor, *Early Western Travels, 1748–1846*, 32 vols. (Cleveland: Arthur H. Clark Company, 1904–1907), 3: 131; 9: 44, 137–138; 10: 95; 11: 263; 12: 67; 22: 49, 60, 69–70; 24: 143, 165, 173; David John Jeremy, editor, *Henry Wansey and His American Journal, 1794* (Philadelphia: American Philosophical Society, 1970), pp. 72–73; James Silk Buckingham, *America: Historical, Statistic, and Descriptive*, 3 vols. (London and Paris: Fisher, Son & Co. [1842]), 2: 71; 3: 164–166, 374–375; Charles Dorenkott, Jr., "A Portuguese View of Eighteenth Century America; the Costa Pereira Mission," *Records of the American Catholic Historical Society of Philadelphia* 85 (1974): 70–87.

41. Caroline M. Borowsky, "The Charleston Museum, 1773–1963," *Museum News* 41 (February 1963): 11–21; Laura M. Bragg, "The Birth of the Museum Idea in America," *Charleston Museum Quarterly* 1 (First Quarter 1923): 3–13; William G. Mazyck, *The Charleston Museum: Its Genesis and Development* (Charleston: Charleston Museum, 1908), pp. 5–28; Paul M. Rea, "A Contribution to Early Museum History in America," American Association of Museums *Proceedings* 9 (1915): 53–65.

42. Lloyd Haberly, "The American Museum from Baker to Barnum," *New-York Historical Society Quarterly* 43 (1959): 273–288; Robert M. McClung and Gale S. McClung, "Tammany's Remarkable Gardiner Baker: New York's First Museum Proprietor, Menagerie Keeper, and Promoter Extraordinary," *New-York Historical Society Quarterly* 42 (1958): 142–169; Rita Susswein Gottesman, *The Arts and Crafts of New York, 1777–1799: Advertisements and News Items from New York City Newspapers* (New York: New-York Historical Society, 1954), pp. 29–33, 385–405; Gottesman, "New York's First Major Art Show . . . 1802 and 1803," *New-York Historical Society Quarterly* 43 (1959): 288–305.

43. P. J. P. Whitehead, "Museums in the History of Zoology," *Museums Journal* 70 (1970–1971): 50–57, 155–160; Lemoine, "Museum of Natural History, Paris," pp. 4–19; Mullens, "Leverian Museum and Bullock's Museum" 15: 123–129, 162–172; 17: 51–56, 132–137, 180–187; Altick, *Shows of London*, pp. 28–33, 235–252; E. G. Hancock, "One of Those Dreadful Conflicts—a Surviving Display from William Bullock's Museum, 1807–1818," *Museums Journal* 57 (March 1980): 172–175.

44. Sellers, *Peale*, pp. 256–257, 263–264, 310, 328; Charles Edwards Lester, *The Artists of America* (New York: Baker & Scriber, 1846), p. 208; Jeremy, ed., *Henry Wansey Journal*, pp. 73, 104–105; 1 *Ackermann's Repository* 3 (June 1810): 387–388; William Bullock, *Catalogue . . . of the London Museum of Natural History . . . Which Will Be Sold at Auction . . .* (London: William Bullock, 1819), part third, 13th day.

45. Sellers, *Peale*, pp. 265–266, 273–274; Sellers, *With Patron and Populace*, pp. 5–6; Sellers, *Mr. Peale's Museum*, pp. 164, 213.

46. P. T. Barnum, *Struggles and Triumphs;* Neil Harris, *Humbug: The Art of P. T. Barnum* (Boston: Little, Brown, 1973); John Rickards Betts, "P. T. Barnum and His Popularization of Natural History," *Journal of the History of Ideas* 20 (1959): 353–358; Sellers, *Mr. Peale's Museum*, pp. 229, 301.

47. Barnum, *Struggles and Triumphs*, pp. 66–73, 101–103, 180–181; Harris, *Humbug*, pp. 38–40, 309n.; Poesch, *Titian Ramsey Peale*, pp. 95–96; Hunter, "Tribulations of a Museum Director," pp. 214–222; Sellers, *Mr. Peale's Museum*, pp. 304–314.

48. Sellers, *Mr. Peale's Museum*, pp. 54–61, 81, 148–151, 188–189; Sellers, *Peale*, pp. 240, 257–258, 302–303, 313, 330, 380–390, 394; Edward P. Alexander, *Museums in Motion: An Introduction to the History and Functions of Museums* (Nashville, Tenn.: American Association for State and Local History, 1979), pp. 50–53.

49. Sellers, *Mr. Peale's Museum*, pp. 71–77, 151–152, 194–195, 225–234.

50. Sellers, *Peale*, pp. 321, 351; Harris, *Humbug*, p. 309n.

51. Sellers, *Mr. Peale's Museum*, pp. 255–306.

52. Sellers, *Mr. Peale's Museum*, pp. 319–331; George Gaylord Simpson and H. Tobien, "The Rediscovery of Peale's Mastodon," American Philosophical Society *Proceedings* 98 (1954): 279–281; Hunter, *America's Oldest Museum Building*, p. 11; William Faxon, "Relics of Peale's Museum," *Bulletin of Museum of Comparative Zoology at Harvard* 9 (1915): 119–148; Horace Wells Sellers, "Engravings by Charles Willson Peale, Limner," *Pennsylvania Magazine of History and Biography* 57 (1933): 155–156; Sellers, *Peale Portraits and Miniatures*, pp. 16–17.

## SELECT BIBLIOGRAPHY

Altick, Richard D. *The Shows of London*. Cambridge, Mass., and London: Harvard University Press, 1978. 553 pp.

Barnum, P. T. *Struggles and Triumphs: Or, Forty Years' Recollections . . . Written by Himself.* 1869. Reprint. New York: Macmillan Company, 1930. 577 pp.

Bell, Whitfield J., Jr., and Others. *A Cabinet of Curiosities: Five Episodes in the Evolution of American Museums*. Charlottesville, Va.: University Press of Virginia, 1967. 166 pp.

Colton, Harold Sellers. "Peale's Museum." *Popular Science Monthly* 75 (September 1909): 221–238.

Ellis, Richard P. "The Founding, History, and Significance of Peale's Museum in Philadelphia." *Curator* 9 (1966): 235–258.

Faxon, William. "Relics of Peale's Museum." *Bulletin of Museum of Comparative Zoology at Harvard* 9 (1915): 119–148.

Flexner, James Thomas. *America's Old Masters*. Rev. ed. New York: Dover Publications, 1967. 365 pp.

Fowble, Eleanore McSherry. "Rembrandt Peale in Baltimore." Master's thesis, University of Delaware, 1965. 172 pp.

Haberly, Lloyd. "The American Museum from Baker to Barnum." *New-York Historical Society Quarterly* 43 (1959): 273–287.

Hunter, Wilbur Harvey, Jr. *The Peale Family and Peale's Baltimore Museum, 1814–1830*. Baltimore: Peale Museum, 1965. 35 pp.

————. *The Story of America's Oldest Museum Building: The Peale Museum, 1814–1964.* Baltimore: Peale Museum, 1964. 36 pp.

————. "The Tribulations of a Museum Director in the 1820's." *Maryland Historical Magazine* 49 (1954): 214–222.

McClung, Robert M., and Gale S. McClung. "Tammany's Remarkable Gardiner Baker: New York's First Museum Proprietor, Menagerie Keeper, and Promoter Extraordinary." *New-York Historical Society Quarterly* 42 (April 1958): 143–149.

Poesch, Jessie J. "Mr. Peale's 'Farm Persevere': Some Documentary Views." American Philosophical Society *Proceedings* 100 (1956): 545–556.

————. *Titian Ramsay Peale, 1799–1885: And His Journals of the Wilkes Expedition.* Philadelphia: American Philosophical Society, 1961. 214 pp.

Richman, Irwin, "Charles Willson Peale and the Philadelphia Museum." *Pennsylvania History* 29 (1962): 257–277.

Sellers, Charles Coleman. *Charles Willson Peale.* New York: Charles Scribner's Sons, 1969. 514 pp.

————. *Charles Willson Peale: Early Life (1741–1790); Later Life (1790–1827).* 2 vols. Philadelphia: American Philosophical Society, 1939, 1947. Vol. 1, 293 pp.; vol. 2, 468 pp.

————. *Charles Willson Peale with Patron and Populace: A Supplement to Portraits and Miniatures . . . with a Survey of His Work in Other Genres.* American Philosophical Society *Transactions,* new series, 59, pt. 3. Philadelphia; American Philosophical Society, 1969. 146 pp.

————. *Mr. Peale's Museum: Charles Willson Peale and the First Popular Museum of Natural Science and Art.* New York: W. W. Norton & Company, Inc.; A Barra Foundation Book, 1980. 370 pp.

————. "Peale's Museum and 'The New Museum Idea'." American Philosophical Society *Proceedings* 124 (February 1980): 25–34.

————. *Portraits and Miniatures by Charles Willson Peale.* American Philosophical Society *Transactions,* new series, 42, pt. 1. Philadelphia; American Philosophical Society, 1952. 369 pp.

————. "Rembrandt Peale, 'Instigator'." *Pennsylvania Magazine of History and Biography* 79 (1955): 331–342.

Silverman, Kenneth. *A Cultural History of the American Revolution: Painting, Music, Literature, and the Theatre in the Colonies and the United States . . . , 1763–1789.* New York: T. Y. Crowell Company, 1976. 699 pp.

Simpson, George Gaylord, and H. Tobien. "The Rediscovery of Peale's Mastodon." American Philosophical Society *Proceedings* 98 (1954): 279–281.

# 4

Dominique Vivant Denon
and the Louvre of Napoleon:
The Art Museum
as Symbol of National Glory

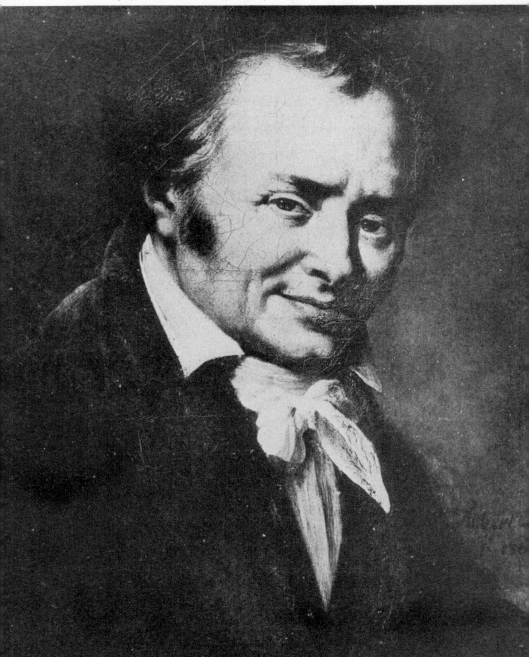

Fig. 6. Baron Dominique Vivant Denon (1747–1825). First Director of the Musée du Louvre, 1802–1815. Portrait by Robert LeFèvre in the Musée du Louvre, Paris. *(Courtesy of the Musée du Louvre, Paris.)*

N THE spring of 1798, the rumor ran about Paris that General Bonaparte was planning a campaign to strike a blow at Britain by invading Egypt, possibly the Middle East, and even India. The general intended to take along on the expedition a commission of more than one hundred learned men—mathematicians, astronomers, engineers, naturalists, architects, artists, and even a poet or two. Among those who longed to accompany him was Vivant Denon, engraver, amateur collector and student of art, traveler, former foreign service officer, and fascinating talker with beguiling anecdotes, ready wit, and quick understanding of ways to appeal to men of distinction and women of beauty. The only difficulty was that Denon was fifty-one years old—too aged, some might think, to take part in a military campaign that promised to be exhausting and dangerous. The anecdotes that Denon told so well also cling to his own career and often make it difficult to separate myth from truth. Thus, the story goes that Denon met Bonaparte some years before 1798, at Talleyrand's home, courteously gave the shy young artillery officer his own glass of lemonade, and charmed him with his animated, knowing conversation about Italy and Corsica. The two men parted without exchanging names, but when they met again, much later, at the beautiful Josephine de Beauharnais's salon, Napoleon belatedly recognized his unknown benefactor. Josephine, who was married to Napoleon in 1796, was already an admirer of Denon, and she had the poet Antoine Arnault plead Denon's case and gain Napoleon's consent that he go on the expedition.[1]

Dominique Vivant de Non was born near Chalon-sur-Saône in Burgundy on January 4, 1747, the only son and eldest child of Marie Nicolle Boisserand and Vivant de Non, in a moderately well-to-do family of the provincial aristocracy. The young man was tutored by an Abbé Buisson, who accompanied him, aged sixteen, to Paris, where he had a great-uncle who was an intimate of the royal court. De Non—who was to change the spelling of his aristocratic name during the French Revolution—studied jurisprudence, at his family's bidding, but found that he did not enjoy the law and decided to devote himself, instead, to drawing, engraving, and painting, under the guidance of Noel Hallé.

Determined to know Louis XV, young De Non went to Versailles

frequently, to stand where the king passed each day, staring at him intently. Louis became aware of this calculated scrutiny and asked Vivant what he wanted; the young man replied, "To see you, Sire," and nothing else "unless it is to be able to escape from the bayonets and guards who prevent me from approaching you." The king was captivated by Vivant's polished manners and gaiety, by the way he gave stories a humorous twist, and he bestowed upon the young courtier an official title: "Gentleman in Ordinary to the King." He also put him in charge of a collection of precious stones and medals that had belonged to Madame Pompadour. Thus was fulfilled part of an anecdote about a gypsy beggar girl, to whom the seven-year-old Vivant had emptied his little purse; the gypsy is supposed to have prophesied: "You will live long, be loved by beautiful women, and will frequent the most brilliant courts of Europe; in short, you will obtain your utmost desires." Another part of the prophecy was also coming true; Vivant, with his manners, audacity, wit, and imagination, was sowing many wild oats with the young actresses of the Comédie Française. He even wrote a play for this theater, in 1769, though *Julie, ou le Bon Père*, in three acts, was amateurish and unsuccessful. Vivant was to have many affairs with women during his long life; his short erotic tale *Point de Lendemain* (1777)—still considered a masterpiece of its kind— probably describes one of his amours. He also published a set of twenty-three of his pornographic engravings, *L'Oeuvre priapique* (1793), that contained contemporary voluptuous feminine poses, as well as portraying licentious sexual fantasies of ancient Pompeii.[2]

In the summer of 1772, Louis XV had De Non attached to the Russian embassy in St. Petersburg. On his way there, the young man stopped in Berlin and Potsdam to add Frederick the Great to his list of distinguished acquaintances and then went on to the court of that other enlightened despot, Catherine the Great. The French embassy found him an excellent secretary, with his lively letters to the home office, and he enjoyed "conducting diplomacy and love affairs concurrently." The learned Diderot visited Empress Catherine during Vivant's term of service and indeed smuggled back to France a secret map of Russian Black Sea fortifications that the young man had managed to copy. In May 1774, however, De Non's stay in Russia ended. Another junior French diplomat and he tried to rescue a youthful Russian actress they thought unjustly imprisoned; they caught her as she jumped from a window, but the police captured the three of them as they drove away in a carriage. The young men escaped imprisonment, but had to leave Russia as *personae non gratae*.[3]

De Non visited Stockholm on his way back to France and called on the French ambassador, Comte de Vergennes, who, later, as royal minister of foreign affairs, would further the young man's diplomatic career. Vergennes seems to have sent De Non on some kind of secret mission to Switzerland in the summer of 1775, and he stopped en route at Ferney to approach his idol Voltaire. The old philosopher at first refused to see him, but De Non won him over by declaring himself a *gentilhomme ordinaire du roi* who recently had spent a year in St. Petersburg. He charmed Voltaire with his sprightly conversation and even made a watercolor painting of the household at dinner (*Le Déjeuner de Ferney*), though Voltaire complained that the composition made him look emaciated and was a virtual caricature.[4]

Vergennes dispatched De Non in 1778 to a more important post as counselor to the French ambassador at the court of Naples. The young man remained there for seven years, the last three as chargé d'affaires in virtual command, after the ambassador had gone home. The situation was extremely difficult, with a weak king, Ferdinand IV; an ambitious and licentious queen, Marie Caroline, sister of Marie Antoinette of France; and Marie Caroline's current lover, the driving, abrasive prime minister, John Francis Edward Acton. The last two despised France and did all they could to make De Non's life miserable. He finally had to be recalled, when Talleyrand took over as ambassador. De Non then retired from the foreign service, and the king granted him a pension of twenty-four hundred livres per year and an extraordinary gift of ten thousand livres.[5]

Despite De Non's diplomatic troubles, he learned much from his Neapolitan experience. He traveled widely, not only to the excavations at Pompeii and Herculaneum, but also to Rome and Greece. He joined Abbé Richard de Saint-Non in preparing an elegant five-volume publication with maps, engravings, and text on the ancient ruins of Naples and Sicily. The abbé enlisted a group of artists to do the illustrations on the spot, and De Non accompanied them and wrote a descriptive journal. Saint-Non used the account in his publication, and De Non in 1778 brought out his own *Voyage en Sicile*, describing his adventures in both Sicily and Malta. During his stay in Naples, De Non also began seriously to collect art works as well as to produce his own drawings and engravings; there were not many paintings to be found in the region, but there was a great deal of archaeological material available, such as vases, medals, figurines, and other objets d'art. Vivant discovered a canvas by Giovanni Guerchin and sold it and his collection of 520 Etruscan vases to Louis XVI.[6]

When De Non returned to Paris in 1787, he was elected to the Aca-

demie Royale des Beaux-Arts as an engraver and artist of diverse talents. He wrote a highly complimentary review of the paintings of Jacques Louis David, on exhibition in the Salon of 1787, a judgment that was to stand him in good stead a bit later. He also found that his inheritance from his father, who had died two years earlier, left him with a comfortable income of about twenty thousand livres per year from rents and vineyards. Having decided to write a general history of painting, De Non returned to Italy for study, and made his way through Lombardy, Turin, Parma, Florence, and Bologna to Venice. There he remained for more than two years, devoting his days to studying art, perfecting his engraving skills, and teaching that craft to some young friends. At night, he enjoyed the sophisticated and dissolute Venetian society to the full, fascinating all with his malicious and witty stories and his seeming command of many fields—natural history, the arts, and ancient monuments. He also consorted intimately but discreetly with several handsome women.[7]

The French Revolution, however, was threatening his security; he feared that he might be placed on the list of emigrés deemed disloyal to the Republic, and thus have his property in Burgundy confiscated. In fact, it was becoming difficult to receive remittances, and for a time he was virtually dependent on selling wine sent from his vineyards. In August 1792, Venice expelled all French nationals, and he went to Florence, only to be ordered out, there, after two months. Thus he decided to risk returning to France and arrived at Paris in December. He at once ceased using the aristocratic particule *de* in his name: the chevalier *de Non* became plain Citoyen Denon. The painter David befriended him, commissioned him to do the engraving of David's historical painting of the *Serment du Jeu de Paume* (oath of the tennis court), and vouched for his loyalty. He also made Denon a national engraver of Republican uniforms and provided living quarters for him at the Louvre. In reporting on his activities in that position to the Committee for Public Safety, Denon met the greatly feared Jacobin leader Maximilien Robespierre, who was sending so many aristocrats to the guillotine, and won his support in a brilliant conversation that lasted most of the night.[8]

This, then, was Vivant Denon, who, at age fifty-one, prepared to accompany General Bonaparte to Egypt. An accomplished courtier and diplomat, Denon had charmed personalities as varied as Louis XV, Frederick the Great, Voltaire, Robespierre, and Josephine de Beauharnais. His suave manners, his wealth of stories spiced with wit and double entendre, his vivacity coupled with discretion appealed to most of the men and women he met. An inveterate traveler, he knew Europe from

Russia and Sweden to Sicily and Malta, and he had observed carefully much of its art. He was a curious mixture of hedonist and what we today would call a workaholic. No one labored more diligently during the day, drawing and engraving, collecting art objects, and studying art and art history, yet no one pursued social and erotic pleasures more avidly than he at night, in salon, cafe, and boudoir.

Denon joined Napoleon's army of 38,000 men and 328 vessels at Toulon and sailed on the frigate *Junon* in the advance guard on May 19, 1798. He was one of the 36 savants comprising the Commission of Sciences and Arts or the Institut of Egypt. The expedition, fortunate to evade Admiral Horatio Nelson's warships, then searching for it, stopped at the Island of Malta, which quickly surrendered, and then went on to capture Alexandria at the mouth of the Nile, with a loss of about 200 men. Denon was present at the Battle of the Pyramids near Cairo, where Napoleon soundly defeated Murad Bey and his cohorts; the French cannon mowed down the courageous charging Mamelukes and Arabs, with their medieval arms and accoutrement. After a month in Cairo, Denon returned to Alexandria, in time to observe, from a tower, by telescope, the devastating defeat of the French fleet by Nelson in the Battle of the Nile off Aboukir. That decisive engagement doomed the French Egyptian expedition to failure. Napoleon led a diversion up the coast of Palestine, but failed to take Acre by siege; thus, any French threat to India remained but an ill-conceived dream. Denon did not participate in the Palestinian invasion; instead, he accompanied General Desaix (Louis Charles Antoine Desaix de Veygoux) and 3,200 troops as they fruitlessly chased Murad Bey into Upper Egypt. On the ascent of the Nile, Denon was especially impressed by the ruins that he sketched with care at Hermopolis Magna, Dendera (Tentyris), Thebes, Hermonthis, and Edfu. They penetrated as far as the first cataract of the Nile and visited Aswan and the Elephantine and Philae islands. Denon said that he trembled lest Murad Bey decide to fight no longer or Desaix catch him, so that Denon would see no more monuments. He rejoined Napoleon before the French victory over the Turks in the land battle of Aboukir and then returned to Cairo, where Napoleon inspected and approved his hundreds of sketches, including those of the Aboukir battlefield. The general slipped away to France on August 19, 1799, taking Denon with him and leaving his army, which was forced to surrender ignominiously to the British, two years later.[9]

Denon was a great success with the officers and men of the French army. With witty good nature, he shared the hardships of the campaign—seasickness, long marches, thirst, mirages, sand storms, eye inflamma-

tion, camel rides, bedbugs, and the rest. He gained admiration from all for his nonchalant conduct under fire; he philosophically had decided that if death was to come, it would come. He often recklessly rode ahead of the army or loitered behind, in order to secure good drawings. He made quick, realistic sketches of ruins, mummies, hieroglyphics, battles, and many aspects of Egyptian life—tent homes, harems, weddings, funerals, feasts, schools, public baths, water pumps, ovens, and straw boats. These sketches were done with difficulty, as Denon said, "on my knee, or standing, or even on horseback. I have never finished one as I would have wished. During a whole year I have not once found a table sufficiently steady for using a ruler." His sketch of the ruins of Hiera-conpolis includes a self-portrait of an insouciant Denon busily drawing; he is dressed in a tricorn, long-tailed coat, and Egyptian pantaloons and curved pointed slippers. On one occasion, he said that an Arab fired at him while he was sketching; he stopped long enough to shoot his assail-ant. Later, when General Desaix told him the horizon of his sketch was not right, Denon said it was the fault of the Arab who shot too soon.[10]

Upon Denon's return to Paris in October 1799, he began work at once on his monumental book, *Voyage dans la Haute et la Basse Égypte,* published in two handsome elephant tomes (Paris, 1802). The first volume gives a lively account of his journey and descriptions of the 141 plates that comprise the second volume. Dedicated to Napoleon, the book was one of the first serious examinations of Egyptian antiquities to appear in Europe, with striking and truthful illustrations. Denon also realistically sketched battles and incidents of the campaign and wrote of his own adventures with verve, well spiced with anecdote and good humor. By 1810, six editions had appeared, as well as translations in Italian, Dutch, German, and two in English. This publication was by far the most important of all Denon's writings and did much to establish his reputation as an art historian and to lead to his appointment as Napoleon's virtual director of fine arts. It also was influential in forwarding an Egyptian style in the architecture and decorative arts of the day.[11]

Now a new opportunity came to Denon. First Consul Bonaparte, in the course of reorganizing the French government, considered the Musée Central des Arts at the Louvre. Since its founding by the National Assembly in 1793, it had been administered by a succession of commissions composed usually of several elderly artists. But Napoleon did not like commissions; he thought single administrators more decisive, responsible, and efficient. Whom should he appoint for the Louvre? The artist David had taken the lead in organizing the Institut de France to replace the ancient royal academies, and he was an enthusiastic and flattering

Fig. 7. Denon sketching the ruins of Hieraconpolis, 1799. Self-portrait made in 1799, during the Egyptian Campaign. Hieraconpolis is today at Kôm el Ahmar, north of Edfu. From Dominique Vivant Denon, *Voyage dans la Basse et la Haute Égypte . . .* , 2 volumes (Paris: P. Didot l'Aîé, 1802), 2: Plate 54 bis.

portraitist of Bonaparte, though the first consul found him always seeking special privileges as well as higher prices for his work. Napoleon created David First Painter of the government in 1800, but David refused the post, because it lacked the title and powers to make him minister of the arts. Ennius Quirinus Visconti, former curator of the Capitoline Museum in Rome and librarian of the Vatican, was virtually acting director of the

Louvre, with excellent professional qualifications; and Jean Lebrun, art-
ist, restorer, and art dealer, was openly seeking the appointment.
Napoleon may have considered all of them, but on November 19, 1802, he
put an end to the museum commission and appointed his friend and
former companion at arms, Vivant Denon, director general of the Musée
Central at an annual salary of twelve thousand francs. During the thirteen
years he held the post, Denon took charge of the Musée des Monuments
Français started by Alexandre Lenoir, the special museum of paintings of
the French school at Versailles, the twenty-two provincial museums, and
the galleries of various palaces. He supervised the design of coins and
medals, bronzes, precious stones, and mosaics; the commissioning of
national paintings and portraits; the state manufactures of Sèvres por-
celain, Gobelin tapestries, and Savonnerie carpets; and eventually the
archaeological excavations in the Départment of Rome. He was
Napoleon's intimate adviser on scores of art projects including architec-
tural monuments for Paris and national festivals large and small. In short,
Denon gradually came to serve as director of fine arts for what soon
became the Napoleonic Empire.[12]

## II

The Louvre, the former royal palace, had been opened on August 10,
1793, as the Muséum Français or Muséum National, with 537 paintings on
the walls and 104 objets d'art on tables in the center of the long Grande
Galerie that extended beside the Seine. Most of these art works came from
the royal collection that had been housed chiefly at Versailles, but there
were some confiscations from suppressed churches or from emigrés. The
French revolutionaries who beheaded the king and many aristocrats and
abolished the churches might have decided to destroy paintings, sculp-
tures, and historical monuments as hateful reminders of the *ancien régime*.
Instead, intoxicated by visions of the spread throughout Europe of liberty,
equality, and fraternity, they decided that great works of art belonged to
all the French people and should be placed in the museum for democratic
enlightenment and inspiration. Under the new calendar, the *décade* had
replaced the seven-day week, and at the Louvre the first five days were
reserved for artists and copyists, the next two for cleaning, and the last
three for visitation by the people. The crowds on public days were large
and attracted swarms of prostitutes who stayed so late that street lights
had to be installed to try to discourage them.[13]

As the revolutionary conflagration spread through Europe and

resulted in wars against hated despots, a new source of art works appeared. Commissioners accompanied the French armies to requisition, as spoils of war or reparations, paintings and sculptures for the Louvre, as well as rare books and manuscripts for the Bibliothèque Nationale and natural history collections for the Jardin des Plantes. The French of the Revolution liked to think of themselves as successors to the Romans, who had paraded their exotic lootings through the streets. When the French army overran Belgium in 1794, handsome young Luc Barbier, a former pupil of David, was a commissioner who helped send to the Louvre some forty paintings by Rubens that included his *Descent from the Cross*, out of the Antwerp cathedral. Barbier defended the confiscation of such "immortal works left us by the brush of Rubens, Van Dyck, and other founders of the Flemish school" and asserted that "These masterpieces had been sullied over long by the aspect of servitude: it is in the bosom of free folk that the works of celebrated men should remain; the tears of slaves are unworthy of their glory."[14]

General Bonaparte, in his conquest of Italy, between 1796 and 1797, further systematized the official looting of art and other cultural treasures. He took along on his campaigns a team of experts to select the best paintings, sculptures, manuscripts, zoo specimens, and other rarities, and he included provision for the transfer of their ownership to France in the truces and treaties that he negotiated. For example, the Treaty of Tolentino (February 17, 1797) forced the Pope to give up 100 masterpieces and 500 manuscripts; the 73 sculptures the commissioners chose included the *Apollo Belvedere, Laocoön, Dying Gaul,* and the colossal groups of the *Nile* and the *Tiber,* while among the 17 paintings were Raphael's *Transfiguration* and Domenichino's *Last Communion of St. Jerome.* The arrival in Paris of the largest convoy of the confiscated art works from Italy in July 1798 led to a great two-day-long *fête de la liberté.* The triumphal parade worked its way from the Jardin des Plantes to the Champ de Mars, where it formed a triple circle around an Altar to Liberty. Enormous wagons pulled the four bronze horses from St. Mark's Basilica in Venice, the carefully packed statues, huge crates labeled in large letters, "Transfiguration by Raphael" or "Christ by Titian," and cages of bears and lions, followed by plodding camels. There was a band, there were marching artists, scholars, and prominent statesmen, speeches, patriotic songs, and wild applause resounded from a huge crowd.[15]

French artists differed in opinion about taking art masterpieces as spoils of war. One petition of 1796 to the Directory argued that "The French Republic, by its strength and superiority of its enlightenment and

its artists, is the only country in the world which can give a safe home to these masterpieces. All other Nations must come to borrow from our art, as they once initated our frivolity." But Quatremère de Quincy, the secretary of the Academie des Beaux-Arts, in the same year wrote a protest against despoiling Italy of her artistic and scientific patrimony and suggested that France would do better to investigate her own treasures, such as the ruins of Provence, the antiquities of Vienne, Arles, Orange, Nîmes, and Autun. Among those who joined this protest was Denon himself, as well as David, the antiquary Alexandre Lenoir, and the architects Pierre Fontaine and Charles Percier. Supposedly, Denon's intimate acquaintanceship with Napoleon caused him to change his mind and become a chief instrument in plundering conquered countries of art for the benefit of the French museums. In 1803, upon his election to the chair of fine arts of the Institut, Denon, without showing any trace of scruple, gave a lecture in which he defended the right of France to the sculptures, paintings, and other treasures arrived from Italy.[16]

Denon, always the diplomatic courtier, got off to a good start in his new post by making the suggestion, quickly agreed to by everyone, that the central museum be called the Musée Napoléon, and he had the new name cut in gilded letters above the main entrance. Napoleon had little if any appreciation of art, but he considered the museum an important symbol of national glory that would bring attention and splendor to his reign. Denon and he agreed that the Musée Napoléon must be the most beautiful museum on earth. The first problem was to get the building itself into usable shape. The Grande Galerie was lighted by windows on both sides, and Denon wished to fill them in, so that he could hang more pictures, and to install a continuous skylight for their better illumination. The architects Fontaine and Percier, however, opposed giving up views of the quai and the Carrousel on the sides and, since they functioned independently of Denon, a compromise was necessary. The renovation also provided an opportunity to adopt Hubert Robert's old plan of providing more manageable space while retaining long vistas by erecting at appropriate intervals protruding double columns crowned by transverse arches. Thus the gallery was divided into nine bays, with overhead and side lighting alternating. Denon used the Salon Carré for the customary Salons (held on even-numbered years) to exhibit the paintings, sculptures, architecture, and engravings of living artists; but he also staged in the chamber with great imagination, occasional special exhibitions and national celebrations. When the Institut vacated the Salle des Caryatides, Denon expanded the halls of antiquities and redistributed the many

superb sculptures. Also the Louvre was joined at one end to the Tuileries palace.

Sometimes Denon's tiffs with the architects were amusing, as in 1808 when he wrote Fontaine in the high style of the day:

You are having dismantled at this moment, Sir, both the public and the staff latrines . . . without making alternative accommodation available. . . . I have the honor to point out to you that the museum is unable to dispense with these conveniences. . . . I therefore invite you urgently, Sir, to give orders for reinstalling them as soon as possible, in order to avoid evacuations in the courtyards, the staircases, and perhaps even in the exhibition rooms of the museum—a situation which will infallibly arise.[17]

Denon, for long a passionate collector of art, was now in a position most congenial to him as official collector of the empire. He began to go along on Napoleon's campaigns in order to seek out the best art works and secure them on the spot, while conditions were chaotic, and before their owners could hide them or send them away. The French soldiers who saw him at work affectionately called him "*l'huisser priseur* (the bailiff appraiser) *de l'Europe.*" Denon's reckless bravery under fire was still evident, especially since he was often sketching the battlefields for details to be used in the series of commemorative paintings he was commissioning on Napoleon's career. At Eylau, the emperor found him in the midst of the fiercest action, with bullets flying all around, and ordered him to the rear.[18]

In 1806, Denon participated in Napoleon's North German campaigns and had a free hand in looting the princely galleries of Brunswick, Hesse-Cassel, Mecklenburg-Schwerin, and Berlin and Potsdam. He took nearly a thousand paintings, including many works by Rembrandt, Dürer, Holbein, and Cranach, though he excluded the excellent Watteaus of the often largely unappreciated eighteenth century. Napoleon sometimes vetoed his suggestions, for political reasons; for example, Denon wished to despoil the Dresden gallery, the finest in all Germany, that included Raphael's famed *Sistine Madonna*, but Napoleon decided he needed the military aid of the Saxon king. In the winter of 1808–1809, Denon was in Spain, on the Peninsular Campaign, though Joseph Bonaparte, the puppet king there, and a commission that included Goya outwitted him and sent mostly second-rate works in the fifty paintings he requisitioned; Denon reported that only six of them were worthy of hanging. In 1809, Denon took about four hundred pictures from the Austrians in Vienna, but the Upper Belvedere museum men managed, before the French

takeover, to send into hiding fifty-four cases of what they regarded as their most important old masters.[19]

Denon's last foraging expedition was to Italy, from August 1811 to January 1812. It differed from the three preceding forays in that it was not made during wartime and thus called upon Denon's diplomatic and negotiating skills. Pisa, Siena, Genoa, Perugia, and Florence were now *départments* of France, and Denon was supposed to be acquiring property from the monasteries that had been suppressed in September 1810. Benjamin Zix accompanied him as draftsman and to help sketch some of Napoleon's earlier battlefields. The fascinating aspect of that expedition is that Denon showed a new, independent taste in his collecting. Instead of the Hellenistic and Roman sculptures and master paintings of the sixteenth and seventeenth centuries, he was acquiring Italian primitives of the fifteenth century, a school of artists then generally unknown and unappreciated. When he exhibited some of the results of his expeditions in the Salon Carré in July 1814, 82 of the 124 items were primitives and included important works of Cimabue, Giotto, Fra Angelico, Fra Filippo Lippi, and others. An unexpected virtue of the collection soon appeared, in that it was so little understood and valued that it did not have to leave the museum when restitution came, after Waterloo.[20]

Not only did Denon secure paintings and art works for the Louvre. In 1800, Napoleon had established fifteen museums in the départments, at Bordeaux, Caen, Dijon, Lille, Lyons, Marseilles, Nancy, Nantes, Rennes, Rouen, Strasbourg, Toulouse (and Brussels, Geneva, and Mainz, then incorporated into France), and they received 656 paintings from the Louvre. By 1814, there were twenty-two such museums, and Denon had sent them, sometimes reluctantly, many more pictures. In Italy, regional museums were established, the most successful ones the Brera at Milan and the Accademia in Venice. Denon effected exchanges between the Louvre and the Brera, and, if he could have enjoyed a longer administration, might have distributed judiciously paintings of the different national schools among all the outlying museums. The various palaces also required art works. Josephine, after the annulment of her marriage in 1806, was especially greedy for paintings. Denon had hitherto secured jewels and small objects for the emperor to give her, but she acquired forty-eight masterpieces seized from Cassel for her palace at Malmaison that Denon had intended for the Louvre. He tried to include her pictures (as well as those in possession of her successor, Marie Louise) in the inventory of the Louvre collection, but Josephine's heirs eventually sold them to the tsar of Russia. Napoleon also commandeered certain art

works for the palaces of the Tuileries, Saint-Cloud, Fontainebleau, the Trianon, or Meudon. He compelled Denon to return some paintings to churches and emigrés, as he tried to solidify his empire by conciliating these groups. In most instances, however, Denon was the chief distributor of plundered art and usually decided where it should be placed.[21]

One good result of the far-flung art confiscation was the cleaning, lining, transfer, and repair of paintings that had been neglected since their creation. Picault, the father of a father-and-son team, was a restorer working at Versailles under the royal superintendent of buildings. About 1750, he discovered how to detach and transfer a paint surface from a panel, a wall, or a canvas to a new canvas. He tried to keep his methods secret, but another father-and-son team named Hacquin understood transposition as well as lining or rebacking a canvas or cradling a panel. They worked for the Musée Central and then for the Musée Napoléon. The elder Hacquin transferred Raphael's *Madonna di Foligno* from a wooden panel to canvas in 1801, and a ten-page report described the process in detail. Denon continued to use the Hacquins and also had Pierre Paul Prud'hon, sometimes called "the French Correggio," repaint the badly damaged head of Correggio's *Io*. Sometimes this conservation activity was used as further justification for the looting of art from conquered countries; the former owners had been too ignorant or too negligent to take care of their masterpieces that were now properly appreciated and preserved by sensitive and skilled French master craftsmen. The Hacquins were correctly conservative in their methods; they guarded against overcleaning pictures and did a minimum of retouching.[22]

Denon, usually a tireless worker acquainted with every detail of a problem, proved a remarkably capable administrator. He knew how to delegate much of his authority to his small professional staff of only a secretary general and three curators. Athanase Lavalée, the secretary or administrative assistant, had been employed at the museum since its opening, had knowledge of almost every detail, and worked with abounding zeal and loyalty. Visconti, in charge of sculptures, had an unexcelled background in antiquities and had been curator and librarian at the Vatican before accompanying the sculptures requisitioned from the Pope to the Louvre. Though passed over for the directorship, Visconti appreciated Denon's diplomatic skills and supported him faithfully. Henri Beyle (later better known as Stendhal), as auditor for the Council of State, made an inventory of the Louvre's collections and helped Denon inspect foreign art works for possible requisition. The director general also commanded a handful of clerks, thirteen guards, and two doormen. Though

theoretically under the Minister of the Interior, often subject to the Intendant General of the emperor's household, and never in charge of the architects, Denon was virtually independent in most matters, and his free approach to and intimacy with Napoleon gave him many advantages. He saw that good financial accounts were kept, a matter of much importance to the emperor, and helped devise a comprehensive inventory or registration system entered in large volumes. He also handled personnel sensitively, was firm toward wrongdoers, but considerate of the financial and personal needs of faithful workers. The effectiveness of Denon's administration is clearly evident, in that the museum ran smoothly from day to day, even though he made numerous expeditions to foreign lands that sometimes lasted for several months. After he retired from the museum, a visiting lady once complimented him on the breadth of his knowledge of the arts and remarked: "You must have studied a great deal in your youth." Denon's reply would delight any good administrator; he said that, on the contrary, he had found study tiresome, and besides, "those who know more about these things advise me, which is why I enjoy knowing a great deal without ever having taken any pains to acquire it."[23]

The Musée Napoléon was indeed a busy center, humming with life. On some public days, it attracted as many as five thousand visitors. Not only did the exhibits change constantly, as new masterpieces poured in from Napoleon's requisitions; not only was the fabric of the palatial building improved to accommodate the new accessions; but the first consul or emperor and his imaginative, energetic director general realized the value of holding timely special events and social galas at the museum to keep both members of the court circle and the general public aware of its beauty, superb quality, and national importance. On Napoleon's birthday in 1803, at 6:00 A.M., the first consul and his party came to open the new halls of antiquities and see the *Venus de Medici*, once a treasure of Florence, but now, according to Napoleon, the bride of *Apollo Belvedere*. Denon gave him a medal struck to commemorate the acquisition of the statue, and that night the galleries were illuminated with flaring torches. That same year, while French troops were poised to invade Britain, Denon installed the famed Bayeux Tapestry in the Salon Carré, to remind the people of the previous successful incursion of William the Conqueror. In 1804, Denon personally arranged the Salon of works of contemporary artists, the press praising his exquisite taste and deep knowledge. In using the Salon Carré as a hall of special exhibits, he sometimes featured requisitioned masterpieces such as Veronese's *Marriage of Cana* or outstanding contemporary pictures, such as David's *Coronation of the Emperor, 1804*.

Most spectacular of all, however, was Napoleon's second marriage, in 1810, to the young Archduchess Marie Louise of Austria. Josephine had failed to bear him a son and thus a more or less amicable annulment of that marriage had been arranged. A few weeks before his marriage to Marie Louise, Napoleon informed Denon that the actual ceremony was to take place in the Salon Carré, and that the wedding party was to traverse the length of the Grande Galerie between tiers of seats for the female guests on either side, with the men standing behind. Thus, eight thousand persons were to witness the procession. Denon feared lest several of the huge paintings in the salon be harmed and protested that they were too large to move, whereupon Napoleon suggested that he could burn them. Denon rolled and stored some of the paintings, hung rich cloths over others, and the whole brilliant ceremony went off smoothly and is carefully documented in Benjamin Zix's drawings.[24]

Denon gave his chief attention to creating a picture gallery that would be the world's greatest. Within a few months after his appointment as director, he had arranged one part of the Grande Galerie with sixteen paintings by Raphael clustered about the *Transfiguration* so as to show the development of that artist. "I will continue," he said, "in the same spirit for all the schools and in a few months, in walking through the galleries, it will be possible to perceive the historic course of art and particularly of painting." He hung pictures *en tapesserie*—that is, from floor to ceiling— and too close together, as was the fashion of that day; the smaller ones were installed to the side or below the large ones. By 1811, the whole museum had reached nearly its full development. On the ground floor was the expanded Salle des Antiquities that contained more than 400 statues. A new grand stairway connected it with the second floor, where the Salon Carré for temporary exhibits opened into the 1,200-foot-long Grande Galerie, with its nine bays and 1,176 paintings. The first bay contained 107 French paintings, led by 24 Poussins. In the next four bays were 606 Dutch, Flemish, and German pictures that included 14 Van Dycks, 15 Holbeins, 33 Rembrandts, and 54 Rubenses. The last four bays were devoted to the Italian schools, 463 paintings including 7 Leonardos, 10 Tintorettos, 15 Veroneses, 24 Titians, and 25 Raphaels. For modern eyes, the collection had some unevenness; the unsuccessful Peninsular Campaign brought few Spanish pictures, the failure of the English invasion produced none, and there were not enough works on nonreligious subjects or from the eighteenth century.[25]

After the Treaty of Amiens (1802) brought a truce in the war between France and England, many English artists visited the Musée Napoléon, led by Benjamin West, the American-born president of the Royal Acad-

emy. Joseph Farington's diary of his five-week stay in Paris shows him going to the museum almost daily, making careful notes on the pictures, arguing about their merit with young J. M. W. Turner and other artists, and going behind the scenes to inspect the current work of David or François Pascal Gérard. He saw Hacquin separate Raphael's *Ste. Cecelia* from its panel and visited Denon in his crowded living quarters in the Louvre (he was not yet named director) hung with Dutch and Flemish paintings and his own engravings after Rembrandt. Martin Arthur Shee, another painter, found the museum's gallery

on the first view, quite embarrassing. All is confusion and astonishment: the eye is dazzled and bewildered, wandering from side to side—from picture to picture; like a glutton at a feast, anxious to devour everything, till the intellectual stomach, palled and oppressed by variety, loses the pleasure of taste, and the power to digest.

Only "a longer and more systematic examination" would overcome "the chaos of confused forms and erroneous impressions."

The additions that Denon made to the collection and the improved arrangement added only to the dazzling effect. The Reverend William Shepherd visited it in 1802 and again in 1814. On the latter trip, he commented on the great progress made in exhibiting pictures in the Grande Galerie and the better lighting obtained by filling in part of the side windows and using skylights. In the Salle des Antiquities, he again marveled at the perfection of the sculptures, though he rather primly found the *Venus de Medici* possessed only of worldly beauty, while the *Apollo Belvedere* seemed to him godlike in form, pose, and countenance. In any event, the Musée Napoléon, everyone agreed, was the greatest art museum the world had ever known.[26]

### III

Benjamin Zix, about 1813, drew a curious allegorical portrait of his collaborator and friend Vivant Denon at his writing desk in the Louvre. Pen in hand, Denon is seen working on a paper entitled "Musée Napoléon," while reading from books that include his *Campaign of Egypt* and *Campaigns in Italy and Germany* on top of a stack of thick volumes. Beside him are models of the Obelisk of the Pont-Neuf, the Austerlitz Column of the Place Vendôme, and the Elephant Fountain of the Place de la Bastille. In a pile of miscellaneous objects in the foreground can be discerned Lorenzo Bartolini's bust of Napoleon. In the background is the

Salle de Diane, with its ancient sculptures. The portrait stresses the tireless activity of Denon and the great variety of his duties as director general of the museum and superintendent of fine arts.[27]

Denon acquired these varied responsibilities gradually during his administration as museum director. Both Napoleon and Josephine found him full of attractive ideas on art matters and, when policies had been agreed upon, dependable in carrying them out promptly and efficiently. Thus he was able to hold and even to improve his position amid the infighting of the Napoleonic bureaucracy, and when David, as "First Painter of the Emperor," tried to take over some of Denon's control of design, painting, sculpture, and drawing in the museum at Versailles and at the manufactories of Gobelin, Sèvres, Savonnerie, and Beauvais, David was turned down and Denon's authority upheld.[28]

Both Napoleon and Denon had a keen sense of history. Not only were they determined to use the most beautiful museum in the world to make everyone aware of the splendor of the new French empire, but they wished to present the rise of Napoleon in a series of historical paintings, engravings, and commemorative medals; to commission portraits of him, his family, military commanders, and state dignitaries in paintings or statues; to erect splendid monuments in the prominent squares of Paris; and to have products of the state factories such as Sèvres porcelain or Gobelin tapestries employ such historical themes. Thus, recent or contemporary history was to be used to establish a Napoleonic legend and to animate and strengthen the empire by which he was seeking to unify Europe.

First came the historical paintings. They emphasized military events, chiefly battle scenes, but they also treated important civil happenings—for example, David's *Coronation of the Emperor*. Denon drew up a list of important events, though Napoleon had his own ideas and sometimes consulted other advisers; Denon suggested the painters and the approximate size of the paintings. He established a standard remuneration of twelve thousand francs for large pictures and six thousand francs for smaller ones, though top artists like David, Gros, or Gérard managed to increase their commissions by bargaining, sometimes directly with the emperor. After a painting was agreed upon and the budget established, Denon furnished the artist with documentation—sketches and notes on the correct topography, position of troops, principal characters, and their poses and dress. He saw that artists adhered to a schedule and exhibited their finished works in the Salon Carré before placing them in fitting spots in the imperial buildings. Denon tried hard to include the whole French

Fig. 8. Allegorical portrait of Baron Vivant Denon, 1813. By Benjamin Zix. Portrait
in the Musée de Louvre, Paris. (*Courtesy of Cabinet des Dessins, Musée du Louvre,
Paris.*)

art establishment in his programs. David, Girodet, Gros, Prud'hon, and Gérard were the stars, but he paternalistically gave many younger and less prominent artists commissions.

Napoleon might have little appreciation for art, but he insisted upon accurate and realistic details. Meanwhile, a mystique developed about the way he should be treated in the paintings. He was always portrayed more simply dressed than his associates or his enemies were, in their showy uniforms, and he was to be shown as calm and noble in mien, no matter how violent the scene. Once Denon perhaps made a mistake in maintaining that image when he had Claud Gautheret paint *Napoleon Wounded before Ratisbonne, 1809*. The wound was trifling, and the emperor bore it well, but he was shown to be mortal, not invulnerable. Nor were details in the paintings always strictly authentic. Thus, Josephine, after the annulment of her marriage, was taken out of David's *Distribution of the Eagles, 1804*, an event in which she had participated, to avoid any possibility of hurting the feelings of the new empress. Napoleon's mother was also shown in David's *Coronation*, though she had not been present on that glorious occasion. The treatment of history here reminds one of similar actions by official artists of the Soviet Union in our own day.[29]

Denon was most anxious to promote the art of sculpture that he thought unjustly neglected in France. He saw that public monuments received sculptured groups wherever possible—in fact, he used so much marble that he urged Napoleon to annex Carrara, so as to guarantee a sufficient supply. But he believed that the Greek and Roman artists were right in considering that sculpture most sublime and timeless which portrayed outstanding heroes in the nude. That deeply held conviction brought him difficulties, for both Napoleon and the French public were hesitant, indeed embarrassed, to adopt this taste. The emperor charged Denon to erect in the Place des Victoires a bronze likeness of General Desaix, who had won the battle but had been killed at Marengo. Denon had served with Desaix in Upper Egypt, and the two men had admired each other greatly and had become intimate friends. Thus, Denon wished to devise a masterpiece, and he commissioned the statue—in the nude. In 1810, when it was unveiled, both the emperor and the public were mortified by the nudity, and the palisade around the work was quickly re-erected. Even more disastrous was the reception of the colossal marble statue of Napoleon himself that Denon had appointed the famed Italian sculptor Canova to do, also in the nude. When it arrived at the Louvre in 1811 and Napoleon hastened to inspect it, he maintained an ominous silence. The statue was removed at once to a remote niche and hidden from view by planks and a curtain.[30]

Denon's promotion of artists reached into other fields—landscapes of the camps of Napoleon in Africa and Europe, early romantic or anecdotal pictures in what was soon to be known as the Troubador style, genres of everyday life, still-life paintings of flowers, fruits, and animals, miniatures and enamels, drawings and engravings, and a comprehensive series of medals that gave a history of the Napoleonic era. On the great monuments of Paris, he worked with various architects to place the four bronze horses from Venice atop the Arc de Triomphe Carrousel in the Tuileries park or to design the monuments for Place Vendôme and other squares. The products of the national art factories used scenes of recent or contemporary history for themes. Thus, Alexandre Brongniart, the director of Sèvres, brought that porcelain to high technical excellence and provided elaborate gifts that Napoleon could bestow upon his associates and use for diplomatic purposes. An unusual Egyptian dessert service of 102 pieces had a centerpiece in biscuit of temples, statues, and colonnades more than 22 feet long, standing figures of Nubian slaves, scenes copied from Denon's *Voyage* on the plates, and sugar bowls with hieroglyphs and heads from that work. The famous background color of rich blue was retained. Two sets of this master work were created, one given by Napoleon to Tsar Alexander I and the other later bestowed upon Wellington by Louis XVIII.[31]

Denon also secured furniture and furnishings for the imperial households. For example, after Napoleon negotiated the Concordat of 1801 with Pope Pius VII, which partially re-established the Roman Catholic Church in France, he virtually forced the Pope to preside at his coronation as emperor. Denon furnished the Pavillon de Flore (then part of the Tuileries) as the papal quarters for his four-month stay. Denon and Pius got along well together there. Later, when Napoleon seized the Papal States and Rome, he was excommunicated by Pius, took him prisoner, and brought him to Fontainebleau in 1812. Denon frequently visited the captive Pope, who addressed him as "my son" and questioned him closely about Egypt and its antiquities. The Pope insisted on reading Denon's book on the subject and was surprised when Denon told him, afterwards, that he had excommunicated both the book and its author for speculating about other accounts of the creation of the world than that contained in Genesis.[32]

But the day of reckoning was approaching. After the unsuccessful Russian campaign of 1812, the allied armies defeated Napoleon in a series of battles, and on April 6, 1814, at Fontainebleau, he abdicated. The Bourbon Louis XVIII was restored to the throne, and Napoleon was exiled

to the island of Elba. The allies sought to strengthen the new king's popularity and thus, at least for the moment, generously refrained from demanding the restitution of the art works of the Louvre (now the Musée Royal) to their former owners. Louis agreed to return works in storage and not on exhibition to the Low Countries and Prussia and even dared to assert, in a speech to the new Chambers, that "The glory of the French armies has not been tarnished; the monuments of their bravery remain, and the masterpieces of the arts belong to us from now on by stronger rights than those of victory." Denon did everything he could to show off the museum and its treasures at their spic-and-span best and cordially conducted the allied rulers about "as visitors and admirers rather than as conquerors." When Louis XVIII came to the Louvre, he was guided by Denon on one side and Comte Louis N. P. A. de Forbin, a painter and archaeologist obviously slated to replace Denon, on the other.[33]

Everything changed, however, when Napoleon escaped from Elba in 1815, met final defeat at Waterloo, and was banished to St. Helena. The allies decided that the French people needed a lesson, and while the final Convention of Paris said nothing about restitution of art works, the victorious powers informally agreed upon it. Denon's term as director general was probably extended for several months by the situation, but it was a frustrating and oftentimes bitter experience for him.[34]

Denon tried desperately to keep as many of the conquered masterpieces as he could for his museum. Beginning on July 7, the Prussians appeared, demanding their paintings and art objects, as well as those of other German states. Denon imaginatively thought of all kinds of obstructions; their authority was not in proper form, his poor memory would not let him find some works, others had been sent to the provinces, he could act only on orders from his king, he needed to call in a troop of National Guards to protect the art, and on and on. The Prussians brought twenty-five soldiers, set sentinels at the museum entrance, and threatened to arrest Denon and imprison him in the fortress of Grandentz, in eastern Prussia. He finally had to yield to force and let the troops take down and pack their masterpieces, but he delayed the takeover for about a month and won one small victory. Some ancient marble columns from Aachen Cathedral in Aix-la-Chapelle had been built into the Louvre and supported a roof. When they were demanded, Denon wrote the king of Prussia and received permission to retain the supporting columns, though he gave up others in storage. Wellington helped the Low Countries obtain their art treasures; he and the British played an impartial but firm role in the restitution process, though Denon unjustly suspected

them of planning to seize the *Apollo Belvedere* and other masterpieces for the British Museum. The Austrians were most courteous in their negotiations and left Denon some of their paintings. The Papal States and Rome were especially galling, because their art works had been carefully covered by treaty and had been in the Louvre for nearly twenty years. The sculptor Canova acted for them, and he and Denon did not get along well. By November 1815, the despoiling of the Louvre was complete. Denon took such an unbending attitude throughout the process that Secretary Lavalée became the chief negotiator and diplomat. His figures showed that 2,065 paintings had been returned, along with 130 sculptures, and numerous bas-reliefs, bronzes, vases, and other art objects. Denon's and Lavalée's evasive tactics, however, had saved many items for the museum; for example, of 506 paintings taken from Italy, 9 had disappeared, 249 were returned, and 248 remained in France.[35]

The French people were deeply angered by the restitution and sometimes gathered in menacing groups, though Paris was still occupied by allied troops. Henri Beyle voiced the intellectual's reaction to the situation when he wrote, of the Italian art works: "I hope I may be permitted to observe that we acquired them by a treaty, that of Tolentino. On the other hand the allies have taken our pictures without treaty." Many of the English visitors hated to see the Louvre's great collection torn apart. Sir Thomas Lawrence said "that every artist must lament the breaking up of a collection in a place so centrical for Europe, for everything was laid open to the public with a degree of liberality unknown elsewhere." [36]

It would be wrong, however, to try to defend the French, Napoleon, and Denon in their plundering of art works from the conquered countries. The requisitions from French churches and emigrés were part of the larger revolution and at least placed the paintings, sculptures, and objets d'art in museums, where they could be seen, though arguments could be made for leaving the religious art in the places for which it was designed and where it had a spiritual function. But many of the other works were seized from collections already open to the public, or soon to be so, after the political tumult had quieted. Fortunately, the widespread rape of art did not become the accepted pattern in the later wars of the nineteenth century and was opposed by both sides in World War I. The Nazis, however, led by dictator Adolf Hitler, carried such plundering to new heights during World War II. Hitler planned to establish a Fueherermuseum of masterpieces of art and a cultural center in his boyhood city of Linz and, in a manner reminiscent of Napoleon, systematically raided museum and private collections in Austria, Czechoslovakia, Poland,

Holland, France, and Italy. His field marshal, Hermann Goering, just as vigorously built a competing collection. Hitler's advisory expert, Dr. Hans Posse, director of the Dresden State Museum, reminds one of Denon in his collecting forays. Fortunately, these rapacious schemes were defeated, and restitution took place, though many European art treasures disappeared in the process. The whole affair makes one wonder whether some future conflict may again lead to looting of museum and individual collections.[37]

On October 3, 1815, Comte de Pradel, writing for King Louis XVIII, addressed a cool formal note of thanks to Denon for his work in saving for the crown paintings and other works of art. Denon replied, just as formally, thanking Pradel for his kind words, recommending Lavalée, Morel d'Arleaux (curator of bronzes and drawings), and Visconti for their competent, faithful service, and enclosing a brief letter of resignation for the king, made, he said, because of his advanced age (sixty-eight) and failing health. The *Gazette de France* announced the retirement and the king's thanks for Denon's zeal in saving for France part of the masterpieces of which she might otherwise have been deprived. Denon was surprised and pleased to receive a warm note from Baron von Ribbentrop, a principal Prussian antagonist of his in the struggle over restitution, expressing his personal esteem for Denon as a scholar and as a conserver of great art.[38]

Free now from official duties, Vivant Denon spent most of his time in his elegant apartment at 9 quai Voltaire, near the Louvre. A suite of six rooms contained his art collection or private museum, which he had gathered for nearly forty years. He planned to complete its arrangement and to push forward his long-projected "General History of Art from Ancient Times to the Nineteenth Century." Fortunately, he was comfortably fixed, financially, thanks to his inheritance, royalties from his popular book on Egypt, and his former official salary. Many awards had come to him; he had received the *Legion d'honneur* in 1803, had been made an officer in the society, and then had been created a baron of the empire in 1812. In fact, Baron Denon and his collection became one of the attractions of Paris, and he greatly enjoyed showing about distinguished visitors, especially young and pretty women, and charming them with his colorful, amusing tales of the provenance of selected objects. He also went out occasionally to attend meetings of the Institut and regularly to appear at the most prestigious salons.[39]

Much of Denon's collection was housed in superb cabinets made by the eboniste Boule, some of which had belonged to Louis XIV. When

Denon's holdings were sold in 1826, after his death, the catalogue listed 3,178 lots, comprised of ancient and historical, and modern antiquities, bronzes, medals, vases, oriental objects, paintings, drawings, engravings, and miniatures. Denon had intended to arrange these materials to show historical progression of the arts, but they still had traces of a general collection of curiosities. The several thousand engravings were high in quality and contained some exceptional series. The medals were excellent, from those of Greece and Rome through the set of 116 bronze and 130 silver ones commemorating the high points of Napoleon's reign. Vases were numerous—Greek, Etruscan, Roman, pre-Columbian from Peru, Chinese, Japenese, and European. Paintings were comparatively few—56 Italian; 81 Flemish, German, and Dutch; 53 historic French; and 32 contemporary French—but several were outstanding, including, for example, Raphael's *The Deposition*, Rembrandt's *Jesus in the Garden of Olives*, Chardin's *La Serviette*, Watteau's *Gilles*, Gérard's *Portrait de Mlle. George*, and David's unfinished portrait of General Bonaparte of 1797. One curiosity was the little mummified foot that Denon had brought back from Egypt and romanticized as the foot of a princess that had curled up on a divan or tripped lightly through the orange groves of the Delta. Another, from about the sixteenth century, was a gilded brass reliquary in the form of a Gothic cathedral, complete with flying buttresses. It held materials taken from sepulchers—bone fragments of El Cid and his Ximena, Héloise and Abelard, Molière and La Fontaine; hairs from the heads of Agnes Sorel, Inés de Castro, and General Desaix; and moustache clippings of Henri IV; part of the shroud of Vicomte de Turenne; and a strip of the bloody shirt Napoleon wore at his death. Chatelain has succeeded in tracing the routes through which Denon acquired many items in his collection, and he finds no conflicts of interest. Paintings and objets d'art sold at low prices, then, and Denon did not use his official position to acquire things for himself that should have gone to his museums or to force artists or dealers to make gifts or offer him bargains.[40]

Unfortunately, Denon's attention to the arrangement of his collection and its interpretation delayed work on his book. He visualized it as an encyclopedic history of art, organized around numerous illustrations, many of them based on his own collection. At his death, he had completed 271 lithographs, virtually all he had planned for the book, but he left only a few notes and scraps for the text, which Amaury Duval prepared and saw published in 1829.[41]

On April 26, 1825, Baron Denon attended an art auction and, on coming away, experienced a chill. Early next morning, he was dead, at age

seventy-eight, and after having maintained his physical energy and mental acuity almost to the end. His nephews commissioned Pierre Cartellier to do a sculptured marble portrait for his tomb at the Père Lachaise cemetery. His decease called forth still another anecdote. After Edme François Jomard had given an elegy for the Commission d'Egypt and Gros another for the Academie des Beaux-Arts, the painter J. A. D. Ingres, a longtime Denon enemy, appeared, in time to take a last look at the grave and cry: "Good, good, that's good! He is there, this time he will stay there." [42]

## IV

Upon the dissolution of the Musée Napoleon, Baron Denon wrote in despair:

Such an assembly—this comparison of the achievements of the human mind through the centuries, this tribunal where talent was constantly being judged by talent—in a word, this light which sprang perpetually from the inter-reaction of merits of all kinds has just been extinguished, and will never shine again. [43]

But the baron was wrong. He valued so highly the unparalleled collection of masterpieces that Napoleon's victories and, to a large extent, his own connoisseurship had brought together that its loss made him think that his innovative planning and skillful exhibition had counted for nothing and that his attempt to create the most beautiful museum of the world was now an abject failure. No one at that time, of course, could realize how completely the Louvre had become a precious symbol of French national glory. Sprung from the people in revolution and then nurtured and consolidated by absolute power, it was now an institution that could not be dropped. Louis XVIII and Charles X imitated Napoleon's cultural efforts as best they could, and they spent 731,000 francs to secure 135 pictures for the museum, while Fontaine and Percier improved part of the fabric of the Louvre as the Musée Charles X. Other French rulers were to continue such expenditures—Louis Philippe in niggardly fashion, it is true—but Napoleon III in a great burst of enthusiasm and energy that did much for the museum. The French common people that the first Napoleon had boasted were the most museum-wise *canaille* in the world loved their Louvre and were willing to see the state, whether royalist or republican, use their taxes to support it. After all, as the painter Lawrence had noted, in this museum "everything was laid open to the public with a degree of liberality unknown elsewhere." Also the artists were given special privileges to study, sketch, or copy the works of art on days not

open to the general public, and thus the museum received more and more support from the private sector, both artists and collectors.[44]

After restitution, the bare spaces on the walls of the Grande Galerie were soon filled, as Secretary General Lavalée brought from the Luxembourg palace the series of huge paintings on the triumphs of Marie de Medici by Rubens, those on the life of St. Bruno by Charles Alexandre Lesueur, and Joseph Vernet's views of the harbors and ports of France. Visconti had to rename some of his halls of antiquities such as those of Apollo or Laocoön, but he had many fine statues left—Michaelangelo's *Slaves*,for example, and the gigantic *Tiber* group that Denon had persuaded the Austrians to let him keep. Soon new masterpieces began to arrive: in 1821, the famed *Venus de Milo*, excavated on the island of Melos and obtained for Louis XVIII by the French ambassador to Turkey. Five years later, an Egyptian Department was organized, with Jean François Champollion, the decipherer of the Rosetta Stone, as curator. Another department of Oriental Antiquities was established in 1847 that received numerous rare objects excavated by expeditions to ancient Assyria, Babylon, Chaldea, Persia, and other Near and Middle Eastern sites.[45]

Napoleon III, like his forebear, wished to make the Louvre a splendid symbol for an illustrious reign. Between 1852 and 1857, he carried out the long-held dream of uniting the Louvre with the Tuileries Palace. He persuaded his parlement to appropriate 4.8 million francs to buy a major part of the Campana Collection sold at auction in Rome. Especially strong in Italian primitives and antique vases, it was shown as the Musée Napoléon III in the Palais de l'Industrie until turned over, under the same name, to the Louvre in 1862. After the Franco-Prussian War resulted in the emperor's downfall, the revolutionaries of the Commune burned the Tuileries but not the Louvre, and the ruined palace was not rebuilt.[46]

As part of the expansion under Napoleon III, the Pavillon Denon became the principal entrance of the Louvre and remains so today. Gifts to the museum were numerous; in 1857, Charles Sauvageat left it a collection on the Middle Ages and the Renaissance; in 1869, Dr. Louis La Caze gave the museum its greatest single gift in modern times: 582 paintings, many of them masterpieces, of which 275 remained in the Louvre, and 307 went to the départments; and in 1897, the Society of Friends of the Louvre was formed. In 1886, the Nike (Winged Victory) of Samothrace was discovered by an archaeological expedition to Greece and placed on a landing of the grand Daru staircase. Several generous donors have also given the Louvre great collections of French Impressionist and post-Impressionist paintings. This rapid survey makes it clear that the

Louvre has remained one of the greatest art museums of the world, with collections that permit a universal study of world art history and yet present an unmatched panorama of French art. If Baron Denon could return, he would have to admit that it is a greater museum today than when he presided over it, more than a century and a half ago.[47]

Denon also had great influence on other European art museums. The French Revolution and the Napoleonic wars had shaken loose abundant art works from religious establishments, displaced persons, and conquered regions; thus, it was a heyday for collectors, whether princes, nobles, artists, or the rising class of wealthy industrialists and merchants. Denon's museum showed what constituted great art and demonstrated ways in which it could be exhibited to inspire and inform not only aspiring artists and members of the court circle, but also the common people. Thus, the Pope and the princes who reclaimed their art treasures after Waterloo looked at them with new eyes, determined to show them in better order, and to open them to both artists and the public. Denon's tasteful arrangements by schools and then, chronologically, by individual artists were generally accepted, as were his practices of conservation and careful record-keeping.

Denon's connoisseurship directly influenced the French départmental museums and started them along the path that has caused them today to be known as "a second Louvre" situated in the provinces. The Brera in Milan, the Accademia in Venice, and other satellite museums also knew Denon well and occasionally profited by his collecting activity. The Rijksmuseum (1808) in Amsterdam and the Prado (1809) in Madrid came into existence as a result of resistance to French efforts to requisition paintings and other art works for Paris, but they followed many of the museum practices of the Louvre.

British and German visitors flooding Paris in 1802 and after Waterloo were much impressed by Denon and his willingness to have artists study his holdings and go behind the scenes to observe French artists and museum assistants at work. Benjamin West, Sir Thomas Lawrence, and other artists pushed hard to form, in London, a painting gallery similar to that of the Louvre; it came into being in 1824, when Sir George Beaumont, who promised it his own choice collection of paintings, and Lord Liverpool, the prime minister, persuaded Parliament to vote £57,000 to buy the thirty-nine old masters of the late John Julius Angerstein and to establish the National Gallery. The only major European art museum not developed from a royal or papal collection, the National Gallery at once received strong support from both collectors and artists and opened its

impressive new building on Trafalgar Square in 1838. The German prin-
ces, upon the return of their art works, strengthened their collections and
often put up new buildings. The Prussian king, Friedrich Wilhelm III,
greatly admired Denon and his museum; in 1821, he founded the royal
Prussian Picture Gallery, with Gustav Waagen as director. It opened in a
handsome neoclassic building by Karl Friedrich Schinkel, at Berlin in
1830. Tsar Alexander I also appreciated Denon greatly and purchased for
the Hermitage, from Josephine's estate at Malmaison, the collection of old
masters from Cassel.[48]

Though we may not approve Denon's part in looting the art works of
conquered nations, we must esteem his connoisseurship in choosing
works of the highest quality and his originality in venturing into the new
field of Italian primitives. His smooth administration and efforts to follow
sound techniques of conservation, registration, and exhibition are also to
be commended. Making the museum serve the general public as well as
artists and students, he used special events such as reunions of
Napoleon's soldiers, awards of the *Legion d'honneur* to artists, or torch-lit
night galas to keep the museum alive and exciting. Thus, the fertile-
minded and always energetic Denon made many contributions to the
museum world and may justly be considered the first truly professional
art museum director.

## NOTES

1. Judith Nowinski, *Baron Dominique Vivant Denon (1747–1825)*, pp. 74–79; Jean
Chatelain, *Dominique Vivant Denon et le Louvre de Napoléon*, pp. 77–81; Pierre Lelièvre, *Vivant
Denon*, pp. 23–24; Pierre Lelièvre, "Le Chevalier Denon," pp. 18–27; Paul Wescher, "Vivant
Denon and the Musée Napoléon," p. 181; Michèle Cotta, "Le baron Denon: L'homme qui a
sorti l'Egypte de la nuite de temps," *Connaissance des Arts* (December 1966): 78.

2. Nowinski, *Denon*, pp. 23–32, 71–73, 188–207; Chatelain, *Denon*, pp. 21–30, 37–38,
74; Lelièvre, *Vivant Denon*, pp. 15–16, 47; Dominique Vivant de Non, *Point de lende-
main . . . suivi d'une notice historique d'Anatole France.*

3. Nowinski, *Denon*, pp. 32–37; Chatelain, *Denon*, pp. 31–33; Lelièvre, *Vivant Denon*,
pp. 16–17; Lelièvre, "Chevalier Denon," pp. 18–21.

4. Nowinski, *Denon*, pp. 37–44, 255–262; Chatelain, *Denon*, pp. 33–37; Lelièvre, *Vivant
Denon*, pp. 17–18.

5. Nowinski, *Denon*, pp. 44–46; Chatelain, *Denon*, pp. 38–48, 51–56; Lelièvre, *Vivant
Denon*, pp. 18–21.

6. Nowinski, *Denon*, pp. 46–50; Chatelain, *Denon*, pp. 48–51; Lelièvre, *Vivant Denon*,
pp. 19–21; M. de Non, *Travels in Sicily and Malta.*

7. Nowinski, *Denon*, pp. 56–63; Chatelain, *Denon*, pp. 57–64.

8. Nowinski, *Denon*, pp. 64–69; Chatelain, *Denon*, pp. 65–73; Lelièvre, *Vivant Denon*, pp. 21–23.

9. Vivant Denon, *Voyage dans la Basse et la Haute Égypte*, 1: 7–265. Two English translations are by Arthur Aikin, *Travels in Upper and Lower Egypt . . . during the Campaigns of General Bonaparte . . .*, 2 vols.; and by E. A. Kendal, *Travels in Egypt during the Campaign of General Bonaparte . . .*, 2nd edition, 2 vols. See also Chatelain, *Denon*, pp. 81–93; Lelièvre, *Vivant Denon*, pp. 23–26; Lelièvre, "Chevalier Denon," pp. 21–24; C. W. Ceram, *Gods, Graves, and Scholars*, pp. 75–82; Alan Moorehead, *The Blue Nile*, pp. 47–133.

10. Denon, *Voyage dans Egypte*, 2: plate 54 bis; Denon, *Travels in Egypt* (Kendal), 1: lxii–lxv, 33–34, 38–41, 163–164, 190; 2: 103–105, 111–114; Denon, *Travels in Egypt* (Aikin), 1: 57–58, 62, 86, 180, 205–206; 2: 163, 186–201; Nowinski, *Denon*, pp. 79–83.

11. Lelièvre, *Vivant Denon*, pp. 24–26; Nowinski, *Denon*, pp. 83–88; Chatelain, *Denon*, p. 82.

12. Chatelain, *Denon*, pp. 86–87, 95–104; Nowinski, *Denon*, pp. 88–90; Lelièvre, *Vivant Denon*, pp. 22–42; Francis Henry Taylor, *The Taste of Angels*, pp. 547, 552; Cecil Gould, *Trophy of Conquest*, pp. 86–87; Dorothy Mackay Quynn, "The Art Confiscations of the Napoleonic Wars," pp. 437–460, esp. p. 442; Germain Bazin, *The Museum Age*, pp. 176–181; Germain Bazin, *The Louvre*, pp. 52–53, 56–57; Linda Nochlin, "Museums and Radicals: A History of Emergencies," *Art in America* (July-August 1971): 26–39, esp. pp. 28–29.

13. Nowinski, *Denon*, pp. 64–69; Chatelain, *Denon*, pp. 65–73, 289–304; Bazin, *Louvre*, pp. 46–48; Niels von Holst, *Creators, Collectors and Connoisseurs: The Anatomy of Artistic Taste from Antiquity to the Present Day* (New York: G. P. Putnam's Sons, 1967), pp. 217, 252.

14. Chatelain, *Denon*, pp. 163–164; Gould, *Trophy of Conquest*, pp. 30–40; Nochlin, "Museums and Radicals," pp. 26–29; Taylor, *Taste of Angels*, pp. 539–541.

15. Chatelain, *Denon*, pp. 164–167; Gould, *Trophy of Conquest*, pp. 41–68; Taylor, *Taste of Angels*, pp. 542–547, 554; Bazin, *Louvre*, pp. 48–49, 53–54; Nochlin, "Museums and Radicals," pp. 28–29; Quynn, "Art Confiscations," pp. 437–438.

16. Chatelain, *Denon*, pp. 164, 167–168, 317–326; Gould, *Trophy of Conquest*, pp. 67–68, 121; Taylor, *Taste of Angels*, pp. 543–544; Quynn, "Art Confiscations," pp. 438–440.

17. Chatelain, *Denon*, pp. 104–105, 114, 126, 199–204; Christiane Aulanier, *Histoire du Palais et du Musée du Louvre*, 1: 21, 46–51, 2: 40–42, 46; Gould, *Trophy of Conquest*, pp. 70–71, 88–89; Bazin, *Louvre*, p. 51.

18. Chatelain, *Denon*, pp. 161–163, 171–173; Taylor, *Taste of Angels*, pp. 555–558, 560–563; Gould, *Trophy of Conquest*, pp. 90, 92; Aulanier, *Louvre*, 1: 20.

19. Chatelain, *Denon*, pp. 168–181; Gould, *Trophy of Conquest*, pp. 91–102; Taylor, *Taste of Angels*, pp. 560–562; Quynn, "Art Confiscations," pp. 443–445.

20. Chatelain, *Denon*, pp. 181–187; Gould, *Trophy of Conquest*, pp. 110–115; Taylor, *Taste of Angels*, pp. 502–563; Bazin, *Louvre*, pp. 50–51, 88–89, 110–111, 124–125.

21. Bazin, *Museum Age*, pp. 180–181, 183, 186; Bazin, *Louvre*, pp. 52, 55–57; Chatelain, *Denon*, pp. 178–181, 191–198.

22. Roger H. Marijnissen, *Dégradation, Conservation, et Restoration de l'Oeuvre d'Art*, 1: 34–37, 44, 47, 50; Helmut Ruhemann, *The Cleaning of Paintings: Problems and Potentialities, With Bibliography and Supplementary Material by Joyce Plesters* (New York: Frederick A. Praeger, 1968), pp. 155–156, 380, 382, 384, 386; H. H. Pars, *Pictures in Peril* (New York: Oxford University Press, 1957), pp. 55–57, 60–64, 151–152; A. L. Millin, *Dictionnaire des Beaux-Arts*, 3 vols. (Paris: J. N. Barba, 1806), 3: 454–458; Bazin, *Museum Age*, pp. 116–118, 176; Gould, *Trophy of Conquest*, pp. 20, 68–70; Taylor, *Taste of Angels*, p. 551.

23. Chatelain, *Denon*, pp. 105–107, 200–203; Lelièvre, *Vivant Denon*, 41–45; Bazin,

*Louvre*, p. 52; Nowinski, *Denon*, pp. 99–101; Marie Henri Beyle ("Stendhal"), *Stendhal Correspondence, 1800–1842*, edited by V. Del Litto and Henri Martineau, 3 vols. (Paris: Victor Gollancz, 1962–1968), 1: 629–631, 642–644, 648–649.

24. Chatelain, *Denon*, pp. 204–208; Joseph Farington, *The Diary of Joseph Farington*, 5: 1864, 1876; Gould, *Trophy of Conquest*, p. 103; Holst, *Creators, Collectors and Connoisseurs*, pp. 218–219; Taylor, *Taste of Angels*, pp. 558–559; Aulanier, *Louvre*, 1: 24–28, pls. 35–38; 2: 46–47, 50–54, pls. 27–30; 10: 64–66.

25. Taylor, *Taste of Angels*, p. 558; Chatelain, *Denon*, pp. 209–210, 301–305; Gould, *Trophy of Conquest*, pp. 103–115.

26. Farington, *Diary*, 5: 1809–1918; Chatelain, *Denon*, pp. 211–215; Gould, *Trophy of Conquest*, pp. 80–85; Taylor, *Taste of Angels*, p. 578.

27. Aulanier, *Louvre*, 3: 80, pl. 53; Chatelain, *Denon*, facing p. 288; Holst, *Creators, Collectors and Connoisseurs*, p. 221.

28. Chatelain, *Denon*, pp. 128–129; Lelièvre, *Vivant Devon*, pp. 39–55.

29. Chatelain, *Denon*, pp. 131–135, 150–154; Aulanier, *Louvre*, 2: 54–55; Lelièvre, *Vivant Denon*, pp. 57–82, 93–118; Lelièvre, "Chevalier Denon," pp. 23–24; Nowinski, *Denon*, pp. 92–94.

30. Chatelain, *Denon*, pp. 141–144; Nowinski, *Denon*, pp. 244–245.

31. Chatelain, *Denon*, pp. 140–141, 145–147; Joan Wilson, " 'Little Gifts Keep Friendship Alive'," pp. 50–60.

32. Chatelain, *Denon*, pp. 119–120; Aulanier, *Louvre*, 10: 55–58; E. E. Y. Hales, *Napoleon and the Pope: The Story of Napoleon and Pius VII* (London: Eyre & Spottiswoode, 1962).

33. Chatelain, *Denon*, pp. 217–224; Taylor, *Taste of Angels*, pp. 571–572; Gould, "Art Confiscations," pp. 445–446; Gould, *Trophy of Conquest*, pp. 116–117; Nowinski, *Denon*, pp. 101–102; Albert Babeau, *Le Louvre et Son Histoire* (Paris: Firmin-Didot, 1895), p. 272.

34. Chatelain, *Denon*, pp. 224–226; Taylor, *Taste of Angels*, p. 572; Gould, *Trophy of Conquest*, p. 117.

35. Chatelain, *Denon*, pp. 226–251; Taylor, *Taste of Angels*, pp. 572–589; Quynn, "Art Confiscations," pp. 447–460; Gould, *Trophy of Conquest*, pp. 117–135; Nowinski, *Denon*, pp. 102–103.

36. Taylor, *Taste of Angels*, pp. 578, 588.

37. Bazin, *Louvre*, pp. 57–58; Dixon Roxan and Ken Wanstall, *The Rape of Art: The Story of Hitler's Plunder of the Great Masterpieces of Europe* (New York: Coward-McCann, 1964); James J. Rorimer and Gilbert Rabin, *Survival: The Salvage and Protection of Art in War* (New York: Abelard Press, 1950).

38. Chatelain, *Denon*, pp. 251–254; Nowinski, *Denon*, pp. 104–105.

39. Chatelain, *Denon*, pp. 261, 279–280; Nowinski, *Denon*, pp. 245–246.

40. Chatelain, *Denon*, pp. 261–278, 335–343; Nowinski, *Denon*, pp. 105–110; Taylor, *Taste of Angels*, pp. 569–570; Bazin, *Louvre*, p. 48.

41. Chatelain, *Denon*, pp. 258–260; Amaury-Duval, *Monuments des arts du dessin chez les peuples tant anciens que modernes*.

42. Chatelain, *Denon*, pp. 280–281; Nowinski, *Denon*, pp. 110–111.

43. Bazin, *Louvre*, p. 81.

44. Taylor, *Taste of Angels*, p. 578; Mary Knight Potter, *The Art of the Louvre . . .* (Boston: Page, 1904), p. 33.

45. Aulanier, *Louvre*, 1: 28; 6: 110, 8: 80; Bazin, *Louvre*, p. 61; Potter, *Art of the Louvre*, p. 33; Babeau, *Le Louvre*, p. 280.

46. Aulanier, *Louvre*, 1: 32, 34; 3: 67–72; 10: 7; Bazin, *Louvre*, pp. 66–69; Babeau, *Louvre*, pp. 308–315.

47. Aulanier, *Louvre*, 3: 72–77; 4: 29, pls. 7–8, 33–41, 53; Bazin, *Louvre*, pp. 72–85; Babeau, *Louvre*, pp. 303, 308–311, 325–328.
48. Jean-Pierre Babelon, *The Museums of France* (New York: Meredith, 1968), pp. 5–12; Bazin, *Louvre*, pp. 55–57; Bazin, *Museum Age*, pp. 184–185; Holst, *Creators, Collectors and Connoisseurs*, pp. 220–233; Frank Herrmann, *The English as Collectors: A Documentary Chrestomathy* (London: Chatto and Windus, 1972), pp. 263–265; Philip Hendy, "The National Gallery," in *Art Treasures of the National Gallery, London* (New York: Henry N. Abrams, 1955), pp. 9–25.

## SELECT BIBLIOGRAPHY

Aulanier, Christiane. *Histoire du Palais et du Musée du Louvre.* 11 volumes. Paris: Editions des Musées Nationaux, 1947–1971.
Bazin, Germain. *The Louvre.* Translated by M. I. Martin. New York: Harry N. Abrams, Inc., 1958. 323 pp.
———. *The Museum Age.* Translated by Jane van Nuis Cahill. New York: Universe Books, Inc., 1967. 302 pp.
Ceram, C. W. [Kurt W. Marek]. *Gods, Graves, and Scholars: The Story of Archaeology.* Translated by E. B. Garside and Sophie Wilkins. 2nd edition. New York: Alfred A. Knopf, 1975. 441 pp.
Chatelain, Jean. *Dominique Vivant Denon et le Louvre de Napoléon.* Paris: Libraire Academique Perrin, 1973. 379 pp.
Denon, Dominique Vivant. *Julie, ou le bon père, comédie en trois actes . . . représenté . . . sur le théâtre de la Comédie française, le 14 juin 1769.* Par M. D\* N\*\* . . . Paris: Praut fils, 1769. 37 pp.
———. *Point de lendemain, par Dominique Vivant de Non, suivi d'une notice historique d'Anatole France. Ed. . . . par Roger Stéphane reproudisant . . . le texte de l'edition de 1803.* [Paris]: J. J. Pauvert, 1959. 101 pp.
———. *Travels in Sicily and Malta : Translated from the French of M. de Non . . .* London: G. G. J. and J. Robinson, 1789. 427 pp.
———. *Travels in Upper and Lower Egypt, During the Campaigns of General Bonaparte . . . Translated . . . by Arthur Aikin . . . ,* 2 volumes. New York: Heard and Forman, 1803.
———. *Travels in Upper and Lower Egypt during the Campaigns of General Bonaparte. Translated . . . by E. A. Kendal.* 2nd edition, 2 volumes. London: T. Hurst, T. Ostell, and B. Crosby and Co., 1803.
———. *Voyage dans la Basse et la Haute Égypte, pendant less campagnes du général Bonaparte.* 2 volumes. Paris: P. Didot l'Aîné, 1802.
Dubois, L. J. J. *Description des objets d'arts composent le cabinet de feu M. le baron V. Denon . . . Monuments antiques, modernes; ouvrages orientaux, etc.* 3 volumes. Paris: Impr. d'H. Tilliard, 1826.
Duval, Amaury Pineu. *Monuments des arts du dessin chez les peuples tant anciens que modernes. Recuilles par le baron Vivant Denon . . .* 4 volumes. Paris: Chez M. Brunet Denon, 1829.
Fizelière, Albert de la. *L'oeuvre originale de Vivant Denon . . . ; collection of 317 eaux-fortes dessinées et gravées par ce celèbre artiste . . . avec un notice par M. Albert de la Fizelière.* 2 volumes. Paris: A. Barraud, 1873.
Farington, Joseph. *The Diary of Joseph Farington.* Edited by Kenneth Garlick and Angus

Macintyre. Volume V (August 1801–March 1803). New Haven and London: Yale University Press, 1979. pp. 1581–2002.

Gould, Cecil [Hilton Monk]. *Trophy of Conquest: The Musée Napoléon and the Creation of the Louvre*. London: Faber and Faber, 1965. 151 pp.

Huyghe, Rene. *Art Treasures of the Louvre . . . with a Brief History of the Louvre by Milton S. Fox*. New York: Harry N. Abrams, 1951. 178 pp.

Institut d'Égypte. *Description de l'Égypte, ou Recueil des Observations et des Recherches qui ont été en Égypte pendant l'expédition de l'armée Française . . .* 24 volumes. Paris: De l'Imprimerie Impériale, 1809–1828.

Lelièvre, Pierre. "Le Chevalier Denon . . . ," *L'Oeil: Art, Architecture, Décoration*, no. 50 (February 1959): 18–27.

_____. *Vivant Denon, Directeur des Beaux-Arts de Napoléon*. Paris: Libraire Floury, 1942. 120 pp.

Marijnissen, Roger H. *Dégradation, conservation et restauration de l'oeuvre d'art*. 2 volumes. Bruxelles: Editions Arcade, 1967.

Moorhead, Alan. *The Blue Nile*. New York and Evanston: Harper and Row, 1962. 308 pp.

Nowinski, Judith. *Baron Dominique Vivant Denon (1747–1825): Hedonist and Scholar in a Period of Transition*. Rutherford, New Jersey: Farleigh Dickinson University Press, 1970. 280 pp.

Quynn, Dorothy Mackay. "The Art Confiscations of the Napoleonic Wars." *American Historical Review* 50 (April 1945): 437–460.

Taylor, Francis Henry. *The Taste of Angels: A History of Art Collecting from Rameses to Napoleon*. Boston: Little, Brown and Co., 1948. 661 pp.

Wescher, Paul. "Vivant Denon and the Musée Napoléon." *Apollo* (new series) 80 (September 1964): 178–186.

Wilson, Joan. " 'Little Gifts Keep Friendship Alive': An Historic Sèvres Dessert Service." *Apollo* (new series) 102 (July 1975): 50–60.

# William Jackson Hooker
# and the Royal Botanic Gardens
# of Kew:
# The Botanical Garden

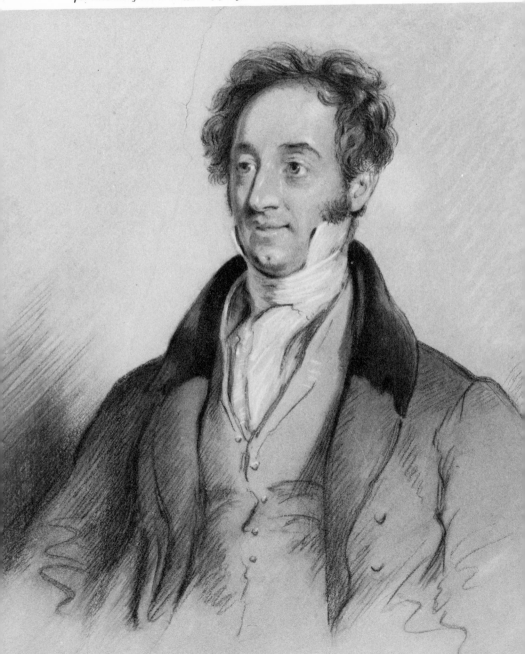

Fig. 9. Sir William Jackson Hooker (1785–1865), 1841. Chalk portrait by Daniel Macnee shows Sir William just before he left Glasgow for Kew. (*Reproduced with the permission of the Director, the Royal Botanic Gardens, Kew.*)

I

N AUGUST 1809, William Jackson Hooker, a tall young man of twenty-four, left Reykjavik in Iceland on the ship *Margaret and Anne*, Captain Liston commanding, to return to his native England. Sir Joseph Banks, president of the Royal Society and a leading botanist, had visited Iceland in 1772, and it was at his suggestion that Hooker had spent the summer exploring the Icelandic countryside, with its quiescent volcanoes, hot springs, gushing geysers, and barren, moonlike terrain. Hooker had studied the accounts of previous travelers, mainly Danes, and everywhere he went, he kept copious notes on the landscape, people, animals, and plants. He also gathered a multitude of botanical specimens, intending later to mount them on thick sheets of paper for the herbarium he had started back home at Norwich in East Anglia.

Iceland was a Danish possession; but during Hooker's stay there, a comic opera kind of revolution had taken place. Britain and Denmark technically were at war, as part of the Napoleonic disturbances, but at the moment both sides were trying to keep Iceland neutral and to supply the Icelanders with food and other necessities. Still, the *Margaret and Anne* was an armed privateer, with a letter of marque, and her owner, Samuel Phelps, a London soap manufacturer, was aboard. Phelps had brought foodstuffs to sell and had hoped to lade a return cargo of fish oil and tallow. On coming into port, Phelps had ordered Captain Liston and his men to seize Count Trampe, the Danish governor, and the Danish brig *Orion* as prize. Jorgen Jorgensen, a Dane living in England, had sailed on the *Margaret and Anne* with Phelps, and he now proclaimed himself "the Protector of Iceland and Commander in Chief by Sea and Land." Jorgensen took over the government of the island, harassed the Danish officials, and issued a windy manifesto promising native Icelanders various privileges. His brief rule came to an end when the British sloop of war *Talbot*, under Captain Alexander Jones, arrived. Captain Jones deposed Jorgensen and restored most Danish officials, but allowed the *Margaret and Anne* to proceed on her way, taking Count Trampe to England as prisoner, followed by the *Orion*, with Jorgenson in command.

On the morning of August 27, as the *Margaret and Anne* plowed through heavy seas, the oil and tallow below decks were found to be on

115

fire. The flames could not be extinguished, and ship and cargo were about sixty leagues from shore, with only enough lifeboats to hold half the number of those aboard. Fortunately, the *Orion*, which had taken a shorter course, hove into sight; and Jorgensen, showing superior sea-manship, rescued all hands from the *Margaret and Anne*, though they could save little more than the clothes they wore. Jorgensen then turned his overloaded ship back to Reykjavik. Some of the Danes aboard the *Margaret and Anne* were accused of setting the shipboard fire and were placed in irons. Young Hooker, starting for home again, on board the *Talbot*, had lost all of his collections and two-thirds of his notes.[1]

Sir Joseph Banks commiserated with Hooker on his losses but thought that the young man had conducted himself well. Having heard from friends in Iceland who condemned Jorgensen's attempted coup, Banks decided that the Dane had planned the uprising before he left England and concluded: "My mind is that Jorgensen is a bad man, Phelps as bad, and that Count Trampe is a good man." Hooker, however, continued to try to help Jorgensen, who was now imprisoned, because he felt that the Dane had saved his life. Jorgensen's later career was unsavory, and he was transported to Van Diemen's Land (Tasmania). Joseph Dalton Hooker, William's son, encountered him there in 1840, much given to drink and to maudlin weeping when he recalled his friendship with William.[2]

William Jackson Hooker was born in Norwich on July 6, 1785. His father Joseph was a confidential clerk for Baring Brothers, merchant bankers, who had sent him to Norwich, a center of the worsted and cloth business. Joseph Hooker understood German and was an amateur botanist, with a little garden and greenhouse of succulents beside his home. William's mother was Lydia Vincent, whose family dealt in worsted weaving. The boy attended the Norwich Grammar School operated by the Reverend Dr. Samuel Forster, a vain and indolent man. William Jackson of Canterbury, Lydia's brother-in-law, for whom William was named—he was also the boy's godfather—died suddenly, and at age twenty-one the young man inherited a considerable competency. His parents then sent young William to study estate management for two years under Robert Paul, a wealthy farmer, at Starston Hall in Suffolk.[3]

Norwich was known as the City of Gardens, and its county of Norfolk—with its long seacoast, tidal rivers, connected shallow lakes called "the Broads," abundant woods, and fertile grain-growing fields—was a paradise for naturalists. Hooker was interested in all aspects of nature, and for a time could not decide whether to devote himself to collecting

and studying insects, birds, or plants. In 1805, however, he discovered near Norwich a rare moss (*Buxbaumia aphylla*), never before known in England. This find brought him to the attention of the numerous naturalists of the region, including Dr. James Edward Smith and Dawson Turner. Dr. Smith had purchased the herbarium and other materials left by the famed Linnaeus himself and had been a founder of the Linnean Society; and Turner was a Yarmouth banker who collected both plants and antiquites and was an authority on cryptogams—plants that bear no flowers or seeds but propagate by means of spores. Seaweeds were his specialty. When he found that Hooker could draw plants skillfully, he cajoled him into illustrating seaweeds. These two authorities and many other amateur naturalists in the neighborhood were impressed by the young man's knowledge, collecting ability, writing, and illustrations, as well as by his agreeable personality, and it was natural that they should urge him to go to London and give him letters of introduction to the leading, almost legendary botanical entrepreneur of that day, Sir Joseph Banks.[4]

In 1806, Hooker called on Sir Joseph in his house on Soho Square. Banks, always on the lookout for promising young naturalists, easily won over Hooker with warm friendliness and a cordial invitation to come to use his library and herbarium at any time. Hooker was proud to be received as a fellow scientist by the man who had sailed around the world with Captain Cook in the *Endeavour* and was known as "the Father of Australia." Sir Joseph talked to him about the Royal Gardens of Kew near London. As George III's adviser there earlier, Sir Joseph's long-range wish for Kew Gardens was well known: he wanted to see them not only present beautiful plants from all over the world for the pleasure of the general public, but also to serve as acclimatizing nurseries that would distribute plants of economic importance where they would do the most good throughout the British Empire. Hooker dreamed of becoming a plant explorer and botanizing at exotic places where no trained naturalist had ever trod in Ceylon, Java, Persia, India, Australia, South Africa, or the Brazils.[5]

Hooker even talked of going back to Iceland, but then, in 1818, he became fascinated with Ceylon—though a revolt broke out there—and with Java a year later. Sir Joseph would help financially if Hooker would send plants back to Kew, but the young man's parents and Norfolk friends were frightened at the reputation of malarial Java as a white man's grave. Dawson Turner also urged Hooker to finish his projected books and, not incidentally, to continue his drawings for Turner. The inheritance that Hooker had thought would help finance his life as a plant explorer was

proving instead to be a hindrance. Difficulties in selling some of his lands—finally sold for twenty thousand pounds—had involved him in lawsuits, he had lost money investing in Spanish funds, and he had bought a share in a brewery at Halesworth in Suffolk that was proving unprofitable. Hooker thus finally decided to give up the Java adventure.

Sir Joseph was nettled to have his advice ignored and wrote Hooker a sarcastic letter that ran, in part:

But, pressed as you are, I advise you to submit and sacrifice if you can your wish for travelling to the importunities of those who think they can guide you, to a more serene, quiet, calm, sober mode of slumbering away life, than you proposed for yourself . . . . I was about twenty-three when I began my peregrinations. You are somewhat older; but you may be assured that if I had listened to a multitude of voices that were raised to dissuade me from my enterprise, I should have been now a quiet country gentleman, ignorant of a number of matters I am now acquainted with, and probably have attained to no higher rank in life than that of a country Justice of the Peace.[6]

Hooker lived in a house at the brewery, as its manager, but he begrudged the personal attention the business demanded and spent most of his time preparing for publication his Icelandic *Journal* and botanical treatises on liverworts, mosses—both exotic and British—and the flora of London. He managed some traveling in Britain, and in 1814 accompanied the Dawson Turners and their daughters Maria and Elizabeth in Paris, going on by himself for seven months through France, Switzerland, and Italy. He met and formed warm friendships with such leading botanists of the day as Jean Baptiste Lamarck, A. P. De Candolle, and Alexander von Humboldt, for whom he agreed to write the cryptogamic part of a work on South American botany.[7]

In 1815, Maria Sarah Turner and William Hooker were married: she was only sixteen and Hooker almost thirty at the time of their marriage. They made a long honeymoon trip through England, Ireland, and Scotland, taking time to visit friends and do some botanizing. During their life together, Maria proved to be a devoted wife to William and mother to the couple's children, two sons and three daughters. She was a competent botanist and illustrator, as well.[8]

By 1820 Hooker had settled down as a promising young British botanist, but he was weary of managing the brewery and faced the possibility that his declining investments would not provide steady income for his growing family, much less finance his professional career of botanical research, writing, and illustration. He decided that the best course was to seek a university appointment. His rich private library and herbarium

would be real assets for such a future. There was an opeining in the regius professorship of botany at the University of Glasgow that also included the directorship of the Glasgow Botanic Garden. Regius professors in British universities held chairs founded by royal command; and Hooker's friend, botanist Joseph Brown, and Sir Joseph Banks (as one of the last acts of his life) persuaded the Duke of Montrose, patron of the university, to have the crown appoint Hooker to the post. Hooker worried somewhat about the requirement that he address a discourse in Latin to the faculty senate before he could be admitted to his position, but Dawson Turner, an accomplished Latin scholar, wrote "De Laudibus Botanicis" for him, and he gave it with such savoir faire that his listeners observed "he seems to have composed it extempore and delivered it forthwith." Five days later, the senate conferred as LL.D. upon him.[9]

## II

When Professor Hooker began meeting his classes at Glasgow, he was somewhat fearful because he had had no previous experience at teaching or lecturing. It turned out, however, that he was a born teacher, and his son Joseph many years later said that "he had resources that enabled him to overcome all obstacles: familiarity with his subject, devotion to its study, energy, eloquence, a commanding presence, with urbanity of manners, and above all the art of making the student love the science he taught." He usually devoted the second half of the hour-long period to analysis; students were equipped with a kit of pocket lens, knife, and forceps, and they led the discussion of actual specimens. Hooker drew deft sketches on the blackboard and made huge colored drawings of plants and their parts that he hung on the classroom walls. An Edinburgh publisher issued his book of *Botanical Illustrations* (1821), showing the terms employed in his lectures, and every two students shared a copy between them, as he spoke. He invited the better students to his home to use his private library and the herbarium, which he had been collecting since before 1805—probably the largest herbarium anywhere in private hands. He added to it continually by collection, exchange, and purchase of other herbariums, and he kept it accessibly arranged. [10]

Hooker also took some thirty students on botanizing excursions in the summer. On two Saturdays, they journeyed within ten miles of the city and then, for five or six days, in the rugged western Highlands, with tents in a wagon drawn by a sturdy Highland pony. Once Hooker, who had been known to walk sixty miles in a day, was surprised that some of the

students were worn out after covering only half that distance. Frequently, well-known British or continental botanists joined the tours. Hooker's first-year students showed their appreciation of the excursions by presenting him with a handsome silver vasculum or plant-collecting box decorated with a design of *Hookeria lucens*, a moss Dr. Smith had named for him. Hooker's *Flora Scotica*, 2 volumes (1821) was largely written to supplement this field work.[11]

Director Hooker likewise used the living plants of his Glasgow Botanic Garden to educate his students, and held his classes there in the summer. The university had had a small Physic Garden in the eighteenth century, to assist in training its medical students. In 1817, an enthusiastic group of townsmen shareholders formed the Royal Botanic Institution and raised three thousand pounds, to which the university added two thousand more. Two years later, the Glasgow Botanic Garden opened to the public, on an eight-acre site at Sandyford Road. Hooker had Sir Joseph Banks's promise to send surplus plants from Kew, and he dispatched his curator Stewart Murray to beg specimens from his collecting and nurserymen friends. He was soon corresponding with twelve English and Irish gardens, twenty-one on the continent, and five tropical ones, as well as with some three hundred private collectors. As his students were graduated, many of them traveled or worked abroad and sent him plants. When he came to Glasgow, there were nine thousand species in the garden; and when he left, nearly twenty thousand. Hooker put the greenhouses and stoves in good order and used the lodge, with its lecture room that held two hundred persons. But the Sandyford site was being overwhelmed by city growth around it, and he planned to move the garden west, beside the Kevin River, a step taken under his successor, Dr. John Hutton Balfour. Hooker also thought the university did not have enough control of the garden and that the Royal Botanic Institution was too restrictive about exchanges with other public gardens. Prominent botanists who visited the garden reported it excellent and on a par with other leading gardens in Britain and Europe.[12]

During the twenty years he spent in Glasgow, Hooker reached his full stature as a scholar. He regularly taught only one or two terms and during the remainder of the year worked from after breakfast to midnight on his heavy correspondence with other botanists and his numerous articles and books. He became editor of the *Botanical Magazine*, 13 volumes (1827–1839), *Botanical Miscellany*, 3 volumes (1830–1833), and *Journal of Botany*, 5 volumes (1834, 1840–1842) and, after he moved to Kew, the *London Journal of Botany*, 7 volumes (1842–1847) and *Hooker's Journal of*

*Botany and Kew Garden Miscellany* (1849–1865). He also edited *Icones Plantarum*, 10 volumes, on ferns (1827–1854). His more important books written or begun at Glasgow, in addition to the two mentioned above, included *Exotic Flora* (1823–1827), a new edition of Curtis's *Flora Londinensis* (1817–1828), *Icones Filium*, 2 volumes with R. K. Greville (1829–1831), *Flora Borealis-Americana* (1829, 1840), four editions of the *British Flora* (1830–1838), and the *Botany of Captain Beecher's Voyage*, to the Pacific and Bering Strait, 1825–1828 (1841). Hooker was chiefly a descriptive taxonomist who received specimens from many sources throughout the world and worked with his library and herbarium to identify, delineate, and describe the specimens properly.[13]

His herbarium was growing so rapidly that from his own pocket he paid an assistant, James Chalmers, to keep it well arranged and up to date. Chalmers came from Dundee in 1825 to handle the three thousand species added in three months; and Johann Friedrich Klotzch from Berlin took over in 1830. Klotzch later became keeper of the Royal Herbarium there. When Walter Fitch from East Anglia, who had been apprenticed to a calico-printing firm, started work at the herbarium, Hooker quickly recognized his artistic talent and assigned him to drawing plants. Fitch became a principal botanical artist associated with William Hooker and his son Joseph for sixty years.

Hooker bought a second house in Glasgow, to take care of family, herbarium, library, and museum of economic botany. The museum was used by his classes and contained samples of plant products employed for food, building, medicine, cordage, paper, tanning, dyeing, and in a hundred other ways.

For some time, Maria Hooker and the children had been summering on the Clyde at Helensburg, with the professor joining them on weekends, though he often left on Sunday afternoon to walk twenty-two miles so as to meet his Monday morning class. In 1837, he bought a cottage near Kilman, at the head of Holy Loch, and rescheduled his class for Saturday morning.[14]

Soon after going to Glasgow, Hooker became restive. Though he enjoyed teaching, and his pay was satisfactory, he considered London the center of British botany and Glasgow too far away and too provincial. He discussed moving to the British Museum, but received no encouragement there. In 1827, he was appointed professor of botany at University College, London, but did not need to take the chair for two years and finally resigned before serving. Gossip said that William Townsend Aiton, the royal gardener at Kew, was considering retirement, and Hooker carefully

approached several noblemen who would have influence in that appoint-
ment. An opening appeared at Oxford, but he found that anyone
appointed there needed a doctorate in medicine, must be an Oxford
graduate, and would receive only £260 per year. Meanwhile, in 1836,
William Jackson Hooker became Sir William, a knight of the order of
Hanover, for his services to botany.[15]

Conditions were becoming more uncomfortable at the university.
Though Hooker remained a popular teacher who attracted to his classes
as many as 130 students, townspeople, and even officers from a nearby
barracks, he was involved in bitter quarrels with the faculty. He protested
to the senate when a medical student received a degree without studying
botany, and he opposed admitting other students who had taken botany
courses in London or Dublin. Such practices would cut into his compen-
sation that still included student fees. In 1841, a faculty petition against
Hooker and a professor of surgery maintained that, as members of the
Church of England, they were not meeting the requirements that pro-
fessors subscribe to the Confession of Faith and conform to the worship of
the Church of Scotland. These disputes angered Hooker so much that,
when he left for Kew, he did not bother to transmit his resignation to the
university.[16]

Hooker had had his eye upon the directorship of Kew since about
1834, when Aiton's retirement was rumored. Kew had become a royal
property in 1730, as Frederick, Prince of Wales, obtained a lease on Kew
House there. After Frederick's death, Augusta, Princess Dowager of
Wales and mother of George III, took over the property and about 1759
established there a small botanical garden of some nine acres. John Stuart,
Earl of Bute, who incidentally was not admired by the American colonies,
became Augusta's botanical adviser, and the architect Sir William Cham-
bers embellished the garden and its neighboring pleasure grounds with
temples and ornamental stuctures, the most important of which remain-
ing today are the ruined Arch (1759), the Orangery (1760), and the Pagoda
(1761–1762). William Aiton, who had worked for Philip Miller at the Physic
Garden in Chelsea, became the head gardener; he and his son William
Townsend Aiton served Kew for more than a century. When the princess
died in 1772, George III combined Kew with his adjoining Richmond
estate as the "Royal Gardens of Kew." He employed Lancelot
("Capability") Brown to do some of the landscaping.[17]

Under George III, Sir Joseph Banks became botanical director of the
Royal Gardens of Kew. As Hooker well knew, Banks had envisioned a
great national garden and had sent botanical explorers all over the world

to seek plants that would serve the economic needs of the empire. When George III and Sir Joseph both died, in 1820, Kew's fortunes began to decline; and with the coronation of Victoria in 1837, some of the queen's advisers wished to abandon the botanic garden entirely. The royal treasury, in 1838, set up a committee "to inquire into the management, etc. of the Royal Gardens" with Dr. John Lindley, an excellent botanist and a protege of Hooker, as chairman, and two professional gardeners, one of whom was Joseph Paxton, later designer of the Crystal Palace.[18]

Before the committee reported, Lord Surrey, who had supervision of this royal private property as Lord Steward, decided to do away with the scientific aspects of the gardens, throw out the rare exotic plants, and make the greenhouses and pits into vineries. He offered the plants to the Horticultural Society for its garden at Chiswick and to the Royal Botanic Society for Regent's Park. Both institutions indignantly refused the gifts, and when the public journals heard about the scheme, they criticized it as "a disgrace to the nation." After spirited debate in the House of Lords, control of the gardens was transferred from the private holdings of the royal family under the Lord Steward to the national domain under the Commissioners of Woods and Forests.[19]

In the meantime, the report of the treasury committee of inquiry was distributed widely. Its key recommendations ran:

A national garden ought to be the centre, round which all minor establishments of the same nature should be arranged; they should be all under the control of the chief of that garden, acting in concert with him, and through him with one another, reporting constantly their proceedings, explaining their wants, receiving their supplies, and aiding the mother-country in every thing that is useful in the vegetable kingdom. Medicine, commerce, agriculture, horitculture, and many valuable branches of manufacture, would derive much benefit from the adoption of such a system. From a garden of this kind, government would be able to obtain authentic and official information on points connected with the founding of new colonies: it would afford the plants there required.[20]

During these events, Hooker's friends had not been idle. The Duke of Bedford, who for long had hoped to see Hooker installed at Kew, had died, but the duke's son, Lord John Russell, was in the government and was a strong supporter of Hooker. When William Townsend Aiton, at age seventy-three—and after forty-seven years of service—announced his retirement from the gardens, the treasury in March 1841 officially appointed Hooker director, at a salary of three hundred pounds, with an allowance of two hundred pounds for house rent. By May, Hooker had loaded sixty great packages of books, his plants—arranged and unar-

ranged—his economic museum collection, and much furniture on five boats in Glasgow to be landed on the Thames bank near the brick house he had secured about ten minutes' walk from Kew. Before the appointment, Joseph Hooker, then the botanist on Captain J. C. Ross's expedition to the Antarctic, well understood his father's ambition and wrote him that "to be able to raise Kew to the rank of a tolerably good national establishment would be the most honourable service a Botanist could render his country, besides being the most pleasant one you could set your mind to."[21]

### III

The Kew to which Sir William came, when he was fifty-five, was a small, almost private garden, cut up by brick walls, with few plant species, slight public attendance, and with no library or herbarium to attract scholarly botanists. The new director had two chief aims. First, he would provide garden-loving visitors with "an extensive series of useful and ornamental plants from all lands and climates, together with their products, whether as food, drugs, dyes, timbers, textiles, or cabinet work." The plants and their products would convey useful information and aesthetic enjoyment to the general public. Second, he would serve the cause of scientific botany by encouraging scholarly researches and publications and "training plant collectors and gardeners for home, colonial, and foreign service."

Hooker at once moved to bring the gardens to life by admitting visitors every weekday, from 1:00 P.M. to 6:00 P.M. in summer and until sunset in winter. They could wander about freely, whereas, before, guides had watched them closely. In nine months, attendance totaled 9,147, and visitors had been well-behaved, not harming the plants or picking the flowers. Hooker wrote a guidebook in 1844 that sold for sixpence and ran through twenty-one editions. His library, herbarium, and museum collection occupied thirteen rooms in his house near the gardens and were open freely for scholarly use.[22]

Hooker was always an agreeable host, ready to drop his administrative duties when nobility or other important personages drove up in their carriages or when learned botanists came calling. Queen Victoria and Prince Albert visited frequently, inspecting thoroughly every planting and greenhouse. Princess Mary Adelaide (later Duchess of Teck), who lived at Cambridge Cottage next to the gardens, enjoyed them almost daily, on foot or in a pony cart; she argued with "Hookey" about laying out

flower beds, he sometimes out of patience because she put beauty above botany. Lord Lincoln (later Duke of Newcastle) and his fellow Commissioners of Woods and Forests made frequent inspections and were so pleased with Hooker's improvements that they gave him almost a free hand.[23]

Kew's area expanded rapidly from the 11 acres with which Hooker started. Victoria gave 4 acres in 1842, to provide a new main entrance at Kew Green, for which Decimus Burton, the architect, designed handsome iron gates. The next year, the queen added 45 acres from the former Pleasure Grounds; and in 1845, the remainder of that plot, more than 200 acres, was handed over to Hooker. A year later, the queen granted 14 acres of the Royal Kitchen Garden. For a time, also, Hooker nominally administered the 375 acres of the Old Deer Park, but in 1850 that area was retained by the Commissioners of Woods and Forests, while Kew Gardens were placed under the Board of Works and Public Buildings. The expansion of Kew allowed Hooker to make an entirely new plan for the nearly 300 acres. He retained W. A. Nesfield, a prominent landscape gardener, to advise him. They laid out three spacious vistas culminating in the new Palm House. The first plot was the 25-foot-wide gravel Broad Walk, which connected the new Main Entrance with the former Orangery and then turned at a right angle to proceed 500 yards south to the pond beside the Palm House. From there, the Sion Vista provided a wide view west across the Thames to Sion House Park, and the Pagoda Vista looked southwest to the old Pagoda of Sir William Chambers. The last two vistas cut through the new National Arboretum, situated in the 200-acre grant of the Pleasure Grounds and planted between 1848 and 1850.[24]

The new plan centered around a charming curved Palm House, constructed of iron and glass, between 1844 and 1848. It was 362 feet long, with a transept 106 feet wide and 62 feet high, and it contained 45,000 square feet of glass. Three men were responsible for this building: Hooker; Decimus Burton, the architect; and Richard Turner, the engineer. A reflecting pond on one side set it off well, and there was a formal parterre garden on the other side. The structure had some influence on the famed Crystal Palace of the Great Exhibition of 1851, though Joseph Paxton's two glasshouses—a British term for greenhouses—at Chatsworth were more closely related. To avoid the need for ugly chimneys on the Palm House, Burton designed a 107-foot-high campanile some 150 yards away, connected with the Palm House by an underground flue; but the ground in that area was so wet that two chimneys eventually had to be added to the conservatory.[25]

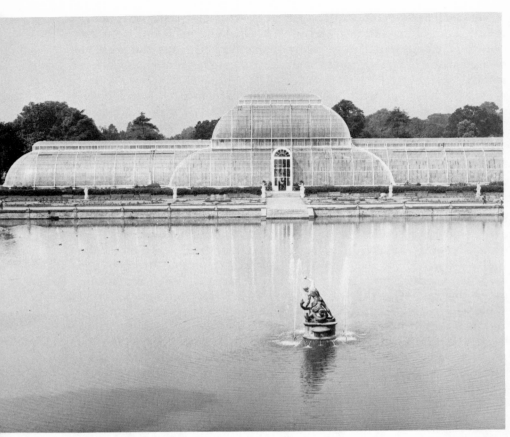

Fig. 10. The Palm House, Royal Botanic Gardens, Kew. Designed by Decimus Burton, architect, William Jackson Hooker, director, and Robert Hunt, engineer. Completed in 1844. (*Reproduced with the permission of the Director, the Royal Botanic Gardens, Kew.*)

Hooker was the creator of a new kind of specialized museum within the gardens—the Museum of Economic Botany. At Glasgow, he had collected for the use of his classes vegetable products and shown the plants from which the products came, together with pictures, models, or apparatus to illustrate the process by which they were prepared. In 1846, when Queen Victoria gave the Royal Kitchen Garden to Kew, Hooker took a building used partly as a gardener's cottage, partly as a fruit room, and, as his son Joseph later described it:

Fig. 11. Museum of Economic Botany, Royal Botanic Gardens, Kew. William Jackson Hooker established this museum in 1847. *(Reproduced with the permission of the Director, the Royal Botanic Gardens, Kew.)*

Procuring a few trestles and planks, he formed of them a long table in the central room . . . , arranged all these articles on it, ticketed them, and invited the Commissioners [of Woods and Forests] to come and see them. This they did and listened to his eloquent discourse . . . , during which he showed how such a collection of vegetable products might, besides interesting and instructing the public, prove of great service to the scientific botanist, the physician, the merchant, the manufacturer, the chemist and druggist, the dyer, and to artisans of every description.

To take a single exhibit as an example, the coconut palm was pictured growing near the sea in a tropical land with, next to it, a portion of the trunk and a bunch of coconuts in their husks. Then there were samples of coconut oil, with soap and candles made from it; toys, teapots, and ladles from the shell; ropes, handbags, and brushes from the husk; and native dresses, ornaments, and many other products. The museum, opened in 1848, was popular with visitors, and the world's fairs of 1851 and 1862 in London and 1855 in Paris contributed so many such exhibits to Kew that a second museum building was devoted to them in 1857, and still a third in 1863.[26]

These improvements in the physical appearance of the gardens continued throughout Hooker's administration. In 1845, an Orchid House was built, chiefly to hold the collection of orchids from Woburn that the Duke of Bedford had given to the queen for presentation to Kew. The gigantic water lily from South America called *Victoria amazonia* (formerly *regia*) had leaves six feet in diameter that would support a little girl. It bloomed at Kew in 1850 (Joseph Paxton achieved such flowering at Chatsworth the year before) and was installed in its own circular tank thirty-six feet in diameter two years later. The Temperate House designed by Decimus Burton was opened in 1862. Hooker suggested for the National Arboretum area an artificial scenic lake fed by the Thames. The lake was completed in 1861, the same year in which a 159-foot-tall Douglas fir was successfully erected as a flagpole. There were also spectacular plants such as the nine-foot-high cactus from Mexico that weighed one ton and the forty-three species of rhododendrons sent back from Sikkim in the Himalayas by Joseph Hooker.[27]

The public appreciated the innovations taking place at Kew, and attendance went up markedly. In 1851, the year of the Great Exhibition, it reached 329,900. A great step forward was taken in 1857, when the gardens, including the glasshouses and museums, were opened on Sunday afternoons. This was a courageous step by the Board at a time when religious reasons kept museums and other educational attractions closed

on the very day when working people could best visit them. Both Sir William and Lady Mary, as devout Episcopalians, regretted the opening; but their son Joseph, by that time assistant director to his father, while he disliked giving up his one quiet day, considered "it a wise and beneficial measure in a public point of view." And attendance jumped 100,000 in the first year after the opening.[28]

Sir William was determined to make the small garden he had received, with its ten mediocre glasshouses, into a great national center of scientific botany. He used various official and unofficial channels in Britain and around the world to obtain plants, and he provided favorable environments for them by means of outdoor plantings, pits and frames, glasshouses, and hothouses or "stoves." When he arrived, there was no library or herbarium to allow study of living plants and dried specimens. Hooker's own large library and herbarium in his home was used by him for his editing, articles, and books, and was also open freely to scholars, some of whom were invited there for a meal, as well. These resources were required, serviced, and maintained out of the director's pocket, and Hooker asserted that they sometimes cost half his salary.

Sir William and his son Joseph enjoyed an unusually close relationship, and the father generously tried to use his library and herbarium to advance his son's career. After Joseph returned from three years as plant explorer, in the Antarctic, he substituted for a time for Dr. Robert Graham, professor of botany at the University of Edinburgh. His father decided that if Joseph should succeed to that post permanently, he might give the young man the library and the herbarium, to be placed at the university or the botanical garden at Edinburgh, but Joseph was not elected to the position. In 1846, Sir William offered to present his collections to Kew, provided Joseph was appointed his assistant and successor at eight hundred pounds per year, but Lord Morpeth, the chief commissioner, though friendly, thought himself not empowered to make such an arrangement.

In 1853, the situation changed, when the library and herbarium of Dr. William Arnold Brumfield, a former student of Sir William at Glasgow, was given to Kew. The next year, an even more valuable collection came from George Bentham, a wealthy botanist who constantly worked on his writings at Kew. Bentham and Sir William had purchased specimens cooperatively for years, and Bentham's herbarium of flowering plants had cost him six thousand pounds. In 1855, Hooker was given an official residence facing Kew Green and backing on the gardens, and the large Hunter House near the main entrance became the library and herbarium. In addition to the Kew holdings, Sir William's collection was placed there,

and the commissioners agreed to pay for the collection's maintenance and to furnish a curator, since it was open to scholars. No fund was provided for purchases of specimens, and Hooker often paid for them himself. After Sir William's death, his collection was sold to Kew for seven thousand pounds, and Joseph bought the Gay Herbarium of European plants in Paris for four hundred pounds and presented it to Kew. Today Kew's herbarium is the largest in the world, with more than seven million dried specimens mounted on sheets.[29]

While the general public and professional botanists were important audiences for Kew, an even greater objective for the gardens, in the director's opinion, was the promotion of economic botany to benefit the British Empire. Sir William's son Joseph described his father's efforts in exploring and developing that area as follows:

He invited the Duke of Northumberland and the Earl of Derby to contribute to such expeditions and share the produce. At the same time, through his influence with the Admiralty, he obtained the privilege of having all packages addressed to Kew coming by the Royal Mail India steam packet sent freight free. By these means Mr. Purdie was sent to New Grenada, and Burke and Geyer to California and Oregon, with the most satisfactory results to all parties; and by similar arrangements with the Treasury, Foreign, Indian, and Colonial Offices there were subsequently sent Oldham and Wilfred to Japan, Formosa, and Corea, Mann to the Cameroons, Gaboon River, and Fernando Po, Baikie and Barter to the Niger, Kirk to the Zambesi with Livingstone, Meller to East Africa and Madagascar, myself to the Himalaya, Bourgeau to Canada, Lyall to British Columbia, Edmonstone, followed by Seeman, to Western and Arctic America in H.M.S. *Herald*, and the latter to Fiji Islands with Col. Smythe's mission, Macgillivray to Torres Straits in H.M.S. *Rattlesnake*, Milne to the Pacific in H.M.S. *Herald*, Spruce to Ecuador for Cinchona seeds, and Hewett Watson to the Azores. The practice was definitely abandoned when the great nurserymen took it up, and liberally shared their proceeds with Kew in exchange for its Director's services in indicating countries worth exploring, giving the collectors letters of recommendation to his correspondents abroad, naming and publishing their novelties and rarities, etc.

Living plants in Wardian cases (small portable greenhouses) and dried specimens for the herbarium poured into Kew from all around the world. Such plants as breadfruit, yams, rice, coffee, tea, sugar, cocoa, pepper, nutmeg, allspice, cloves, ginger, cotton, teak, and mahogany were raised and improved at Kew and sent to appropriate spots within the empire.[30]

Much of Kew's work in economic botany was achieved because of close co-operation with a growing network of colonial gardens that included

Calcutta (1787) with several branches: Peradeniya (1821), on Ceylon; Pampelmousse (founded by the French in 1735, but taken over by Britain in 1810) on Mauritius; Singapore (1859); Cape Town (1848); Sydney (1816); and St. Vincent (1764), Jamaica (1774), and Trinidad (1819), in the West Indies. Sir William was called upon by the Colonial Office and the India Office virtually to appoint the directors of these gardens and of smaller botanical stations. For some time, he had been employing as skilled gardeners at Kew young men who had had four years of experience in other gardens and would stay for about two years with him. They attended lectures on botany and had access to library materials. They would later work in colonial or foreign botanical gardens or plantations, as managers of public parks or private gardens in Britain, or in some horticulturally related trade. This system grew so that, in 1908, there were some seven hundred of these alumni organized into a Kew Guild with its own newsletter; those outside Britain were stationed as follows: Asia, forty-six; Africa, thirty-four; America, sixty; Australasia, eighteen; Europe, sixty-three.[31]

The way in which Kew's network promoted economic botany in the empire is well illustrated in the case of the bark of the cinchona tree, which contained quinine. Malaria had for centuries been a leading killer disease of humankind. That it was spread by mosquitoes was still unrecognized; but since the seventeenth century it had been known to be controllable by the wonder drug cinchona, or Jesuit's bark, obtained from trees growing in the South American Andes. In 1859, the India Office called upon Hooker for help in collecting cinchona seedlings and seeds. Clements Markham, a junior clerk in the office, went to Bolivia and Peru, assisted by a Kew gardener and another Englishman resident in Peru, and Hooker persuaded his botanist friend Richard Spruce, who was in Ecuador, to embark on the search and sent Robert Cross, another Kew gardener, to help him. Despite the opposition of local officials, these expeditions succeeded in obtaining cinchona plants and seeds for Kew, which devoted a forcing-house to the project and then sent seeds and seedlings to every suitable British colony, while also making generous gifts to Portuguese, French, and Mexican gardens. Official plantations were established in the Nilgiri Hills of southern India, Sikkim near Darjeeling, and Ceylon. As Lucile H. Brockway has pointed out, quinine served as an arm of empire, protecting the British army and allowing imperial officials to take their families to their posts with them, especially in India, Ceylon, and Africa.

Kew's great botanical exchange system worked well in dozens of less

spectacular instances. Cork oaks were obtained from Portugal, nurtured
at Kew, and sent to Australia; superior strains of tobacco traveled to Natal;
and Chinese tea went to Assam. A little later, when Joseph Hooker was
director, wild para rubber plants were gathered in Brazil, improved at
Kew, and domesticated in huge plantations in India, Ceylon, and Malaya;
the rise of the motor car made the rubber industry expand enormously. A
third major plant transferred to many areas was sisal hemp. Another
director of Kew, W. T. Thiselton-Dyer, Joseph Hooker's son-in-law, helped
the spread of sisal when the *Kew Bulletin* in 1892 printed full information
on the plant and directions for raising it. While British colonies helped
break the monopoly in sisal production that Mexico had enjoyed, the
German East Africa Company for a time took the lead in developing it.[32]

In 1855, Sir William at last succeeded in having his son Joseph
appointed assistant director at Kew and gradually turned over much of
the administration to him. The change was a good one, all around. Sir
William had been too modest in his personal demands; he was so enthusi-
astic about what he was doing that he scarcely thought he deserved pay
for it, and he still had enough income from his inheritance that he could
contribute books, herbarium specimens, and minor expenditures. He did
not object to doing his heavy correspondence, and he got along without a
personal secretary or clerk. He also enjoyed people and was uncomplain-
ing about the hours he spent showing members of the aristocracy about.
Joseph was a tougher fiber and had learned to resist the bureaucratic
demands of the navy, the Geological Survey, and Indian officialdom. He
took a harder line, for example, with the library and the herbarium and
insisted that the commissioners pay for their maintenance and provide a
curator.[33]

Sir William continued his prolific research and publication. He tried,
both in the magazines he edited and in his articles and books, to delineate
accurately the plants with which he came in contact. Joseph estimated that
his father's writings contained eight thousand plates, eighteen hundred
of them from his own drawings. In 1857, Sir William proposed that Kew
issue a series of twelve colonial floras in English, moderately priced,
convenient in size, and without plates. The Colonial Office agreed to
finance the project in 1863. Dr. August H. R. Grisenbach covered the West
Indies (1865); George Bentham, Hong Kong (1861) and Australia, seven
volumes (1863–1878); and Joseph Hooker, New Zealand, two volumes
(1864–1867), British India, seven volumes (1875–1897), and Ceylon, five
volumes (1864–1900), of which Dr. Henry Trimen had done three volumes
before his death. Sir William continued his research on ferns, completing
ten volumes and nearly an eleventh.[34]

Sir William Hooker died peacefully on August 12, 1865, in his eighty-first year and still hard at work. He had taken Queen Emma of the Sandwich Islands (Hawaii) and her retinue around his beloved gardens less than a week before, and he was reading proofs for his book on ferns four days before the end. These actions symbolized his twofold aim in creating Kew as a pleasure spot for visitors from all over the world and as a scientific center for national and international botany.

And never have a father and son worked more closely together or appreciated each other more. As Joseph Hooker wrote Charles Darwin:

> My father has been my companion as well as parent for 25 years, our intimacy has never been broken; our aims have been one as much as those of father and son ever could by possibility be . . . . he was one of the most truly liberal and modest men I ever knew; he had not an atom of self in him, always thought nothing of himself, and never took any self-seeking steps to raise himself in the estimation of the Government or of scientific men.[35]

## IV

When Joseph Hooker succeeded his father as director of Kew in 1865, he at once began to make garden improvements. They included the Hawthorne Avenue, the Cedar Vista connecting the Sion and Pagoda vistas, the Holly Walk, Chestnut Avenue, a new Pinetum, and a Rock Garden contributed by George Curling Joad in 1881. The Herbarium and Library received a new wing, and Hooker persuaded his friend T. J. P. Jodrell to build and equip the Jodrell Laboratory (1876) for microscopic studies and research on plant physiology, palaeobotany, anatomy, and cytology. Miss Marianne North, an accomplished plant artist, presented 848 of her paintings to Kew and built a gallery for their display (1882).

Joseph carried on a heavy correspondence with botanists and botanical gardens around the world and issued numerous important publications. In 1881, he began supervision of the *Index Kewensis*, an invaluable list of all known plant names, with their authors, places, and dates of publication. Hooker continued his plant explorations with a two-month trip to Palestine and Syria in 1860 while still assistant director, six weeks in Russia (1869), two months to Morocco and the Atlas Mountains (1871), and three months in the United States (1877), chiefly from Colorado to California with his friend Asa Gray, professor of natural history at Harvard.[36]

Sir William Hooker had been a descriptive botanist, a taxonomist or systematist intent upon recognizing, delineating, describing, and classifying plants from around the globe. As did most of the scientists of his day, he treated the species as fixed and immutable. Joseph also appreci-

ated the values of descriptive botany and once remarked sadly to a young botanist: "You young men do not know your plants." He was an excellent taxonomist, but he went further than that. He sought to understand the origin of the species and was a close friend of Darwin, who told him in confidence of his theory of evolution about fifteen years before its publication. Joseph Hooker enforced and broadened the concept from his own work on geographical distribution in the botanical field. He became one of Darwin's strongest defenders in the controversies that followed. In 1887, when Hooker was awarded the Copley Medal of the Royal Society, he joked that since both his grandfather (Dawson Turner) and his father were distinguished botanists, he received the medal "by a process of Evolution" and was "the puppet of Natural Selection," though by no means "the Survivor of the fittest!"[37]

The dramatic highlight of Joseph Hooker's administration at Kew took place between 1870 and 1872, when Acton Smee Ayrton, Hooker's superior as First Commissioner of Works in Prime Minister William Gladstone's government, in the name of economy attacked the scientific functions of the establishment. Ayrton thought "the maintenance of a huge park, which despite the protests of scientists, seemed chiefly recreational, made a mockery of the Government policy of retrenchment," though as a matter of fact Kew spent only £12,000 or 1 percent of Ayrton's departmental appropriation of £1,200,000. But the commissioner was a rough-speaking and antiaristocratic radical who went over Hooker's head to his staff and interfered in many petty, even underhanded ways, apparently hoping to make Hooker resign.

Hooker was thoroughly aroused, not only by Ayrton's personal attacks, but by his threats to reduce Kew to the status of a mere public park or pleasure ground. When appeals to Gladstone secured no action, Hooker enlisted his fellow botanists and friends in government in Kew's defense. Eleven leading scientists, headed by Sir Charles Lyell, Darwin, and the presidents of the Linnean Society, Royal Institution, Colleges of Physicians and Surgeons, and Geographical Society signed a strong memorandum, with documentation showing Ayrton's overbearing behavior; they pointed out the great value of Kew and of Joseph Hooker to English science and to the government. This memorandum was leaked to the newspapers, which ridiculed Ayrton and supported Hooker.

Both the House of Commons and the House of Lords heard debates on the quarrel, and Ayrton laid before the Commons a report on Kew by Professor Richard Owen, head of the Natural History Departments of the British Museum, which he had not let Hooker see. Owen was a bitter enemy of Hooker and Darwin in the controversy over evolution, and his

report was not only unfair, but especially hateful to Hooker, because it attacked his father's administration of Kew. It made fun of the herbarium as an expensive device for "attaching barbarous binomials to dried foreign weeds." The rough and ready Ayrton showed himself a formidable deba- ter before the Commons. Though no vote was taken, Hooker was asked to withdraw his statement against Ayrton or resign. He did neither.

Gladstone finally transferred to Ayrton to the post of Judge Advocate General, and the government he led soon fell to that of Disraeli. Ayrton failed twice to be re-elected to Parliament, while Joseph Hooker was chosen president of the prestigious Royal Society and made Knight of the Star of India in 1877. Though the confrontation between science and government had not been definitely decided, Kew had had enough friends to repel the attack on its administration. And when Joseph Hooker retired in 1885, his son-in-law William Turner Thistelton-Dyer, who had been his assistant director for ten years, succeeded him.[38]

Thistelton-Dyer continued as director through 1905, thus giving the Hooker family and their connections a total of sixty-five years of service. He continued improving the gardens, adding to the scientific work of the Jodrell Laboratory, and vigorously pushing economic botany, especially for the West Indies and Africa. Joseph Chamberlain, England's well-known colonial secretary, declared in 1898 that "several of our more important Colonies . . . owe whatever prosperity they possess to the knowledge and experience of, and the assistance given by, the authorities at Kew Gardens." Since that day, Kew has become an ever more important scientific center, and recently its research has dealt with such matters as threatened plants of the world; improvement of cocoa by exchanging plants among South America, Africa, and the Far East; conducting a tree-root survey in England; intensive study of ferns; dealing with plants of antiquity, such as papyrus; and sending out expeditions, for example, to the rain forests of South America. In fact, Kew is a great storage depot for the world's flora, a center for taxonomic, anatomical, cytological, bio-chemical, and ecological research. Kew also has an outlying property leased from the National Trust: Wakehurst Gardens (1965), in Sussex, five hundred acres with rolling terrain and ideal growing conditions.[39]

Great gardens with plants imported from foreign parts have been known for centuries, their origins lost in myth and legend. The king of Thebes and Thutmose II in Egypt at the temple gardens of Karnak (both about 1500 B.C.), Aristotle in Athens and the Mouseion at Alexandria (both fourth century B.C.) raised exotic plants, many valued for their medicinal uses. The early medieval monasteries cultivated herbs and simples, and the Conquistadores encountered impressive gardens in Mexico and Peru,

for the Aztecs and the Incas understood much about medical botany. In sixteenth-century Europe, however, true botanical gardens with many species of plants arranged according to some system began to appear. Though usually attached to the medical schools of universities, these gardens were often open to the general public. The leading early university gardens were at Padua, Pisa, Florence, Leiden, Zurich, Bologna, Leipzig, Montpellier, Paris, and Heidelberg. In London, the Holburn Physic Garden (1575) had no university connection, nor did the Chelsea Physic Garden (1673) formed by the Society of Apothecaries.

The Jardin des Plantes (1635) in Paris had medicinal plants and soon welcomed the public and took an interest in plant classification. It became closely associated with the Muséum National d'Histoire Naturelle (1783), which had twelve professorships in the sciences, including chairs of natural history and of gardening. A series of renowned botanists served the Jardin, but they took little interest in ornamental horticulture or economic botany. Uppsala, St. Petersburg, and Berlin also had important botanical gardens by the beginning of the nineteenth century.[40]

Kew's influence was important in the establishment of new botanical gardens throughout the world, though its closest ties were with those of the British Empire. Its publications circulated everywhere, and botanists called on Kew for counsel and assistance. The leading botanical gardens of the United States, for example, profited from Kew's guidance. Henry Shaw, the wealthy English-born merchant who founded the Missouri Botanical Garden in 1859 in St. Louis, asked Joseph Hooker to recommend someone to advise him, and Hooker told him that George Engelmann, a German-born physician living in St. Louis, was a skilled botanist. Engelmann, Professor Asa Gray of Harvard, and Hooker co-operated in seeing that "the Mississippian Kew" paid the proper attention to research, and Shaw purchased the important herbarium of German botanist John Jacob Bernhardi, with its 57,000 species. During his trip to the United States in 1877, Hooker stayed with Shaw at the latter's Tower Grove mansion. Charles Sprague Sargent, the learned and spirited director of Harvard's Arnold Arboretum (1872) just outside Boston, corresponded and exchanged visits with both Joseph Hooker and Thistelton-Dyer. In 1887, Sargent found the arboretum at Kew much improved, but thought it could not compare with that of the Arnold Arboretum. Sargent's famed collector Ernest Henry ("Chinese") Wilson had been trained as a Kew gardener. The other research-centered American institution, the New York Botanical Garden (1891), was founded too late for much contact with Joseph Hooker.[41]

Kew succeeded in outdistancing its rivals largely because Sir William Hooker transformed it into a botanical garden that combined horticultural beauty, rich research resources, and economic values. He managed to unite many elements of the then powerful British Empire in its support. His courtly treatment of visitors pleased royal family, aristocracy, and common folk on holiday. His scholarship obtained exotic plants and attracted professional botanists, to whom he also offered opportunities for publication in the magazines he edited and the books he promoted. His encouragement of economic botany built a network of colonial botanical gardens operated by his appointees, usually Kew-trained, and exchanging with Kew commercially promising plants. And Kew and its satellites were supported by central government agencies, colonial officials, industrialists and businessmen, the press, and the general public. Sir William also left his son Joseph, carefully trained from childhood in natural history and garden administration; and Joseph's son-in-law Thistelton-Dyer, another well-educated professional botanist, carried on the great tradition.

Thus did Sir William Hooker fulfill the early dream of his friend and mentor, Sir Joseph Banks. He established a model botanical garden and built a sound foundation for his successors, so that, today, a recent examiner may conclude: "After two centuries, during which Kew has acquired millions of plants, it is the largest, most deeply respected, and most influential institution of its kind anywhere."[42]

## NOTES

1. William Jackson Hooker, *Journal of a Tour in Iceland in the Summer of 1809.* esp. 1: 352–369; 2: 3–102; Hector Charles Cameron, *Sir Joseph Banks, K.B., P.R.S.*, pp. 220–229; Mea Allan, *The Hookers of Kew, 1785–1911*, pp. 44–65; Joseph Dalton Hooker, *A Sketch of the Life and Labours of Sir William Jackson Hooker*, pp. xiv–xviii.

2. Sir Joseph Banks to William Hooker, October 1, 1809, June 15, 1818; William Hooker to Banks, June 20, July 27, 1810, in Warren G. Dawson, editor, *The Banks Letters*, pp. 421–422; Leonard Huxley, *Life and Letters of Sir Joseph Dalton Hooker*, 346–348, 483–486.

3. Huxley, *Letters of Sir Joseph Hooker*, 1: 8–9; Allan, *Hookers of Kew*, pp. 18–20, 25–28.

4. Allan, *Hookers of Kew*, pp. 18, 20–21, 30–35.

5. Allan, *Hookers of Kew*, pp. 35–37, 58–60.

6. Banks to William Hooker, June 19, 1813, in Edward Smith, *The Life of Joseph Banks*, pp. 296–297; Huxley, *Letters of Sir Joseph Hooker*, 2: 379–382; Allan, *Hookers of Kew*, pp. 64–65; Cameron, *Sir Joseph Banks*, p. 87.

7. Allan, *Hookers of Kew*, pp. 57–60, 72.

8. Huxley, *Letters of Sir Joseph Hooker,* 1: 15–17; Allan, *Hookers of Kew,* pp. 69–70, genealogical chart in rear.

9. Huxley, *Letters of Sir Joseph Hooker,* 1: 10–11, Allan, *Hookers of Kew,* pp. 73–76; James Coutts, *A History of the University of Glasgow, from Its Foundation in 1451 to 1909,* pp. 531–533.

10. F. O. Bower, "Sir William Hooker, 1785–1865," in *Makers of British Botany,* edited by Francis Wall Oliver, pp. 130–131; J. D. Hooker, *William Jackson Hooker,* pp. xxviii–xxx; Huxley, *Letters of Sir Joseph Hooker,* 1: 11–13; Allan, *Hookers of Kew,* pp. 17, 80–81.

11. Bower, "William Hooker," p. 132; Huxley, *Letters of Sir Joseph Hooker,* 1: 13–15; Allan, *Hookers of Kew,* pp. 79–81; Joseph Reynolds Green, *A History of Botany in the United Kingdom from the Earliest Times to the End of the 19th Century,* p. 391.

12. Bower, "William Hooker," pp. 129–130; Green, *Botany in the United Kingdom,* pp. 283, 391, 429–430; Allan, *Hookers of Kew,* pp. 78–83; Christopher Sherry, *The Glasgow Botanic Gardens: Its Conservatories, Greenhouses, Etc.* (Glasgow: D. Bryce and Son, 1901), pp. 5–10.

13. J. D. Hooker, *William Jackson Hooker,* pp. xli–xliii; Bower, "William Hooker," pp. 141–150; Allan, *Hookers of Kew,* pp. 86, 97; Green, *Botany in the United Kingdom,* p. 391; William Bartram Turrill, *Joseph Dalton Hooker,* pp. 3–4.

14. Allan, *Hookers of Kew,* pp. 82, 87, 90–91, 95, 155–156; David Murray, *Glasgow and Helensburgh,* pp. 10–11, 22.

15. Allan, *Hookers of Kew,* pp. 81–82, 86, 88–89, 92, 94–95.

16. Coutts, *University of Glasgow,* pp. 419, 531–533, 551–553; Allan, *Hookers of Kew,* pp. 102–103, 111; Bower, "William Hooker," pp. 130–133; Green, *Botany in the United Kingdom,* p. 393.

17. William Jackson Bean, *The Royal Botanic Gardens of Kew,* p. 4–17, 80–85; William Bertram Turrill, *The Royal Botanic Gardens: Kew, Past and Present,* pp. 17–21, 111–113; Allan, *Hookers of Kew,* p. 96.

18. Bean, *Gardens of Kew,* pp. 18–28; Turrill, *Kew, Past and Present,* pp. 21–24.

19. Bean, *Gardens of Kew,* pp. 28–31; Allan, *Hookers of Kew,* pp. 95–96, 105–106; Turrill, *Kew, Past and Present,* p. 25; Green, *Botany in the United Kingdom,* pp. 354–355; Lucile H. Brockway, *Science and Colonial Expansion,* p. 60.

20. Sir William Jackson Hooker, *Kew Gardens,* p. 11; Bean, *Gardens of Kew,* pp. 28–29; Brockway, *Science and Colonial Expansion,* p. 80.

21. Bean, *Gardens of Kew,* pp. 30–32; Allan, *Hookers of Kew,* pp. 107, 109–111; Green, *Botany in the United Kingdom,* p. 357; Huxley, *Letters of Sir Joseph Hooker,* 1: 158.

22. Green, *Botany in the United Kingdom,* p. 401; J. D. Hooker, *William Jackson Hooker,* pp. lxiii–lxiv; W. J. Hooker, *Kew Gardens,* pp. 11–12; Bean, *Gardens of Kew,* p. 35; Turrill, *Kew, Past and Present,* pp. 26–29; Allan, *Hookers of Kew,* p. 141.

23. Bean, *Gardens of Kew,* pp. 34, 39; Allan, *Hookers of Kew,* pp. 145, 147, 157–158, 178.

24. Bean, *Gardens of Kew,* pp. 36–41, 87–88; Turrill, *Kew, Past and Present,* pp. 26–27.

25. Bean, *Gardens of Kew,* pp. 38–39, 77–78, 130–135; Turrill, *Kew, Past and Present,* pp. 154–157; Allan, *Hookers of Kew,* pp. 148–149; Henry-Russell Hitchcock, *Early Victorian Architecture in Britain,* 2 vols. (New Haven: Yale University Press, 1954), 1: 513–515; 2: xv, 29–33.

26. J. D. Hooker, *William Jackson Hooker,* pp. lxxvi–lxxx; Bean, *Gardens of Kew,* pp. 41, 45, 82, 125–129; Turrill, *Kew, Past and Present,* pp. 62–86; Allan, *Hookers of Kew,* pp. 156, 176, 185.

27. Bean, *Gardens of Kew,* pp. 35–36, 42, 44–47, 95, 144, 150–151, 158, 164–166; Turrill, *Kew, Past and Present,* pp. 28, 30, 98–99, 106, 136, 157; Allan, *Hookers of Kew,* pp. 178, 184, 202–203.

28. Huxley, *Letters of Sir Joseph Hooker,* 1: 377; Bean, *Gardens of Kew,* pp. 43–45.

29. Huxley, *Letters of Sir Joseph Hooker*, 1: 192, 210, 215, 346–347, 377–378; 2: 47–49; Bean, *Gardens of Kew*, pp. 44, 55, 108–114; Turrill, *Kew, Past and Present*, pp. 27, 47–55; Allan, *Hookers of Kew*, pp. 187–189; Green, *Botany in the United Kingdom*, p. 406; Brockway, *Science and Colonial Expansion*, pp. 81–83.

30. J. D. Hooker, *William Jackson Hooker*, p. lxiii; Brockway, *Science and Colonial Expansion*, pp. 83–84; Bean, *Gardens of Kew*, pp. 35–36, 47–48; Green, *Botany in the United Kingdom*, pp. 407–408.

31. Edward S. Hyams and William MacQuitty, *Great Botanical Gardens of the World* pp. 200–227, 250–265; Brockway, *Science and Colonial Expansion*, pp. 75–76; Bean, *Gardens of Kew*, pp. 66–68; Allan, *Hookers of Kew*, p. 179; Green, *Botany in the United Kingdom*, p. 410.

32. Brockway, *Science and Colonial Expansion*, pp. 103–183; Bean, *Gardens of Kew*, pp. 169–172; Turrill, *Kew, Past and Present*, pp. 65–66, 86–89; Huxley, *Letters of Sir Joseph Hooker*, 2: 1–7, 326, 402–410.

33. Huxley, *Letters of Sir Joseph Hooker*, 1: 14–15, 346–347.

34. Huxley, *Letters of Sir Joseph Hooker*, 1: 15; 2: 41–48; Turrill, *Joseph Dalton Hooker*, pp. 120–121, 142–143, 162, 177–179, 219; Allan, *Hookers of Kew*, pp. 200–201, 243–244; Bean, *Gardens of Kew*, pp. 115–116; Turrill, *Kew, Past and Present*, pp. 34, 56–57; Green, *Botany in the United Kingdom*, pp. 410–411.

35. Huxley, *Letters of Sir Joseph Hooker*, 2: 64, 68; Allan, *Hookers of Kew*, pp. 209–210; Green, *Botany in the United Kingdom*, pp. 410–411.

36. Turrill, *Joseph Dalton Hooker*, pp. 110–113, 122–123, 125–140, 150–162, 165–174; Huxley, *Letters of Sir Joseph Hooker*, 2: 86–88, 90–97, 205–218; Bean, *Gardens of Kew*, pp. 50–56; Turrill, *Kew, Past and Present*, pp. 30–35, 55–61; Allan, *Hookers of Kew*, pp. 211–215, 217–220, 231–233.

37. Huxley, *Letters of Sir Joseph Hooker*, 1: 12, 486–503; 2: 307–308, 421–422; F. O. Bower, "Sir Joseph Dalton Hooker, 1817–1911," pp. 315–323.

38. Huxley, *Letters of Sir Joseph Hooker*, 2: 159–177; Turrill, *Joseph Dalton Hooker*, pp. 123–125, 163–165; Brockway, *Science and Colonial Expansion*, pp. 96–99; Roy MacLeod, "The Ayrton Incident," pp. 43–78; Allan, *Hookers of Kew*, pp. 220–223.

39. Bean, *Gardens of Kew*, pp. 57–62; Turrill, *Kew, Past and Present*, pp. 35–36, 51–61, 86–96, 113–114; Brockway, *Science and Colonial Expansion*, pp. 81–86; Eugene Kinkead, "Our Far-Flung Correspondents: New and Old at Kew," pp. 73–81.

40. Hyams and MacQuitty, *Great Botanical Gardens*, pp. 18–23, 34–43, 76–85, 87, 104–125, 174–177; Howard S. Irwin, "Botanical Gardens in the Decades Ahead," pp. 45–55.

41. Hyams and MacQuitty, *Great Botanical Gardens*, pp. 132–135, 148–152; Joseph Andorfer Ewan, editor, *A Short History of Botany in the United States*, pp. 9, 43–44, 143; Stephane Barry Sutton, *Charles Sprague Sargent and the Arnold Arboretum* (Cambridge, Mass.: Harvard University Press, 1970), pp. 43, 47, 68–69, 128–130, 149–150, 188, 209, 226, 335–336.

42. Kinkead, "New and Old at Kew," p. 73.

## SELECT BIBLIOGRAPHY

Allan, Mea. *The Hookers of Kew, 1785–1911*. London; Michael Joseph, 1967. 273 pp.

Bean, William Jackson, *The Royal Botanic Gardens of Kew: Historical and Descriptive*. London, New York: Cassell, 1908. 222 pp.

Bower, F. O. "Sir William Hooker, 1785–1865." In *Makers of British Botany: A Collection of Biographies of Living Botanists,* edited by Francis Wall Oliver, 126–150. Cambridge: University Press, 1913.

————. "Sir Joseph Dalton Hooker, 1817–1911." In *Makers of British Botany: A Collection of Biographies of Living Botanists,* edited by Francis Wall Oliver, 302–323. Cambridge: University Press, 1913.

Brockway, Lucile H. *Science and Colonial Expansion: The Role of the British Royal Botanic Gardens.* New York: Academic Press, 1979. 240 pp.

Cameron, Hector Charles. *Sir Joseph Banks, K.B., P.R.S.: The Autocrat of the Philosophers.* London: Batchworth Press, 1952. 341 pp.

Coutts, James. *A History of the University of Glasgow from Its Foundation in 1451 to 1909.* Glasgow: James Maclehose and Sons, 1909. 615 pp.

Dawson, Warren G., ed. *The Banks Letters: A Calendar of the Manuscript Correspondence of Sir Joseph Banks Preserved in the British Museum, the British Museum (Natural History) and Other Collections in Great Britain.* London: British Museum (Natural History), 1958. 965 pp.

Ewan, Joseph Anderfer, ed. *A Short History of Botany in the United States.* New York: Hafner Publishing Company, 1969. 174 pp.

Green, Joseph Reynolds. *A History of Botany in the United Kingdom from the Earliest Times to the End of the 19th Century.* London and Toronto: J. M. Dent and Sons, 1914. 648 pp.

Hooker, Joseph Dalton, *A Sketch of the Life and Labours of Sir William Jackson Hooker, K.H., D.C.L. Oxon, F.R.S., F.L.S., etc., Late Director of the Royal Gardens of Kew.* Oxford: Clarendon Press, 1903. 90 pp.

Hooker, William Jackson. *Journal of a Tour in Iceland, in the Summer of 1809.* 2nd edition, 2 vols. London: Longmans, Hurst, Rees, Orme, and Brown; John Murray, 1813.

————. *Kew Gardens; or, A Popular Guide to the Royal Botanic Gardens of Kew.* 9th edition. London: Longman, Brown, Green, and Longmans, 1851. 60 pp.

Huxley, Leonard. *Life and Letters of Sir Joseph Dalton Hooker . . . Based on Materials Collected and Arranged by Lady Hooker.* 2 vols. London: John Murray, 1918.

Hyams, Edward S., and William MacQuitty. *Great Botanical Gardens of the World.* New York: Macmillan, 1969. 288 pp.

Irwin, Howard S. "Botanical Gardens in the Decades Ahead," *Curator* 16 (1973): 45–55.

Kinkead, Eugene, "Our Far-Flung Correspondents: New and Old at Kew." *New Yorker* 55, September 3, 1979: 73–81.

MacLeod, Roy. "The Ayrton Incident: A Commentary on the Relations of Science and Government in England, 1870–73." In *Science and Values,* edited by Arnold Thackray and Everett Mendelsohn, 43–78. New York: Humanities Press, 1974.

Murray, David. *Glasgow and Helensburgh: As Recalled by Sir Joseph D. Hooker.* Hellensburgh: MacNear and Bryden, 1918. 23 pp.

Saunders, Herbert Washington. *A History of the Norwich Grammar School.* Norwich: Jarrold and Sons, 1932. 400 pp.

Smith, Edward. *The Life of Joseph Banks.* London: John Lane, 1911. Reprint. New York: Arno Press, 1975. 348 pp.

Turrill, William Bertram. *Joseph Dalton Hooker: Botanist, Explorer, and Administrator.* London: Thomas Nelson and Sons, 1963. 228 pp.

————. *The Royal Botanic Gardens: Kew, Past and Present.* London: H. Jenkins, 1959. 256 pp.

# 6

# Henry Cole
# and the South Kensington
# (Victoria and Albert) Museum:
# The Museum
# of Decorative Art

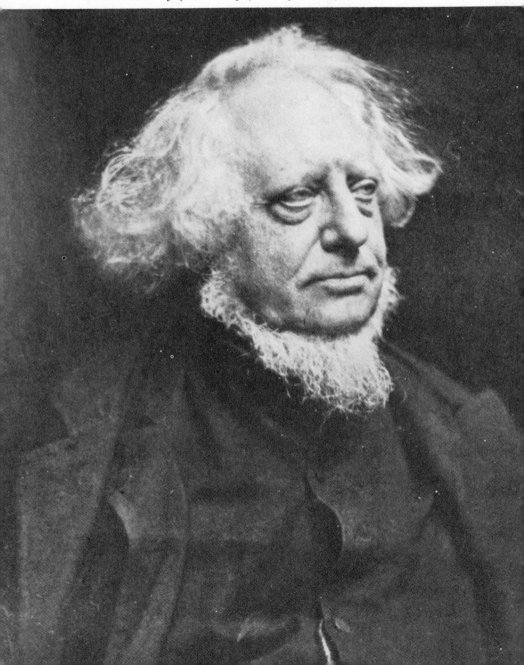

Fig. 12. Sir Henry Cole (1808–1882), about 1872. *(Photograph by Mrs. Julia Margaret Cameron. Courtesy of the Library of the Royal Society of Arts, London.)*

*T*HE SOCIETY of Arts in London had had an honorable history since its founding in 1754 and for long had cherished the hope of improving British manufactures through the application of the fine arts and science. By 1843, however, the society had become lethargic and almost moribund. In that year, Prince Albert, Queen Victoria's consort, accepted the presidency of the society. He was a sensitive young man, hurt by English resentment of his German background and determined conscientiously to further the arts and science and use them to improve English manufacturing, especially in the field of the applied or decorative arts. In 1846, John Scott Russell, secretary of the society, persuaded his friend Henry Cole to become a member and soon saw to it that Cole was placed on its governing council. Cole was an activist of almost incredible energy, a civil servant in the Public Record Office, an advocate of numerous reforms for the benefit of the masses—*and* a skilled administrator, accomplished bureaucratic in-fighter, and far-seeing, clever publicist.

Prince Albert and Cole hit it off immediately. The prince had found an ingenious, able lieutenant to carry out the slogging, detailed minutiae of his well-intentioned projects; he liked to make puns and sometimes remarked, "When we want steam, we must get Cole."[1] The civil servant, on his part, had acquired a patron whose influence would help him penetrate the maze of parliamentary government and rise up the social ladder controlled by the English aristocracy. The two men stimulated each other's ready imaginations and enthusiasms, and they shared also a strong, almost reverent sense of social morality.[2]

Henry Cole was born at Bath on July 15, 1808, the son of Captain Henry Robert Cole of the First Dragoon Guards and Laetitia (Downer) Cole. At nine, he went to Christ's Hospital School, where he continued until 1823, when he left to become a clerk to Francis Palgrave, barrister at law at the Inner Temple and subcommissioner of the Record Commission. Cole stayed with Palgrave for nine years and then gave full time to the records as a subcommissioner. During much of that period, he lived with his father in a house belonging to Thomas Love Peacock, poet and novelist, who kept two rooms there. Peacock became a close friend of young Cole, who sketched for him and helped him write musical criticism.[3]

143

Peacock introduced Cole to John Stuart Mill, Charles Buller, and George Grote, known as Philosophical Radicals because of their advocacy of reform and a more democratic Britain. The whole group was lively and witty, though doing good was the main purpose of their lives. John Mill and Henry Cole were especially close; they dropped into each other's offices (Mill was a clerk with the East India Company), drank tea, often walked home together. They collected plants and geological specimens, played the piano, attended concerts and the opera, and went to exhibitions at the Royal Academy and the New Water Colour Society Collection. They belonged to the London Debating Society, which Mill had founded, and joined a smaller group twice a week at Grote's house on Threadneedle Street to discuss political economy and logic. On Sundays, some of the friends would walk into the countryside for ten or twelve miles before enjoying a hearty breakfast and doing another fourteen or fifteen miles to return home; Cole once wrote that "the whole day was passed in a virtuous state of disputation & pleasantry" and again described these excursions as "walking, talking and glee." The pattern changed when Cole was married to Marian Fairman Bond on December 28, 1833. The couple had three sons and five daughters, and Cole was an unusually affectionate and jolly father who delighted in family-centered evenings of amateur dramatics and music.[4]

At the Record Commission, Secretary Charles Purton Cooper proved both autocratic and inefficient. He quarrelled with the commissioners and with Cole, who actively opposed him; Cole got his friend Buller, then in the House of Commons, to secure an investigating committee. It reported, in 1836, against Cooper and the existing record system. Cole, Buller, and Sir William Molesworth established a monthly journal, the *Guide*, that appeared in 1837 and 1838, to enlist support for their side of the dispute and to promote other Radical reforms. Cole played a somewhat spectacular role in 1834, when he saved the records in the Augmentation Office as the Houses of Parliament burned. When a new Public Record Office was constituted, four years later, Cole was made one of four assistant keepers. In 1841, he took charge of arranging a huge mass of records in the Carlton House Riding School, and Prince Albert visited the school, met Cole, and praised his arrangement of the records.[5]

Public records did not take all of Cole's time, and in 1838 he became secretary of a committee to promote the introduction of Rowland Hill's penny postage. He again edited a journal, the *Post Circular*, to propagandize the cause, got up petitions, and arranged meetings. Parliament voted for the new postal scheme. These successes brought Cole considerable

notice. Richard Cobden asked him to become secretary of the Anti-Corn Law League, but he decided not to do so. In 1838, Charles Buller, who was leaving London as principal secretary to Lord Durham, the new governor general of Canada, invited Cole to go with them. Cole recalled later that "the temptations to do so were great, but the tears of my dearest and best adviser, and my recent return to public service with the Records, prevented my acceptance."[6]

Cole was an extremely versatile personality. He studied watercolor painting, medieval art, and wood engraving, and he learned to etch; he showed his watercolors and etchings in exhibitions at the Royal Academy. He was an enthusiastic musician, playing the flute, bassoon, and piano, and singing in choirs. While working for postal reform, he made sketches for adhesive stamps, which he originated, and his sketches won a premium. When the Society of Arts offered a prize for an earthenware tea set suitable for everyday use, Cole designed one and persuaded a friend, pottery manufacturer Herbert Minton, to produce it. Queen Victoria used a set, and Prince Albert admired especially its cream jug. The society awarded the set a silver medal and ten guineas. Cole employed a pseudonym, Felix Summerly, for his entry. He had adopted that alias for his series of guidebooks on public buildings and churches, such as Hampton Court and Westminster Abbey, and for two series of children's books (*Summerly's Home Treasury*), one illustrated by leading British artists of the day. Cole also commissioned J. C. Horseley, R.A., in 1845, to design the first successful Christmas card. In 1847, Cole formed Felix Summerly's Art Manufactures and brought artists and manufacturers together to produce ceramic, glass, metal, and other art objects. Cole received a royalty for his skillful public relations and promotional services; in commenting on the second annual exhibition of the Royal Society of Arts in 1848, *Art Union* magazine said that it looked "strangely like a display of Felix Summerly's series of Art Manufactures—accompanied by some others." Cole withdrew from the project when his work promoting the Great Exhibtion of 1851 began to become heavy.[7]

Cole realized that the Society of Arts that he had joined could become a potent instrument in accomplishing the numerous reforms he had in mind. He established the society's weekly *Journal* to help further his many improvement schemes that included art, science, and musical education, postal and patent reforms, railway standard gauge, better London cabs, military drills for boys in the schools, and aids to better health, such as efficient public water closets. His most immediate interest was in exhibitions of the application of art to manufacturing, especially machine-

produced decorative art that he called "art manufactures." In 1847, he staged an Exhibition of British Manufactures in the society's Great Hall; Scott Russell and he had to call on manufacturers personally and persuade them to participate. The exhibit of about two hundred items of furniture and furnishings attracted an attendance of twenty thousand during the month it was open. In 1848, businessmen were eager to cooperate and sent some seven hundred exhibits, while attendance reached thirty-two thousand; the next year, a plethora of entries made their limitation necessary, and a hundred thousand visitors taxed the facilities of the society's building. In 1850, another special exhibition dealt with Ancient and Medieval Decorative Art. Cole arranged to circulate materials from these shows among the twenty schools of design that had been set up in Britain since the 1830s. He defeated a conservative movement in the society's council to do away with exhibitions of art manufactures and of paintings and for a time served as chairman of the council. He also proposed a National Exhibition of British Manufactures and Decorative Arts for 1851. Digby Wyatt, Francis Fuller, and he went to Paris in 1849 to attend the French national trade exposition and discuss its organization with the officials in charge.[8]

Upon the return of the society emissaries from France, Prince Albert—in a series of conferences at Buckingham Palace, Balmoral, or Osborne, his new mansion on the Isle of Wight—assumed the leadership of the movement that was to result in the Great Exhibition of the Industry of All Nations of 1851, the first true world's fair. On June 30, 1849, Prince Albert, Scott Russell, Cole, Fuller, and Thomas Cubitt, the architect of Osborne, met at Buckingham Palace and made the first crucial decisions about the exhibition. It would include raw materials, machinery, manufactured products, and sculpture; it would take place in Hyde Park, between Kensington Road and Rotten Row; it would have international scope—that is, be open to entries from all nations; it would confer substantial monetary prizes upon the best exhibits. A Royal Commission headed by Prince Albert would govern the fair; and the group would look to private voluntary subscriptions for financial support. After another meeting at Osborne, Cole, Fuller, and Digby Wyatt visited sixty-five industrial centers in England, Scotland, and Ireland, to rouse the enthusiasm of manufacturers. In October, the Lord Mayor of London called a great public meeting at the Mansion House, where Cole explained the plan for the exhibition and announced the support already accorded it by the East India Company and Napoleon III.[9]

While most manufacturers enthusiastically supported the plan for the

Great Exhibition, strong opposition arose, led by an eccentric reactionary Tory member of Parliament from Lincoln—Colonel Charles de Laet Waldo Sibthrop. He maintained that foreigners coming to the exhibition would bring the plague and venereal disease into the area, that England would be flooded by cheap foreign goods, that Hyde Park would become a bivouac of vagabonds, and that foreigners would rent houses nearby for brothels. Attempts might be made to assassinate Queen Victoria, he held, and revolutionary riots similar to those that convulsed the continent in 1848 might threaten indeed to overthrow the British Government and create a Red Republic. Perhaps worst of all, said Sibthrop, many great elms in Hyde Park would need to be cut down to make room for the exhibition building. The *London Times* entered the fray at this point and opposed the exhibition. These criticisms, no matter how ridiculous, disturbed the sensitive Prince Albert, but he remained firm in his planning, though he worried incessantly and suffered from insomnia. On March 21, 1850, the prince made an eloquent speech to a crowded Lord Mayor's banquet at the Mansion House; he not only pointed out the importance of the exhibition to British industry, but stressed its possible beneficial effect on international peace and world civilization. It would, he said, give "a living picture of the point of development at which mankind has arrived, and a new starting point from which all nations will be able to direct their future exertions."[10]

Meanwhile, Cole was working night and day to solve the many practical problems facing the exhibition, scheduled to open on May 1, 1851, only a few months away. He drew the document setting up the Royal Commission for Queen Victoria's appointment; it consisted of twenty-four members headed by Prime Minister Lord John Russell and including former Prime Minister Sir Robert Peel and William Gladstone, soon to be made Chancellor of the Exchequer. Cole himself took a two-year leave from the Record Office and was paid £800 yearly by the commission. Though not a member of that body, he was the mainspring and real brains of the exhibition, serving on its small executive committee. Cole did not have the full confidence of the commission, and when Lyon Playfair was added to the executive group, Cole regarded it as a vote of no confidence and wrote out his resignation. He changed his mind when the conciliatory Playfair convinced him that they could work together and that the exhibition would fail if he left. The contractors, Munday Brothers, agreed in 1849 to finance the exhibition for 5 percent interest on moneys they advanced and a share of the profits, but Cole cannily inserted a clause in the agreement that allowed the society to cancel it by February 1, 1850, if it

secured other financing. When the commission succeeded in raising nearly £80,000 by subscription and more than £350,000 in guarantee funds that enabled it to borrow from the Bank of England, the arrangement with the Mundays was terminated.[11]

The most crucial problem facing the Royal Commission was an exhibition building. A building committee was appointed, which established a competition, with the provision that the committee might adapt entries to its own uses. It received 245 designs and finally extracted from them its own plan—a monstrous brick building, topped by a 200-foot dome, that required nineteen million bricks. Few liked the design, but shortly before notices inviting bids for its construction went out, Joseph Paxton came to see Cole. Paxton had served as gardener and estate manager for the Duke of Devonshire and had built two large greenhouses at Chatsworth. The first conservatory had been admired by Prince Albert during a visit in 1843, and the second used ingenious new iron and glass construction techniques to protect the Victoria Regia water lily. Paxton proposed an exhibition building chiefly of iron and glass, constructed on 24-foot modules with standardized components. Cole was convinced that Paxton's proposal was superior to the committee's plan, and he inserted a clause in the invitations to bid that permitted new proposals. Paxton soon made his famed sketch of the exhibition building—on blotting paper, during a meeting of a board of the Midland Railway—and leaked a finished drawing to the *Illustrated London News*. The drawing was greeted by the public with much acclaim, and the Building Committee reluctantly adopted Paxton's plan on July 15, 1850, with the addition of an arched transept that allowed the inclusion inside the building of two of Colonel Sibthorp's precious elms. Construction—with its new methods and technology and employment of as many as 2,000 men—attracted numerous spectators; the building was substantially complete by January 1, 1851. It was 1,848 feet long (sometimes expressed as 1,851 feet, to coincide with the year of the exhibition), 408 feet wide, more than 100 feet in height, and it enclosed 18 acres. Some critics predicted that heavy storms or snows would ruin the glass roof; and it is true that, like most glass buildings, it leaked, at first, so that Cole demanded "more putty." By good fortune, the building received a glamorous, captivating name when Douglas Jerrold, an editor of *Punch*, called it the "Crystal Palace."[12]

While the building was going up, Cole was beginning to receive 14,000 exhibit entries winnowed by 330 local British committees and by foreign ones and to organize them into exhibits. He alloted 400,000 square feet to British products and about the same area to foreign nations—France, the

German states, Russia, Austria, the United States, and others. The plan for cash prizes of £20,000 was abandoned in favor of medals, but committees of award had to be organized. Some idea of the amount of labor in all these preparations can be sensed in the fact that Cole and his assistants dispatched 161,131 handwritten letters between October 1849 and December 1851 and received 51,913 missives during the same period. On April 30, two companies of Grenadier Guards swept the huge exhibition areas clean of belated exhibits, crates, and litter, and on May 1, 1851, the Great Exhibition opened, on a bright day, in its gleaming, fairyland-like Crystal Palace.[13]

## II

The Great Exhibition was a tremendous success with all classes. Queen Victoria wrote lyrical descriptions of it in her diary, and Prince Albert thought the Crystal Palace "truly a piece of marvellous art." The royal family paid more than fifty visits to the exhibition in the 164 days it was open, and the aged Duke of Wellington attended almost every day, once causing a near riot among those who wished to see the old hero. The railroads brought in people from all over Britain, and many visitors came from France and the continent. The exhibits, to view all of which would have required walking ten or eleven miles, contained more than a hundred thousand objects. A tiny fraction of them included an operating Machinery Court with huge hydraulic press and steam hammer, locomotives, the McCormick reaper from America, naval guns, pleasure carriages, and many other mechanical marvels. The Koh-i-noor diamond or "Mountain of Light" was on display, as were numerous ingenious home furnishings—a papier maché "Daydreamer" easy chair, gutta-percha sideboard, brass four-poster bed in Renaissance style, and alarm bed that waked a sleeper by throwing him out on the floor. There was a Medieval Court arranged by A. W. N. Pugin and even an "Air-exhausted coffin, intended to preserve the dead from putrefaction." Outside the building, near the Knightsbridge Barracks, was a four-family model dwelling house for working classes, commissioned by Prince Albert himself. In the central avenue, beneath the lofty crystal transept with its elm trees, was Follett Osler's crystal fountain—made of four tons of crystal glass—and two rows of statues that included two of Victoria, one on horseback, an Amazon battling a tiger, the whole cast in zinc, and several titillating nudes—under a red velvet canopy, the *Greek Slave* by Hiram Powers, an American sculptor; the *Circassian Slave in the Market at Constantinople,*

*Andromeda Exposed to a Sea Monster,* and the *Veiled Vestal.* The art may have been overblown and often inappropriate, but never had the common people seen a more glorious show or had more fun. Thackeray well caught their spirit in his good-natured satirical "Mr. Molony's Account of the Crystal Palace," one stanza of which ran:

> Amazed I pass
> From glass to glass.
> Deloighted I survey 'em;
> Fresh wondthers grows
> Before me nose
> In this sublime Musayum![14]

What did the exhibition actually accomplish? From the viewpoint of modern taste, with its emphasis on functionalism, the exhibits were over-ornate and sometimes ludicrous, but the technology of the Machine Court was impressive. Queen Victoria reported that "Many schools have visited the Exhibition, including ours from Windsor Park, each child writing a very nice account of it," and the exhibits, even when poorly arranged and crowded, were a novel educational experience for most visitors. Railway excursions became a popular amusement as a result of the exhibition. Also foreign travel and entertainment were stimulated to some extent; for example, the French invited the commissioners, executive committee, and prominent English officials to Paris for a week-long fete. Cole thought it a promising international development that "for the first time, the men of Arts, Science, and Commerce were permitted by their respective governments to meet together to discuss and promote those objects for which civilized nations exist." He hoped that, from this start, a new system of international political negotiation might develop and that open council might be substituted for secret diplomacy. That attitude was perhaps a faint intimation of the later League of Nations and the United Nations.[15]

When the Great Exhibition closed, on October 11, it was found that the total attendance had been 6,039,195 and that the record for one day was 109,915. After the accounts were all in, there was a profit of some £186,000. Prince Albert already had begun to plan ways to use any surplus to carry out the chief purpose of the exhibition, namely, to "extend the influence of Science and Art upon Productive Industry." On August 10, at Osborne, he wrote out his plan to purchase land in South Kensington, south of the exhibition site, to hold a kind of industrial university with teaching institutions, museums, and a meeting place for learned societies. He

believed in using museum collections for instruction, and in the desirability of keeping colleges, institutes, and museums contiguous. The Commissioners of the Exhibition of 1851 were retained as a permanent governing body to carry out this general plan, and, beginning in 1852, they purchased eighty-seven acres in South Kensington, partly in partnership with the government, which was to maintain its Department of Science and Art there.[16]

Prince Albert and Cole differed on what to do with the Crystal Palace. Cole favored keeping it in Hyde Park as a Winter Garden and Sculpture Gallery, a people's palace, where the public could walk or ride, in any weather, among flowers, fountains, and sculpture. It would also be available for future exhibitions, if that proved desirable. Cole wrote a pamphlet to support these ideas, signing it "Denarius," which caused one learned lord to wonder whether "Denarius" was Latin for "coal." Prince Albert insisted, however, that the commissioners, in order to obtain the Hyde Park site, had agreed to remove the palace when the exhibition ended and that that arrangement must be honored. A private company was formed and, between 1852 and 1854, the Crystal Palace was taken down, piece by piece, and re-erected at Sydenham, across the Thames, in south London. The company offered to make Cole its manager, but he refused. (The Crystal Palace remained at Sydenham until finally destroyed by fire in 1937.)[17]

For Henry Cole, the Great Exhibition was only one phase of the movement to advance the arts and science and use them to improve British industry and international trade. In March 1849, Cole had founded the monthly *Journal of Design and Manufactures,* which he published through February 1852. While this innovative magazine, with its striking engravings, actual swatches of textiles and wallpapers, and other ingenious inserts, served chiefly as a promotion device for the Great Exhibition, it also examined the aesthetic principles behind art manufactures, advocated improvements in copyright and patent laws, and criticized the network of schools of design. That system had been set up in 1837, under the Board of Trade, and consisted of a central school in Somerset House, three branches in London, and eighteen more elsewhere in Britain. They had been poorly administered, with several scandals occurring and many resignations, and Cole determined to become their head. He secured a Select Committee of Parliament in 1849, to inquire into the schools, but the committee rejected Cole's critical report in favor of one by his opponents. In January 1852, however, thanks to Prince Albert's influence, Cole took over the schools as secretary of a Department of Practical Art, under

the Board of Trade. The next year, the new organization became the Department of Science and Art, with Lyon Playfair as joint secretary in charge of science. In 1857, the department was placed under the Education Committee of the Privy Council, with Cole as sole secretary, a position he held until his retirement in 1873.

In general, Cole was opposed to the overornate design of industrial wares or art manufactures. He thought that the machine ought not be used to ornament, emboss, countersink, or raise surfaces in imitation of traditional handicraft practices, but should "produce in each article superior utility" and "select pure forms." The Cole circle included Owen Jones, Richard Redgrave, and—for a time—the German Gottfried Semper, whose "knowledge both of architecture and general decoration" Cole found profound "and his taste excellent." Sigfried Giedion, Nikolaus Pevsner, and Henry-Russell Hitchcock have all praised Cole's efforts to obtain more functional and less fussy industrial design.[18]

Cole furnished the schools of design with the efficient and imaginative administration they needed, but he believed that the only way successfully to apply art to industrial design was not only to teach design but especially to provide art instruction in the elementary schools, so that a large portion of the general public would come to appreciate good design, elevate the general taste, and back supporting programs. By the time of his retirement, Cole could point out proudly that the 20 "limp Schools of Design" of 1852, with fewer than 5,000 students, had grown to 122 flourishing schools of art attended by 22,800 in all parts of the United Kingdom and had inspired similar schools in the colonies and in the United States. In addition, where nothing had existed previously, elementary drawing was taught to 194,500 boys and girls in schools for the poor, 538 night drawing classes served 17,200 artisans, and 36,783 students attended 948 science classes.[19]

The system of art education for children that Cole and his art superintendent, Richard Redgrave, provided remained in force in Britain until the 1930s. It taught by copying geometrical and ornamental patterns (Cole thought it "a disgrace to every one who effects to be well educated if he cannot draw a straight line") instead of sketching the human figure. Order and neatness were the prime requirements; creative imagination and fantasy would not be tolerated. John Ruskin, who believed in limiting art instruction to the talented, derided "the sudden luminous idea that Art might possibly be a lucrative occupation" and thought that Cole "has corrupted the system of art-teaching all over England into a state of abortion and falsehood from which it will take twenty years to recover."[20]

Cole continued to serve as Britain's authority on industrial exhibitions. In 1852, he attended the opening of one in Cork and in the next year advised the planners of New York City's Crystal Palace. In 1855, he headed the British delegation that gathered and installed extensive exhibits in the French exposition in Paris. Meanwhile, he continued to plan another world's fair for London, intended for the tenth anniversary of the Great Exhibition but postponed until 1862 by the Franco-Austrian War of 1859. Cole commissioned Captain Francis Fowke of the Royal Engineers to design a huge brick exhibition building with two massive glass domes. Godfrey Sykes, an imaginative decorative artist, also joined Cole's team and did the interiors. The structure was placed in South Kensington, Cole hoping that it would meet some of his permanent museum needs and perhaps house future industrial fairs. The 1862 exhibition attracted slightly more attendance than that of 1851, but barely broke even financially and then only because the contractors generously trimmed their charges. It was arranged in classes of materials, rather than by countries, and it included fine arts and music. Prince Albert's death from typhoid fever in December 1861, at age forty-two, was a real blow to Cole, and he wondered how the commissioners could withstand pressures from the House of Commons without the prince's help. Cole himself was becoming unpopular in some quarters, because of his bold operating methods; and while Queen Victoria and the Prince of Wales (later Edward VII) usually supported him, he missed the intimate relationship he had enjoyed with Prince Albert. The two men had acted as salutary checks on each other; thus, in 1851, Albert had taken the side of the angry foreign exhibitors when Cole wished to charge them admission to the Crystal Palace, and, in turn, Cole had convinced Albert it would be self-defeating to charge journalists. Cole was not given a free hand to run the Exhibition of 1862, even though he was hired as consulting officer at a salary of £1,500. And much to his grief, Fowke's building was torn down in 1864, though the government acquired its site for later use for the British Museum (Natural History).[21]

Cole again headed the British delegation to the French exhibition at Paris in 1867. By then, he agreed with Prince Napoleon that world's fairs were becoming too large, too costly, and too difficult to comprehend and ought to be confined to special topics. In 1871, he began a series of supposedly ten annual exhibitions at South Kensington, financed by the Commissioners of 1851. Attendance of a little more than one million in 1871 dropped to less than one-half million in 1874, and the commissioners lost about £144,000 on the series, which they thereupon

cancelled. By then, Cole was deciding that museums were a sounder instrument than industrial exhibitions for applying the arts and science to industry.[22]

Henry Cole was the chief force behind the development of the eighty-seven acres that the Commissioners of 1851 acquired in South Kensington. He agreed entirely with Prince Albert's desire to place a series of colleges, museums, and other educational facilities in the area, and Richard Redgrave and he developed a plan in 1854 for an expandable building that would contain many units of these elements. As money became available, portions of the plan could be built, from time to time. Such spasmodic financing made the growth of South Kensington an improvised, crazy-quilt kind of operation. When Gladstone was in power, as Prime Minister, almost no government funds were appropriated, while a Disraeli cabinet would furnish moderate means. Cole managed to control construction in the area and made the available money, whether public or private, borrowed or earned, go far by using officers of the Royal Engineers, who were well trained and already on the government payroll, instead of better-known architects and by having the art classes do some of the work.[23]

In 1857, the Iron Building—a large, tri-partite, cast-iron structure painted with green and white horizontal stripes in an effort to impart some of the gaiety of a tent—opened in the section called Brompton. George Godwin, editor of the *Builder,* added to its established drawbacks of poor lighting, leaky roof, and lack of ventilation by christening it the "Brompton Boilers." It contained the whole South Kensington Museum, as well as the Patent Museum under the Commissioners of Patents, with models and rare historical machines such as Arkwright's cotton-spinning jenny, a Newcomen type of atmospheric engine, and Stephenson's *Rocket* locomotive. Bennet Woodcroft had independent charge of the collection, with its own separate entrance; Woodcroft had quarrelled with Cole and refused to collect six-pence admission charges on student days.[24]

Meanwhile, offices, museums, and schools were housed in a varying patchwork of old buildings and new galleries, ranges, courts, and a quadrangle. Cole himself and three other museum officers were provided with handsome living quarters above some of the galleries. Not until 1899 did Queen Victoria, in one of her last public appearances, break ground for Aston Webb's additional—and still extant—large monumental building and rename the complex the Victoria and Albert Museum. Cole was responsible for still other projects on the South Kensington plot. They

Fig. 13. South Kensington Museum, Iron Building, South Front. Probably designed by W. Dredge for Messrs. C. D. Young, 1855–1856. *(Courtesy of the Victoria and Albert Museum, London.)*

Fig. 14. Consultation in South Kensington Museum Quadrangle, about 1864–1865. *Left to right:* Henry Cole, Captain Francis Fowke, Godfrey Sykes, and John Liddell (?). *(Courtesy of the Victoria and Albert Museum, London.)*

included the Royal Horticultural Society Garden (1861–1876), Memorial to the Exhibition of 1851 (1861), Huxley Building (1864) for a School of Naval Architecture and later schools of Science and of Mines, Royal Albert Hall (1871), National Training School for Music (1876), and National Training School for Cookery (1876). The range of these undertakings testify to Cole's versatility, as well as to his management skill.[25]

During his South Kensington period, from about 1856 until his retire-

ment in 1873, Henry Cole became unpopular with many participants in English public life and was often a center of controversy. Partially, it was a natural result of opposition to his advanced and progressive ideas. Partially, it was Cole's disagreement with Gladstone and his chancellor of the exchequer, Robert Lowe. Cole was made a Companion of the Bath in 1851 for his services in the Great Exhibition, but was not given the rank of knight in the order (K.C.B.) until 1875, under Disraeli. Cole said then that he would have considered it treachery to the Prince Consort's memory to have accepted the honor on Gladstone's recommendation. In 1871, when Queen Victoria opened the Royal Albert Hall, for which Cole had worked so hard, she noted in her diary that "Good Mr. Cole was quite crying with emotion and delight." Gladstone and Lowe did not subscribe to seats in the hall and made no mention, at the opening, of Cole's contributions; Cole told General Henry Scott of the Royal Engineers, Captain Fowke's successor and architect of the hall, that he "did not care a 'Damn' for either of them or their acknowlegements." Over the years, Cole acquired a reputation for insisting upon having his own way and for using intrigue and even underhanded methods. He was sometimes referred to as Old King Cole, and one minister refused to give a shilling to Bethnal Green Museum "to make it one of King Cole's Hens and Chickens."[26]

Perhaps the best way to make a judgment of these matters is to listen to two men who knew Cole intimately. The first, Lyon Playfair, worked with him on the executive committee of the Great Exhibition and in the Department of Science and Art. He says:

He [Cole] has often been accused of working with selfish motives. Never was an accusation more unfounded. The public good was always the uppermost—I might almost say the only—motive in his mind. He was constantly misjudged, because his modes of work were not always on the surface. If he came to an obstacle, it was his delight to tunnel under it in secret, and unexpectedly come out at the other side.

Henry Trueman Wood, secretary of the Society of Arts, put it this way:

He liked having his own way, and he generally got it. He disliked opposition, and was ruthless with his opponents. He was a born fighter, and his methods of fighting were often questioned and disliked. Naturally enough, this made him unpopular, while the objects he sought often laid him open to the ridicule which is generally the lot of those who first advocate schemes for the accomplishment of which others in a later age are hailed as the benefactors of their kind. However, he cared little for ridicule or unpopularity, so long as he got what he wanted as he usually did. His best friends and admirers must wish that he had had greater regard for the feelings of others and that he had been content to obtain his objects

without thrusting aside and trampling down those who did not agree with him. But that was not his way, and perhaps gentler methods might have proved less successful. At all events, it is likely that they would have been slower, and of all things, delay was hateful to the impatient soul of Henry Cole.[27]

### III

Prince Albert and Henry Cole agreed that the old traditional museums were wrong in confining their collections to the rare and curious and their audiences to learned people, rich people, and dilettantes. Instead, they believed, museums should have practical utility in applying science and art to productive industry, as well as democratic social value in educating the masses and providing them with improving entertainment. And obviously these purposes were good for the nation, for they could enable Britain to meet the commercial competition of the artistic French, the thorough Germans, and the driving, inventive Americans. Cole's broad statement on museum values, made in a much-quoted speech at Birmingham in 1874, ran:

If you want your Schools of Science and Art to be effective, your health, the air, and your food to be wholesome, your life to be long, your manufactures to improve, your trade to increase, and your people to be civilised, you must have Museums of Science and Art, to illustrate the principles of life, health, nature, science, art, and beauty.[28]

Both Prince Albert and Cole thought that museums attained these idealistic goals by providing objects that enabled designers to teach themselves, that study of the artistic products of the past was the best way to create new and handsome objects of utility. As Cole pointed out, A. W. N. Pugin, architect and designer, was an authority on every aspect of historical Gothic style; sculptor John Flaxman learned much from ancient Greek pottery; and Herbert Minton, ceramics manufacturer, collected and studied French porcelain. A student must understand what had been accomplished by past masters of his specialty; for example, "An educated designer for ceramic manufactures should at least have an adequate knowledge of what Japan, Meissen, Sèvres, and even Chelsea have already done, and he should aim to acquire a power of execution as high as that his predecessors possessed." Though we today may value, in the creative process, personal inspiration and imaginative experimentation above historical knowledge of the craft, most late Victorian art historians accepted the more traditional approach.[29]

While the South Kensington land was being acquired, Prince Albert enabled Cole to start his program by persuading the queen to make Cole a temporary loan of Marlborough House in Pall Mall, with its forty-some rooms on four floors. In 1852, Cole caused to be moved there, from the Central School of Design in Somerset House, a large collection of architectural and sculptural plaster casts and decorative art objects that had been acquired chiefly at some of the French industrial exhibitions. Albert also got the treasury to allot £5,000 for purchases of materials from the Great Exhibition, and Cole served on the committee to make the selections; they bought European, Oriental, and British textiles, metalwork, enamels, ceramics, wood carvings, and furniture. Cole also uncovered in Buckingham Palace storerooms a fine collection of Sèvres that the Queen lent him, along with some rare laces. Prince Albert and other gentlemen made loans to the new Museum of Manufactures, which occupied the main floor of Marlborough House. More than 27,000 persons came, in fourteen weeks, to see the treasures on display. Cole even set up an Exhibit of False Principles (usually called the "Chamber of Horrors"), showing examples of bad design, but he included on the labels the names of the manufacturers, and they complained so vigorously that he had to dismantle the exhibit. He also started an excellent art library, a lecture series, night openings, ample catalogues and guidebooks—along with plentiful labels, so that a poor man need not buy anything "to understand what he is looking at." In 1852, Cole organized a Circulation Department under J. C. Robinson and, two years later, sent out a traveling exhibition of 430 objects and 150 framed drawings and photographs in cases that fitted into a railroad carriage; staff members accompanied the exhibit to unpack and arrange it. In four years, the display appeared in twenty-two localities and drew attendance of 238,882. Cole was determined to have a dynamic, vigorous museum, with a strong and varied program of popular education. His first report of the Department of Practical Art said:

The Museum is intended to be used, and to the utmost extent consistent with the preservation of the articles; and not only used physically, but to be taken about and lectured upon. For my own part, I venture to think that unless museums and galleries are made subservient to purposes of education, they dwindle into very sleepy and useless institutions.

And in his annual report for 1854 he added:

A museum may be a passive, dormant institution, an encyclopedia as it were, in which the learned student, knowing what to look for, may find authorities; or it

may be an active teaching institution, useful and suggestive. The latter has emphatically been the status of this museum from its origin.[30]

With Prince Albert's help, Cole began to collect much original art for his soon renamed Museum of Ornamental Art in Marlborough House. Parliament voted £8,583 to buy the Bandinel Collection of pottery and porcelain; £12,000 for part of the Bernal Collection—pottery, porcelain, glass, and metals; £2,110 for sculpture from the Gherardini Collection; and £3,500 for modern decorative art from the Paris exhibition of 1855 selected by Cole and Redgrave. Most important of all was the acquisition of the collection made by Jules Soulages, an attorney in Toulouse, who had accumulated, chiefly in Italy, 749 objects that included majolica, Palissy ware, Venetian glass, ivories, Limoges enamels, bronzes, Italian sculpture, painted glass, textiles and tapestries, and decorative furniture. Cole visited the collection while he was attending the French exhibition, and his brilliant young curator, J. C. Robinson, and an experienced art dealer, John Webb, negotiated the purchase for £12,000 plus packing and shipping charges. Three times the treasury refused to authorize payment, and Lord Palmerston, the prime minister, when viewing the majolica at the museum, wondered "What is the value of such rubbish to our manufacturers?" Cole arranged a guarantee fund of £24,000 for the collection and finally persuaded the Manchester Art Treasures Exhibition Committee of 1857 to purchase and display it and then make a rental-purchase arrangement with Cole, so that he could pay for it from his regular budget, over a twelve-year period. This cunning plan enraged the treasury and added to Cole's reputation for trickery.[31]

When the Prince of Wales took Marlborough House for his residence, the Museum of Ornamental Art moved to the Iron Building in South Kensington. It was joined there by several more utilitarian collections chiefly from the Great Exhibition—the Education Museum of books, appliances, maps, and models of schoolhouses; Museum of Construction, under Captain Fowke, with cements, asphalts, bricks, and other building materials; Architectural Museum (formerly at Westminster), with casts to train stonecarvers and other building craftsmen; Museum of Animal Products, from the Exhibition of 1851; and Food Museum, with realistic models of lamb chops and other viands to show the public the best and cheapest diet. There was also an exhibit of modern British sculptors' work. All these diverse materials constituted the South Kensington Museum, which Queen Victoria opened in 1857. The general public was admitted free on three days and two evenings, and six pence was charged everyone on three student days.[32]

During the remaining years of Cole's superintendence, considerable conflict took place between the conception of the main museum as a collection of great art, mainly decorative, and the idea of a collection of materials immediately useful in contemporary life. Cole was enthusiastic about both approaches and thought they could be combined harmoniously. Curator Robinson of the art collection, however, did not agree. He had been pleased to see the Chamber of Horrors withdrawn at Marlborough House, and he disliked the "motley, medly chaos" of most of the contemporary collections. His chief interest lay in the decorative arts of the medieval and renaissance periods, especially in Italy, Spain, and Portugal, and he applied his great connoisseurship to building and interpreting those fields. In 1863, the Education Committee of the Privy Council ruled that the museum collections should consist of postclassical art "applied to some purpose of utility" and that all periods and geographical areas within that definition should be covered. Robinson disliked the ruling and promptly relinquished the curatorship, though he continued to serve the museum in other positions until forced to resign in 1869. During that period, his suggestion that the museum not accept modern objects was rejected. Cole strongly defended the contemporary collections, such as those on education and food. By 1880, he thought the museum was acquiring too many medieval "Virgins and Childs" and that "teaching Art applied to Industry" was being subordinated to archaeology, the rare, and the curious.[33]

Robinson, in the 1880s and 1890s, contributed several long analytical articles to the *Nineteenth Century* on the three national museums, their problems, and their relationship with the provinces. He praised both Prince Albert and Cole for their great contributions to South Kensington, but thought that the British Museum and National Gallery required better administration. He criticized South Kensington for accepting gifts and bequests indiscriminately and advocated that the three museums appoint a joint committee with strong curatorial representation to approve accessions only when without condition as to disposal and use. He also was appalled at Aston Webb's design for a new building and pleaded for functional structures planned with participation of the museum staff that would use them and free of towers, domes, and other useless adornment. Robinson made it clear that the Circulation Department, which he had organized and supervised, had made its own collection, sometimes from duplicates and superfluous materials, and did not send out rare and fragile objects from the main collection. Instead, reproductions were made by casting, electrotype, or photography from both the collection and from other monuments and museums. He would have had South

Kensington circulate similar materials for the British Museum and
National Gallery, with a union committee, made up chiefly of young
curators, to decide what should circulate and be reproduced, instead of
leaving such crucial decisions to clerks and secretaries untrained in art
history. In general, Robinson's ideas seem sound, by present-day
museum standards, but they indicate considerable conflict within the
museum and suggest that perhaps he was sometimes difficult to work
with.[34]

Disapproving of the increasing emphasis of the museum upon the fine
arts, Cole turned toward developing the Patent Museum into a first-class
museum of science and technology. He greatly admired the Conservatoire
National des Arts et Métiers in Paris and would have liked to see the
Patent Museum become a superb collection of machines, inventions,
models, and manufacturing materials, with a vigorous program of popu-
lar education. He had secured a simplification and improvement of the
Patent Act, in 1852, that was unexpectedly bringing in nearly £80,000
yearly to the general fund of the Treasury. In 1874, he tried—without
success—to persuade that department to turn over that income to the
Patent Museum. He stated that

the Pyramids had never done anything for the world like Watt's first engine, and
this is now in our museum as well as numerous other early contrivances. Indeed it
has been said that if there were any part of the world where one could look for the
origin of the species, it was in the Patent Museum.

Not until 1883 did this museum become a regular branch of the South
Kensington Museum, under the Department of Science and Art. With the
completion of the new building of the Victoria and Albert Museum, in
1909, the technological collection became the independent Science
Museum, still situated across Exhibition Road from the Victoria and
Albert.[35]

By the time of Cole's retirement, the South Kensington Museum had
assumed its place as the greatest decorative art museum in the world. Not
only was the collection superb in both quality and quantity, but it was
serving the London metropolitan area and, indeed, all Britain, in a most
imaginative and vigorous way. A continuous program of exhibits, lec-
tures, and publications kept the museum always before the public. In
1857, its Sheepshanks Gallery of modern British paintings opened two
nights a week with gas-lighting, "the first experiment of the kind in a
public building," said Cole, and he waxed sentimental in describing its
effect on the laboring classes:

The working man comes to this Museum from his one or two dimly lighted cheerless dwelling rooms, in his fustian jacket, with his shirt collar a little trimmed up, accompanied by his threes and fours and fives of little fustian jackets, a wife, in her best bonnet, and a baby, of course, under her shawl. The looks of surprise and pleasure of the whole party when they first observe the brilliant lighting inside the Museum show what a new, acceptable, and wholesome excitement this evening entertainment affords to them all. Perhaps the evening opening of Public Museums may furnish a powerful antidote to the gin palace.

Cole wished to open his museum and, indeed, all British museums on Sunday afternoons. He argued that the working man would enjoy better recreation there with his wife and children than boozing in public house or gin palace. "The Museum," he said, "will certainly lead him to wisdom and gentleness, and to Heaven, whilst the latter will lead him to brutality and perdition." But Cole could not get permission to open on Sundays; the government did not yet dare challenge the strong clerical and church membership opposition.[36]

This looking upon the museum as a means of social amelioration is also shown in the establishment of the Bethnal Green Museum as a branch of the South Kensington institution. Bethnal Green, situated in the midst of the then crowded, run-down, and poverty-stricken East Side of London, was an ideal spot to experiment with the beneficial social influence of museum activities. In 1867, part of the Iron Museum was taken down and moved there; it was covered with a brick shell, to make it weather-tight and more architecturally acceptable. The construction, architectural, animal products, and food collections were moved from South Kensington, as well as many surplus objects including sculptures. Sir Richard Wallace lent his superb collection of old master paintings, and, in 1872, the Prince of Wales opened the new facility. It was so successful that in the first three months it attracted 700,000 viewers, and Cole had the Society of Arts prepare a declaration signed by 150 peers, members of Parliament, and other influential leaders. The document asked the government to forward the establishment of local museums, libraries, and galleries of science and art in British population centers that would bear their share of the cost. Prime Minister Gladstone refused to meet with a society committee to discuss the petition, and the society wrote him a rather sharp letter; it stated that such museums were "absolutely necessary to the industrial progress of the country, which is behind other countries already in possession of them." All public museums, both national and local, ought to be placed in a co-ordinated national system with financial aid from the government. Still Gladstone did not act.[37]

In the area of exhibition, Cole made many advances. During an era of far too much florid architectural decoration of building interiors, the stark Iron Museum represented an unusual situation. Cole installed screens with neutral backgrounds to set off his objects and, in the opinion of Henry-Russell Hitchcock, devised a more meaningful, more appealing arrangement of the decorative art collection than it was to receive until Leigh Ashton, after World War II, divided it into two series—Primary Exhibition Galleries, showing the development of decorative art history, and Study Collections. Cole also devised cases and frames for the objects, and the French Industrial Exhibition at Paris in 1867 awarded him a medal of honor for an ingenious exhibition stand. Both Robinson and Cole recognized the value of photography for museums and established a studio at South Kensington to distribute photographs of its holdings, as well as form a collection of documentary prints.[38]

So far as conservation went, Cole was working in a day before air conditioning and humidity control, but he believed thoroughly in fire prevention, good ventilation, and adequate lighting. He was proud of the precautions he took against fire. he experimented with mosaic, tile, iron, and concrete floors and with lightweight, fire-resistant materials for ceilings; he had water available everywhere at high pressure, a police safety patrol, and a detachment of Sappers resident at the museum to serve as firefighters. He was sensitive about ventilation, apparently obtained by window control, and he admired Captain Fowke's designs that directed overhead lighting to the space above where pictures were hung, so as to avoid glare.

Cole argued continually that his museum was a national, not a metropolitan London, institution. He sent out carefully packed museum materials to art schools throughout Britain. In 1876, he stated that, in twenty years, the museum had circulated 26,907 art objects and 23,911 pictures among the art schools and that these exhibits had been seen by more than six million persons, in addition to being copied by students. Some exhibits were left in the localities visited for several months. The museum awarded grants-in-aid to the schools to pay half the cost of acquiring objects, sold them duplicates and surplus materials at half price, and furnished casts, electrotypes, and photographs at reasonable cost.

In Cole's mind, every town of ten thousand or more should have its museum of science and art. The national museums and galleries ought to furnish such an establishment most of its objects by sale or on loan, the locality should provide safe, clean premises, and museum visitors should pay a small admission fee to help with upkeep and make them appreciate

more what they were seeing. He urged other national museums, especially the British Museum and National Gallery, to adopt that approach and was disgusted when they refused to do so because, they said, their objects were "things rare and curious," not collected for educational purposes.[39]

Cole was a consistent, often savage, critic of the British Museum. It was, he said in an unsigned article on "Irresponsible Boards," in the *Edinburgh Review* for 1866, in hopeless confusion, overcrowded, unhealthy for persons and specimens, insufficiently ventilated, ill-cared-for, ill-lighted, its sculptures disfigured by dirt, natural history specimens not in dust-tight cases, and labels lacking; in short, "there is throughout an air of sleepy, slatternly shabbiness except in the libraries and a very few other portions." Most of the trouble, he maintained, lay in its administration. Cole was an almost fanatical believer in direct lines of authority and responsibility. His museum and department were under the Education Committee of the Privy Council, and he reported to a Crown Minister and the Council; above them was Parliament itself, to settle major questions of policy. The British Museum, on the other hand, had an independent Board of Trustees numbering about fifty—chiefly busy, ecclesiastical and governmental members. They were too numerous and too irresponsible to see that the museum's annual grant of about £100,000 was efficiently administered and properly spent.[40]

Ironically enough, soon after Cole's retirement in 1873, a movement arose in Parliament to put the South Kensington Museum under the board of trustees of the British Museum. Cole, of course, was furious, and in numerous speeches and articles urged everyone to see that his member of Parliament opposed the plan. He spoke to all his friends and acquaintances in high places, including the Prince of Wales, who promised to "protect Kensington." Cole fought with his usual perspicacity and energy. The Society of Arts already included in its membership "Institutions in Union," mainly local organizations that sent representatives to the annual meetings and had their activities publicized and promoted in the *Journal*; in 1855, there were 368 such bodies—museums, libraries, mechanics' institutes, and local societies from throughout Britain. Cole persuaded the society's council to establish a large standing committee on museums that contained peers, members of Parliament, Society of Arts principals, and numerous leaders of local art schools and museums; the committee list took up more than two closely printed pages of the *Journal*. Its objectives were to have all national museums benefit the local organizations, especially by lending them objects and exhibits; to get Parliament to subsidize the arrangement; and to place all national museums and

galleries under a Crown Minister directly responsible to Parliament and abolish governance by boards of trustees. Such prompt and bold action helped defeat the attempt to place the South Kensington Museum under the British Museum board.[41]

Cole also advocated that the museums and museum workers of Britain form a co-operative professional organization, to let each other know what was going on in the field and to establish professional standards. These objectives could best be forwarded by extending to a Secretary of Education in the British Cabinet the supervision of museums and libraries, as well as that of schools. The idea was too advanced for that day, however, and the Museums Association of Britain was not formed until 1889, the broadened Board of Education not established until ten years later. And most of the national museums retained their independent boards of trustees; only the Victoria and Albert and the Science museums are today included in the Department of Education.[42]

## IV

The South Kensington Museum had enormous influence on other museums, both inspiring the formation of new decorative art ones and persuading more general museums to imitate its active educational program directed at students and the general public. In 1874, Cole said that his museum "has set an example which has been copied by thirty-five museums in Europe." The European replicas included museums devoted to the decorative arts in Vienna (1864), Karlsruhe (1865), Berlin (1867), Cologne (1868), Hamburg (1869), and Budapest (1872). An earlier proponent of using such collections for the improvement of industrial design was Baron Alexander von Minutoli, a Prussian civil servant who set up the Institut Minutoli in 1845 at Liegnitz (now Lagnica, Poland) in Silesia. Though its founder looked upon his creation as primarily a trade school, it was also actually a museum with an excellent decorative art collection, period rooms, photographic records of objects, conservation workshop, and circulating exhibits. Apparently, Prince Albert and Cole did not know about von Minutoli's work until about 1854, and most of his collection was purchased by 1869 for the Berlin Gewerbe-Museum. France was slow to follow South Kensington, though the Union centrale des Beaux-Arts appliqués à l'Industrie, formed after the Great Exhibition, was trying to organize such a museum. The French feared that Britain had greatly outshone them at the Philadelphia Centennial and that British schools and museums applying art to industrial purposes were "daily refining

their taste and elevating the character of their works." The Musée des Arts Décoratifs finally was founded at Paris in 1880.[43]

In the United States, George Brown Goode, director of the Smithsonian's United States National Museum, was thoroughly familiar with South Kensington and had talked with its venerable director. Goode described his idol, Spencer Fullerton Baird, second secretary of the Smithsonian, as the master mind of the National Museum, in the same class with Cole of South Kensington. Goode found Cole's museum vigorous and democratic, and he quoted frequently from Cole's addresses. He pointed out, too, that the English museum had for years spent nearly $42,000 per annum on acquisitions, while the Smithsonian, up to 1887, had expended only a total of $20,000 in that area. Goode considered the British system, which had 150 museums, many of them encouraged by South Kensington, a better model for the United States than either France or Germany. He praised Britain's museum growth in the nearly forty years since the Exhibition of 1851 and hoped that the United States would have progressed as far in a like period after the Philadelphia Centennial.[44]

The Metropolitan Museum of Art in New York, chartered in 1870, in many ways took South Kensington as a model. At an organization meeting, George Fiske Comfort, a young Princeton professor, praised the London museum and urged the Metropolitan to devise a strong educational program with useful decorative or applied arts, loan exhibitions, attractive displays, lectures, and programs for schoolchildren. Charles C. Cole, Henry's brother, living in New York, suggested "that special emphasis should be placed upon the Loan Collection, which from the very first had proved 'the very back-bone of the South Kensington Museum.' " An early promotional pamphlet of the Metropolitan promised "the formation of a collection of industrial art, of objects to which decorative art has been applied, ornamental metalwork, carving in wood, ivory, and stone, painted glass, glass vessels, pottery, enamel, and all other materials . . . for the use of our mechanics and students." And Joseph H. Choate, in his 1880 speech at the opening of the new building in Central Park, lauded the South Kensington Museum's influence on English industrial design and workmanship, reminding the businessmen among his listeners that such a program resulted in greater commercial profits. The Metropolitan could teach "artisans of every branch of industry . . . what the past had accomplished for them to imitate and excel."[45]

The Museum of Fine Arts in Boston, chartered also in 1870, took a similar attitude. Charles C. Perkins, one of its founders, thought it should have "the character of that at South Kensington" and aim to provide "a

means of culture to the public, of education to artists and artisans, and of elevated enjoyment to all." Martin Bremmer, its first president, noted that many industries, still in their infancy, would use a decorative art collection and concluded that "The designer needs a museum of art, as the man of letters needs a library, or the botanist a herbarium." And in 1897, two daughters of Abraham Hewitt, founder of New York's Cooper Union for education of the laboring classes, established the Cooper Union Museum, devoted exclusively to the decorative arts. It was absorbed, in 1976, into the Smithsonian Institution museum complex as the Cooper-Hewitt Museum of Decorative Arts and Design and placed in the Carnegie Mansion on Fifth Avenue.[46]

Henry Cole, of course, was a utilitarian who used his museum to throw light on many social and economic problems of his day. Since then, the Victoria and Albert Museum has retained popular cultural and educational purposes but has narrowed the scope of its collection to the decorative arts from the Byzantine period, though with considerable attention to the pressent day. It has given up many purely practical materials and activities to other institutions. As Sir Roy Strong, its present director, points out, it has been the ancestor of the Royal College of Art, the Science Museum, the Building Centre, the Design Centre, the National Maritime Museum, and the Tate Gallery. The museum also has several branches: Bethnal Green Museum, which became the Museum of Childhood in 1975, and three historic houses—Apsley House (the Wellington Museum), also in London; Ham House at Richmond in Surrey; and Osterley Park in Middlesex. At present, it is organizing from its holdings a Theatre Museum that will be housed in Covent Garden, and future decentralized museums may deal with the Art of Dress, Musical Instruments, and Oriental Art.[47]

The Victoria and Albert remains popular with both general public and scholars. A major tourist attraction, in 1977 its attendance reached 2,339,593. Yet as Trenchard Cox, a former director, says: "To scholars throughout the world it is the richest treasure house of the decorative arts, with reserves so vast that they could not be exhausted in a lifetime of study by any single human being." Its present director makes crystal clear the museum's devotion to its audience when he writes:

Every museum within its four-fold brief, to collect, to preserve, to display and to elucidate, needs constantly to re-think its aims and objectives. And in no areas more often than those directly dealing with the public, what I would categorize as the servicing departments: information, publications, exhibitions, education, design. Such aspects relate directly to the present, to contemporary society as it

actually exists at the moment. These areas of a museum must be in perpetual dialogue with the community, sensitively attuned to changing moods and attitudes towards the artefacts it houses. Each period requires new ways of appreciation, something conditioned by a million factors from evolving systems of education to the fleeting face of fashion, and even within a single period there will be need for a multiple approach to reach every level . . . .[48]

But the Victoria and Albert is beset with serious problems. Aston Webb's building is a "major disaster" as a showcase for exhibitions, and Leigh Ashton's imaginative attempts to establish paths through primary and reserve collections have ended up confusing visitors. At present, the Huxley Building next door is being renovated to provide offices and galleries, and has been fittingly renamed the Henry Cole Building. The attempts of the government to cut costs so as to curb inflation are having calamitous effects. The museum's civil service staff is being reduced from about 750 to 550, and the building is shut every Friday and, on other days, as many as one-third of the exhibits close because of lack of guards. Worst of all, the famed Regional Services (formerly Circulation) Department that, since the 1850s, had regularly sent exhibits throughout Britain was eliminated entirely.[49]

John Pope-Hennessy, who served as director, first, of the Victoria and Albert and then of the British Museum, compared the two institutions in 1975. The V and A, he said, "is a post-industrial revolution organization. It was planned not exactly for the world in which we live, but for a society recognizably related to it, and it was, through its early terms of reference, concerned with the country as a whole." Two of its tasks as defined in 1851 were "the fruitful system of circulating through the whole of England works of art belonging to the museum, and that of subventions for the creation of local museums." The museum "spoke to the big public, and not just to art historians and connoisseurs." The British Museum, on the other hand, was "a pre-industrial revolution museum, and the ideas behind it go back to the eighteenth century." It met Diderot's ideal of a neo-classic museum centered on a library with antiquities and art works around it, and houses for celebrated scholars who cared for and knew about the books and objects. And Pope-Hennessy ended up by declaring

There are really only two kinds of museums. There are inward-looking museums, which exist primarily for the benefit of scholars or of their own staffs—which ignore the world outside their gates. And there are outward-looking museums, which address themselves to the public as a whole and whose main concern is to exploit as great a part of their resources as is practicable in the public interest.[50]

How Henry Cole would have appreciated these descriptions! As a skilled public relations expert, he would have been proud of the image his museum created; and as a fighting administrator, he would have rejoiced to see the hated British Museum painted in its true colors. On the whole, he would be as satisfied with his museum today as his reforming nature would allow. Though it had dropped many utilitarian functions, they were being well looked after by other institutions. The Science Museum was flourishing as he had dreamed. The Victoria and Albert, for which he had worked so long and so devotedly, was still serving the British people. Even more important, he had given the museum a new definition that was spreading worldwide—an institution using objects to teach the general public, old and young. And one, the varied activities of which—exhibits, traveling exhibits, night openings, special events, parties, lectures, workshops, seminars, publications, and many more—were bringing understanding and enjoyment to many varied audiences.

## NOTES

Betty Bradford (Mrs. Rowland) Elzea and her husband, of Wilmington, Delaware, kindly read and made helpful suggestions for this chapter.

1. Quoted in Betty Bradford, "The Brick Palace of 1862," p. 15.

2. Derek Hudson and Kenneth W. Luckhurst, *The Royal Society of Arts, 1754–1954*; Sir Harry Trueman Wood, *A History of the Royal Society of Arts*. Some of the best works on Prince Albert include Winslow Ames, *Prince Albert and Victorian Taste*; Roger Fulford, *The Prince Consort* (London: Macmillan, 1949); Theodore Martin, *The Life of His Royal Highness, the Prince Consort*, 5 vols. (London: Smith, Elder, 1875–1880); and Reginald Pound, *Albert: A Biography of the Prince Consort*. The key printed source on Cole is Sir Henry Cole, *Fifty Years of Public Work . . . Accounted for in His Deeds, Speeches and Writings*, edited by his son Alan S. Cole and daughter Henrietta, 2 vols.

3. Cole, *Fifty Years*, 1: 1–5; "Henry Cole," in *Dictionary of National Biography* 4: 724–726. Cole edited *The Works of Thomas Love Peacock . . .* , 3 vols. (London: Richard Bentley and Son, 1875).

4. Anna J. Mill, "Some Notes on Mill's Early Friendship with Henry Cole," pp. 2–8.

5. Cole, *Fifty Years*, 1: 1–33; *DNB*, 4: 724–726; John Stuart Mill, *The Earlier Letters of John Stuart Mill, 1812–1848*, edited by Francis E. Mineka, 2 vols. (Toronto, London: University of Toronto Press, 1963), 2: 613–614; A. S. Levine, "The Journalistic Career of Sir Henry Cole," pp. 60–65; Ames, *Prince Albert and Victorian Taste*, pp. 82–83.

6. Cole, *Fifty Years*, 1: 1–12, 16, 34–69, 101; 2: 160–162, 178–207; *DNB*, 4: 724–726; John Steegman, *Consort of Taste, 1830–1870*, pp. 151–152.

7. Cole, *Fifty Years*, 1: 103–115; *DNB*, 4: 724–726; "Sir Henry Cole on Tonic Sol-Fa," *Journal of the Society of Arts* 29 (June 10, 1881): 623; Wood, *History of the Royal Society of Arts*, pp. 154, 406; Steegman, *Consort of Taste*, pp. 152–153; Shirley Bury, "Felix Summerly's Art Manufactures," pp. 28–33; Nikolaus Pevsner, *High Victorian Design: A Study of the Exhibits of*

*1851* (London: Architectural Press, 1951), pp. 13, 93, 142–146. (This study is reprinted, with better illustrations, in Pevsner's *Studies in Art, Architecture and Design,* 2 vols.: 2: 38–107); Quentin Bell, *The Schools of Design,* pp. 212–215.

8. Cole, *Fifty Years,* 1: 117–123, 378–389; Wood, *History of the Royal Society of Arts,* pp. 357–358, 370–371, 382, 407–410, 477, 496–497; Hudson and Luckhurst, *Royal Society of Arts,* pp.182–183, 222, 226, 242, 324–325, 372; Kenneth W. Luckhurst, *The Story of Exhibitions,* pp. 93–100; Steegman, *Consort of Taste,* pp. 209–210.

9. Cole, *Fifty Years,* 1: 117–144; 2: 208–220; Luckhurst, *Story of Exhibitions,* pp. 93–100; Patrick Beaver, *The Crystal Palace, 1851–1936: A Portrait of Victorian Enterprise* (London: Hugh Evelyn, 1970), pp. 11–14; Christopher Hobhouse, *1851 and the Crystal Palace,* pp. 4–9; Charles Harvard Gibbs-Smith, compiler, *The Great Exhibition of 1851,* pp. 5–7; Pound, *Albert,* pp. 204–207, 213, 229; Steegman, *Consort of Taste,* pp. 209–211.

10. Beaver, *Crystal Palace,* pp. 20–22; Hobhouse, *1851 and the Crystal Palace,* pp. 10–14; Gibbs-Smith, *Great Exhibition,* pp. 8, 26–28; Pound, *Albert,* pp. 213, 228–230; Steegman, *Consort of Taste,* pp. 211–218.

11. Cole, *Fifty Years,* 1: 161–174; 2: 220–227; Luckhurst, *Story of Exhibitions,* pp. 100–110; Henry-Russell Hitchcock, *The Crystal Palace,* pp. 17–18; Hobhouse, *1851 and the Crystal Palace,* pp. 9–14; Gibbs-Smith, *Great Exhibition,* pp. 35–36; Pound, *Albert,* pp. 204–205; Lyon Playfair, *Memoirs and Correspondence,* pp. 114–115.

12. Cole, *Fifty Years,* 1: 163–174; Luckhurst, *Story of Exhibitions,* pp. 104–110; Hitchcock, *Crystal Palace,* pp. 22–23; Henry-Russell Hitchcock, *Early Victorian Architecture in Britain,* 2 vols.: 1: 536–538; Beaver, *Crystal Palace,* pp. 23–31; Gibbs-Smith, *Great Exhibition,* pp. 11–13, 32–34; Pound, *Albert,* pp. 225, 228–230; Steegman, *Consort of Taste,* pp. 212–215.

13. Cole, *Fifty Years,* 1: 161–162; Hitchcock, *Crystal Palace,* pp. 17–18; Luckhurst, *Story of Exhibitions,* p. 111; Hobhouse, *1851 and the Crystal Palace,* pp. 69–70, Gibbs-Smith, *Great Exhibition,* p. 7, 14.

14. Pevsner, *Art, Architecture, and Design,* 2: 9–11, 32–33, 48–51, 54–57, 84–89; Gibbs-Smith, *Great Exhibition,* pp. 15–33, 60–63, 78–83, 101, 111, 128–133, 139; Hobhouse, *1851 and the Crystal Palace,* pp. 174–176.

15. Cole, *Fifty Years,* 1: 200–202; 2: 233–256; Gibbs-Smith, *Great Exhibition,* pp. 22, 38–39; Luckhurst, *Story of Exhibitions,* pp. 113–116; Hobhouse, *1851 and the Crystal Palace,* pp. 149–150; Pound, *Albert,* p. 231.

16. Cole, *Fifty Years,* 1: 203, 313–328; Gibbs-Smith, *Great Exhibition,* pp. 37–38; Hobhouse, *1851 and the Crystal Palace,* pp. 150–151; Martin, *H.R.H., the Prince Consort,* 2: 391, 569–573; Pound, *Albert,* p. 236; Steegman, *Consort of Taste,* pp. 219–229; *Journal of Design and Manufactures* 6 (October 1851): 48–50; International Exhibit of 1862, *The Illustrated Catalogue,* 3 vols. (London: For Her Majesty's Commissioners, 1862), 1: 32–34; Greater London Council, *Survey of London, Volume XXXVIII,* pp. 49–64.

17. Cole, *Fifty Years,* 1: 204; Denarius, "Should We Keep the Crystal Palace . . . ?" *Journal of Design and Manufactures* 5 (July 1851): 127–131; Playfair, *Memoirs and Correspondence,* pp. 124–125; Gibbs-Smith, *Great Exhibition,* pp. 32–34; Steegman, *Consort of Taste,* pp. 229–232.

18. Cole, *Fifty Years,* 1: 294–296, 300–312; Henry Cole, *Addresses of the Superintendents of the Department of Practical Art . . .* (London: Chapman and Hall, 1853), pp. 10–13; *Survey of London,* 38: 76–78; Playfair, *Memoirs and Correspondence,* pp. 141–143; *Journal of Design and Manufactures* 6 (February 1852): iii–iv; Bell, *Schools of Design,* pp. 215–251; Steegman, *Consort of Taste,* pp. 146–147; Sigfried Geidion, *Mechanization Takes Command,* pp. 346–358; Pevsner, *High Victorian Design,* pp. 13, 142–146; Hitchcock, *Early Victorian Architecture,* 1: 209–210, 304.

19. Cole, *Fifty Years*, 2: 347; Cole, *Addresses of Superintendents of Practical Art*, pp. 13–33; Sir Henry Cole, "Art Students of Hanley Speech," *Journal Society of Arts* 21, October 31, 1873: 912–915; *Survey of London*, 38: 74–79; Ames, *Prince Albert and Victorian Taste*, p. 92; Stuart Macdonald, *The History and Philosophy of Art Education* pp. 157–158, 222–224, 226–233.

20. John Ruskin, *The Works of John Ruskin*, edited by E. T. Cook and Alexander Wetherburn, 39 vols. (London: George Allen, 1903–1912), 16: xxviii; Bell, *Schools of Design*, pp. 253–263; R. R. Tomlinson, *Children as Artists* (London: King Penguin Books, New York, 1947).

21. Cole, *Fifty Years*, 1: 207–271; *Survey of London*, 38: 64, 91, 137–147, 196–200; Bradford, "Brick Palace of 1862," pp. 15–21; Luckhurst, *Story of Exhibitions*, pp. 118–119, 130–131; Ames, *Prince Albert and Victorian Taste*, pp. 153–156; Henry Hardy Cole, "The London International Exhibit of 1874," *Journal Society of Arts* 22, March 29, 1874: 426–429.

22. Cole, *Fifty Years*, 1: 264–271; 2: 257–273; Wood, *History of the Royal Society of Arts*, pp. 484–487; Luckhurst, *Story of Exhibitions*, pp. 129, 134–135; *Survey of London*, 38: 196–200.

23. *Survey of London*, 38: 85–94, 97, 107–108, 115; Ames, *Prince Albert and Victorian Taste*, p. 85.

24. Cole, *Fifty Years*, 1: 324–326; *Survey of London*, 38: 198–200; Hitchcock, *Early Victorian Architecture*, 1: 567–570; Macdonald, *Art Education*, pp. 201–205; Cole Miscellanies, 11: 143–151, Victoria and Albert Museum Art Library.

25. *Survey of London*, 38: 124–136, 148–195, 217–219, 234–237; Cole, *Fifty Years*, 1: 358–377; Marcus Binney, "The Origins of Albert Hall," *Country Life* 149, March 25, 1971: 680–683; Steegman, *Consort of Taste*, pp. 288–290, 326.

26. *Survey of London*, 38: 115, 156, 191n.; Cole, *Fifty Years*, 1: 354.

27. Playfair, *Memoirs and Correspondence*, p. 115; Wood, *History of the Royal Society of Arts*, pp. 358–359.

28. Henry Cole, "On the National Importance of Local Museums . . . Birmingham Address," *Journal Society of Arts* 22, January 23, 1874: 167.

29. Cole, "Hanley Speech," pp. 912–915; Cole, "Birmingham Address," p. 171; Ames, *Prince Albert and Victorian Taste*, p. 120.

30. Cole, *Addresses of the Superintendents of the Department of Practical Art*, pp. 23–37; Henry Cole and Lyon Playfair, *First Report of the Department of Science and Art, January 1, 1854*, and Henry Cole, *6th Report of Science and Art Department of the Committee of Council of Education, January 1, 1859*, in Cole Miscellanies, 9: 187–188, 377–382, Victoria and Albert Museum Art Library; *Journal Society of Arts* 24, October 20, 1876: 997; Cole, *Fifty Years*, 1: 283–289; 2: 291–294; *Survey of London*, 38: 79–80; Hobhouse, *1851 and the Crystal Palace*, p. 151; Macdonald, *Art Education*, pp. 177–182; Ames, *Prince Albert and Victorian Taste*, pp. 84–85; Roy Strong, "Forty Years On: The Victoria and Albert Museum and the Regions," *Museums Journal* 75 (December 1975): vi–vii; John Pope-Hennessy, "Interaction between National and Regional Museums," *Museums Journal* 75 (December 1975): 110–113.

31. Cole, *Fifty Years*, 1: 283–294; *Survey of London*, 38: 79–80, 98–99, 117; Frank Herrmann, *The English as Collectors: A Documentary Chrestomathy* (London: Chatto and Windus, 1972), pp. 288–292; J. C. Robinson, *Catalogue of the Soulages Collection . . .* (London: Chapman and Hall, 1856); Macdonald, *Art Education*, p. 272; Levine, "Journalistic Career of Sir Henry Cole," p. 84; Richard D. Altick, *The Shows of London* (Cambridge, Mass.: Belknap Press, 1978), p. 498; Roy Strong, "The Victoria and Albert Museum—1978," *Burlington Magazine* 120 (May 1978): 272–274.

32. "Design of Iron Building," *Journal Society of Arts* 5, February 27, 1857: 237; Cole, *Fifty Years*, 1: 325–326; 2: 291–294; Cole, *5th Report of Science and Art Department of Committee of Council on Education, January 1, 1858*, in Cole Miscellanies, 9: 298, 323–337, Victoria and

Albert Museum Art Library; *Survey of London*, 38: 98–101; Altick, *Shows of London*, p. 498; Trenchard Cox, "History of the Victoria and Albert Museum and the Development of Its Collections," Royal Institution of Great Britain *Proceedings* 37, pt. 3, no. 167 (1959): 281–283.

33. *Survey of London*, 38: 117–118; J. C. Robinson, "Our Public Art Museums: A Retrospect," *Nineteenth Century* 42 (December 1897): 957.

34. *Nineteenth Century* 7 (June 1880): 972–994; 8 (August 1880): 249–265; 32 (December 1892): 1021–1034; 42 (December 1897): 940–964; 44 (December 1898): 971–979.

35. Cole, *Fifty Years*, 1: 272–278; *Journal Society of Arts* 12, April 1, 1864: 324; 22, January 16, 1874: 142; January 23, 1874: 154; *Survey of London*, 38: 248–250.

36. Cole, *Fifty Years*, 1: 325–326; 2: 291–294, 357–369; Cole, "Birmingham Address," pp. 167–171; *Journal Society of Arts* 12, March 18, 1864: 294–295.

37. *Journal Society of Arts* 15, July 15, 1866: 35; November 30, 1866: 35; 20, June 21, 1872: 651; June 28, 1872: 670–672; November 15, 1872: 962–963; 21, October 31, 1873: 907–908; Cole, *Fifty Years*, 1: 354; Cole, "Hanley Speech," p. 913; *Survey of London*, 38: 94, 113, 249.

38. Cole, *Fifty Years*, 1: 329–330; Hitchcock, *Early Victorian Architecture*, 1: 567–570; *Survey of London*, 38: 91; *Journal Society of Arts* 27, January 31, 1879: 175; John Physick, *Photography and the South Kensington Museum* (London: Victoria and Albert Museum, 1975).

39. Cole, "Birmingham Address," pp. 168–170; *Journal Society of Arts* 24, October 20, 1876: 997.

40. [Henry Cole], "Public Galleries and Irresponsible Boards," *Edinburgh Review* 123 (January 1866): 29–42; *Journal Society of Arts* 14, February 2, 1866: 191.

41. *Journal Society of Arts* 2, June 15, 1855: 539; 5, June 26, 1857: 466–467; 21, October 3, 1873: 859; October 31, 1873: 909–910; 22, January 23, 1874: 166–171; January 30, 1874: 196; 25, January 19, 1877: 142–144; Cole, "Hanley Speech," pp. 912–915.

42. *Survey of London*, 38: 115; Leigh Ashton, "100 Years of the Victoria and Albert Museum," *Museums Journal* 53 (May 1953): 45–46; "Victoria and Albert Museum Special Issue," *Burlington Magazine* 120 (May 1978): 271.

43. Winslow Ames, "London or Liegnitz?" *Museum News* 43 (October 1964): 27–35; Ames, *Prince Albert and Victorian Taste*, pp. 119, 191–198; *Journal Society of Arts* 23, January 30, 1874: 196; 25, December 8, 1876: 59–61; Nikolaus Pevsner, *Academies of Art: Past and Present*, pp. 256–257.

44. Smithsonian Board of Regents, *Annual Report, U.S. National Museum, 1884*: 9; *1887*: 4; *1893*: 10; *1897*: 71–72, 239, 247–248.

45. Winifred E. Howe, *A History of the Metropolitan Museum of Art . . .*, 2 vols. (New York: Metropolitan Museum of Art, 1911, 1946), 1: 114, 143–144; Calvin Tomkins, *Merchants and Masterpieces: The Story of the Metropolitan Museum of Art* (New York: E. P. Dutton, 1970), pp. 28, 30–31.

46. Walter Muir Whitehill, *Museum of Fine Arts, Boston: A Centennial History*, 2 vols. (Cambridge, Mass.: Belknap Press, 1970), 1: 8–10; Cooper Union Museum for the Arts of Design, *An Illustrated Survey of the Collections* (New York: Cooper Union Museum, 1957), pp. 3–5; Allan Nevins, *Abram S. Hewitt: With Some Account of Peter Cooper* (New York: Harper and Brothers, 1935), pp. 586–587.

47. Strong, "Victoria and Albert Museum, 1978," pp. 272–276; *Museums Journal* 80 (December 1980): 134.

48. Cox, "Victoria and Albert Museum," p. 276; Strong, "Forty Years On," p. vi.

49. Ashton, "100 Years of the Victoria and Albert," pp. 43–47; Strong, "Victoria and Albert Museum, 1978," p. 275; "Editorial: Mishandled," *Burlington Magazine* 120 (May 1978): 271–272; *Museums Journal* 80 (December 1980): 133, 134.

50. Pope-Hennessy, "National and Regional Museums," pp. 110–113.

## SELECT BIBLIOGRAPHY

Ames, Winslow. "London or Liegnitz?" *Museum News* 43 (October 1964): 27–35.
_____. *Prince Albert and Victorian Taste.* London: Chapman & Hall, 1967. 238 pp.
Ashton, Sir Leigh. "100 Years of the Victoria & Albert Museum." *Museums Journal* 53 (May 1953): 43–47.
Bell, Quentin. *The Schools of Design.* London: Routledge and Kegan Paul, 1963. 290 pp.
Binney, Marcus. "The Origins of the Albert Hall." *Country Life* 149, March 25, 1971: 680–683.
Bradford, Betty. "The Brick Palace of 1862." *Architectural Review* 132 (July 1962): 15–21.
Bury, Shirley. "Felix Summerly's Art Manufactures." *Apollo* 85 (January 1967): 28–33.
Cole, Sir Henry. *Fifty Years of Public Work . . . Accounted for in His Deeds, Speeches and Writings.* Edited by his son Alan S. Cole and daughter Henrietta. 2 vols. London: George Bell and Son, 1884.
_____. "On the National Importance of Local Museums of Science and Art: An Address Delivered in . . . Birmingham, on the 21st Jan., 1874 . . . *Journal of the Society of Arts* 22, January 23, 1874: 166–171.
_____. Unsigned. "Public Galleries and Irresponsible Boards . . . ." *Edinburgh Review* 123 (January 1866): 29–42.
_____. "Speech to Art Students of Hanley." *Journal of the Society of Arts* 21, October 31, 1873: 912–915.
Cox, Trenchard. "History of the Victoria and Albert Museum and the Development of Its Collections." Royal Institution of Great Britain *Proceedings* 37 (Pt. 3, No. 167, 1959): 276–304.
Gibbs-Smith, Charles Harvard, compiler. *The Great Exhibition of 1851: A Commemorative Album.* London: His Majesty's Stationery Office, 1950. 143 pp.
Gibbs-Smith, Charles Harvard, and Katharine Dougharty. *The History of the Victoria and Albert Museum.* London: Victoria and Albert Museum, 1952.
Giedion, Sigfried. *Mechanization Takes Command: A Contribution to Anonymous History.* New York: Oxford University Press, 1948. 743 pp.
Greater London Council. *Survey of London, Volume XXXVIII: The Museums Area of South Kensington and Westminister.* F. H. W. Sheppard, general editor. London: Athloe Press, University of London, 1975. 465 pp. and 118 pp. of plates.
Hitchcock, Henry-Russell. *The Crystal Palace: The Structure, Its Antecedents and Its Immediate Progeny; an Exhibition Organized by Smith College Museum of Art and Massachusetts Institute of Technology.* Northhampton, Mass.: Smith College Art Museum and Massachusetts Institute of Technology, 1951. 39 pp.
_____. *Early Victorian Architecture in Britain.* 2 vols. New Haven: Yale University Press, 1954.
Hobhouse, Christopher. *1851 and the Crystal Palace: Being an Account of the Great Exhibition and Its Contents; of Sir Joseph Paxton; and of the Erection, the Subsequent History and the Destruction of His Masterpiece.* London: John Murray, 1937. 181 pp.
Hudson, Derek, and Kenneth W. Luckhurst. *The Royal Society of Arts, 1754–1954.* London: Murray, 1954. 411 pp.
*The Journal of Design with Numerous Illustrations.* 6 vols. London: Chapman and Hall, March 1849-February 1852 (monthly).
*The Journal of the Society of Arts, and the Institutions in the Union,* 1—. London: For the Society, November 1854—(weekly).
Levine, A. S. "The Journalistic Career of Sir Henry Cole." *Victorian Periodicals Newsletter* 8 (June 1975): 60–65.

Luckhurst, Kenneth W. *The Story of Exhibitions*. London, New York: Studio Publications, 1951. 221 pp.

Macdonald, Stuart. *The History and Philosophy of Art Education*. London: University of London Press, 1970. 400 pp.

Mill, Anna J. "Some Notes on Mill's Early Friendship with Henry Cole." *Mill News Letter* 4 (Spring 1969): 2–8.

Pevsner, Nikolaus. *Academies of Art: Past and Present*. Cambridge: Cambridge University Press, 1940. 323 pp.

———. *Studies in Art, Architecture and Design*. 2 vols. New York: Walker and Company, 1968.

Playfair, Lyon. *Memoirs and Correspondence*. . . . Edited by Wemys Reid. London, Paris, New York, and Melbourne: Cassel and Company, 1889. 487 pp.

Pope-Hennessy, John. "Interaction between National and Regional Museums." *Museums Journal* 75 (December 1975): 110–113.

Pound, Reginald. *Albert: A Biography of the Prince Consort*. New York: Simon and Schuster, 1973. 378 pp.

Robinson, John Charles. "On Our National Art Museums and Galleries." *Nineteenth Century* 32 (December 1892): 1021–1034.

———. "Our National Art Collections and Provincial Museums." *Nineteenth Century* 7 (June 1880): 979–994; 8 (August 1880): 249–265.

———. "Our Public Art Museums: A Retrospect." *Nineteenth Century* 42 (December 1897): 940–964.

———. "The Reorganization of Our National Art Museums." *Nineteenth Century* 44 (December 1898): 971–979.

Steegman, John. *Consort of Taste, 1830–1870*. London: Sidgwick and Jackson, 1950. 338 pp.

Strong, Roy. "Forty Years On: The Victoria and Albert Museum and the Regions." *Museums Journal* 75 (December 1975): vi–viii.

———. "The Victoria and Albert Museum—1978." *Burlington Magazine* 120 (May 1978): 272–276.

"Victoria and Albert Museum." *Architectural Review* 85 (June 1939): 273–274.

"Victoria and Albert Museum Special Issue." *Burlington Magazine* 120 (May 1978): 271–304.

Wood, Sir Henry Trueman. *A History of the Royal Society of Arts*. London: John Murray, 1913. 558 pp.

# 7

Ann Pamela Cunningham
and Washington's Mount Vernon:
The Historic House Museum

Fig. 15. Ann Pamela Cunningham (1816–1875), about 1866. *(Courtesy of the Mount Vernon Ladies' Association.)*

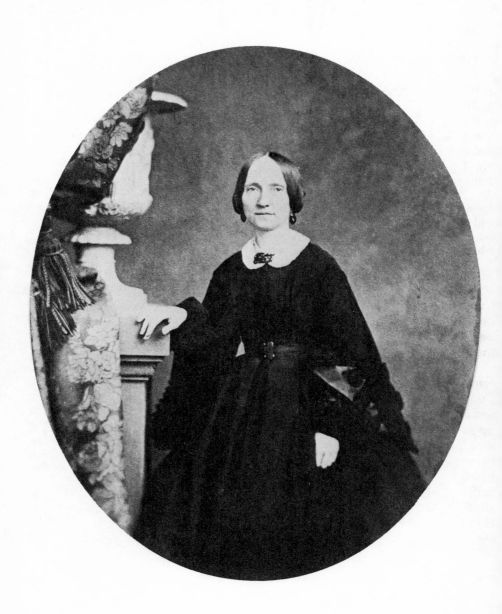

I

$\mathcal{H}$ RS. LOUISA BIRD Cunningham had left her invalid
daughter Ann Pamela at Philadelphia with Dr. Hodge for
medical treatment in the winter of 1853 and was returning to
her plantation, Rosemont, in South Carolina. As the steamboat on which
she was traveling down the Potomac passed Mount Vernon, the former
plantation home of George Washington, crewmen followed the custom of
tolling the ship's bell in memory of the great man. Mrs. Cunningham
went on deck and, in the bright moonlight, could see the dilapidated
mansion, its sagging columned portico, the decayed outbuildings, the
unkempt, overgrown grounds, and the tumbledown wharf. When she
got back to Rosemont, Mrs. Cunningham wrote her daughter in
Philadephia:

I was painfully distressed at the ruin and desolation of the home of Washington,
and the thought passed through my mind: Why was it that the women of his
country did not try to keep it in repair if the men could not do it? It does seem such
a blot on our country![1]

That suggestion, which Pamela Cunningham enthusiastically adopted
at once, was to change her life markedly. At age thirty-seven, Pamela
Cunningham had found a cause to which she could devote her fertile
imagination and abundant mental energy, her persuasive fervor and
personal charm, a cause that, in large measure, would enable her to lessen
the loneliness and pain of her invalid existence.

Ann Pamela Cunningham was born on Rosemont Plantation in Lau-
rens County, South Carolina, August 15, 1816. Her father, Captain Robert
Cunningham—he had served in the War of 1812—was master of a rich
and hansome up-country plantation. Her mother, born Louisa Bird, grew
up in Pennsylvania and had Virginia family connections. Pamela was
brought up with a governess and attended the South Carolina Female
Institute, a select boarding school at Barhamsville, near Columbia. Unfor-
tunately, at about age seventeen, she was thrown from a horse and
suffered injury to her spine. When local physicians could not cure her
affliction, she was taken to Philadelphia to be treated by Dr. Hugh Lenox
Hodge, a well-known surgeon specializing in women's diseases. The
exact nature of her infirmity is unknown; though not paralyzed, she was

179

often "confined to her couch" and experienced much pain. She spent considerable periods of treatment in Philadelphia and regarded Dr. Hodge as a second father.[2]

When Ann Pamela received her mother's suggestion that women ought to save Mount Vernon, she exclaimed: "I shall do it!" and sent off a letter that the *Charleston Mercury* printed on December 2, 1853. Addressed "To the Ladies of the South," it was signed, "A Southern Matron." The communication deplored the crass commercialism and industrialism that threatened to destroy Mount Vernon and urged Southern women to raise the money to purchase the estate and turn it over to the federal government and the commonwealth of Virginia. Money collected should be sent to the governors of the states for transmittal to the governor of Virginia, who would make the purchase. The property could be maintained through "a trifle . . . charged each visitor." Miss Cunningham's appeal reached its height when she wrote, in the flowery language of that day:

> A spontaneous work like this would be such a *monument* of love and gratitude, as has never yet been reared to purest patriot or mortal man; and while it would save American honor from a blot in the eyes of a gazing world, it would furnish a shrine where at least the *mothers* of the land and their innocent *children* might make their offerings, in the cause of the greatness, goodness, and prosperity of their country.[3]

That letter and another from the Southern Matron in the *Washington Union*, April 20, 1854, resulted in meetings of women in South Carolina, Georgia, Virginia, and Alabama, at which a few hundred dollars were raised.[4] The project, however, was too ill-defined; three things were needed to make it feasible: some kind of legal organization to assure its permanence, the agreement of the sensitive owner of Mount Vernon, John Augustine Washington, Jr., great-grandnephew of General Washington, to sell the property, and a practicable way to raise the money.

Miss Cunningham now demonstrated the ingenuity, flexibility, and leadership that were to fashion a women's organization that could achieve its purposes, despite the violent antifeminine prejudice of that day. The little blonde invalid maiden lady with the clear gray eyes was a master of the art of persuasion. She first got James L. Petigru, eminent Charleston lawyer, to draw a charter to transform the dispersed women volunteers into a legal entity. On March 17, 1856, the Virginia Legislature authorized the Mount Vernon Association to raise $200,000 to turn over to the commonwealth of Virginia for purchase of the mansion, tomb, garden, grounds, and wharf, some two hundred acres in all. The association could then operate the property under state supervision. There was opposition,

however, among some women backers of the movement; the Pennsylvania committee thought that the property ought to be held by the federal government, rather than by a single state. Miss Cunningham met the crisis by obtaining a new Virginia charter, March 19, 1858, that authorized the Mount Vernon Ladies' Association of the Union to purchase, hold, and operate the property with the governor of Virginia appointing five visitors to make an annual inspection. The two charters had met some opposition among the lawmakers, but well-organized bevies of women lobbied at social events and the legislative gallery to secure their passage.[5] Miss Cunningham also managed to overcome the objections of those who regarded the Mount Vernon movement as sectional. She dropped her "Southern Matron" anonymity and boldly signed her name to appeals. She argued that "Washington belonged not alone to the South! . . . not to one State alone!" and urged "ye women of the North and of the South, of the East and of the West . . . [to] rally to the work."[6]

Augustine Washington did not approve of the 1856 charter to the Ladies' Association and announced that he was withdrawing the property from sale. His whole role in the Mount Vernon transaction is somewhat puzzling. He lacked the resources to keep up the estate and yet did not want to sell it for hotel or industrial development; he asserted that he had turned down $300,000 from one group of speculators. He offered it to the federal government or the commonwealth of Virginia for $200,000, and his feelings were hurt when the price was considered exorbitant and he was criticized by the newspapers and the general public for being greedy.[7]

Miss Cunningham called on Washington at Mount Vernon, on a hot June day in 1856; she had been sick on the steamboat coming down from Washington and had to be carried up the steep hill from the landing in a chair. At first, she could not persuade Augustine Washington to sell, but, the next morning, when she missed the steamboat back to the capital city, failed to overtake it in a sailboat, and returned to the landing "almost dead," she took full advantage of the delay. As she told Washington how much she sympathized with him because "the public had behaved abominably toward him" and the Virginia legislature had framed the Ladies' Association charter "contrary to the terms he had expressed himself willing to accept," she observed "what a change in his face!" and realized that she "had at last touched the sore spot." She succeeded in convincing him that the association had not plotted with the legislature to humiliate him. She described the victory she believed she had won thus:

I held out my hand; he put his in mine; then, with quivering lips, moist eyes, and a heart too full for him to speak, our compact was closed in silence. . . . None

but God can know the mental labor and physical suffering that Mount Vernon has cost me.[8]

Still, it was not until the Virginia legislature had refused to pay him by issuing bonds (to be retired by the Ladies' Association) that John Augustine Washington signed the agreement to sell directly to the association, April 6, 1858. The ceremony took place in Richmond, with poor, ill Miss Cunningham on a low couch signing, she said, "with almost lifeless fingers" and then living "in a mental stupor for three weeks."[9] By now, it is clear how skillfully Ann Pamela used the sympathy stirred by her illness to forward her aims.

While these negotiations were going on, Miss Cunningham made her first great coup on the money-raising front. Edward Everett, of Massachusetts, then aged sixty-one, had been the first American to receive the degree of Doctor of Philosophy from a German university. Everett had served as Unitarian pastor and professor of Harvard, and he next became, in turn, congressman, governor of Massachusetts, minister to Great Britain, president of Harvard, and United States senator. The silver-tongued orator of his day, he could go on for two hours or so in a mellifluous and moving manner. (He later gave a long oration at Gettysburg, on the occasion when President Lincoln made his celebrated address). Deeply troubled by the increasingly bitter disputes between North and South, Everett hoped that emphasis upon George Washington, whom both sections could admire, would reduce the heat of conflict and foster a spirit of union. On February 22, 1856, he delivered a highly successful lecture at Boston on the character of Washington that stressed the general's role as builder of the Union. Everett repeated the speech at Richmond, the following March 19; Miss Cunningham was dramatically wheeled onto the stage on a couch to hear him. Everett had called on her in Philadelphia, on the way down, and the two of them hit it off immediately (he later wrote to her as "My dearest daughter" or "My dear little Pam" and signed himself, "Your poor old Papa"). He generously decided to donate the proceeds of the Richmond and subsequent Washington orations to the Mount Vernon cause. In the next three years, he spoke 129 times throughout the country as far west as St. Louis and also, for one year, wrote a weekly column for the *New York Ledger,* giving the $10,000 he received for the column to the Ladies' Association. Not only did he widely publicize the cause, but he paid his own expenses and set up a trust fund so that his contributions would earn interest until they were called for. All in all, Everett furnished $69,024 for the purchase of Mount Vernon—more than one-third of the contract price of $200,000.[10]

Ann Pamela Cunningham's enthusiasm enlisted Everett's support, but her sense of promotion and public relations used his talent skillfully, as illustrated in his Washington lecture at Charleston on April 13, 1858. He had been invited to speak there two years earlier, but the brutal beating that Congressman Preston Brooks of South Carolina gave Charles Sumner of Massachusetts on the floor of the Senate so inflamed sectional feeling that Everett wisely decided to postpone his lecture. Miss Cunningham lined up support for his appearance with unfailing good judgment, and when he finally spoke, the governor, mayor, and prominent judges were in the assemblage of two thousand, and the two newspapers, including the fire-eating *Courier,* carried lyrical praise of the oration. The audience paid $1,781.48 to hear it, the largest sum a single speech of his brought the Ladies' Association.[11]

## II

As soon as Pamela Cunningham had signed the contract for Mount Vernon with Augustine Washington, she gave her full attention to raising the purchase money. Her first concern was to perfect the organization called for under the charter of 1858. She visualized the Ladies' Association as a centralized, elitist organization with her, as regent, firmly in command and a viceregent in each state with a viceregent's own corps of lady managers in counties, towns, cities, and villages to assist in the money-raising. At Everett's suggestion, Miss Cunningham approached George Washington Riggs, a District of Columbia banker of great reputation, and persuaded him to become the association's treasurer. He furnished financial experience and organizational wisdom, and was especially valuable during the confused conditions of the Civil War.[12]

In choosing viceregents, Miss Cunningham consulted Everett and many other state leaders. Samuel Ruggles of New York pointed out to her that the viceregent's office required

a rare combination of qualities—fitness of character, personal acceptability to her State, Revolutionary connection, if possible, freedom from cares of a young family, sufficient health, pecuniary (affluence), knowledge of accounts, knowledge of women—and of men too. . . . In some respects young unmarried ladies are preferable, if possessing sufficient maturity and dignity.[13]

Miss Cunningham probably took the last sentence as a compliment, and she followed most of this advice. In her opinion, her viceregents comprised "a band of women combining such rare talent, such high cultivation of mind, such true, womanly delicacy and such liberal patrio-

tism as will make them hereafter distinguished as a sisterhood of whom the country may well be proud." She appointed thirty-one viceregents between 1858 and 1860. A few of them had already helped her raise money, as, for example, her "cousin" Mrs. Philoclea Edgeworth Casey Eve of Georgia and Mrs. Anna Cora Ogden Mowatt Ritchie of Virginia, a talented actress. Among the others were Madame Catherine Daingerfield Willis Gray Murat of Florida, grandniece of George Washington and widow of Prince Achille Murat, Napoleon Bonaparte's nephew, and Mrs. Louisa Ingersoll Gore Greenough of Massachusetts, widow of sculptor Horatio Greenough. Miss Mary Morris Hamilton of New York was the granddaughter of Alexander Hamilton and great-granddaughter of Robert Morris, the financier of the Revolution; Mrs. Margaret Ann Douglas Comegys of Delaware, wife of Chief Justice Joseph P. Comegys, became virtually acting regent during the Civil War; and Madame Lily Lytle Macalester Berghams (later Mrs. J. Scott Laughton) of Pennsylvania, wealthy wife of the Belgian Minister in Washington, afterwards was the one Miss Cunningham chose to succeed her as regent. The abilities, social standing, and practical contributions of the viceregents bear testimony to Miss Cunningham's sound assessment of character and persuasive leadership.[14]

The fund drive of the Ladies' Association is fully documented in the two volumes of the *Mount Vernon Record,* an illustrated monthly magazine published from July 1858 to June 1860. "Devoted to the Purchase of the Home and Grave of Washington," it was established through "the Patriotism of friends of the cause in Philadelphia" and published with the "Official Sanction of the Regent." The *Record* printed reports of the officers of the Ladies" Association, lists of all individual contributions to the Mount Vernon fund, and miscellaneous historical sketches, anecdotes, and verse that comprised "a complete Washingtoniana." The magazine cost one dollar per year, "invariably in advance," with any profit going to Mount Vernon, as was the case with its sales of copies of Gilbert Stuart's *Gold Mounted Portrait* of Washington, a similar portrait of Edward Everett, and an illuminated version of Washington's "Farewell Address." The *Mount Vernon Record* was a superb promotional and public relations device for newspapers and the general public, as well as for participants in the fund drive.[15]

The basic fund-raising of the Ladies' Association was solicitation of individuals by the viceregents and their numerous lady managers that usually brought in contributions running from $1.00 to $10.00, all carefully acknowledged in the *Record*. In addition, however, the ladies used

varied approaches to keep their cause before the public. The Masonic and Odd Fellows lodges were persuaded to make systematic collections for Mount Vernon, as also were fire companies, even those not named for Washington.[16] State legislators helped, giving individually or, in the instance of Missouri, appropriating $2,000.[17] The military responded well—elite infantry companies such as New York's Seventh Regiment ($2,000); West Point ($2.00 per cadet); Annapolis ($2.50 per midshipman); western military posts, for example, in Nebraska, Texas, New Mexico, and Oregon; and naval units such as the U.S. sloop of war *St. Mary's,* off Acapulco ($130).[18]

Private and public schools gave, and much was made of small contributions, as when a Georgia class of forty sent in $2.00. In fact, Susan Fenimore Cooper, the daughter of novelist James Fenimore Cooper, even wrote *A Letter to the Children of America* that contained the ringing exhortation:

> Children of America! The solemn guardianship of the home, and of the grave of General Washington is now offered to us, the women of the country. . . . And we, your countrywomen—your mothers, your sisters, your friends—would fain have you share with us this honorable, national service of love. . . . Whatever you may be enabled to give, be it a bright dime or clean copper, fresh from the mint, we ask that you give it feelingly—as a simple act of love and respect for the memory of the great man.[19]

Not only did newspaper editors and typographical societies donate, but the newsboys in New York remitted $4.18.[20] Subscriptions came from the Sandwich Islands (today Hawaii), Havana, and Paris.[21] Gifts from important persons were publicized—$50 from President James Buchanan; $500 from Washington Irving, a biographer of Washington; $50 from the merchant Alexander Stewart, who advised against reproducing Lady Washington's wedding dress for sale; and $1,000 from C. H. Marshall of New York, in memory of his Revolutionary grandfather, Captain Nathan Coffin.[22] Express companies carried packages of circulars and other bulky materials free of charge, and several railroads gave passes to the viceregents.[23]

Benefit theatrical performances were frequently staged for the Mount Vernon fund. Edwin Booth, Laura Keene ($500), Agnes Robertson Boucicault, Keller's Artistic Troupe in St. Louis ($178.75), Ullman's Festival ($1,200), and Sniffin's Campbell Minstrels ($100) were some of those listed.[24] Paul Murphy, the chess champion, while blindfolded bested four opponents simultaneously in Philadelphia and turned over $300.[25] Per-

haps even more fun for the lady managers were the special events they organized themselves, often on Washington's Birthday or July Fourth. They might call in Everett, William L. Yancey of Alabama, or some lesser orator and follow the lecture with a luxurious feast, or they might have a tableaux and supper, concert, fancy dress ball, or some more ambitious festival, once with a demonstration of telegraphy.[26] One of the more unusual contributions was $100 from Barber, Palmer and Company of New York, manufacturer of Mount Vernon Fine-Cut Chewing Tobacco.[27]

The money came pouring in. Miss Cunningham had paid Augustine Washington $18,000 down in April 1858 and had promised $57,000 for the next January 1 and $41,666.66 on each Washington's birthday from 1860 through 1862. She hoped, however, to pay off the entire amount by February 22, 1859, thus avoiding 6 percent interest payments on the sum outstanding. Though that objective was not quite met, by November 1859, Treasurer Riggs had paid all the principal except $6,666.66. He had at hand or in the state pipelines about $32,000, but delayed making the final payment because of the need to spend some $20,000 at Mount Vernon for repairs.[28]

Miss Cunningham estimated it would cost about $8,000 to $10,000 annually for maintenance, security, and repairs, of which admissions would bring in $1,500 to $2,000. She thus urged that the viceregents and lady managers redouble their efforts so as to raise $125,000 to $150,000 as an endowment for operating expenses. Everett thought that Congress might be prevailed upon to appropriate $100,000 to the endowment; and in April 1860, Miss Cunningham had Mrs. Riggs invite the legislators and their families to make an excursion by two steamboats to visit Mount Vernon. Viceregent Harriet Satterlee Fitch of Indiana, whose husband was in the Senate, thought that *"Truly this is our Valley Forge,"* and the association ladies were their most gracious and persuasive selves. The Marine Band played en route, and between two hundred and three hundred people listened to some of the legislators speak, on the piazza— with its rickety posts—on subjects that Mrs. Fitch called *"Dilapidation, decay, money, Association."* But congress appropriated nothing, and the approaching war kept the endowment drive from succeeding. Of the purchase price of $200,000, Massachusetts (including Everett) had collected $90,000; New York, under the skilled administration of Miss Hamilton, $30,000; Alabama, $10,000; California, $9,500; Pennsylvania, $9,000; North Carolina, $8,000; and the other states, lesser amounts.[29]

Augustine Washington, greatly impressed and pleased, made a notable contribution when he recommended as superintendent of the prop-

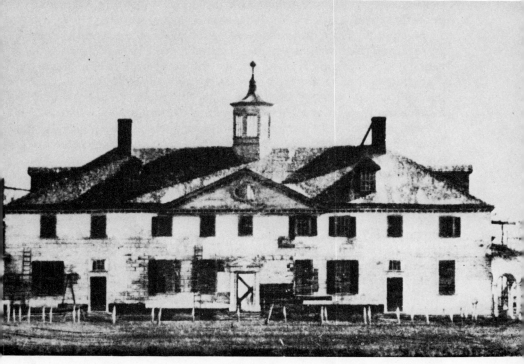

Fig. 16. Mount Vernon, about 1860. The Mount Vernon property as it appeared at the time when the Ladies' Association took it over. (*Courtesy of the Mount Vernon Ladies' Association.*)

erty Colonel Upton H. Herbert, of good Virginia family and a veteran of the Mexican War. Washington authorized the Ladies' Association to start preservation and maintenance work on the property at once; on July 1, 1859, Herbert began repairing outbuildings, cleaning paths, improving the road from the steamboat landing, and strengthening the wall around the garden.[30] By the next spring, Miss Cunningham was planning to live at Mount Vernon for a time; her mother's Victorian sensibilities were shocked by this "worse than wild scheme . . . when the Washington family will be away and none there but Mr. Herbert, a bachelor."[31] The daughter solved the problem by hiring as her secretary—on the recommendation of Mrs. Mary Booth Goodrich, viceregent of Connecticut—a level-headed, pretty secretary, Sarah C. Tracy of Troy, New York. Thus, in

December 1860, Miss Cunningham did move to Mount Vernon, but properly accompanied by Sarah Tracy and several servant girls.[32]

Meanwhile, basic decisions were being taken about Mount Vernon's preservation. Extravagant schemes were advanced for making it a proper national shrine. Some wished to save the mansion but tear down the outbuildings that had housed menials. Others advocated a hall-of-fame park filled with statues of the nation's illustrious leaders; a marble mausoleum instead of Washington's simple tomb; a new wharf with a colossal *arc de triomphe;* or an iron-and-glass dome like London's Crystal Palace, built over the mansion for its protection. An English architect suggested taking the house down, piece by piece, and replacing it with a marble-faced replica covered with a roof of white tiles.

Fortunately, Pamela Cunningham took a common-sense attitude toward preservation. From the beginning, she declared that the Ladies' Association would "preserve with sacred reverence" Washington's house and grounds "in the state he left them." Treasurer Riggs, after an inspection of the outbuildings with Superintendent Herbert, echoed this wise principle when he reported: "They should, I think, be repaired at once, retaining in them everything that can be retained and restoring them as nearly as possible to what they were in General Washington's days."[33] These sane plans were interrupted, however, by the outbreak of cataclysmic civil war.

## III

Miss Cunningham left Mount Vernon for Rosemont at Christmastime 1860, intending to return the following March. On the plantation at Rosemont, however, she found many problems. Her father had died in 1859, and her mother had no head for business; moreover, Mrs. Cunningham was a violent secessionist who urged her daughter to resign as regent and stop trying to maintain a personal neutrality in the mounting crisis. As the Civil War began, it was too late for Miss Cunningham to return to Mount Vernon, and she was to remain away for almost six years. No longer could she spend part of the summer, as had been her wont, in the cool breezes of Cape May. The responsibility of running the family plantation under wartime conditions made her more of a hypochondriac than ever; she complained that her hands were crippled with rheumatism, feared she was going blind, and often felt herself at death's door. She began to take larger doses of laudanum, an opium-compound pain-killer with hallucinogenic and addictive characteristics. The laudanum was

dissolved in alcohol, so that, in later years, Miss Cunningham sometimes appeared intoxicated.[34]

Fortunately for Mount Vernon, the shrine was in good hands. Upton Herbert stayed on as superintendent, turning down a Virginia army commission and keeping away from Washington and the federal lines lest he be imprisoned for refusing to take the loyalty test oath.[35] George W. Riggs was a strong support, always ready with sound advice and willing to advance his own money in financial emergencies. Best of all—in fact, indispensable for Mount Vernon's survival—there was Sarah Tracy.

Miss Tracy was about forty years old—small, slight, well educated at Emma Willard's ladies' seminary in Troy, New York, stylishly dressed, warm and gracious in manner, courageous and ingenious, and with a somewhat perverse sense of humor that the literal-minded Miss Cunningham did not always appreciate; she had lived in New Orleans as a governess and spoke good French. Once Sarah Tracy had moved permanently to Mount Vernon, in the spring of 1861 (Miss Mary McMakin of Philadelphia soon joined her, to make it proper for her to live near the bachelor superintendent), she continued the task of filling the rooms left bare when the Augustine Washingtons moved out. With the coming of the war, Mr. Riggs had Superintendent Herbert cut back the Mount Vernon working force to only two men, as an economy measure; and, though the mansion roof leaked badly, its repair was postponed for several months. The steamboat that brought visitors from Washington began to run fitfully and was eventually confiscated by the federal government; jittery Secretary of War Edwin M. Stanton feared that, in landing on Virginia soil, the boat might furnish an opportunity for espionage and treason. Miss Tracy continued to collect some twenty-five-cent admission fees, mainly from Northern soldiers who were admitted to the house and grounds, provided they stacked their arms outside the entrance.[36]

Mount Vernon was in a kind of no man's land, surrounded by federal troops but not attacked by the Confederates. Miss Tracy went to Washington, occasionally, to charm Generals Winfield Scott and George B. McClellan and even Mr. Lincoln, into preserving the plantation's neutrality and to receive support from Treasurer Riggs and from Mrs. Riggs, acting viceregent for the District of Columbia. She also journeyed to Alexandria (soon under federal control) to obtain passes for the servants to sell crops and obtain supplies. Miss Tracy was a good hostess who received Prince Napoleon, cousin of Napoleon III, and his party when they visited Mount Vernon; they were impressed by her excellent French and the tasty brunch that she served. She made bracelets from Kentucky

coffee beans strung on elastic and arranged bouquets to eke out the slender income from admissions.[37]

Miss Tracy was quick to reply with spirit to false rumors in the newspapers that General Washington's bones had been moved to the mountains of Virginia, that Miss Cunningham was "residing at Mount Vernon and entertaining her friends like a princess," that the shrine had been overrun by rebel bands, and that the Ladies' Association was operated by a secessionist. (It is true that, though the regent said she was determined to maintain an impartial neutrality, her letters showed that she believed propaganda reports such as the one that Northern troops carried thirty thousand pairs of handcuffs and plentiful halters with which to capture and hang Confederates). Miss Tracy, always loyal to the regent, wrote her weekly, begged her to express herself cautiously since her letters might be intercepted and published, and kept in touch with the viceregents, especially Mrs. Comegys, to whom the regent had told her to turn for advice. Miss Cunningham, on her part, appreciated Miss Tracy's services and wrote Mrs. Comegys in the fall of 1861: "Nothing could have prevented mischief or kept that spot as it is still kept, but for her firmness and courage. I am glad you urged her to stay. I have implored it. She has promised she will not fail. God bless her."

Miss Tracy at first asserted, "I am glad I have remained, but for my *own*, I have a thousand times wished I was in *China!*" Yet her letters show that she really enjoyed the excitement of her position, and she was a persistent and skillful problem solver. With cloak and dagger flourishes, she made her way to Washington or Alexandria, to see military commanders and sometimes had to take a round-about route past barricades and sentinels in order to get back. Once, while they were fishing off the Mount Vernon wharf to obtain their breakfast, Mary McMakin fell into the river, but was saved from drowning when Sarah took off her billowy skirt and threw one end of it to Mary. Another time, for four days, Sarah nursed a sick young lieutenant from a Michigan regiment who had collapsed on the grounds and was wild with delirium.

In 1864, a crisis occurred in the affairs of the Ladies' Association. Viceregent Hamilton of New York ordered the reluctant Miss Tracy to call in Washington for February 22 the annual meeting required by the association's constitution. Viceregents attended from Delaware, the District of Columbia, Indiana, Iowa, Maine, Michigan, New Jersey, New York, and Pennsylvania. The council elected Miss Tracy secretary of the association, but Miss Hamilton surprised the meeting by introducing a resolution (which had Mr. Everett's blessing) to turn Mount Vernon over to the

federal government "on condition that it shall be ever faithfully kept by them as a national treasure." She argued that the shaky financial situation of the Ladies' Association and the possibility of suit by its unpaid staff (Miss Tracy, Mr. Herbert, and others) made this move desirable. Not a single viceregent voted for the motion, and Miss Tracy afterwards assured Miss Hamilton that there was not the slightest danger of a suit from the staff. Miss Cunningham, when informed of the proceedings, was furious, and Miss Hamilton felt rebuffed and resigned as viceregent late in 1865.[38]

Mount Vernon had thus survived the war, chiefly because of the devoted service of Sarah Tracy and Upton Herbert. During the next eight years, while its prospects brightened somewhat, the sad decline of Miss Cunningham's health and her wavering judgment brought new threats to Mount Vernon's existence. By April 1866, the steamboat was arriving there three times weekly, with heavy patronage, and the photographs that Miss Tracy had had taken of the place, as well as her bouquets, were selling well. Though malaria spread by clouds of mosquitoes continued to fell Miss Tracy, Mr. Herbert, and their assistants, from time to time, they managed to keep the operation going.[39]

Miss Cunningham, now convinced that she had an organic heart disease, though her doctor told her it was a case of nerves, finally made a short visit north in November 1866, to hold a rather uneventful Grand Council, with only five viceregents present in addition to Treasurer Riggs and Secretary Tracy. Miss Cunningham, always interested in the latest styles, wrote Miss Tracy in advance that she had before her *Mme. Demaret's Fashion Book* for October and needed advice "to see that my head and neck gear are comme il faut." She had just lined and dressed her bonnet. The next year, she remarked that she had not had a new dress, bonnet, or cloak for eight years. Undoubtedly the war and her run-down plantation would make it difficult to keep up with the New York and Parisian frocks of some of the wealthy viceregents. Miss Tracy tried to give her sound advice: Kate, the seamstress could alter her bombazine; jet sets (brooch and earrings) were expensive, costing from ten to twenty dollars; caution should be used in shortening dresses, especially in back, for small hoops and long tails were in vogue.

The next Grand Council, in December 1867, was a fateful one. To everyone's amazement, Miss Cunningham asked that Miss Tracy be dismissed. Since she had wished to leave several times in the past, the regent asserted, she could do so now. Besides, the meeting called by Miss Hamilton in 1864 had appointed Miss Tracy secretary of the association illegally, when she actually was only Miss Cunningham's private secre-

tary. Mr. and Mrs. Riggs defended Miss Tracy warmly, as did some of the other viceregents, but Miss Cunningham threatened to resign unless she got her way. Thereupon, Miss Tracy resigned, as did also Mr. and Mrs. Riggs. Miss Cunningham tried to defend her action to two of the absent viceregents by misquoting some of Miss Tracy's earlier letters and insisting that she had intended to leave Mount Vernon as soon as its future was assured. It was a shameful way to reward Miss Tracy's great service. The kindest explanation is that the regent's declining health and increasing use of laudanum were responsible.[40]

After the meeting, Miss Cunningham continued to reside at Mount Vernon, and on her insistence, the Grand Council in November 1868 let Superintendent Herbert go as an economy measure. (Sarah Tracy and Upton Herbert, each aged fifty-three, were married in 1873). He took his furniture with him, thus denuding the mansion, but Mrs. Nancy Wade Halsted, the new viceregent from New Jersey, constructively moved that each viceregent from the original thirteen states be assigned a room to furnish and be responsible for raising the money for that operation. With the 1868 Grand Council, the viceregents began to meet for several days at Mount Vernon, bringing their own blankets, towels, silverware, and supplies. They sometimes slept three in a bed in the mansion and put umbrellas over their pillows when it rained. In 1869, Miss Cunningham, with her old persuasiveness, pushed an indemnity bill through Congress, giving the Ladies' Association seven thousand dollars for loss of revenue during the war while the steamboat was suspended. Expenditures had to be made through the federal superintendent of public buildings, however, and most of the fund went for rebuilding the greenhouse instead of making much-needed repairs to the mansion.[41]

Though Miss Cunningham's talents as organizer, promoter, and publicist had been great, in her ill health she now proved a poor day-to-day administrator. She could not keep an effective superintendent, and the newspapers became more and more critical about the way the shrine was run; one article accused the regent of holding Mount Vernon "for her own uses without rendering any account of expenditures and receipts." By 1870, the viceregents began to realize they must assume more responsibility. They selected a new superintendent, Colonel James McHenry Hollingsworth, and despite Miss Cunningham's strong resistance, finally managed to install him. In 1872, a committee of the viceregents (subsequently backed by the whole board) unanimously voted to ask the regent to reside no longer at Mount Vernon and to "refrain from all interference with the administration of finances and the management of the estate." Miss Cunningham was reluctant to relinquish power; she appeared at the

Fig. 17. Grand Council of the Mount Vernon Ladies' Association of the Union, 1873. Miss Cunningham faces Houdon's bust of Washington. *Left to right, standing:* Mrs. Barry (Illinois), Mrs. Walker (North Carolina), Mrs. Washington (West Virginia), Mrs. Halsted (New Jersey), Mrs. Emory (District of Columbia), Mrs. Chase (Rhode Island). *Seated:* Mrs. Mitchell (Wisconsin), Mrs. Brooks (New York), Mrs. Sweat (Maine), Miss Cunningham, Mrs. Comegys (Delaware), Mrs. Eve (Georgia). *(Courtesy of the Mount Vernon Ladies' Association.)*

Grand Council of 1873 to announce that her resignation would take place the next year and to appoint Madame Berghmans to act pro tem.[42]

Miss Cunningham had returned to Rosemont and was too feeble to attend the Council of 1874 (she died May 1, 1875), but she, like her great hero, had composed a farewell address that she sent along to be read at the meeting.[43] Since 1907, it has been repeated at the opening of each council and reprinted in each *Annual Report* of the Ladies' Association. One of its paragraphs contains the stern admonition:

Ladies, the home of Washington is in your charge. See to it that you keep it the home of Washington! Let no irreverent hand change it; no vandal hands desecrate it with the fingers of *progress*. Those who go to the home in which he lived and

died, wish to see in what he lived and died! Let one spot in this grand country of ours be saved from "change"! Upon you rests this duty.[44]

<p style="text-align:center">IV</p>

Ann Pamela Cunningham's impact on the historic house movement in the United States was great. She had furnished imaginative and energetic leadership to organize and plan, to enlist help from many sources in raising money, to promote, publicize, and lobby. She had proved the practical worth of a privately controlled, self-perpetuating cultural organization. Mount Vernon became the model that similar historical projects sought to emulate, and all over the country they began to refer to themselves as "second only to Mount Vernon." Valley Forge and Stenton in Pennsylvania, the Hermitage in Tennessee, the William Henry Harrison House in Indiana, the George Walton House in Georgia, Abraham Lincoln's log-cabin birthplace in Kentucky, and in Virginia, Jefferson's Monticello, the Lees' Stratford, and George Mason's Gunston Hall were a few of those inspired by what Mount Vernon had accomplished.[45]

Historic houses had occasionally been preserved in Europe, but usually with government aid. Nor were all American historic houses saved by private organizations. In fact, the first successful one, the Hasbrouck House in Newburgh, New York, that opened in 1850, failed to obtain private support and was preserved by the state of New York. This little rough stone house, built by Jonathan Hasbrouck about 1750, had served as General Washington's headquarters from the spring of 1782 until the late summer of the next year. The general was living in this house when his dissatisfied and unpaid officers resolved upon a military coup to make him an American king, and he wrote there the speech in which he angrily reprimanded his comrades for daring to think of betraying the republican cause for which they were fighting. Later, at the news of peace, he quietly said goodbye to his weeping soldiers on the front lawn.

The grandson of the builder mortgaged the house in 1837 for a two-thousand-dollar loan from the commissioners of the United States Deposit Fund and, when he could not pay the interest, the state comptroller foreclosed the mortgage in 1848. Several years earlier, a committee that included Washington Irving had tried in vain to raise the purchase money. They argued that

No traveller who touches upon the shores of Orange County [the house has a magnificent view of the Hudson], will hesitate to make a pilgrimage to this beautiful spot, associated as it is with so many delightful reminiscences of our

early history. And if he have an American heart in his bosom, he will feel himself to be a better man; his patriotism will kindle with deeper emotion; his aspirations for his country's good will ascend from a more devout mind, for having visited "Headquarters of Washington."[46]

Commissioner Andrew J. Caldwell of Blooming Grove, the state-appointed custodian of the property, was the hero in saving the Hasbrouck House. He refused to sell it privately and appealed to Governor Hamilton Fish, who urged the New York Legislature to approve its purchase. On April 10, 1850, the legislature appropriated $2,391.02 to satisfy the mortgage, an additional $6,000 to buy land formerly part of the house plot, $500 for a flagstaff, and $100 for an American flag to bear Daniel Webster's words: "Liberty and Union, now and forever, one and inseparable." The state agreed to maintain and operate the house and made the Newburgh Village Board of Trustees custodians. They were "to keep it as it was during General Washington's occupancy." (The Hasbrouck House is today part of the New York State Park system).[47]

Thus, American historic houses from the beginning have been supported either by governmental agency, private nonprofit organization, or by some compromise arrangement between the two. The majority of them, however, have chosen the private form, a decision upon which Mount Vernon has had much influence. After all, Washington's plantation home was a potent symbol and was situated near the national capital, where it received maximum exposure. American historic houses, no matter how organized, however, were from the first popularly supported institutions, close to the grassroots and even more influential as their mission shifted from patriotic shrine to public education. Today there are about two thousand of them in this country.[48]

Miss Cunningham's success at Mount Vernon was important also in the history of women's rights. Her main organization of regent and viceregents was entirely female, and while the *Mount Vernon Record* talked about having each contributor to the fund become a member of the Ladies' Association, nothing was done to implement the idea. Miss Cunningham herself made the important decisions for the association, though the viceregents advised and assisted her. (They even became independent and powerful enough to force her resignation in the last deteriorating years of her life). Men were called upon, when they could be useful—Petigru, to draw the charter; Everett, to raise money; Riggs, to handle accounts as treasurer; a small male advisory committee, and, of course, legislators to get bills through the Virginia General Assembly or Congress. But no one could deny that women saved Mount Vernon,

when state and federal governments had failed. The Ladies' Association also inspired women to work in other movements with broader aims than preserving a single house; the Daughters of the American Revolution and the National Society of Colonial Dames of America are only two of many examples.[49]

Not that the feminine victory at Mount Vernon had been an easy one. John Augustine Washington himself had hesitated to sell to the association, because he doubted that a group of women could raise the money or administer the property. The association suffered frequent newspaper attacks, partially because some writers thought charging twenty-five cents admission to visit a national shrine was wrong, but mainly because the project was run entirely (many attackers thought autocratically) by women. Still, Mount Vernon proved that practical, imaginative, and energetic women were abundantly able to plan an important and complex project, raise the money for its purchase and operation, and run it effectively, year after year.

From the point of view of historical preservation, Miss Cunningham's conservative policy of trying to keep Mount Vernon as Washington knew it was a wise one. Little was understood in that day of the need for sound historical research in order to obtain authenticity of buildings, grounds, furnishings, and interpretation. By moving slowly and carefully, the Ladies' Association did little irremediable harm to the buildings and their exterior and interior settings. General Nathaniel Michler, federal superintendent of public buildings, perhaps fortunately spent most of the steamboat indemnity on rebuilding the greenhouse and made few changes in the mansion.[50]

Furnishing the house presented great problems. When the Washingtons moved out of Mount Vernon in 1860, the rooms were left almost bare, and Miss Tracy was dispatched to New York to buy carpets, furniture, and furnishings, including table and kitchen ware, so that the regent and her assistants could live comfortably. The only original pieces in the mansion were Houdon's bust of Washington, the terrestrial globe he had ordered from London in 1789, and the key to the Bastille sent him by Lafayette. But the drive to obtain furnishings that actually had been there in Washington's day began early and soon gained strength. The first gift came from a Washington collateral descendant in 1859, the harpsichord that the general had given Nelly Custis before her wedding. After 1868, the viceregents furnished the rooms assigned to them with a mixture of antique and contemporary materials, and the situation was

even more confused when the regent lived in the mansion, as did some of the viceregents during council meetings.

Miss Cunningham had some instinct for authenticity. In 1869, she painfully crawled up the staircase and found seven layers of wallpaper in one bedroom. The inside paper was yellow, and since a document in Washington's handwriting mentioned one blue and one yellow bedroom, she decided that this was the yellow one. Not until much later, between 1979 and 1982, was Mount Vernon to receive careful scientific and historical research of its paint colors that restored them closely to what they had been in Washington's day and that set an example for other historic houses and similar museums to follow. But in the early days, she and the viceregents were almost entirely dependent upon their own taste, and no one knew much about historical styles in the decorative arts; the practice of leaving the furnishing of rooms to individual viceregents was not discontinued until 1910. The whole council sometimes did no better than the individuals; it accepted the gift of Rembrandt Peale's mammoth equestrian *Washington Before Yorktown* (1823), said to be worth ten thousand dollars and bestowed in 1873 by Peale descendants. The portrait had never been in the mansion, of course, and had been intended for the Rotunda of the Capitol; the huge canvas (121 by 139 inches) was out of scale with the room and ruined it artistically. Fortunately, perhaps, dampness from the window in front of which it was placed was harming the painting, and the ladies had an excuse to deposit it in the Corcoran Gallery of Art in 1902.[51]

As early as the 1890s, the Ladies' Association faced practical landscape problems that included draining and filling malarial swampland, building a sturdy seawall, and trying to prevent landslides into the Potomac. In 1901, Mrs. Justine Van Rensselaer Townsend of New York, the third regent, invited Charles Sprague Sargent, director of the Arnold Arboretum at Jamaica Plain, Massachusetts, to make suggestions about Mount Vernon trees. Dr. Sargent was intrigued with the opportunity to preserve and plant the kinds of trees and shrubs that Washington had known, and he generously agreed to serve without fee, provided the ladies would give him a free hand and not interfere with his decisions. That stipulation was too much for the strong-minded viceregents, and Sargent was not retained. In 1909, Miss Harriet Clayton Comegys of Delaware, the fourth regent, reversed the decision, and Sargent began work on the plantings, though he had to remind the regent that "the removal of every worthless tree" ought not "be passed on by a Committee

of the Council, the members of which cannot be expected to have technical knowledge about trees and their requirements and prospects of long life." Sargent had found a determined and clever ally in Miss Comegys, and they usually managed to outwit Superintendent Dodge and the viceregents.

Sargent studied the voluminous plans, letter, diaries, and other Washington materials that the association sent him and in 1917 submitted a report, which pointed out that

no trees planted by man have the human interest of the Mount Vernon trees. They belong to the nation and are one of its precious possessions. No care should be spared to preserve them, and as they pass away they should be replaced with trees of the same kinds, that Mount Vernon may be kept for all time as near as possible in the condition in which Washington left it.

Though Washington's gardens were not restored until 1933, Mount Vernon by then had been an important model in historical landscape and horticultural matters for other preservation projects, a pioneer in forwarding the principle of using historical garden design and period plantings.[52]

The project was slow to take a leading role in the movement to use historic houses to teach American social history and to interpret the way of life of a historical period. Miss Cunningham regarded Mount Vernon as a shrine, a holy place to be guarded and preserved intact. She was sure that the exterior of the mansion, its beautiful situation on the Potomac, and the tomb would tell their own story and stir a sense of patriotism in almost any visitor. While historical research was desirable and authentic furnishings should be gathered, they would add only small refinements to the picture of Washington's plantation. Miss Cunningham regarded as minor matters her personal use of three important rooms in the mansion, leaving other rooms bare, and then turning over their furnishing to the individual tastes of the viceregents. And though she enjoyed taking important visitors such as members of Congress or foreign dignitaries about the plantation and charming them with her enthusiasm, the ordinary tourist was given almost no guidance.

The governance of Mount Vernon presented certain peculiarities. Most authorities agree today that the board of trustees of a nonprofit museum should give its attention to securing and budgeting funds, selecting a director or administrator, and determining general policies for the conduct of the organization. The board should leave the day-to-day administration to the administrator, who should select and supervise the staff in accordance with accepted professional standards. The board

should act as a body and be careful to speak to the public through its chairman and to the staff through the director. Obviously, Ann Pamela Cunningham did not operate according to these principles, and many of her difficulties with Miss Tracy, Mr. Herbert, Mr. Hollingsworth, and others arose because of her insistence on having her way in the smallest detail. After 1867, when she was living at Mount Vernon, she also indiscriminately mixed association and personal funds, a practice that today would be decried as conflict of interest. She was, however, feeling her way in an ill-defined field and should not be judged too harshly by modern-day standards. Nor should her accomplishments be assessed with too much emphasis on her later career, when her always-frail health was deteriorating and she was using heavy sedation to try to dull the pain.

The Ladies' Association, since Miss Cunningham's day, has conformed more closely to accepted canons of governance. In 1885, Harrison Howell Dodge became its third superintendent and filled the post with ability and devotion, tact and good humor, for fifty-two years. Dodge provided the professional administrative skill the association required. Having worked in a bank, he understood accounting and financial matters. Decisive and yet sensitive and friendly, he was skilled at handling personnel. His courtly manner and wry humor pleased the Association Ladies and impressed visiting heads of state and other notables. He not only ran Mount Vernon well, from day to day, but made occasional major contributions. He persuaded Jay Gould to donate thirty-three and a half acres containing a hill that overlooked the plantation and Christian Heurich to give four acres of Hell Hole swampland that had brought malaria to Washington and his successors, including the association staff, until it was drained in 1912. All in all, Dodge secured, from various donors, two hundred and sixteen acres to add to the original two-hundred-acre tract.[53]

Charles Cecil Wall assisted Dodge for eight years, beginning in 1929, and then succeeded him as resident director, 1937–1976. Trained in economics at the University of Pennsylvania, Mr. Wall was also deeply interested in American history, a competent researcher and discriminating writer. He proved an efficient and tactful administrator and greatly refined the project, bringing buildings, grounds, and furnishings ever closer to their appearance in Washington's day. The association obtained originals or copies of all pertient Washington manuscripts, built a fine research library, and helped publish Washington's diaries and papers. Strict standards of preservation were observed at the mansion, the rebuilt greenhouse and slave quarters, and other outbuildings, under the direc-

tion of a competent restoration architect. A constant search went on for original furnishings, and much progress was made in achieving historically authentic rooms. Washington's gardens were rebuilt, their authenticity buttressed by documentary and archaeological research. Many excellent books on Mount Vernon and its history were issued, as well as two films that were widely distributed. For two years, the project staged "The Father of Liberty," a *son et lumière* dramatization that France gave the American people in 1976 as a bicentennial gift. Mr. Wall also took an active part in the fight to preserve the all-important vista across the Potomac as Washington knew it. In fact, he regarded the establishment of Piscataway National Park to keep this unspoiled view of the opposite Maryland shore as the major contribution of his forty-seven years of service.[54] Thus, the Ladies' Association since 1885 has enjoyed excellent professional leadership.

Miss Cunningham's contributions to the historic house movement in the United States had great significance for both history museums and historic preservation. Historic houses have constituted the most numerous and certainly one of the most successful kinds of history museums in this country. They also—for more than a half a century—were the chief American form of historic preservation, though leadership in that field may have passed now to historical villages such as Colonial Williamsburg and Old Sturbridge Village and to historic districts for contemporary residential and sympathetic or adaptive uses (Charleston and New Orleans in the 1930s were pioneers in this area). In any event, the National Trust for Historic Preservation was right in 1960 in presenting the first Louise du Pont Crowninshield Award for superlative achievement in the preservation and interpretation of historical properties to the Mount Vernon Ladies' Association of the Union, "which laid the foundation stone of today's conservation achievements through the first example of historic preservation by a private society in the United States."[55] Though Ann Pamela Cunningham might have appreciated more sentimental language in the citation, she would have been proud to see her brainchild so honored and to know that the organization that she had built was continuing its great work of preservation.

## NOTES

1. Grace King, *Mount Vernon on the Potomac*, p. 18; Elswyth Thane, *Mount Vernon Is Ours*, pp. 15–16; Gerald W. Johnson, *Mount Vernon: The Story of a Shrine*, pp. 3–4.

2. King, *Mount Vernon on the Potomac*, pp. 14–18; Thane, *Mount Vernon Is Ours*, pp. 14–15, 267; Johnson, *Story of a Shrine*, pp. 8–10; Charles C. Wall, "Ann Pamela Cunningham: First Lady of Preservation," p. 10; Mount Vernon Ladies' Association, *Historical Sketch of Ann Pamela Cunningham*, "*The Southern Matron*"; Mount Vernon Ladies' Association, *Catalogue of the Centennial Exhibition Commemorating the Founding . . . , 1853–1953*, pp. 6, 24.

3. King, *Mount Vernon on the Potomac*, pp. 18–23; Thane, *Mount Vernon Is Ours*, p. 16; Johnson, *Story of a Shrine*, pp. 10–12; Mount Vernon Ladies' Association, *Centennial Exhibition*, p. 25.

4. Thane, *Mount Vernon Is Ours*, pp. 17–28; Mount Vernon Ladies' Association, *Illustrated Mount Vernon Record*, 2 vols., 2: 124, 146, 178.

5. King, *Mount Vernon on the Potomac*, pp. 47, 52–54; Thane, *Mount Vernon Is Ours*, pp. 38–40, 60, 66–74; Johnson, *Story of a Shrine*, pp. 17–19; Thomas Nelson Page, *Mount Vernon and Its Preservation, 1858–1910*, pp. 30–39.

6. *Mount Vernon Record*, 1 (July 1858): 1; Mount Vernon Ladies' Association, *Centennial Exhibition*, p. 28.

7. Thane, *Mount Vernon Is Ours*, pp. 8–13; Johnson, *Story of a Shrine*, pp. 14–16; Mount Vernon Ladies' Association, *Centennial Exhibition*, pp. 22–24, 26.

8. King, *Mount Vernon on the Potomac*, pp. 44–47; Thane, *Mount Vernon Is Ours*, pp. 40–46; Johnson, *Story of a Shrine*, pp. 19–21; Mount Vernon Ladies' Association, *Centennial Exhibition*, pp. 26–27.

9. King, *Mount Vernon on the Potomac*, pp. 47–49; Thane, *Mount Vernon Is Ours*, pp. 73–74; Johnson, *Story of a Shrine*, pp. 21–22; *Mount Vernon Record*, 1 (July 1858): 1, 4; Mount Vernon Ladies' Association, *Centennial Exhibition*, p. 30.

10. King, *Mount Vernon on the Potomac*, pp. 36–41; Thane, *Mount Vernon Is Ours*, pp. 29–37, 62–64; Johnson, *Story of a Shrine*, pp. 12–13, 16–17; Charles B. Hosmer, Jr., *Presence of the Past*, pp. 46–48; Mount Vernon Ladies' Association, *Centennial Exhibition*, pp. 48–51.

11. John B. Riggs, "Everett's Visit to Charleston," Mount Vernon Ladies' Association *Annual Report*, 1953: 33–42; Hosmer, *Presence of the Past*, p. 47; *Mount Vernon Record*, 1 (March 1859): 93.

12. Thane, *Mount Vernon Is Ours*, pp. 77–78; King, *Mount Vernon on the Potomac*, p. 81; Johnson, *Story of a Shrine*, p. 34; Hosmer, *Presence of the Past*, pp. 49–50; Mount Vernon Ladies' Association, *Centennial Exhibition*, pp. 54–56.

13. Thane, *Mount Vernon Is Ours*, pp. 78–79. Compare King, *Mount Vernon on the Potomac*, p. 78; Johnson, *Story of a Shrine*, p. 35.

14. Elswyth Thane has carefully examined the backgrounds of each viceregent in *Mount Vernon Is Ours*, pp. 17–27, 50–59, 79–82, 91–97, 103–104, 106–109, 173–175, 201–203. See also King, *Mount Vernon on the Potomac*, pp. 71–81; Johnson, *Story of a Shrine*, pp. 34–38; Mount Vernon Ladies' Association, *Centennial Exhibition*, pp. 8–19, 34–35, 77–78.

15. *Mount Vernon Record*, esp. 1: 1, 4–5, 8, 12, 18, 22, 72; 2: 17; Mount Vernon Ladies' Association, *Centennial Exhibition*, pp. 32–58.

16. *Mount Vernon Record*, 1: 6, 13–14, 95, 117, 142–145.

17. *Mount Vernon Record*, 1: 21, 95, 96.

18. *Mount Vernon Record*, 1: 77, 97, 117, 178; 2: 44.

19. *Mount Vernon Record*, 1: 21, 38, 43, 117; Susan Fenimore Cooper, *Mount Vernon: A Letter to the Children of America* (New York: D. Appleton, 1859), pp. 68–69; Mount Vernon Ladies' Association, *Centennial Exhibition*, p. 43.

20. *Mount Vernon Record*, 1: 141; 2: 147.

21. *Mount Vernon Record*, 1: 89, 175; 2: 61.

22. *Mount Vernon Record,* 1: 21, 61, 97; 2: 59.

23. *Mount Vernon Record,* 1: 6, 14–15, 22, 30, 116, 117.

24. *Mount Vernon Record,* 1: 54, 89.

25. *Mount Vernon Record,* 2: 120.

26. *Mount Vernon Record,* 1: 21, 77, 97, 116, 117.

27. *Mount Vernon Record,* 2: 29.

28. *Mount Vernon Record,* 1: 1, 4, 46; 2: 84.

29. Johnson, *Story of a Shrine,* p. 24; Thane, *Mount Vernon Is Ours,* pp. 136–141; Mount Vernon Ladies' Association, *Centennial Exhibition,* p. 59.

30. *Mount Vernon Record,* 2: 19; Thane, *Mount Vernon Is Ours,* pp. 118–123; Hosmer, *Presence of the Past,* p. 52.

31. "Mrs. Cunningham Protests," Mount Vernon Ladies' Association *Annual Report, 1967:* 32–33.

32. Thane, *Mount Vernon Is Ours,* pp. 110, 127–130.

33. "Restoration in Retrospect," Mount Vernon Ladies' Association *Annual Report, 1958:* 14–18; Elswyth Thane, *Mount Vernon: The Legacy,* pp. 42–43.

34. Thane, *Mount Vernon Is Ours,* pp. 86, 128, 143, 162–165, 183, 266, 277–278, 285–286; *Mount Vernon Record,* 2: 5.

35. Thane, *Mount Vernon Is Ours,* p. 190.

36. Thane, *Mount Vernon Is Ours,* pp. 170, 173, 186, 198, 227, 241–242; Johnson, *Story of a Shrine,* pp. 25–27. For Miss Tracy's delightful correspondence during the war, see Dorothy Troth Muir, *Presence of a Lady;* Mount Vernon Ladies' Association, *Centennial Exhibition,* pp. 61–70.

37. Thane, *Mount Vernon Is Ours,* pp. 188–189, 197–198, 218–223, 231–232, 264, 281.

38. Thane, *Mount Vernon Is Ours,* pp. 192–193, 201–203, 212–217, 224, 234–236, 246–247, 252–262, 265–266, 269, 271–272, 276, 302–303; Johnson, *Story of a Shrine,* p. 45; Hosmer, *Presence of the Past,* pp. 52–53.

39. Thane, *Mount Vernon Is Ours,* pp. 287–293, 301–302, 306, 323.

40. Thane, *Mount Vernon Is Ours,* pp. 305, 312–318, 322, 326, 329, 331–346.

41. Thane, *Mount Vernon Is Ours,* pp. 344, 349–357, 362–364, 370–372; Thane, *Mount Vernon: The Legacy,* pp. 68, 76–77; Hosmer, *Presence of the Past,* p. 53.

42. Thane, *Mount Vernon Is Ours,* pp. 416, 429–430.

43. Thane, *Mount Vernon Is Ours,* pp. 439–443.

44. Thane, *Mount Vernon Is Ours,* pp. 442–443; Mount Vernon Ladies' Association *Annual Report, 1977:* 48–49; Hosmer, *Presence of the Past,* p. 54; Mount Vernon Ladies' Association, *Centennial Exhibition,* p. 5.

45. Hosmer, *Presence of the Past,* pp. 57–62.

46. New York (State) Legislature, Assembly, *Select Committee on the Petition of Washington Irving and Others to Preserve Washington's Headquarters in Newburgh.* No. 356, March 27, 1839, pp. 1–5.

47. Richard Caldwell, *A True History of the Acquisition of Washington's Headquarters at Newburgh, by the State of New York* (Salisbury Mills, N.Y.: Stivers, Slausen, & Boyd, 1887), pp. 7–41; Amos Elwood Corning, *The Story of the Hasbrouck House, Washington's Headquarters, Newburgh, New York* (Newburgh: Board of Trustees, 1950); Hosmer, *Presence of the Past,* pp. 35–37.

48. American Association of Museums, *The Official Museum Directory, 1981* (Skokie, Ill.: American Association of Museums, 1981), pp. 1,035–1,045.

49. Hosmer, *Presence of the Past,* p. 62.

50. Thane, *Mount Vernon Is Ours,* p. 362.

51. Thane, *Mount Vernon Is Ours,* pp. 12, 117, 148–154, 375, 388, 433–435; Thane, *Mount Vernon: The Legacy,* pp. 5, 94, 115; Gustavus A. Eisen, *Portraits of Washington,* 3 vols. (New York: R. Hamilton & Associates, 1932), 2: 419–420; Mount Vernon Ladies' Association, *Centennial Exhibition,* p. 31.

52. Mount Vernon Ladies' Association *Annual Report, 1894:* 7; *1895:* 6–7; *1900:* 12; *1903:* 14; *1904:* 6–7; *1915:* 10–11; *1917:* 46–60; *1934:* 12–16; Mount Vernon Ladies' Association, *The Mount Vernon Gardens;* Thane, *Mount Vernon: The Legacy,* pp. 198–209; Stephane Barry Sutton, *Charles Sprague Sargent and the Arnold Arboretum* (Cambridge, Mass.: Belknap Press, 1970), pp. 310–312; Mount Vernon Ladies Association, *Centennial Exhibition,* pp. 77–78.

53. Thane, *Mount Vernon: The Legacy,* pp. 1–15, 131–132, 175–178, 181, 184–185. For Dodge's amusing personal recollections, see Harrison Howell Dodge, *Mount Vernon: Its Owner and Its Story.*

54. Thane, *Mount Vernon: The Legacy,* pp. 12, 25–26, 62, 154, 213, 221; Charles Cecil Wall, "The Mount Vernon Experience," pp. 18–23; Charles Cecil Wall, "A Thing of the Spirit," pp. 13–19.

55. *Historic Preservation* 12 (1960): 152; Mount Vernon Ladies' Association *Annual Report, 1960:* 2, 8.

## SELECT BIBLIOGRAPHY

Dodge, Harrison Howell. *Mount Vernon: Its Owner and Its Story.* Philadelphia and London: J. B. Lippincott, 1932. 232 pp.

Hosmer, Charles B., Jr. *Presence of the Past: A History of the Preservation Movement in the United States Before Williamsburg.* New York: G. P. Putnam's Sons, 1965. 386 pp.

Johnson, Gerald W. *Mount Vernon: The Story of a Shrine; an Account of the Rescue and Rehabilitation of Washington's Home by the Mount Vernon Ladies' Association Together with Pertinent Extracts from the Diaries and Letters of George Washington . . . Selected and Annotated by Charles Cecil Wall.* New York: Random House, 1953. 122 pp.

King, Grace. *Mount Vernon on the Potomac: History of the Mount Vernon Ladies' Association of the Union.* New York: Macmillan, 1929. 491 pp.

Lossing, Benson J. *The Home of Washington; or Mount Vernon and Its Associations, Historical, Biographical, and Pictorial.* Hartford, Conn.: A. S. Hall, 1870. 446 pp.

Mount Vernon Ladies' Association of the Union. *Annual Report* (title varies), *1858, 1866–1868, 1870, 1872—.* Mount Vernon, Va.: MVLAU.

———. *Catalogue of the Centennial Exhibition Commemorating the Founding . . . 1853–1953.* Mount Vernon: MVLAU, 1953. 84 pp.

———. *Historical Sketch of Ann Pamela Cunningham, "The Southern Matron," Founder of the Mount Vernon Ladies' Association.* Jamaica, N.Y.: Marion Press, 1903. 49 pp.

———. *Illustrated Mount Vernon Record . . . , July 1858–June 1860,* 2 vols. Philadelphia: Devereux and Company, 1859–1860.

———. *Mount Vernon: An Illustrated Handbook.* Mount Vernon, Va.: MVLAU, 1972. 115 pp.

———. *The Mount Vernon Gardens, with Notes Pertaining to the Domestic Life of George and Martha Washington.* Mount Vernon, Va.: MVLAU, 1941, 40 pp.

Muir, Dorothy Troth. *Presence of a Lady: Mount Vernon, 1861–1868.* Washington, D.C.: MVLAU, 1946. 90 pp.

Page, Thomas Nelson. *Mount Vernon and Its Preservation, 1858–1910: The Acquisition, Restoration, and Care of the Home of Washington by the Mount Vernon Ladies' Association of the Union for Over Half a Century.* Mount Vernon, Va.: MVLAU, 1910. 84 pp.

"Restoration in Retrospect," Mount Vernon Ladies' Association *Annual Report, 1958:* 14–18.

Thane, Elswyth (Mrs. William Beebe). *Mount Vernon Is Ours: The Story of Its Preservation.* New York: Duell, Sloan and Pearce, 1966. 467 pp.

———. *Mount Vernon: The Legacy. The Story of Its Preservation and Care Since 1885.* Philadelphia and New York: J. B. Lippincott, 1967. 241 pp.

Wall, Charles Cecil. "Ann Pamela Cunningham: First Lady of Preservation." Mount Vernon Ladies' Association *Annual Report, 1975:* 10–17.

———. "The Mount Vernon Experience." *Museum News* 38 (September 1959): 18–23.

———. "A Thing of the Spirit." *Museum News* 46 (February 1968): 13–19.

Wilstach, Paul. *Mount Vernon: Washington's Home and the Nation's Shrine.* Garden City, N.Y.: Doubleday, Page, 1916. 301 pp.

8

# Wilhelm Bode
# and Berlin's Museum Island:
# The Museum of World Art

Fig. 18. Wilhelm von Bode, about 1910. Dr. Bode stands beside a portrait head, sculptured by an unidentified artist. *(Courtesy of Dr. Rudolf Rimpau.)*

N 1872 a dynamic, somewhat imperious young man, Dr. Wilhelm Bode, became assistant at the Prussian Royal Picture Gallery in Berlin. Born at Calvörde in the Prussian province of Braunschweig (Brunswick) on December 10, 1845, he grew up in the Harz mountain region and spent much time in the open air. As a youngster, he suffered a severe illness that left him with migraine headaches, stomach upsets, and a circulatory weakness that brought him occasional periods of sickness throughout his long life. His father, a member of the Reichstag, and his grandfather, a mayor of Braunschweig, were lawyers who held government posts, and thus Wilhelm was sent to study jurisprudence at the universities of Göttingen and Berlin; he received his law degree in 1867. Though he took a position as auditor in the Braunschweig government, his heart was not in it, and he resigned in 1869. He later often jokingly described himself as a ducal lawyer on vacation leave.

For a time, Bode had wanted to study geology—he had a good collection of stones and fossils—but some of his happiest moments were spent in visiting art museums in Berlin, Kassel, Munich, and Dresden. He finally persuaded his father to let him study art in Berlin. He began making his own catalogues of the paintings and art objects he saw, and he studied drawing with Max Liebermann, a fellow student, so that he could make sketches to accompany the catalogue descriptions. After more graduate courses in art history at Vienna, he took his doctorate at the University of Leipzig in 1870, his dissertation on Frans Hals and his school. Characteristically, Bode thought he knew more than the professors who examined him and was angered by some of the questions they asked that he considered puerile.

Bode was married in 1882 to his cousin and childhood sweetheart, Marie Rimpau, when they were both thirty-six years old, and she died three years later after the birth of a daughter Marie. Bode was remarried in 1894 at Stuttgart to Anna Gmelin, and they had two daughters.

Bode's background of law helped make him an efficient, even a formidable administrator as he went up the curatorial ladder to become director of the Picture Gallery in 1890 and of the new Kaiser Friedrich Museum in 1904, and general director of the Berlin Museums the next year. He was given his title "von" in 1914 by his patron, Kaiser Wilhelm II.

Though he retired formally in 1920, he continued to come to his office at the Kaiser Friedrich to proffer advice and acquire collections, plan exhibits and buildings, and write numerous books and articles.[1]

When Bode assumed his first post, neither Berlin nor its museums attracted many general tourists or art lovers. King Friedrich Wilhelm III of Prussia, impressed by Vivant Denon's spectacular Musée Napoléon at the Louvre, in 1815 had converted the royal cavalry stables into an art museum. Gustav Friedrich Waagen (1794–1868), endowed with the sharp eye of the connoisseur and well trained in the evolving discipline of art history, was appointed the first director of the Royal Art Gallery in 1821, and the Alte (Old) Museum, a handsome neoclassic building designed by Karl Friedrich Schinkel, opened its doors in 1830. Another impressive classical structure, the Neue Museum, was completed in 1859. The two buildings occupied sites on a peninsula formed by the Spree and Kupfergraben rivers and known as the Museum Island, and the Prussian kings had the good sense to purchase the remainder of the island, so as to provide for future expansion.[2]

Waagen added many excellent old master works of art to the Royal Gallery, a large number from the holdings of Edward Solly, an eccentric English collector living in Berlin. Waagen was known especially, however, for his concise and informative catalogues. He traveled extensively, surveying art collections in Italy, Britain, France, the Netherlands, Belgium, Spain, and Russia. His convivial good nature made him popular in English high society, and his series of volumes on *Works of Art and Artists in England* (1838) and their revision, *Treasures of Art in Great Britain* (1854–1857), explored public and private art collections. In 1861, Waagen went as consultant to St. Petersburg to arrange the Hermitage Gallery and supervise the issuance of its catalogue. Bode had the pleasure of meeting the aged Waagen, so that his knowledge of the Berlin Museums went back to their beginning.[3]

Despite Waagen's discriminating work as connoisseur and art historian, Bode found the Berlin Museums uninvitingly arranged in many small, dirty rooms. His plans for improvement, however, were to flourish, because of the rise of the new German Empire fashioned by Chancellor Bismarck and proclaimed in 1871 in the Hall of Mirrors at Versailles, after the defeat of France in the Franco-Prussian War. Germany's nationalistic efflorescence included not only the army and navy, industry and commerce, and colonial ventures, but also the arts and the Berlin Museums. Five billion gold francs came from France as reparations; German industrialists, bankers, shippers, and businessmen enjoyed a

booming era of prosperity; tax yields were high; and the German state railways, after 1879, showed a profit.[4]

The German rulers took a personal interest in museums and the arts. The first emperor, Wilhelm I, perceiving the enmity between Crown Prince Friedrich Wilhelm and Bismarck, kept his son out of governmental affairs but gave him and his wife Victoria (eldest child of Britain's Queen Victoria) supervision of the museums. Bode knew both emperor and crown prince, and, a few years after his appointment, he arranged a tour of Italy with Friedrich and interested him in Italian renaissance sculpture. "Ever afterwards," Bode wrote later, "he was most energetic in furthering all our plans for its better arrangement and rehousing."[5] Friedrich died of throat cancer in 1888, after reigning as emperor for only about three months, but his son Kaiser Wilhelm II, though not so knowledgeable in art as his father had been, took a vigorous part in museum affairs. Wilhelm II disliked contemporary art of his day, as is shown in his speech opening the Siegesallee (Avenue of Victories) at Berlin in 1901:

Art should help to educate the people; it should also give to the lower classes after their hard work . . . the possibility of lifting themselves up to ideals. . . . If art, as so frequently happens now, does nothing more than paint misery more ugly than it is, it sins against the German people. The cultivation of the ideal is, moreover, the greatest work of civilization; if we wish to be and remain an example for other countries, the entire nation must co-operate. If culture is going to fulfill its task, it must penetrate into the deepest layers of the people. This it can do only if it proffers a hand to uplift, instead of to debase.[6]

Though Bode at first had trouble with his museum superiors, who did not understand nor appreciate his enthusiastic collecting activities, he eventually won out, and the Prussian and Imperial German governments supported his efforts to make the Berlin Museums reach the heights attained long before by Paris's Louvre and London's British Museum, National Gallery, and South Kensington Museum (now the Victoria and Albert). In 1873, the government appropriation was raised from between 16,000 and 20,000 thalers to 106,000 thalers. The next year, a special grant of £50,000 bought the rich Barthold Suermondt collection of old masters, and in 1885, £82,000 was earmarked for extraordinary purchases. In 1878, Bode was also made director of a new department of Christian sculpture. His collecting successes brought such a flood of art works that continual building renovation and expansion were needed. Through the years, magnificent structures—usually connected by elevated, covered footbridges—were added at the Museum Island: the National Gallery

(1876) of German art; the beautiful, spacious Kaiser Friedrich Museum (1904) for old masters; and the Pergamon Museum (1930), its central part housing ancient antiquities and its two wings devoted to German and early Netherlandish art and to the Near East. Since Bode was the chief planner and executive force for these improvements, it was quite proper that the Kaiser Friedrich should be renamed the Bode Museum in 1956. Other collections—arts and crafts, decorative arts, Indian and Far Eastern art, and ethnography—overflowed into other buildings near the island and into a new Ethnological Museum begun in 1914 and situated some distance to the southwest in the suburb of Dahlem. Kaiser Wilhelm also backed archaeological expeditions that brought to the island many objects including the Altar of Pergamon (180–160 B.C.), the Babylonian Processional Way and the Gate of Ishtar (sixth century B.C.), and the Market Gate of Miletus (A.D. 165). At Bode's urging, Wilhelm also helped obtain as a gift from the sultan of Turkey the Islamic desert palace facade of Mshatta (A.D. 743–745). These huge structures still rank among the great masterpiece exhibits of antiquities in the museum world.[7]

Before we go further in examining Bode's supreme achievement—the creation of a great museum of world art—we ought to take a closer look at this intricate personality. Let us start with the summary of John Russell, the British-born art critic of the New York *Times*. Russell describes Bode and his work thus:

All this would have been impossible had not the scholarship of Berenson and the diplomacy of Duveen been combined in the person of Bode. Such was Nature's economy in producing this remarkable man that he was able to know what works of art he wanted and where to get them, and how to get other people to pay for them—functions more usually divided among a whole committee of enthusiasts. . . . But while it lasted—the best part, that is to say, of half a century—Bode's Berlin was an astonishing phenomenon, and Bode himself a museum-man of rare gifts. . . . The prototype . . . was Vivant Denon, first Director of the Musée Napoléon, later to become the Louvre; but Bode was the first to ally the inspired activity of a Denon to the politico-social function of the modern museum-director and the standards of strict scholarship which have been established since Denon's day.[8]

How did Bode know what works of art he wanted? First of all, he examined and studied thousands of paintings, sculptures, and other art objects of all European schools of art. While he was a good documentary historian, he put his main reliance on the art works themselves and was contemptuous of scholars so interested in developing sweeping theories

that they remained unmoved by the beauty of great art. He expressed his faith in the methods of connoisseurship as follows:

Anyone who has been for some length of time at the head of a great Art Collection with the task of constantly increasing, turning over, and placing works of art in the most advantageous light, will gratefully acknowledge the beneficial effect of this occupation on his capacity for acquiring knowledge. The fact of being directly, and unceasingly, busied with the art treasures, the responsibility in acquiring them, the opportunity for constant comparison while travelling in search of them, cultivate and sharpen the eye of one who is not born blind, as far as art is concerned, in a way quite beyond the most industrious turning over of photograph portfolios.[9]

A man of inexhaustible energy, Bode worked constantly, even on express trains and in hotel rooms. His output for publication contained about fifty book titles, as well as some five hundred articles. He was a rapid writer, and Dr. Max J. Friedländer, his assistant and then successor, said that "he hardly ever changed a word, crossed out a sentence." Bode's visual memory was almost unbelievable, and, as a young assistant, he some-times embarrassed his superiors by showing how much deeper his knowledge was than theirs. Modern scholarship over the past fifty years has, of course, modified many of his attributions, but his research and publication were unexcelled in his day, and most of his scholarly work still shows great insight.[10]

How did Bode know where to get the works of art he wished to acquire? Through his constant reading, conversations, correspondence, and travel that took him frequently to his beloved Italy, but also all over Europe and even twice to America. His methods are well illustrated in his systematic raids upon English private collections. He studied Waagen's *Treasures of Art* to learn where the best old masters reposed, visited London dealers to see what they had available, studied special exhibi-tions, and attended auctions to make purchases. He also took notes on items bought by others that he might wish to acquire later, and he employed a knowledgeable Paris dealer to approach unsuspecting owners. On the fiftieth anniversary of his service with the Berlin Museums, he described the manner in which the loosely organized London market could be used by an alert connoisseur:

Since 1873 I had made repeated journeys to England and had observed after my many visits to sales and the London dealers that there was a strong prejudice against certain sorts of subject, as well as whole periods of art; that there was an appalling lack of knowledge about the work of numerous painters; and that sales

were poorly attended if some big collecting name was not attached to them. All this, as well as the wholly uncritical description of items in sales catalogues, was evidence that there were wonderful opportunities here for our museums.

Thus did Bode acquire, at reasonable prices, great works by Rubens, Tiepolo, Rembrandt, Dürer, and many others.[11]

The painter Max Liebermann called Bode a renaissance *condottiere* who "knows where every picture is, where it was before, and who is going to buy it." The German government made him virtually its official collector, but such support had its frustrations; unperceptive superiors and bureaucratic regulations frequently prevented quick action, and desirable works would be lost. Bode solved that difficulty in several ways. He encouraged the rising industrial and commercial class (many of them Jewish and seeking social acceptance) to become collectors, advising them what to buy, giving them or the dealers who served them certificates of authentication of art works, and sometimes preparing elaborate and handsome catalogues of their holdings. The result was that important collections were formed by amateurs such as Oscar Hainauer, banker; Oscar Huldschinsky, mining magnate; Eduard Arnold, coal baron; Rudolph Mosse, newspaper tycoon; James Simon, textile manufacturer; and many others. To show their gratitude for Bode's advice, these collectors made gifts to his museums and sometimes planned to bequeath their holdings to them.[12] Bode is said to have persuaded James Simon—who donated the famous bust of Nefertiti and gave works for a room in the Kaiser Friedrich named for him—to buy a painting he did not like, with this argument: "The museum needs it; we cannot let it go, and we can't afford to buy it. Meanwhile, you might just as well have it, and you'll probably learn to like it."[13]

Bode had bemoaned the fact that there were no art dealers in Berlin in 1872 and that he had to travel at least twenty-four hours, mainly on German trains then without parlor cars or diners, to reach English, French, or Italian art centers and auctions. Soon, however, a host of Berlin-based dealers and international luminaries such as Joseph Duveen, Jacques and Germain Seligman, and René Gimpel came calling on Bode and his principal assistants. Duveen, for example, starting in 1906, sought Bode's counsel before spending $10.5 million in purchasing three great collections—of Oscar Hainauer (for which Bode had written the catalogue), Rudolphe Kann, and Maurice Kann.

Whether it was wise or ethical to issue certificates of authentication to dealers or collectors remains debatable, but Bode used these documents

for the good of his museums and not to amass a personal fortune, as did his great rival, Bernard Berenson, in his villa *I Tatti* near Florence. Gimpel, in commenting upon Duveen, wrote:

> To make up for his lack of knowledge, he surrounds himself with all the great experts. Bode and Friedländer cost him only a few gifts to the Berlin Museum, but Berenson is expensive, as he exacts 25 per cent of the profits, whether he is assisting in the purchase of a picture or giving his opinion or introducing the client. I too pay this fee.[14]

That statement suggests fascinating psychological differences between the two experts. Bode, the Prussian aristocrat, comfortably brought up and inheriting considerable money, would have thought private gain from his valuations dishonorable; Berenson, of a Boston Jewish immigrant family that had to struggle to remain above the poverty line, found the acquisition of personal wealth much more important.

In 1894, Bode decided to organize the private sector of wealthy German friends of art and collectors more formally in support of the Berlin Museums as the Kaiser Friedrich Museums Verein. This society was the first of the Friends of the Museum organizations that have since become so popular throughout the museum world. Named for the new Kaiser Friedrich Museum that Bode was planning, the society was incorporated formally in 1897; the Kaiser served as its patron, and each member paid five hundred marks yearly into its treasury. Bode could dangle imperial audiences, titles, and even knighthoods before prospective members and donors; jokes were made about the peril of having Kaiser Wilhelm drop by for coffee and to see a collection. Bode would brief him carefully on both the collector and his masterpieces, and the personable young kaiser would turn on the charm and point out how the collector could help the Berlin Museums and thus glorify the German empire. The saying ran: "Whoever drinks coffee with the Kaiser must count on losing his paintings." The Verein brought popular pressure on the German government to build the new Kaiser Friedrich Museum, solicited gifts of art works, and raised funds for purchases. It owned these works, but deposited them in the Berlin Art Gallery. As a matter of fact, the new organization virtually permitted Bode to make purchases quickly without government red tape. Thus, by the turn of the century, Bode had pulled together into his own hands all the strings of the German art establishment. The *Burlington Magazine* of London, in an editorial entitled "À Berlin!," bemoaned the number of old master works leaving Britain for Germany and analyzed the phenomenon thus:

That the director of the Berlin Museum has unique authority among living critics counts for much, but the organization he has introduced into German art affairs counts still more. He has gathered round him not only other German museum directors, but also the great leaders of German society, politics, and finance, united in an association infinitely more strong and real than anything of which Great Britain can boast.[15]

But Bode did not stop there. He began, with his own staff, to build a strong corps of art historians in Germany. Dr. Friedrich Lippmann, the capable director and organizer of the museum print room, on his death in 1903, was followed by Dr. Friedländer, just as learned. Dr. Friedrich Sarre headed the new Islamic Department, and Dr. Ernst Kühnel, another expert in that field, worked with Bode on revisions of his pioneering book, *Antique Rugs from the Near East* (1902). When J. P. Morgan became president of the Metropolitan Museum of Art in New York, he asked Bode, who was writing a two-volume catalogue on Morgan's renaissance and later bronzes, to recommend a curator of decorative arts, and Dr. Wilhelm T. Valentiner, Bode's young assistant, began his distinguished American career in 1908 at that position. Valentiner later recalled that during his two years with Bode, he "had to go through a museum training course of almost Spartan character." Every curator in the Berlin Museums was expected to publish, and since his museum duties kept him busy during the day, Valentiner could do most of his writing only after hours in the evening. "Dr. Bode," said Valentiner, "wrote his articles mostly at night, and he was rather shocked when he found that I needed much more sleep than he." Though Bode often appeared threatening and brusque, he could be warm and friendly and was always ready to talk with and help young scholars. "Many a person entered his office with trepidation," recalled Friedländer, "but left it in high spirits, under the impression that he, and only he as an exception, enjoyed the confidence of such an exalted and demanding personality." Bode inspired and was in touch with art history studies in the German universities, and a two-year course for curators opened at the Berlin Museums in 1902. Five years later, a new National Art Historians' Association was organized, "its heart and soul . . . Generaldirektor Bode," partially supported by a government grant, and with its own scholarly magazine. Thus did Bode do his part to strengthen the German museum profession.[16]

II

In 1891, at the request of editor Frank Harris, Bode wrote an article for the *Fortnightly Review* of London that examined with varying degrees of

frankness the progress of the Berlin Picture Gallery, of which Bode had become director the year before.[17] So as not to increase the alarm of English collectors against the old-master art drain taking place toward Berlin, Bode emphasized that the National Gallery of London had both larger operating and purchasing funds than did he. In Britain, there was much more generous private support, more numerous capable art dealers, and a friendlier attitude toward national museums by the press and by contemporary artists. Bode stated that the Picture Gallery already had a good collection (thanks to Gustav Waagen) that could now be better shown since the Alte Museum had been renovated in 1885 to provide more spacious and handsome rooms. The Berlin Museums were trying to fill gaps in their holdings, to secure especially excellent works of masters of the second rank, and to acquire objects of prime archaeological importance. When the new Kaiser Friedrich Museum should be completed, Bode hoped to obtain some especially dramatic works of art for its opening.

Bode then went over the holdings of the Art Gallery in some detail. He was especially proud of the renaissance Italian sculpture collection that he had been building for eight years and thought it compared favorably with those of the South Kensington Museum, the Louve, and even the Museo Nazionale of Florence. In Italian painting, the collection was strongest in the fifteenth century, with the *Last Judgement* triptych by Fra Angelico and seven works by Sandro Botticelli. No other museum had as excellent a collection of Old Netherlandish art as Berlin, with its six double-winged altarpieces by Herbert and Jan van Eyck; its later Flemish holdings were outstanding, also, with numerous examples by Rubens and Van Dyck. Its Dutch art, Bode thought, could not compare with that of London, Paris, or even St. Petersburg, though it had seventeen Rembrandts and eleven of Frans Hals's works in the best collection of that artist's production outside of Haarlem. The German sculpture and pictures were worthy of the capital of the empire, though the paintings as yet were surpassed by the Munich and Vienna collections.

Bode systematically added important paintings and sculpture to that core; and by 1914, he had made Berlin one of the great art centers of the world, a keen competitor with greatest European and American museums. Its collection included Italian, German, Netherlandish, Dutch, Flemish, and some Spanish works running from the thirteenth to the twentieth centuries. In only about forty years, Bode had rounded out the gallery's former holdings or assembled newly acquired art for each period, the masterpieces representative of the great artists' development and buttressed by their lesser productions, as well as by the works of less-

important masters. The whole process of accumulation had been stimulating and exciting, both intellectually and artistically. Bode had written a score of important, ground-breaking books based on his collecting efforts—eight volumes on Rembrandt's pictures, two thick tomes on Frans Hals, and others on Florentine renaissance sculptors, fourteenth- and fifteenth-century Italian painters, Dutch and Flemish masters, Brouwer and Botticelli. His work had defined new artistic periods and schools and resurrected forgotten old masters and lesser lights. And the great colleciton ws there, presumably to be used for centuries in other research and to bring understanding and pleasure to art lovers of various degrees of sophistication who would continue to crowd the gallery.

Much of Bode's work was done, too, despite great physical pain. During nearly ten years after 1894, he was seriously ill with thromboses, embolisms, and infections that sometimes kept him from the office and confined him at home or in sanatoriums, but even then he continued to plan buildings and exhibits and to write books and articles.

Some of Bode's acquisitions were indeed spectacular. In the attics of his own museums he found dozens of valuable paintings long since discarded, and he re-examined Andrea del Sarto's *Madonna and Child with Eight Saints* (1528), supposedly ruined by a restorer in 1867, but actually intact when the oil varnish was removed. In Paris, he recognized a bronze portrait bust thought to be a forgery as a study of Ludovico Gonzaga, by Donatello, for an equestrain statue. An English dealer friend brought him an unidentified bronze putto that he saw was by Donatello and bought for only £400. In London, he thought genuine—and purchased, for £1,000— Dürer's *Young Woman with the View of the Ocean* that the National Gallery had refused because it seemed to lack Dürer's monogram signature; when the painting was unframed, it was found to have been folded so as to hide Dürer's monogram from view. In 1872, Bode bought a Rubens sketch used by the artist as a model for his *Conquest of Tunis by Emperor Charles V* that was displayed for sale by the doorkeeper of the Hermitage in St. Petersburg for the incredibly low price of 650 rubles (about $325). The first painting purchased by the Kaiser Friedrich Museums Verein in 1896 was Hans Memling's *Portrait of an Old Man*. An art dealer showed it to Bode in the streetcar on his way home from the museums as an unknown painting of trifling worth; Bode recognized it as a Memling and bought it on the spot. In 1903, an important *Adoration of the Shepherds* by the Ghent artist Hugo van der Goes was acquired when Bode spotted it in the sales catalogue and sent Friedländer and Richard Schöne to investigate it where it hung in an obscure spot in a Madrid palace. Thus could a knowledgeable connoisseur help make his lucky breaks.[18]

Still, most of the growth of the collections depended on ceaseless research and alert attention to opportunities for acquisition. German museum directors, dealers, and collectors appeared at, and frequently dominated, every European art auction. Friedländer, Bode's principal assistant and his intimate for several decades, thought that

Bode's fanatical eagerness for work, his universal connoisseurship and his authority, created a close network of connections with collectors and dealers all over the world, with the result that in his study works of art were offered for sale, placed on show and came up for judgement each and every day.

Friedländer perceptively pointed out, however, that the era of the universal connoisseur was rapidly coming to a close. The art expert depended less upon photographs, books, or a dictionary of concepts than upon first-hand examination of works of art and vigorous visual memory. Yet, "the capacity of memory is limited. Even a Wilhelm Bode, whose gifts as a connoisseur were of an unexampled many-sidedness, was unavailing in many directions. The reliable and successful experts are specialists." Conoisseurs also had their own taste that sometimes interfered with wise collecting; thus, though Bode was more catholic than most discriminating scholars, in a day when Italian renaissance art was riding high, he twice turned down El Grecos for Berlin.[19]

The broad-based connoisseurship that Friedländer admired in Bode was also demonstrated by his interest in non-European art, and he indeed made Berlin a center of world art. He personally collected oriental carpets, most of which he gave to his museums; he wrote a monograph on them in 1902 that, seventy years later, one reviewer found "still the most convenient handbook on the subject"; and he founded Berlin's Islamic collection in 1904. Bode regarded art forms of different cultures and nationalities as historical and understandable dialects of a universal human speech, and he saw Asia as the source of European art. He established the Islamic collection, first, largely because of the acquisition of the Mshatta Facade; but in 1907, he founded the East Asiatic collection, which became for long the leader in that field among European museums. Bode even generously contributed a large sum (tragically lost by the German government during the catastrophic period of inflation) raised from the sale of his private library for a new Asiatic Museum building in Dahlem. On a trip to the United States in 1911, Bode went on to Guatemala to examine and purchase pre-Columbian objects. In the field of modern art, though no admirer of cubist or other abstract movements, he supported Ludwig Justi, director of the National Gallery from 1909, helped send an exhibition of contemporary German art to the Metropolitan

Museum of Art in that year, and took much pleasure in planning the Germanic wing of the Pergamon that included such works.[20]

Bode had original ideas about the exhibition of art. He vehemently disliked the way most museums used the "wallpaper" display method of plastering the walls from ceiling to floor with paintings "like herrings one above another," and thought that the Louvre and South Kensington Museum constituted miserable labyrinths. He detested abstract light from above, cool north light, and too much boring symmetry. He advocated the greatest possible isolation of each work, the use of historical frames, and believed that the size and shape of the gallery, the color and decoration of the walls, and the lighting should resemble the room for which the painting or sculpture was intended originally. In planning the Kaiser Friedrich, he wished to show the eighteenth-century works in a rococo gallery, the Rubens and Van Dyck in a baroque room, Rembrandt and the lesser Dutch masters in a council chamber or comfortable lounge, and Botticelli and Fra Filippo Lippi in a fifteenth-century Florentine salon. Moreover, he said,

Pictures and sculpture require a few good pieces of furniture, and occasionally some tapestries and decorative products of the applied arts in the character of that particular time. Thus every museum room, as a whole, will make an advantageous and distinguished impression and the effect of the pictures and statues will be heightened.[21]

All this was professional heresy at the turn of the century. Uniting paintings, sculpture, and a few pieces of old furniture was thought to lower masterpieces to the status of historical footnotes; one young curator spoke for the predominant majority when he declared that "great works of art are not a means of decoration. They should be placed on an altar, not over a sofa." But the public that came in droves to the new Kaiser Friedrich Museum thought differently. Here was art that appeared familiar; it could be grasped at a glance, and it appealed to the emotions. The visitors marveled at the great ground-floor basilica (Kirchenraum) with its sculptures and architectural fragments. Bode showed off his large, sectioned altarpieces to great advantage; he even had a special veneer saw devised to cut the wing panels of one of them in two, so that the paintings on both sides could be compared. His "mixed rooms" were soon imitated by much more elaborate period rooms in the art museums of the United States. They paralleled the historical period rooms that for half a century had been springing up in museums at Nuremburg, Munich, and Zurich to give visitors the illusion of walking through several centuries of German history.[22]

Fig. 19. Kaiser Friedrich Museum interior, Berlin, 1925. The carved chest and fabric wall hanging show how Bode tried to enhance the historical atmosphere of the paintings by use of appropriate decorative arts. *(Courtesy of Staatliche Museen, East Berlin.)*

Bode did not approve the idea of a utopian museum that would go so far as to exhibit only the greatest art of all periods for the general public, nor the dual-arrangement compromise of the Museum of Fine Arts in Boston that prescribed a series of masterpieces for the public and, in another location, a reserve collection of lesser works for the scholar. The *Burlington Magazine* asserted, somewhat loftily, that German museum-goers were interested "not as much in instinctive taste as in the classification of minute details" and that thus a full historical setting was more compatible for the audience of the Kaiser Friedrich. Bode himself argued for some mixture of masterpieces and lesser works, and held that "if the visitor has to look around, as he does now, and decide for himself what appears good to him, he will be much more likely to find his way to pleasure and understanding than if people dictate to him what he is to see in advance."[23]

The archaeological treasures of the Pergamon Museum, which Bode helped plan—though it did not open until 1930, the year after his death—were also spectacularly exhibited. The west front of the Altar of Pergamon, built by Eumanes II and regarded as one of the Seven Wonders of the ancient world, was reconstructed, and the original marble friezes, one depicting the struggle of sea gods with giants, were placed nearby. The altar in its tasteful, unobtrusive hall measured 118 by 111 feet at the base and was about 50 feet high. The 77-yard-long Babylonian Processional Way, with its Ishtar Gate (46 feet high) and Throne Room Facade, built by Nebuchadnezzar II, was dazzling with turquoise and tan ceramic lions, horses, bulls, and dragons. The British museum professionals at the opening of the Peragmon agreed that "whole buildings as exhibits in vast museum halls and on such a scale" were an innovation that "impressed even those experts who disapproved the amount of reconstruction work which had to be added to the original parts." No one could deny that "the public is given an opportunity of visualizing aspects of the common foundation of European civilization which no systematic arrangement of finds, fragments, or even models in museum cases can ever give."[24]

Another Bode innovation was the installation of special loan exhibitions in the Kaiser Friedrich Museum. British and American museums had presented such displays for a long time, but the Berlin Museums had regularly refused to do so. In 1905, however, Bode hung the Carstanjen collection, mainly of Dutch and Flemish paintings, and also showed Friedrich Sarre's Persian and Arabic art. The next year, the Kaiser Friedrich Museums Verein held a loan show of five hundred works in the Palais Redern, not far from the Museum Island, and "The Centenary Exhibition of German Art" occupied part of the Neue Museum and all of the National Gallery. Other special exhibitions were held elsewhere in Berlin. In 1908, great English paintings of the eighteenth century were sent there, in honor of the emperor, with uniformed sentinels on guard and command attendance by German high society. In 1910, a most unusual exhibition displayed the works done by miners, dockhands, factory workers, and other laborers in their spare time. Truly, as the kaiser had hoped, culture seemed to be penetrating into the deepest layers of the people. Public response to the lively special exhibits of the Berlin Museums was so great that the Kaiser Friedrich initiated days when admission fees were charged, to limit the crowds and to remunerate its staff for working overtime. Imaginative collecting on an international scope, spectacular exhibition, and superb research and publication were making the Berlin Museums popular at home, as well as known and

respected by professional art historians and museum authorities through-out the world.[25]

## III

The rivalry of Britain and Germany in world affairs was reflected also in art history and museums. As old master paintings and sculpture, archaeological treasures from Mesopotamia, Egypt, Greece, and Rome, carpets and ceramics from the Near East, art rarities from India, China, and Japan, and ethnographical objects from the Americas, Africa, and Oceania came to Berlin, other museum centers looked on enviously. British art historians were especially sad, as a steady stream of European old-master creations went to the German capital from the stately mansions of Britain. Based in Italy and England, a group of art historians that considered Bode a chief enemy began to coalesce. Bernard and Mary Berenson of *I Tatti*, Roger Fry, for a time joint editor of the *Burlington Magazine*, Dr. Sidney Colvin, keeper of prints and drawings at the British Museum, and Claude Phillips, keeper of the Wallace Collection, were some of its members.[26]

Bode was not an easy mark for critical attacks. Many German scholars could be accused of not appreciating great art, of being interested only in the grubby details of art history, but not Bode. He constantly demon-strated in his museums and his writings that he combined the deep learning of the scholar with "the unceasing gusto for beautiful things" of the connoisseur. He did not share Berenson's admiration for the Italian senator Giovanni Morelli (sometimes writing as "Ivan Lermolieff"), who, probably because of his training as a surgeon, tried to make art criticism more scientific by careful observation of the morphological details of the artist's style—the uniform way he painted hair, ears, noses, fingers, and the like. Bode considered that theory a "Lermolieff mania" appropriate for a quack doctor and insisted that connoisseurship could better take into account the overall spirit of the painter and his use of color, perspective, and other artistic elements. Both approaches had their virtues, and most critical authorities of the day considered Berenson the better authority of Italian painting, but believed Bode to be superior on Italian sculpture.[27]

Bode could be attacked as dictatorial and positive in his manner, but so also could Berenson. Germain Seligman felt somewhat uncomfortable in Bode's presence, not because of "his rather brusque and categorical way of speaking" or from any doubt of his knowledge, but "simply because he always reminded me of Bismarck." A German art editor considered Bode

a Bismarck of the museum world who combined Prussian thoroughness with American push. Bode's friends agreed that he was both "a great friend and a great hater." Berenson also was a passionate antagonist. Gimpel thought that "The hatred he expends he gets back in full measure; but if he were in a cage with one of his detractors, he would not be the one to be devoured. His deadliest enemy is Bode . . . who has dared to study and understand Italian sculpture." Berenson got along well with several of Bode's associates, and Valentiner arranged a meeting of the two rivals, but it was not a success. On an ocean crossing, Berenson was annoyed by a young Bode disciple who kept quoting the great man and finally made him pause by asking: "Bode, Bode? How do you spell it?"

Perhaps Friedländer understood Bode best, though he was too much the hesitant scholar to appreciate fully the decisive man of action. At any rate, this is his carefully considered estimate:

The deepest motive of the scholar, namely, disinterested love of truth, could not function productively in a nature always resolutely aiming for effectiveness and visible results. Bode was utterly unphilosophical, he considered no affair from more than one side. He saw black or white, good or bad, advantageous or inimical; he knew no intermediary steps. To foresee obstacles, to fear, to guard them, was not his way. Consequently he became angry as soon as he encountered opposition. He made more mistakes by acting than by failing to act. He was a hunter, not an angler.[28]

In the spring of 1903, the *Burlington Magazine*, an art monthly for connoisseurs, began publication in London with handsome typography and numerous fine illustrations, some of them in color. Robert Dell, its editor, recruited a Consultative Committee of forty prominent collectors and art historians that included Berenson, Fry, Colvin, Phillips, Sir Purdon Clarke—soon to leave the directorship of the Victoria and Albert Museum for that of the Metropolitan—Charles Eliot Norton of Harvard, Dr. Lippmann of Berlin's print room, and Dr. Bode. By the end of its first year in publication, the magazine was in financial trouble. Charles J. Holmes, a painter and art historian, now became an editor and helped reorganize the venture. He approached the Berensons, who were considering helping with the magazine's revival, but when he found that they were talking of controlling editorial policy as well as contributing to the financing, Holmes backed away, for he knew that many English art historians, to say nothing of Dr. Bode, would resent Berensonian dictatorship. In the end, Dell raised enough money to continue his control, partially through Bode's appeal to Alfred Beit, a South African mil-

lionaire, whose art collections Bode had catalogued and who later gave pictures to the Berlin Museums. Holmes thought "Bode's action deserves to be remembered as a rare piece of international generosity. How many people here, I wonder, would try to raise money for a German magazine?"[29]

Soon, an incident occurred that heightened the cold war between the British and German art worlds. Murray Marks, a London art dealer and friend of Bode, was assisting him in issuing three folio volumes on *The Italian Bronze Statuettes of the Renaissance* (1908–1912). Marks, in 1909, acquired a wax bust of *Flora*, which seems once to have belonged to Lord Palmerston, from a King Street dealer, who had bought it in Southampton for only thirty-five shillings. Marks thought it was Italian of the renaissance period, possibly even by Leonardo da Vinci himself, and he persuaded Holmes to publish three photographs of the bust in the *Burlington Magazine* for May, though with a skeptical note intended to date it much later than Leonardo's day. The news that Bode had purchased it for the Kaiser Friedrich at a high figure (about £8,000) and attributed it to Leonardo or his school "came like a thunderbolt" to Holmes. A bitter controversy erupted at once in the London newspapers, many writers claiming the bust was the original work of a Victorian English sculptor, Richard Cockle Lucas.[30]

By May 1910, the *Burlington* editors, Roger Fry and Lionel Cust, though they denied emphatically that the dispute was due "to mere racial animosity between England and Germany," had decided that the bust, "whatever its artistic merits, is entirely the work of Richard Cockle Lucas." In June, they published the legal affidavit of Albert Dürer Lucas, Richard's only son, aged eighty-one, who swore under oath that in 1846 his father created the bust for a London art dealer who furnished him as a model an oil painting attributed to Leonardo. The son assisted his father with the modeling and painted the hair and flowers. Thomas Whitburn, friend and contemporary of Albert Lucas, in another affidavit affirmed that he was a frequent visitor at the Lucas household and in 1846 saw the father, helped by the son, fashion the original bust. All this was too much for Dr. Bode, and on July 5 he angrily resigned from the *Burlington* Consultative Committee. The magazine published his letter and regretted his action, acknowledging that Bode had been its true friend and had rendered invaluable service during a critical period of its early existence.[31]

Bode maintained that the *Flora* had been sent to Lucas for repair and that anyone who examined his other work would see clearly that he could never have created the bust. That explanation accounted for certain Vic-

torian features of the modeling and for the piece of nineteenth-century quilted material found in the hollow of the sculpture that caused so much sarcastic merriment among Bode's detractors. Bode issued elaborately illustrated articles on the bust and the scientific reports of the chemists in the museum laboratories that found it contained traces of argil, a common constituent of sixteenth-century sculptures not often used in later days. Murray Marks offered to refund the purchase money for the bust and even sent a draft for the amount to Bode, who returned it.[32]

Most of the non-German art critics took the Lucas side in the controversy and were delighted to see the great Bode humbled. A veteran English authority wrote Holmes: "Nothing for a long time has given me purer joy. It will be an end for good and all of that arrogant dictatorship from which we have all suffered so long." Gimpel reported that Berenson "cut out articles from all the papers and went about with his pockets stuffed with clippings. . . . He was convinced, and rightly so, that the bust was a fake." Jacques Seligman also thought Bode had made a mistake, but he sympathized with him and gave him an important painting to try to ease his pain, as did several other leading dealers. German collectors and dealers, except for a few enemies, stood solidly behind Bode, as did Kaiser Wilhelm; Berenson much later (1944) argued that "the way the whole of Germany was marshaled to support him, gave, before the First World War, a foreboding of what was cooking up in Berlin and Potsdam and how they would conduct hostilities and propaganda." Bode in his *Memoirs* recalled that his British connections "were always of a thoroughly friendly kind until England's jealousy of Germany's advance made a difference." By 1925, he had mellowed in his feelings toward the *Burlington Magazine*, and, having suggested through a friend that he would be glad to do so, he accepted an invitation to rejoin the Consultative Committee; he also contributed an article and received Roger Fry cordially in Berlin. But until the day of his death, he maintained that the *Flora* was a product of at least a Leonardo contemporary and that it had only been restored (and clumsily, at that) by Richard Cockle Lucas. The obituary editorial on Bode in the *Burlington* was, on the whole, fair and generous, though it self-righteously urged the reader to "take a lesson from a very great man, who like other really great men, was not infallible." The *Museums Journal*, official organ of the Museums Association of Britain, was less discerning when it referred to Bode's error in the "purchase as a probable Leonardo of a wax bust subsequently proved to have been made by R. C. Lucas about 1846—and the public laughed."[33]

A fair modern critical summary of the question is that of Sir Kenneth Clark, who wrote in 1939:

It is precisely the absence of sensitive surface modelling which prevents us from attributing to Leonardo's own hand the wax bust of Flora. . . . This insensitiveness is probably due to the restoration of a sculptor named Lucas, whose son afterwards claimed that his father fabricated the whole piece. The claim was widely believed at the time, and made the pretext of malicious attacks on Dr. Bode, but it cannot be substantiated. Nothing in Lucas's work suggests that he was capable of the noble movement of the Flora, and the evidence advanced of his authorship only proved that he had subjected the bust to a severe restoration. The original texture is still visible in the breast, and presumably Lucas reduced the head to its present dull uniformity of surface. Bode was right in seeing this piece as a clever indication of Leonardo's later sculpture. . . . In her present condition she is little more than another of those mutilated documents through which, alas, so much of Leonardo's art must be reconstructed.[34]

In 1965, the Department of Sculpture in the West Berlin State Museums at Dahlem reinstated *Flora*, her original authenticity seemingly fully reestablished, as one of its greatest treasures, with maximum museological treatment and lighted to perfection.[35]

Bode had considerable difficulty with the rising anti-Semitism in Germany during his day. The Prussian nobility and much of the imperial bureaucracy were intensely anti-Jewish, and yet many of the most generous patrons of the Berlin Museums and members of the Friends organization were Jews. About 1907, two incidents brought Bode violent criticism from both sides. He was helping the leading women of Berlin put together a tour of private collections, with the entrance fees to be donated to a charity, when envelopes somehow got switched, and Frau Wallich, prominent Jewish leader of the affair, received Bode's letter intended for a bigoted young aristocratic collector and stating: "I can't blame you, if you don't want your costly carpets to be trod upon by flat Jewish feet." Bode also wrote an appreciative article in a leading art journal for his Jewish friend Max Liebermann's sixtieth birthday, in which he pointed out that Liebermann's painting was really pure German in its sensitivity and he one of the most German of all living artists. Bode said the article "released a teutonic furor among all hyper-Germans and antisemites," and he reflected sadly on his condition: "So, fellow Jew and antisemite at the same time!"[36]

Bode's greatest competitors for old masters were wealthy Americans who were stimulated, aided, and abetted by clever dealers. At first, he was not upset and even attended and admired the Columbian Exposition at Chicago and many American museums, especially along the East Coast. By 1905, he observed that "In collecting, as in other matters, the Americans are developing the energy and toughness which is peculiar to

themselves." Soon he was fearful that they were draining Europe of the old masters still in private hands. He appealed to the patriotism of German collectors to keep masterpieces at home, and he considered but rejected as counterproductive advocating laws to restrict the outflow. The trouble was that American millionaires—Morgan, William Randolph Hearst, Andrew Mellon, John D. Rockefeller, Jr., H. E. Huntington, Henry Clay Frick, Andrew Carnegie, Benjamin Altman, P. A. B. Widener, and many others—had the means to pay the enormous prices that imaginative art salesmen demanded. Money was proving an even more potent means of art conquest than force of arms. As prices were bid up, it was almost impossible for museum curators, no matter how deep their knowledge or how skilled their connoisseurship, to find the bargains they once enjoyed. And when Germany lost World War I and then underwent catastrophic inflation, German collectors who once had planned to leave their treasures to the Berlin Museums could no longer afford to do so.[37]

Bode tried to take an enlightened and philosophic view of that sad situation. In his review of his fifty years as a museum authority, he wrote:

As European collectors became poorer, so did Americans become richer in their collections. It is regretful for Europe, but when one sees what enthusiasm for art reigns in America, how in large cities from East to "Wild West" new museums are being erected and how quickly they are filling up with art works, how the youth, through instruction and field trips to museums, take pleasure in and have an understanding of art, and how, at the same time, European museums are being visited by more and more foreigners, especially Americans, then one cannot really regret this development from the European standpoint. With an ever sinking culture, European art no longer seems capable of reviving, while over there (America), this new enthusiasm for art may nourish a native art from this strong and pulsating life, which may one day help improve European art.

In 1928, the year before his death, Bode again discussed the future of American art museums in an article in the *Kunstwanderer* of Berlin. Every week, he said, one heard of Rembrandts, Raphaels, Van Dycks, or Vermeers sold at fantastic prices to American dealers for their rich clients. Within less than two centuries, Bode feared, the masterpieces in private hands in Europe would have passed to American owners who ultimately would give them to American museums. Bode concluded that

Eventually the number of really inportant museums in the United States will not be far behind that of the continent. Of these the old continent now boasts approximately two dozen. In many directions the American museums will have outstripped our European art galleries, especially in Asiatic art and ethnology.

While continental museums for the moment enjoyed "more expert and scientific management" than those in the United States, they might not continue long to do so because of the eagerness of Americans to study art in all its phases and because of what Bode considered the growing ineptitude of European art museum curators.[38]

In 1914, at the outbreak of war, the Berlin Museums had been at the height of their development. Their collections were fabulous, their future growth seemingly assured by a host of enthusiastic collectors, a world-wide network of knowledgeable and co-operative dealers, and a solid financial support, to which both the Prussian and Imperial governments and the wealthy Kaiser Friedrich Museums Verein were contributing generously. The war, however, changed that rosy prospect. The rapid German victories in France and Belgium raised the question of what would happen to enemy works of art if Germany should win the war. An Italian writer in Florence charged that Bode had given the German military authorities a proscriptive list of art works to be taken as plunder from France and that he had advised the destruction of Reims Cathedral. Bode organized a League of German Scholars and Artists for the Advancement of Culture; it issued a slender leaflet written by Bode in which he characterized such stories as foolish and libelous and pointed out that he had caused a museum director from Berlin to be sent along with the German army to try to preserve works of art and architectural monuments for the Belgian people. In another place, he stated flatly: "My conviction is that all civilized countries should have their own artistic creations and all their lawful artistic possessions left them intact and the same principles should be exercised in enemy territory as at home." He also was against using works of art for war indemnities.[39]

The feelings that ran so high on both sides were reflected in propaganda statements. While the British *Museums Journal* quoted Bode's statement on preserving enemy art, it reminded its readers of "the Bismarckian maxim that the civilians of a district through which a German army has passed should be left with nothing but their eyes to weep with." British art lovers signed a statement deploring German destruction of the medieval monuments of Belgium and France, especially at Louvain, Malines, Termonde, Senlis, and Reims. Roger Fry, Bode's old antagonist, wrote a letter to the *Nation* on the destruction of Reims, in which he condemned German arrogance and especially that of Bode, but rejected the idea of seizing art works from the enemy as reparations at the close of the conflict.[40]

When the war ended disastrously for Germany, the Versailles peace

treaty contained two reparations clauses, drawn by John Foster Dulles of the United States delegation, that affected the Berlin Museums. They were required to return two altarpieces to Belgium. One of them had been a glory of the Picture Gallery for nearly a century—six leaves of the polyptych of the *Mystic Lamb* painted by the Van Eyck brothers, formerly in the Church of St. Baven in Ghent. Acquired in the Solly Collection (1821), it went back to Ghent in 1920, to be reunited with the center panel still there. Two leaves of the *Last Supper* painted by Diereck Bouts and formerly in the Church of St. Peter in Louvain had been in Berlin since 1834. They, together with another two leaves from the Alte Pinakothek in Munich, were sent to Louvain to be placed with the central panel there. Bode was aggrieved and enraged by this action.[41]

## IV

In commenting upon Wilhelm Bode's museum career, John Russell properly appreciated Bode's unusual capacities and great achievements but, from the vantage point of 1965, was saddened to realize that "The Berlin which Bode knew, and to a certain extent shaped, has vanished as completely as any of the earlier civilizations to which he turned his attention." The reasons for that tragic debacle are found within the larger history of Germany. Just as the Berlin Museums shared in the meteoric rise of the German empire, they participated in its dissolution in World War I and the terrible hardships that followed. Wild currency inflation occurred in the early 1920s, and the mark came to be exchanged at twenty-five million to the dollar. To cite a single instance, Artur Schnabel, the pianist, received a suitcase full of bills as a concert fee but could purchase only three sausages for the lot. Hjalmar Schact finally stabilized the currency in 1924, but soon the Great Depression followed, with the rise of the Nazis, the catastrophic destruction of World War II, and the cruel division of Berlin by its ugly wall. These misfortunes tore Bode's great museum creation apart.[42]

Even before the first war ended, Bode complained that profiteers were putting money into art works as the safest investment, to escape taxes, and for conspicuous display. The Oppenheim collection of Dutch and Flemish paintings that Bode had catalogued was to be auctioned in March 1918, with delivery outside Germany through neutral agents. During the period of runaway inflation, works of art became extremely valuable, because they could be sold abroad to obtain money backed by gold. Bode had always encouraged collectors to give or bequeath their treasures to

the Berlin Museums, and he had had remarkable success in that area. For example, Alfred Beit in 1896 presented a landscape by Rubens to the Verein, and Oscar Huldschinsky soon gave the Verein a painting by Hugo van der Goes. To observe the opening of the Kaiser Friedrich Museum, Franz von Mendelssohn contributed a painting of the Hieronymous Bosch school to the Verein, and Adolph Theim, a broker from San Remo, gave the Picture Gallery a Netherlandish madonna. At the same time, James Simon's bequest of several paintings that included a madonna by Mantegna and a portrait by Bellini was installed in its own small gallery, and in 1906 Frau Hainauer gave a sixteenth-century religious picture by the Amsterdam Master. But with inflation and economic depression, collectors were tempted to turn their paintings into hard money. A Titian owned by Eduard Simon went to an American dealer, and Huldschinsky's collection was sold at auction in 1928.[43]

After the first war, money was tight in Germany, and Bode did well to secure his new Pergamon Museum building. Its opening in 1930 presents an opportunity to see how far Bode had come in achieving his plans. On the Museum Island itself, the Greek and Roman antiquities were scattered in the Alte, Neue, and Pergamon museums, and the Egyptian collection was in the Neue. The Near East materials now had their own wing in the Pergamon and were to be joined by the Islamic art from the Kaiser Friedrich. The early Christian and main collection of paintings and sculpture were in the Kaiser Friedrich, with some Netherlandish art and the German art in the National Gallery or the Germanic wing of the Pergamon. Engravings and drawings were in the Neue, and the coin cabinet in the Kaiser Friedrich. In the neighborhood of the Museum Island were several buildings that included the Armoury, the Hohenzollern Schloss (decorative arts), arts and crafts, and German folk culture materials. Two buildings known as Ethnological Museums I and II held Asiatic, African, Oceanian, American, prehistoric, and early historic collections, all eventually supposed to go to Dahlem, where some of these materials were already stored. Then there were museum, art, and costume libraries, chemical (conservation) laboratories, and six lecture halls. The Berlin Museums had come a long way since Bode began work there in 1872.[44]

Bode was dead when Hitler and the Nazis came to power and began to harm the Berlin Museums. In 1933, Ludwig Justi, the respected director of the National Gallery, was dismissed, and Max Friedländer resigned and went to live in Amsterdam. Members of the staff with Jewish blood were discharged. Goebbels took down the gallery's pictures by Van Gogh, Gris, Beckmann, Feininger, Grosz, Kandinsky, Kokoschka, and other modern

artists and in 1937 staged an exhibit of "Degenerate Art" that was rather popular; some of these paintings were deliberately destroyed.[45] During World War II, Allied bombing raids starting in 1943 brought terrible destruction to the Museum Island. Most of the paintings and smaller art works had been moved to salt mines and other safe repositories, but the Miletus Market Gate and Mshatta Facade, though sandbagged in place, suffered some damage from direct hits. Worst of all, more than three hundred paintings, mainly large ones, placed in a bunker at the anti-aircraft tower of Friedrichshain were burned in 1945, shortly after hostilities had ended. The fire seems to have started accidentally, from careless smoking or use of candles. Ten paintings by Rubens, the multifigured compositions of Van Dyck, all those of Jordaens, many of the North Italian school, and a scattering of others were among the casualties.[46]

After the war came the struggle over the control of Berlin. West Berlin, an enclave in East Germany, belonged to West Germany and lay in American, British, and French occupation zones. East Berlin, in the Russian zone, was part of East Germany. The Allied Air Lift kept West Berlin independent, but in 1961 the East Germans erected a wall that definitely divided the city. Meanwhile, the art works that had been stored during the war were recovered by the Russian and the Allied armies. The Museum Island, the Mint, the Friedrichshain antiaircraft tower, and other East German sanctuaries fell into Russian hands, and the art works found there were removed in May 1945 to Moscow, Leningrad, and Kiev. (In 1958 the Russians returned this art, beautifully restored, to the East German government). In 1946, Ludwig Justi returned to the Museum Island as general director and with a devoted staff began to repair the badly damaged buildings with their burned-out shells and empty windows. The old Hohenzollern Castle at the neck of the island, to the Russians a hated symbol of Prussia and the German empire, was demolished. The Kaiser Friedrich (renamed the Bode), the Pergamon, the Alte, and the National Gallery were gradually restored. The Neue Museum will need to be almost entirely rebuilt. Justi and his staff worked hard to install thoroughly professional exhibitions, but an air of sadness clung to them. Eleanor Lansing Dulles, who visited the Bode and the Pergamon in 1965, commented: "The collections are in good condition, but the oppressive air of delapidation is emphasized by the long grayish curtains covering the windows like dirty sheets with many a patch and darn." Perhaps she was only showing Western cold-war prejudice when she continued: "It seems strange to see these relics of ancient culture in a place where the present is miserable and the future uncertain."[47]

The East Berlin museum professionals in charge of the Museum Island today have two main purposes. The first is educational, with exhibits designed to attract the widest possible public and activities that include art discussions with clubs, behind-the-scenes tours, visiting school groups, small traveling exhibits for the schools and outside Berlin, and Young Peoples' Sundays. The second aim is to continue the scholarly tradition of Bode's day, with exhibits for specialists, research and publication, and enlargement of the collections. At present, the Egyptian treasures are well displayed at the Bode, awaiting the eventual reconstruction of the Neue Museum.[48]

The Museum Island has lost some of its finest collections to West Berlin. Stored during the war in the Kaiserooda mines east of Eisenach, at Grasleben northeast of Brunswick, and Bleicherode southwest of Nordhausen, they were captured by the British and Americans, taken by their control commissions to storage depots at Wiesbaden and Celle, and then turned over to West Germany. A governmental foundation, the Preussischer Kulturbesitz, was organized in 1962 to administer fourteen state museums, the state library, state archives, and two special institutes. Today, the foundation has three museum centers in West Berlin. The largest at present is in Dahlem, with old master paintings, sculptures, prints, and drawings in the former Ethnological Museum building that has been greatly enlarged to include ethnology; Indian, Islamic, and Far Eastern art; and special exhibits for children and the blind. A second center at or near Charlottenburg Palace exhibits objects of prehistory and history, applied arts, Egyptian antiquities (including the famed *Nefertiti* bust), and Greek and Roman survivals. The third complex at the Tiergarten contains the new National Gallery and the National Library. The plan is to move the old master paintings and sculpture, prints and drawings, and decorative arts to a new building in the Tiergarten area, and Dahlem will then be devoted to ethnological and non-European collections.

The Berlin Museums as Bode built them are not in as perilous a condition as they seemed to be at the end of the war and during the struggle over control of Berlin. The economic growth of West Germany, the founding of the Preussischer Kulturbesitz, and the reactivation of the Kaiser Friedrich Museums Verein in the 1950s, with its decision to place its holdings in West Berlin, have meant that the most important part of the old master painting and sculpture collection is substantially as Bode knew it and is being expanded, conserved, exhibited, and interpreted according to the highest museum standards. Still, the division of the great

collections between the Museum Island and West Berlin presents much difficulty for the scholar. To use both portions, one must pass through the wall at a checkpoint and conform to strict passport, currency, and tariff regulations on the East German side. Even when the Museum Island proved too small to house the massive collections of Bode's day, it was relatively easy to move freely among the island buildings, neighboring museums, and Dahlem. Now the situation has changed entirely, and East and West Berlin occupy different countries and almost different worlds.[49]

Perhaps Wilhelm von Bode was fortunate to die while his great production was still intact, and he, despite his poor health, was active and hard at work, as well as loaded down with honors. After fifty-seven years of brilliant service to his museums, he died swiftly and quietly in his own home at age eighty-three on March 1, 1929. Four days later, he received a hero's funeral in the crowded basilica of his Kaiser Friedrich Museum. His simple, bare coffin was surrounded by six flaring candles in front of a great Persian carpet, one of his last gifts to "the Museum which he used to refer to laughingly as his favorite daughter." Wreaths were piled high before the coffin, and a choir sang Bach and Palestrina during the service. Admirers—associates, collectors, dealers, and friends—were present, and some of them spoke of the achievements of "the greatest Museum Director of our time or of any other" and remembered him as a pungent, positive personality. Eric Maclagan, director of the Victoria and Albert Museum, Bode's intimate friend, and a fellow scholar who shared his enthusiasm for Italian renaissance sculpture, wrote of the funeral ceremony in the *Burlington Magazine*:

A great friend and a great hater, one of the speakers said. A man of unshaken courage, in a position that needs it; how few of the people that make easy jokes about the Flora bust (and she remains rather an enigmatic lady still, even after the discovery of that unforgettable fragment of a Victorian bed-quilt in her waxen interior) know of the various genuine masterpieces which Bode bought cheap for his Museum because others said they were forgeries or were afraid they might be. A man with almost unbelievable gifts of memory, so that if you spoke to him of a rather insignificant piece of sculpture that had turned up in London he would tell you where it had hung in somebody's house in the 'seventies, and which corner was damaged, and how much it had fetched in somebody else's sale in the 'nineties, and what so-and-so had said about it then; and like as not what a fool so-and-so was. A man of inexhaustible energy; working (to quote another speaker) in express trains, in hotel bedrooms; writing, day after day, those scores of letters with his own hand; receiving, with unhurried courtesy, streams of visitors in his office in the Museum or even after hours in the brick house in the Uhlandstrasse, where you might find him sitting . . . perhaps with his game leg propped up in front of him if it was being more than usually painful. . . .

[As a museum man,] he arranged the Museum rooms and lighting, he fought with architects and ministers, he advised collectors and conciliated possible benefactors, he plunged into the ungrateful details of administration.

Fittingly, "they had put his bust with a laurel wreath" on the grand staircase of the Kaiser Friedrich Museum, small remembrance indeed within that part of the great institution of world art that he had created.[50]

## NOTES

Dr. Rudolf Rimpau of Hochheim on Main near Frankfurt in West Germany is Wilhelm von Bode's grandson. He has been most helpful to me in obtaining books and illustrations, directing me to knowledgeable authorities, answering specific questions, and reading critically the whole chapter. I am most indebted and deeply grateful to him.

1. Wilhelm von Bode, *Mein Leben* [My Life], 2 vols. (Berlin, 1930), 1: 5–65; Gerhard Masur, *Imperial Berlin*, pp. 205–208; *Museums Journal* 28 (April 1929): 332; [West] Berlin Staatliche Museen (State Museums), "Treasures in the Staatliche Museums, [West] Berlin," *Apollo* 102 (December 1975): 396–465.

2. Germain Bazin, *The Museum Age* (New York: Universe Books, Inc., 1967), pp. 195–197, 214; [East] Berlin Staatliche Museen (State Museums), *Art Treasures in the [East] Berlin State Museums*, pp. 16–22; "Gustav Friedrich Waagen, First Director of the Berlin Gallery," *Apollo* 102 (December 1975): 396–403; Niels von Holst, *Creators, Collectors and Connoisseurs*, pp. 230–232. See also Wilhelm von Bode, *Fünfzig Jahre Museumsarbeit* [Fifty Years of Museum Work], pp. 1–2.

3. Gustav Friedrich Waagen, *Works of Art and Artists in England*, 3 vols. (London: 1838); Gustav Friedrich Waagen, *Treasures of Art in Great Britain: Being an Account of the Chief Collections of Paintings, Drawings, Sculptures, Illustrated Mss., Etc.*, 3 vols. (London: John Murray, 1854); Gustav Friedrich Waagen, *Galleries and Cabinets of Art in Great Britain . . . Supplemental Volume* (London: J. Murray, 1857); Frank Herrmann, comp., *The English as Collectors*, pp. 145–147; "Waagen, First Director," pp. 396–403; *Apollo* 9 (April 1929): 263–264.

4. Wilhelm Bode, "The Berlin Renaissance Museum," *Fortnightly Review* 56 (October 1891): 506; Bode, *Mein Leben*, 1: 69–90; Wilhelm Treue, *Art Plunder*, p. 210; R. R. Palmer, *A History of the Modern World* (New York: Knopf, 1952), pp. 529–539.

5. Bode, "Berlin Renaissance Museum," p. 508; Bode, *Fünfzig Jahre*, pp. 2–6; Bode, *Mein Leben*, 1: 67–69, 105–108.

6. Masur, *Imperial Berlin*, p. 211; Bode, *Fünfzig Jahre*, pp. 7–10.

7. Bode, "Berlin Renaissance Museum," pp. 506–515; Bode, *Fünfzig Jahre*, pp. 13–21, 39–42, 62; Bode, *Mein Leben*, 1: 90–93, 170–178, 239–248; Masur, *Imperial Berlin*, pp. 205–211; East Berlin State Museums, *Treasures*, pp. 16–22; West Berlin State Museums, "Treasures," pp. 427–431.

8. East Berlin State Museums, *Treasures*, p. 12.

9. Wilhelm Bode, *Florentine Sculptors of the Renaissance*, p. 91.

10. "Bode," *Burlington Magazine* 54 (April 1929): 165–166; American Library Association, *National Union Catalogue: Pre-1956 Imprints* (London and Chicago: Mansell, 1969), 62: 650–656; British Museum, *General Catalogue of Printed Books . . . to 1955* (London: Trustees of the British Museum, 1965), 22: 349–353; Germain Seligman, *Merchants of Art*, p. 124; Holst,

234     *MUSEUM MASTERS*

*Creators, Collectors and Connoisseurs,* p. 257; Max J. Friedländer, *Reminiscences and Reflections,* p. 22.

11. Bode, *Fünfzig Jahre,* pp. 27–31; Herrmann, *English as Collectors,* pp. 388–389.

12. Walter Kiaulehn, *Berlin: Schicksal einer Weltstadt* (Berlin: Fate of a World City) (München/Berlin: Biederstein Verlag, 1958), pp. 318–326; Masur, *Imperial Berlin,* pp. 95, 209–210; Treue, *Art Plunder,* pp. 210–211; West Berlin State Museums, "Treasures," pp. 427–431; Holst, *Creators, Collectors and Connoisseurs,* p. 257; W. G. Constable, *Art Collecting in the United States of America,* pp. 100–102; Friedländer, *Reminiscences and Reflections,* pp. 103–104. For catalogues by Bode, see *Die Sammlung Oscar Hainauer* (Berlin, 1897) and *Die Sammlung Osdar Huldschinsky* (Frankfurt a Main: J. Bauer, 1909).

13. Bode, *Fünfzig Jahre,* pp. 22–26; Seligman, *Merchants of Art,* p. 223; Holst, *Creators, Collectors and Connoisseurs,* p. 257.

14. Bode, *Fünfzig, Jahre,* pp. 34–36; René Gimpel, *Diary of an Art Dealer,* p. 225. See also Bode, "Berlin Renaissance Museum," p. 510; Constable, *Art Collecting,* p. 103; Herrman, *English as Collectors,* p. 35; Samuel Nathaniel Behrman, *Duveen,* pp. 67–69, 133; Kenneth Clark, *Another Part of the Wood: A Self-Portrait* (London: John Murray, 1974), pp. 138–142; Joseph Henry Duveen, *Collections & Recollections: A Century and a Half of Art Deals* (London: Doubleday, Doran, 1935), p. 268.

15. "À Berlin," *Burlington Magazine* 15 (April 1909): 3–4. See also Bode, *Fünfzig Jahre,* pp. 32–33; Bode, *Mein Leben,* 2: 110–115; Kiaulehn, *Berlin,* pp. 326–327; Masur, *Imperial Berlin,* p. 208; Treue, *Art Plunder,* p. 211; West Berlin State Museums, "Treasures," pp. 427–431; Herrmann, *English as Collectors,* pp. 373–374; Holst, *Creators, Collectors and Connoisseurs,* p. 257; Kaiser-Friedrich-Museums-Verein, Berlin: *Erwerbungen* (Collection), *1897–1972,* and *Kunstwerke aus dem Besitz* (Artwork in Its Possession).

16. "German Art and the German Character," *Burlington Magazine* 8 (November 1905): 77–79; "Art in Germany," *Burlington Magazine* 12 (November 1907): 116–117; Constable, *Art Collecting,* p. 103; Gimpel, *Diary of an Art Dealer,* p. 143; Seligman, *Merchants of Art,* p. 258; *Museums Journal* 8 (March 1909): 331; Frits Lught, "In Memoriam: Dr. Wilhelm von Bode and Mr. J. P. Heseltine," pp. 263–264; "The Late Dr. Lippmann," *Burlington Magazine* 4 (January 1904): 7–8; Max J. Friedländer, *On Art and Connoisseurship,* p. 15; Friedländer, *Reminiscences and Reflections,* pp. 20, 94–96; Nicky Mariano, *Forty Years with Berenson* (London: Hamish Hamilton, 1966), p. 51; Arthur Upham Pope, "The Problem of the Asiatic Museum in Berlin," *Museum Work* 7 (September/October 1924): 67; Bode, *Fünfzig Jahre,* pp. 59–62; Wilhelm Bode, comp., *Collection of J. Pierpont Morgan: Bronzes of the Renaissance and Subsequent Periods,* 2 vols. (Paris: Libraire centrale des beaux arts, 1910); Bode, *Mein Leben,* 2: 192–196; W. R. Valentiner, "Scholarship in Museums," pp. 65–68.

17. Bode, "Berlin Renaissance Museum," pp. 506–515.

18. H. H. Pars, *Pictures in Peril,* pp. 4–5, 153–156, 191–192, 195; Ignaz Beth, *Verzeichnis der Schriften von Wilhelm v. Bode* (Catalogue of Bode's Publications); Picture Gallery, [West] Berlin, Staaliche Museum Preussischer Kulturbesitz, *Catalogue of Paintings, 13th-18th Century,* 2nd revised edition (Berlin-Dahlem: Picture Gallery, 1978), pp. 183–184, 286, 382; West Berlin State Museums, "Treasures," pp. 429, 456; Bode, *Fünfzig Jahre,* pp. 50–51; Bode, *Mein Leben,* 2: 122–127. See also Wilhelm von Bode, ed., *Frans Hals: His Life and Works,* 2 vols. (Berlin: Photographische Gesellschaft, 1904).

19. Bode, *Mein Leben,* 2: 104–109; Friedländer, *On Art and Connoisseurship,* pp. 15, 176–177; Treue, *Art Plunder,* pp. 211–213; Denys Sutton, *Christies's since the War, 1945–1958: An Essay on Taste, Patronage and Collecting* (London: Privately Printed, 1958), p. 58; Holst, *Creators, Collectors and Connoisseurs,* pp. 311–312.

20. Bode, *Fünfzig Jahre,* pp. 59–62; Bode, *Mein Leben,* 2: 155–157; Klaus Brisch, "Bode as

Founder of Museums of Islamic Art and Far Eastern Art" (MS), Memorial Service on Fiftieth Anniversary of von Bode's Death, April 9, 1979; A. Mahr. "The Centenary Celebrations of the Prussian State Museums (Berlin, October 1–2, 1930)," pp. 353–360; Pope, "The Asiatic Museum in Berlin," 67–72; Wilhelm von Bode, *Antique Rugs from the Near East*, pp. 5, 9, 12; Wendy Hefford, "Review of Bode and Ernst Kühnel, *Antique Rugs of the Near East*," *Museums Journal* 70 (March 1971): 190; East Berlin State Museums, *Treasures*, pp. 14, 18, 34–38; West Berlin State Museums, "Treasures," pp. 412–416, 422–423; [West] Berlin State Museums, "State Museums of the Preussischer Kulturbesitz," pp. 206–227; Otto Friedrich, *Before the Deluge*, pp. 160, 386; Roger Fry, *Letters*, 1: 304n.

21. Holst, *Creators, Collectors and Connoisseurs*, Bode, *Fünfzig Jahre*, pp. 66–67; Bode, "Berlin Renaissance Museum," pp. 511–512; "German Art and German Character," pp. 77–79.

22. Holst, *Creators, Collectors and Connoisseurs*, pp. 285, 378; West Berlin State Museums, "Treasures," p. 427; Charles R. Richards, *Industrial Art and the Museum* (New York: Macmillan, 1927), pp. 5–8, 10–20.

23. Holst, *Creators, Collectors and Connoisseurs*, p. 288; "The Purpose and Policy of the National Museums," *Burlington Magazine* 9 (April 1906): 4.

24. Bode, *Mein Leben*, 2: 97, 134, 151, 178, 189; East Berlin State Museums, *Treasures*, pp. 19, 27, 29, 30, 32–33, 101–104, 122–124; Mahr, "Centenary Celebrations," pp. 353–360. See also Evamaria Schmidt, *The Great Altar of Pergamon* (Boston: Boston Book and Art Shop, 1965).

25. Bode, *Fünfzig Jahre*, pp. 63–65; *Burlington Magazine* 8 (December 1905): 218; (March 1906): 444; 9 (April 1906): 49–51; 10 (November 1907): 398; 13 (April 1908): 53–54; 16 (October 1909): 62; (January 1910): 242.

26. Fry, *Letters*, 1: 220; 2: 703, 709, 741; *Burlington Magazine* 11 (June 1907): 181–182; (July 1907): 249.

27. *International Studio* 92 (April 1929): 59–60; Ernest Samuels, *Bernard Berenson*, pp. 72–73, 441; Bode, "Berlin Renaissance Museum," p. 509; Bode, *Mein Leben*, 2: 57–64; Seligman, *Merchants of Art*, p. 126; Gimpel, *Diary of an Art Dealer*, p. 283.

28. Seligman, *Merchants of Art*, p. 124; Treue, *Art Plunder*, p. 215; *Apollo* 9 (April 1929): 263–264; *Burlington Magazine* 54 (April 1929): 165–166; Gimpel, *Diary of an Art Dealer*, p. 4; Mariano, *Forty Years with Berenson*, p. 51; Constable, *Art Collecting*, p. 103; Friedländer, *Reminiscences and Reflections*, p. 23.

29. C. J. Holmes, *Self and Partners (Mostly Self)*, p. 215; Samuels, *Berenson: Connoisseur*, pp. 382–383, 390–401; *Burlington Magazine* 54 (April 1929): 165–166; Wilhelm Bode, *The Art Collection of Mr. Alfred Beit . . .* (Berlin: Privately Printed, 1904); "Fifty Years of the Burlington Magazine," *Burlington Magazine* 95 (March 1953): 63–65.

30. George Charles Williamson, *Murray Marks and His Friends*, pp. 29, 187–193; Holmes, *Self and Partners*, pp. 230–231; *Burlington Magazine* 15 (May 1909): 108–113; (September 1909): 399; George Savage, *Forgeries, Fakes, and Reproductions: A Handbook for the Art Dealer and Collector* (New York and Washington: Frederick A. Praeger, 1963), pp. 108–111; Gerald Reitlinger, *The Economics of Taste: The Rise and Fall of Picture Prices, 1760–1960* (London: Barrie and Rockliff, 1961), p. 198; Pars, *Pictures in Peril*, pp. 91–102.

31. *Burlington Magazine* 17 (May 1910): 69; (June 1910): 178–183; (August 1910): 253–254; 54 (April 1929): 165–166.

32. Reitlinger, *Economics of Taste*, p. 198; Williamson, *Murray Marks*, pp. 191–192; Frank Arnau, *The Art of the Faker: Three Thousand Years of Deception* (Boston: Little Brown, 1961), pp. 104–105; Hans Tietze, *Genuine and False: Copies, Imitations, Forgeries* (New York: Chanticleer Press, 1948), pp. 46–47; Savage, *Forgeries, Fakes, and Reproductions*, pp. 108–111.

33. Holmes, *Self and Partners*, pp. 269–270; Gimpel, *Diary of an Art Dealer*, pp. 143–144;

Seligman, *Merchants of Art*, p. 122; *Burlington Magazine* 17 (June 1910): 189; 54 (April 1929): 165–166; West Berlin Museums, "Treasures," p. 430; Bernard Berenson, *Rumor and Reflection* (New York: Simon and Schuster, 1952), p. 220; Treue, *Art Plunder*, p. 211; *Museums Journal* 28 (April 1929): 332.

34. Kenneth Clark, *Leonardo da Vinci: An Account of His Development as an Artist* (Cambridge, England: Cambridge University Press, 1952), pp. 145–146.

35. *Connoisseur* 158 (March 1965): 181.

36. Bode, *Mein Leben*, 2: 198–200; Werner Weisbach, *Und alles ist zerstoben* (And Everything Has Vanished) (Vienna: Verlag H. Reichner, 1937), pp. 103–104; Wilhelm Bode, "Max Liebermann zu seinem sechzigsten geburtstag (on His Sixtieth Birthday)," *Kunst and Kunstler* (1907): 181–192.

37. Bode, *Mein Leben*, 2: 83, 97–101, 144–146; Aline B. Saarinen, *The Proud Possessors: The Lives, Times and Tastes of Some Adventurous American Collectors* (New York: Random House, 1958), pp. 56–117; Behrman, *Duveen*, pp. 87–145; Constable, *Art Collecting*, pp. 100–102; Wilhelm R. Valentiner, "Diary from My First American Years," *Art News* 58 (April 1959): 34–36; *International Studio* 92 (April 1929): 59–60.

38. Bode, *Fünfzig Jahre*, pp. 65–66.

39. Wilhelm von Bode, *The German Government in relation to Works of Art in Belgium* [Berlin: League of German Scholars and Artists for the Advancement of Culture, 1914]; Treue, *Art Plunder*, pp. 217–220.

40. Treue, *Art Plunder*, pp. 218–220; *Museums Journal* 14 (November 1914): 176–177; Fry, *Letters*, 1: 55.

41. Philip Mason Burnett, *Reparations at the Paris Peace Conference: From the Standpoint of the American Delegation*, 2 vols. (New York: Columbia University Press, 1940), 1: 1,130; 2: 241–242; Bode, *Fünfzig Jahre*, p. 38; West Berlin State Museums, "Treasures," pp. 425, 426.

42. East Berlin State Museums, *Treasures*, p. 12; Friedrich, *Before the Deluge*, pp. 124–125; John Mander, *Berlin: The Eagle and the Bear* (1959; reprint, Westport, Conn.: Greenwood Press, 1979) pp. 126–128.

43. Bode, *Fünfzig Jahre*, p. 38, *Museums Journal* 17 (March 1918): 144; West Berlin State Museums, "Treasures," pp. 430, 440, 446, 456–457; Masur, *Imperial Berlin*, p. 209.

44. East Berlin State Museums, *Treasures*, p. 19; West Berlin State Museums, "Treasures," pp. 424, 440; Mahr, "Centenary Celebrations," pp. 359–360.

45. East Berlin State Museums, *Treasures*, pp. 14–15, 20; West Berlin State Museums, "Treasures," pp. 424, 440; Friedrich, *Before the Deluge*, p. 386.

46. Treue, *Art Plunder*, pp. 256–258; East Berlin State Museums, *Treasures*, pp. 14, 20; West Berlin State Museums, "Treasures," pp. 448–451, 456–458.

47. Treue, *Art Plunder*, pp. 256–257; East Berlin State Museums, *Treasures*, pp. 20–21; Eleanor Lansing Dulles, *Berlin: The Wall Is Not Forever* (Chapel Hill, N.C.: University of North Carolina Press, 1967), p. 126.

48. East Berlin State Museums, *Treasures*, pp. 21–23.

49. "State Museums of the Preussischer Kulturbesitz," pp. 206–228; West Berlin State Museums, "Treasures," pp. 396–465; Eva Jantzen, "The New Antiquities Department in Berlin-Charlottenburg," *Museum* 14 (1961): 169–174; Ludwig Mies van der Rohe, *New National Gallery, Berlin, West Germany, 1968*. Global Architecture Series 14 (Tokyo: A.D.A. Edition, 1972), pp. 2–7, 9–27.

50. *Burlington Magazine* 54 (April 1929): 165–166. For other obituaries, see *Apollo* 9 (April 1929): 263–264; *International Studio* 92 (April 1929): 59–60; *Parnassus* 1 (November 1929): 32. See also *Wilhelm von Bode:: Ansprachen bei der Trauerfeier in der Basilika des Kaiser-Friedrich*

*Museums, am 5. Marz 1929* (Speeches near the Bier in the Basilica of the Kaiser Friedrich Museum, 5 March 1929) (Berlin: Privately Printed, 1929).

# SELECT BIBLIOGRAPHY

Behrman, Samuel Nathaniel. *Duveen*. New York: Random House, 1952. 302 pp.

Berenson, Bernard. *The Selected Letters*. Edited by A. K. McComb. London: Hutchinson, 1965. 310 pp.

Berlin, [East,] Staatliche Museen. *Art Treasures of the Berlin State Museums*. New York: Harry N. Abrams, 1965. 269 pp.

Berlin, [West,] State Museums Curatorial Staff. "State Museums of the Preussischer Kulturbesitz, Berlin." *Museum* 25 (1973): 206–228.

————. "Treasures in the Staatliche Museen, Berlin." *Apollo* 102 (December 1975): 396–465.

Beth, Ignaz. *Verzeichnis der Schriften von Wilhelm v. Bode* (Catalogue of Bode's Publications). Berlin and Leipzig: Behr, 1915. 140 pp.; 515 entries.

Bode, Wilhelm von. *Antique Rugs from the Near East*. With Contributions by Ernst Kühnel. 3rd revised edition. New York: E. Weyhe, 1922. 65 pp.

————. "The Berlin Renaissance Museum." *Fortnightly Review* 56 (October 1891): 506–515.

————. *Florentine Sculptors of the Renaissance*. Translated by F. L. Rudston Brown. 2nd revised edition. 1928. Reprint. New York: Hacker Art Books, 1969. 258 pp.

————. *Fünfzig Jahre Museumsarbeit* (Fifty Years of Museum Work). Bielefeld and Leipzig: Velhagen & Klasing, 1922. 68 pp.

————. *Mein Leben* (My Life). 2 vols. Berlin: Verlag Harmann Reckendorf, 1930.

*Burlington Magazine*. "Bode." Vol. 54 (April 1929): 165–166.

Constable. W. G. *Art Collecting in the United States of America: An Outline of a History*. London: Thomas Nelson and Sons, 1964. 209 pp.

Friedländer, Max J. *On Art and Connoisseurship*. Boston: Beacon Press, 1960.

————. *Reminiscences and Reflections*. Edited from the literary remains and with a foreword by Rudolph M. Heilbrunn. Translated from the German by Ruth S. Magurn. London: Evelyn Adams & Mackay, 1969. 109 pp.

Friedrich, Otto. *Before the Deluge: A Portrait of Berlin in the 1920s*. New York: Harper and Row, 1972. 418 pp.

Fry, Roger. *Letters*. Edited by Dennys Sutton. 2 vols. New York: Random House, 1972. 787 pp.

Gimpel, René. *Diary of an Art Dealer*. New York: Farrar, Strauss and Giroux, 1966. 465 pp.

Herrmann, Frank, comp. *The English as Collectors: A Documentary Chrestomathy*. London: Chatto & Windus, 1972. 461 pp.

Holmes, C. J. *Self and Partners (Mostly Self): Being the Reminiscences of C. J. Holmes*. New York: Macmillan, 1936. 404 pp.

Holst, Niels von. *Creators, Collectors and Connoisseurs: The Anatomy of Artistic Taste from Antiquity to the Present Day*. New York: G. P. Putnam's Sons, 1967. 400 pp.

Jantzen, Eva. "The New Antiquities Department in Berlin-Charlottenburg." *Museum* 14 (1961): 169–174.

Kaiser-Friedrich-Museums-Verein, Berlin. *Erwerbungen* (Collections), *1897–1972*. Berlin: Verein, 1972. 165 pp.

———. *Kunstwerke aus dem Besitz des Kaiser-Friedrich-Museums-Vereins* [Artwork in Its Possession]. Berlin: Verein, 1966. 52 pp.

Lught, Frits. "In Memoriam: Dr. W. von Bode and Mr. J. P. Heseltine." *Apollo* 9 (April 1929): 263–264.

Mahr, Dr. A. "The Centenary Celebrations of the Prussian State Museums. [Berlin, October 1–2, 1930]." *Museums Journal* 30 (March 1931): 353–360.

Masur, Gerhard. *Imperial Berlin*. New York: Basic Books, 1971. 353 pp.

Pars, H. H. *Pictures in Peril*. Translated from the German by Kathrine Talbot. New York: Oxford University Press, 1957. 240 pp.

Picture Gallery, [West] Berlin. Staaliche Museen Preussischer Kulturbesitz. *Catalogue of Paintings, 13th–18th Century*. Translation by Linda B. Parshall. 2nd revised edition. Berlin-Dahlem: Picture Gallery, 1978. 499 pp.

Samuels, Ernest. *Bernard Berenson: The Making of a Connoisseur*. Cambridge, Mass., and London: Belknap Press of Harvard University Press, 1979. 477 pp.

Seligman, Germain. *Merchants of Art, 1880–1960: Eighty Years of Professional Collecting*. New York: Appleton-Century-Crofts, 1961. 294 pp.

Treue, Wilhelm. *Art Plunder: The Fate of Works of Art in War and Unrest*. First published at Dusseldorf, 1957; New York: John Day, 1961. 264 pp.

Valentiner, Wilhelm R. "Scholarship in Museums: Personal Reminiscences." *College Art Journal* 19 (Fall 1959): 65–68.

Waetzoldt, Stephan. "New [German] Museum Buildings." *Museum* 21 (1968): 158–169.

Williamson, George Charles. *Murray Marks and His Friends: A Tribute of Regard*. London and New York: John Lane, 1919. 206 pp.

# Artur Hazelius
# and Skansen:
# The Open Air Museum

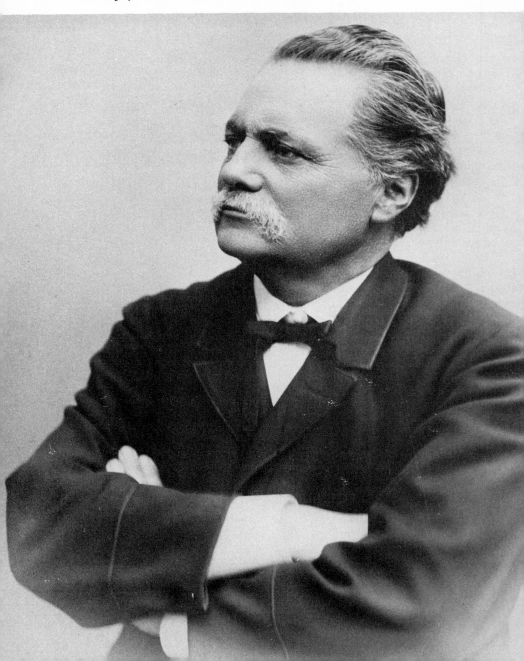

Fig. 20. Artur Hazelius (1833–1901), 1890. *(Photograph by Dahllof, Stockholm. Courtesy of the Nordiska Museet, Stockholm.)*

RTUR IMMANUEL HAZELIUS, the younger son of a good middle-class family, was born in Stockholm on November 30, 1833. Many of his forebears were clerics, but his father, Johan August Hazelius (1791–1871), was an officer in the Swedish army who rose from sublieutenant to major general. The elder Hazelius founded a school for cadets at Stockholm and wrote manuals that ran into several editions on artillery and fortification, as well as a history of the Franco-Prussian War. He also furthered patriotic efforts to reinvigorate Swedish culture. He was a close friend of the romantic poet, Carl Jonas Love Almqvist, and they made walking tours together into the countryside to taste the moral and religious beauty of Swedish peasant life. Almqvist himself took part briefly in a rural communal settlement that tried to live close to nature, and he also drafted rules for the Manhem Society, which aimed to let young men glimpse the true spirit of old Sweden. He devised a series of degrees for that order, each with its symbolic room and ritual. Johan Hazelius was an enthusiastic member of the society.[1]

The elder Hazelius was small in stature, but of vigorous energy and full of progressive ideas. In addition to his teaching in the military academy, he published a small newspaper, in which he discussed the social problems of the day. Artur said, much later, that his father's heritage to him was a burning patriotism, a hatred of the pettiness and prejudice so often found in politics and bureaucracies, a love for independence and clear thinking, and a devotion to hard work for noble ends. With those ideals, Johan Hazelius admired Swedish traditions as found in peasant life as much as he distrusted the corrupting influence of the city. Consequently, when Artur was nine, their father sent the boy and his elder brother to study and board with a vicar, Thure Reinhold Ekenstam, in Smaland on charming Lake Vindomen. The Reverend Mr. Ekenstam was a gifted, though pedantic teacher; and on his glebe farm, Artur learned the meaning of hard work.[2]

When the boy was fourteen, he returned to Stockholm to enter a progressive private school, on the board of which his father served. A good scholar and athlete, Artur was chosen the "head boy" to keep order in his class and soon was known for his fairness. He frequently took long hikes into the countryside; in 1852, for example, he journeyed through

Jämtland, encountering everywhere the folk traditions that interested him more and more, and on another trip he learned to weave, he thought rather well. Two years later, he passed his baccalaureate examinations for the University of Uppsala and started his six years of study there. He was impressed by learned faculty members such as Christoffer Jacob Boström, whose philosophical teachings he admired, though he deplored Boström's conservative political views. He played cards with the wife of a colonel, Malla Montgomery Silferstolpe, who jokingly admonished him to sit up straight. He was a lively participant in student life and kept a list of his friends in his journal, but he was a bit puritanical and did not admire those who engaged in the heavy drinking bouts that so many students enjoyed.[3]

In 1856, the Scandinavian Students' Union met at Uppsala to discuss the desirability of closer cultural ties among Denmark, Norway, and Sweden. This pan-Scandinavianism appealed to young Hazelius, and he participated actively in the meeting and was pleased to make friends with Danish and Norwegian students in attendance. When Oscar I, king of Sweden and Norway, invited the whole student meeting to dinner at Drottningholm Palace outside Stockholm, Hazelius brought home about twenty guests; his mother (born Eva Lovisa Svanberg, from Ångerman-land) had to obtain a large schoolroom in which they could sleep. On another occasion, after an excursion to Drottningholm, Artur returned with seventy merry young people for an evening of dancing, and his mother provided supper for them all.[4]

Throughout his stay at the university, Hazelius was concerned greatly with improving the Swedish language, an interest he shared with his father. His doctoral dissertation dealt with the *Hávamál*, a collection of early Norse Eddic aphorisms; he defended it successfully in 1860, not only against the faculty, but also against a prominent authority on the Gothic language, Anders Uppström, who gave Artur a rather warm time with his searching questions. Some of Artur's friends wanted him to remain at the university to begin his climb up the academic ladder, but his father convinced him that a practical, active life was better than mere theoretical research.[5]

After graduation from Uppsala, Hazelius began teaching Swedish language and literature in the preparatory school he had attended and then went on to become professor of several normal schools in Stockholm, where he was enormously popular with the young people in attendance. He was interested in trying to obtain more uniform spelling of the Swedish language and wrote three weighty treatments of orthography, published in 1870 and 1871. In 1864, he was married to Sofi Elisabet

Grafström, daughter of Anders Abraham Grafström, prominent clergy-man at Umeå and a member of the Swedish Academy. Hazelius was critical of the attempt of a committee to translate the Bible into Swedish, even though he agreed that there should be such a Bible in every home for the educated and the uneducated, the rich and the poor. He did not follow his father-in-law's suggestion that he translate the New Testament, but he did compile a series of patriotic reading materials for children and young people. In 1868, he ceased teaching and, after two more years of school administration, resigned in order to decide what he wished to do with his life; by then he thought spelling reform too small and pedantic a goal.[6]

For the next few years, Artur was unemployed, and Sofi took in boarders to help keep the family finances solvent. Hazelius considered devoting himself to archaeology, to re-erecting runic stones and inventorying prehistoric sites, and the Swedish Archaeological Association invited him to become its secretary—but without salary. Artur and Sofi had spent several summer holidays tramping about Sweden, and in 1872 they visited the lake-filled province of Dalarna. Hazelius was distressed to find that the pleasant, coherent, and highly individualized way of living he had known as a schoolboy and had observed in Dalarna on trips, before his marriage, was beginning to disappear. The Industrial Revolution, he feared, was bringing about a stifling and tasteless uniformity and threatening both the natural beauty of the environment and the rich cultural variety of Swedish life. The booming grain market was making farmers prosperous, tempting them to buy luxury goods, and changing traditional ways of dress, food, and even religion.

In thinking about the situation, Hazelius decided that a broad knowledge of Swedish history and a fresh use of traditional ideas and patterns might help save the essential spirit of his country; and during the 1872 tour, he decided to collect the old costumes, furniture, furnishings, tools, paintings, music, dances, and sayings of the folk, so that the culture they represented could be preserved, studied, and understood. The end result, he hoped, would be sound patriotism, devoid of the emotional frenzy and jingoism that characterized so much nationalism; he envisioned it, instead, as broad-based, tolerant, humanistic, and suited to modern civilization. He defined the *folk* as all classes of the nation, rural and urban—nobles, merchants, professional men, craft workers, and peasants. Collecting, preserving, and studying the everyday life, both material and immaterial, of the peasants, however, was the new element; some collections and studies already existed of the high art of the aristocratic and wealthy.[7]

Hazelius's ideas fitted well into the romantic and idealistic aura of the

age. Oscar Montelius had explored the field of Swedish archaeology, and G. O. Hyltén-Cavallius had done an ethnographic description of the old province of Varend in South Smaland. Though not a trained ethnologist, Hazelius's development of a folk museum, with its collections of material culture and traditions, greatly advanced the study of both ethnography and social history. Hazelius also shared other reform enthusiasms of the day, especially the pan-Scandinavian movement. He determined to collect materials and study the oral cultures of Denmark, Norway, Finland, and their possessions, as well as those of Sweden. Hazelius did not advocate copying old institutions and patterns exactly, but believed that students who understood the Swedish past would use tradition as a starting point and go on to express themselves in distinctive Swedish ways, suitable for their day and the new materials at hand. Thus they would avoid the monotonous, stereotyped, and even sordid aspects of the industrial age. A knowledge of the design and techniques of the old handicrafts, for example, would give modern craftsmen new inspiration and lead to more original work; and the machine not only could avert drudgery but could be used creatively and with imagination.[8]

Thus, Artur Hazelius, at almost forty years of age, embarked on a new career. With the faithful help of his young wife, he began to gather folk materials and traditions, at first emphasizing the varied costume or dress of the provinces. His thoroughness in collecting was demonstrated when he brought home a pile of knitted peasant caps from Vingäker. His sister laughed and said she thought that one or two examples would have been enough, but Artur said that he must save all such things before it was too late. He also made it a rule to keep full records on the materials he acquired and the traditions he studied, with sketches and meticulous notes on their history or provenance, and Sofi rendered great assistance in that area. The young couple was not wealthy, but their enthusiasm made them popular with the common people and the peasants, and much material came in as gifts. Soon their little house was crowded with old domestic implements and tools, as well as with chests and boxes of other materials piled high.[9]

Obviously, Hazelius needed some place to put his growing collection and, eventually, a place to exhibit it. His father died in 1871, and Artur began to use his inheritance to further the cause, but that was not enough. For a time, he hoped to raise 5,000 kronor (about $1,700) from a wealthy merchant, but ceased his efforts when the man wished to impose restrictions; Hazelius had to be content with 1,000 kronor borrowed from a relative.

He began to show his costume collection in rented quarters, and then moved everything into the two small Northern and Southern Pavilions at Drottninggatan, in the center of Stockholm. He opened his holdings to the public on October 24, 1873, as the Museum of Scandinavian Ethnography.

From the beginning, he emphasized naturalistic or functional arrangement, then a fresh approach to exhibition replacing the systematic scheme of rows of labeled objects arranged geographically or by type, many of them in heavy glass cases. He was ever ready to experiment and was aware of recent movements in the museum world—the somewhat crude but full-scale habitat groups of animals and plants appearing in natural history museums and the period rooms exhibited at world's fairs and beginning to find their way into museums. He also realized the attraction of waxwork tableaux still popular in Europe and adapted that device to show the costumes of old Sweden. He developed a series of display techniques that included the historical period room with authentic interior architecture, furniture, and furnishings; the theatrical tableau, portraying a dramatic, sentimental story, as did the waxworks, but adding an authentic setting and accurately dressed figures; and the panorama, with costumed mannequins posed in a proper milieu before a painted background, with careful attention paid to perspective. In a sense, Hazelius was applying the prototype habitat group of the natural history museum to ethnography, social history, or folk life, with modeled human figures predominant instead of animals preserved by taxidermy.[10]

While these exciting developments were attracting crowds to Drottninggatan, in 1874, Sofi Hazelius died in childbirth, leaving a grief-stricken Artur with his new son Gunnar. Artur plunged into work for his museum with great concentration, and, though he had many friends, he became more and more a kind of dedicated loner who participated sparingly in the intellectual and social life of Stockholm. He also began to suffer a nervous twitching of the face that made him somewhat sensitive in social groups. In 1878, at the Universal Exhibition—the world's fair held in Paris, at the Trocadéro Palace—Hazelius secured world-wide attention for his museum with his striking exhibits devoted mainly to peasant life in Sweden, but with some attention to Norway, Denmark, Finland, and Esthonia, as well. He took along thirty mannequins in folk costumes and arranged them as a series of "living pictures." He used costumed receptionists and home craft demonstrators. A panorama of a Lapp encampment with its tepee-like turf and pole hut, a reindeer pulling a sled, two hunters on skis, and a mother and family, the whole set in a snow-covered

forest, was nothing short of a sensation, and an illustration of it appeared on the front page of Le Journal Illustré of Paris. Equally popular was a touching tableau of a grieving family group gathered about the cradle of a dying child, based upon Amalia Lindegren's sentimental painting, The Little Girl's Last Bed. The local newspapers reported that "Never have wax or wooden figures or theatre decorations achieved such artistic effects of truth and life. All mothers cry beside the little one's last bed." Hazelius, always aware of the public relations value of such accounts, translated the stories and sent them to the Swedish press.[11]

Artur returned from Paris, to find himself dissatisfied with his museum. His collections were growing so rapidly that they were swamping the small Drottninggatan pavilions. In the first four years of collecting, he had listed more than ten thousand accessions (usually containing three or four times that many objects); and during his entire thirty years of assembling museum materials, he was to enter more than two hundred thousand accessions. Surviving photographs show that, by the late 1870s, Hazelius's exhibits had become crowded and confusing to the eye. An alcove with a period setting and carefully dressed models was engulfed visually by encroaching typological exhibits, such as serried rows of wooden containers, ceramic plates suspended on the walls, and a wooden stand of glass wing panels that contained numerous prints. Even pleasant women from Dalarna serving as museum guides or interpreters and dressed in picturesque peasant garb could not overcome the sense of disarray that visitors to the crowded collection experienced.[12]

Hazelius decided that the first thing he must do would be to revamp the organization of the museum. He offered his collections to the Swedish state, but they were refused, although—beginning in 1875—the Swedish Parliament gave him an annual grant of between five thousand and seventy-five hundred kronor. Then, in 1880, he turned his museum over to the public in another way, under a Committee of Trustees consisting of the director of the museum (at first, Hazelius himself) and six others, usually senior civil servants, industrialists, or scientific and cultural leaders. The committee co-opted its members except that, beginning in 1909, the state insisted on appointing one trustee. The new institution, which did not belong to the state, though it received increasingly large annual state subsidies, was named Nordiska Museet—that is, Northern or Nordic Museum, so as to underline its pan-Scandinavian character. Its seal contained the motto "Know Thyself," appropriately, since Hazelius thought it essential that Scandinavians become aware of their identity by understanding the materials and traditions of their folk past.

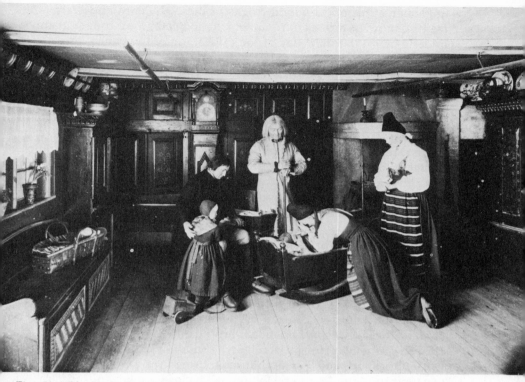

Fig. 21. "The Little Girl's Last Bed," about 1877. This period room was created by Artur Hazelius, based on a painting (1858) by Amalia Lindegren. It was shown at the Paris World's Fair of 1878. *(Courtesy of Nordiska Museet, Stockholm.)*

Ten years later, Hazelius's guidebook for the museum stated that it was occupying four pavilions at Drottninggatan, with sections devoted to peasant life (twenty-one rooms including a storeroom, two workrooms, and two rooms for library and archives); to Finland, Denmark, Schleswig, Lapland, and Greenland (seven rooms); to craft corporations and guilds (five rooms and storeroom); to higher classes of society (twenty-seven rooms); to Norway (twelve rooms, including one for Iceland); to Swedish and Danish kings and other famous men (two rooms); to maritime objects (one room); to pharmaceutical materials (one room); and to recent accessions (two rooms). Individual functional exhibits mentioned in the guidebook included a mannequin of a peasant girl with tapestries and domestic

implements; historical period rooms of the eighteenth and early nine-
teenth centuries; a peasant room with a modeled group congratulating a
bride-to-be on the third day of the publishing of the banns; three such
groups of Laplanders, one on their autumnal journey from the mountains
to the warmer plains; and *The Little Girl's Last Bed*.[13]

Hazelius also began to push, as early as the late 1870s, to obtain a new
building for the museum. The king gave him a beautiful site on
Djurgården (Deer Garden) Island, overlooking Stockholm Harbor, and
furnished part of the capital cost. During the 1880s and 1890s, Hazelius
made extensive visits to several hundred museums in England, France,
Germany, Austria, Hungary, Belgium, the Netherlands, and Switzer-
land; he carefully inspected, sketched, and made notes on their buildings
and exhibits. For example, he attended the Millennial Exhibit at Budapest
in 1896, to visit an ethnographic village assembled there with twenty-four
peasant farmsteads and four public buildings. Isak Gustav Clason, the
architect, assisted by Hazelius and Richard Mejborg, a Danish cultural
historian, designed a quadrangular renaissance castle in the Dutch-
Danish style, based upon Fredericksborg and Rosenborg castles in Den-
mark and Vadstena and Gripsholm in Sweden. The building would cost
about three million kronor, and the money came in slowly—the largest
sum from a lottery organized by the state and smaller amounts from
bazaars, legislative appropriations, private gifts, and revolving loans that
Hazelius arranged. He said later that the building was raised almost by his
two empty hands and that he endured fourteen years of horrible financial
uncertainty. Ann Margret Holmgren, a close friend and admirer of
Hazelius, stated that there was violent and long-lived opposition to his
plans; some insisted that the state should own the museum outright,
some accused him of depriving other regions (Norway especially) of their
patrimony, and still others ridiculed his storytelling exhibits. He was
attacked so bitterly in the newspapers that he himself once wrote: "It is as
though I were a criminal."[14] Construction of the building began in 1888,
but was delayed by the Stockholm International Industrial Exhibition of
1897 held on Djurgården Island and was not completed until 1907, long
after Hazelius's death. Only one side of the quadrangle was built, the
whole about one-third the size of the original plan. It had a hall more than
three stories high, as large as a cathedral, and intended by Hazelius to
house great national festivals. Twenty-eight side rooms at the ground
level were to contain life-sized panoramas facing the hall. The first- and
second-floor galleries that encircled the great room were to exhibit inte-
riors of peasant cottages and other rural materials. By the time the build-
ing was well along, however, Hazelius had given the world a new kind of

open air museum, to exhibit not only the material possessions, but also the life of the folk in a convincing and natural way.[15]

## II

During the 1880s, Hazelius's concept of the folk museum sharpened. He continued to collect objects of material culture, to preserve them carefully, record them precisely, and do research on them with thorough scholarship. He instituted field studies on the way the folk lived—their houses, gardens, and interior furnishings, household implements, tools, and clothing as well as their beliefs, customs, and amusements. At first, his assistants went about Sweden by train and on foot, sketching and writing down their observations and interviews; later they bicycled and took their cameras. His continuing aim was to use the past to inspire national consciousness in the Swedish people and to serve as a cultural balance during a period of rapid industrial and social change. He tried to devise functional exhibits that would attract visitor participation and bring objects to life. He also longed for the completion of the museum building with its great hall designed as a gathering place on Swedish national and seasonal holidays.

With that background, it was a natural step for Hazelius to begin collecting buildings from throughout Sweden and placing them on a hillside that overlooked the harbor and city and was near the new building then under construction. He had seen vernacular historical structures at the Paris Exhibition in 1878, and he soon was planning an outdoor section for his folk museum; by 1884, he had a definite design for it in his mind. The site he chose on Djurgården Island was called Skansen (Redoubt) after a seventeenth-century fortification found there, and thus the world's first extensive open air museum was named Skansen when it opened to the public on October 11, 1891. Now Hazelius had a vehicle that would allow him to present not only aged buildings, settings, and furnishings, but also costumed guides, household crafts, and folk music and dance. He came to regard both indoor and outdoor sections as necessary components of a folk museum, though his chief interest shifted gradually to the open-air part. Still, Nordiska Museet would provide proper processing, storage, and conservation of objects, broad service to scholars, and scientific research and publication, while Skansen stressed popular education, with much reliance on sensory perception—sight, sound, smell, touch, and the kinetic or muscle sense—and would allow visitors to glimpse the past and be pleasantly entertained while doing so.[16]

Scattered experiments with open air museums had preceded Skansen.

King Charles XV of Sweden (who reigned from 1859 to 1872) had built a replica of a medieval loft-house from Dalarna beside his Ulriksdal castle, and Oscar II (who reigned from 1872 to 1907) had an old stave church dating from about 1200 and several other buildings (they are now in the Norwegian Folk Museum) near his residence outside Christiana or Oslo. These royal buildings, however, were not open to the public. Several world's fairs exhibited African or Oriental natives with their own huts, costumes, food, arts, and rites. The International Colonial Exposition at Amsterdam in 1883 showed an Indonesian *Kampong* accurately furnished and with plaster figures in native dress. Two years later, this open air village was moved to the National Museum of Ethnology in Leiden, where it drew large crowds until damage from the harsh winters caused it to close in 1891. But Skansen was the first true open air museum as the term is understood today.[17]

In 1891, Hazelius acquired seven acres known as Upper Skansen for 25,000 kronor and began building roads, cleaning ponds, and planting trees and shrubbery, but he realized at once that the tract was too small. He advanced his own credit to purchase the adjoining Bredablick parcel of fifty acres for 100,000 kronor, while he found 115 donors who pledged 100 kronor each annually for a period of ten years. Other plots were added between 1896 and 1901, and small increments since then have brought the total to about seventy-five acres. The situation of the land was handsome indeed, with rocky hills, ponds, woods, and fields, as well as a spectacular view of Stockholm and its harbor. There were a few structures on the property, and Hazelius kept the "Yellow House" (about 1814) for his residence, another building for administration, and the red brick Bredablick look-out tower (1874–1876) nearly 100 feet high and with a commanding view. At first, he was not sure what he wanted to do and in a newspaper interview talked of exhibiting prehistoric graves and placing a medieval castle as the crowning feature atop the highest point. The first historic house for the new museum was a trimmed-log peasant principal dwelling of the sixteenth century, from Mora in Dalarna, purchased in 1885, and it was soon accompanied by a Hackstugan, or "chipping house," used by farmer stonecutters at Orsa in Dalarna; by a farmhouse from Kyrkhult in Bleckinge that had a low, turf-covered log cabin between two-story storehouses; and a Lapp settlement with turf and pole tepees and an elevated storehouse, soon enlivened during summers by a Lapp family and its reindeer. By the end of the century, Hazelius had added the eighteenth-century Bollnas farmhouse from Halsingland, the impressive wooden Mällestad church belfry (1732), 125 feet high, from Östergotland,

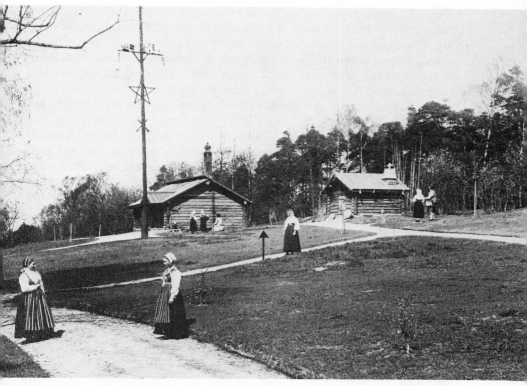

Fig. 22. Farmsteads and maypole at Skansen, 1892. *(Courtesy of Nordiska Museet, Stockholm.)*

the three-part eighteenth-century Oktorps farmstead from Halland with thatched roofs, and a simple crofter's cottage from Hornborga in Västergötland that contained living room, small cowhouse, and barn. These buildings, like most of those moved to Skansen, were of wood, well preserved in the dry, cold climate, and were comparatively easy to take down, transport, and reassemble. They were placed around the tract in no meaningful order, not arranged by province or constituting a true village. The interiors were furnished with great respect for authenticity and often were charmingly decorated, sometimes with bright woven or painted textiles. The exterior settings, while composed of native plants, did not try to reproduce exactly the crops or gardens that would have been found on the original sites. While Hazelius had the romantic idea of

showing Sweden in miniature, Skansen's rocky terrain was not suitable for the many different natural environments found throughout the country. Other features there included charcoal burners' huts, a maypole, a granary from Mora (1595), another tall church belfry, a retired soldier's simple cottage, and a windmill. Several of the farmsteads were quadrangular, with living quarters, outbuildings, stables, and the like set about a rectangular hard-surfaced working space. The whole effect was extremely picturesque.[18]

The mention of reindeer reminds one that Skansen, almost from the beginning, contained a zoo. The whole island was for long a royal game preserve; and in the eighteenth century, circuses sometimes played there, and bear-baitings took place. Hazelius stocked his open air museum not only with domestic animals—goats, cattle, sheep, reindeer, geese, ducks, chickens, and the like—but with cages, enclosures, and pits of wild animals such as elk, bears, lynxes, wolves, storks, other assorted Swedish fauna, and more exotic animals, such as monkeys. In Hazelius's day, before many of the present approximately 150 historical buildings were in place, the zoological garden was more prominent and occupied about as much space as the ethnographic displays.[19]

Skansen gave Hazelius every opportunity to bring this part of his folk museum to life. The guides and caretakers wore costumes authentic for the buildings in which they worked, and on Sundays the men donned uniforms of the times of Gustav Adolphus or Charles XII. Domestic crafts were demonstrated in the buildings—baking, with its delicious aromas; spinning, weaving, and needlework; the making of candles, soap, and cheese; and other activities. Folk music enlivened the old houses, and fiddlers from all over Sweden were encouraged to visit and to compete with each other. The birchbark horn, cow horn, "hummel" (a kind of zither), "key harp", and other folk instruments were played. Folk dancing was popular with young and old, and the "Friends of the Swedish Folkdance" was formed at the Yellow House in 1893. Several restaurants were set up and served much traditional food, while sometimes there were exciting theater performances in the summer. Moreover, Hazelius now had a stage for his festivals. Some of them re-enacted moments of history on appropriate anniversaries: Gustav Vasa, the founder of modern Sweden, would again march with his peasant troops, as if against Stockholm; Gustav Adolphus would sing his old battle hymns, as if at Leipzig and Lutzen; and Charles XII would lead his blue-coated troops, as if against Russia. In 1893, Hazelius began to celebrate June 6, the day of Gustav Vasa's accession, as Sweden's National Birthday or Flag Day. Then

there were Walpurgis Night (April 30), which dates from Viking times, with enormous beacon fires to welcome the coming of spring; Midsummer's Eve (June 23), and dancing around the maypole; and near Christmas, "star boys" clothed in white and with white crowns illuminated by candles carried the Star of Bethlehem from building to building. All this activity helped reduce Hazelius's financial worries. From its first opening, Skansen attracted crowds that were willing to pay the modest admission fees and special charges. Here were exhibitions that the common person could understand and enjoy, with none of the forbidding elitism and hands-off attitude associated with so many museums. Here were presented serious concepts of education and patriotism, combined with recreation and the air of the picnic.[20]

Though Hazelius gave fresh energy and more and more enthusiastic attention to Skansen, he continued to direct Nordiska Museet with skill and deep interest. He built a staff of accomplished scholars in ethnography and provided them with an extensive research library that contained not only books but also historical manuscripts, prints and photographs, and notes of field investigations, many of these materials gathered by the scholars themselves. Beginning in 1881, Hazelius edited the museums' yearbook that continues today as the *Fataburen* (Storehouse), jointly published by Nordiska Museet and Skansen. Nordiska Museet also brought out in 1882 his study of the rural life of the Nordic people. Other titles issued during his directorship dealt with Romanesque rural churches; lace in the museum; Finland in Nordiska Museet; an early seventeenth-century court judgment book of Västergötland; drawings of Icelandic objects in the museum; drawings and photographs of houses from a parish in Dalarna; eighteenth-century beliefs and household remedies of two parishes near Stockholm; the ancient musical instrument called the "key harp"; a parish shoemaker's memoirs from the 1820s; illustrations of exhibits in the museum; wood engraving designs in the peasant style; and pictures of Skansen. These publications, in addition to an increasing flow of catalogues of museum exhibits, started Nordiska Museet on the path that allows it, today, to claim that it "produces a greater number of books and papers of varying nature than any other museum in Europe."[21]

Hazelius was adept at enlisting both scholarly and volunteer help for his museums. He was friendly, enthusiastic, and tactful; he despised petty quarreling, and readily acknowledged the assistance of others in collection, research, and other fields. And yet he was hard-driving and demanding with his staff. He issued written orders on standard-sized slips of paper, and while he was unstinting in his praise for work well

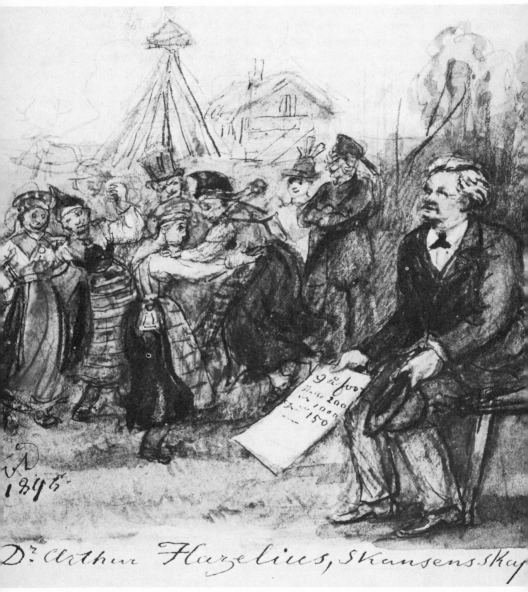

Fig. 23. Caricature of Artur Hazelius at Skansen, 1896. By Fritz von Dardel. *(Courtesy of Nordiska Museet, Stockholm.)*

done, he had biting reprimands for failure. Axel Key, professor of pathological anatomy at Stockholm's medical center, the Karolinska Institute, and a member of Parliament, was second only to Hazelius in services to Nordiska and Skansen. Key furnished the business ability they needed, set up a sound accounting system, and did much fund raising. In 1880, he helped Hazelius found the Association for the Promotion of the Nordiska Museet, later known as the Skansen Society. The painter Jakob Kulle made numerous collecting trips in Sweden, and another painter, Thure Cederström of Munich, was Hazelius's chief buyer from German antique dealers. Sophie Adlersparre, who started a handicraft society in 1873, for a time worked as an assistant in the museum. Bud Erik Olsson, one of Hazelius's close friends in the farming community since the 1860s, purchased the Mora farmhouse for Skansen, and Torjus Leifson Bolkesjö, a Norwegian farmer, collected the majority of the Norwegian objects in the museum. Hugo Samzelius gathered items of Lapp culture. Per Gustaf Wistrand made collecting and research excursions into the country and then became an assistant and librarian at the museum while continuing his journeys during the summer. Men and women like these gave Hazelius firm support and deserve much credit for helping the folk and open air museum conceptions overcome the many obstacles encountered during their early history.[22]

In 1893, Nordiska Museet struck the Artur Hazelius Medal bearing a portrait of Hazelius in profile and presented it to the founder on his sixtieth birthday. Since that time, the museum has awarded the medal in gold, silver, or bronze to those who have given it valuable service or contributed outstanding research. Hazelius continued to serve the two parts of his museum for more than seven years longer, until he died at home from a heart attack on May 27, 1901. The archaeologist Oscar Montelius, in a final oration, assured the dead founder: "You have lovingly guarded the memories of the Swedish people. The Swedish people will lovingly guard your memory." Hazelius was buried not far from the Hällestad belfry in his beloved Skansen, his grave marked by a huge, simply inscribed granite slab.[23]

In Skansen, Hazelius discovered a new principle for organizing an ethnographic or historical museum. He presented a full-scale, in-the-round, three-dimensional environment covering several historical periods that could be authentic and true if based on careful scientific research. This arrangement was more convincing for the ordinary person than any systematic display of museum cases with objects and labels could be. Hazelius recreated the life of the different periods, thus playing upon the

emotions of the viewers and giving them a memorable experience. As they walked about the carefully restored environment of other days, their thoughts and feelings helped bring the place to life. Their experience, Hazelius hoped, would furnish historical perspective and inspiration that would add values to their everyday existence.

As Andreas Lindblom, a later director of Nordiska Museet and Skansen, put it:

Hazelius proceeded from the principle that knowledge and love of the past are an essential foundation for all kinds of new productions. . . . The old houses and rooms of Skansen . . . are comforting and stimulating because they suggest life, not death, life not only in the houses but also outside, for Skansen attracts people who are full of zest for living.

And Iorwerth C. Peate, one-time director of the Welsh Folk Museum, asserted that "Hazelius's achievement was that of taking a sudden leap in museum technique and so transforming the museum from a curiosity shop into a home of national inspiration."[24]

Did Hazelius succeed in his underlying objective of teaching a sensible and useful patriotism to his fellow Swedes? Perhaps so, if we are to judge from the comments made in 1916, on the occasion of the twenty-fifth anniversary of the opening of Skansen. Admirers from home and abroad joined, to place wreaths on his grave. F. A. Bather, who for long had known and esteemed Hazelius and his work and who had advocated— strongly but vainly—establishing a national folk museum in England, called the observance "The Triumph of Hazelius" and reported in the British *Museums Journal*:

The bequest of Artur Hazelius to his countrymen, and indeed to the world at large, was something more than a new idea of museum-arrangement, something more than these material representations. It was the conception that the greatness of a country, the strength of its industries, the beauty of its art, have their firm root in that country's own history. The pillar of cloud that should ever float before us, woven of the high ideals towards which we press, must arise always from the breath of those who first carved out the path and paved the way for succeeding generations. Let each nation trust in its own spirit and bind together all its far-scattered children by the firm bond of a common past.[25]

But that was a romantic day, before two world wars and atomic armaments had made humankind uneasy about unbridled nationalism and a time when imperialism still had its strong defenders. Still, one should remember that Hazelius's aspirations were cultural, rather than militaristic, territorial, or commercial.

Did Hazelius help inspire a material cultural renaissance among his fellow Swedes and Scandinavians? Certainly such a blooming has taken place, and Swedish, Norwegian, Danish, Finnish, and Icelandic furniture, textiles, silver and stainless steel, glass, ceramics, and other craft wares are admired throughout the world. Lilli Zickerman and her Associates for Swedish Home Crafts, founded in 1899, knew well Nordiska Museet's large collections of everyday things, domestic craftwork, and practical wares, and she gave the museum her studies of old Swedish textiles with some 24,000 illustrations. But the chief designers and craftworkers guiding the production of twentieth-century wares were influenced by many international movements, as well, including the functionalism of the Bauhaus and the abstractions of modern art. It is true, however, that Swedish designers were determined not to make fine and exclusive products for the few, but rather to allow everyone to share in good technical and aesthetic quality; thus, democratic mottos were popular, such as "Beauty for all" and "More beautiful everyday things." The objects in Hazelius's peasant collections at both Nordiska Museet and Skansen had been created with similar aims in an earlier day and could serve, sometimes as models and patterns from which to start, sometimes as contrasts, for the new, leaner, and more disciplined style so well suited for modern living. In any event, the bipartite folk museum had its own values, and too much should not be claimed for its influence on later craft and industrial production.[26]

## III

The death of Artur Hazelius for a time imperiled his museum ideal. In a few testamentary notes, he had nominated his son Gunnar to succeed him as director. Gunnar was then twenty-seven and completing his doctorate in history at Uppsala. The Committee of Trustees of Nordiska Museet promptly appointed him manager of Skansen and secretary of the board, but elected an assistant keeper, Dr. John Böttiger, to Artur Hazelius's place on the board and put Böttiger in charge of Nordiska Museet affairs. Böttiger argued that Nordiska and Skansen should each have its director, and when the board refused formally to adopt that arrangement, he resigned his administrative post, though retaining his place on the board. Dr. Bernhard Salin, an archaeologist and assistant keeper of the State Historical Museum, was then appointed keeper of Nordiska Museet.

Salin was able to persuade the board to change its plans for the new

building that was now far enough along to begin receiving materials from the Drottninggatan pavilions. He did not admire the popular functional exhibits favored by Artur Hazelius, but considered them old-fashioned and overromantic. Instead, Salin wished to show as much of the whole collection as possible, with the objects classified and arranged scientifically and systematically. Gunnar Hazelius fought against exhibition by geographic or technical classification and enlightenedly advocated a dual arrangement, with attractive exhibits for the general public and well-ordered, accessible storage of other objects for study by the scholar and expert. The board upheld Salin, turned over Artur Hazelius's Great Hall to the Royal Armory and its displays, and partitioned off the twenty-eight side rooms facing it to receive crowded, uninspiring case and wall exhibits. Ironically enough, the old-line museum keepers could maintain that Skansen satisfied the need for popular functional exhibits and festivals so that Nordiska Museet could devote itself to more important areas of collection, conservation, classification, scientific research, and scholarly publication. Gunnar saw many of his father's dreams being thwarted, and he decided that the only way to save the ideal of an indoor and outdoor section of a folk museum under unified management was to resign, so that Salin could become director of both branches. The fight between conservative and progressive museum concepts had been fierce indeed; Gunnar Hazelius died in 1905, at thirty-one, of a severe gastric hemorrhage.[27]

Under Dr. Salin, 1902–1913, and his successor, Dr. Gustav Upmark, 1913–1928, Nordiska Museet devoted itself chiefly to ethnographic and historical research and publication. Its conventional, neatly arranged systematic exhibits and artistic period rooms in the palatial new building, opened to the public on June 8, 1907, were to remain largely unchanged for a quarter century. Hazelius had organized departments of peasant culture, upper classes, and library (today with more than a hundred thousand volumes on ethnography, folk life, crafts, and the like), and then cultural history and natural history for Skansen. At his death, the collection of non-Swedish materials ceased. Publications, based mainly on in-house research, increased, and in 1918 the museum appointed a professor of ethnology, to teach also at Stockholm University and to be housed, soon, in an Institute for Folk Life Research in its own villa near the museum. The naming of Andreas Lindblom, professor of art history at Stockholm University, as director of Nordiska Museet and Skansen in 1929 brought fresh life to the two institutions. A department of education with a museum lecturer, the first in Sweden, served both Nordiska and

Skansen and developed a comprehensive program to handle school visits and to send school kits all over the country. In 1940, the museums added materials of the industrial worker to their fields of collection. At Nordiska, attention was given to making exhibits attractive; items displayed were arranged more frequently according to functional or ethnological principles, rather than geographical or typological ones, and changing, temporary displays became more numerous. The collections were growing so rapidly (between five hundred thousand and a million objects, today) that storage became an increasing problem, and only about 10 percent of the holdings could be shown. Field research expanded greatly, with volunteers from throughout the nation and teams from Nordiska contributing reports, recordings, and visuals; the museum now has about one-half million photographs and films. Today, Nordiska Museet has become a national institution, a cultural central museum collecting objects and data for the period from about 1500 to date, doing research and publication in this field, and making interlibrary loans throughout Sweden. The museum has acquired several far-flung manor houses and other properties that are starting to store part of the museum's collections and to serve as branch regional cultural centers. The Swedish state is making increasingly large appropriations for Nordiska Museet, though the museum remains a private organization.[28]

Several large donations permitted Lindblom to make great improvements in both the cultural and natural history departments of Skansen, and just at the time when an important world's fair was being held at Stockholm in 1930. The entire quadrangular gray, weatherbeaten farmstead (dating from about 1590) from Mora in Dalarna was installed, with Prince Charles of Sweden speaking at the opening. A small seventeenth-century manor house, Skogaholm, modernized between 1794 and 1796, with Louis XVI interiors, was moved into the park, to show the life of the upper classes. That same year, for the first time, Skansen's attendance exceeded one million. In 1932, the opening of the Old Town Quarters that included the house in which Hazelius was born added a new urban historical dimension and permitted the demonstration of some twenty commercial crafts that included tanning, shoemaking, papermaking, gold beating, engraving, coopering, pewtering, printing, bookbinding, baking, glass blowing, and the making of pottery, as well as an operating grocery and pharmacy. The products of the potter and glass blower sold well as souvenirs. The eighteenth-century church from Seglora had been erected earlier (1918), in a prominent spot near the marketplace, where snacks and souvenirs were sold. The church was reconsecrated,

and regular Lutheran services were held each Sunday; it was also a favorite place for weddings, about two hundred of which took place each year.

Lindblom appreciated Hazelius's conception of Skansen as a people's park or public pleasure ground and encouraged its recreational use. It was indeed a lively place. Flax and rye grew at various plots there, in the summer, and numerous domestic animals wandered about the Oktorp operating farm. Children could go wading, take rides on ponies or on a miniature railroad, and pet small animals at Little Skansen. Music was everywhere—fiddlers, dance bands, vocalists, and symphony orchestras. On festival days, the king might come to speak to the great crowds. Special "days" were arranged, for craft and other interest groups, and special "weeks" were devoted to separate provinces or regions. Plays were staged, during the summer, in a charming outdoor theater, sometimes presenting works by Shakespeare, sometimes by Selma Langerlöf, or other Swedish favorites. (After 1955, Skansen appeared frequently on television.) A huge ballroom accommodated modern ballroom dancing, and on a smaller platform, vigorous folk dances were led by a costumed troupe, with traditional music. In the winter, skating and skiing were popular. And on special occasions, great bursts of fireworks lighted the skies.[29]

The joint administration of Nordiska Museet and Skansen under a single director and a committee of trustees with seven members that included the director worked reasonably well for some seventy years. Nordiska's yearly attendance grew to about 150,000, while Skansen's usually exceeded 2,000,000. Skansen learned from visitor surveys that 70 percent of its patronage attended between May and August, that family groups with children were most common, that they stayed about one and a quarter hours, and that 60 percent were from Stockholm, 30 percent from elsewhere in Sweden, and 10 percent from abroad. The Swedish nation virtually supported Nordiska and was willing to pay for the cultural history program for Skansen. From the beginning, into the 1940s, Skansen showed an annual surplus from admission fees and special events, gifts and endowment, and appropriations from the state and the city of Stockholm, though probably not enough allowance was made for proper conservation and maintenance. The city, however, was dissatisfied with the arrangement and complained that the Skansen profits were spent mainly on Nordiska Museet projects and that Skansen nonmuseum activities were often slighted. While the city agreed, in principle, that it ought to underwrite the zoological garden programs and recreational

activities open to the public, it refused to do so unless Skansen was given its own independent organization and financing.

The city's attitude combined with the general rising inflation placed the two institutions in a precarious financial position, and, in 1963 and 1964, they were forced to agree to separate. Nordiska's seven-member board that included the director as a full voting member was retained and made entirely state-appointed. Skansen was given a seven-member board, of which four, including the president, were named by the state (though two were nominated by the Nordiska board), with the other three named by the city. The Skansen board selected the director, who was not a board member, though he attended its regular meetings. The state was entirely responsible for financing Nordiska, while Skansen obtained about one-third of its income at the gate, and of the remainder the city furnished some 60 percent and the state 40 percent. The two museums continued to co-operate closely; Nordiska handled nearly all the registration of collections for both, maintained the library and archives, and did the major share of the publications, though the *Fataburen* yearbook was issued jointly. The older staff members disliked the separation and saw a lessening of co-operation, but new members joining the two organizations seemed well satisfied with the arrangement.[30]

Perhaps the chief problem facing both museums was space for future expansion. Nordiska needed much more room for exhibition, storage, and workshops, and yet was saddled with a solidly constructed but often inconvenient monumental building. Using its properties scattered about Sweden could at least partially meet Nordiska's needs for specific kinds of space. The museum planned to develop Julita Manor in Södermanland, about seventy miles west of Stockholm, into an open air agricultural museum with ample storage facilities and conservation workshops, and prepared to place textiles and costumes, with supporting workshops, at Forsbacka Manor, in the Gävle-Sandviken area, some eighty miles north of Stockholm. Nordiska also owned Tyresö Castle, about twelve miles from the capital, Svindersvigk Manor only three miles out, and several other properties. Thus Nordiska had the opportunity to develop as a true central museum with collections, workshops, exhibits, and interpretive activities placed in regional branches. Skansen had more difficulty finding additional space, though it may decide eventually to keep only animals suitable for its buildings and to discontinue stocking the exotic animals that aroused criticism by diluting the Swedish theme of its exhibits and activities. Skansen could also replace some of the more modern structures on its periphery to make room for other historical exhibits.[31]

IV

The folk museum, and especially its open-air section, as developed by Hazelius, inspired a revival of national and community pride throughout Sweden that resulted in some eight hundred regional and local folk museums. They helped enhance the social movement called *hembygdsvård* that glorified the home community. Most of the museums were small, built around a little farm, a single old dwelling on the town common, a manor house in its surrounding park, an ancient workshop, a small vicarage, an aged parish church, or an abandoned village. They became lively community centers, cherished by the young people. Pageants and festivals flourished there in the summer. The youngsters would dress in traditional costumes and bring out old wagons and gaily decorated horse collars in order to stage a mock wedding or the annual begging procession to raise money for the museum. They learned old fiddle tunes, revived lively dances, recited aged funny stories, jokes, and rhymes. On the darker side, many of the museums faced the same desperate fight for existence that small, weak, and ill-financed cultural properties undergo throughout the world, and they often neglected properly preserving their buildings and furnishings.[32]

The open-air-museum idea spread rapidly elsewhere in Scandinavia. Bernhard Olsen of Copenhagen, the head designer at Tivoli amusement park there, saw Hazelius's exhibits in 1878 at the Paris International Exhibition. He at once realized that "Here was something new—the emergence of a fresh museum concept associated with a class, the life and activities of which had hitherto been disregarded by the traditional and official view of what was significant to scholarship and culture." Though he rejected Hazelius's highly emotional tableaux, which he found "similar to the way it is done at a waxworks," Olsen admired greatly an authentically furnished historical period room in the Dutch displays that made him feel as if he were "in another world—far away in time and space from the crowded, modern exhibition"; it was clear to him "that this was the way a folk museum should be." Olsen returned home to organize the Danish Folk Museum. Despite the opposition of traditionalists in the National Museum—one of whom sneered that "Rubbish is rubbish even if it's old rubbish"—he succeeded in making his collection of rooms, furnishings, library, archives, and photographs a section of the National Museum. In 1897, he established a small open air Museum of Buildings in the Rosenborg Castle gardens in Copenhagen. He then began to develop a beautiful rural park at Lyngby near the Sorgenfri Palace, about eight

miles from Copenhagen, and the Frilandsmuseet opened there in 1901 with farmhouses, barns, cottages, craft shops, and water- and windmills situtated on a ninety-acre tract not far from the undulating green banks of the Mollea River. Frilandsmuseet, now a separate department of the National Museum, developed a painstaking technique for moving buildings, made its exterior settings attain the high accuracy of its furnishings, and brought life to the picture of another day with its craft demonstrations and spirited folk dances.[33]

The broad-gauged collecting activities of Hazelius were responsible for another important open air museum, at Lillehammer in Norway. Anders Sandvig, a young Norwegian dentist, came there for his health, supposedly with only a short time to live. In 1886, he saw five wagonlaods of furniture and furnishings of the Gudbrands Valley that Hazelius's agents were sending to Stockholm. Sandvig thought it shameful for these beautiful folk materials to leave their native region, and, as he practiced his profession, he began to collect such objects, making trips to the farms and posting stations of Gudbrandsdal. In 1894, he moved an aged building (and then five others) into his garden, but they were somewhat in danger from fire, since a railroad passed nearby. In 1904, a society was formed to purchase Sandvig's collection and move it to Maihaugen (May Hill), a place where the Norwegian National Day was observed every May 17. Dr. Sandvig continued to collect for Maihaugen and served as its director. It was always one of the loveliest of the open-air group, its four separate sections of some one hundred structures occupying seventy-five acres and grouped around five small lakes. Maihaugen was a self-contained organization without a large related indoor museum to supplement it. One section comprised about fifty workshops in a large modern building where, during the summer, such varied types of craftsmen as a joiner, cooper, wood turner, wheelwright, screwmaker, printer, bookbinder, gunsmith, locksmith, painter, engraver, clock maker, shoemaker, saddler, and others plied their trades.[34]

Dr. Hans Aall founded the Norsk Folkemuseum at Oslo in 1894 and, eight years later, moved it to Bygdoy, a peninsula extending into Oslo Harbor. The museum had an excellent indoor section, and its open-air part contained a hundred and fifty buildings on thirty-five acres, arranged according to the Norwegian provinces and with urban structures forming an old town. At Aarhus, in the province of Jutland, in northern Denmark, Den Gamle By (the Old Town) became the first open air museum devoted exclusively to town life. Peter Holm, an enthusiastic and friendly schoolmaster, in 1909 moved a fine half-timbered renaissance

house (dating from 1597) to a spacious park in Aarhus as the centerpiece of a city celebration and went on to develop about fifty houses and workshops in a fifty-two-acre park with town square, two streets, and a waterfront. Den Gamle By had no supporting indoor museum. When Holm permitted visitors to walk through its rooms, the National Museum's director predicted that "the things would be trampled down and stolen" and Holm would bitterly regret his insane idea. Professor Axel Olai Heikel brought Finland into the open-air-museum movement in 1909, when he founded one on the Island of Seurasaari, near Helsinki; it is now a department of the National Museum of Finland.[35]

Today an Association of European Open Air Museums (established in 1968) holds biannual meetings and has issued a useful handbook that lists one hundred and eighty-five such museums. On the continent, eighty-seven of them are in Scandinavia and eighty-seven in Austria, Belgium, Bulgaria, Czechoslovakia, France (where they are known as ecological museums), the two Germanies, Hungary, the Netherlands, Poland, Romania, the Soviet Union, Switzerland, and Yugoslavia. Though a group of British museum leaders greatly admired the Scandinavian models, they failed to obtain a national open air museum, although a small local one appeared on the Isle of Man, in 1938. After World War II, however, several regional open air museums were founded. They included the Welsh Folk Museum (1948) at St. Fagans, near Cardiff; the Ulster Folk and Transport Museum (1958) at Holywood, County Down, near Belfast; the Avoncroft Museum of Buildings (1963) at Bromsgrove, Worcestershire; the Ironbridge Gorge Museum (1968) at Telford, Shropshire; the Weald and Downland Open Air Museum (1969) at Singleton, West Sussex; and the North of England Open Air Museum (1970) at Beamish Hall, County Durham. Most of them followed the Scandinavian pattern, but some presented important variations. Avoncroft's chief aim was to preserve buildings of historical or artistic merit, preferably on their original sites but, if necessary, moved to Avoncroft. It also had a few carefully researched and reconstructed Iron Age huts, as did the Weald and Downland museum.

Ironbridge and Beamish were chiefly science and technology museums, with an open-air approach to what the British call "industrial archaeology." Ironbridge, which covered about three square miles, had original structures and sites that included Coalbrookdale, where Abraham Darby helped start the Industrial Revolution by smelting iron ore with coke (1709), the original cast-iron bridge over the Severn (1779), four seventeenth-century and eight eighteenth-century workers' cottages,

one-half mile of the Shropshire Canal and one thousand feet of the Hay Inclined Plane at Coalport, and the Coalport Tar Tunnel (1787). Buildings and industrial equipment in the region that could not be saved on their original sites were moved to the forty-two acres of Blists Hill Open Air Museum. Much of the three square miles was occupied by contemporary buildings in Telford New Town. Beamish collected, preserved, and interpreted chiefly late nineteenth- and early twentieth-century "buildings and machinery, objects, and information illustrating the development of industry and way of life in the north of England." Its holdings included a chain-smithy, nineteenth-century dairy, 1858 steam engine, steam-powered thresher, single-deck tram car, and five North-Eastern Railway coaches. It also operated a considerable stretch of streetcar or tram line.[36]

In the United States, the outdoor museum has taken two chief forms—actual historic preservation sites operated as museums, or buildings of historical or artistic importance moved to a convenient, unhistorical tract. The historic house as conceived by Ann Pamela Cunningham and her followers was one source of the movement that perhaps culminated in Colonial Williamsburg (1926) in Virginia. This project, for which John D. Rockefeller, Jr., furnished leadership and finances, preserved and restored the colonial capital of Virginia as a living museum with about a hundred main buildings on one hundred and seventy-five acres. The streets, external milieu, and many gardens were open to all comers, and more than thirty exhibition buildings and craft shops with costumed guides and workers received ticketed visitors. In addition, about one hundred properties (some of them small outbuildings) were occupied by Williamsburg residents or visiting tourists; thus the project also constituted a historic district. Many other historic preservation outdoor museums existed throughout the country, such as Historic Deerfield (1952), a typical trim New England village in Massachusetts; Old Salem (1950), an early Moravian settlement at Winston-Salem, North Carolina; the frontier community of Spring Mill Village (1927) in Mitchell, Indiana; and the Franciscan mission preserved at San Juan Bautista State Historic Park (1933) in California.[37]

Not all historic preservation areas were operating museums. Many of them constituted historic districts with exteriors of the buildings and the over-all layout presenting a museumlike appearance, but with the interiors housing contemporary residences, professional offices, shops, restaurants, community organizations, even small museums, or other modern activities. Many of the structures thus were given over to consonant adaptive uses, rather than being used for their original purposes.

The historic district was designed to provide a pleasant historical aura for contemporary living, although, of course, it did attract numerous tourists who regarded it somewhat as a museum. Charleston had the first major historic district in 1931, soon followed by the Vieux Carré of New Orleans; and since the enactment of the federal Historic Preservation Act of 1966, hundreds of such districts are being placed on the National Register of Historic Places. So far as the future is concerned, the historic district is much more important for historic preservation than the historic house museum, the historic preservation museum village, or the conventional open air museum.[38]

Closer to the Scandinavian folk museum in character was Greenfield Village and the Henry Ford Museum (1929) in Dearborn, Michigan, founded by automobile pioneer Henry Ford. Its large indoor museum exhibited collections of industrial and technological materials as well as of the decorative arts, and its village included buildings once connected with Ford and his family; with Edison, the Wright Brothers, and other inventors; a New England village green, with its surrounding buildings; and, from Britain, a Cotswold cottage and barn, as well as a Cheapside London jewelry store. Many American open air museums did not gather structures so indiscriminately, but instead followed a carefully reasoned historical theme. Old Sturbridge Village (1946) in Massachusetts, for example, presented the story of New England farm and rural village life from 1790 to 1840 and hopes some day to bring together an early industrial portion built around a cotton textile mill. The Conner Prairie Pioneer Settlement (1964) at Noblesville, Indiana, showed the pioneer life of the region in the 1830s, and the Stuhr Museum of the Prairie Pioneer (1961) at Grand Island, Nebraska, treated a later period that began with Gold Rush days. American museums of this type usually aimed to build theme-centered villages with emphasis upon social, economic, and even political history, rather than upon more general ethnology.[39]

The open air museum has continued to spread around the world. There are some fourteen Japanese examples, two important clusters of which include farm houses at Toyonaka City, near Osaka, and traditional folk dwellings in Kawasaki City, a suburb of Tokyo. Not far from Bangkok, Muang Boran (the Ancient City), a living museum of two hundred acres in the shape of the map of Thailand, includes temples, palaces, ancient objects, art, crafts, music, a houseboat village, carefully tended native landscape, and domestic animals roaming freely. Africa has several open air museums, such as the one at Niamey (1960) in the Republic of Niger and the African Craft Village (1959) at Livingston, Zambia.[40]

In 1957, under the auspices of the International Council of Museums, twenty-four leaders of the open-air-museum field met in Denmark and Sweden and drew up a dozen resolves to serve as guidelines for the movement. The conference defined such a museum as a collection of buildings transported from their original settings to a convenient, villagelike situation and open to the public. As a rule, the museum contained the dwellings of farmers, shepherds, fishermen, craftsmen, shopkeepers, and laborers with their outbuildings, places of business, shops, churches, and public buildings. Though these structures were chiefly of vernacular or popular architecture, they might include buildings of more sophisticated style or historical importance. All of them should contain appropriate furnishings and equipment, and consideration should be given to providing them with an authentic landscape setting. Auxiliary structures might supply information, orientation, rest room, restaurant, and auditorium facilities that usually included an open air theater for folk performances.

The experts agreed that the open air museum was an important means of preserving a nation's cultural heritage. It had a significant educational mission, and its recreational aspects could attract heavy tourist visitation. The conference recommended a central open air museum for each country, with adequate scientific, technical, and financial resources, and pointed out the advantages of attaching it to an excellent indoor museum of ethnography. Regional open air museums were approved, especially for countries with wide cultural differences, but too much proliferation of them might lead to scientific and financial problems. The establishment of an open air museum should be preceded by a scientific survey of the architecture and folk life of an area.

An open air museum might contain full-scale reconstructed buildings, furnished and equipped as the originals would have been, but this formula should be used with caution and only when originals cannot be found or acquired. The reconstruction work should be based on careful historical research, should employ the strictest scientific methods, and should use old materials wherever possible. In working with aged buildings, technicians might remove features of a modern industrial nature, but they should avoid following any preconceived idea of purity of style and should retain traditional work of a later period. The dismantling, transport, re-erection, and upkeep of such buildings requires architects trained in ethnography, as well as skilled craftsmen, to preserve the maximum documentary record. Physicists and chemists could help preserve structures and exhibits from damage by climate, weather, insects,

and the like. Though the principles of the international committee were based upon the continental European experience, they were useful to American, British, and other museums that to some extent altered the folk approach, placing less stress on agriculture and the peasant and more on actual historical happenings, as well as industrial and technological development.[41]

These principles would have pleased Hazelius, because they preserved well the personality of the brainchild he had sired. To him, the open air museum was a means of cherishing his nation's heritage, of enabling its citizens to understand their historical traditions. To him, the museum's educational function was all-important, but it should also provide opportunities for pleasant recreation and entertainment. And the architecture, furnishings, settings, and traditions were to be scientifically gathered and studied. At first, Hazelius had been overromantic about Skansen; he liked to think of it as Sweden in miniature and applauded when a poet friend described it as a folk poem turned into reality. Hazelius gloried in his story-telling, sentimental tableaux, though, as he went along, he used more historical period rooms and settings, realistically and truthfully furnished. Perhaps he paid too much attention to peasant and rural life at the expense of urban dwellers and industrial workers, but his followers quickly remedied such lapses. Perhaps he put too much emphasis on patriotic spectacles, so that some critics accused him of preferring masquerades to education, but—again—his successors easily changed that stress. Perhaps he would have been wise to remove the monkeys, polar bears, and other exotic wild animals to a less distracting location. Yet, despite such minor flaws, Hazelius's contributions to the museum world were radically new and lasting.

Outdoor museums, too, had other inherent shortcomings and weaknesses. They tended to present too beautiful, too neat and clean a picture of the past, to romanticize its great personages and important happenings, and to appeal too much to the nostalgia of the present-day visitor. They often omitted or played down the ugly features of the age they presented—the grinding hard work, pervasive poverty, injustices of serfdom, slavery, or working class, and the ravages of disease. They also had the problem of freezing a moment or a short time period of the past, of failing to show the development and the flow of history. And they necessarily had to compromise between the customs of the historic period they portrayed and the comfort and safety of their modern visitors.

Bo Lagercrantz of the Stockholm Stadmuseum, writing in 1964, believed that Hazelius's greatest innovation was the placing of historical

objects in their functional context, and when Le Corbusier, the great functional architect, visited the International Exhibition at Stockholm in 1930, he "applauded the genuine, timeless fuctionalism he observed in the timbered cabins of Skansen." Most museums of that day neglected this holistic approach and distributed objects systematically; for example, a medieval altar piece would be broken up with the painted panels, sculptures, and wood carvings sent to three separate departments. Hazelius at Skansen reversed that practice and tried to bring together buildings, outbuildings, objects, landscape, and livestock "against the background of their entire cultural environment." Then he interpreted the whole with costumed guides and workers, dancers and musicians, as well as allowing the visitors to participate in demonstrations, ride in carriages, eat traditional food, perform ancient dances, sing the old songs, and parade in national festivals. Thus, the outdoor museum became a living museum, sensed through the visitors' feelings as well as understood by their minds.

Lagercrantz pointed out that Hazelius's functionalistic views on the display of historical objects have never influenced museums as much as they should have. Art and history museums especially would do well to study the exhibition methods of the open air museum and to note how they are adapted by museums of anthropology, natural history, and science and technology. And "the curators of applied arts have much to learn from that great pioneer . . . Artur Hazelius, whose ideas reach far beyond the problem of the preservation of old buildings." Lagercrantz went on to argue that no more Skansens were needed, because the ease of modern transportation made it possible to visit historic buildings on their original sites. That point of view may be proper when well-located historic properties or historic preservation villages are the alternative. Still, many worthy buildings may be hard to reach or may even be threatened by their surroundings; it may be much easier to safeguard, maintain, exhibit, and interpret them in a carefully planned open air village; and visitors can get to them more easily and often understand them more readily than by wandering about the countryside. The growing popularity of the open-air format would seem to prove that they are here to stay.[42]

## NOTES

1. The best scholarly treatment of Hazelius is Gösta Berg's *Artur Hazelius: Mannen och hans verk* [The Man and His Work]. (The reference here is pp. 3–5, 7, 9). Professor and Mrs.

270      MUSEUM MASTERS

Berg (Gunnel Hazelius-Berg is Artur Hazelius's granddaughter) generously have read and
commented upon this chapter. Both of them began work at Nordiska Museet in 1924. Dr.
Berg was director of Nordiska Museet and Skansen, 1956–1963, and then until his retire-
ment in 1968 director of Skansen under the reorganization. Mrs. Berg was curator of textiles
and costumes at Nordiska. An older work that emphasizes genealogical and family matters
is Frederick Böök, *Artur Hazelius, en Levnadsteckning* [a Biography]. See also Bertil Romberg,
"Johan August Hazelius," *Svenskt Biografiskt Lexicon*, 18: 356–359; Gösta Berg, "Artur Imma-
nuel Hazelius," *Svenskt Biografiskt Lexicon*, 18: 359–364; Edwin Björkman, "The Fame of a
Dead Man's [Artur Hazelius's] Deeds," *American-Scandinavian Review* 12: 400–410; Ernst-
Folke Lindberg, *Gunnar Hazelius: Och Nordiska Museets Installationsfråga* [and Nordiska
Museet's Installation Policy], p. 51. For Almqvist, see Sten Lundwall, "C. J. L. Almqvist in the
Nordiska Museet," *Fataburen, 1966:* 111–126; Sten Lundwall, "Carl Jonas Love Almqvist,
Country Life and the Idea of a Museum," *Fataburen, 1967:* 9–22; Elisabet Stavenow-Hide-
mark, "Why Do You Travel? Carl Jonas Love Almqvist as a Traveler," *Fataburen, 1978:* 41–48.
   2. Berg, *Hazelius*, pp. 4–5, 8–9.
   3. Berg, *Hazelius*, pp. 6–7, 10–11, 28–29.
   4. Berg, *Hazelius*, pp. 12–14; Björkman, "Dead Man's Deeds," p. 403; Ann Margret
Holmgren, "Artur Hazelius: In Memory of His Hundredth Anniversary, November 30,"
*American-Scandinavian Review* 21: 494–497; Mats Rehnberg, *The Nordiska Museet and Skansen*,
p. 12.
   5. Berg, *Hazelius*, p. 16; Artur Hazelius, *Inledning till Hávámal eller Odens sång* . . .
(Uppsala: C. A. Leffler, 1860).
   6. Berg, *Hazelius*, pp. 17–20, 26, 58.
   7. Berg, *Hazelius*, pp. 28–29, 50, 59–61; Björkman, "Dead Man's Deeds," pp. 403–405;
Holmgren, "Hazelius Anniversary," pp. 494–497; Rehnberg, *Nordiska Museet and Skansen*,
pp. 9–14; A. Modén, "Open Air Museums in Sweden," *American-Scandinavian Review* 21:
341–350; "Artur Hazelius: 30th November 1833–27th May 1901," *Museums Journal* 33:
270–272; Nils-Arvid Bringéus, "Artur Hazelius and the Nordiska Museet," *Fataburen, 1972:*
7–32.
   8. Berg, *Hazelius*, pp. 38–45, 47, 59; E. Klein, "Rural Museums in Sweden," *Museums
Journal* 30: 257–263; Modén, "Open Air Museums in Sweden," pp. 342–343; Iorwerth C.
Peate, *Folk Museums*, pp. 9–17.
   9. Berg, *Hazelius*, pp. 84–85; Gösta Berg, "The Nordiska Museet as a Research and
Education Institution," *Fataburen, 1972:* 33–56; Björkman, "Dead Man's Deeds," p. 405;
Holmgren, "Hazelius Anniversary," pp. 494–497; Bringéus, "Hazelius and Nordiska
Museet," p. 32.
   10. Berg, *Hazelius*, pp. 55, 62–63, 67, 69, 73; Gösta Berg, "Artur Hazelius's Studies of
Foreign Museums," *Fataburen, 1967:* 24, 26; Björkman, "Dead Man's Deeds," pp. 405–407;
Holmgren, "Hazelius Anniversary," pp. 494–497; Rehnberg, *Nordiska Museet and Skansen*,
pp. 13–15, 72–74; Bringéus, "Hazelius and Nordiska Museet," pp. 13–14, 19, 21.
   11. *Exposition Ethnographique du Musée d'Ethnographie Scandinave à Stockholm, Representé
par le Docteur Artur Hazelius, Fondeur et Directeur du Musée*, 8 pp.; Berg, *Hazelius*, pp. 30–31,
77–79, 85, 141; Rehnberg, *Nordiska Museet and Skansen*, pp. 72–74, 101; Bringéus, "Hazelius
and Nordiska Museet," pp. 14–17, 32.
   12. Berg, *Hazelius*, pp. 63, 69.
   13. Berg, *Hazelius*, pp. 80–81; Rehnberg, *Nordiska Museet and Skansen*, pp. 16–20; Artur
Hazelius, *Guide to the Collections of the Northern Museum in Stockholm*, 54 pp.
   14. Berg, *Hazelius*, pp. 80–83, 87–90; Holmgren, "Hazelius Anniversary," p. 497.

15. Berg, *Hazelius*, pp. 87–89; Berg, "Nordiska Museet as Research and Education Institution," pp. 24, 26; Gösta Berg, "Artur Hazelius Budapesten," *Különnyomat az Ethnographie* 88 (1977): 478–492; Rehnberg, *Nordiska Museet and Skansen*, pp. 14–15, 17; Lindberg, *Gunnar Hazelius*, pp. 5, 7–8, 51.

16. Berg, *Hazelius*, pp. 94–95, 99–100; Berg, "Nordiska Museet as Research and Education Institution," pp. 33–56; Bengt Nyström, Marianne Olsson, and Annika Osterman, "On Ethnological Documentation," *Fataburen*, 1972: 177–200; Rehnberg, *Nordiska Museet and Skansen*, pp. 20–22, 38–42, 72–74, 154–155, 157; Bringéus, "Hazelius and Nordiska Museet," pp. 7–32; Arne Biörnstad and Ingemar Liman, "The Skansen Programmes and the Time Trend," *Fataburen*, 1972: 97–112; Björkman, "Dead Man's Deeds," p. 410; *Museums Journal* 33 (November 1933): 271.

17. Rehnberg, *Nordiska Museet and Skansen*, pp. 105, 122; Berg, *Hazelius*, pp. 103–106; Hermann Heinrich Frese, *Anthropology and the Public: The Role of Museums* (Leiden: E. J. Brill, 1969), pp. 11, 12; P. H. Pott, *National Museum of Ethnology, Leiden, 1837–1962* (The Hague: National Museum of Ethnology, 1962), pp. 4–5.

18. *Skansen, Stockholm: A Short Guide for Visitors*, pp. 6–8, 15–16, 19–24, 31, 51, 53; Gustaf Upmark, "Skansen 25 år [25th Year]," *Fataburen*, 1916: 97–194; Berg, *Hazelius*, pp. 94–107; Holmgren, "Hazelius Anniversary," p. 497; Rehnberg, *Nordiska Museet and Skansen*, pp. 109, 123–125; F. A. Bather, "Open-Air Folk Museums," *Museums Journal* 29: 379; Sten Granlund, "Sweden," in *Peasant Art in Sweden, Lapland and Iceland*, edited by Charles Holme (London/Paris/New York: Studio, Ltd., 1910), pp. 3–30 and plates; Karl Baedeker, *Norway, Sweden and Denmark* . . . 10th edition (Leipzig: Karl Baedeker, 1912), pp. 341–343; C. E. Freeman, "Museum Methods in Norway and Sweden," *Museums Journal* 37: 490–491; J. A. Sidney Stendall, "Museums in Scandinavia," *Museums Journal* 38: 402–403.

19. Upmark, "Skansen 25th Year," pp. 114–126, 141–146; *Skansen Guide*, pp. 57–72; Rehnberg, *Nordiska Museet and Skansen*, pp. 112–113, 126–140; Baedeker, *Norway, Sweden and Denmark*, pp. 341–343.

20. Björkman, "Dead Man's Deeds," p. 410; Baedeker, *Norway, Sweden and Denmark*, pp. 341–343; Rehnberg, *Nordiska Museet and Skansen*, pp. 93, 152, 154–161; Stefan Bohman, "Folk Music at Skansen," *Fataburen*, 1979: 35–68; Nordiska Museet and Skansen, *Swedish Folk Dances* (Picture Book 9) (Stockholm: Nordiska Museet, 1939); Nordiska Museet and Skansen, *Skansenboken* (Stockholm: Nordiska Museet, 1943), pp. 35–37, 62–63; Berg, *Hazelius*, p. 103.

21. Berg, "Nordiska Museet as Research and Education Institution," pp. 33–56; Rehnberg, *Nordiska Museet and Skansen*, pp. 46–67.

22. Berg, *Hazelius*, pp. 116–134; Rehnberg, *Nordiska Museet and Skansen*, pp. 19–21; Sten Lundwell, "C. U. Palm and the Nordiska Museet," *Fataburen*, 1955: 17–32.

23. Rehnberg, *Nordiska Museet and Skansen*, pp. 20–21; Holmgren, "Hazelius Anniversary," p. 497.

24. Peate, *Folk Museums*, pp. 19–21.

25. F. A. Bather, "The Triumph of Hazelius," *Museums Journal* 16: 136.

26. Maj Sterner, *Homecrafts in Sweden* (Stockholm: C. E. Fritzes, 1939), pp. 143–163; Bringéus, "Hazelius and Nordiska Museet," p. 32; Erik Zahle, editor, *A Treasury of Scandinavian Design* (New York: Golden Press, 1961) pp. 51–70; Eileene Harrison Beer, *Scandinavian Design: Objects of a Life Style* (New York: Farrar, Straus and Giroux, 1975), pp. 3–5.

27. Lindberg, *Gunnar Hazelius*, pp. 51–53; Rhenberg, *Nordiska Museet and Skansen*, p. 74.

28. Rehnberg, *Nordiska Museet and Skansen*, pp. 27–90; Andreas Lindblom, "Graphic Presentation of Life in the Past," *Fataburen*, 1956: 33–48; Berg, "Nordiska Museet as Research

and Education Institution," p. 56; Sigfrid Svensson, "Years of Crisis and Years of War," *Fataburen*, 1972: 57–74; Elisabet and Ove Hidemark, "House and Home in Sweden," *Fataburen*, 1972: 119–136; Hans Melius, "The Nordiska Museet in Education," *Fataburen*, 1972: 137–152; Göran Rosander, "The Collecting Policy of the Nordiska Museet," *Fataburen*, 1972: 153–176; Anna-Maja Nylén, "The Nordiska Museet—a Central Museum of Cultural History," *Fataburen*, 1972: 235–250.

29. *Skansen Guide*, pp. 21–22, 25–29, 39–49; Rehnberg, *Nordiska Museet and Skansen*, pp. 70, 110–175; Yvonne Frendel, "The Skansen Theatre—the First Open-Air Stage in Sweden," *Fataburen*, 1962: 109–130; Svensson, "Years of Crisis and War," pp. 57–74; Biörnstad and Liman, "Skansen Programmes," pp. 97–112; Bengt Benson, "The Old Town Quarters at Skansen as a Living Milieu," *Fataburen*, 1972: 114–118; James R. Short, *A Report to the Sponsors of the Scandinavian Seminar, June 13–August 15, 1965* (Williamsburg, Va.: Privately Published, 1965), pp. 66–71; Laurel Ball, "Swedish Folk Museums," *Museums Journal* 70: 19–23.

30. *Fataburen*, 1964: 298; 1965: 7–14, 235, 277; 1975: 164; 1976: 315; Rehnberg, *Nordiska Museet and Skansen*, p. 70; conversations in June 1980 with Gösta Berg, former director of Nordiska Museet and Skansen; Sune Zachrissen, director, Nordiska Museet; Jonas Berg, curator, Nordiska Museet; Arne Biörnstad, curator and secretary, Skansen; Mats O. Janson, curator, Skansen.

31. Nylén, "Nordiska Museet as Central Museum of Cultural History," pp. 235–250; "The Building Project for the Nordiska Museet at Julita in Södermanland," *Fataburen*, 1972: 251–264.

32. Berg, *Hazelius*, pp. 137–141; Klein, "Rural Museums in Sweden," p. 257; Rehnberg, *Nordiska Museet and Skansen*, p. 84; Modén, "Open Air Museums in Sweden," pp. 341–350; Peate, *Folk Museums*, pp. 31–33; Bather, "Triumph of Hazelius," p. 132.

33. (Holger Rasmussen, editor,) *Dansk Folkemuseum & Frilandsmuseet* (Copenhagen: National Museet, 1966), pp. 7–36; National Museum of Denmark, *The National Museum of Denmark* (Copenhagen: National Museum, 1957), pp. 20–22, 129–183; Peter Michelsen, "The Origin and Aims of the Open-Air Museum," in Rassmussen, *Dansk Folkemuseum & Frilandsmuseet*, pp. 227–244; Peter Michelsen, "The Outdoor Museum and Its Educational Program," in National Trust for Historic Preservation and Colonial Williamsburg, *Historic Preservation Today: Essays Presented to the Seminar on Preservation, Williamsburg, Virginia, September 8–11, 1963* (Charlottesville, Va.: National Trust/Colonial Williamsburg, 1966), pp. 201–224; Berg, *Hazelius*, p. 142; J. W. Y. Higgs, "Display Problems in Folk Museums," *Museums Journal* 61 (December 1961): 168; Frode Kirk and Bjarne Stokland, "Moving Old Buildings," in Rasmussen, *Dansk Folkemuseum & Frilandsmuseet*, pp. 245–263; Kai Uldall, "Open Air Museums," *Museum* 10: 68–96; Short, *Scandinavian Seminar*, pp. 5–10.

34. Fartein Valen-Senstad, *The Sandvig Collections: Guide to the Open Air Museum* (Lillehammer: Gjøvik, 1958); Sigurd Grieg, "Anders Sandvig, the Creater of Maihaugen," *The Norseman* 8 (May/June 1950): 196–198; Eivend J. Engelstad, *Norwegian Museums*, pp. 21–22; Berg, *Hazelius*, p. 142; Short, *Scandinavian Seminar*, pp. 103–108.

35. Stendall, "Museums in Scandinavia," pp. 401, 404–407; Reider Kjellberg, "Scandinavian Open Air Museums," *Museum News* 39: 18–22; Engelstad, *Norwegian Museums*, pp. 16–17; F. A. Bather, " 'The Old Town' Museum at Aarhus," *Museums Journal* 29: 381–384; Peter Holm, "The Old Town: A Folk Museum in Denmark," *Museums Journal* 37 (April 1937): 1–9; Peate, *Folk Museums*, pp. 25, 29–31, 33; Uldall, "Open Air Museums," pp. 69–71; Berg, *Hazelius*, pp. 142–143; Short, *Scandinavian Seminar*, pp. 23–25, 31–33, 114–117.

36. Association of European Open Air Museums, *Handbuch der europäischen Freilichtmuseen*; Association of European Open Air Museums, *Open Air Museums and the Preservation of*

Monuments; [British] Museums Association, *Museums Yearbook, 1979* (London: Museums Association, 1979); Bather, "Open Air Museums," pp. 377–381; Frank Atkinson, "New Open-Air Museums [in Britain]," *Museum* 23: 99–107; Atkinson, "Open Air Museums and Environmental Conservation," *Museums Journal*: 97–99; Frank Atkinson and Michael Holton, "Open Air and Folk Museums," *Museums Journal* 72: 140–142; J. Geraint Jenkins, "Folk Museums: Some Aims and Purposes," *Museums Journal* 69: 17–20; Peate, *Folk Museums,* pp. 37–63; Michael Thomas, "The Avoncroft Museum of Buildings," *Museums Journal* 71: 153–156; Neil Cossons, "The Ironbridge Project," *Museums Journal* 72: 135–139; Neil Cossons, *Ironbridge;* Neil Cossons, "The Museum in the Valley, Ironbridge Gorge," *Museum* 32 (1980): 138–153; John Lowe, "The Weald and Downland Open Air Museum," *Museums Journal* 72: 9–12.

37. Charles B. Hosmer, Jr., *Preservation Comes of Age,* 2 vols., 1: 11–73, 121–129, 363–365, 391–397, 419–421; 2: 898–906, 957–987; A. Lawrence Kocher and Howard Dearstyne, *Colonial Williamsburg;* "Restoration Villages [East of the Mississippi]," *Art in America* 43; Frances Griffin, *Old Salem in Pictures.* Photographs by Bruce Roberts (Charlotte, N.C.: McNally and Loftin, 1966); American Association of Museums/National Register Publishing Company, *The Official Museum Directory 1980: United States and Canada* (Skokie, Ill.: AAM/NRPC, 1979).

38. Walter Muir Whitehill and others, in Special Committee on Historic Preservation, United States Conference of Mayors, *With Heritage So Rich* (New York: Random House, 1966), pp. 35–56; Hosmer, *Preservation Comes of Age,* 1: 231–377.

39. Hosmer, *Preservation Comes of Age,* 1: 75–130; 2: 987–992; Henry Ford Museum Staff, *Greenfield Village and the Henry Ford Museum;* Geoffrey C. Upward, *A Home for Our Heritage;* Catherine Fennelly, *Life in an Old New England Country Village: An Old Sturbridge Village Book* (New York: Thomas Y. Crowell, 1969); *Conner Prairie Pioneer Settlement* (Noblesville, Ind.: CPPS, [1976]); *Official Museum Directory, 1980.*

40. Hitsatsugu Sugimoto, "Open Air Museums in Japan," in Association of European Open Air Museums, *Cardiff Conference Report, 1978,* pp. 136–139; Open Air Museum of Japanese Farm Houses, [*Illustrated Guidebook* in Japanese] (Toyanaka City, Osaka, 1963); Japanese Open-Air Museum of Traditional Houses, folder (Kawasaki City, 1978); Muang Boran (Ancient City), Thailand, folder (1978); Pablo Toucet, "The National Museum of the Republic of Niger, Niamey," *Museum* 16 (1963): 188–196; Gervas C. R. Clay, "The Rhodes-Livingstone Museum, Livingstone," *Museum* 16 (1963): 167–173.

41. "Icom Meeting on Open Air Museums," *ICOM News* 11: 22–25.

42. Bo Lagercrantz, "A Great Museum Pioneer of the Nineteenth Century [Artur Hazelius]," *Curator* 7: 179–184; Berg, *Hazelius,* pp. 105–115. See also Jenkins, "Folk Museums," pp. 17–20; Atkinson, "Open Air Museums and Environmental Conservation," pp. 97–99; Atkinson and Holton, "Open Air and Folk Museums," pp. 140–142.

## SELECT BIBLIOGRAPHY

"Artur Hazelius: 30th November, 1833–27th May, 1901." *Museums Journal* 33 (November 1933): 270–272.
Association of European Open Air Museums. *Handbuch der europäischen Freilichtmuseen.* By Adelhart Zippelius. Köln: Rheinland-Verlag and Bonn: Habelt-Verlag, 1974. 327 pp.
————. *Open Air Museums and the Presevation of Monuments: A Report of the Conference [at] Cardiff, 1978.* Koln: Rheinland-Verlag and Bonn: Habelt-Verlag, 1980. 159 pp.

Atkinson, Frank. "New Open-Air Museums [in Britain]." *Museum* 23 (1970–1971): 99–107.

―――――. "Open Air Museums and Environmental Conservation." *Museums Journal* 72 (December 1972): 97–99.

Atkinson, Frank, and Michael Holton. "Open Air and Folk Museums." *Museums Journal* 72 (March 1973): 140–142.

Austin, Robin. "Scandinavian Folk Museums." *Museums Journal* 57 (February 1958): 253–257.

Ball, Laurel. "Swedish Folk Museums." *Museums Journal* 70 (June 1970): 19–23.

Bather, F. A. "Open-Air Folk Museums" and " 'The Old Town' Museum at Aarhus." *Museums Journal* 29 (May 1930): 377–384.

―――――. "The Triumph of Hazelius." *Museums Journal* 16 (December 1916): 132–136.

Berg, Gösta. *Artur Hazelius: Mannen och hans verk* [The Man and His Work]. Stockholm: Bokforlaget Natur och Kultur, 1933. 156 pp.

―――――. "Artur Hazelius's Studies of Foreign Museums." *Fataburen, 1967*: pp. 23–30.

―――――. "Artur Immanuel Hazelius." *Svenskt Biografiskt Lexicon,* 18 (Stockholm, 1969–1971): 359–364.

―――――. "The Nordiska Museet as a Research and Education Institution." *Fataburen, 1972*: 33–56.

Björkman, Edwin. "The Fame of a Dead Man's [Artur Hazelius's] Deeds." *American-Scandinavian Review* 12 (1924): 400–410.

Böök, Frederik. *Artur Hazelius, en Levadsteckning* [a Biography]. Stockholm: P. A. Norstedt & Söners, 1923. 438 pp.

Bringéus, Nils-Arvid. "Artur Hazelius and the Nordiska Museet." *Fataburen, 1972*: 7–32.

Cossons, Neil. *Ironbridge: Landscape of Industry.* London: Cassell, 1977. 160 pp.

―――――. "The Ironbridge Project." *Museums Journal* 72 (March 1973): 135–139.

Engelstad, Eivend J. *Norwegian Museums: Museums of Art and Social History.* Oslo: Norwegian Ministry of Foreign Affairs, Office of Cultural Relations, 1959. 54 pp.

Exposition Universelle de Paris, 1878. *Exposition Ethnographique du Musée d'Ethnographie Scandinave à Stockholm, Representé par le Docteur Artur Hazelius.* Stockholm: Imprimerie Centrale, 1878. 8 pp.

*Fataburen: Nordiska Museet's and Skansen's Yearbook.* Special Nordiska Museet Centenary Issue. Stockholm: 1972. 304 pp.

Freeman, C. E. "Museum Methods in Norway and Sweden." *Museums Journal* 37 (January 1938): 471–492.

Hazelius, Artur, *Guide to the Collections of the Northern Museum in Stockholm.* Translated by Isabel C. Derby. Stockholm: Northern Museum, 1899. 54 pp.

Henry Ford Museum Staff. *Greenfield Village and the Henry Ford Museum.* New York: Crown Publishers, 1974. 247 pp.

Holmgren, Ann Margret. "Artur Hazelius: In Memory of His Hundredth Anniversary, November 30." *American-Scandinavian Review* 21 (1933): 494–497.

Hosmer, Charles B., Jr. *Preservation Comes of Age: From Williamsburg to the National Trust, 1926–1949.* 2 vols. Charlottesville, Va.: University Press of Virginia, 1981. 1,291 pp.

"Icom Meeting on Open Air Museums." *International Council of Museums ICOM News* 11 (February 1958): 22–25.

Jenkins, J. Geraint. "Folk Museums: Some Aims and Purposes." *Museums Journal* 69 (June 1969): 17–20.

Kjellberg, Reidar. "Scandinavian Open-Air Museums." *Museum News* 39 (December 1960–January 1961): 18–22.

Klein, E. "Rural Museums in Sweden." *Museums Journal* 30 (January 1931): 257–263.

Kocher, A. Lawrence, and Howard Dearstyne. *Colonial Williamsburg: Its Buildings and Gardens* . . . Revised edition. Williamsburg, Va.: Colonial Williamsburg, 1966. 104 pp.

Lagercrantz, Bo. "A Great Museum Pioneer of the Nineteenth Century [Artur Hazelius]." *Curator* 7 (1964): 179–184.

Lindberg, Ernst-Folke. *Gunnar Hazelius och Nordiska Museets Installationsfråga* [and Nordiska Museet's Installation Policy]. Stockholm: Trykeri A. B. Thule, 1957. 53 pp.

Lowe, John. "The Weald and Downland Open Air Museum." *Museums Journal* 72 (June 1972): 9–12.

Lundwell, Sten, "C. U. Palm and the Nordiska Museet." *Fataburen, 1955*: 17–32.

Modén, A. "Open Air Museums in Sweden." *American-Scandinavian Review* 21 (1933): 341–350.

Nordiska Museet. *Guide to the Nordiska Museet, Stockholm*. Stockholm: Nordiska Museet, 1947. 37 pp.

Peate, Iorwerth C. *Folk Museums*. Cardiff: University of Wales, 1948. 64 pp.

Rehnberg, Mats. *The Nordiska Museet and Skansen: An Introduction to the History and Activities of a Famous Swedish Museum*. Stockholm: Nordiska Museet, 1957. 194 pp.

"Restoration Villages [East of the Mississippi]." *Art in America* (May 1955): Special Issue.

Romberg, Bertil. "Johan August Hazelius." *Svenskt Biografiskt Lexicon*, 18 (Stockholm, 1969–1971): 356–364.

Short, James R. *A Report to the Sponsors of the Scandinavian Seminar, June 13–August 15, 1965*. Williamsburg: Privately Published, 1965. 154 pp.

Skansen. *Skansen: A Short Guide for Visitors*. Stockholm: Skansen, 1977. 72 pp.

Stendall, J. A. Sidney. "Museums in Scandinavia." *Museums Journal* 38 (November 1938): 397–424.

Thomas, Michael. "The Avoncroft Museum of Buildings." *Museums Journal* 71 (March 1972): 153–156.

Thordeman, Bengt, and Monica Rydbeck. "Swedish Museums." *Museum* 2 (1949): 4–64.

Uldall, Kai. "Open Air Museums." *Museum* 10 (1957), 68–96.

Upmark, Gustaf. "Skansen 25 år" [25th Year]. *Fataburen, 1916*: 97–194.

Upward, Geoffrey C. *A Home for Our Heritage: The Building and Growth of Greenfield Village and Henry Ford Museum, 1929–1979*. Dearborn, Mich.: Henry Ford Museum Press, 1979. 180 pp.

# 10

George Brown Goode
and the Smithsonian Museums:
A National Museum
of Cultural History

Fig. 24. George Brown Goode (1851–1896), about 1896. From photograph by T. W. Smillie. *(Smithsonian Institution Archives. Courtesy of the Smithsonian Institution.)*

I

N 1876, the International Exhibition of Arts, Manufactures, and Products of the Soil and Mine was held in Philadelphia's spacious Fairmount Park, to celebrate the one-hundredth anniversary of American Independence. President Ulysses S. Grant opened the Centennial Exhibition on May 10, with Dom Pedro II, emperor of Brazil, and Empress Theresa as especially glamorous guests and the gigantic Corliss engine that powered the clattering exhibits in Machinery Hall as the celebration's predominant symbol. Before the exposition closed, on November 10, a total of 9,789,392 visitors had viewed the 30,864 displays, of which United States exhibitors furnished 8,175. A contemporary writer thought that the centennial observance had modified "the rigors of the prevalent hard times," that it would result in improved American manufactures because of "the study by inventors, skilled mechanics, and men of enterprise of the products of the globe," and that it would prove of moral benefit to the country, since foreign commissioners, jurors, journalists, and travelers had seen "the excellence of our manufactures, our schools, our railroads, our newspapers, and the soundness of our social life." These advantageous results were not lessened, but enhanced, on the amusement side, by certain popular piquant touches—such as the nude female statues sent over by the Italians, the strange hookahs and several-feet-long tobacco pipes of the Turkish Bazaar, and the provocative young woman who dared show her comely ankles during her scarf dance in the Turkish Cafe.[1]

The sixth largest structure of the Centennial Exhibition was the United States Government Building that covered about two acres, with the exhibits of the Smithsonian Institution, including the United States Fish Commission, occupying the largest area, some 26,600 square feet. Professor Spencer Fullerton Baird, learned naturalist, assistant secretary of the Smithsonian in charge of its United States National Museum, and chief of the Fish Commission, represented the institution and the commission at Philadelphia. Baird assigned his young assistant curator, George Brown Goode, to plan and supervise exhibits to illustrate the animal and fishery resources of the United States. Goode, for more than a year, systematically formed committees of natural scientists throughout the country to collect specimens and had most of them prepared for exhibition at the

National Museum. He also oversaw the preparation of an encyclopedic catalogue of 351 printed pages that classified North American animals and fishes beneficial or injurious to man, the means of their pursuit and capture, methods of preparation, animal products and their uses, and animal and fish protection and culture.

The catalogue served as an outline for the exhibits at Philadelphia. The lists of animals and fish used the regular Linnean binomial classification that divided them into orders, suborders, and species. Birds were omitted, for lack of exhibition space. Specimens were listed by catalogue number, nature (mounted, head, skeleton, cast, photograph, etc.), place obtained, and by whom. For the other topics, Goode devised his own classifications and tried to apply a taxonomic system to cultural and historical objects. The means of pursuit and capture, for example, had ten chief headings: hand-implements (simple tools), implements for seizure, missiles, nets, traps, apparatus for wholesale destruction, hunting animals, decoys and disguises, and pursuit—its methods and applications. Then there were fifty subheadings. This comprehensive approach resulted in long, scientifically arranged and labeled series of specimens or objects, of interest mainly to scholars and specialists, though there were occasional dramatic highlights, such as the stuffed walrus from the North Pacific—fully fifteen feet long, with tusks of about two feet; a monster sea lion; an American elk with magnificent antlers; assorted bears; and several specimens of man-eating sharks. About 600 fish were portrayed, mounted on screens, some by photographs, but most of them by plaster or papier maché casts delicately painted after freshly-caught specimens. Two huge refrigerators with transparent sides held some 200 kinds of fresh fish, supplied by a public-spirited fish dealer, many of them sold off each evening to restaurants on the fairgrounds. Weapons used in the chase, including firearms, were displayed, along with small watercraft like birch canoes, kayaks, and umiaks, and dioramas that showed modeled whaling ships and the adventure and techniques of the whale hunt. Assistant Secretary Baird reported that the whole government exhibit (the departments of War, the Navy, the Treasury, the Postoffice, Interior, and Agriculture also participated) "was considered by all visitors as decidedly the best part of the International Exhibition, in view of the extent and exhaustiveness of the collection and the method and order of its display."[2]

Brown Goode (as he was usually called by his friends) thus began his career as exhibit specialist at world's fairs and expositions; he later represented the United States at the Berlin and London International Fisheries Expositions (in 1880 and 1883) and the Columbian Exposition (1892) at

Fig. 25. Smithsonian Exhibition of Mammals at the Philadelphia Centennial, 1876. Arranged by George Brown Goode. *(Smithsonian Archives. Courtesy of the Smithsonian Institution.)*

Madrid. He also took National Museum and Fisheries Commission displays to exhibitions throughout the United States—to Louisville in 1884, New Orleans in 1885, Cincinnati in 1888, the World's Columbian at Chicago in 1893, and Atlanta in 1895. Though modern exhibit designers, with their emphasis on showing fewer objects dramatically mounted and arranged so as to tell a story, would have found these displays overcrowded and frequently dull, Samuel Pierpont Langley, the third secretary of the Smithsonian, thought that Goode "did more than any person in America to engraft upon" the expositions "museum ideas and widen their scope from the merely commercial and industrial to the educational and scientific." Langley went on to tell how the materials would be delivered at the assigned space not long before the opening date of the exhibition.

The cases would be unpacked and the specimens put in them in whatever position they happened to stand, and up to the last day all would seem to be in confusion; but Doctor Goode knew his resources and his men as a general knows his army. Suddenly all detailed work would come to an end, and in the course of a few hours, as if by magic, the entire exhibit would be put in place. He had a pardonable pride in this sort of generalship, for whether at Chicago or Atlanta it had never failed him, and it earned the highest encomiums in Berlin, London, and Madrid.[3]

George Brown Goode was born in his maternal grandfather's house at New Albany, Indiana, on February 13, 1851, the only child of Francis Collier Goode and Sarah Woodruff Crane. His mother died during his infancy, and his father remarried; the second wife, Sally Ann Jackson, established a close and affectionate relationship with the boy. Francis Goode retired from the mercantile business in Ohio and Indiana in 1857, and the family moved to Amenia, in Dutchess County, New York. The father was interested in science and possessed a set of Smithsonian reports, which the boy pored over with delight. He did not attend public school, but was tutored privately; he was also a good musician, liked to sing, and played several instruments. The family moved to Middletown, Connecticut, in 1866, so that Brown could enroll in Wesleyan University, from which he was graduated four years later at age nineteen. He then began graduate work in natural science at Harvard under dynamic Louis Agassiz and received the degree of Master of Arts. Before the year was up, however, Professor Agassiz recommended Goode as curator of the museum being installed in the new Orange Judd Hall of Natural Science at Wesleyan. Judd was a pioneer farm journalist who advocated the application of science to agriculture, and the Judds and the Goodes were neighbors in Middletown. Judd's daughter, Sarah Lamson Ford, was a keen naturalist, and she and Brown went on many collecting rambles together. They were later married, on November 27, 1877.

Young Goode had come to admire the writings on natural history of Professor Baird, who in 1850 had left teaching at Dickinson College in Carlisle, Pennsylvania, to join Professor Joseph Henry, the first secretary of the Smithsonian Institution, as assistant secretary. Through his step-mother, Goode met Baird at Eastport, Maine, in 1872 and then again at Portland, the next year, at the meeting of the American Association for the Advancement of Science, where Goode presented a paper on "Do Snakes Swallow Their Young?" (They do sometimes carry them in their stomachs to protect them from threatening danger.) Baird was known as an excellent judge of the potentialities of young men, and he offered Goode volunteer work with the Fish Commission that had been organized in 1871

with Baird as commissioner. In the next year, Goode began to spend summers collecting fish off the Atlantic coast at Eastport, Casco Bay, Noank on Long Island Sound, Florida, and Bermuda and then, beginning in 1873, to pass the winters at the Smithsonian arranging fish specimens. Professor Henry liked the young man and accepted him into his "family" with an office in a tower of the "Castle," as the Smithsonian Building was known. Goode continued for some time to receive his salary from Wesleyan and to work without compensation from the Smithsonian, except for the numerous duplicate specimens he sent to the Wesleyan Museum.

Goode was an inveterate writer of papers based on his research. He began with some half dozen in the Wesleyan *College Argus,* including "History of Wesleyan University" (1870) and "Our Museum" (1871). His first scientific contribution was "The Billfish in Fresh Water" (1871) in the *American Naturalist.* Starting in 1874, he did numerous articles based on his Fish Commission research, and in 1876 his first publication for the Smithsonian appeared—a catalogue of fishes of the Bermudas, based chiefly on the National Museum collections. During his career, Goode turned out more than two hundred articles and many books on a great variety of subjects, both scientific and historical.[4]

The Centennial Exhibition, however, proved a traumatic experience for Brown Goode. For months he had been working fourteen-hour days in order to complete his exhibits. Baird himself came to Philadelphia on June 1, to see that everything went well, to conduct important visitors about, and to answer questions that might arise. He had three assistants, one for mineralogy, another for ethnology, and Goode for the animal and fish displays. Baird reported, however, that Goode was forced to leave soon "in consequence of the illness caused by overexertion." He had had a similar attack or breakdown soon after coming to the Smithsonian and was said to possess "an overwrought nervous system" and to suffer from occasional "severe mental depression." A Chicago newspaper reporter later wrote: "He is nervous in his actions and smokes cigarettes continually, and does not cease even to converse." By that winter, Goode had recovered enough to resume his research in Bermuda. In 1877, his "A Preliminary Catalogue of the Reptiles, Fishes, and Leptocardians of the Bermudas" appeared in the *American Journal of Science and Arts.* Later that year, Goode terminated his curatorship at Wesleyan, was married, and moved to Washington permanently. When Baird became secretary of the Smithsonian in 1878, following Henry's death, he at once made Goode curator of the United States National Museum and put him in charge of

the other assistants. The next year, Goode became assistant director of the museum directly under Baird, who also assigned him the preparation of material on *The Fisheries and Fishery Industries of the United States* for the Superintendent of the Census of 1880. This co-operative work filled seven large quarto volumes.[5]

<div align="center">II</div>

The National Museum, of which Goode was given virtually complete charge in 1879, had developed slowly at the Smithsonian Institution. James Smithson's will had been most general, and his bequest of 105 bags of gold sovereigns worth $508,318.46, delivered in 1835, had been made "to the United States of America, to found at Washington, under the name of the Smithsonian Institution, an establishment for the increase and diffusion of knowledge among men." Smithson, the illegitimate son of an English duke, had been a keen amateur student of chemistry and mineralogy who had never visited America. Congress, somewhat reluctant to accept English gold, debated proposals that included establishing a national university, a museum of natural science, an astronomical observatory, a national library, a school to train teachers of natural science, or a lecturing establishment. Former President John Quincy Adams, still serving in the House of Representatives, fought hard to keep Smithson's bequest for permanent scientific purposes, and Congress in 1846 passed an incorporation act that was a compromise among different points of view. It called for not only scientific research, but for a building that would include a museum, chemical laboratory, library, art gallery, and lecture rooms.[6]

The Board of Regents of the new organization appointed Professor Joseph Henry, an eminent physicist teaching at Princeton, its first executive head or secretary. He emphasized that the Smithsonian should give its main attention to "increasing knowledge, or enlarging the bounds of human thought by original research." He would take care of the diffusion function by publishing fresh scientific work in the *Smithsonian Contributions to Knowledge* and sending these volumes throughout the country and the world in exchange for the publications of other learned and scientific societies. He would make grants to experienced scientists to solve important practical problems. Thus he set up six hundred volunteer meteorological stations in the United States to study storms and weather and to do some forecasting of weather conditions by telegraph; in accord with his principle of letting other capable institutions carry on work proved prac-

ticable by the Smithsonian, after twenty-five years, Henry turned this meteorological network over to the Weather Bureau of the United States Signal Service. He also somewhat cautiously backed exploring expeditions to the West, the Pacific, and the polar regions.[7]

The Smithsonian endowment yielded only about forty thousand dollars per year, and Secretary Henry was determined to keep as much of that sum as he could for the advancement of pure or abstract science. The Smithsonian Building, designed in Norman style by James Renwick, Jr., and finished in 1855, ultimately used nearly five hundred thousand dollars of accumulated unspent funds from the endowment and included the facilities demanded by the act of incorporation, as well as offices and living quarters for the Henry family. At first, Henry agreed to devote one-half of the endowment income to science research projects and, with reluctance, the other half to library, museum, and lectures. In 1855, he dismissed his librarian and, after a Congressional investigation, established the principle that the Board of Regents as trustees controlled the Smithsonian and could decide which of the functions listed in the founding act their endowment could afford; the library, except for reference volumes, was later deposited in the Library of Congress.

Though the Smithsonian was entitled to receive all museum materials belonging to the federal government, Henry realized that their care would gobble up the small income from the endowment. Thus he delayed taking over the "National Collection of Curiosities" exhibited in a hall in the Patent Office Building. It consisted chiefly of a miscellaneous collection of art, historical, and scientific materials accumulated since 1840 by the National Institute for the Advancement of Science, and it included the natural science and ethnographic collections from the Wilkes Exploring Expedition to the Pacific and Antarctic (1838–1842). The Smithsonian finally accepted all these objects in 1858, but only after Congress had agreed to pay for new cases, moving expenses, and four thousand dollars yearly for maintenance. Spencer Baird, Henry's assistant secretary, brought two freight-car loads containing his own collection along with him to the Smithsonian and believed strongly in a natural history museum (including ethnography and archaeology), especially for research, but also for educational use. He was too loyal to oppose Henry directly, but his promotion of natural history research, such as the later Fish Commission, brought a multitude of museum accessions. Henry won small skirmishes in the contest; botanical specimens went to the Department of Agriculture, anything concerned with human physiology to the Army Medical Museum, and most paintings and art materials were

deposited on loan with the Corcoran Art Gallery. By 1856, however, Henry was referring to the Smithsonian's National Museum.[8]

The Centennial Exhibition brought the museum question up for careful re-examination. Henry realized that many of the exhibits accumulated for the centennial would come to the National Museum and demand additional space. He therefore conservatively proposed that Congress give the museum its own organization entirely separate from the Smithsonian and take over the Smithsonian Building for the museum, repaying the money it had cost the endowment fund. The museum would grow "far beyond its present magnitude," and Congress could add wings or buildings as required. One-half the income of the Smithsonian bequest would no longer need to be devoted to the museum and other local projects, nor would the institution be forced to appeal to Congress each year for funds. Its endowment income, Henry thought, would be large enough to maintain its private and international scientific reputation through its researches, publications, and exchanges.[9]

By the end of 1876, the space situation was indeed serious. Many states and thirty-four foreign countries had given their Philadelphia art, industrial, and technological exhibits to the United States; whereas the Smithsonian had sent twenty-one freight-car loads of exhibits to the exposition, double that number came back. The Castle was already crammed with 25,000 square feet of exhibits, and its 400-foot-long basement was filled with materials in storage. Congress provided the four-storied Armory building (not of fire-resistant construction) that took care of 20,000 square feet of boxed materials stacked from floor to ceiling in each room. The Smithsonian Board of Regents petitioned Congress for a one-storied, fireproof building "of durable though inexpensive material" situated near the original one and roughly 300 feet square, to cost $250,000. Congress made the appropriation in 1879, and the present Arts and Industries Building was previewed on March 4, 1881, when 7,000 persons attended the Inaugural Ball given there for President James A. Garfield.[10]

The new building was ready for occupation in October, and Goode issued his first report, for the year 1881, as assistant director and executive officer of the United States National Museum and curator of its department of arts and industries.[11] This remarkable document outlined a new kind of national museum and attempted "a perfect plan of organization and a philosophical system of classification" with three aspects. First of all, it was a *Museum of Record,* a concept that Goode as a natural scientist probably developed because of the type specimens so treasured in botani-

**Fig. 26.** The United States National Museum. Opened in 1881, this structure today is known as the Arts and Industries Building. *(Smithsonian Archives. Courtesy of the Smithsonian Institution.)*

cal and zoological collections. This treasure house idea, he said, went back to Ptolemy's Mouseion in Alexandria, to the Greek temples and medieval churches, and to the European royal collections. Goode explained it thus:

Objects, which have served as a foundation for scientific study, or which, from their historical significance, are treasured up and preserved from destruction that they may serve purposes of record, permanent land-marks of the progress of the world in thought, in culture, or in industrial achievement not only are . . . records of what has been done in the past, but . . . constitute the most valuable of all materials for future study.[12]

The *Museum of Research,* on the other hand, was more recent, perhaps chiefly from the eighteenth century, accompanying the rise of inductive

philosophy and scientific method. Linnaeus, Sir Hans Sloane, and the French savants of the Muséum National d'Histoire Naturelle gathered collections that could be used for taxonomic or other research. This kind of museum, since it was intended chiefly for investigators, conformed to Huxley's definition as a "consultative library of objects."

And finally, the *Educational Museum* that began, Goode said, with the Crystal Palace Exhibition at London in 1851 was devoted to "the systematic exhibition of the products of the earth and the achievements of human industry for the instruction of visitors, the improvement of public taste, and the fostering of the arts of design." While Goode, as a practicing scientist, thought scientific research justification enough for a museum, he took a more liberal view and insisted "that public institutions of this kind are not intended for the few, but for the enlightenment and education of the masses." He lost patience with an eminent natural scientist who at a professional meeting opposed exhibiting certain scientific collections to "the gaping clowns who form the majority of the visitors to our museums." The educational purpose of a museum was most important, and Goode even argued that "The present demand is for something better, more systematic, more definitely instructive in its aims—something which shall afford the same long vistas into the palaces of nature and art, and at the same time provide guide-marks to explain their meaning."[13]

Goode thought that the kind of museum he visualized had not yet been achieved anywhere. It would "show, arranged according to one consistent plan, the resources of the earth and the results of human activity in every direction." More than an industrial museum, it would be a museum of the history of culture. The National Museum of the United States in a few years could attain this character and become "the most comprehensive and educational museum in the world." To define the idea further, Goode went on:

the collections should form a museum of anthropology, the word *anthropology* being applied in its most comprehensive sense. It should exhibit the physical characteristics, the history, the manners, past and present, of all peoples, civilized and savage, and should illustrate human culture and industry in all their phases; the earth, its physical structure and its products, is to be exhibited with special reference to its adaptation for use by man and its resources for future needs. The so-called natural history collections—that is to say, the collections in pure zoology, geology, and botany—should be grouped in separate series, which, though arranged on another plan, shall illustrate and supplement the collections in industrial and economic natural history.

Goode later made clearer what he meant by *a museum of cultural history,* by examining the relationship of such a museum to other kinds of museums. Historical museums preserved historical objects "associated with the events in the history of individuals, nations, or races," and art museums and archaeological museums were also museums of history. Anthropological museums illustrated the natural history of man and contained objects of prehistoric archaeology, while history museums took over those of historic archaeology. In Goode's opinion, many materials in art museums would be better shown in museums of anthropology or of history. Museums of industry and technology, of course, could be thought of as history museums. And Goode, as we have just seen, intended to include natual history collections in his museum. Thus he was combining materials of art, natural history, anthropology, history, and industry and technology in one great museum, best described per-haps as a museum of cultural history—"the natural history of cult, or civilization, of man and his ideas and achievements." Goode worked out a classification system, under which any object, natural or man-made, could find its place in his museum. Its eight major divisions (with sixty-four principal sections) were: mankind; the earth as man's abode; natural resources; the exploitative industries; the elaborative industries; ultimate products and their utilization; social relations of mankind; and intellec-tual occupations of mankind.[14]

In 1889, Goode looked back at his comprehensive plan for a museum on the history of civilization and admitted that it had been ferociously criticized by the editors of *Science* because they "at that time thought it an undesirable innovation to depart from the old plan of a zoological, geo-logical, and ethnological museum." Since then, he concluded sadly, his dream had been defeated simply by a lack of space. For example, at least two thousand packing cases were stowed away, many from the Centen-nial of 1876 never opened; only eight thousand of nearly sixty thousand birds were exhibited; and the ethnology collection could have filled the entire Museum Building. Meanwhile, money was wasted on expositions that stimulated commerce and manufacturing, but not public education. Arranged like bazaars, they ignored museum methods he thought a hundredfold more effective.[15]

In the field of exhibition, Goode liked to say: "The people's museum should be much more than a house full of specimens in glass cases. It should be a house full of ideas, arranged with the strictest attention to system." Every article should convey an idea, no two objects the same idea. Each object's label should tell any intelligent visitor why the object

was shown and what lesson it taught, and general or collective labels should describe groups of objects and their relation to each other. Guidebooks or manuals ought to contain all information on the labels and illustrate the more important objects.

Another favorite Goode axiom was: "An efficient museum, from one point of view, may be described as *a collection of instructive labels, each illustrated by a well-selected specimen.*" That attitude and his continuing interest in detailed classification suggest that his exhibits were often too comprehensive. Secretary Langley showed more sensitivity toward the popular audience when he wrote Goode, in 1887, that he had walked through the bird collection and wondered whether the labels ought to tell more colorful facts, whether duplicate South American hummingbirds could be shown in the sunlight in a circular case, duplicate game birds with nests, eggs, and something of their habits, and state birds in a special case. He tactfully added that these were "the crude notions of an amateur submitted to your professional criticism." Two years later, the secretary was proposing the establishment of a Children's Room, sending Goode label copy for the skylark, cuckoo, and robin redbreast, advocating that their Latin names be dropped, and suggesting a case on "Birds in Literature."[16]

Goode decided to divide the four large halls of his new building into seventeen smaller sections by means of uniform (equaling 8 feet, 8 inches wide), interchangeable, and easily movable cases. The cases were made of polished, natural-finished mahogany and equipped with small storage drawers or glass-covered exhibit boxes of uniform size (24 by 30 inches) that could be arranged within cases or stored in racks or screens. Careful attention was paid to suitable case backgrounds and to labels, printed in large and legible type upon tinted paper in soft colors.[17]

In 1882, Goode issued his Circular No. 1, *Plan of Organization and Regulations,* to his staff. In 58 pages and 156 different topics, Circular No. 1 treated both general and detailed concerns. The foundation, scope, functions, and aims of the National Museum were clearly stated, the classification of departments, duties of staff, and the numbered exhibit halls, laboratories, and offices (with plans). The issuance of keys, records to be kept, labels, loans, receipts, passes, correspondence, kinds of ink to be used, cases, supplies, accounts, electric service, etc., etc., etc., were covered. Through the next fourteen years, shorter circulars appeared, occasionally, for the guidance of both staff and possible donors. Goode obviously left nothing to chance or to imprecise oral communication. When he came to the Smithsonian in 1873, it had some two hundred

thousand specimens supervised by a staff of thirteen, and at his death in 1896, there were more than three million objects and in excess of two hundred employees.

Frederic W. True, Goode's executive curator, described him as an administrator thus:

Gifted with a philosophical mind, a profound love of nature, a marvelously retentive memory, and untiring energy, he acquired a range of knowledge and a grasp of affairs which astonished his associates, while his modesty, gentleness, and love of fair play attracted to him and bound to his service men of the most diverse capacities and opinions.

Both True and others considered Goode as an administrative genius, and one of his staff said that even when Goode turned down some of his most cherished projects, he never went to sleep without entirely forgiving him. Though Goode drove himself mercilessly and could be puritanically tough in demanding high standards of accomplishment and moral conduct from his staff, he had the faculty of putting himself in the place of his humblest helper and thus leading instead of pushing dictatorily.[18]

By 1866, Professor Baird was in poor health; and on January 12, 1887, he appointed Samuel Pierpont Langley, eminent astronomer, physicist, and aviation pioneer, assistant secretary to handle exchanges, publications, and the library. Goode was made assistant secretary in charge of the National Museum. Less than a month later, Langley became acting secretary; and on Baird's death, in August, was made secretary. President Grover Cleveland appointed Goode head of the Fish Commission in Baird's stead, but Goode accepted only provisionally, until a paid commissioner could be chosen; he was offered the post—and at a higher salary than he was receiving—but he preferred to stay with the museum. Langley was seventeen years older than Goode and had a greater reputation in the scientific world. The regents designated Goode to act as secretary whenever Langley was absent, and Langley gave him much freedom in the administration of the museum. There is little doubt that, had Goode lived, he would have succeeded Langley as secretary of the Smithsonian.[19]

Goode and his staff worked hard to unpack the collections stored in the basement of the Castle, the Armory, and several small wooden buildings; and by 1886, they had most of the collection under control. In all, Goode estimated that he had thirty thousand drawers or boxes and ten thousand cases. The new Arts and Industries Building had a basic plan of four spacious halls leading to a simple rotunda; by placement of

cases, Goode fitted exhibits into these spaces. It was not difficult to classify the biological and geological sections, but the arts and industries collections, of which Goode himself remained curator, presented many difficulties and were often changed. Goode classified them by function, rather than by races or tribes and used a teleological instead of a geographic arrangement. In 1895, these collections were divided into fourteen sections. Naval architecture, transportation, textiles, and foods and chemicals were grouped together as technological collections, with a subsection devoted to electricity. Then there were fisheries; animal products; graphic arts; historical collections, coins, and medals; physical apparatus; musical instruments (one of the largest collections in the world, in which Goode took special pleasure, often playing on new accessions); porcelains and bronzes; materia medica; forestry; and oriental antiquities and religious ceremonial objects. There were few fine arts materials, though some were on deposit in the Corcoran Gallery and the Library of Congress, the George Catlin paintings of American Indians numbered more than five hundred, and miscellaneous holdings included thirty-two plaster busts that portrayed American governors of about 1860. Goode did not expect his museum to contain as much ancient and medieval art as did the European galleries, though he thought a representative series would no doubt accumulate.

In addition to these miscellaneous cultural collections, the Smithsonian Institution acquired a zoo. It began as a small collection of live animals, quartered in an enclosure behind the Castle, to assist the taxidermists in obtaining more realistic models. Secretary Langley, aware of the desire of scientists to preserve American animals such as the bison from extinction and of the popularity of the specimens exhibited, assisted Charles Glover, a Washington banker, in the campaign to persuade the nation and the District of Columbia jointly to purchase land along Rock Creek for a National Zoological Park, and the project was placed under the administration of the Smithsonian regents in 1890. Goode helped Langley administer the zoo and also, in 1894, negotiated the return of the National Herbarium, which Secretary Henry had relinquished to the Department of Agriculture in 1869, and the herbarium became a separate section in the National Museum.[20]

Goode believed in an exhibition series of collections in the main halls of the National Museum for laymen and the general public and a study or reserve collection in laboratories and storerooms for research use by specialists and students. This dual arrangement concept was also becom-

Fig. 27. Statue of Freedom in the Rotunda, United States National Museum, about 1890. Shown here is the original plaster cast, nineteen feet and five inches high, made by Thomas Crawford in Rome for the bronze statue surmounting the United States Capitol. (*Smithsonian Institution Archives. Courtesy of the Smithsonian Institution.*)

ing popular in Europe, and when the British Museum (Natural History) moved to South Kensington, about 1880, its collections were soon placed on this plan, which Sir William Henry Flower, its director, referred to as the "New Museum Idea." Goode was enabled to develop exhibition series at the expositions to which he took Smithsonian materials; thus he once shipped 140,000 pounds of collections to New Orleans and 17,000 pounds to Cincinnati and Louisville. The good will achieved by these special exhibitions probably more than balanced the temporary partial dismantling of the Smithsonian halls that they occasioned.[21]

Unfortunately, however, the crowding of the two Smithsonian buildings on the Mall kept Goode from an entirely effective multilayered arrangement for his museum. He tried to design through the collections a route with wide aisles that would give the layman a quick, bird's-eye view, with the more detailed exhibits of greater interest to the scholar in narrower aisles or alcoves off the main route. But the constant growth of accessions led to overcrowding that defeated many of these attempts. The new Arts and Industries Building (officially known as the National Museum) opened in the fall of 1881; but by 1883, Secretary Baird was begging Congress for another structure at least twice the size of the previous one. He also pointed out the unhealthy location of the National Museum—over a miasmic swamp—and the resulting illnesses of the staff, as well as the grave danger of fire from specimens in alcohol and from temporary wooden structures nearby. Not until after Goode's death did Congress appropriate money for galleries around some of the museum's halls, and only in 1911 did the third building (today the National Museum of Natural History/National Museum of Man) at last open. Both Langley and Goode, to no avail, sought increased appropriations for a more balanced collection, a larger and better paid staff, and restoration of cuts in the budget for publications exchange. They asserted that valuable American collections were going to London, Paris, and Berlin and that New York's American Museum of Natural History in 1895 spent $41,959.65 for natural history specimens alone, while the National Museum expended $3,336 on all its varied collections.[22]

### III

Goode did much for the museum movement in both this country and abroad. His annual reports from 1881 to 1896 made many contributions to sound museum administration; for example, in 1893, he devoted a section to "Recent Advances in Museum Methods." He stressed there the impor-

tance of museums in the education of the young (he had once argued that youngsters were well enough educated by the schools and that museums were mainly for the enlightenment of the adult public), praised the formation of the Museums Association (1889) in Britain, and thought that it ought to be followed soon by a similar organization in this country. He then gave well-illustrated presentations on museum cases, the preparation of labels, taxidermy, representations of the human figure, and other technical subjects, always accompanied by offers to share Smithsonian specifications and professional knowledge freely with other museums. Throughout the piece, Goode referred to what many other museums at home and abroad were doing—in New York, in Salem and Cambridge, Massachusetts, in London, Cambridge, Liverpool, Brighton, in Dresden, Bremen, Leiden, in Milan, and Turin.[23]

Goode summarized and crystallized his thoughts on museum administration in three important papers. The first one, entitled "Museum History and Museums of History," he read in 1888, before the annual meeting of the American Historical Association in the auditorium of the Arts and Industries Building, in which he had arranged an exhibit of American prints, portraits, and historical objects. He traced the history of museums sketchily from Greek and Roman times, credited Sir Francis Bacon in his *The New Atlantis* (1627) with "the idea of a great national museum of science and art," and mentioned the Ashmolean Museum at Oxford, the British Museum in London, the Louvre in Paris, and Peale's Museum in Philadelphia as some of the key developers of the museum idea. He praised the Crystal Palace Exhibition of London and the Philadelphia Centennial as important stimulants of the modern museum movement and noted that "under the wise administration of the South Kensington staff, a great system of educational museums has been developed all through the United Kingdom."

Goode pointed out, however, that historians study events and causes and are accustomed to using library materials rather than objects. Yet he was confident that the museum could become "a most potent instrumentality for the promotion of historical studies." Though several museums researched and exhibited anthropological, archaeological, and ethnological materials well, there was "not in existence a general museum of history arranged on the comprehensive plan adpoted by natural-history museums." The best art museums were historically ordered and contained, more than any other, the materials Goode would have liked to see utilized in the historical museum. But he summed up the problem in this way:

What the limitations of historical museums are to be it is impossible at present to predict. In museums administrative experience is the only safe guide. In the scientific museum many things have been tried, and many things are known to be possible. In the historical museum, most of this experimental administration still remains to be performed.[24]

In 1889, Goode used much of this same material in an address before the Brooklyn Institute on "The Museums of the Future." He considered museums in the United States far behind the spirit of their people, less progressive than those in England, Germany, France, Italy, or Japan, and he argued that

The museum of the past must be set aside, reconstructed, transformed from a cemetery of bric-a-brac into a nursery of living thoughts. The museum of the future must stand side by side with the library and the laboratory, as part of the teaching equipment of the college and university, and in the great cities co-operate with the public library as one of the principal agencies for the enlightenment of the people.

Goode urged his listeners to push forward in starting the Brooklyn Museum (it was organized in 1893) and advised them to obtain an administrator of ability, enthusiasm, and experience and provide him with an adequate salary fund before erecting a building.[25]

In 1895, Goode presented before the British Museums Association annual congress at Newcastle a comprehensive seventy-three-page treatise on "The Principles of Museum Administration." It was didactically worded, in some parts in the form of axioms, in the hope that it would provoke much critical discussion. The Museums Association was deeply impressed, and more than fifty years later the document was reprinted and distributed among South African museums as a valuable guide for their improvement. Even today, though somewhat dated, it remains an important and useful examination of museum administration.[26]

Goode defined a museum as "an institution for the preservation of those objects which best illustrate the phenomena of nature and the works of man, and the utilization of these for the increase of knowledge and for the culture and enlightenment of the people." Zoological parks, botanical gardens, and aquariums were essentially museums, as were some churches, public monuments, and historic cities. The museum, university and college, learned society, and public library had distinctive purposes, though they should aid each other in "the increase and diffusion of knowledge." The museum differed from the exposition or fair in that it sought to advance learning rather than promote industry and commerce.[27]

"The public museum is a necessity in every highly civilized community," said Goode, and the community should provide adequate means for its support. It advanced learning as a museum of record and of research, was an adjunct to the classroom and lecture room of elementary, secondary, and higher schools, and served "the general public, through the display of attractive exhibition series, well planned, complete, and thoroughly labeled." Museums should not engage in "envious rivalry" with each other, but, instead, co-operate, each adopting a specialized plan, exchanging collections, and, when possible, making joint expenditures for, say, labels, catalogues, supplies, and specialized curators or preparators.[28]

Each museum, Goode believed, had five cardinal necessities. The first was a permanent organization with adequate support from government, connection with an institution of learning, or its own well-financed structure. Next, a museum needed a clearly defined plan and ought to be pre-eminent in at least one specialty. Then, a museum must build good collections, through gift, purchase, exchange, collecting and field exploration, construction, and deposit and temporary loan. (Goode was less cautious about accepting long-term loans than administrators would be today.) Collections should be free from conditions as to disposal or installation, but should be properly acknowledged on labels and in public reports.

In the fourth place, "A museum without intelligent, progressive, and well-trained curators is as ineffective as a school without teachers, a library without librarians, or a learned society without a working membership of learned men." (Goode, in keeping with the custom of his day, mentions only men and actually employed few women on his scientific and administrative staff.) Collaborators, associates, and volunteers might be recruited, especially university professors or scientific experts. No one was fitted to be a museum officer "who is disposed to repel students or inquiries or to place obstacles in the way of access to the material under his charge." A museum employee "should, for obvious reasons, never be possessor of a private collection." (Modern practice sometimes modifies that rule, but carefully avoids conflicts of interest between curators or administrators and their museums.) In a large museum, the persons handling administrative and financial matters should understand the meaning of museum work and be in sympathy with its highest aims, and the executive head of the museum should control both its business affairs and scientific or subject-matter work. (Today, this question has become more controversial, and some museums are choosing businessmen rather than academically trained experts as their chief executives.) And finally, a

museum building should be absolutely fireproof, well lighted and venti-
lated, dry, and protected from dust. Its architecture ought to be simple
and dignified, as well as flexible because unexpected development might
necessitate rearrangement of halls. A building should not be erected until
a museum plan had been adopted and a staff appointed. The opinion of
the architect should not outweigh the judgment of the museum person-
nel responsible for the building's utilization.[29]

Goode classified museums in two ways, the first according to the
character of their contents. He examined those devoted to art, history,
anthropology, and natural history and their interconnections. Tech-
nological and industrial museums dealt with materials and their sources,
tools and machinery, methods and processes, and products and results.
They treated exploitative industries (such as agriculture, mining, or fish-
eries), elaborative industries (such as textiles and ceramics), auxiliary
industries (such as transportation), and technical professions (such as
engineering, war, medicine, and engraving). No good general museum
then existed in the latter field, conducted on a liberal plan and doing
useful educational work. (Today, there are several outstanding museums
of science and technology and many lively science/technology centers.) A
second classification examined museums devoted to the nation; to
locality, province, or city; to college or school; to a profession or class,
such as medical, military, and patent museums; and private museums or
cabinets.[30]

Goode devoted much space to the function of exhibition. He empha-
sized the desirability of arranging exhibition series or the "People's
museum" for the general public and study series or the "Student's
museum" for researchers. He gave many principles, both large and small,
for installation. For example, a single entrance and one line of progress
was desirable, with wide aisles, so that the casual visitor could easily
obtain an over-all view of the exhibits on a rapid stroll through the halls,
while more detailed displays near the landmark exhibits would serve the
experts or students. The exhibit at the entry to a hall should be especially
attractive, so as to lead visitors on, and striking exhibits easily visible at the
ends of wide aisles served a similar purpose. Goode devoted nearly a
whole section to exhibition labeling and its requirements of terse, easily
understood writing and legible format. (Some of his general or case labels
seem to have been longer than good practice would permit today.) He also
had sound separate sections on the preservation and preparation of
museum materials (recording, restoration, models, taxidermy, and dupli-
cates) and on museum records (accessions, catalogue cards, corre-
spondence files, and marking or labeling of specimens.).[31]

The final part of the paper was devoted to "The Future of Museum Work." Museum administration was improving, with more men of ability and originality entering the field and making it a profession. Museums were drawing more visitors and becoming tourist attactions; "the Venus of Melos had brought more wealth to Paris than the Queen of Sheba brought to King Solomon." If the principles of good museum administration could be summarized in a single sentence, it might read: "The degree of civilization to which any nation, city, or province has attained is best shown by the character of its public museums and the liberality with which they are maintained."[32]

Though Goode's most lasting contributions lay in the museum field, he was also a competent scientist and historian. Secretary Langley said that he was "a man of the widest interests I have ever known, so that whatever he was speaking of at any moment seemed to be the thing he knew best." As a leading authority on fish, he contributed numerous articles and books, perhaps the most scientific single work with Tarleton H. Bean, curator of fish at the National Museum, *Oceanic Ichthyology, a Treatise on the Deep-sea and Pelagic Fishes of the World . . .* , 2 volumes (1896). Goode's most widely-known book in this area was the charmingly written *American Fishes: A Popular Treatise upon the Game and Food Fishes of North America . . .* (1888). He also had under way at his death a gigantic index bibliography on ichthyology that would have included all known genera and species. Dr. David Starr Jordan, prominent fellow ichthyologist and president of Indiana University, in 1886 conferred a kind of honorary Ph.D. degree on Goode, accepting his *Catalogue of the Fishes of the Bermudas* (1876) as his thesis, and Wesleyan University, his alma mater, granted him an LL.D. in 1888.[33]

In addition, Goode was a painstaking and respected historian of American science. His longest and most important addresses or papers were "The Beginnings of Natural History in America" (1886), "The Beginnings of American Science: The Third Century," (1888) "The Literary Labors of Benjamin Franklin" (1890), "The Origin of the National Scientific and Educational Institutions of the United States" (1890), and "The Genesis of the United States National Museum" (1893). He also planned, edited, and wrote four key chapters in *The Smithsonian Institution, 1846–1896: The History of Its First Half Century* (1897). He compiled three valuable bibliographies, of Spencer Fullerton Baird (1883), Charles Girard (1891), and Philip Lutely Sclater (1895). His *Virginia Cousins: A Study in the Ancestry and Posterity of John Goode of Whitby . . .* (1887), upon which he had worked for twenty-five years, was a model genealogy. The American Historical Association was founded at Saratoga in 1884, and five years later

Goode was instrumental in securing its incorporation by Congress. The association was to report annually to the secretary of the Smithsonian, who would forward the documents or portions of them to Congress, thus assuring their appearance in print. The association was also permitted to deposit with the Smithsonian its collections, manuscripts, books, pamphlets, and other materials. Goode was elected to the association's Council and remained there until his death.[34]

Goode was a devoted family man. In 1880, he bought a large tract on Lanier Heights in Washington and built a Queen Anne half-timbered house (enlarged in 1887) that overlooked Rock Creek Park. He sold adjacent lots to three young colleagues at the Smithsonian. The Goodes had a daughter and three sons, one of whom described their father in this manner:

> He taught us all the forest trees, their fruits and flowers in season, and to know them when bare of leaves by their shapes; all the wayside shrubs, and even the flowers of the weeds; all the wild birds and their notes, and the insects. His ideal of an old age was to have a little place of his own in a mild climate, surrounded by his books for rainy days, and friends who cared for plain living and high thinking, with a chance to help someone poorer than he.

Goode suffered increasingly from attacks of bronchitis. He spent the winter of 1891–1892 in Italy with his wife and a son, and Secretary Langley in vain urged him to go further south to Egypt, to acquire a turban, jasmine-stemmed pipe, and donkey, to visit museums only for pleasure, and to take a year off if necessary. But an attack of bronchitis (could it have been emphysema?) eventually turned into pneumonia, and he died in his home on September 6, 1896, at age forty-five.[35]

## IV

What has become of G. Brown Goode's dream of a great national museum of the history of culture that would make use of the materials of biology, geology and paleontology, anthropology and archaeology, history, industry and technology, and art? Gradually and by different routes, during the last eighty-five years, the Smithsonian Institution has gathered many of the collections needed to achieve such a conception, though they of course could not be synthesized into a single museum. More than a dozen separate museums have developed, each with its own purposes and programs. Today they constitute the largest museum megalopolis in existence and attract an astonishing total annual attendance of more than twenty-seven millions.[36]

For a time, the growth of this complex was slow, partially because of the reluctance of Congress to finance museum expansion and partially because Secretary Langley (1887–1906) and his three immediate successors—Charles D. Walcott (1907–1927), Charles G. Abbot (1928–1944), and Alexander Wetmore (1944–1952)—were more interested in pure science than museums and were not skillful enough administrators and promoters to obtain the needed funds. Laurence Coleman was right in 1939 in pointing out that the Smithsonian museums had lost the leadership in the museum movement that they had held in Goode's day. They were uneven in their research, no longer technically superlative in their exhibits, and had developed no active educational program. They deserved their reputation as "the nation's attic."

Leonard Carmichael, the next secretary (1953–1964), not only supported scientific projects, but reversed the downward trends of the museums. He obtained funds to build the National Museum of History and Technology, which opened in 1964, and massive new wings (opened in 1963 and 1965) for the National Museum of Natural History. Even more important, he enlivened exhibits that had scarcely been touched for half a century by bringing in designers to work with the curators to obtain attractive, colorful, well-lighted, and compelling presentations of ideas. He also began to pay attention to interpretation and education as museum functions. S. Dillon Ripley, the present secretary (1964—), defined the Smithsonian Institution as "an independent establishment devoted to public education, basic research, and national service in science, the humanities, and the arts." He rejuvenated every part of the Smithsonian operations, both scientific and educational, and stimulated a great flowering of the museums with new buildings, programs, and activities, many of them great fun for the visitor participants.[37]

Upon Goode's death, Secretary Langley had appointed as assistant secretary Charles Walcott, who had been director of the United States Geological Survey and was an outstanding paleontologist. Walcott did not give full time to the National Museum as had Goode, but he reorganized it into three departments (anthropology, biology, and geology), with a head curator to administer each one. Anthropology absorbed Goode's old department of arts and industries and paid less attention to them than to ethnology and archaeology. At last, in 1903, Congress voted a new building situated across the Mall from the Castle, 500 by 330 feet in area, four stories high, with about 10 acres of floor space. Opened in 1911 as the National Museum of Natural History, the new building left the old structure of 1881 for the collections of arts and industries. Two wings were authorized for the new building in 1932, but were not constructed until

the 1960s; and in 1978 and 1979, Congress appropriated money for a Museum Support Facility in Suitland, Maryland, to provide space for storage and laboratories, to give the main structure more exhibition space. The National Zoological Park, which supplements the biology collections of Natural History, has grown enormously and has been in process of thorough rejuvenation; in 1974, it acquired a breeding and research wild animal park in Front Royal, Virginia.[38]

About 1900, Secretary Langley, having recalled engravings and paintings lent to the Library of Congress and the Corcoran Art Galley, established an Art Room in the Castle. (Though a shy bachelor, Langley loved children and personally designed a cheerful Children's Room, also in the Castle, with colorful specimens on low shelves, an aquarium, and a cage with singing birds). In 1903, Harriet Lane Johnston, James Buchanan's niece who had served as First Lady in the White House during Buchanan's administration, left the Smithsonian her art collection; and, three years later, the National Gallery of Art was established as a Smithsonian independent bureau not under the National Museum. President Theodore Roosevelt had urged formation of such a gallery and had also encouraged the Smithsonian to accept, in 1906, an exceptional art collection, offered by Charles Lang Freer, Detroit industrialist. The Freer Gallery of Art included rare oriental ceramics, screens, and other art materials and American paintings chiefly by James McNeil Whistler. Mr. Freer not only gave his great collection, but provided a building (opened in 1923) and liberal endowment.[39]

In 1937, Andrew W. Mellon bestowed upon the nation a carefully chosen collection of masterpiece paintings and sculptures, as well as funds for a magnificent building (opened in 1941) on the north side of the Mall, near the Natural History Museum. Though nominally a bureau of the Smithsonian, the Mellon collection was virtually an independent entity, with its own large private endowment and self-perpetuating board of trustees. (The John F. Kennedy Center for the Performing Arts opened in 1971 with a similar status). The Mellon gift became the National Gallery of Art, and the former gallery of that name was rechristened the National Collection of Fine Arts (changed in 1980 to the National Museum of American Art). A separate National Portrait Gallery was created and moved with the National Collection of Fine Arts in 1966 to the refurbished Patent Office Building. The original Corcoran Gallery of Art building— next to Blair House, across Pennsylvania Avenue from the White House—became the Renwick Gallery and opened as a branch of the National Collection in 1972. To enlarge the scope of fine art holdings, in

1966 Joseph B. Hirshhorn gave the Smithsonian his large and distinguished collection of modern art that became the Hirshhorn Museum and Sculpture Garden, housed in a circular building on the Mall (opened in 1974). In 1968, the Smithsonian Institution also helped save from dispersal the collection of decorative arts of the Cooper Union Museum (1897) in New York and installed it in the former Carnegie Mansion on Fifth Avenue as its Cooper-Hewitt Museum of Design and Decorative Arts, opened in 1976. At the request of Congress, the Smithsonian absorbed in 1979 the Museum of African Art, privately funded and begun in Washington in 1964. And, in 1982, Dr. Arthur W. Sackler pledged a thousand items from his celebrated Near Eastern collection, as well as $4 million toward the construction of a new facility to form a Center for African, Near Eastern, and Asian Cultures, with museums, seminar rooms, and educational programs. That center was planned to occupy a quadrangle of space, largely underground, bounded by the Castle, Freer, and Arts and Industries buildings.[40]

These art museums are not what Goode had in mind when he planned adding art materials to his museum of the history of civilization. Benjamin Ives Gilman, secretary of the Museum of Fine Arts in Boston, had examined critically Goode's ideas and maintained, as early as 1899, that, unlike the natural history museum, the art museum's chief purpose was to provide its viewers with aesthetic enjoyment, rather than to convey information or historical knowledge. "A museum of science," he wrote, was "in essence a school; a museum of art in essence a temple." Works of art communicated directly with their beholders and needed little labeling (though Gilman did invent the docent as a means of interpretation); art museums were "not didactic but aesthetic in primary purpose." Many of the art museums in the Smithsonian complex essentially shared that concept.[41]

History and technology were well served at the Smithsonian with the opening, in 1964, of the National Museum of History and Technology (since 1980, the National Museum of American History). On the technological side, the National Air Museum was established in 1946, in a World War I hangarlike metal building in the south yard behind the Castle, to be superseded in 1976 by the huge National Air and Space Museum building on the south side of the Mall, today the most popular of all Smithsonian museums. It too has received back-up warehouse buildings for storage and conservation of objects in Silver Hill, Maryland. The Old Arts and Industries Building of 1881 once more became a museum, with the opening of a massive permanent exhibit on the Philadelphia

Centennial of 1876 restored for the American Bicentennial of 1976. Another museum with much historical emphasis opened in an abandoned motion picture theater in 1967, the Anacostia Neighborhood Museum, a small community museum dedicated to the history of the Washington neighborhood of Anacostia and American Negro history.[42]

By 1973, Secretary S. Dillon Ripley was examining the conception of still another kind of museum, a museum of culture that he described as follows:

> Could we not complete the chain of museums on the Mall in Washington with a final museum, a museum of the Family of Man? In such a museum we could perhaps transmit something that has eluded museums as collections of objects. We could show the concept of the creations of the spirit of man, the development of ideas which arise in the human species wherever it happens to exist. Could we show the unity of man as an explorer of ideas—in art, science, invention—all the stuff of culture, moved by spirit, which occurs in our species no matter how diverse our environments?

The next year, Secretary Ripley reported that "we are thinking of drawing from everything that our museums, whether of natural history, history of science, culture and technology, or art museums, are exhibiting, each in its own way." Ripley was gratified to find, at the Copenhagen meeting of the International Council of Museums (ICOM), that the Soviet Union was thinking of erecting such a Museum of Man. In 1977, he referred to the design of a new hall in "the National Museum of Natural History/Museum of Man" devoted to "the history of what we know as 'culture,' the history of aggregations of peoples, hunting parties, family groups living in shelters, on to clans, tribes, the beginning of towns and cities." The new interdisciplinary approach would make use of the latest studies in animal domestication, social characteristics and psychology, and the cultivation of plants. So, "the separation between our knowledge of ancestral man as part of fossil deposits laid down two or three million years ago and the earlier levels of integration of higher primate species as a living part of the environment are all beginning inexorably to flow together as a series of object lessons in the development of man and his place and his time."[43]

Thus, George Brown Goode's idea of a National Museum that "should exhibit the physical characteristics, the history, the manners, past and present, of all peoples, civilized and savage, and should illustrate human culture and industry in all their phases" is being revived, and experimentation has begun to put it into effect with the sounder scientific knowledge and better exhibition and interpretive techniques developed in the years

since Goode's death. The creative conception of this first modern American museum director was indeed an insightful one and deserves experimental implementation, though not in the form of a single great comprehensive or encyclopedic museum. The Smithsonian system of museum pluralism has develped much too far and too successfully to turn back to a single centralized pattern. In any event, George Brown Goode, in the last quarter of the nineteenth century, through his advanced and progressive ideas, his improvements in exhibition at the Smithsonian, and his persuasive speeches and writings, spread widely his deep conviction that the museum was a powerful force for education of the general public. He well deserves to be known as the father of the modern American museum.

## NOTES

James M. Goode, a distant cousin of George Brown Goode and Curator of the Castle of the Smithsonian Institution, has carefully read and made improvements in this chapter.

1. James D. McCabe, *The Illustrated History of the Centennial Exhibition . . .* , pp. 65, 96–106, 291–298; Richard R. Nicolai, *Centennial Philadelphia*, pp. 16–17, 31, 38–39, 41, 49, 66, 80; Robert C. Post, editor, *1876: A Centennial Exhibition*, pp. 10–23.

2. Smithsonian Institution Board of Regents, *Annual Report, 1875* (hereafter cited as Smithsonian *Annual Report*): 58–71; *1876*: 70–83; George Brown Goode, *Catalogue of the Collection . . .* , pp. 4–6, 8, 10–13; McCabe, *Illustrated History, Centennial Exhibition*, pp. 65, 207–209; Post, *1876: A Centennial Exhibition*, pp. 74–79.

3. "A Memorial of George Brown Goode," part 2 (hereafter cited as *Goode Memorial*): 53–55; Frederick W. True, "An Account of the United States National Museum," in *Annual Report, U.S. National Museum* (hereafter cited as U.S. National Museum *Annual Report*), *1896*: 306.

4. *Goode Memorial*, pp. 1–61; Theodore Gill and S. F. Langley, "George Brown Goode," *Science* (new series) 4: 661–668; David Starr Jordan, "Biographical Sketch of George Brown Goode," in *The Smithsonian Institution, 1846–1896*, edited by George Brown Goode, pp. 501–518; Carroll Lindsay, "George Brown Goode," in Clifford L. Lord, editor, *Keepers of the Past*, pp. 127–140; Paul H. Oehser, "George Brown Goode (1851–1896)," *Scientific Monthly* 66: 195–205, and Paul H. Oehser, "George Brown Goode, the Young Genius," in Oehser, *Sons of Science*, pp. 92–109.

5. Smithsonian *Annual Report, 1876*: 66; *1877*: 44; *1878*: 6, 75; *Goode Memorial*, pp. 60–61; Chicago newspaper clippings, 1890, Smithsonian Institution Archives, Goode Papers, record unit 7050, box 27.

6. Smithsonian *Annual Report, 1876*: 8, 169, 515; Goode, *Smithsonian Institution*, pp. 1–58, 247–261. See also Paul H. Oehser, *The Smithsonian Institution*, pp. 3–25, 248–255; Walter Karp, *The Smithsonian Institution*, pp. 7–19; Geoffrey T. Hellman, *The Smithsonian*, pp. 26–55; Wilcomb E. Washburn, "Joseph Henry's Conception of the Purpose of the Smithsonian Institution," in *A Cabinet of Curiosities: Five Episodes in the Evolution of American*

*Museums,* by Whitfield J. Bell, Jr., and Others (Charlottesville, Va.: University Press of Virginia, 1967), pp. 106–166.

7. Smithsonian *Annual Report, 1848*: 173–184; *1874*: 8; *1878*: 8; Goode, *Smithsonian Institution,* pp. 115–156; Oehser, *Smithsonian Institution,* pp. 26–40, 256–263.

8. *Goode Memorial,* pp. 147–156; Smithsonian *Annual Report, 1879*: 60; Goode, *Smithsonian Institution,* pp. 157–200.

9. Smithsonian *Annual Report, 1875*: 8, 70; *1876*: 11–13; *1877*: 7–9.

10. Smithsonian *Annual Report, 1876*: 13–14; *1878*: 41; *1879*: 70–71, 125–140; *1881*: 1–3; Goode, *Smithsonian Institution,* pp. 261–262.

11. Smithsonian *Annual Report, 1881*: 81–159.

12. Smithsonian *Annual Report, 1881*: 82.

13. Smithsonian *Annual Report, 1881*: 83; U.S. National Museum *Report, 1884*; 9; *1888*: 16.

14. Smithsonian *Annual Report, 1881*: 89; *Goode Memorial,* pp. 208–215, 256.

15. Smithsonian *Annual Report, 1881*: 86, 89–94; Post, *1876: A Centennial Exhibition,* pp. 206–213; "The U.S. National Museum," *Science* 2, July 20, 1883: 63–66; August 3, 1883: 119–123; Spencer C. Baird to F. W. True, Woods Holl, Massachusetts, July 25, August 3, 1883; G. Brown Goode to Senator [Joseph Roswell] Hawley, Washington, August 8, 1889, Smithsonian Institution Archives, record unit 54: series 1, box 1; series 2, box 3, letterbook, 1889–1892, pp. 112–128.

16. *Goode Memorial,* p. 249; Smithsonian *Annual Report, 1881*: 85–87; Goode to Melvil Dewey, June 8, 1892, Smithsonian Institution Archives, record unit 7050, box 4, letterbook, 1883–1895, p. 306; Langley to Goode, December 19, 1887, January 24, 1890, Smithsonian Institution Archives, record unit 54: box 1, folder 8; box 2, folders 1, 3.

17. Smithsonian *Annual Report, 1881*: 84, 94–95; *1882*: 119–121; U.S. National Museum *Report,* 1893: 23–31.

18. Department of the Interior, *Proceedings of the United States National Museum* 4 (Washington, D.C., 1882): 479–536; True, "United States National Museum," p. 305; *Goode Memorial,* pp. 45–47. For an example of Goode's firmness in disciplining an employee, see Goode to Langley, Washington, October 4, 1894, Smithsonian Institution Archives, record unit 54: series 1, box 1, folder 10.

19. U.S. National Museum *Report, 1887*: 3–4; *1888*: 3–4; Smithsonian *Annual Report, 1896*: 18, 305; Goode, *Smithsonian Institution,* pp. 201–234.

20. Smithsonian *Annual Report, 1886*: 26–28; *1889*: 25–32; *1890*: 34–41, 67–74; *1891*: 21–25, 48–52; U.S. National Museum *Report, 1882*: 128, 130; *1883*: 175–183; *1884*: 14–15; *1889*: 5; *1893*: 21–23; *1895*: 25, 74–80, 87–92; *1896*: 107; Frank Baker, "The National Zoological Park," in Goode, *Smithsonian Institution,* pp. 443–458.

21. U.S. National Museum *Report, 1884*: 24–25; *1885*: 13–14; William Henry Flower, *Essays on Museums and Other Subjects Connected with Natural History* (London and New York: Macmillan and Company, 1898), pp. 1–53.

22. Smithsonian *Annual Report, 1887*: 17; *1889*: 5–7; *1892*: 24; *1894*: 21–22; *1896*: 16–19; *1897*: 16–17; Smithsonian Institution, *The Smithsonian Experience,* p. 54.

23. U.S. National Museum *Report, 1893*: 21–58.

24. *Goode Memorial,* pp. 63–81.

25. *Goode Memorial,* pp. 241–262 (quotation on pp. 243–244); American Historical Association, *Papers* 3 (New York and London: G. P. Putnam's Sons, 1889): 246, 257, 268, 495–519; Oehser, *Smithsonian Institution,* p. 87.

26. *Goode Memorial,* pp. 193–240; Oehser, *Sons of Science,* pp. 102–103.

27. *Goode Memorial,* pp. 196–199.

28. *Goode Memorial,* pp. 199–201.

29. *Goode Memorial,* pp. 202–208.

30. *Goode Memorial,* pp. 208–217.

31. *Goode Memorial,* pp. 218–237.

32. *Goode Memorial,* pp. 237–240.

33. *Goode Memorial,* pp. 17–24, 49–53; Oehser, *Sons of Science,* pp. 100–103; Jordan, "Biographical Sketch," pp. 506, 509–515; Cara (Mrs. Kenneth) Goode Mackarness to James M. Goode, Philadelphia, postmarked April 9, 1973, James M. Goode Papers.

34. *Goode Memorial,* pp. 13–16, 56–58; Oehser, *Sons of Science,* p. 103. For Goode's history of the Smithsonian, see Smithsonian Institution Archives, record unit 54: series 1, box 3, letterpress vol. 1, pp. 188–199.

35. *Goode Memorial,* pp. 11, 48, 61; James M. Goode, *Capital Losses,* pp. 86–87.

36. *Smithsonian Year, 1972:* 3–4. In 1965, the Smithsonian *Annual Report* and the U.S. National Museum *Report* were combined and entitled *Smithsonian Year.* In 1977, the *Statement of the Secretary* began to be issued separately from the main report, *Smithsonian Year.* See also Langley to Goode, Washington, February 14, 16, March 26, 1892, Smithsonian Institution Archives, record unit 54: series 1, box 2, folder 1.

37. Smithsonian *Annual Report, 1954:* 2; *1956:* 11–12; *1959:* 1–5; *1963:* 2–7; Oehser, *Smithsonian Institution,* pp. 37, 48–71; Laurence Vail Coleman, *The Museum in America: A Critical Study,* 3 vols. (Washington, D.C.: American Association of Museums, 1939), 1: 143–153.

38. U.S. National Museum *Report, 1897:* 3, 6–7; *1898:* 19–20; Smithsonian *Annual Report, 1903:* 16–18, 25; *1904:* 27; *1911:* 17, 26–27; *Smithsonian Year, 1974:* 13; *1979:* 16; Oehser, *Smithsonian Institution,* pp. 191–193, 197–198.

39. Smithsonian *Annual Report, 1900:* 18–20; *1905:* 20–22; *1906:* 27–35; *1907:* 31–33; *1908:* 28, 36; *1910:* 32; *1918:* 4–5, 44; *1920:* 15, 30, 49–50; *1923:* 3, 19–20; Oehser, *Smithsonian Institution,* pp. 92, 136–137, 141–144, 194–196; Hellman, *The Smithsonian,* pp. 119–120, 159–167, 177–179.

40. Smithsonian *Annual Report, 1937:* 1–2; *1941:* 1, 3–4; *1963:* 19, 22–23; *1964:* 10; *Smithsonian Year, 1966:* 10, 13; *1967:* 13–14; *1968:* 4–6, 20–22; *1969:* 3–4; *1972:* 15; *Statement of the Secretary, 1977:* 2; *1979:* 17; Oehser, *Smithsonian Institution,* pp. 144–152, 153–155, 198–202; S. Dillion Ripley, "The View from the Castle," *Smithsonian* 13 (February 1983): 74–89.

41. Benjamin Ives Gilman, "Dr. Goode's Thesis and Antithesis," in *Museum Ideals of Purpose and Method,* 2d ed., by Benjamin Ives Gilman (Cambridge, Mass.: Harvard University Press, 1923), pp. 77–81.

42. Smithsonian *Annual Report, 1946:* 12; *1964:* 9; *Smithsonian Year, 1966:* 12; *1967:* 7, 13; *1968:* 6–11; *Statement of the Secretary, 1977:* 5; Oehser, *Smithsonian Institution,* pp. 96–104, 178–179, 189–191, 193–194, 196–197.

43. *Smithsonian Year, 1973:* 9; *1974:* 11–12; *Statement of the Secretary, 1977:* 10, 15.

## SELECT BIBLIOGRAPHY

Carmichael, Leonard, and J. C. Long. *James Smithson and the Smithsonian Story.* New York: G. P. Putnam's Sons, 1965. 316 pp.

"George Brown Goode." *Science* (new series) 4 (September 18, 1896): 365–366.

Gill, Theodore, and S. P. Langley. "George Brown Goode." *Science* (new series) 4 (November 6, 1896): 661–668.

Goode, George Brown. *Catalogue of the Collection to Illustrate the Animal Resources and the Fisheries of the United States, Exhibited at Philadelphia in 1876 by the Smithsonian Institution and the United States Fish Commission, and Forming a Part of the United States National Museum*. Washington: Government Printing Office, 1879. 248 pp.

_____. "A Memorial of George Brown Goode, Together with a Selection of His Papers on Museums and on the History of Science in America." In Smithsonian Institution, *Annual Report for 1897*, Part 2; *Report of the U.S. National Museum*. Washington: Government Printing Office, 1901. 515 pp.

_____. "Report of the Assistant Director of the United States National Museum for the Year 1881." In Smithsonian Institution, *Annual Report 1881*: 81–165.

_____. *Virginia Cousins: A Study in the Ancestry and Posterity of John Goode of Whitby, a Virginia Colonist of the Seventeenth Century, with Notes upon Related Families, a Key to Southern Genealogy, and a History of the English Surname Gode, Goad, Goode or Good from 1148 to 1887*. Richmond, Va.: J. W. Randolph & English, 1887. 526 pp.

_____. editor. *The Smithsonian Institution, 1846–1896: The History of Its First Half Century*. Washington: Smithsonian Institution, 1897. 856 pp.

Goode, James M. *Capital Losses: A Cultural History of Washington's Destroyed Buildings*. Washington, D.C.: Smithsonian Institution Press, 1979. 517 pp.

_____. "A View of the Castle." *Museum News* 54 (July/August 1976): 38–45.

Gurney, Gene. *The Smithsonian Institution: A Picture Story of Its Buildings, Exhibits, and Activities*. New York: Crown Publishers, Inc., 1964. 131 pp.

Hellman, Geoffrey T. *The Smithsonian: Octopus on the Mall*. Philadelphia, New York: J. B. Lippincott Company, 1967. 224 pp.

Jordan, David Starr. "Biographical Sketch of George Brown Goode." In George Brown Goode, editor, *The Smithsonian Institution, 1846–1896: The History of Its First Half Century*, pp. 501–515.

Karp, Walter. *The Smithsonian Institution: An Establishment for the Increase and Diffusion of Knowledge among Men*. Washington: Smithsonian Institution and Editors of *American Heritage* Magazine, 1965. 128 pp.

Lindsay, G. Carroll. "George Brown Goode." In *Keepers of the Past*, edited by Clifford L. Lord, pp. 127–140. Chapel Hill: University of North Carolina Press, 1965.

McCabe, James D. *The Illustrated History of the Centennial Exhibition Held in Commemoration of the One-Hundredth Anniversary of American Independence* . . . Philadelphia, 1876; reprint, Philadelphia, National Publishing Company, 1975. 302 pp.

Nicolai, Richard R. *Centennial Philadelphia*. Bryn Mawr, Pa.: Bryn Mawr Press, Inc., 1976. 96 pp.

Oehser, Paul H. "George Brown Goode (1851–1896)." *Scientific Monthly* 66 (March 1948): 195–205.

_____. *The Smithsonian Institution*. New York, Washington, London: Praeger Publishers, 1970. 275 pp.

_____. *Sons of Science: The Story of the Smithsonian Institution and Its Leaders*. New York: Henry Schuman, 1949. 220 pp.

Post, Robert C., editor. *1876: A Centennial Exhibition: A Treatise upon Selected Aspects of the Great International Exhibition Held in Philadelphia on the Occasion of Our Nation's One-Hundredth Birthday, with Some Reference to Another Exhibition Held in Washington Commemorating That Epic Event* . . . Washington, D.C.: National Museum of History and Technology, 1976. 226 pp.

Rhees, William J. *An Account of the Smithsonian Institution, Its Founder, Building, Operations, Etc.* . . . Washington: Thomas McGill, Printer, 1859; reprint, New York: Arno Press, 1980. 75 pp.

———. *Visitor's Guide to the Smithsonian Institution and United States National Museum in Washington.* Washington: Judd and Detwiler, 1887. 94 pp.

Smithsonian Institution. *The Smithsonian Experience: Science—History—The Arts . . . The Treasures of the Nation.* Washington, D.C.: Smithsonian Institution, 1977. 256 pp.

Smithsonian Institution Archives. Assistant Secretary in Charge of the United States National Museum (George Brown Goode) Records, 1877–1896. Record unit 54 (MSS).

———. G. Brown Goode Papers, 1798–1896. Record unit 7050 (MSS).

Smithsonian Institution Board of Regents. *Annual Reports, 1846–1964.* Washington: Government Printing Office. Succeeded by *Smithsonian Year.*

———. *Report of the United States National Museum under the Direction of the Smithsonian Institution, 1884–1964.* Washington: Government Printing Office. Succeeded by *Smithsonian Year.*

———. *Smithsonian Year, 1965—.* Washington: Smithsonian Institution Press. In 1977 began to be issued in separate volumes with *Statement of the Secretary* and *Programs and Activities* as subheadings.

True, Frederick W. "An Account of the United States National Museum." In *The Smithsonian Institution, 1846–1896: The History of Its First Half Century,* edited by George Brown Goode, pp. 303–366.

True, Webster P. *The First Hundred Years of the Smithsonian Institution, 1846–1946.* Washington, D.C.: Smithsonian Institution, 1946. 64 pp.

United States Department of the Interior. *Proceedings of the United States National Museum* 4: 477–682. Washington: Government Printing Office, 1882.

# [ 11 ]

## Carl Hagenbeck
## and His Stellingen Tierpark:
## The Moated Zoo

Fig. 28. Carl Hagenbeck (1844–1913), 1908. *(Courtesy of Carl Hagenbeck's Tierpark, Stellingen.)*

I

ARL HAGENBECK'S outstanding characteristic was his love for animals, especially wild animals. He was born on June 10, 1844, in St. Pauli, a suburb of Hamburg, to Gottfried Clas Carl Hagenbeck and his wife, née Louise Juliana Richers. Carl's elementary school education was meager. His father was a fishmonger, and the boy was too busy playing with live fish and animals to spend much time in school, though he was proficient in studying English and French. His father told the children (Carl had two brothers, three sisters, and later two half brothers) that they did not need higher education because they "were not expected to become parsons." When Carl was four years old, his father began to exhibit, in his wife's two large wooden washtubs, six seals that his fishermen suppliers had caught in their nets; he charged one penny to view the seals and gradually added goats, a cow, a talking parrot, geese, and other fowl to form a small menagerie with an admission price of four pennies. The family's yard on the Spielbudenplatz was crowded with a growing, fascinating mixture of animals in and out of cages. Today Carl Hagenbeck's Tierpark (Wild Animal Park) at Stellingen in Hamburg traces its beginning to the 1848 menagerie.[1]

In 1855, Carl went with his father to Bremerhaven to help bring back a large raccoon (that escaped en route), two possums, monkeys, and parrots. When Carl was twelve, a kind dealer gave him a small alligator, three and one-half feet long and blind in one eye, that the boy soon sold for about three dollars—to him, a considerable sum. In 1857, Gottfried Hagenbeck purchased his first large collection of wild animals, from the Egyptian Sudan, with five lions, panthers, cheetahs, hyenas, antelopes, gazelles, and monkeys. By then, the elder Hagenbeck was energetically buying and selling animals, and he asked Carl to ponder whether he wished to become an animal dealer or a fishmonger, advising him that the latter calling was more stable and certain. In March 1859, Carl, then nearly fifteen, left school for good to take charge of the menagerie and to learn the animal business, and at twenty-one he took over entirely from his father, who, however, remained his trusted adviser. Carl agreed that Gottfried would not be responsible for more than five hundred dollars if any loss should occur. But there were no losses, for Carl proved an excellent businessman—an ingenious problem solver, persuasive sales-

313

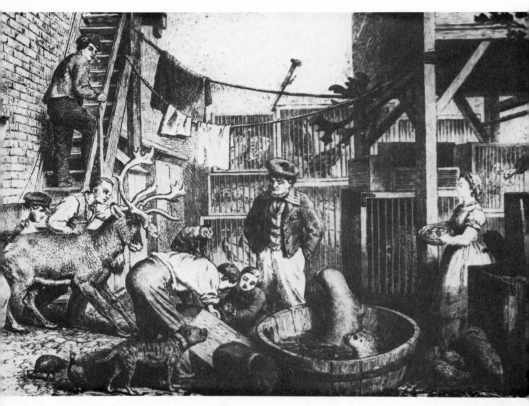

Fig. 29. Carl Hagenbeck in his father's yard, St. Pauli, 1848. Young Carl (kneeling in the center) helps his father uncrate monkeys just purchased from the sailor standing nearby. The washtub in the center contains some of the seals that started the menagerie. *(Etching by Heinrich Lentemann. Courtesy of Carl Hagenbeck's Tierpark, Stellingen.)*

man, prompt and decisive in action, his word always to be depended upon.[2]

In 1864, Carl journeyed to Dresden to buy beasts that the Italian trader, Lorenzo Cassanova, had brought from Nubia. Carl then made his initial selling trip to London. He signed a contract to purchase animals at fixed prices from Cassanova, who thus became Hagenbeck's first foreign agent in a network that eventually covered most of the globe. The next year, Cassanova brought him two elephants, lions, ostriches, and other African

animals with which to supply the zoos, traveling menageries, and small circuses proliferating in Europe and America. In 1870, Carl hastened to Suez to take charge of a huge consignment gathered by Cassanova and Migoletti, another hunter—five elephants, fourteen giraffes, four Nubian buffaloes, a rhinoceros (the first African one acquired by the London Zoo), twelve antelopes and gazelles, two wart hogs, four aardvarks, seven lions, eight panthers and cheetahs, thirty hyenas, and sixteen ostriches. About a hundred nanny goats accompanied this massive, noisy congregation, to provide milk for the younger animals and eventually to be fed to the carnivores. There were numerous problems in feeding and lodging the animals, in keeping them safely confined, and in loading, transporting, and unloading them on and off freight carriers by sea and by rail. The procession, which attracted crowds of spectators along the way, went through Alexandria (where Cassanova died), Trieste, Vienna, Dresden, and Berlin to Hamburg; and Hagenbeck made several sales en route.[3]

Such successes demanded larger quarters for the business. In 1864, Carl expanded the buildings at his father's home on the Spielbudenplatz and, in April 1874, moved to the Neuer Pferdemarkt in Hamburg, with a comfortable house and two acres behind it filled with numerous paddocks, stables, and outbuildings. Carl had been married to Amanda Mehrmann in 1871, and their growing family (eventually five children) was also demanding more room. At the new site, Hagenbeck began to stage ethnological shows, with strange, primitive human beings. When he imported reindeer from Lapland, his friend Heinrich Leutemann, an animal painter, suggested that he bring along some Lapps, those small but sturdy people who lived in northern Scandinavia near the Arctic Circle. In 1875, Hagenbeck hired a Norwegian to escort five Laplanders— three men and a woman with her baby and four-year-old daughter. The group lived behind Hagenbeck's house, with their reindeer, and all Hamburg hurried to see "Lapland in miniature" and especially the milking of the reindeer. In another year came Nubians from the Sudan, with their great black dromedaries. Even more popular were the Eskimos that a Norwegian captain, Adrian Jacobsen, brought in his brig *Walrus* from Greenland in 1877 and 1878—Ukubak, his pretty little wife and two small daughters, and two young men. The Eskimos occupied a hut in the garden, and Ukubak amazed visitors by demonstrating his skill with the kayak skin canoe. Hagenbeck took them to Paris, Dresden, and Berlin; Emperor Wilhelm I greeted them at the Berlin Zoo and was afraid that Ukubak would drown when he used his double paddle to whirl the kayak

upside down. So popular were these exotic visitors that Hagenbeck brought others almost every year—Somalis, American and East Indians, Tierra del Fuegans, Australian aborigines, Kalmucks, Singhalese, Patagonians, Hottentots, and others.[4]

Meanwhile, the wild animal business was booming, as Hagenbeck supplied traveling circuses in both Europe and America. Phineas T. Barnum, the American entertainment impresario, came to Hamburg in 1872 to buy fifteen thousand dollars' worth of beasts, including his first giraffe. Though Hagenbeck turned down Barnum's offer for a one-third share in Barnum's circus business, he often sold animals to the master showman. Hagenbeck sent Joseph Menges, who had been up the White Nile with "Chinese" (Charles G.) Gordon and was to spend forty years as a Hagenbeck agent, to Colombo in Ceylon, where Hagenbeck's half brother John traded in animals, to secure twenty-seven elephants, many of them sold to Barnum or to his competitor, Adam Forepaugh. Wilhelm Grieger, another Hagenbeck representative, in 1901 went to the Gobi desert to bring back thirty-two slant-eyed wild ponies similar to those the hordes of Genghis Khan had ridden; they were the first Przhevalski horses seen in western Europe. Still another hunter, Jürgen Johannsen, began to use drugs to subdue wild animals, fifty years before that technique became common.[5]

Supplying zoos was also profitable. William Temple Hornaday, director of the New York Zoological Society (Bronx Zoo) bought from Hagenbeck polar bears, Russian wolves, Przhevalski horses, wisents (European bison), an Indian elephant, an Indian rhinoceros (at $6,000), and many other beasts. In 1902, Hornaday visited Europe and Hamburg with $17,000 earmarked for animals, most of that sum supplied by Andrew Carnegie, the philanthropist. During one week in 1903, Hagenbeck shipped $2,500 worth of beasts to the Cincinnati zoo, $3,500 to Philadelphia, and a large consignment to the Bronx. He was then selling about a hundred camels and fifty zebras per year, and he had forty-three elephants on hand. Since insurance of wild-animal shipments was prohibitively high, Hagenbeck sent his own trained men along with large orders. On one shipment to the Mikado of Japan, only one monkey died; on another shipment worth $17,000, to the Sultan of Morocco, he lost a tiger and a crane; and American orders were especially successful, with only trivial losses. All in all, Hagenbeck had a staff of fifty or sixty hunters, who employed numerous natives to catch animals; he had five game depots in Asia, several in Europe, and one at Cincinnati in North America. He was selling lions for $500 to $1,000 apiece, tigers for $375 to

$1,500, hippopotamuses at $2,500 to $3,000, rhinoceroses for slightly more, and giraffes for $2,500 and up.[6]

In his home, Carl Hagenbeck was a kind but somewhat unbending father; he once paddled his son Lorenz when the boy's two guinea pigs were neglected, and he would whistle shrilly when he found something wrong. He had two English boys—Charly Judge and Reuben Carstang—living in his home and learning to train animals, and he took the whole neighborhood on picnics and fishing jaunts. Family feasts were shared with members of his staff and friends such as his traveler Menges or the animal painter Leutermann, and at Christmas there was much food and good cheer, gifts for all, and recitations and humorous skits.[7]

A good instance of Hagenbeck's business alertness is seen in his letter to the *London Times* of March 1898, during the Klondike gold rush. He wrote to recommend the Bactrian, a two-hump snow camel, as a useful beast of burden there. He asserted:

The best animal for the Klondike climate is the big Siberian camel. These camels transport all merchandise from China to Russia, and can stand Siberian cold as well as the greatest heat. They never need shelter and sleep out in the deepest snow. . . . They can carry from 5 cwt. to 6 cwt., and also go in harness and pull as much as a big horse. They can cross mountains as well as level country. As for the difficulty of procuring them, there is none. I can deliver as many as may be wanted for £40 apiece in London or Grimsby [Ontario], or £60 duty paid, in New York.[8]

The gold prospectors on the Yukon did not heed Hagenbeck's suggestion, but continued to depend upon teams of native dogs to pull their sleds.

Hagenbeck soon needed to expand his quarters again. In 1902, he found a four-and-one-half-acre plot in Stellingen, a suburb of Hamburg, and purchased it in two days, added two more estates within twenty-four hours, and with his brothers Wilhelm and Dietrich began to buy contiguous properties. (The family eventually sold off many tracts, but today the Stellingen zoo contains about sixty-seven acres). Within five months, Hagenbeck had a dozen large enclosures and five animal houses on his new estate. It was a fine base for the largest animal trader in the world, whom the English press called "the King of menagerie owners." A good example of his efficiency was shown in 1905, when he agreed to furnish German troops in German Southwest Africa with 1,000 dromedaries equipped with suitable saddles. He sent his two sons Heinrich and Lorenz along with Joseph Menges to gather camels in German East Africa, designed a saddle that he had made in quantity in Hamburg,

chartered steamers, had stalls built, and dispatched the first ship to East Africa to pick up 403 animals and take them around the Cape of Good Hope to Swakopmund. Only six camels died in transit, and the remaining part of the order was delivered within three months, whereupon the German government ordered another 1,000 beasts.

Hagenbeck continued to send out agents, who sometimes found exotic wild species. Thus Hans Schomburgk, in 1913, brought back from Liberia five pygmy hippopotamuses, three of them sold to the Bronx Zoo.

In 1908, Hagenbeck took a census of his animals and found that he owned about 2,000, valued at more than $250,000. He also laid out an ostrich farm at Stellingen, secured as its manager John Millen, a young American who had operated a similar venture in the south of France, and equipped the farm with its own incubator. With typical promotional imagination, he persuaded the German empress to appear at the ceremony opening the farm, and he set up a workshop to use ostrich feathers in making women's hats and boas.[9]

The whole business enterprise—wild-animal capture and trade, the exhibition of traveling troupes of trained animals and primitive peoples, and the development of a new kind of zoo—was financed by Hagenbeck himself. Except for the land-buying agreement (he put up $37,500, and his two brothers paid $25,000 each), he got along without a stock company or a financial syndicate.[10] A flourishing wild-animal trade that brought him a reasonable profit and considerable renown around the world and a steady flow of admission fees from animal and ethnological performances and from the zoo gave Hagenbeck a solid financial foundation. Behind this commercial activity, however, lay a genuine love for animals and a desire to understand and help them. Hagenbeck's humane, idealistic drive would result in original developments in the training, exhibition, and conservation of wild animals.

II

Carl Hagenbeck looked upon himself first of all as a naturalist who loved wild animals and wished to understand them. He was interested in their acclimatization to the conditions of captivity and thought it better for most of them, from the point of view of both their physical and mental health, to wander in groups in large paddocks with free access to protected cages or lairs. He rejoiced in breeding animals in captivity and experimented with crossing various species such as lion and tiger, horse and zebra, and Persian fallow and ordinary European deer. In 1908,

Hagenbeck visited the Cardinen country estate in Prussia, where the German kaiser was trying to cross native cattle with Indian zebus in the hope of developing a disease-resistant tropical breed. During this trip, the kaiser bestowed upon Hagenbeck the title of Royal Prussian Commercial Counsellor.

Hagenbeck wanted humankind everywhere to treasure wild animals and not destroy them carelessly and wantonly. With that kind of motivation, it was natural for him to exhibit his beasts at his collecting and training headquarters—that is, to conduct a zoo, for which he charged admission to his visitors. The zoo served as a showplace to display his wares and to increase public admiration and concern for animals. Hagenbeck also studied the animal psyche and sought the best ways to train beasts to perform. While he sometimes doubted whether the trained troupes were profitable, in monetary terms, they were good advertising that increased the sale of animals both for zoos and for traveling menageries or circuses. Hagenbeck had developed the small menagerie into a formal zoo by 1887. He admitted visitors to animal-training sessions, and he took performing beasts to many world's fairs and expositions, beginning with one at London's Crystal Palace in 1891. He considered his exhibitions of exotic peoples an extension of the same kind of appeal. Thus his Singhalese expedition of 1883–1884, composed of sixty-seven persons, twenty-five elephants, and multitude of wild cattle, toured Germany and Austria.[11]

Hagenbeck was not the first promoter to exhibit this kind of showmanship. Charles Willson Peale's small menagerie, especially well furnished with snakes, was part of Peale's museum of natural history in Philadelphia, at the end of the eighteenth century. William Bullock, who for a time conducted a popular museum of natural history in London, had created a sensation in 1822 by importing a Lapp family with their reindeer and later had a Mexican Indian living in a hut at his special exhibition of ancient and modern Mexico. P. T. Barnum, beginning in the 1840s, showed animals, primitive people, and freaks at his American Museum in New York. The public responded enthusiastically to his exhibits, and showed special interest in the feeding of serpents and in the two whales swimming in salt-water tanks. From that start sprang Barnum's touring circus with many spectacular acts that included, for a time, the famed elephant Jumbo that Barnum purchased from the London Zoo.[12]

Hagenbeck was also not the first animal trainer to discard the use of whips, steel rods, red-hot irons, and other cruel methods used to strike fear in wild animals and terrorize them into learning tricks and routines.

He believed in making friends with the beasts and rewarding them with bits of meat, petting them, calling them by name, and speaking in a quiet, affectionate tone of voice to train them to do his will. As he explained it, "Compassion for my animals led me to devise humane methods of training. I was convinced that there must be a way to reach the psyche of animals." His basic philosophy here ran as follows:

Brutes, after all, are beings akin to ourselves. Their minds are formed on the same plan as our minds; the differences are differences of degree only, not of kind. They will repay cruelty with hatred, and kindness with trust. What, therefore, could be more foolish than the senseless manner in which every spark of intelligence was driven out of the hapless pupils? I know full well from long and intimate association with the lower animals that their understanding develops wonderfully by close friendship with man, and I was convinced that far more could be achieved by gentleness and sympathy than ever accomplished by tyrannical cruelty. This, however, was not my only discovery. I had also found from experience that animals of the same species differed most remarkably in character, and from this I inferred that if the talents of each animal were to be fully developed, individual tuition during training would be absolutely essential. Here again we have a point of similarity to ourselves.

Other animal trainers had used this humane approach, but Hagenbeck succeeded in making his "gentling" techniques of training known throughout Europe and, indeed, the world.[13]

Hagenbeck insisted that only young forest-bred animals or those born in captivity could be trained, and not all of them. In fact, a cardinal principle of successful training was the selection of responsive animals and the dropping of unintelligent, clumsy, and unco-operative ones. Thus, in 1887, Hagenbeck and Edward W. H. Deyerling, the English trainer that he hired, kept for their performing troupe only four of the twenty-one lions with which they started, and in 1902 one of Hagenbeck's American shows had only sixteen animals left of the sixty he began to train. The gentling process demanded infinite patience and usually a considerable period of time. At first, the trainer stood beside an animal's cage so that it would become accustomed to him; he used the animal's name, talked to it calmly, and gave it small portions of meat. After a series of steps, the trainer eventually would enter the cage, feed the animal from his hand, and seat himself in the cage unconcernedly to read a book or a newspaper. Other animals to be tried out for the performing group would have their cages placed nearby so that they could become familiar with one another. Then the training sessions shifted to a roomy, round cage with a net over the top and playpen equipment of pedestals, steps,

Fig. 30. Carl Hagenbeck with young walruses at Stellingen, 1908. *(Courtesy of Carl Hagenbeck's Tierpark, Stellingen.)*

blocks, barrels, and the like inside. Each animal was trained individually to have its own resting place on stand or steps, and learned exactly the routine expected of it. Finally, the whole troupe performed together, with the trainer settling any disputes among the animals. He must never show fear, must praise and caress them, and must reward good behavior frequently with small pieces of meat.[14]

Trainers needed always to be on guard lest an unexpected minor incident disturb an animal, especially during mating seasons, and cause it to revert to wild and dangerous behavior. But when, during their act,

animals snarled, roared, or made lightning-fast jabs toward the trainer while he waved his stick angrily or cracked his whip, that was part of the spectacle and training. Animals became exceedingly fond of their trainers, and as Hagenbeck visited zoos around the world, the beasts that he had taught frequently recognized him; once, at the Bronx Zoo, for example, two lions and a tiger greeted him effusively with loud purrs, to the surprise of Director Hornaday.[15]

Hagenbeck himself began training animals in the 1870s, and his headquarters was soon regarded as a "kindergarten school" for gentling carnivores, his favorite kind of beast. He estimated, in 1902, that he had taught about seven hundred large animals. His father Gottfried had trained a mixed troupe consisting of a Bengal tiger, an Indian panther, and a fox terrier. His brother Wilhelm was probably the best trainer in the family, the first to use a troupe of polar bears and to teach a young lion to ride on the back of a horse, and his wife's brother, Heinrich Mehrmann, took a dozen lions as well as tigers, cheetahs, and bears to the Crystal Palace as early as 1891. Hagenbeck turned down an offer of $50,000 for that troupe, only to have its members die of glanders soon after it returned from London. He lost other valuable animals in a cholera epidemic at Hamburg and then himself took a new troupe to the World's Columbian Exposition at Chicago in 1893, where they were a major attraction at the Midway Plaisance. He sent another group to the Louisiana Purchase Exposition at St. Louis in 1904. Richard Sawade (and his pupils Alfred Kaden and Rudolf Matthies), Julius Seeth, and Willy Peters were some of the host of Hagenbeck-trained men who made the gentling art known in exhibitions and circuses everywhere.[16]

Carl Hagenbeck himself was not greatly interested in developing a traveling tented circus. After Mehrmann and he had gone to the United States to see the Barnum and Bailey Circus and to consult James H. Bailey, in April 1887, Hagenbeck did open the "International Circus and Singhalese Caravan" at Hamburg, though a violent gale blew down the big tent just before the first night's performance. The show contained trained elephants, lions, tigers, and panthers; more than forty show horses with accomplished Argentinian girl riders; tight-rope walkers; clowns; and a pantomime entitled "An Excursion to Wategama in Ceylon." This circus traveled in Germany, but Hagenbeck sold it sometime in 1889 and, in his usual decisive manner, he told his son Lorenz: "No, my lad, you are not going to be one of those caravan folk." Lorenz, however, thought differently. He had had a passionate love for the circus, ever since his father had given him a leather rocking elephant and a miniature circus for his fifth

birthday. After his brother Heinrich and he had helped their father with the exhibit at St. Louis in 1904, they, together with three American partners, started the Carl Hagenbeck Circus. The brothers later joined with Benjamin Wallace to form Hagenbeck-Wallace. This famed American organization, with its forty-five railroad cars, was in existence as late as 1938, though in its last years it was owned by John Ringling. Two Hagenbeck sister-shows often operated throughout Europe, and Lorenz took a Carl Hagenbeck Circus three times to South America. In 1909, he ordered sea elephants and penguins from a Norwegian sea captain cruising the Antarctic. His father and mother came out to Buenos Aires, and Lorenz gave his father seventy penguins for his sixty-sixth birthday. In 1933 and 1934, Lorenz took the circus around the world in its own ship— known as "the modern Noah's ark"—by way of Japan, Shanghai, India, Egypt, and Spain. After the Second World War, Lorenz's circus made five tours of Europe before it finally disbanded, after the 1953 season.[17]

### III

When Carl Hagenbeck bought his tract at Stellingen in 1902, he had developed definite ideas on methods of keeping and exhibiting wild animals. For about fifty years, he had helped others build and stock zoological gardens in all parts of the world. He did not, however, approve of the way that most zoos treated wild animals, and he dared dream of a "barless zoo." On May 7, 1907, after three years of construction, he opened Carl Hagenbeck's Tierpark at Stellingen. In a witty speech, the director of the Copenhagen Zoo called Carl and his wife Amanda "the Adam and Eve of an animal paradise on the banks of the Elbe," and Chief Hersy Eggeh and his Somali dancers from Abyssinia formed a spectacular part of the opening ceremonies. Hagenbeck's basic philosophy for the new zoo relied upon his study of the acclimatization of wild animals. Some of those that had been free to roam the deserts or plains and compelled to exercise cunning and swiftness in order to secure food were, in most zoos, condemned to the solitary confinement of a cage. Hagenbeck was determined to give his animals maximum liberty, to free them to wander within as spacious limits as possible, to play together, and to gaze about with no bars to remind them of their captivity.[18]

At Stellingen, Hagenbeck wrote, there are

wide tracts of meadow-land in which wander animals of many different species, though all are provided with shelters in case of unfavorable weather. Rocky ranges

rise high into the air dotted with mountain animals from various parts of the world, and on a high plateau a herd of reindeer may be seen. A rock is provided, in as exact an imitation as possible of an iceberg, so that the polar bears may think they are still in Arctic regions: and there are great ponds with numerous shelter corners in which seals, penguins, and water birds may feel they are in their own home.[19]

Hagenbeck explained succinctly to a visiting journalist what he was trying to do. He said:

My whole aim is to erect a zoological garden in a natural manner. I shall place my animals in surroundings as much like their natural haunts as possible. I fully believe that hitherto animals have been too cramped in our zoos, and also not allowed enough open-air exercise. I shall give my animals here plenty of room to move about freely in their inclosures, and also keep them in the open air as long as possible. Fresh air is necessary for every living creature, and I feel convinced that one of the faults of present-day zoos is the keeping of animals in heated houses—animals, I mean, that could easily become acclimated. I feel sure, too, that zoological gardens of the future will be erected on this plan.[20]

By 1896, Hagenbeck had developed his ideas on barless exhibition far enough that he was able to obtain an imperial German patent for his "Panorama." The elements of the panorama were so easily varied, however, that he did not make any money from licensing his plan to other users. Panoramas or cycloramas had been known as exhibition devices since the eighteenth century. Usually the observer was placed in the middle of a rotunda surrounded by a mammoth painting of a battle, great fire, shipwreck, or other extensive scene, sometimes with actual objects in the foreground, illumination from above or furnished by men with moving lights, and simulated sounds. Gustaf Kolthoff had even set up a Biological Museum near Skansen at Stockholm, in 1893, in the form of a panorama that showed animals of Sweden preserved by taxidermy against realistically painted backgrounds and could be viewed from two different levels. Two panoramas were then on view in Hamburg—one on the *Storming of St. Privat* and the other on the *Great Fire of Hamburg.* But Hagenbeck's *Polar Panorama* set up in Heiligengeist Field was much more exciting. Against mountains of artificial ice, with an ice-locked ship in the background, live polar bears, seals, and seabirds roamed, with sound effects consisting of actual roars, hoarse barks, and rasping bird cries. The whole scene was brilliantly lighted for night performances. A deep ditch separated the animals and their admiring observers. The *Illustrierte Zeitung* carried a full-page illustration of "a most exciting open-air polar

landscape, and for the first time of its kind, this panorama has been enriched with live animals moving about in complete freedom." This exhibit, repeated at Berlin, Leipzig, and Paris, was used later in expanded form and with great success at the St. Louis exposition and the Olympia Hall show in London. It was also adapted as a permanent installation at Stellingen.[21]

While still at the Neuer Pferdemarkt, Hagenbeck had carried out practical experiments with a view to building moats largely to take the place of bars and fences. He tied a stuffed pigeon to a branch about ten feet from the ground and found that lions and tigers could jump only about six feet, six inches high and that even panthers could not bring down the pigeon. In the long jump, panthers and tigers could cover only about ten feet from a standing start and thirteen to fourteen feet from a running one. Thus, he determined to make his trenches twenty-eight feet wide, with a five-foot ledge on the inner side to protect any animal that fell over the edge. He also planted prickly shrubs along the outer rim, to keep the public back from the moat. Zoos today have worked out different kinds of moats, with or without water, for different animals and have used varying kinds and weights of fencing and heavy plate glass to supplement moats, but they still remain a characteristic zoo feature and follow the general plan that Hagenbeck devised.[22]

Hagenbeck's zoo at Stellingen was situated on a level plain, but he hired the Swiss sculptor and designer, Urs Eggenschwyler, to build simulated rock mountains of concrete, other natural-appearing backgrounds, and artificial valleys, lakes, ponds, and streams. Eggenschwyler, a huge, jovial man with a scraggly full beard, specialized in animal sculpture, kept several wild beasts as pets, and had virtually a small zoo in Zurich. Hagenbeck had given him a panther to train, sent from Colombo to Hagenbeck by his half brother John. Eggenschwyler could be stubborn, and so could Hagenbeck; they often argued acrimoniously about features of the new zoo's plan. In laying out the original thirty-six acres, laborers moved more than fifty thousand cubic yards of earth by wheelbarrow or on special drays pulled by elephants. Hagenbeck also hired Heinrich Hinsch as general architect, and he had landscapers plant trees, plants, and flowering shrubs to make the zoo habitat more comfortable for the animals and more attractive for the visitors.

A chief feature of Hagenbeck's Tierpark was its sheer beauty. The sculptured natural forms of cliffs, caverns, ponds, and meadows that Eggenschwyler created; the trees, shrubs, and flowers that Hinsch employed to give an aura of color and fragrance; the prehistoric, mythical,

and contemporary animals that the pipe-smoking Josef Pallenberg, another well-known animal sculptor, molded in bronze or concrete; and other artistic features, such as the bright red Torii gates or the brooding Buddha of the Japanese Island were intrinsically handsome and made an impressive background for the living animals. And the scale of the whole production was comfortable and humane—not the largest or richest zoo in the world, but intimate and endearing to the hundreds of thousands of Hamburg citizens, young and old, who visited it each year.

The main gate, with its background of lacy foliage and—in season— bright flowers, had an ornate style, with bronze sculptures of animals and hunters by Pallenberg. Upon entering, one soon came to the African panorama, with a big pond in the foreground filled with water birds of many varieties, including flamingos, cranes, and pelicans. Behind the pond was a meadow for zebras, antelopes, and ostriches. Towering above the plain was a realistic-looking mountain with a gorge for lions below and, at the top, steep cliffs enclosing Barbary sheep and a hill for mountain goats. Deep moats between the sections kept predators from attacking their traditional prey. Another panorama of arctic life contained reindeer, seals, walruses, and polar bears. There were various open-air enclosures, houses for sixteen elephants, for reptiles, and giraffes. The Japanese Island contained vermilion gates and bridge, grotesque bronze animals, beautiful flowering shrubs, waterlilies, goldfish, and a meadow for more flamingos. Everywhere there was a pleasing combination of plant and animal life, together with artistic highlights. And a sense of intimacy pervaded the whole composition. The paths were ingeniously intertwined, to keep the tract ordered but compact.

The zoo was a lively place, for Hagenbeck furnished the animals with play equipment, such as a rod in the water upon which the sea lions could balance, a hanging bag of straw for the rhinoceroses to butt, much as a prizefighter would punch a heavy bag, and a barrel for the wild cattle to roll or toss in the air. The walruses were "as tame as dogs, clever, and touchingly affectionate"; born clowns, one played a mouth organ and swiveled around in a circle, others beat their breasts with their flippers, and some filled their mouths with water to squirt at unsuspecting visitors.

Other amenities at Stellingen included two dining rooms seating seven hundred and decorated with mounted animal horns and heads valued at fifteen thousand dollars, an arena where one could watch animals being trained, a children's playground, and rides for young and old on elephants, dromedaries, zebras, and ponies. In the next two years, Hagenbeck added a native village for his ethnographic shows (part of it

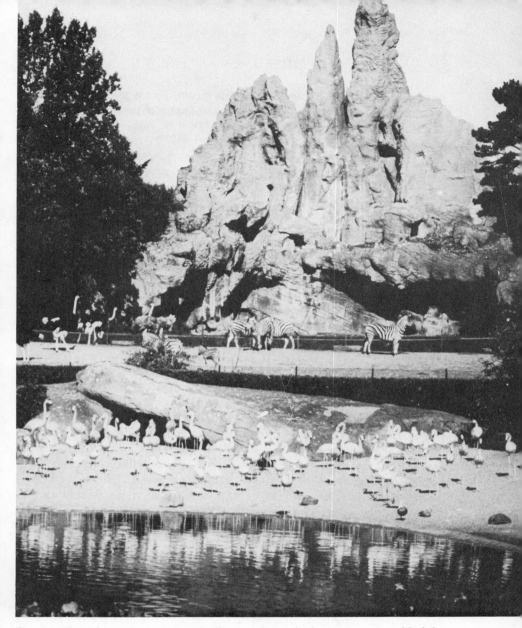

Fig. 31. The African Panorama at Stellingen. Deep ditches or moats enabled the Tierpark to separate the flamingos in the bird pond, the ostriches and zebras in the middle distance, and the lions in their dens beneath the "mountain." *(Courtesy of Carl Hagenbeck's Tierpark, Stellingen.)*

survives today as the Burmese temple ruins) and a miniature railroad running around a small lake with a dozen concrete prehistoric creatures by Pallenberg that included forty-foot-high dinosaurs. These huge replicas probably reflected Hagenbeck's interest in the tales Rhodesian natives told of sighting, in the great swamps there, a monster, half elephant, half dragon. When several reliable travelers, including Menges, brought Hagenbeck this story, he sent out an expedition toward Lake Bangweolo, but it failed to find such a dinosaur-dragon. Supposedly, saurians had been extinct for centuries, but Hagenbeck continued to wonder whether one might turn up in the vast unexplored wilderness of central Africa.[23]

The use of moats revolutionized the principles on which zoo exhibits were organized. Previously, systematic displays housed similar animals in the same ornate buildings—for example, lions, tigers, leopards, panthers, and other carnivores in separate cages in the Lion House, or elephants, rhinoceroses, hippopotamuses, and other huge mammals in the Elephant House. While such an arrangement permitted visitors to study the individual animals at close range, it was not very inspiring to plod along from one cage or enclosure to another. With the moat, however, most zoos began to use a geographic arrangement, under which animals of the African plains, monkeys and other primates, or arctic polar bears, walruses, and seals could mingle, though safely separated from the public and, whenever necessary, from each other, by almost invisible trenches. A variation of the geographic display emphasized the habitat or ecology by putting together animals from similar environments such as water, desert, or grassland. Another arrangement might stress the behavioral background by grouping animals active at night (sometimes in houses of darkness, where special reverse lighting tricked the animals into activity during the daytime hours in front of visitors and to sleeping through the night), or flying animals, or burrowing animals in their lairs below ground, as at the Arizona-Sonora Desert Museum today. The moated system also allowed predators and prey seemingly to live together, and it was thrilling (and yet reassuring) for visitors to observe a pride of lions come to attention ready to spring when an eland or a zebra ran by on the other side of a moat. The geographic arrangement and its variations were not unlike the period room of the art or history museum or the habitat group of the natural history collection, in providing a dramatic display that could be grasped at a glance and that brought a sense of unity and naturalness to the exhibition of many individual specimens.[24]

Hagenbeck thought that his kind of zoo could be afforded by a city of 100,000 population. No monumental buildings were required, but only paddocks and ponds, with shelters where animals could retreat in bad weather or to find solitude. Nor was it necessary to show the great number of species that the mainstream zoos exhibited. A zoo and an animal refuge could be established for only about $200,000 to $250,000. Herr Friedrich Falz-Fein, a German naturalist in the Crimea, the Duke of Bedford at Woburn Abbey in Bedfordshire, and Lord Rothschild at Tring in Hertfordshire showed that private gentlemen could maintain animal parks. Hagenbeck considered Florida an ideal climate for zoological gardens in the United States. Astute businessman that he was, he knew that such developments would help his trade in wild animals, for even as it became more difficult to obtain beasts in the shrinking wildernesses, the zoos themselves were proving excellent breeding centers.[25]

The fame of Stellingen quickly spread around the world. Hagenbeck's book, *Beasts and Men* (1908), sold a hundred thousand copies in Germany and was translated into several languages. A popular musical comedy song had a refrain: "Let's go round to Hagenbeck's, to Hagenbeck's, to Hagenbeck's." One writer entitled his magazine piece "Hagenbeck as an Educator," because of the respect for wild animals shown by the zoo and its strong plea for their conservation. Director Hornaday of the New York Zoological Society wrote Hagenbeck that he had made his office into a private hall of fame with the names of great zoologists painted as a frieze around the room, next to the ceiling. "Between the name of Roosevelt— the greatest sportsman-naturalist in the world—and Henry A. Ward— the greatest [natural history] museum builder in the world—stands the name 'HAGENBECK' " as the greatest zoological garden creator in the world. P. Chalmers Mitchell, secretary of the prestigious Zoological Society of London, also had a high opinion of Hagenbeck, his business, and his zoo. He described him as a "tall, lean man, with a bony, weather-beaten face, shaven lips, and a short, grizzled beard of the kind known as 'chin fringe,' " a shrewd, kindly man who might pass for a New England sea captain. As a businessman, he was friendly, direct, and scrupulously careful in carrying out his share of the bargain. Most animal dealers ran small, shoddy businesses, but not Hagenbeck; "he is a naturalist with a genuine affection and sympathy for animals." In Hagenbeck's zoo, "the animals are given shelters into which they can retreat, and in these some amount of artificial heat is supplied in severe weather, but in every case room for exercise, abundant fresh air, and free exposure to rain and sun

are provided for." Moreover, Mitchell found "the devices by which bars
and railings are replaced by ditches and undercut ledges of rock-work are
extremely attractive and . . . pleasing."[26]

<div style="text-align:center">IV</div>

Carl Hagenbeck's innovations in developing zoological gardens are
generally accepted throughout the world today. Placing animals in
groups in large enclosures protected by moats, with individual dens to
which they may withdraw, keeping them in open air instead of confined
to small, barred cages, surrounding them with a pleasant environment of
plants and trees, abetting their playfulness as a means of overcoming the
boredom of captivity (this attitude may be an anthropomorphic reaction
more important to the human observers than to the animals themselves),
encouraging their breeding and looking upon zoos as animal refuges and
a kind of species bank, and conducting scientific research studies of the
physical, mental, and social characteristics of animals—all these ideas
were adopted at Stellingen and followed by progressive zoos every-
where. Fortunate indeed was it that such institutions were available as the
growth of human population and the spread of agriculture and industry
encroached upon the wilderness areas that once sheltered wild animals,
and as hunters and poachers relentlessly killed them for trophies, at the
beck of fashion, or for special qualities such as the supposed aphrodisiacal
potency of rhinoceros horn. Zoos were important havens of animal con-
servation and could keep alive species that were disappearing in the wild.
    The Hagenbecks advanced their exhibition ideas aggressively, even
after Carl's death, as shown by the installation of "Carl Hagenbeck's
Wonder Zoo and Big Circus" at the Olympia Hall in London during the
winter of 1913–1914. In one corner of the building were seven lions sitting,
prowling, sleeping, and roaring "on a mass of rockwork, with a back-
ground painted to resemble caves and tropical vegetation" and "nothing
between them and their visitors except an empty trench across which they
cannot jump." In another corner were sixty or seventy Arabian baboons,
loud, clamorous, and playful, on "an exact reproduction of the rocks in
Abyssinia on which the monkeys live when they are free." The Monkey
Rock also was separated from the spectators by a moat. A kindergarten or
children's zoo had young bears, hyenas, lion cubs, and puppies playing
together under the supervision of a young woman armed only with a
broomstick to help her keep order. The Bird Village contained peacocks,
macaws, flamingos, and cranes; the Water Hole brought together elands,

zebras, white-bearded gnus, and ostriches and other birds; and the Guinea Pig Castle (there is still such a castle at Stellingen today) was a model chalet where the cavies munched bread and cabbage leaves. An editorial in the *Spectator*, while in general complimentary of the exhibition, looked askance at putting together, at the same water hole, zebras and black swans, as well as gnus and upland geese that do not belong in the same wildernesses. It also considered the Guinea Pig Castle sentimental showmanship rather than zoological enlightenment. The editorial commented that the rock-work, while valuable for such exhibits, in zoos would become dirty and attract rats, an ever-recurring nuisance there. One wonders whether these criticisms might have originated with Secretary Mitchell of the London Zoo, for in another place he questioned the desirability of "grouping incongruous animals in 'happy families,' " disliked "the more exuberant forms of . . . artificial scenery with painted backgrounds," and commented that rock-work was hard to keep clean and free from rats.[27]

The Hagenbeck ideas encountered other difficulties that slowed their adoption. The older zoos of Europe, situated on small tracts in crowded cities, did not have enough land to provide the spacious vistas required by the moated system and the attractively planted environment. Moats hindered the public from engaging in the popular sport of feeding the animals, even though progressive zoos were doing away with much indiscriminate feeding. Moats filled with water lost their effectiveness when they froze during the winter in northern climates. Director Hornaday of the Bronx Zoo reported in 1912 that "the zoological garden directors of all Germany were industriously engaged in boycotting Mr. Hagenbeck" because he "had had the temerity to build at Hamburg a private zoological garden so spectacular and attractive that it made the old Hamburg Zoo look obsolete and uninviting." But Hornaday himself refused to use moats, because they kept the public sixty or seventy feet away from the animals. Fortunately, the St. Louis Zoo disregarded Hornaday's advice to them and opened the first American moated bear pits in 1919. Hornaday's successors at the Bronx adopted the Hagenbeck system, as shown today in their exhibits such as African Plains, Lion Island, and Wild Asia. The Philadelphia Zoo (1854), the oldest in the United States, for a time deplored the "Hagenbeckization" of American zoos and wondered whether the family was plotting to have Stellingen-trained men used to construct the rockwork involved. Some leading zoos did adopt the Hagenbeck approach, however—the London Zoo, which added the Mappin Terraces with moats in 1914; the Paris Parc Zoologique at Vin-

cennes (1934), especially impressive because it started with an entirely new site; and the Frankfurt Zoo, rebuilt with moats after World War II and in 1971 planning larger enclosures in another part of the city.[28]

In fact, some of the mainstream zoos of the world are establishing wild animal parks far from their city properties, with public admission strictly regulated and in some cases prohibited. The Zoological Society of London, a world leader, had only 36 acres in Regent's Park there and in 1931 opened a 566-acre branch thirty miles away at Whipsnade, near Dunstable in Bedfordshire. The Zoological Society of San Diego in 1972 established its Wild Animal Park at San Pasqual on a 1,800-acre tract thirty miles distant from its city zoo. Both the National Zoological Park of the Smithsonian Institution in Washington and the Bronx Zoo have breeding farms respectively at Front Royal, Virginia, and Saint Katherine's Island, off the Georgia coast. These developments emphasize the increased importance of the animal breeding and research functions of the modern zoo. They reflect Hagenbeck's ideas of spacious paddocks for the animals, but not his practice of bringing the public into intimate contact with wild beasts.

The safari zoo may be regarded as an extension of the Hagenbeck plan. It allows animals to roam freely in large enclosures, with their human observers virtually placed in the cages—in this case, usually their own automobiles or air-conditioned busses, all with their windows tightly closed to avoid injury from the animals. The cars drive through the enclosures, enabling an observer to encounter a lion or tiger "eyeball to eyeball," or an elephant or a camel to nuzzle an automobile. This kind of zoo was started by Lord Bath in 1966, with his Lions of Longleat, on his estate in Wiltshire, to be followed in the next year by the commercial venture, Lion Country Safari, on 640 acres near West Palm Beach, Florida. There, prides of lions or herds of giraffes apparently grazed freely, while outside the enclosures were more conventional displays of snakes, chimpanzees, shore birds, pygmy hippopotamuses, and sea lions. These safari zoos are widespread today in the United States, often combined with amusement park rides and other entertainment features. Some drive-through zoos are well run, with good conservation and zoological research programs, but in other instances the desire for financial gain predominates, and the management lacks trained personnel that understand and respect the animals.[29]

Stellingen has had its share of problems that have accompanied the rise and fall of German governments. Carl Hagenbeck was aided greatly by the blooming of the German empire and its colonial adventures in

Africa and Asia. Since he died on April 14, 1913, he did not experience the decline that began with World War I. At the coming of peace, Carl's son Heinrich took over the management of Stellingen and domestic animal trading, while Heinrich's brother Lorenz had charge of the circus and overseas animal trading. The wild inflation that followed the war made the zoo close from October 1920 to May 1924. The worldwide depression and the coming of the Nazis were taken in stride without much trouble, because wild animals, the circus, and the zoo had intrinsic values and were comparatively uncontroversial, not like modern art or literature. World War II, however, brought disaster to the Hagenbeck enterprises. A massive air raid on Hamburg on July 25, 1943, started a dreadful firestorm that killed forty thousand citizens and burned three hundred thousand homes. Stellingen lost nearly all its buildings and equipment; nine attendants were killed; and about 80 percent of the twenty-five hundred animals were destroyed by bombs or had to be shot by their keepers. Enough elephants were left to hitch to scrapers to fill the bomb craters, and some of the surviving animals were sent to neutral Sweden, only to be confiscated after the war as enemy property. When peace returned, Arnulf Johannes, one of the experienced Hagenbeck hunters, was sent to French West Africa to obtain animals. Stellingen gradually reopened by 1948, and Lorenz Hagenbeck got out his old circus tent that would hold three thousand people and used it to put on a season of light opera. In 1949, he had enough animals to start up the circus again, with two trains that contained a hundred and thirty cars in the traditional blue and orange colors. After 1953, however, the circus closed, and animal trading was given up in the late 1960s. The rapid depletion of animals in the wilds, the rise of native nationalism, and the strict regulation of animal exportation and importation made that kind of commerce no longer profitable.[30]

Carl Hagenbeck's Tierpark, the only privately owned zoo in Germany, has shown steady improvement. In a city of nearly two million, it enjoys an annual attendance of about one million. In 1978, its staff numbered seventy-nine, and its 1,600 individual animals belonged to 282 species. Today, it still contains the African panorama as its first great attraction, not far from the entrance gate. Next to the panorama is the spacious paddock for giraffes, with their feed baskets of alfalfa hay attached high on the trees. Other airy enclosures contain the monkey cliffs, the plain for American bison, a jungle setting for Siberian tigers, and a fairly new open-air paddock for elephants, with its own wading pool, another pool for the Indian rhinoceroses, and the nearby elephant and rhinoceros house. Then there are the Japanese Island and flamingo meadow, an

aviary for flying birds, a troparium for tropical fish, and the arctic and antarctic panoramas with polar bears, sea lions, penguins, and walruses. The indoor dolphinarium is especially popular with sea lions and fun-loving dolphins performing their tricks before the seated audience in the arena that borders a pool. The children's playground is always crowded, its swings and play equipment in use, and nearby are rides on elephants and ponies and a miniature mechanized autobahn.[31]

Running a privately owned zoo has presented many problems through the years. The Tierpark has had to pay full property and income taxes, just as any other private business does, though school classes have comprised a large part (about 17 percent) of its attendance, and it has had from the beginning a strong educational purpose. Carl Hagenbeck himself was bitter because the city of Hamburg gave no support to his zoo, openly opposed his efforts to expand in the Neuer Pferdmarkt site, and fought hard for its inadequate City Zoo, eventually abandoned because of successful Stellingen competition. There were also disputes about roads, tram lines, and subways. Heinrich Hagenbeck in 1936 at last succeeded in diverting from the park the important Kaiser Friedrich Road (today the Hagenbeckstrasse) that passed through the zoo property and required an overpass between the two sections; and in 1966, Hagenbeck's Tierpark became a main stop on a new and convenient subway line. There were signs that the city of Hamburg was better recognizing the touristic and community importance of the Stellingen Zoo.[32]

On the professional side, Stellingen has kept up with the latest zoo developments. Carl Heinrich Hagenbeck in 1951 sent an expedition to Iran seeking new species such as onagers, and the zoo has had many breeding successes, as, for example, with Indian rhinoceroses. Both Carl Heinrich and Dietrich Hagenbeck contributed articles to the *International Zoo Yearbook* published by the Zoological Society of London. They discussed Stellingen experience in training elephants, raising its great Indian rhinoceroses, on the exhibition of penguins, and the feeding of walruses. The zoo is proud of its well-equipped Veterinary Department, which would have pleased Carl Hagenbeck, who was an accomplished amateur veterinarian and stressed the importance of keeping his animals healthy.[33]

The Hagenbeck family for more than 130 years has constituted a dynasty devoted to wild animals—their capture, training, and exhibition, either through zoos or in circuses. Carl's father Gottfried (1810–1887) began the family preoccupation with beasts in 1848, when he showed the six seals in his wife's wash-tubs. Carl himself (1844–1913) had the greatest

influence; his combination of showmanship and business ability made him the most successful animal trader of his day, an animal trainer of distinction, and the prime developer of the modern moated zoo. Carl's sons Heinrich (1875–1945) and Lorenz (1882–1956) were trained by their father, served as his assistants, and succeeded him as animal traders and proprietors of Stellingen. Of Carl's grandsons, Carl Heinrich (1911–1977) managed the zoo, assisted by a great-grandson Dietrich Thomas (1933—). Dietrich and another great-grandson, Dr. Carl Claus Hagenbeck (1941—), a veterinarian, are the present directors and owners of Stellingen. Thus far, five generations of Hagenbecks have devoted themselves to wild animals. As Lorenz Hagenbeck put it: "You see, we have a century-old tradition to maintain. There never will be a day when the Hagenbecks do not own, train, and exhibit our friends, the animals." Today, while animal trading, ethnological shows, and the circus have disappeared, the zoo remains strong and continues the training and performances of sea lions, dolphins, and elephants.[34]

Carl Hagenbeck took the old confined menagerie and the zoological garden type of museum in new directions. He devised a new form of institution that collected wild animals from all over the globe, looked after their health and encouraged them to reproduce, exhibited them to the public in more natural and yet dramatic ways, and studied their physical, mental, and social characteristics. As a keen businessman, he found and distributed animals from Africa, Asia, the Americas, Australia, the Arctic, and the Antarctic. As a skillful publicist, he made viewing wild animals popular with the general public, either in spectacular trained-animal acts or in appealing natural settings in zoos. He aroused public compassion for the animals and helped to save endangered species. His ideas have continued to live, partly through the efforts of his own descendants, but more largely because animal lovers all over the world have accepted his pleas for respect and conservation of wild animals.

## NOTES

Dietrich Thomas Hagenbeck, a great-grandson of Carl, who, with Dr. Carl Claus Hagenbeck (another great-grandson) owns and directs Stellingen today, has been most co-operative in helping me develop this chapter. He has let me wander about the zoo and inspect illustrative materials in its archives, and he has answered freely my many questions.

1. Carl Hagenbeck, *Beasts and Men*, pp. 1–2; Lorenz Hagenbeck, *Animals Are My Life*, p. 13; Günter H. W. Niemeyer, *Hagenbeck*, p. 246; Bernard Livingston, *Zoo*, pp. 138–139;

O. K. Armstrong, "The Hagenbecks and Their Animal Friends," *Reader's Digest* 61: 81–84; *Carl Hagenbecks Tierpark* (Guidebook), [p. 30].

2. C. Hagenbeck, *Beasts and Men*, pp. 4–7, 200–201.

3. C. Hagenbeck, *Beasts and Men*, pp. 7–8, 11–14; Niemeyer, *Hagenbeck*, pp. 249–250; Livingston, *Zoo*, pp. 140–141; Henry Scherren, *The Zoological Society of London* . . . (London, Paris, New York, and Melbourne: Cassell and Company, 1905), p. 140; "Karl Hagenbeck," *Literary Digest* 46: 1091–1095; Harold J. Shepstone, "The Scientific Training of Wild Animals," *Scientific American* 87: 260–261.

4. C. Hagenbeck, *Beasts and Men*, pp. 8, 15–25; L. Hagenbeck, *Animals Are My Life*, pp. 16, 17, 25, 28; Niemeyer, *Hagenbeck*, frontispiece, pp. 67–70, 250; Livingston, *Zoo*, pp. 142–144; Armstrong, "Hagenbecks," pp. 81–84.

5. C. Hagenbeck, *Beasts and Men*, pp. 8–11, 26–29, 145; L. Hagenbeck, *Animals Are My Life*, pp. 36–37; Niemeyer, *Hagenbeck*, p. 250; James Fisher, *Zoos of the World*, pp. 138–139; Richard Lewinsohn, *Animals, Men, and Myths*, pp. 287–288; Harry Gersh, *The Animals Next Door*, p. 21.

6. C. Hagenbeck, *Beasts and Men*, pp. 44–45; William Bridges, *Gathering of Animals*, pp. 70, 82, 123, 130–132, 212–214, 218–219, 231–232, 335; Harold J. Shepstone, "The Trade in Wild Animals," *Scientific American* 88: 376–378; Niemeyer, *Hagenbeck*, pp. 253–254.

7. L. Hagenbeck, *Animals Are My Life*, pp. 23–24.

8. "The Snow Camel," *Spectator* 80: 373–374.

9. C. Hagenbeck, *Beasts and Men*, pp. 38–45, 251, 255–272; L. Hagenbeck, *Animals Are My Life*, pp. 16, 65–73, 82–83; Niemeyer, *Hagenbeck*, p. 254; Shepstone, "Trade in Wild Animals," pp. 376–378; "Karl Hagenbeck," *Literary Digest* 46: 1091–1095; Bridges, *Gathering of Animals*, pp. 382–383; Willy Ley, *The Lungfish, the Dodo, & the Unicorn*, pp. 147–150; Lee S. Crandall, *A Zoo Man's Notebook*, pp. 185–186; *International Zoo Yearbook* 2 (1960): 133–134; 10 (1970): 191.

10. C. Hagenbeck, *Beasts and Men*, p. 254.

11. C. Hagenbeck, *Beasts and Men*, pp. 29, 38–45, 215–219; L. Hagenbeck, *Animals Are My Life*, p. 95; Niemeyer, *Hagenbeck*, opp. pp. 160–161, pp. 251, 254; Armstrong, "Hagenbecks," pp. 81–84; Crandall, *Zoo Man's Notebook*, p. 135; Shepstone, "Trade in Wild Animals," pp. 367–368; Shepstone, "Training of Wild Animals," pp. 260–261.

12. For Peale, see above, chapter 3. William Bullock, *An Account of the Family of Laplanders* . . . (London: For W. Bullock, [1822]); William Bullock, *A Description of the Unique Exhibition Called Ancient Mexico* . . . (London: For the Proprietor, 1824); P. T. Barnum, *Struggles and Triumphs: or Forty Years' Recollections* . . . *Written by Himself* (Hartford, Conn.: J. W. Burr & Co., 1870), pp. 119–125; M. R. Werner, *Barnum* (New York: Harcourt, Brace & Co., 1923), pp. 50–52, 94–98, 235–252.

13. C. Hagenbeck, *Beasts and Men*, pp. 31, 118–146; Ruth Manning-Sanders, *The English Circus*, pp. 193–194; Hermann Dembeck, *Animals and Men*, pp. 311–312.

14. C. Hagenbeck, *Beasts and Men*, pp. x–xi, 126; Manning-Sanders, *English Circus*, pp. 218–226; Livingston, *Zoo*, pp. 144–146; Shepstone, "Training of Wild Animals," pp. 260–261; Niemeyer, *Hagenbeck*, pp. 145, 251–252.

15. C. Hagenbeck, *Beasts and Men*, pp. 31–37, 101–102, 106–111; Manning-Sanders, *English Circus*, pp. 222–224; Shepstone, "Training of Wild Animals," pp. 260–261.

16. C. Hagenbeck, *Beasts and Men*, pp. 31–37, 102, 126, 135–146; Armstrong, "Hagenbecks," pp. 81–84; Niemeyer, *Hagenbeck*, pp. 251–252, 254.

17. L. Hagenbeck, *Animals Are My Life*, pp. 18–19, 32, 56–64, 74–76, 84–92, 124–127, 200–209, 238–242; Niemeyer, *Hagenbeck*, pp. 251, 254, 255–259; George L. Chindahl, *A History of the Circus in America*, pp. 150, 152, 160, 207–209, 251.

18. C. Hagenbeck, *Beasts and Men*, pp. 203–204; L. Hagenbeck, *Animals Are My Life*, p. 77; Harold J. Shepstone, "Carl Hagenbeck's Novel Zoological Park," *Scientific American* 95: 345–346; Shepstone, "The Completion of Carl Hagenbeck's Zoological Park," *Scientific American Supplement* 64: 88–89; Niemeyer, *Hagenbeck*, p. 254; Fisher, *Zoos of the World*, pp. 164–167.

19. C. Hagenbeck, *Beasts and Men*, p. 211.

20. Shepstone, "Hagenbeck's Novel Zoological Park," p. 346.

21. *The Biological Museum, Djurgården* (Stockholm: The Museum, 1978); L. Hagenbeck, *Animals Are My Life*, pp. 28, 51, 78; Niemeyer, *Hagenbeck*, opp. p. 41, pp. 253, 254, 255.

22. C. Hagenbeck, *Beasts and Men*, pp. 234–236; Crandall, *Zoo Man's Notebook*, pp. 122–125; Heini Hediger, *Man and Animal in the Zoo*, pp. 186–191; R. Bigalke, "The Use of Moats in Zoological Gardens," *International Zoo Yearbook* 2 (1960): 62; "Dimensions of Moats and Ditches at Detroit Zoo," *International Zoo Yearbook* 2 (1960): 63–67; Ronald T. Reuther, "Barrier Dimensions for Lions, Tigers, Bears and Great Apes," *International Zoo Yearbook* 16 (1976): 217–222; C. Sherpner, "Moated and Fenced Enclosures at Frankfurt Zoo," *International Zoo Yearbook* 11 (1971): 57–62.

23. C. Hagenbeck, *Beasts and Men*, pp. 95–97, 106, 236–241, 253–254; L. Hagenbeck, *Animals Are My Life*, pp. 36, 73–74, 77–80; Shepstone, "Hagenbeck's Novel Zoological Park," pp. 345–346; Shepstone, "Completion of Hagenbeck's Zoological Park," pp. 88–89; "Hagenbeck as an Educator," *American Review of Reviews* 44 (October 1911): 491–492; Gersh, *Animals Next Door*, pp. 27–39; Heniger, *Man and Animal*, p. 188; Carl Heinrich Hagenbeck, "Notes on Walruses . . . in Captivity," *International Zoo Yearbook* 4 (1962): 24–25; Fisher, *Zoos of the World*, pp. 164–167; *Carl Hagenbecks Tierpark* (Guidebook); Ley, *Lungfish, Dodo, & Unicorn*, pp. 163–164, 167; Niemeyer, *Hagenbeck*, opp. pp. 17, 40.

24. Gersh, *Animals Next Door*, pp. 34–35.

25. C. Hagenbeck, *Beasts and Men*, pp. 212–215; L. Hagenbeck, *Animals Are My Life*, pp. 33–34.

26. C. Hagenbeck, *Beasts and Men*, pp. iv–ix; L. Hagenbeck, *Animals Are My Life*, pp. 95–96; "Hagenbeck as Educator," pp. 491–492; Bridges, *Gathering of Animals*, p. 377.

27. C. Hagenbeck, *Beasts and Men*, pp. viii–ix; L. Hagenbeck, *Animals Are My Life*, p. 98; "The Hagenbeck Zoo," *Spectator* 112: 12; Livingston, *Zoo*, pp. 150–151; Leonard Robert Brightwell, *The* [London] *Zoo Story* (London: Museum Press, 1952), p. 177; Niemeyer, *Hagenbeck*, p. 255.

28. Toward the end of his life, Hagenbeck was planning to open a moated zoo in Berlin with the Kaiser's backing, but the project did not come to fruition. L. Hagenbeck, *Animals Are My Life*, pp. 134, 143–144; Bridges, *Gathering of Animals*, pp. 382–383, 387–388, 411–413; "Hagenbeck as Educator," pp. 491–492; Crandall, *Zoo Man's Notebook*, pp. 122–125; Fisher, *Zoos of the World*, pp. 164–167; Gersh, *Animals Next Door*, pp. 27–34; Brightwell, *Zoo Story*, p. 178; Scherpner, "Moated and Fenced Enclosures," pp. 57–62; Reuther, "Barrier Dimensions," pp. 217–222.

29. Edward P. Alexander, *Museums in Motion: An Introduction to the History and Functions of Museums* (Nashville, Tenn.: The American Association for State and Local History, 1979), pp. 110–115; Solly Zuckerman, "The Zoological Society of London," *Nature* 183, April 18, 1959: 1082–1084; Gersh, *Animals Next Door*, pp. 19–25; Livingston, *Zoo*, pp. 197–200.

30. Armstrong, "Hagenbecks," pp. 81–84; Gersh, *Animals Next Door*, p. 15; Niemeyer, *Hagenbeck*, opp. p. 176, p. 258.

31. *International Zoo Yearbook* 2 (1960): 133–134; 10 (1970): 191; 18 (1978): 260; *Carl Hagenbecks Tierpark* (Guidebook).

32. C. Hagenbeck, *Beasts and Men*, pp. 38–40; L. Hagenbeck, *Animals Are My Life*, pp. 36, 95, 210; Niemeyer, *Hagenbeck*, pp. 258, 260.

33. L. Hagenbeck, *Animals Are My Life*, pp. 238–241; *International Zoo Yearbook*, 2 (1960): 11; 4 (1962): 24–25; 6 (1964): 82–87; 7 (1965): 31: 11 (1969): 99–101.

34. Erna Mohr, "Carl Hagenbeck," *Neue Deutsche Biographie* (Berlin: 1965), 7: 487–488; Hediger, *Man and Animal*, p. 9; Armstrong, "Hagenbecks," p. 84; *International Zoo Yearbook* 18 (1978): 260; Niemeyer, *Hagenbeck*, frontispiece genealogical chart.

## SELECT BIBLIOGRAPHY

Armstrong, O. K. "The Hagenbecks and Their Animal Friends." *Reader's Digest* 61 (July 1952): 81–84.

Bridges, William. *Gathering of Animals: An Unconventional History of the New York Zoological Society.* New York: Harper and Row, 1974. 518 pp.

*Carl Hagenbecks Tierpark* [Wild Animal Park] [Guidebook]. [Hamburg: Carl Hagenbeck's Tierpark, 1979.] 32 unnumbered pp.

Carson, Anthony. "The Parrot Woman." *New Statesman* 54 (November 30, 1957): 724–725.

Chindahl, George L. *A History of the Circus in America.* Caldwell, Idaho: Caxton Printers, 1959. 279 pp.

Crandall, Lee S., in collaboration with William Bridges. *A Zoo Man's Notebook.* Chicago and London: University of Chicago Press, 1966. 216 pp.

Dembeck, Hermann. *Animals and Men.* Garden City, N.Y.: American Museum of Natural History, 1961. 390 pp.

Fisher, James. *Zoos of the World: The Story of Animals in Captivity.* Garden City, N.Y.: For the American Museum of Natural History by Natural History Press, 1967. 254 pp.

Gersh, Harry. *The Animals Next Door: A Guide to Zoos and Aquariums of the Americas.* New York/London: Fleet Academic Editions, 1971. 170 pp.

Hagenbeck, Carl. *Beasts and Men: Being Carl Hagenbeck's Experiences for Half a Century among Wild Animals.* Abridged Translation by Hugh S. R. Eliot and A. G. Thacker, with Introduction by P. Chalmers Mitchell. London: Longmans, Green, and Co., 1909. 299 pp.

"Hagenbeck, Carl . . . ." *Neue Deutsche Biographie*, 7: 487–488. Berlin: Duncker & Humblot, 1965.

"Hagenbeck as an Educator." *Review of Reviews* 44 (October 1911): 491–492.

Hagenbeck, Carl Heinrich. "Elephant Techniques at Hamburg Zoo." *International Zoo Yearbook* 2 (1960): 11, plates 15, 16.

——. "Notes on the Artificial Rearing of a Great Indian Rhinoceros . . . at Hamburg Zoo." *International Zoo Yearbook* 11 (1969): 99–101.

——. "Notes on Walruses . . . in Captivity." *International Zoo Yearbook* 4 (1962): 24–25, plates 4–5.

Hagenbeck, John. "An Elephant Kraal." *Living Age* 319, December 15, 1923: 509–514.

Hagenbeck, Lorenz. *Animals Are My Life.* Translated by Alec Brown. London: The Bodley Head, 1956. 254 pp.

"The Hagenbeck Zoo." *Spectator* 112, January 3, 1914: 12.

Hediger, Heini. *Man and Animal in the Zoo: Zoo Biology.* New York: Seymour Lawrence/Delacorte Press, 1969. 303 pp.

"Karl Hagenbeck." *Literary Digest* 46, May 10, 1913: 1091–1095.

Lewinsohn, Richard. *Animals, Men, and Myths: An Entertaining History of Man and His Animals Around Him.* New York: Harper & Brothers, 1954. 422 pp.

Ley, Willy, *The Lungfish, the Dodo, & the Unicorn: An Excursion into Romantic Zoology.* New revised and enlarged edition. New York: The Viking Press, 1948. 361 pp.

Livingston, Bernard. *Zoo: Animals, People, Places.* New York: Arbor House, 1974. 290 pp.

Manning-Sanders, Ruth. *The English Circus.* London: Werner Laurie, 1952. 359 pp.

Niemeyer, Günter H. W. *Hagenbeck: Geschicte and Geschicten* [History and Stories]. Hamburg: Hans Christians, 1972. 260 pp.

Shepstone, Harold J. "Carl Hagenbeck's Novel Zoological Park." *Scientific American* 95, November 10, 1906: 345–346.

———. "The Completion of Carl Hagenbeck's Zoological Park." *Scientific American Supplement* 64, August 10, 1907: 88–89.

———. "The Scientific Training of Wild Animals." *Scientific American* 87, October 18, 1902: 260–261.

———. "The Trade in Wild Animals." *Scientific American* 88, May 16, 1903: 376–378.

"The Snow Camel." *Spectator* 80, March 12, 1898: 373–374.

# 12

## Oskar von Miller
## and the Deutsches Museum:
## The Museum of Science
## and Technology

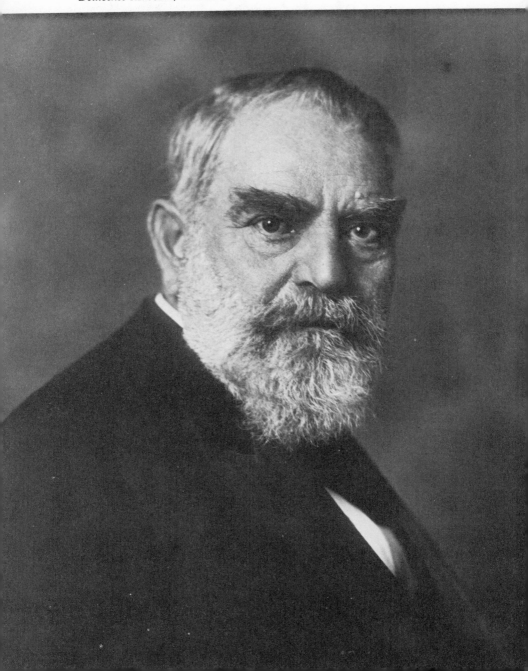

Fig. 32. Oskar von Miller (1855–1934), 1925. *(Photograph by Hillsdorf. Courtesy of the Deutsches Museum, Munich.)*

I

EGINNING IN the spring of 1891, the Frankfurt Electrical Exhibition attracted about one million visitors in a six-month period. Its well-kept grounds, buildings, and exhibits were crowded, and one could inspect historical German inventions such as the original Seemering telegraph of 1809, Reiss telephone of 1863, and Hertz radio apparatus, as well as the latest dynamos, motors, and other equipment made by the firms of Siemens & Halske, Schuckert, and Helios (Ganz & Company of Vienna). There was also plentiful entertainment—the grounds at night lighted by one million candlepower; a life-sized panorama of a transatlantic steamer entering New York harbor; lectures, pantomime, and ballet; music transmitted from the Munich Opera House two hundred miles away; and many convivial beer halls.

The most important feature of the industrial fair, however, for the electrical engineers who attended the Fourth International Electrical Congress held there in August, was the exhibit of incandescent lighting with one thousand bulbs of sixteen-candlepower and the one-hundred-horsepower motor that drove a centrifugal pump operating an attractive artificial waterfall about sixty-five feet high. The lights and motor were powered by three-phase alternating current transmitted over high-tension lines from a hydroelectric turbine at Lauffen, on the upper Neckar, some 110 miles away. The Lauffen Portland Cement Company lent the experiment one of its turbines, to drive a three-hundred-horsepower rotary current generator made by Oerlikon that produced fifty volts, stepped up by a transformer to sixteen thousand volts for transmission over three bare wires strung on porcelain oil insulators to Frankfurt and then reduced to seventy-five volts by another transformer. The experiment proved that power could be transmitted great distances safely and economically by alternating current at high tension and thus made feasible grid electric distribution networks that would serve large areas. (A diorama of the Lauffen power station, the original three-phase machine, and an oil insulator are exhibited at the Deutsches Museum in Munich today).[1]

Electricity was just coming into use in the last quarter of the nineteenth century. Both Thomas Alva Edison in the United States and Joseph Wilson Swan in England independently had perfected incandescent lamps about 1879, and central power stations were being constructed to

343

provide lighting and drive motors, while the battle of the currents (whether to use direct or alternating) was under way. In Germany, Emil Rathenau formed the German Edison Company for Applied Electricity in 1883. Years later, he explained why he sought the right to use the Edison patents in these words:

The Edison system of lighting was as beautifully conceived down to the very details, and as thoroughly worked out as if it had been tested for decades in various towns. Neither sockets, switches, fuses, lamp-holders, or any other accessories necessary to complete the installation were wanting; and the generating of the current, the regulation, the wiring with distributing boxes, house connections, meters, etc., all showed signs of astonishing skill and incomparable genius.[2]

As central generating stations developed, electricity slowly won out over illuminating gas, and incandescent lamps gradually replaced the arc lights used to illuminate city streets.[3]

The technical director of the Frankfurt Exhibition was Oskar von Miller. Born at Munich on May 7, 1855, he was the fourteenth and youngest child of Ferdinand Miller, a well known bronze founder later ennobled by the king of Bavaria for his fine artistic work. The father served on the Munich City Council, Bavarian Parliament, and German Reichstag. He championed cultural causes and wished to see German industrial arts outstrip foreign competitors, especially France. His large art bronze castings won him a gold medal at London's Crystal Palace in 1851, and he organized an exhibition of German and Austrian handicrafts in 1867 that combined old masterpieces and new inventions and had an Honor Court of great craftsmen and inventors. A compulsive worker himself, Ferdinand Miller demanded much from his children, and their mother Anna (von Pösl) von Miller was frequently called upon to mediate in their behalf. Oskar ended up with great admiration for both parents and spoke out for the women's movement and women's independence.

Oskar's secondary school record was not exceptional, and his mischievous pranks frequently brought him disciplinary punishments. He took little interest in classical subjects, though he excelled in mathematics. Later, he studied civil engineering, specializing in railroads, waterways, and bridges, at the Munich Polytechnium, from which he was graduated in 1878. He entered public service that dealt with building contracts and, within the next few years, visited the Conservatoire National des Arts et Métiers in Paris and the Patent Museum at South Kensington in London, then the two leading museums of science and technology in the world.[4]

The Conservatoire was created by the revolutionary national Assembly in 1794, to collect machines, tools, models, designs, descriptions, and books on arts and trades and to give explanations and distribute materials to the public on the construction and use of tools and machines. Its underlying purpose was to improve the artistic and industrial production of French workers, an aim advocated by Descartes in the previous century. The Conservatoire's collection began with the machines, models, and other materials made or acquired by Jacques Vaucanson (1709–1782), inventor and engineer, who exhibited them to the public beginning in 1775 and bequeathed them to the French government at his death. The collection was enlarged afterwards by the considerable holdings of the Academie Royale des Sciences, gathered since its founding in 1666. The Conservatoire in 1799 occupied the old Priory of St. Martin-des-Champs and in 1820 appointed three professors to give free public lectures on mechanics, chemistry, and industrial economy. By the time of Miller's visit, it was a mute museum, the collections crowded, dusty, and poorly lighted, and little attempt was made to interpret to visitors the great storehouse with its thousands of systematically arranged industrial objects. The well-informed observer, however, appreciated the outstanding rarities such as ornamental turning lathes from Peter the Great, materials on the development of the Jacquard loom, apparatus from Lavoisier's laboratory, and Daguerre's early photographic equipment. French displays from the world's fairs that began at London in 1851 were adding new materials to the collection, and industrial competition with Great Britain was increasing French official interest and financial support. The Conservatoire experimented with running some of its hydraulic exhibits with waterpower supplied by reservoirs in the tower of the Priory and with testing new machines by means of two steam engines that together produced thirty horespower. In the 1860s, 14 professors lectured each year to nearly 177,000 students, chiefly foremen, workingmen, and apprentices; and the conservatoire library contained 22,000 volumes on science and industrial art. One admiring Englishman thought that in "no place in the world can the student find so much solid information" or "the working artisan . . . read the models and profit by their teaching to become a better citizen and a more educated man."[5]

In London, the Patent Museum at South Kensington was then at a low point in its development. Its founder and chief energizer, Bennett Woodcroft (1803–1877), had retired in 1876, and its future status was uncertain. The Royal Society for the Encouragement of Arts, Manufactures and Commerce had held the first industrial exhibition in London (and proba-

bly in the world) in 1761 and had maintained an industrial museum for about ninety years before turning the collection over to Woodcroft, then professor of machinery at University College, London. Appointed to the Patent Office in 1852, Woodcroft brought books and three-dimensional objects with him to form the nucleus of the Patent Office Library and the Patent Museum. In 1857, he moved to the newly-opened South Kensington Museum, but quarreled with its director, Henry Cole, who insisted upon charging a sixpence admission fee to students on students' days. Woodcroft housed his library and museum in the Iron Building (popularly known as the "Brompton Boilers"), also occupied by several sections of the South Kensington Museum. The Patent Museum demonstrated its independence by its own separate entrance. Though the museum was overcrowded and abominably lighted, Woodcroft was a discerning collector of key equipment of the British Industrial Revolution. Miller saw there Watt's first pumping engine, "Old Bess," 1777; Watt's rotative "Lap Engine," 1788; Arkwright's cotton machinery, 1769–1780; Symington's marine engine, 1788; Bell's "Comet" marine engine, 1812; two locomotives—Hedley's "Puffing Billy" and Stephenson's "Rocket"; and much other early machinery. (1n 1883, the Patent Museum became part of the South Kensington (Victoria and Albert) Museum and then in 1909 separated as the independent Science Museum).[6]

Though the two industrial museums that Oskar von Miller visited were not well arranged and displayed by modern standards, their collections were extensive, and Miller, as a knowledgeable engineer, did not require much interpretation of the machinery and equipment. While he was appalled in London to find important locomotives and engines unlabeled in an open shack in a courtyard, he was deeply impressed to see how much had been saved, and he said later that he resolved then to found a museum of science and technology for Germany.[7]

Miller transferred to the Transportation Ministry at Munich in 1879 and persuaded his superior to send him in 1881 to the International Electrical Exposition and the First International Electrical Congress in Paris, where he examined with increasing excitement Edison's incandescent lamp and direct-current dynamo, as well as much European electrical equipment that included arc lamps, telephones, and motor-driven devices. (One of Edison's direct-current machines, 1879, shown at the exposition is today in the Deutsches Museum). At Paris, too, Miller inspected closely the Conservatoire's hydraulic engineering collection. All of this was an eye-opening experience for the young man that made him resolve to work in the new electrical engineering field and to investigate the application of

the abundant waterpower of the Bavarian Alps to the production of electricity.[8]

In 1882, Miller organized the Munich Electrical Exhibition, the chief feature of which was the transmission of electrical energy over an experimental line of telegraph wire from Miesbach to Munich, a distance of about thirty-five miles, to drive a centrifugal pump that operated a waterfall about six and one-half feet high in the Munich Glass Palace. At that time, many authorities doubted whether electric power could be transmitted farther than one thousand meters, but Marcel Depréz, the French engineer, insisted that it was possible, theoretically, and Miller proved him right. (The Miesbach direct-current dynamo and the motor that powered the waterfall are in the Deutsches Museum). The Munich experiment was not so successful or well known as the later Frankfurt one. At Frankfurt, a panel of engineers watched, as thirty thousand volts of three-phase alternating current were sent over the lines and found that 72 percent of the power was delivered from Lauffen, while only 22 percent had been transmitted by direct current from Miesbach to Munich. Miller's Frankfurt experiment was a sensation in the engineering field, and professional men from all over the world and especially from the United States flocked to Frankfurt to see with their own eyes the first important breakthrough in long-distance power transmission. It helped prepare the way for the successful commercial line twenty-seven miles long between Niagara Falls and Buffalo in 1896. And Frankfurt established the reputation of Oskar von Miller as a daring and yet dependable electrical engineer.[9]

In 1883, Miller visited France, Britain, and the United States to study their electrical development. He formed a warm friendship with Edison, met Henry Villard and other railroad magnates, and visited the Patent Building in Washington, with its numerous models. Upon Miller's return, Emil Rathenau urged Miller to join him, at a salary of twenty thousand marks (four thousand dollars) and a share of the profits in the German Edison Company, to design and build central power stations for Berlin. Miller, always fiercely loyal to Munich, was reluctant to leave there, but he could not persuade his superiors to back his plans for developing Bavarian waterpower, and his salary was only fifteen hundred marks.

In 1884, too, Miller, a Catholic, dared to wed Marie Seitz, a Lutheran, in an ecumenical ceremony; the happy union lasted almost fifty years and produced seven children.

Miller finally took a two-year leave of absence to go to Berlin. There he proved himself ingenious and forceful at solving technical problems. He

designed central stations for what then was the largest electrical generating system in Europe. Rathenau furnished distinguished leadership to expand his firm in 1887 into the Allgemeine Elektricitäts Gesellschaft (AEG), a great holding company that became one of the leading electrical manufacturing organizations of the world, and the Berliner Elektrizitätswerke, a major utility company. Though Rathenau begged him to remain with the company, Miller thought that most of the technical problems had been overcome, and he was not at all interested in working on the financial side. Even with a tenfold cut in salary, he preferred to return in 1890 to Munich, where he formed his own consulting engineering firm.

Miller's consulting business soon was thriving; he came to employ about thirty engineers and built electric plants for cities in Germany and abroad. Though he prospered moderately, he did not wish to become a very rich man, for he feared that too much money might spoil his children. His greatest triumph was the building of a co-ordinated electrical grid for Bavaria, one of the first such constructions in the world. It combined hydroelectric and fossil-fuel plants into a unified transmission system under state authority that supplied all Bavaria with power and light. As Thomas P. Hughes has pointed out, Miller was much more than the usual engineer; he was indeed an engineer-entrepreneur who successfully introduced technical change and innovation into the industrial and social fabric of his day. In solving economic and technological problems, he did not fail to consider the ecology, landscape aesthetics, social values, and political and institutional factors.

In 1909, the Prince Regent of Bavaria named Miller to the upper house (Reichsrat) of Parliament and made him Commisssioner of Electrical Development. Miller proved to have the faculty of making technological problems clear to the ordinary legislator, to be an effective debater and a magnetic leader. Though World War I delayed his plans, Miller was appointed State Commissioner by the new republican Bavarian government in January 1919, to erect the Walchensee (Walchen Lake) power works and a Bavarian distribution network. Miller argued that these projects would employ many returning soldiers and that electrification would improve greatly the life of Bavaria's predominantly rural population. The Walchensee generating plant, situated on the Kochelsee, about six hundred feet below the Walchensee, would power the state-owned railroads and furnish current for the general system at peak periods. Streams flowing into the Walchensee were carefully controlled and sometimes operated subsidiary generating plants. The grid itself came to cover all Bavaria and included plants owned by the state, municipalities, and

private companies. Though Miller had to make some compromises that he considered unwise, the Walchensee works (which he regarded as his contribution to his homeland and for which he refused to take any personal commisssion) and the Bavarian distribution system were in operation in 1924 and have continued to function effectively ever since.

Miller continued his engineering career to the day of his death at almost seventy-nine. Even as late as 1930, he submitted a plan to the German government to provide a unified grid for the whole country. Electrical engineers such as Miller made Germany a world leader in that field. In electrical manufacturing, for example, Germany was second only to the United States and that by a small margin. On the eve of World War II, Rathenau's AEG and the Siemens-Schuckert combine were especially versatile and effective, and the German exports of electrical equipment were the largest in the world, two and one-half times as great as Britain's and about three times those of the United States.[10]

Oskar von Miller was a powerful personality. He was tall, massively built, and bearded, with a leonine appearance and sharp, eaglelike glances. Fond of athletics, he engaged in mountain climbing, hiking, bicycling, and touring by automobile. Even in old age, he could tire men twenty years younger who tried to keep up with him. An inveterate traveler, he went around the world in his seventies and then visited the Soviet Union to observe communist technology. He was not much interested in theory, but delighted in detailed analysis, practical experimentation, and problem-solving. He took every task seriously and, when serving on boards, was the first to arrive, in command of the smallest details, and full of suggestions, some of them likely to be frank and disturbing. He liked to think that he possessed his father's traits—simplicity, gaiety, patriotism, open-mindedness, a deep sense of duty and responsibility, loyalty to family, and love of craftsmanship. Miller was the last to leave a party and delighted in entertaining openhandedly in his big house at Ferdinand-von-Miller Platz or at his villa just outside Munich on Sternberger See. He was people-oriented, rather than desk-bound, believed his best thoughts came out of conversations, and found that problems often were solved more satisfactorily, not in official meetings, but in his own living room. In short, he was energetic, enthusiastic, imaginative, forceful, persuasive, even charismatic.[11]

## II

In 1903, Miller was chairman of the Bavarian chapter of the Society of German Engineers that was to hold its annual congress at Munich in June.

In characteristic fashion, he determined to give the society something positive and practicable to consider. He invited carefully chosen representatives of the German Empire, the State of Bavaria, the City of Munich, engineering and scientific institutions from throughout Germany, and major German industries to meet in advance at the Bavarian Interior Ministry assembly room in Munich on May 5 and presented to them a detailed plan for forming a Deutsches Museum von Meisterwerken der Naturwissenschaft und Technik (German Museum of Outstanding Achievements in Natural Science and Technology). At the meeting, he mentioned the two similar museums in Paris and London and declared that the Deutsches Museum's purpose would be to show the development of science and technology and to give a vivid history of the influence of invention and mechanical progress upon human society; instruments and machines would be collected and a pantheon or Hall of Fame arranged to contain likenesses of outstanding leaders of science and technology. The museum was to serve all Germany and would seek the support of governments, industries, universities, scientific and professional organizations, and individuals. The meeting accepted the concept by acclamation, and Miller immediately persuaded the state and the city to give the museum a temporary home in the old building of the Bavarian National Museum on Maximilianstrasse (and later to add the Isar dragoon barracks), and George Krauss, a manufacturer of locomotives, subscribed a hundred thousand marks as endowment for the new project. A completely organized museum, with constitution, and Crown Prince Ludwig as royal patron, was presented in June to the engineering congress, which enthusiastically adopted Miller's plan.[12]

Miller set to work at once to obtain a collection. The museum's honorary administration, headed by the German chancellor, included the German minister of the interior and the Bavarian minister-president and minister of education. Its Board of Directors or Advisory Council in 1913 numbered 102, of whom 63 were appointed by the German and Bavarian governments and 39 by a General Committee of 575 members composed of leaders of German science, technology, and industry. The board of directors met yearly, and general committee members were consulted individually in developing museum exhibits and securing financial support. The real power of the organization lay in a small executive committee of only three members—Miller as president, a Bavarian privy councilor, and a University of Munich professor; Miller believed strongly in keeping the direction of the museum in his own hands. Carl Duisberg, the founder and general director of I. G. Farben and a later chairman of the

museum board of directors, affectionately said that one could become Miller's friend only by holding strong opinions and squabbling with him and that Miller's unwritten rule at the museum was: "Here, everyone may do what I want." His staff of about thirty-five professional employees— department heads, engineers, architects, technicians, and draftsmen— recommended accessions to Miller for approval, and he consulted the general committee to find where original objects could be obtained and how models and other exhibit material could be fabricated.[13]

The new preliminary museum opened on November 13, 1906, with the German emperor and the Prince Regent and Crown Prince of Bavaria participating in the ceremonies. Miller always enjoyed celebrations and tried to involve the whole city in them. The museum in its temporary quarters, the site of the permanent building, and the landmark Isator nearby all took on festive decorations. (Even the annual meetings of the museum board were accompanied by numerous lighthearted parties and often with civic festivities; Miller thought that this approach kept the museum and its administration democratic). The new museum had fifty-six rooms on three floors devoted, with typical German system and thoroughness, to geology, mining, metallurgy, hydraulic motors, steam engines, land transportation, motors, astronomy, geodesy, mathematics, mechanics, optics, heat, acoustics (with an extensive collection of musical instruments), electricity, telegraphy, the telephone, drawing and paint-ing, writing and printing, photography, horology, textiles, agriculture, dairying, brewing and distilling, chemistry, hydraulic engineering, inland navigation, canals, naval architecture, library and collection of plans, and court of honor. These subjects, properly subclassified, con-tained a wealth of full-scale original materials and models, many of which the visitor could operate by pressing a button or turning a crank. They included Siemens's first electric mine locomotive, 1881; the first Diesel engine of 1897; an old Romanian waterwheel similar to that described by Leonardo da Vinci next to several historic German turbines; exact copies of the "Puffing Billy" and "Rocket" at South Kensington; automobiles by Benz, 1885, and Daimler, 1886; the original apparatus used by Fraunhofer, Helmholtz, Kirchoff and Bunsen, Ohm, Ampère, and Röntgen; laborato-ries of a sixteenth-century alchemist, of the eighteenth century, of Liebig, 1839, and of the present; and portaits in oil, bas reliefs, or busts of prominent German scientists and inventors. After the museum had been opened, the celebrities moved to an island in River Isar to break ground and lay the cornerstone for the new permanent building; the site, for-merly used as a coal dump, was the gift of the city of Munich.[14]

Miller later put down some of his general ideas on the administration of the museum in a piece on "Technological Museums as Centers of Education" that he wrote in 1929. He divided the collections into about forty subjects, under the general headings of science, transportation, and industry. Each subject was to be developed from the earliest beginnings to the present, with historical objects where possible. There were to be models that could be touched, many of them to be put in motion. Certain commemorative exhibits would honor great scientists and inventors. Trained interpreters were to be available to explain each area. The museum must reach the largest possible audience; it was to be open for many hours and at times when people could visit it; entrance fees must be kept low so as not to impede visitation; and exhibits should be made understandable through printed labels, catalogues, and oral interpretation. Finally, since science and technology were advancing so rapidly, and unlimited expansion of the museum was impossible, the collections should be reviewed periodically to meet changing conditions, pare down antiquated holdings, and make room for new objects.[15]

Miller was adept at raising money for his museum; he insisted that it was not exclusively a Munich or a Bavarian institution, but represented every part of the German population, and he obtained ready support from central and northern municipalities, industries, and shipping companies. He enjoyed his reputation as "the biggest highwayman and sturdiest beggar in Christendom." Miller and Kaiser Wilhelm had a good-natured tiff at breakfast, before the emperor laid the cornerstone in 1906. Miller had persuaded the Kaiser to give a cutaway steamship model as his gift for the occasion, and Wilhelm remarked to the Bavarian Prince Regent: "Today I can be proud, that Miller not only praised me, but was even satisfied with me," and, in talking of the construction of the model, added that he hoped "there are some people in the German Empire who can make something good enough for the Deutsches Museum." Miller then surprised him by saying that the model, at a 1:20 scale, would be as long as the room they were in and would cost between 80,000 and 100,000 marks. Another, probably apocryphal, story relates that a train on which Miller was riding in Mexico was held up by robbers. As they were emptying everyone's pockets, their chief asked Miller whether he was *the* Miller from Munich, and when he assented, the robber assured him they never stole from colleagues.

The German, Bavarian, and Munich governments, as well as the German industrial establishment, contributed $1.4 million, about one-half the cost of the new building, and industry gave materials or furnished

them at cost, labor charged no overtime, and the railroads provided free transport for building materials. So far as running expenses went, in 1913, of a total budget of about $58,000, $33,000 came from the empire, Bavaria, and the cities of Munich, Hamburg, and Berlin, as well as from various industries and their associations or foundations; $12,500 from membership dues; and $12,500 from admission fees and publications sales. This strong support of the museum by government, industry, and the general public has continued to the present day.[16]

The new building of reinforced concrete was nearly complete in 1913, but war followed by revolution and inflation delayed its opening until May 7, 1925, Miller's seventieth birthday. During a week of festivities, the city was decorated by the artists of Munich, and one day was observed as a public holiday, with a grand parade. After the annual meeting of the museum board of directors, a dinner for eighteen hundred German and foreign guests was held in a great hall of the museum, left unfurnished for the occasion, accompanied by speeches, folk dancing, dramatic skits, and singing; the affair lasted for four hours. On May 7 itself, students from the university, in their colorful uniforms, escorted the guests; a festive pageant by Gerhart Hauptmann, Germany's leading poet and Nobel Prize laureate, was presented by actors from the City Theatre, lunch was served in another museum gallery, and, after a few more speeches, staff members conducted the guests through the huge building, the exhibits of which stretched lineally for about seven to eight miles.[17]

Miller followed the examples of the Conservatoire in Paris and the Science Museum in London in making his museum a chronological encyclopedia of the history of science and technology, for he admired meticulously classified original machines and equipment. Still, he introduced many innovations. Doubtless spurred by his experiences with conducting electrical expositions, he was determined that his museum would serve not only the scientist and the engineer, but also the general public and especially its younger segment. He hoped, too, that the museum could make understandable natural laws and basic scientific concepts such as matter and energy and the ways in which they were adapted by technology. Exhibits were to be devised to clarify the underlying theories and yet convey the variety and excitement of a world's fair. Thus, Miller would use experimental demonstrations, sectioned working models, dioramas, period interiors, diagrams and charts, labels, cartoons, mural paintings, and any other devices that would supplement original historical machines and objects and communicate concepts and ideas forcefully and effectively. Especially popular were exhibits activated

Fig. 33. Casting of aluminum. Demonstration at the Deutsches Museum. (*Courtesy of the Deutsches Museum, Munich.*)

either by staff members, as demonstrators, or by the public itself, that pressed buttons or turned cranks to set them in motion and even performed simple experiments. Miller avoided glass cases as much as possible, and his attendants were chiefly demonstrators and interpreters, rather than guards. An early commentator on the museum grasped Miller's aims well when he wrote that, while the Deutsches fulfilled Huxley's definition of a museum as a "consultative library of objects" for the engineer and man of science, yet "it is something more . . . an efficient agency for the enlightenment and education of the masses."[18]

Miller was the kind of strong personality who stubbornly set himself the task of making his new temple of technology intelligible to the ordinary man and woman. He considered himself a layman in nearly all fields of science, and he demanded, of himself and his staff, exhibits that would make the laws of science and the wonders of technology clear to the layman. And even when exhibits finally satisfied him, there was the problem of lucid and concise labels and also of popular lectures that dispensed with the scholarly jargon of scientists and curators. Miller pored over such texts and often returned them to staff writers because they were too scholarly. This driving, dedicated personality was no simple schoolteacher, but rather an inspired interpreter of science and technology who wanted to teach and instruct, yes, but also to captivate, hold spellbound, and fulfill.[19]

A spectacular example of the way Miller used museum materials is shown in the field of astronomy. There were the usual celestial globes, sundials, astrolabes, quadrants, sextants, small telescopes, and other equipment, including the original instruments of Tycho Brahe, the Danish astronomer whom Rudolph II brought to Prague. Then there were two operating telescopes in observatories on the roof—Fraunhofer's refractory one of 1838, with which he discovered Neptune, and a reflecting instrument by Goerz of 1914. Most popular of all were two planetariums. One, installed in 1913, showed the solar system as Copernicus conceived it, with the sun in the center. It occupied a circular room about forty feet in diameter, with electric lamps suspended from above around the side of the room representing the planets and their satellites, out to Neptune; a carriage conveying one person at a time traced the earth's annual orbit. The observer viewed the "planets" through a periscope, and it took about twelve minutes to complete a "year's" circuit. (This exhibit was destroyed in the 1944 bombing). The other, the first modern optical planetarium, built in 1923 at Miller's request and according to his general ideas, was the invention of Dr. Walther Bauersfeld of the Carl Zeiss company of Jena. With the observer stationed on the earth, it projected on the ceiling of a hemispherical dome thirty-three feet in diameter optical images of many of the forty-five hundred fixed stars and showed the proper movements of the sun, moon, and planets, compressing the sidereal day of nearly twenty-four hours to four and a half minutes, two minutes, or even fifty seconds. Since that time, this kind of planetarium has become a popular exhibition device in many natural history and science museums throughout the world. The observatories and planetariums of the Deutsches Museum required professional operators, but

the public itself could use astrolabes, quadrants, and sextants to make observations.[20]

This sense of participation by the visitor was all important for the technical museum and a great contribution by Miller to the exhibition techniques of all museums. Especially effective were full-scale exhibits that appealed to the visitors' senses. One could inspect the interior arrangement of a locomotive from a cutaway, full-scale model or could walk through the staterooms of an ocean liner. One could listen to some of the large collection of historical and exotic musical instruments as played by a skilled musician. One could descend dimly lit stairs to the coal, salt, or metals mine, with its crouching, realistic figures in the cramped drifts. No wonder that eight-year-old William Rosenwald, son of the head of Sears, Roebuck in Chicago, found the exhibits fascinating in the old Bavarian National Museum building in 1911; by pushing buttons or working levers, he could do all sorts of exciting things—see the bones of his hand on an X-ray screen, generate static electricity, observe pistons traveling back and forth in an engine with its cylinders exposed, or make the wheels of a gigantic locomotive spin. When at age twenty-three he visited the new building of the Deutsches, he was still fascinated and wrote a friend:

One walks through entire life-sized mines of all sorts containing machinery run by attendants. They have an automatic screw-machine which manufactures tiny souvenir brass kegs. In the basement, they have the U-1, a submarine completely cross-sectioned . . . . The apparatus is always so designed that the visitor may use it himself.[21]

H. W. Dickinson, a keeper in London's Science Museum and a founder of the Newcomen Society, said that Miller

introduced so much that was novel in museum technique that he may be said to have changed fundamentally the attitude of the general public towards museums from looking at them as institutions remote, incomprehensible, even comatose, to regarding them as places that are living, stimulating and close to "men's businesses and bosoms."[22]

In accord with his plan to appeal to both scholars and the general public, and despite the stresses of war, revolution, inflation, and economic depression, Miller provided for two other buildings that contained a library (1932) and a conference center (1935). The library, connected with the main building by a courtyard, has come to contain more than 600,000 scientific and technical books, as well as drawings, plans, films, and photographs. The large auditorium in the conference center seats twenty-

Fig. 34. Replica of coal mine, upper Bavaria, about 1900. Exhibit at the Deutsches Museum, Munich. *(Courtesy of the Deutsches Museum, Munich.)*

six hundred, and there are three smaller meeting rooms. Miller arranged lectures or other presentations for the public or special adult and student groups. As a part of classroom work, every Munich school boy or girl more than ten years old visited the museum at least once a year. Science teachers attended a one-week course to learn how to use the museum's holdings, and a special fund brought six hundred to eight hundred students and apprentices aged seventeen to twenty from all over Ger-

many to spend a week at the museum. Miller also appealed to scholars in other ways than through the collections and library. A publication program issued valuable books and articles on technology. Miller founded an Agricola Society, in honor of Georgius Agricola, the sixteenth-century German metallurgist, and brought out a modern translation of his *De re Metallica* that, incidentally, used as a model the English version done by Mr. and Mrs. Herbert Hoover in 1912. A periodical, *Abhandlungen und Berichte* (Essays and Report), was begun in 1929 and appeared several times per year.[23]

Miller won many honors in his life, both as electrical engineer and museum innovator. He received an honorary doctorate in 1925 from his alma mater, now the Munich Technical University. He was chairman in turn of the Bavarian and National Union of Engineers, a founder of the Research Institute of Hydraulic Engineering and Power, and honorary president of the World Power Conference, as well as a founder of the Academy of Science and Technology. Not only did he serve in the Reichsrat, the upper house of the Bavarian Parliament, but he was a member of the German delegation to the Versailles Peace Conference at the end of World War I. As a rule, however, he turned down prestigious posts unless he thought he could work actively in them to produce worthwhile results.

Dr. von Miller resigned as president of the Deutsches Museum at the annual meeting of the board of directors in May 1933, because, he said, of advanced age and failing eyesight, but also, doubtless, because of his discomfort with the rising National Socialist regime of Adolf Hitler that ran contrary to Miller's strongly held beliefs in internationalism and world peace. Within the year, he was dead, on April 9, 1934, and received a state funeral in the museum's Court of Honor.[24]

## III

Miller's philosophy and plans for the Deutsches Museum have continued to live, and the Deutsches remains one of the world's pre-eminent museums of science and technology. During World War II, direct bomb hits in air raids of July 1944 destroyed a wing of the museum and about 20 percent of its irreplaceable objects, but the building loss has been made good, other relevant objects have been obtained, and many damaged exhibits have been redone. According to Professor Hermann Auer, the museum's scientific director from 1948 to 1971, the Deutsches now attempts to do two main things: (1) to explain the nature of the universe and the natural laws that govern it, from elementary particles through

Fig. 35. The Deutsches Museum, Munich, 1977. From the air, a panoramic view of the three buildings of the Deutsches Museum. *From bottom:* museum, library, and conference center. *(Courtesy of the Deutsches Museum, Munich.)*

atoms, molecules, crystals, planets, and fixed stars to distant spiral galaxies, and (2) to show how man uses technology to adapt matter and energy to his needs. The ideal layout of the museum can be conceived as a central circle with concentric rings. The material elements of the universe and their interrelationships with energy would occupy the circular central hall; around it, the inner concentric circles of physics and chemistry

sections would interpret the natural phenomena; and outside them would lie other concentric circles of the technological exhibits. A visitor could study matter and energy by concentrating on the center or could see each of the other sections by walking around the concentric ring. The basic natural laws upon which a technology rested would be apparent as one went outward from the center, and any particular technology could be analyzed by walking inward from the outer circle. Some adjustment of the circle concept was required at the Deutsches because, while the inner circle and concentric physics and chemistry rings were approximately arranged on the same floor, the technological rings needed to occupy floors above and below. The whole scheme retained the three simpler divisions into which Miller, years before, had divided technology—raw materials, energy, and information.[25]

In pursuing the two purposes of explaining both science and technology, the Deutsches Museum differs from most technical museums that make little attempt to elucidate the scientific principles underlying technology but are content to portray and analyze only the technology itself— how a space rocket operates or an atomic reactor or a laser beam or a computer. The Deutsches Museum from the beginning, in addition to showing historical machines and equipment, was the first to emphasize the manner in which technology worked by means of vivifying exhibits, but it went on to become a true science museum, striving to explain the connections between the exact sciences and technology, between pure scientific research and technological application. Most other technical museums concentrated on technology alone and played down and neglected both historical development and scientific law; they were science/technology centers rather than broad-based museums.

By 1948, the Deutsches Museum had recovered from damage that took place during World War II and was fully open again. Attendance climbed rapidly and today has reached 1.5 million yearly, more than half of it young students; the staff now numbers 370. While its learned technical journal continues, in 1977 a new quarterly magazine, *Kultur & Technik*, was designed, with many illustrations and much color, for the six thousand members of the museum. A Research Institute for the History of Natural Sciences and Technology (1963) was housed at the Deutsches and united this kind of research activity of the museum, Munich Technical University, and the University of Munich. Miller's program of bringing in teachers and students for study and preparation for class visits was enlarged and strengthened in the 1970s by the formation of the Kerschensteiner Kolleg with housing, classrooms, and courses for German

and foreign teachers, museum colleagues, students, and scholarship holders. Construction of a new museum building to house the Department of Aeronautics and Astronautics was begun in 1978, with its opening scheduled for 1983.[26]

Miller would rejoice to see that his flexible approach toward exhibition continues to flourish at the Deutsches in one of his favorite departments, now known as Heavy-Current Electrotechnology. It received a direct hit in a World War II air raid but was reopened in 1957 in two large rooms in a more prominent position on the ground floor. Pioneer dynamos used to produce direct, alternating, and three-phase current are on view, and busts of Delivo-Dobrowolsy, Edison, Siemens, and other electrical pioneers grace the niches in the walls. Siemens's first dynamo of 1866 and some of the equipment used by Miller in his Miesbach-Munich and Lafflen-Frankfurt experiments are shown, as well as scale dioramas of Edison's New York Pearl Street central station of 1882 and Miller's Cafe Bauer one in Berlin of 1884. Visitors may press buttons to see how direct and alternating currents function and how electrical power is converted into mechanical and chemical energy, or into heat and light. Modern machines and paraphernalia, full-scale or models, are contrasted with historical examples nearby. Spectacular demonstrations of high-tension equipment take place several times daily; a surge generator, built by Haefely of Zurich, produces a charge of 1.1 million volts and man-made lightning flashes two meters long that will split a piece of wood or vaporize a wire. This demonstration also shows how a building can be protected against lightning.[27]

The exhibits of a technical museum differ from those of other types of museums in that many of them are constructed or adapted by the museum staff or contributing industries, to show how something works. Sometimes an original machine or piece of equipment can be activated by the observer; sometimes sections are cut away to reveal what goes on inside; sometimes working scale models are constructed; or sometimes simple experiments of physics and chemistry are devised that the observer may perform by touching a button. Early visitors to the Deutsches were surprised at the great amount of machinery and paraphernalia unprotected by glass cases and left open to the public. Today, a change in the attitude of the public and especially of some teen-agers and young adults has made the museum tighten its former permissive attitude. Professor Auer believes, somewhat bitterly, that the reverence of the public for the creations of great men seems to have been disappearing, and it can no longer be assumed that museum goers will operate

Fig. 36. Faraday's Cage demonstration. Visitor being locked into cage to show the cage's effectiveness as a protective shield against high-voltage electricity. (*Courtesy of the Deutsches Museum, Munich.*)

unprotected apparatus so as to avoid accident to themselves or damage to the equipment. He finds that

many visitors, particularly young people, obviously care much less about acquiring knowledge by exercising their intelligence than about the enjoyment and amusement to be got out of brainless "playing about" with the apparatus. A tendency displayed by many visitors to indulge in unrestrained and even aggressive behaviour has unfortunately made it necessary to replace the three-dimensional and accessible models of experiments which it was previously customary to provide, allowing the visitor to "take a hand" in the process himself, by automatic, and often complicated, equipment, viewed at a distance through glass panels and producing its effects at the touch of a knob.[28]

Some critical observers have found the Deutsches Museum today too traditional and too concerned with objects, engineers, scientists, industrialists, and engineering achievements, but hardly at all with ordinary people. Technology cannot be blindly accepted, argue others, as sure to bring human progress; explanations of technical processes should not neglect to consider social matters such as starvation wages, miserable working conditions, and crippling or fatal accidents. Portraits of great engineers, making machinery move, working models, and audiovisual aids are not enough. The big problem is to infuse the museum with genuine humanity. Such critical carping may or may not be right. It makes us realize, however, that no matter how well Oskar von Miller understood the social milieu of *his* day, conditions have changed since then. Still, the institution he founded appears intrinsically strong, and remains flexible enough to continue to serve both the scientific and the industrial establishment and the general public as he had planned.[29]

IV

The Deutsches Museum, then, developed a new kind of museum that had three chief characteristics. First of all, as the Conservatoire des Arts et Métiers and the Science Museum had done before, it presented a historical panorama of important machines and processes that illustrated the development of industry and technology. These objects, combined with an excellent library and conference facilities, were of special interest to the engineer, the industrialist, and the workingman who could apply to their daily rounds the understandings gained from observation and analysis of such material. The second purpose of the museum was to explain how technical devices worked by means of participatory exhibits, visitor-activated experiments, and staff-conducted demonstrations. This func-

tion was largely a new one for the technical museum and was directed at the general public and especially at students and other young people. In the third place, the museum aimed to present, chiefly for the general public but also of interest to scientists, the basic scientific composition of the universe, from microcosm to macrocosm, and the natural laws from the application of which technologies developed.

The success of the Deutsches Museum with both the scientific and the industrial community and the general public was soon communicated to the tourist and museum worlds and influenced greatly the development of technical museums elsewhere. Today, there are about twenty such museums in Europe, thirty in the United States, and a scattering in other places. Near at hand to the Deutsches was the Technisches Museum fur Industrie und Gewerbe (for Industry and Trades), opened at Vienna in 1918 and closely patterned on the Deutsches. Its collections went back to the Industrial Exposition held at Vienna in 1873, and the museum's founding was a chief feature of Emperor Franz Joseph's Jubilee of 1908 that commemorated his sixty-year reign. The museum occupied a well-planned building illuminated by natual light, divided into large flexible spaces, and equipped with abundant outlets for electricity, water, and gas. The exhibits were both historical and technological—full-scale or models, many of them skillfully activated. Other facilities included a technical library and an auditorium seating 300, with demonstration table and projection facilities. Lectures and motion pictures were offered to the public each week, and every Viennese schoolchild between eight and fourteen years old visited the museum annually. The Austrian government supported and controlled the museum, though the city of Vienna and the Society for the Promotion of the Museum had representation on its thirty-one-member Kuratorium and nine-member Board of Directors. There was also a large Advisory Council that could be called on for technical advice in adding accessions. Unfortunately, despite its first-class historical collection and a well-conceived building, the museum has not received proper financial support. In the period between World Wars I and II, its staff was cut from 107 to 37 members, and its collecting slowed.[30]

The two oldest technical museums also were influenced by the Deutsches Museum. The Science Museum of London, reorganized in 1909 as an independent institution, gave close attention to the innovations being made at Munich. Even as early as 1890, while it was the Division of Machinery and Inventions of the South Kensington Museum, with William Isaac Last as keeper, it determined to make itself a living museum

that would emphasize the educational function. It was moving in the same direction as the Deutsches and later went on to increase the number of its exhibits that could be activated, established a popular Children's Gallery in 1931, and instituted special exhibits (about three yearly) on topics of contemporary interest, such as noise and smoke abatement, X-rays, television, and atomic energy. Scientific organizations and industries helped the Science Museum stage these shows, and it sent traveling exhibits to museums, libraries, and other educational institutions throughout Great Britain.[31]

France was slower to follow the example of the Deutsches, but the Palais de la Découverte was opened in Paris at the International Arts and Techniques Exhibition of 1937 and attached to the University of Paris. The Palais contained little historical material and was actually a science center devoted to instructing the general public and school groups in the fields of mathematics, astronomy, physics, chemistry, biology, and medicine. Visitors might use scientific equipment such as microscopes, closed-circuit television, and a large computer. Skilled demonstrators conducted experiments and explained new devices and processes as well as the natural laws and scientific theories behind them. There was a large and excellent Zeiss planetarium. Biological and geological excursions and visits to laboratories and research centers were arranged. Individuals might engage in simple experiments or observe animated ones and attend demonstrations.[32] The Conservatoire National des Arts et Métiers, the oldest technical museum and probably the richest in historical materials, about 1960 began to hold special exhibits on subjects of current interest—for example, on robots, the motor car, space exploration, the Paris electrical network, and the aerotrain. It established an educational service and a young technicians' club. Today, the plan is to move both the Palais de la Découverte and the Conservatoire to a functional building in the Paris suburbs under the aegis of the French Ministry of Education.[33]

Another European technical museum that emphasized the explanation of technology to the general public but had a considerable collection of historical materials was the Tekniska Museet of Stockholm. Collecting for this museum was begun in 1924 by the Academy of Engineering Science and individual engineers and collectors. A private donation of 2 million kronor (about $680,000) made possible the erection of a building with clean modern lines on a site provided by the Swedish government, overlooking Skansen and Nordiska Museet. In 1933, the World Power Conference, of which Oskar von Miller was honorary president, met in Stockholm, and Dr. Miller and several other technology museum experts

inspected the site and plans. The group was impressed by Miller's grasp of detail and numerous helpful suggestions, as well as "by this remarkable old man's personality and enthusiasm"; he was to have laid the cornerstone the next year, but his death intervened. The museum opened in 1936, its Machinery Hall containing the beam steam engine (designed by Samuel Owen, an Englishman from the works of Boulton and Watt) that had worked at the Höganas coal mine from 1832 to 1904, and numerous other original machines. The museum also had an outstanding collection of models, including some built as early as 1697 by Christopher Polham of Stockholm, an experimental laboratory in which was developed the sulfite process of manufacturing wood pulp into paper, a replica iron mine 125 feet long, and a hall of fame with busts of leading Swedish inventors. The power, heating, ventilating, and elevator machinery of the building was on display, and the refreshment rooms on the top were surrounded by a terrace, from which there was a fine view of Stockholm and upon which ancient automobiles sometimes were driven on festive occasions. Ingenious exhibits included an "atomarium" demonstration of nuclear physics, based on planetarium techniques, with the viewers comfortably seated. A multifaceted school program worked closely with the Swedish school system and offered special opportunities to honor students; it employed exhibits, lectures (some by leading scientists), films, closed-circuit television, and prize competitions for young researchers.[34]

Miller's innovations in the technical museum field naturally were of much interest in the United States, that land so devoted to technology and so proud of its multitude of inventors. The Smithsonian Institution, which received some forty freight-car loads of natural and man-made materials from the Philadelphia Centennial Exposition of 1876, built a new red-brick National Museum (today the Arts and Industries Building) to house these and other varied objects and clutter. Through the years, however, art, natural history, historical, and technological collections were sorted out and housed in separate buildings that today include the National Museum of American History (1964) and the huge National Air and Space Museum (1976). Both of these institutions possessed historical materials and curatorial staffs, so that they might be placed with the Conservatoire des Arts et Métiers/Palais de la Découverte, the Science Museum, and the Deutsches Museum as leading institutions that combined the historical, popular technological, and scientific approaches.[35] Another United States museum with vast but somewhat uneven historical collections in the technological field was Greenfield Village and the Henry

Ford Museum, opened by the automobile pioneer at Dearborn, Michigan, in 1929. Ford knew Miller well, welcomed him to Dearborn in 1925, visited the Deutsches Museum five years later, and presented it with a brand new Ford for exhibition. This museum recently has begun to rearrange its technological materials, especially rich in the power machinery and transportation areas, in more coherent fashion, with outstanding examples well displayed and interpreted in an eight-acre Hall of Technology and numerous other objects placed in safe storage but accessible for research.[36]

The American museum most influenced by Miller and the Deutsches Museum, however, was the Museum of Science and Industry in Chicago. Julius Rosenwald, head of Sears, Roebuck and Company, visited the Deutsches that his young son found so fascinating, in its old temporary building in 1911 and came under the spell of the magnetic von Miller. Rosenwald pushed hard for great industrial museum for Chicago, and the Museum of Science and Industry was incorporated in 1926. Rosenwald gave it three million dollars at the start (nearly seven millions, ultimately), and the Chicago South Park Board contributed three and a half million dollars to renovate for its use the run-down old Palace of Fine Arts, a survival of the Columbian Exposition of 1893. The museum consulted Miller on its plans, and its director, curators, and supporting staff began to build collections and install exhibits, but the Great Depression of the 1930s severely inhibited its activities. During the Chicago centennial world's fair, "A Century of Progress," in 1933, the museum partially opened, with a spectacular simulated coal mine; but its financial situation became alarming, and in 1940 the museum board chose for its paid president Major Lenox R. Lohr, who had successfully run "A Century of Progress" for two summers and was then president of the National Broadcasting Company. Lohr applied world's fair promotional methods to the museum, dismissed the director, curators, and many other staff members, and persuaded industries to plan, produce, and install exhibits and to pay the museum a yearly fee for operating, maintaining, and demonstrating them. The museum retained control of each exhibit, to assure that it was truthful, attractive, and educationally effective.

The museum today has exciting, hands-on exhibits that attract more than 3.2 million visitors yearly, including 500,000 students in classes. The coal mine, the German submarine U505 captured by the United States Navy in 1944, a laser beam demonstration called "Light Fantastic," from the Bell Telephone Company, and a farm by the International Harvester Company, with livestock, including baby chicks hatching from an incuba-

tor, are a few of its leading attractions. Programs offered to school classes have included "Science Playhouse," with presentations by professional actors on Galileo, Edison, and Daniel Hale Williams, a black surgeon; "Working for a Better Environment," with animated films, life-sized puppets, and illustrated lectures/demonstrations by leading scientists and engineers; a Children's Science Book Fair; and, for pre-schoolers, a special science exhibit kept in small scale, with simple participatory experiments.[37]

Most American technical museums have followed the pattern set by the Chicago Museum of Science and Industry and regard themselves as science/technology centers, rather than museums with extensive historical collections. This point of view, especially in the case of smaller institutions, is usually entirely necessary, because historical machines and equipment are scarce and often bulky. The science/technology center's emphasis is upon teaching exhibits and permissive hands-on activities that elicit much visitor participation. This concept has spread around the world, and such centers are found today in Sidney, Calcutta, Singapore, and Tokyo. Such museums are closely related to children's museums, which began at Brooklyn, New York, in 1899, though they usually include art, natural history, and history materials as well as those of science and technology.[38]

One of the leaders among these technological institutions is the Ontario Science Centre of Toronto. Founded by the government of Ontario in 1969 as part of the observance of the centennial of the Dominion of Canada, it occupied a striking series of three buildings sited on a hillside and connected by glass-walled bridges and escalators that provided charming views of the one-hundred-acre plot. There were also several gardenlike open-air spaces. The key word for the museum's philosophy was "permissiveness," and visitors were free to operate much equipment and handle many exhibits except where combustible materials, high-voltage electricity, or other dangerous elements require expert demonstration. As one director of the centre put it: "Our visitors may shout, romp, and play, and as long as they are not interfering with the enjoyment of others, or endangering themselves, we want them to react as they please." Visitors wandered at will and decided how long they wished to stay at any exhibit; the Science Centre was viewed as "a supermarket of information." An exception to the general rule obtained in the instance of students in classes who numbered about 250,000 each school year. The sixteen members of the centre teaching staff adapted to the wishes of the class teachers with special lectures, experiments, dem-

onstrations, films, and exercises that employed the inquiry or discovery approach.[39]

The rise of science/technology centers has brought considerable controversy into this museum field. The older, more traditional institutions with historical materials at times may look askance at some of the lively centers and question the value of "mindless" activity for activity's sake. They may decry the lack of subject-matter curators and careful, impartial scientific research and deplore the noise and confusion created when students are allowed to follow their own inclinations. Opposed to these conservative views are those who point out that too often technical museums have concentrated on objects and techniques and neglected humanistic and social values such as ecological degradation, low wages, dangerous working conditions, and industrial accidents. Other progressives emphasize that motivation is often a more important result of museum activity than is information; they cite actual instances where youngsters have resolved to follow scientific careers because of the inspiration they received at such centers. Part of the ideological conflict reflects differences in educational systems. European primary and secondary schools are usually more didactic, regimented, and controlled than American ones that offer a smorgasbord of learning experiences, place a high premium on entertainment as a handmaid of learning, and reject the idea: "I suffer—therefore I learn."[40]

There can be little doubt where Dr. Oskar von Miller would have stood in this dispute. Though an enthusiastic admirer of historic machines and great inventors, he was responsible for starting the process of explaining technology in an exciting and enjoyable way for the general public and especially for young people. He brought fresh verve to the museum idea and caused all museums to give more attention to motion, hands-on activity, and visitor participation and involvement. As a *New York Times* editorial remarked, on the occasion of von Miller's resignation as the museum's president in 1933: "Unlike any other museum, it pulsates with life," and though its founder was a great engineer, the Deutsches Museum probably would remain his most enduring achievement.[41]

## NOTES

1. I have had the good fortune to talk with Mr. Rudolf von Miller, Oskar's youngest child, about his father and to have him read and comment upon this chapter. Several staff members of the Deutsches Museum provided useful information, including Mr. Dicter Schultz, director of administration.

Sources on the Frankfurt fair include *Oskar von Miller: nach eigenen Aufzeichnungen, Reden und Briefen* (From His Own Remarks, Speeches and Letters), edited by Walther von Miller (hereafter cited as O. von Miller, *Remarks*), pp. 54–65; Walther von Miller, *Oskar von Miller: Pionier der Energiewirtschaft, Shopferdes Deutschen Museums* (Pioneer of the Power Industy, Creator of the Deutsches Museum), (hereafter cited as W. von Miller, *Oskar von Miller*); Carl Hering, "Notes on the Frankfort Electrical Exhibition," *Electrical World* 19: 25–27; Carl Hering, "The Transmission of Power," *Cassier's Magazine* 1: 449–456; Georg Siemens, *History of the House of Siemens*, 2 vols., 1: 121–123; Oscar von Miller, "Electric Lighting at Cassel . . . ," in *Continental Electric Light Central Stations* . . . , by Killingworth Hedges, pp. 37–41 (see also pp. iii–iv, 165–174); Thomas Parke Hughes, "The Science-Technology Interaction: The Case of High Voltage Power Transmission Systems," *Technology and Culture* 17: 647; Karl Bässler, "Heavy Current Electrotechnology: A New Department of the Deutsches Museum," *Museum* 7: 162–163; Deutsches Museum, *Illustrated Guide through the Collections*, 6th edition, pp. 42–44.

2. Frank Lewis Dyer and Thomas Commerford Martin, *Edison: His Life and Inventions*, 2 vols. (New York and London: Harper & Brothers, 1910), 1: 283; Francis Jehl, *Menlo Park Reminiscences*, 3 vols. (Dearborn, Mich.: Edison Institute, 1937–1941), 2:750; Siemens, *House of Siemens*, 1: 90–93; Wilhelm Lukas Kristl, *Hier darf jeder tun was ich will: Oskar von Miller in Anekdoten und Monumentaufnahmen* (Here, Everyone May Do What I Want: Miller in Anecdotes and Snapshots) (hereafter cited as Kristl, *Miller in Anecdotes*), pp. 8–14.

3. N. H. Schilling, *The Present Condition of Electric Lighting: A Report Made at Munich, 26th September, 1885* (Boston: Cupples, Upham and Company, 1886).

4. O. von Miller, *Remarks*, pp. 1–11, 104; W. von Miller, *Oskar von Miller*, p. 15; H. W. Dickinson, "Oskar von Miller," *Museums Journal* 34: 76–79; Waldemar Kaempffert," Oskar von Miller," *Scientific Monthly* 38: 489–491.

5. Conservatoire Impérial des Arts et Métiers, *Catalogue des Collections* . . . Par H. Morin, 5th edition; "Imperial Conservatory of Arts and Trades, at Paris," *American Journal of Education* 21: 439–449; H. W. Dickinson, "Museums and Their Relation to the History of Engineering and Technology," *Newcomen Society Transactions* 14: 5–6; Charles R. Richards, *The Industrial Museum*, pp. 7–11; Alexis Blanc, "The Technological Museum of the Conservatoire des Arts et Métiers, Paris," *Museum* 20: 208–213; Silvio A. Bedini, "The Evolution of Science Museums," *Technology and Culture* 6 (1965): 20–21; Kenneth Hudson, *A Social History of Museums: What the Visitors Thought* (Atlantic Highlands, N.J.: Humanities Press, 1975), p. 69.

6. Lord Amulree, "The Museum as an Aid to the Encouragement of Arts, Manufactures and Commerce," *Museums Journal* 39: 350–356; H. W. Dickinson, "The Science Museum, South Kensington, London," *Mechanical Engineering* 48: 104–108; Dickinson, "Museums and Engineering," pp. 4, 6–9; Richards, *Industrial Museum*, pp. 12–19; Eugene S. Ferguson, "Technical Museums and International Exhibitions," *Technology and Culture* 6: 38–39.

7. O. von Miller, *Remarks*, pp. 11–14; Dickinson, "Oskar von Miller," p. 76.

8. O. von Miller, *Remarks*, pp. 14–22, 54–65; Kristl, *Miller in Anecdotes*, pp. 15–16; Dickinson, "Oskar von Miller," pp. 76–79; Thomas Parke Hughes, "British Electrical Industry Lag, 1882–1888," *Technology and Culture* 3 (1962): 27; Deutsches Museum, *Guide*, p. 43.

9. O. von Miller, *Remarks*, pp. 22–31, 54–65, 111; Kristl, *Miller in Anecdotes*, pp. 16–18; "Illustration of Munich Electrical Exhibition Waterfall," *Cassier's Magazine* 9 (January 1896): 220; Hering, "Frankfort Electrical Exhibition," p. 25; Hering, "Transmission of Power," pp. 453–456; Siemens, *House of Siemens*, 1: 104, 121–123; David S. Landes, *The Unbound Prometheus: Technological Change and Industrial Development in Western Europe from 1750 to the Present* (Cambridge, England: At the University Press, 1969), p. 286; Karl Bässler, "Deutsches

Museum: Museum of Science and Technology," *Museum* 2: 171–179; Kaemffert, "Oskar von Miller," pp. 489–491; Deutsches Museum, *Guide*, p. 42.

10. O. von Miller, *Remarks*, pp. 42–55; W. von Miller, *Oskar von Miller*, pp. 22–23, 29, 42, 56–65; Kristl, *Miller in Anecdotes*, pp. 13–14, 18–21; Thomas P. Hughes, "Managing Innovation: Oskar von Miller and the Electrification of Bavaria," Typescript, 1978; Thomas P. Hughes, "Managing Change: Regional Power Systems, 1910–30," Business History Conference, *25–26 February 1977*, pp. 52–68; Siemens, *House of Siemens*, 1: 90–93, 96–100; 2: 137; Kaemffert, "Oskar von Miller," pp. 489–491; Dickinson, "Oskar von Miller," pp. 76–79; Landes, *Unbound Prometheus*, pp. 290, 435–438; Wilhelm Lukas Kristl, *Der weiss-blaue Despot: Oskar von Miller in seiner Zeit* (The Bavarian Despot . . . in His Time), pp. 83, 288–289.

11. O. von Miller, *Remarks*, pp. 158–168; W. von Miller, *Oskar von Miller*, p. 15; Kristl, *Miller in Anecdotes*, pp. 22–34; Kristl, *Bavarian Despot*, p. 244 ff.; Dickinson, "Oskar von Miller," pp. 76–79.

12. Richards, *Industrial Museum*, p. 20; Bennett H. Brough, "The German Museum of Science and Technology," *Nature* 78: 477–478; Dickinson, "Oskar von Miller," pp. 76–89.

13. Richards, *Industrial Museum*, pp. 21–24; Dickinson, "Oskar von Miller," pp. 76–79; Kristl, *Miller in Anecdotes*, p. 40.

14. O. von Miller, *Remarks*, pp. 143–157; W. von Miller, *Oskar von Miller*, p. 86; Richards *Industrial Museum*, pp. 70–101; Brough, "German Museum of Science and Technology," pp. 477–478; Dickinson, "Oskar von Miller," pp. 76–79; Bässler, "Deutsches Museum," pp. 171–179.

15. W. von Miller, *Oskar von Miller*, pp. 75–78.

16. Richards, *Industrial Museum*, pp. 20–21, 102–110; Dickinson, "Oskar von Miller," pp. 76–79; Bässler, "Deutsches Museum," pp. 171–179; Kenneth Hudson, *Museums for the 1980s*, pp. 174–175.

17. H. W. Dickinson, "Opening of the Deutsches Museum, Munich," *Museums Journal* 25: 8–11, 43–48; "The German Museum of Science and Technology," *Nature* 115: 611–612; *Technology and Culture* 9 (1968): 237.

18. Brough, "German Museum of Science and Technology," p. 79. See also Dickinson, "Oskar von Miller," pp. 76–79; Hermann Auer, "The Deutsches Museum, Munich," *Museum* 20: 199–201; Hermann Auer, "Problems of Science and Technology Museums: The Experience of the Deutsches Museum, Munich," *Museum* 21: 128–139; Hermann Auer, "Museums of the Natural and Exact Sciences," *Museum* 26: 68–75.

19. O. von Miller, *Remarks*, pp. 113–114.

20. "The Optical Planetarium at Munich," *Nature* 114: 937–938; Henry C. King and John R. Milburn, *Geared to the Stars*, pp. 341–344; Joseph Miles Chamberlain, "The Development of the Planetarium in the United States," Smithsonian Institution *Annual Report . . . 1957* (Washington, D.C.: Smithsonian Institution, 1958), pp. 262–263 and plate 4; "A Few Recent Planetaria," *Museum* 7 (1954): 202–205; Hermann Auer, "Science Museums and International Understanding," *Museum* 7: 104; Richards, *Industrial Museum*, pp. 29–30.

21. Herman Kogan, *A Continuing Marvel*, pp. 11, 18. See also Richards, *Industrial Museum*, p. 26.

22. Dickinson, "Oskar von Miller," p. 76.

23. O. von Miller, *Remarks*, pp. 124–125; W. von Miller, *Oskar von Miller*, pp. 71, 78; Richards, *Industrial Museum*, pp. 24, 30–32; Auer, "Deutsches Museum," pp. 199–201; Auer, "Problems of Science and Technology Museums," pp. 128–139; Bässler, "Deutsches Museum," pp. 171–179; Deutsches Museum, *Guide*, pp. 121–122, 124; Deutsches Museum, *Abhandlungen and Berichte* [Essays and Report] 1—(1929—).

24. W. von Miller, *Oskar von Miller*, pp. 124–129; *Museums Journal* 45 (April 1945): 13; Bässler, "Deutsches Museum," p. 175; Dickinson, "Oskar von Miller," pp. 76–79.

25. Auer, "Problems of Science and Technology Museums," pp. 138–139.

26. Deutsches Museum, *Guide*, pp. 122–124.

27. Bässler, "Heavy Current Electrotechnology," pp. 161–166.

28. Auer, "Museums of Natural and Exact Sciences," pp. 74–75.

29. Hudson, *Museums for the 1980s*, pp. 91, 174–175.

30. Victor J. Danilov, "America's Contemporary Science Museums," *Museums Journal* 75: 145–148; Victor J. Danilov, "European Science and Technology Museums," *Museum News* 54: 34–37, 71–72; Victor J. Danilov, "Science/Technology Museums Come of Age," *Curator* 16: 183–219; Richards, *Industrial Museum*, pp. 33–45, 111–117; International Council of Museums, International Committee of Museums of Science and Technology, *Guide-Book of Museums of Science and Technology*, pp. 97–104; "Vocational Training: Technisches Museum fur Industrie and Gwerbe, Wien," *Museum* 5 (1952): 198.

31. Dickinson, "Museums and Engineering," p. 9; Dickinson, "Oskar von Miller," p. 77; "The Children's Gallery at the Science Museum," *Museums Journal* 31 (January 1932): 442–444; E. E. B. Mackintosh, "Special Exhibitions at the Science Museum," *Museums Journal* 37 (October 1937): 317–327.

32. Louis de Broglie, "Scientific Museology and the Palais de la Découverte," *Museum* 2: 141–149; André Leveillé, "The History of Sciences in the Palais de la Découverte," *Museum* 7: 195–201; A. J. Rose, "The Palais de la Découverte, Paris," *Museum* 20 (1967): 150, 204–207; International Committee, Museums of Science and Technology, *Guidebook*, pp. 201–208; Danilov, "European Science and Technology Museums," p. 37.

33. Alexis Blanc, "The Technological Museum of the Conservatoire des Arts et Métiers, Paris," *Museum* 20: 208–213; Danilov, "European Science and Technology Museums," p. 34; "A Few Recent Planetaria," pp. 202–203.

34. H. Philip Spratt, "Tekniska Museet: A New Science Museum Opened in Stockholm," *Museums Journal* 36: 243–245; "The Technical Museum, Stockholm," *Museums Journal* 45 (April 1945): 4–6; "Tekniska Museet," *Museum* 2 (1949): 34–35; Thorsten Althin, "The Atomarium of the Tekniska Museum, Stockholm," *Museum* 7 (1954): 167–173; S. Strandh, "The Museum of Science and Technology, Stockholm," *Museum* 20 (1967): 188–191.

35. Edward P. Alexander, *Museums in Motion: An Introduction to the History and Functions of Museums* (Nashville, Tenn.: American Association for State and Local History, 1979), pp. 69–70.

36. W. von Miller, *Oskar von Miller*, p. 96; Alexander, *Museums in Motion*, pp. 72–73; Geoffrey C. Upward, *A Home for Our Heritage: The Building and Growth of Greenfield Village and Henry Ford Museum, 1929–1979* (Dearborn, Mich.: Henry Ford Museum, 1979), pp. 172–174.

37. O. von Miller, *Remarks*, pp. 158–168; W. von Miller, *Oskar von Miller*, p. 79; Alexander, *Museums in Motion*, pp. 70–72; Victor J. Danilov, "Under the Microscope," *Museum News* 52: 37–44; Danilov, "Science Museums as Education Centers," *Curator* 18: 87–108; Danilov, "Your Science Center has the Answer," *Museum Magazine* 1: 74–79; Danilov, "Science/Technology Museums Come of Age," pp. 183–219; Danilov, "America's Contemporary Science Museums," pp. 145–148.

38. "Museums of Science and Technology," Special Issue, *Museum* 20 (1967): 150–228; Kenneth V. Jackson and R. S. Bhatal, "The Singapore Science Centre," *Museum* 26: 110–116; International Committee, Museums of Science and Technology, *Guidebook*.

39. Douglas N. Ormand, "The Ontario Science Centre, Toronto," *Museum* 26 (1974): 76–85; Archie F. Key, *Beyond Four Walls: The Origin and Development of Canadian Museums*

(Toronto: McClelland and Stewart, 1973), pp. 263–264; International Committee, Museums of Science and Technology, *Guidebook*, pp. 121–128.

40. Auer, "Museums of Natural and Exact Sciences," pp. 74–75; Hudson, *Museums for the 1980s*, pp. 174–175; Brooke Hindle, "Museum Treatment of Industrialization: History, Problems, Opportunities," *Curator* 15 (1972): 206–219; George Basalla, "Museums and Technological Utopianism," *Curator* 17 (1974): 105–118; Ormond, "Ontario Science Centre," pp. 76–85; "Some Points of View on Museums of Exact and Natural Sciences," *Museum* 27 (1975): 94–96; Danilov, "America's Contemporary Science Museums," pp. 145–148; Danilov, "European Science and Technology Museums," pp. 34–37, 71–72.

41. *New York Times*, May 9, 1933.

## SELECT BIBLIOGRAPHY

Amulree, Lord. "The Museum as an Aid to the Encouragement of Arts, Manufactures and Commerce." *Museums Journal* 39 (November 1939): 350–356.

Auer, Hermann. "The Deutsches Museum, Munich." *Museum* 20 (1967); 199–201.

———. "Museums of the Natural and Exact Sciences." *Museum* 26 (1974): 68–75.

———. "Problems of Science and Technology Museums: The Experience of the Deutsches Museum, Munich." *Museum* 21 (1968): 128–139.

———. "Science Museums and International Understanding." *Museum* 7 (1954): 104.

Bässler, Karl. "Deutsches Museum: Museum of Science and Technology." *Museum* 2 (1949): 171–179.

———. "Heavy Current Electrotechnology: A New Department of the Deutsches Museum." *Museum* 7 (1954): 161–166.

Blanc, Alexis. "The Technological Museum of the Conservatoire des Arts et Métiers, Paris." *Museum* 20 (1967): 208–213.

Broglie, Louis de. "Scientific Museology and the Palais de la Découverte, Paris." *Museum* 2 (1949): 141–149.

Brough, Bennett H. "The German Museum of Science and Technology." *Nature* 78, September 17, 1908: 477–478.

Conservatoire Inpérial des Arts et Métiers. Catalogue des Collections . . . , cinquième édition. Paris: Imprimerie Viéville et Capioment, 1870. 371 pp.

Danilov, Victor J. "America's Contemporary Science Museums." *Museums Journal* 75 (March 1976): 145–148.

———. "European Science and Technology Museums." *Museum News* 54 (July/August 1976): 34–37, 71–72.

———. "Science Museums as Education Centers." *Curator* 18 (1975): 87–108.

———. "Science/Technology Museums Come of Age." *Curator* 16 (1973): 183–219.

———. "Under the Microscope." *Museum News* 52 (March 1974): 37–44.

———. "Your Science Center Has the Answer." *Museum Magazine* 1 (November/December 1981): 74–79.

Deutsches Museum. *Illustrated Guide through the Collections*, sixth edition. Munich: Deutsches Museum, 1978. 124 pp.

Dickinson, H. W. "Museums and Their Relation to the History of Engineering and Technology." Newcomen Society for the History of Engineering and Technology *Transactions* 14 (1933–1934): 1–12.

_____. "Opening of the Deutsches Museum, Munich." *Museums Journal* 25 (July 1925): 8–11; (August 1925): 43–48.

_____. "Oskar von Miller." *Museums Journal* 34 (June 1934): 76–79.

_____. "The Science Museum, South Kensington, London." *Mechanical Engineering* 48 (February 1926): 104–108.

Ferguson, Eugene S. "Technical Museums and International Exhibitions." *Technology and Culture* 6 (1965): 30–46.

Forbes, George. "Some Electric Lighting Central Stations and Their Lessons." *Journal of the Institute of Electrical Engineers* 18 (1889): 161–196, 211–281.

"The German Museum of Science and Technology." *Nature* 115, April 25, 1925: 611–612.

Hering, Carl. "Notes on the Frankfort Electrical Exhibition." *Electrical World* 19, January 9, 1892: 25–27.

_____. "The Transmission of Power." *Cassier's Magazine* 1 (April 1892): 449–456.

Hudson, Kenneth. *Museums for the 1980s: A Survey of World Trends.* New York: Holmes & Meier Publishers, UNESCO, 1977. 198 pp.

Hughes, Thomas Parke "Managing Change: Regional Power Systems, 1910–30." In Business History Conference, *Papers Presented at the Twenty-Third Annual Meeting, 25–26 February 1977,* pp. 52–68. Urbana, Ill.: Business History Conference, 1977.

"Imperial Conservatory of Arts and Trades, at Paris." *American Journal of Education* 21 (1870): 439–449.

International Council of Museums (ICOM), International Committee, Museums of Science and Technology. *Guide-Book of Museums of Science and Technology.* Prague: Nardoní Technické Museum, 1974. 460 pp.

Jackson, Kenneth V., and R. S. Bhatal. "The Singapore Science Centre." *Museum* 26 (1974): 110–116.

Kaemffert, Waldemar. "Oskar von Miller." *Scientific Monthly* 38 (May 1934): 489–491.

King, Henry C., and John R. Milburn. *Geared to the Stars: The Evolution of Planetariums, Orreries, and Astronomical Clocks.* Toronto/Buffalo: University of Toronto Press, 1978. 442 pp.

Kogan, Herman. *A Continuing Marvel: The Story of the [Chicago] Museum of Science and Industry.* Garden City, N.Y.: Doubleday, 1973. 234 pp.

Kristl, Wilhelm Lukas. *Der weiss-blaue Despot: Oskar von Miller in seiner Zeit.* [The Bavarian Despot . . . in His Time]. München: Richard Pflaum Verlag, 1965. 301 pp.

_____. *Hier darf jeder tun was ich will: Oskar von Miller in Anekdoten und Momentaufnahmen.* [Here, Everyone May Do What I Want: Oskar von Miller in Anecdotes and Snapshots]. Pfaffenhofen: Verlag W. W. Ludwig, 1978. 91 pp.

Leveillé, André. "The History of Sciences in the Palais de la Decouverte." *Museum* 7 (1954): 195–201.

Miller, Oskar von. "Electric Lighting at Cassel . . . . Also a Description of Cassel and Lauffen-Heilbronn Stations." In *Continental Electric Light Central Stations . . .* by Killingworth Hodges. London and New York: E. & F. N. Spon, 1892, pp. 37–41.

_____. *Oskar von Miller: nach eigenen Aufzeichnungen, Reden und Briefen* [From His Own Remarks, Speeches and Letters]. Edited by Walther von Miller. München: F. Bruckman, 1932. 184 pp.

Miller, Walther von. *Oskar von Miller: Pionier der Energiewirtschaft, Shöpferdes Deutschen Museums* [Pioneer of the Power Industry, Creator of the Deutsches Museum]. München: F. Bruckman, 1955. 112 pp.

"The Optical Planetarium at Munich." *Nature* 114, December 27, 1924: 937–938.

Richards, Charles R. *The Industrial Museum.* New York: The Macmillan Co., 1925. 117 pp.

Siemens, Georg. *History of the House of Siemens,* 2 vols. Friedberg/München: Verlag Karl Alber, 1957. Reprint. New York: Arno Press, 1977.

Spratt, H. Philip. "Tekniska Museet: A New Science Museum Opened in Stockholm." *Museums Journal* 36 (September 1936): 243–245.

Zenneck, J. "Oskar von Miller." In Deutsches Museum, *Abhandlungen and Berichte* [Essays and Report] 6 (1934): 27–50.

# [ 13 ]

John Cotton Dana
and the Newark Museum:
The Museum
of Community Service

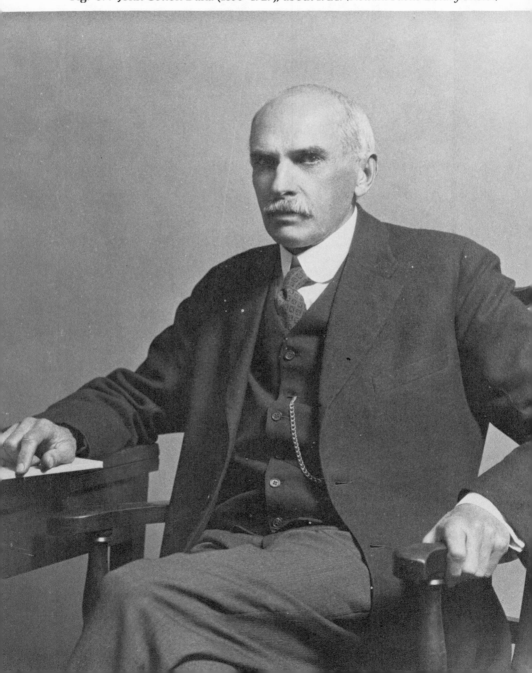
Fig. 37. John Cotton Dana (1856–1929), about 1924. *(Newark Public Library Photo.)*

## I

JOHN COTTON DANA, librarian of the Newark (New Jersey) Public Library and founder and director of the Newark Museum, was a vivid personality. Walter Pach considered him the *enfant terrible* of the American museum profession, who delighted in publishing shocking statements such as "No other public educational institutions give so little return for the money spent on them as do museums." Chalmers Hadley, who knew Dana well and wrote a pathetic biographical sketch of him, said he was the center of every librarians' conference, "jesting, exchanging drolleries or tossing off the epigrams, banter and witticisms for which he was famous." "Watch Dana," Hadley advised, "He will approach two men librarians, make some provocative statement and start an argument. In its midst Dana will leave the disputants to themselves and then repeat the operation elsewhere." He was "pungent, provocative, mischievous, mordant, kind, critical, radical, intense, versatile, stimulative, deeply sympathetic and pronouncedly creative."[1]

Dana was born in Woodstock, Vermont, on August 19,1856, the son of Charles Dana, Jr., and Charitie Scott (Loomis) Dana. Both parents came from old New England Puritan families of English, Scottish, and French descent (the name *Dana*, originally Danna, was Huguenot), and John Cotton was the third of five sons ( a sister had died young). He grew up in a semirural environment, accustomed to the hard work of exacting daily chores such as those involved in gardening and cow-tending. His father ran a general store, and the family occupied a frame house next door; both buildings faced on Woodstock Green and had been erected by Charles Dana, John Cotton's grandfather. The boy became an accomplished whittler and amateur carpenter and also learned to set type and operate a hand press, a craft that he practiced and enjoyed throughout his life. He admired fine printing and with his brothers later, at Woodstock, established the Elm Tree Press in his father's old brick store building. Like his parents, the boy was an omnivorous and eclectic reader, and he did well in school. At age sixteen, with his brothers, he started an amateur, four-page monthly newspaper, *The Acorn*, complete with short stories, poems, editorials, humorous anecdotes, and advertisements of local firms; he shared in all the work—wrote copy, set type, and printed papers. His life

379

in the small New England village (population about fifteen hundred) included sports such as swimming, fishing, skating, sledding, snow-shoeing, and baseball; he knew the joys of maple-sugaring, making and shooting arrows, and observing the Fourth of July by firing an old cannon.[2]

In 1874, Dana went off to Dartmouth College to receive a classical education meant to prepare him for the law. He did well in Greek and Latin and, between college terms, taught in rural schools to earn some of his way, receiving four dollars per week and boarding around with the school committeemen. He led a busy extracurricular life, belonged to Psi Upsilon fraternity, was a ringleader in a student protest against some faculty regulations, edited the humorous classbook, *The Aegis,* in his junior year, and was a good track athlete, once practicing secretly in the woods in order to dethrone the school long-jump champion. (In later life, Dana was an ardent golfer, usually playing in a weekly foursome.) In 1878, he was graduated from Dartmouth, was elected to Phi Beta Kappa, and stood fourth in his class of seventy-four. He was voted "best-read man" by his classmates.[3]

Dana then returned to Woodstock to study law for one and one-half years in the office of French and Southgate, but he said later that he read Blackstone, Kent, Chitty, and other texts "piously and groaned inwardly." He seems to have experienced liver and kidney troubles and may have been threatened by tuberculosis. At any rate, in May 1879, at age twenty-three, he left Vermont to join a close college friend, Frank W. Gove, at a mining camp in Rico, Colorado. He stayed in that healthful climate for about two years, leading an outdoor life as a surveyor of land and mineral claims, and he was admitted to the Colorado bar in 1880. He then went to New York City, where he resumed his law studies for another two years in the offices of Bristow, Peet, and Opdyke and passed the New York bar examinations. Dana lived in New York with his brother Charles, a physician, and the two young men frequently attended theaters, operas, and churches together.

Dana next journeyed to Ashby, a western Minnesota community settled largely by Norwegians, where he practiced a little law and ran a country weekly, the *Ashby Avalanche.* He soon returned to Colorado, to work mainly on surveying and construction crews of the Colorado Midland Railway. Dana described his life then as including

Candlelight breakfasts, twenty-mile walks, climbs over icy cliffs, fare in which hog is a staple, a table on which a four-tine fork is a luxury, flannel shirts, blue jean

pants (trousers—excuse me!), ragged cloths *[sic]*, leggings made of a piece of gunny-sack and a length of bailing wire,—all these and much more must go in to make up the picture of engineering on the frontier.

He also did some insurance and real estate business, some preaching in the Unitarian church, and much writing of letters or articles to newspapers and law journals. In 1887, he bought a small ranch near Glenwood Springs and a year later was married to a handsome young woman, Adine Rowena Waggoner; their friends, the Frank Goves, acted as witnesses. Dana was now thirty-two; she was four years his junior, born in Russellville, Kentucky, and she had lived for some time in Austin, Texas. She was musical, and one of the first purchases of the new household was a piano.[4]

During all this period, Dana read broadly and incessantly, and he described some of his religious conflicts and social beliefs as follows:

I am an agnostic, religiously. I labored with the hosts of orthodoxy for some eight years, finally conquered, and in my present freedom can think without much bitterness of the religious atmosphere of New England in general and Dartmouth College in particular—this, although I sometimes feel as if much of the years of struggle to escape from it were worse than wasted. I have lectured in Glenwood Springs on the Story of the Creation and Religion vs. the church, and also once at Aspen on Religion for the World's People.

Since about 1887 I have gained a much clearer view of the great truths, and am pleased to announce myself an egotist, a pessimist, and an anarchist. . . . I have been in politics not at all. I passed through a mild attack of socialism, and subscribe to the Henry George theory in a measure. I lectured on that subject with a moderate measure of success, some time ago. Am a thorough-going free trader and an unterrified Jeffersonian Democrat.[5]

Dana's early life showed personality traits that influenced his later library and museum careers. His Puritan religious background made him quick to point out mistakes and shortcomings in those who did not agree with him on professional, social, and political matters. His legal training helped develop the disputatious side of his nature and made him enjoy spirited controversy; he became a skilled and formidable debater. And his alacrity in writing to newspapers and journals to express his very definite ideas in clear, often pungent, and sometimes humorous language gave him a reputation as a suggestive and progressive thinker. Yet his outgoing and generous impulses brought him many admirers and friends and kept his abrasiveness stimulating and constructive, rather than irritating and bitter.

Aaron Gove, brother of Dana's friend Frank, was superintendent of the Denver Public Schools, and Dana had written a letter in the *Denver Arbitrator* that outlined his ideas on public instruction of the young. When the Board of Education decided to establish a library in its new high school building that would also serve the general public, Superintendent Gove recommended Dana as librarian, and in May 1889, Dana accepted the position. He also later was elected secretary of the School Board. The post of librarian was to allow him to bring his talents into focus and indeed to transform his whole life.[6]

<center>II</center>

As an avid reader and lover of books, Dana plunged into the detailed work of his new position with vigor and enthusiasm. He was determined to overthrow the old idea of a library as a storehouse, in which "books were kept, kept jealously, and read carefully, and only by a selected few." An anecdote that illustrates this concept of librarianship relates that President Charles W. Eliot of Harvard encountered his librarian, the historian Justin Winsor, in Harvard Yard about 1880 and asked him how things were going with the library. Winsor is supposed to have replied: "Excellently, excellently. All the books are on the shelf except one that Agassiz has, and I'm going after it now." Dana's ideal library, however, was to be a center of community service, a temple "of happiness and wisdom common to all." People should be allowed to choose what they wanted to read, for, as he wrote, "Better a shallow mind than an empty one. It is a proper function of a library to amuse." He insisted that all books, except rarities of interest to experts or scholars, should be on open shelves, easily accessible to readers for browsing and selection. He did away with the requirement that applicants for a library card must secure the signature of an accredited citizen who would be responsible for the borrower. In Dana's view, books were plentiful and cheap enough to allow replacement of the few lost through such lenient regulations.[7]

Dana's general library philosopy is well expressed in the summary paragraph of an address he made in 1902, after he became librarian in Newark:

Librarians have passed through the repository stage, when they did little more than collect and save; the identification stage, when they devoted themselves greatly to classifying, ticketing and cataloguing their books; the memorial stage— which we are unhappily still blundering through—when they surrendered themselves to the task of erecting Greek temples, Italian palaces and composite tombs;

the distribution stage, wherein they find themselves outstripped by commercial ventures which saw the novel had become as much desired as the daily paper; and they are just entering upon the critical, evaluating and educating stage. They are just beginning to find themselves. . . . In this present stage they discover that they are, or may become, the center of many of the forces in their respective communities which make for social efficiency and civic improvement. The modern public library is the helpful friend of scientific, art and historical societies; of the educational labor organizations; of city improvement organizations; of teachers' clubs and parents' societies and women's clubs. At the library should be the books and journals to which all these institutions must come for their guidance or material. Here should be rooms suitable for their gatherings. Here should be a spirit hospitable to them all; knowing what is in books, but keenly alive also to all that is best, all that is striving for helpful expression, in the people who own those books and hope much from them.[8]

Dana used two chief methods to achieve his goal of making the library a center of community service. First of all, he opened its doors almost every day of the year from 9:00 A.M. to 9:00 P.M. and made it useful to many different community groups. He began the first Children's Room in the country, in 1894, with low tables and books on open shelves available to the youngsters—but in a separate room, to minimize noise and confusion. He organized one of the earliest, if not the first, picture collections, enlisting eighth-grade drawing teachers and their classes to mount and classify by artist and subject thousands of visuals clipped from illustrated and art journals and to be lent to the schools or elsewhere. He installed exhibitions of art by the students, started a herbarium of Colorado flowers and plants, and wrote a pamphlet on the state's history, manufacturing, agriculture, and education. He put together libraries of up to fifty volumes that teachers could borrow for classroom use. He placed business volumes with the Chamber of Commerce and collected magazines and books for doctors that ultimately became the Colorado Medical Library. He persuaded the Denver Woman's Club to purchase books for the library and lend them to women's clubs throughout the state. And to insure that the library would have attendants well trained in his concepts of public service, he set up a volunteer apprentice program for young women and hired its graduates on his staff. In 1890, the library lent 1,709 books; in 1892, 7,486; in 1890, there were 1,470 card holders; in 1892, 7,967. By 1896, Denver was lending, annually, four books per capita, as compared with one in Providence, fewer that two in Newark, and three in Minneapolis.[9]

Along with Dana's innovative program went constant advertising of the library. Newspapers and magazines carried stories, and the library issued a small monthly, *Books*, distributing copies. Dana himself was a

great source of publicity, with provocative speeches on many subjects—
for example, his stance in favor of the gold standard in strong free-silver
territory, against woman suffrage but for women's rights, and for novels
as better reading than histories. In 1896, his important address as presi-
dent of the American Library Association at its Cleveland conference was
puckishly entitled "Hear the Other Side." After castigating monumental
library buildings as ill-designed, poorly lighted, and badly ventilated,
and poking gentle fun at the indolents and idlers that inhabited news-
paper rooms, the competitors in word-building contests who wore out
library dictionaries, and the 60 to 80 percent of those who came to the
delivery desk with fiction, often of the poorest kind, he summed up the
situation thus:

If the free public library movement be not absolutely and altogether a good thing
. . . how urgent is the call to us to make each our own library the corrective, as far
as may be. . . . A collection of books gathered at public expense does not justify
itself by the simple fact that it is. If a library be not a live educational institution it
were better never established. It is ours to justify to the world the literary
warehouse. A library is good only as the librarian makes it so.

True librarians must "get in touch with the world" and "be social . . . not
superior and reserved." They ought to work with local book-lovers and
collectors, teachers of literature in colleges and public and private
schools, women's clubs, art associations, historical and scientific
societies, newspaper editors, clergymen and Sunday School libraries,
bookstores, and business men and women. The community should come
to rely upon librarians as persons of worth and dignity, as real profes-
sionals in the business and pleasure of reading.[10]

Dana not only followed his own advice in taking part in community
affairs, but also, through his writing, acquired a national reputation,
especially in the evolving library profession. During his career, he wrote
or edited more than five hundred articles and books. He largely wrote the
professional handbook used by most librarians; *A Library Primer*, first
published in 1896, reached an entirely rewritten sixth edition in 1920. He
early sought an international audience, and his "The Library Movement
in the Far West" appeared in the British Library Association's prestigious
publication at London in 1896.[11]

Dana, however, stirred much controversy with his frank criticisms and
his often radical views. Though he backed the Denver Mercantile Library
that the Chamber of Commerce had started, he was disturbed by the
chamber's attacks on the School Board for supporting the Public Library

too liberally with tax funds. He also had become one of the most original and articulate librarians in the country and began to desire a post with larger opportunities. He thus actively sought positions in Buffalo, Brooklyn, and in Springfield, Massachusetts. Yet when Dana, after eight and one-half years at Denver, decided to become librarian of the City Library Association at Springfield on January 1, 1898, many organizations expressed deep regret at his leaving Denver—the Dartmouth Alumni Association of the Great Divide, Woman's Club of Denver, Women's National Unitarian Alliance, City Improvement Society, Monday Literary Club, Denver Fortnightly Club, Artists Club, Colorado Library Association, and University of Denver. No wonder that Henry W. Kent, secretary of the Metropolitan Museum of Art in New York, later said that his friendship with Dana was "an education for me in public relations, of which he was a master."[12]

At Springfield, Dana took over a large, well-established library of about a hundred thousand volumes. He at once began to apply his canons of public service to its administration. "The library of the future," he asserted, "will not only have a corner for the grocers. It will have corners also for the plumbers, the sanitary engineers, the carpenters and the builders, and for all the trades and callings prominent in the community." He removed railings and barriers throughout the building and installed an elevator, so that visitors could avoid three long flights of stairs. He used open shelves in both general and reference sections and established a Children's Corner, lending collections of pictures and business materials, and training classes for library assistants. He early tripled Sunday attendance with an exhibit of illustrated books and approached school principals, Sunday School superintendents, secretaries of literary, historical, science, and other clubs, and businessmen to see what the library could do to serve them. He solved the question of how to treat popular, short-lived fiction by setting up a rental shelf that charged two cents per day. He also became a leading member of community organizations, perhaps the most rewarding of them known as Samuel Bowles's "talking club" that met monthly to listen to and debate a presentation by one of its members. Bowles was editor of the *Springfield Republican* and chairman of the Library Board of Directors.[13]

With these accomplishments and pleasures, however, went some disappointments. The Library Board was also in charge of the Art Museum, with its new building (1896), and the Museum of Natural History that opened in 1899. Dana had assumed that he would have supervision of both museums and, in an early annual report, stated that

"the city library has added to Literature her proper companions, Art and Science." But G. W. V. Smith, a wealthy private collector, was curator of the Art Museum. He disapproved of Dana's attempt to make the museums serve the whole community and to keep them open on Sundays, and he threatened to remove his art collection to Buffalo. The quarrel caused some schism on the Library Board. Nor did all the library and museum staff members adopt Dana's ideal of public service. On one occasion, after some women volunteers had decorated one of the museums with flowers and ferns, an assistant curator came to Dana and asked him to order the cleaning women to stop what they were doing and sweep up the stems and leaves on the museum floor. According to Dana's account: "I asked her if she could not do it herself, and she flatly refused. I went over there and with the help of the ladies swept the floor."[14]

Another difficulty was of a more personal nature. Mrs. Dana did not like Springfield, and she began to become a hypochondriac and recluse, to show signs of suffering from mental illness. While Dana and his brother Charles were visiting England, Scotland, and France in the summer of 1898, Dana worriedly wrote his brother Joseph to place Mrs. Dana in a sanitarium for a rest if he thought it necessary.[15]

As Dana became more unhappy about his situation, his rising reputation as librarian was bringing him tempting offers of new positions—from Brooklyn, Boston, and the New York Free Circulating Library. Finally, on December 18, 1901, he resigned, to accept the librarianship of the Free Public Library of Newark, New Jersey. He had been at Springfield for almost four full years. In discussing the new position, Richard C. Jenkinson of the Newark Library Board of Trustees warned Dana that the city "was not a book-reading community, not a library center." Dana's reply was characteristically aggressive and optimistic when he said: "Let us make it both."[16]

Dana's career at Newark, where he continued until his death in 1929, was a brilliant success. He applied the principles he had developed at Denver and Springfield to make the library a lively community educational center. Frank P. Hill, a Dartmouth friend of his who preceded him as librarian, had obtained a new library building in a central location, and he left his successor a capable staff led by Assistant Librarian Beatrice Winser. She had attended Melvil Dewey's Columbia University Library School and was a strong and skillful administrator. She handled the everyday running of the library and gave Dana time to apply his fervid imagination to general planning, the installation of original programs, and beguiling public relations. The New York newspapers and magazines

were near at hand to broadcast his probing letters to the editors and his incisive articles. The Library Board of Trustees supported him strongly, and Jenkinson, its president, said later:

I am rounding out nearly thirty years on the Library Board and I was one of the "Founders" of the Museum. I have come to know Dana so well and to like him so much, and to know his value to this city so well, that I have come to the place where I agree to most anything he proposes. . . . He has shown us how to do things, and we are doing them as he suggests.[17]

The kind of service that Dana developed is shown in the series of twenty-one pamphlets (1908–1929) on "Modern American Library Economy as Illustrated by the Newark, N.J., Free Library." Written by Dana and his staff, the pamphlets described in detail the procedures of the Newark library, with the intention of helping other libraries. The Newark Charging System came to be used by a majority of the public libraries of the country. Foreign language books were purchased, since about 70 percent of Newark residents were foreign-born or were children of those who were foreign-born. Dana advertised the library in its own publication, *The Newarker*, in newspapers and periodicals, and even on billboards. When he came to Newark, the library had 79,000 volumes, and 20,000 registered borrowers took out 315,000 volumes yearly; in 1928, the collection reached almost 400,000 volumes, and 90,000 borrowers withdrew 1.8 million volumes.[18]

One of Dana's most successful innovations was the conversion of Branch No. 1, situated in the busy downtown district and ably supervised by Sarah B. Ball, into a Business Man's Branch, today the Newark Business Library. Dana described it as follows:

This branch is much more like a store than a library. It is on the sidewalk level, and has a big show window where books, maps, charts, globes, signs and pictures, often changed, make as interesting a display as does any show window on the street. Inside is one large room, with . . . 3,100 square feet. The room is high, well lighted, quiet and inviting. It is open every week-day from 9:00 A.M. to 9:00 P.M..

Sarah Ball was in touch with other librarians who rendered this kind of special service, and in 1909 the Special Libraries Association was formed, at Dana's suggestion, and with him as its first president.[19]

Dana believed in organizations of librarians as a means of improving libraries and advancing the library profession. He had been president of the Colorado Library Association, had helped form the Western Mas-

sachusetts Library Club, had twice headed the New Jersey Library Association, and had served as president of the New York Library Club. He was also an active member of the American Library Association, having served as president, member of the Council, and on many important committees, including one on co-operation with the National Education Association. At the same time, he was highly critical of many ALA policies, frequently a gadfly to its administration, and, as Melvil Dewey once said, "Now and then his keen sense of humor led him to take a rise out of other librarians by saying or writing things just to 'stir up the animals.' "[20]

Dana had contempt for the usual library building, "perhaps erected to perpetuate a good man's memory—a monument, and of use only as a monument." Often even the Carnegie-built ones were patterned on some palace or temple, ill adapted for library use. Dana was a thorough believer in the architectural canon that form follows function and thought that a library calls "for greater ease of access and facility of communication in the building used than does any form of business, be it industrial, commercial, official, administrative or religious." A modern, tall office building, with a few minor changes, would serve well. Space for expansion and flexibility were all-important: "The essential things . . . are maximum of space, on the fewest possible floors, good light, a minimum of partitions, and no [permanent] fixtures."[21]

At Newark, Dana managed to establish the kind of public service library that he had been thinking through since his early days in Denver. The library was open to all classes of the community—to adults who read in order to solve specific problems or for pleasure; to business men and women, who had their own special branch; to children, who came to the main library or one of the nine branch libraries and especially those established in the schools. Most books were on open shelves, easily examined and charged out. In ten years, 662 different civic and educational organizations held 5,382 meetings at the library, with attendance of 167,335. The main building and its branches were situated where the public would use them, were easy of access, airy, and well lighted. Books were sent to the branches and to the schools, and the picture collection of about one million classified items circulated freely.

Dana thought much about future library problems that could arise from the increasing flood of printed materials created by an affluent industrial society. Books ought to be selected carefully to try to meet community needs, he believed, and he fought courageously against censorship of George Bernard Shaw's works and, during World War I, refused to remove German books from the shelves, even when a New

York newspaper nominated him to receive an Iron Cross. Dead books (those not being used) should be discarded or, in the case of research libraries, those used less frequently should be placed in a central co-operative storage depository serving a whole region and easily accessible on call. Card catalogues must be simplified, so as not to expand unmanageably; the new Library of Congress printed cards would help, and printed bibliographical lists could often be used instead of cards. Dana even let his imagination roam playfully. Borrowers in the future might carry a numbered metal slip instead of a library card. Aeroplanes, automobiles, and trolley cars would transport books in charge of a librarian to central spots. Automatic vendors, not unlike those used for chewing gum, would dispense books and receive returned ones; the "automatic Who, What, and Why Machine" would answer hundreds of questions; and "the famous Pay-Collection of Complete Answers" would be activated by a penny in the slot. Certainly Dana would have welcomed and been at home with such products of modern library technology as microfilm, microfiche, and the computer.[22]

## III

Dana had shown considerable interest in museums before coming to Newark. As a young man, he had admired the exhibits at county fairs that displayed new farming and domestic equipment, livestock, fruit, and farm produce, quilts and fancy needlework, canned goods and pastries, and other specimens and objects of rural life. (During his years at Newark, he spent most of his summer vacations in a house he owned in Woodstock and for a time served on the executive committee of the Windsor County Fair there.) In Denver, he had exhibited art work from the schools at the library. At Springfield, he had brought Henry W. Kent, then director of the Slater Memorial Museum at Norwich, Connecticut, to speak on Greek and Roman sculpture and to form a collection of plaster casts. He had also become acquainted with Japanese prints that appealed to him greatly and even ventured to begin a personal collection. He had hoped to take a more active part in the art and natural history museums but had been frustrated by what he considered the overconservative and elitist attitude of the curator of the Art Museum and others on the staff and board.[23]

In Newark, however, he had an ideal situation for museum activities, just the kind of experimental climate that he loved. The upper floors of his library building were as yet vacant and offered an opportunity to develop exhibition rooms, one for art and the other for science. Thus, in 1903, he

staged an *Exhibition of Paintings Lent by Newark Citizens,* which in a period of two weeks attracted 32,000 viewers. The next year, he persuaded Dr. William S. Disbrow, a local physician—who for long had been collecting, chiefly in the fields of natural science, medical history, and numismatics—to deposit his natural science collection in the library and, later, to make the library a gift of it. It consisted mainly of skeletal remains, economic botany, a herbarium, mineral specimens, rock samples, and fossils.

Dana continued the special exhibits, and by 1908 fifty-six of them had been held on varied subjects, using paintings, posters, bookplates, prints, fine printing, school work in the manual arts, and other materials. The exhibits were prepared by the library staff, were usually in place from four to six weeks, and were accompanied by lectures, related programs, and meetings of interested community groups. From November 1908 to January 1909, the exhibit of the collection of George T. Rockwell, a local pharmacist, of 2,400 Japanese prints and oriental objects, including ceramics, metal work, and textiles, excited much community attention.[24]

When the Rockwell Collection was offered for sale at $10,000, Dana persuaded the Newark City Council to buy it, provided an organization was formed to hold museum property in trust for the people of Newark. On April 29, 1909, the Newark Museum Association was chartered, to establish for the city "a museum for the reception and exhibition of articles of art, science, history and technology, and for the encouragement of the study of the arts and sciences." It was a membership organization governed by fifty-five trustees (five of them *ex officio* municipal officials), with Dana as secretary—and, beginning in 1913, also director—but with salary only as librarian. The city began a yearly appropriation of $10,000 to meet some salary and out-of-pocket expenses, and eventually about 3,200 members were paying annual dues of $46,000.[25]

Dana later articulated his thought on founding the museum thus:

All conditions seemed to point to the advisability of developing for Newark a first reader in visual instruction; something that would please, instruct and provoke to thought and action those who used it, and would serve also as a continuing incentive to the use of treasures to be seen in the great city [New York City] near at hand.

Dana was applying the same standards of community service to the museum that he had demanded from the beginning for his libraries. In his view, museums were not to put their emphasis on acquisition, but on use—exhibition, interpretation, and community service. Their main

audience should consist not of the educated, the privileged, the elite, but of the whole community. In Newark, the manufacturers and laborers were to understand craftsmanship and taste; the foreign-born and racial groups were to take pride in their distinctive backgrounds and cultures; and all the young people were to be inspired to become "home-loving, state-loving, city-loving people," strong in "civic manhood, patriotism, local pride."[26]

Most museums—especially art museums—were then what Dana contemptuously called "gazing museums." He declared that looking at paintings did little to stimulate sound labor or inspire correct morals. Sculptures seemed to overwhelm the viewer, and most engravings were dull. Curios had little use. "Seen in rows in glass cases, they are speechless as mummies and about as instructive as a row of telegraph poles." Dana continued thus:

> From all this one may conclude that the gazing at sculpture or graphic art objects which goes on in most museums of art is mere gazing and little more; and that to expand this little more to something of value to the gazers, and so to the community in general, calls for the new museum methods which are slowly coming into general use.[27]

The best place to find a full statement of Dana's museum philosophy is in three small volumes of his "The Changing Museum Idea: The New Museum Series," printed in editions of only three hundred copies at the Dana brothers' Elm Tree Press in Woodstock, Vermont. *The New Museum* and *The Gloom of the Museum* [*With Suggestions for Removing It*] appeared in 1917, and *A Plan for a New Museum: The Kind of Museum It Will Profit A City to Maintain* in 1920.

Dana thought that only about eighty of the country's six hundred museums could be called "live" or "new." The old conventional art-gallery type usually occupied a palatial building in a park remote from a city's center, its chief aim accumlating collections "to fill rows of cold and costly cases" with old, rare, and high-priced objects fashioned by man or nature. As a result, museums usually were gloomy places, poorly lighted from above. They were "visited by few, that few being made up largely of strangers passing through the city." And the museum curators, directors, and trustees had lost touch with the public; they "go on making beautifully complete and very expensive collections, but never construct a living, active and effective institution.[28]

Dana put his own museum firmly in the van of the new museum movement, with its chief function to be educational or interpretive. He

even hesitated to call it a *museum* and preferred the term *institute of visual instruction*. He hoped that it would entertain and try to instruct casual visitors; employ special exhibits to lure adults inside and conduct tours and classes for them, using labels, leaflets, handbills, talks, and illustrated lectures; and work closely with the schools in arranging tours for student groups. He also wished to lend objects, exhibits, labels, leaflets, lantern slides, and instructors to the schools. Branch museums should be established, "veritable independent teaching centers," in storefront properties on business streets or in rooms with separate entrances in school buildings. Collectors in the community should be enlisted in the museum's work, and young persons should be encouraged to begin collecting and helping to install exhibits in order to enhance their powers of observation, train them in handwork, and develop their good taste. Any museum object should be made available for lending to individuals, groups, and societies for any proper use. Local industry exhibits, small or large, should be shown in the main museum, its branches, and in the schools. The active program of the museum should be kept constantly before the community in the daily press and through leaflets, posters, broadsides, and booklets. As Dana put it, "therefore, advertise, advertise and then advertise again. Advertising is the very life-blood of all the education a museum can give." The museum and the public library should co-operate closely, the one displaying books and journals in its exhibits and the other arranging helpful reading lists on exhibit topics and distributing museum announcements to its readers.[29]

Dana summarized the kind of experimental, lively museum he was advocating on the last page of *A Plan for a New Museum*, the third volume in his "New Museum Series":

Assume for a moment that the wealthy citizens and the governors of the city are willing and eager to spend their own and the public's funds in an effort to make more agreeable, more beautiful, more enduringly satisfying, the products of the factories and the tools of domestic life. Thereupon, in the center of the city, they set up what they are pleased to call a museum, and they place in this museum, as workers, a group of men and women who are sensitive to the appeal of beauty; are persistent students of beauty, down to its most modest appearance in the decoration of a broom handle; are skilled in the arts of presentation and appeal, and believe that most of their fellows are glad to learn, but that they learn best who are least conscious of being taught. This staff of workers surveys the city and its life and industries. It discovers what it produces and what it uses; and the things produced by it and the things used by it are by the museum staff gathered in typical examples into the museum. By these are placed examples, from other cities

and other times, of kindred things, sometimes originals, sometimes copies—often merely pictures of them. It arranges these for display and labels them freely and describes them in leaflets, and, on occasion, sends groups of them to schools, factories and storerooms in all parts of the city. And thus it says to the citizens, "Come and see. We think you will find that, as a result of such a study and daily use of what we can show you in your museum or as we can help you to make in your homes and factories, your products will sell better and at higher prices, your homes will give you more pleasure, your knowledge of and sympathy with the peoples of other lands and other times will be broader and deeper, and you will get more enjoyment out of every working hour."[30]

Dana's three books also gave specific instructions on the proper way to organize a museum with lists of established museums that could help and suggestions about useful printed materials. Dana praised G. Brown Goode, late of the Smithsonian Institution, as the great American museum pioneer who "preached the doctrine that museums in this democratic land should be adapted to the needs of the mechanic, clerk and salesman, as well as to those of the professional man and man of leisure." Goode's U.S. National Museum *Report, 1893,* with its section on "Recent Advances in Museum Methods," his address on "Museums of the Future," and his "Principles of Museum Administration" were seminal documents for anyone interested in museum excellence. Dana also cited the *Proceedings* of the American Association of Museums (founded in 1906) and the studies of Paul M. Rea, then secretary of the association and director of the Charleston (South Carolina) Museum. When Theodore L. Low in 1942 wrote *The Museum as a Social Instrument,* attacking stodgy elitism in art museums and pleading for public-based educational programs, he named Dana as the great pioneer protagonist of this point of view. And in truth Dana, along with his friend Kent, Rea, Charles R. Richards, first director of the American Association of Museums, and Thomas R. Adam of the American Association for Adult Education were the principal leaders who managed to place the emphasis of the American museum movement upon education and community service, rather than upon traditional collecting. Though both functions were necessary and desirable, these innovators made helping people and the community their leading concern, instead of merely collecting and preserving objects.[31]

Dana's argumentative approach and his prejudices against art museums and conservative curators sometimes led him to make extreme statements that cannot be easily justified. He undervalued old masters when he talked of "the undue reverence for oil paint" and argued that "the

oil painting has no such close relation to the development of good taste and refinement as have countless objects of daily use." He stressed too strongly the aesthetic power of his library's picture collection, great as it was, when he described it "as truly a museum as a collection of objects." He also dared assert that reproductions were just about as valuable as originals if they "copy the old so well that only labels and microscopes can distinguish the one from the other," and he praised unauthentic adaptations that "show originality, high skill in design," and "are technically quite perfect." He even wondered whether machine art might not be superior to handcrafted works, in that it was "collective art, art which is the result not merely of one person's expression, but the creative expression of a great, conscious group."[32]

Dana's principal museum techniques clustered about the special exhibition, and, during the twenty-eight years he directed museum affairs at Newark, he planned and presented many outstanding shows. In general, he decried the worship of foreign (especially European) art, supported American painters including "The Eight" of the Ashcan School, and advocated practical, everyday art for homes, businesses, schools, and elsewhere at the community level. Newark's Museum Association in 1910 displayed its recently acquired Rockwell Collection of Japanese art, but also showed paintings and bronzes by contemporary American artists. The next year the association mixed the traditional and the modern with shows on the *Edward N. Crane Memorial Collection of Tibetan Art Objects*, on modern photography (Dana was one of the first to consider photographs worthy of museum collection and display), the paintings of Childe Hassam, and city scenes by Stuart Davis, George Bellows, and others. These exhibitions took place two years before the famed Armory Show of 1913, in New York City, championed the cause of modern art. Almost every year, Newark showed American contemporary art, with major exhibits in 1913 of Max Weber, in 1917 of George Luks, Robert Henri, John Sloan, and others, and in 1926, when the new museum building opened, on *Paintings and Sculpture by Living American Artists* that included items bought for the museum with a fund given by Mr. And Mrs. Felix Fuld (she was Louis Bamberger's sister).[33]

In 1912, Dana presented a notable exhibition of *Modern German Applied Arts* assembled by Karl Ernst Osthaus, director of a German industrial museum at Hagen, and the *Deutscher Werkbund*, an organization dedicated to a new functional approach to industrial design. It contained more than thirteen hundred items of contemporary prints, ceramics, textiles, glass, metalwork, wallpaper, leather, advertisements, photographs, and

books. This first important American exhibition of modern foreign industrial art then traveled to museums in St. Louis, Chicago, Indianapolis, Cincinnati, and Pittsburgh. Dana offered the exhibition also to the Metropolitan Museum of Art in New York—which infuriated him by refusing it as being "too modern and too commercial." A second show on the same subject was held in 1922. Dana also tried to improve the manufactures of the Newark area by holding exhibitions of the wares of local firms. *New Jersey Clay Products* in 1915 displayed the work of forty-two companies, and Dana stirred debate by suggesting that "so far, the great contribution of American art is the American bathroom." The show attracted art classes, housewives, elementary school students with docents, and even blind children. *New Jersey Textiles* the next year was equally successful; it cost less than eight hundred dollars to install, but drew an atttendance of fifty thousand. *Nothing Takes the Place of Leather* was an opening show for the new museum building in 1926, followed in the next year by *The Making of a Weston Electrical Measuring Instrument* and in 1929 by *Jewelry Made in Newark*. In short, Dana thought the museum "should reflect our industries, be stimulating and helpful to our workers, and promote an interest here and elsewhere in the products of our shops."[34]

A *Homeland Exhibit* in 1916 gathered handcrafted objects from at least twenty immigrant nationalities in Newark, including German, Irish, Italian, Russian, Polish, Lithuanian, and Hungarian. Students whose families were of these nationalities brought materials from their homes to their schools, where selections for display were made. A dozen rooms of a large school building held the exhibits, and representatives of the various nationalities gathered in the assembly hall to show their customs, dress, music, dancing, and food. In 1921, Dana created a sensation by taking some of these immigrant handicraft objects to an art history convention at the Sorbonne in Paris. The museum also presented a series of "good neighbor" exhibitions designed to promote international understanding. A comprehensive show on *The Republic of Colombia, South America*, elicited an appreciative note from President Woodrow Wilson and aroused so much interest that it moved on to the Bush Terminal in New York City. In 1923 came *China: The Land and the People;* in 1928, *Primitive African Art;* and in the next year, *Islands of the Pacific,* on the native arts of Oceania.[35]

In 1928 and 1929, Dana created exhibitions on *Inexpensive Articles of Good Design* that had cost ten cents or not more than fifty cents, purchased from local five-and-ten-cent and department stores. His fighting slogan for these shows was: "Beauty has no relation to price, rarity, or age." Other 1929 exhibits were devoted to *Modern American Design in Metal* and

to *Design in Wallpaper and Hardware,* again stressing the point that art could be found in everyday life in anyone's home. These displays were consonant with Dana's belief that

A good museum attracts, entertains, arouses curiosity, leads to questioning—and thus promotes learning. To do these things a museum can use simple, common and inexpensive objects; just as daily life uses wayside flowers and trees; sheep, cattle, ploughs and hoes on the farm; pavements, motors and shop windows in cities, and man and his doings everywhere, to awaken young and old to interest and inquiry about the world outside themselves.[36]

Dana also understood the desirability of bringing exhibitions to life. An earlier library show on the *Colonial Period of American History* included a replica of a well-equipped kitchen. A skilled potter worked at his wheel in the New Jersey clay products show, spinners and weavers at an exhibit of New Jersey textiles, and a leather worker in *Nothing Takes the Place of Leather.* Dana advocated demonstrating processes wherever possible—a painter painting, an engraver engraving, a potter, weaver, sculptor, woodcarver, carpenter, illustrator, designer, or other skilled worker engaged in his or her métier. As an enthusiastic promoter of good printing, Dana purchased a Washington hand press and two fonts of type for the library and the museum, using the equipment to produce labels, posters, broadsides, and other small printing jobs and requiring his museum apprentices to learn the processes involved.[37]

Despite Dana's sometimes playing down the collecting function of museums and the fact that city funds could not be used for acquisitions, the speical exhibits frequently generated gifts to the museum, especially from the large and enthusiastic Museum Association membership. The wealthy and middle-class citizens of the city made collections and bestowed them upon the museum. As a result, the museum today has an excellent collection of American painting and sculpture, especially strong in folk painting, nineteenth-century landscapes, nineteenth- and twentieth-century still life, and early twentieth-century American painters. In European and American decorative arts, the collection is perhaps richest in glass and ceramics. The oriental collections are renowned internationally,—outstanding for Tibet and excellent for Japan, with good materials from China and elsewhere in Asia. The museum's ancient and classical art, coins, ethnological collections from America, Africa, and Oceania, and science holdings are also of unusually high quality for museums of this size.[38]

Dana's chief interest was in the use of the museum, however. He

appointed Louise Connolly educational adviser, and she made sixty-five visits in twenty days to report in 1914 on the educational programs of other museums and to recommend activities suitable for Newark. Dana realized that the public and parochial schools had far more resources,both human and material, than his museum could ever command, and he planned to co-operate closely with the schools. He established a Lending Department that soon was making nine thousand shipments per year of birds, minerals, textiles, sculptures, pottery, dolls in costumes of many countries, and other objects, transported to and from the schools by vans paid for by the Board of Education. For the lending collection, the museum constructed many models that included a pioneer log cabin, an Indian tepee, a Dutch windmill, Christopher Columbus's flagship, the *Santa Maria*, a crusader, a medieval castle, the Plymouth settlement of 1620, and an Eskimo igloo. Other materials were lent to shops and hospitals. The local teachers' college gave credit for courses at the museum showing teachers how to use specimens and objects effectively in the classroom. Dana also advocated loan exhibits to branch museums and experimented successfully with one in a branch library. Though he was unable to finance a permanent program, his assistant, Beatrice Winser, who succeeded him, later established nine small branches in branch libraries and two department stores. Dana in 1916 assigned a room in the library as a Junior Museum and placed Miss Winser in charge of programs for youngsters on Saturday mornings and holidays. A Museum Club encouraged young people to collect natural specimens, stamps, coins, or other objects.[39]

Not all members of the Museum Board of Trustees agreed with Dana's attitude toward "gazing museums." In 1914, the chairman of the Executive Committee, Dr. Archibald Mercer, called a meeting to which he did not invite Dana. The committee declared "that their intention is to collect objects of art, and to employ only such attendants as are necessary to keep these objects clean and uninjured, their expectation being that by placing these collections where the people can visit them, they may raise the taste of the community." When Dana heard of this restrictive action, he threatened, unless the board upheld him and his educational policies, to resign as museum director and to expel the museum from the library building, which was becoming badly overcrowded. The majority of the trustees and the membership stood staunchly behind Dana, and before long he succeeded in quietly having the dissenters removed from the board and the executive committee.[40]

The museum's need for space was now critical, and in 1916 an oppor-

Fig. 38. Newark Museum Junior Museum Club, field trip, 1916. Students collect insects in nearby Washington Park. *(Photograph by Commercial Photo Company. Collection of the Newark Museum.)*

tunity arose to satisfy it. That year marked the two-hundred-and-fiftieth anniversary of the founding of Newark, and Dana was on the Committee of One Hundred in charge of observing the occasion. He hoped that the city might decide to erect a Memorial Building that would house the museum, and, in line with his strongly held principles, he wanted the building near the city center, which he defined as "the center of the daily movement of the citizens." When it appeared that a majority of the

committee was considering paying an extravagant sum for a site and building in an out-of-the-way residential section on South Broadway, Dana and Charles Bradley, prominent business and civic leader and museum trustee, resigned in protest. The *Newark News* then discovered that three committee members had personal or institutional interests in the proposed site, and another museum trustee, Wallace M. Scudder, publisher of the *News*, indignantly left the committee. The scandal defeated the plan for the Memorial Building, and in 1922 the city bought, for more than $200,000, a choice plot in the center city near the library and facing on Washington Park for the museum building. Louis Bamberger, owner of Newark's leading department store and a museum trustee, then came forward and offered to erect a building and give it to the museum. He expected it to cost $500,000, though it actually came to $750,000. Dana, Bamberger, and Jarvis Hunt, the Chicago architect who had designed the Bamberger Department Store, spent many months in careful planning. The trustees, failed, however—much to Dana's chagrin—to raise $1 million by public subscription for equipment, furnishings, garden beautification, and endowment. The new building, opened on March 17, 1926, has two simple bronze bas-relief portrait plaques at the entrance, with the inscriptions: "John Cotton Dana: The Museum Is His Thought and Work" and "Louis Bamberger: He Gave This Building to Newark."[41]

In commenting on his new functional museum structure, Dana said:

I've had a lot of fun. A whole lot of fun . . . though I shall have to admit that now the building is completed and the museum moved into it, I find myself at the end of my immediate imagination. I am going ahead as fast as money permits, but I discover that I am more and more of the opinion I have held for years, that nobody knows how to run a museum.

In 1925, Dana had started a museum apprenticeship course with nine young women college graduates receiving on-the-job training during an academic year; by the time it closed, in 1942, because of wartime conditions, the program had prepared 108 young men and women and placed them in museums in the United States and Canada. That course and the one conducted at Harvard and the Fogg Museum by Paul J. Sachs for twenty-five years, beginning in 1923, were the two pioneering American programs of museum studies.

Dana's health became more precarious, and he was compelled to undergo several operations and spend much time in the hospital or at his Vermont home. While on a trip to Egypt in 1929, he became ill and went to a Cario hospital. Returning to New York, he underwent another operation there and died on July 21.[42]

Fig. 39. John Cotton Dana speaking at the dedication of Newark Museum's new building, 14 May 1925. *(Photograph by Koenig Photo. Collection of the Newark Museum.)*

## IV

Dana's death did not change the course of the Newark Museum. The group of accomplished and devoted women whom he had trained carried on the public service institution as he conceived it. Beatrice Winser became librarian and museum director, with Alice W. Kendall, for long the museum curator, made assistant director. Katherine Coffey, who had

assisted Dana in planning the new building, became curator and took charge of exhibitions, educational programs, and apprentice training. When Miss Winser retired in 1947, Miss Kendall succeeded her for two years, with Miss Coffey as assistant director. Miss Coffey took over the directorship in 1949 and retained the post until her retirement in 1968. Thus, for forty years, the Newark Museum was directed by women, an unusual condition for a museum of that era. Samuel C. Miller, who had been assistant director of the Albright-Knox Art Gallery in Buffalo, New York, became Miss Coffey's assistant for six months before her retirement and then was made director.[43]

The exciting program of special exhibitions that Dana inaugurated has continued to the present. The emphasis on American contemporary painting and sculpture remained strong. Dana also had been one of the first to appreciate and enjoy American folk art, and in 1930 Holger Cahill, who had worked under him, returned to Newark to help install and do the catalogue for *American Primitive Painting*, the first museum exhibition of this American brand of homespun popular art. The show traveled on to Chicago, Toledo, and Rochester and was followed the next year by *American Folk Sculpture*, the first American museum exhibit of ship figureheads, cigar-store figures, weathervanes, bird and animal carvings, and the like. Exhibitions in 1939 featured work of New Jersey artists under the Federal Art Program of the Works Progress Administration and for the New York World's Fair. In 1952, a triennial show was established for New Jersey artists, and in that decade exhibits were devoted to creative photography, modern architecture, and abstract art. *Decorative Arts Today* (1948) showed articles priced at under ten dollars from Newark department stores, and *Christmas Gift Suggestions of Good Design* (1949) applied that formula during holiday seasons and soon added to the exhibits (and for sale) work of New Jersey artists and craftsmen. A *Newark Centennial Exhibition* (1946) contained a recreated Newark street of 1836. *Newark of the Future* (1947) and *Our Town* (1957) with the redevelopment plan for "The New Newark" would have pleased Dana, who had been appointed to the Newark Planning Commission in 1911 and was its most influential member for several years.[44]

The emphasis on New Jersey manufacturing also continued, with exhibitions on *Aviation: A Newark Industry* (1932); *Modern Miracles: Chemistry Changes the World* (1934), since New Jersey then stood second among the states in chemical industries; *War and Peace—the Industrial Front in the Newark Area* (1945), with fifty-six firms participating; *Atomic Energy* (1948); *Newark in World Trade* (1949); and *New Paths in Science and Industry in New Jersey* (1956), in which eleven companies showed their new inventions and

Fig. 40. Newark Museum apprentices, 1926. First graduating class. *Left to right:* Carolyn Heller, Anita Nev, Mabel Tidball, Dorothy Dudley, Dorothy Miller, Ruth Farwell, Cora Ward, Elinor Robinson. *(Photograph by Koenig Photo. Collection of the Newark Museum.)*

techniques. Exhibits also upheld the museum's "good neighbor" policy, with *Three Southern Neighbors—Ecuador, Peru, Bolivia* (1941); *Art in Life in Africa* (1954); *Twentieth-Century Italian Art* (1956) and *Italy's Contribution to American Art* (1962); and *World Areas in the News: Congo and Niger Valleys* (1960).[45]

The educational program of the museum expanded through the years.

In 1933, a Sunday Concert Program began, and adult groups in sketching, modeling, and nature study were established that resulted in a Nature Club, Natural Science Workshop, and Arts Workshop for Adults with classes in weaving, painting, ceramics, sculpture, and the like. In 1937, the museum acquired an 1885 house next door, the former home of John M. Ballentine, and built a four-story brick extension behind it to contain the Junior Museum, Arts Workshop for Adults, Lending Department, and offices. More recently, the Ballentine House has been restored with rooms displaying examples of the decorative arts of New Jersey. In 1939, the museum placed in its spacious garden Newark's Old Schoolhouse of 1784, properly furnished and equipped. Mr. and Mrs. Leonard Dreyfus gave the museum a Spitz Planetarium in 1953 and then a fifty-thousand-dollar endowment for its maintenance and for the installation of a small observatory on the roof, thus making possible regular astronomical shows.[46]

The museum of community service was about to undergo a severe, sobering test, however. From 1860 until about 1910, Newark had participated in an industrial boom, its population increasing from 72,000 to 347,000. It had attracted many European immigrants, but few Negroes (only 2.7 percent of the population in 1910). World War I created much employment, and blacks began to immigrate; while neither employers nor trade unions encouraged them, they found menial jobs and constituted 8.8 percent of the population in 1930. After World War II, however, they moved from the South in droves and by 1974 comprised 60 percent of the city's population. White flight to the suburbs also had been taking place, including many upward-bound immigrants. The blacks lived in appalling slums, experienced shameful segregation, and were subject to much crime, venereal disease, tuberculosis, infant mortality, and drug abuse. One of every four Newark blacks was on relief, and unemployment for males, aged sixteen to twenty-five, reached 40 percent. Whites commuted from suburbs to city to work for insurance companies and other businesses, while almost as many blacks journeyed to the suburbs to serve mainly as unskilled or domestic workers. The local saying went: "The people who work in Newark don't live there, and the people who live there don't work there." The city suffered from corrupt government, dominated by an alliance of older ethnic groups led by Irish and Italians. In July 1967, black discontent turned violent, and in a series of riots that lasted five days, stores and other places in the central city were burned and looted. When the National Guard and State Police had

restored order, twenty-three blacks were found to have been killed. In 1970, Kenneth A. Gibson, a young black engineer, was elected mayor and began conscientiously to attack the seemingly overwhelming problems of what was becoming more and more a black city.[47]

The museum managed to hold its own in the rapidly changing community. During the Great Depression of the 1930s, Miss Winser kept the museum afloat when the city appropriation dropped from $150,000 to $65,000, necessitating shorter opening hours, dismissal of staff, closing departments, and pay cuts of 25 percent. On February 11, 1969, however, a new crisis arose, when the Newark City Council voted unanimously to cut off entirely on April 1 the appropriations for both library (about $2 million) and museum (about $800,000). The council may not have been entirely sincere in this action, possibly hoping that such a dramatic gesture would cause the state to increase its support of the library and begin to appropriate funds for the museum. Since a majority of the museum visitors came from outside Newark, the city also argued that its Essex County and neighboring counties ought to contribute support.[48]

This action came while the museum was in the midst of an ambitious exhibition and African Festival, financed privately by the president of the trustees. It was designed to focus the attention of the black community on the rich cultural heritage of Black Africa, to revitalize general community interest in the museum, and to increase attendance that had declined markedly since the riots of 1967. The main exhibition, on view from January 24 through September, consisted of 112 works chiefly from the museum collection—ceremonial masks, carved ancestral images, fetish figures, musical instruments, weights, ornamented weapons, domestic implements, stools, and neck-rests. Two concurrent smaller shows were devoted to *Photos of People of Africa,* including terrain and animals, and to prints, paintings, and collages by local black artists who called themselves "Black Motion." Three consecutive weekends were devoted to festival special events. The gala opening, with music by an Afro-American dance group, attracted leaders of both the black and the white community and United Nations representatives of African countries, many of them in native costume. Three films on Africa drew standing-room audiences, and "Black Motion" designers staged a Fashion Show in the museum courtyard, with live models showing thirty costumes for men, women, and children based on African motifs. The well-known African drummer, Bababunde Olatunji, and his dancers performed on a Saturday night, and Dr. Nicholas England of the Department of Music, Columbia University, gave an illustrated lecture-demonstration on the history of African music.

Two of the three weekends brought the largest daily attendance the museum had seen in more than twenty-five years, better than one-half from the black community.[49]

The museum for long had paid some attention to black artists. Dana in 1928 had presented an exhibition on Primitive African Art. In 1944, Miss Winser had organized a show of contemporary Negro art of thirty leading painters and sculptors. In 1954, *Art in Life in Africa* explored the tribal concept of the unity of art and religion. After 1969, the number of exhibits in this field increased markedly; for example, in one year (1971) appeared *Black Artists: Two Generations; Black Heroes in History;* and *Art of Africa and Oceania.* The first of these shows was unusual in that it contained works from Miss Winser's 1944 exhibit, to compare with the art of a newer generation.[50]

The museum's attention to all elements of the community paid off when an all-day public hearing was held on the plan of the city council to discontinue the museum and library appropriations. More than four hundred citizens jammed the council chamber, and they represented all groups—right, left, white, black, nonviolent, militant. The Council on Racial Equality (CORE), National Association for the Advancement of Colored People (NAACP), Urban Coalition of Newark, New Jersey Library Association, university and college spokesmen, and many others supported the museum and library. One young black woman accused the council of planning the threatened cut-off of funds in order to spoil the African Festival. Soon after the hearing, several buses took demonstrators to the state capital at Trenton, where Governor Richard J. Hughes promised to ask for state funds to help the museum. The hope was that the state, the city, and the nearby counties each would provide one-third of the government appropriation part of the museum budget. On March 11, 1969, the city council voted to restore the museum and library appropriations. The state began to supply its third for the museum, but Essex was the only county to allot a rather nominal $50,000. The period of crisis seemed to have passed, though in 1973 *New York* magazine printed a rumor that the museum collections might be sold to help city finances. Both Director Miller and Mayor Gibson indignantly denied the story. Miller accused the magazine of irresponsible journalism and worried about the effect the rumor might have on gifts to the museum.[51]

The Newark Museum thus continued its excellent educational program and seemed to prove that a museum conducted for the good of the whole community was relatively securely based, flexible enough to survive economic downturns and violent social change. And Dana's philoso-

phy of community service was widely adopted all over the United States by museums both large and small. For example, Arthur C. Parker, director of the Rochester (New York) Museum of Arts and Sciences (1912), built his museum on Dana's principles and quoted him frequently on the challenge of service. The Smithsonian's Anacostia Neighborhood Museum and other museums today in black, Puerto Rican, Hispanic, Oriental, and American Indian communities continue to follow this ideal.[52]

John Cotton Dana, often during his lifetime called "the first citizen of Newark," remains a kind of folk hero in Newark more than a half century after his death. In 1931, a local college (absorbed into the University of Newark and later into Rutgers University) was named Dana College in his honor and contains the John Cotton Dana Library. In 1935, six hundred people came to the museum courtyard to observe John Cotton Dana Day, to listen to his friend Henry W. Kent recount Dana's contributions, and to enjoy an eighteen-act pageant recounting the museum's history, presented by the staff. In 1956, the centennial of his birth was observed at another John Cotton Dana Day by a convocation at the museum, with addresses by the Chief Justice of the Supreme Court of New Jersey and by the Librarian of Congress. In 1979, the museum marked the seventieth year of its existence and the fiftieth anniversary ot Dana's death with a special exhibition and a publication, the author of which testified that those associated with the museum "are constantly aware of Mr. Dana's spirit and intelligence which still infuse this institution." The American Library Association and the *Wilson Library Bulletin* in 1946 opened a publicity contest for libraries and began to confer "John Cotton Dana Publicity Awards" that paid tribute to "that dean of library public relations pioneers," while the Special Libraries Association, to observe its fiftieth anniversary in 1959, established the John Cotton Dana Lectures in Special Librarianship, to be delivered at library schools.[53]

As Walter Pach wrote, Dana's "was far from being the negative type of mind, for he bristled with constructive ideas. Many a museum man who, at the beginning had his teeth set on edge by Mr. Dana, found himself, later on, to be following in a course strongly affected by the innovator." Perhaps the *Nation,* among the dozens of newspapers and journals that ran editorials at his death, best caught Dana's spirit when it said that he made his museum

serve the people, especially . . . helping them to discover the possibility of beauty and excellence in the machine products of the day. In theory a philosophic anarchist, he was a free man in thought and action, a constant inspiration to the thousands of men and women who knew him personally and to other hundreds

of thousands who knew only his work. He was in the best sense one of the makers of modern America; for the influence of his work has already been felt in the remotest parts of the country, and it will widen and deepen with the years.[54]

## NOTES

Samuel C. Miller, director of the Newark Museum, and Mrs. Barbara Lipton, formerly librarian there and now Special Projects Consultant, graciously have read this chapter and made helpful suggestions. Mrs. Lipton is writing a biography of Dana based on abundant primary sources and has had published a discerning article on "John Cotton Dana and the Newark Museum" (1979).

1. Walter Pach, *The Art Museum in America*, pp. 196–202; Chalmers Hadley, *John Cotton Dana*, pp. 6–7.
2. In 1948, the year before his death, Dana wrote a short autobiographical sketch that described his boyhood; it is quoted in "John Cotton Dana and the Newark Museum," by Barbara Lipton, *Newark Museum Quarterly* 30 (Spring/Summer 1979): 5–13. See also Frank Kingdon, *John Cotton Dana*, pp. 4–9; Norman D. Stevens, "Dana, John Cotton," in *Dictionary of American Library Biography*, edited by Bohdan S. Wynar, pp. 115–120; Julia Sabine, "Dana, John Cotton," in *Encyclopedia of Library and Information Services*, edited by Allan Kent and Harold Lancour, 6: 417–423; Hadley, *Dana*, pp. 8–9.
3. Lipton, "Dana," p. 13; Kingdon, *Dana*, pp. 22–24; Hadley, *Dana*, p. 10.
4. Lipton, "Dana," pp. 13–19; Kingdon, *Dana*, pp. 25–41; Hadley, *Dana*, pp. 10–11.
5. Dana to *Dartmouth Alumni Magazine*, May 1899, in Lipton, "Dana," pp. 17–19.
6. Lipton, "Dana," p. 21; Stevens, "Dana," p. 116; Kingdon, *Dana*, pp. 43–44; Hadley, *Dana*, p. 12.
7. *American Magazine* 94 (October 1922): 14; John Cotton Dana, *Libraries: Addresses and Essays*, pp. 53, 69; Hadley, *Dana*, p. 48.
8. Dana, *Libraries*, pp. 66–67; Hazel A. Johnson, "John Cotton Dana," pp. 50–68, especially p. 55.
9. Lipton, "Dana," p. 21; Stevens, "Dana," p. 116; Kingdon, *Dana*, pp. 43–51; Hadley, *Dana*, pp. 12–32; J. C. Dana, "A New Library Movement in Colorado," *Public Libraries* 1 (December 1896): 304–305.
10. Dana, *Libraries*, pp. 3–8.
11. John Cotton Dana, *A Library Primer* (1896; Boston, New York: Library Bureau, 1920); Dana, "The Library Movement in the Far West," *The Library* (series 1) 8 (1896): 446–450; Hazel A. Johnson and Beatrice Winser, "Bibliography, John Cotton Dana," *Library Quarterly* 7: 68–98; Stevens, "Dana," p. 119.
12. Stevens, "Dana," p. 116; Hadley, *Dana*, pp. 31–33; Kingdon, *Dana*, pp. 58–60; Henry Watson Kent, *What I Am Pleased to Call My Education*, pp. 101–102.
13. Lipton, "Dana," pp. 21–22; Stevens, "Dana," pp. 116–117; Hadley, *Dana*, pp. 33–51; Kingdon, *Dana*, pp. 64–81.
14. Lipton, "Dana," p. 22; Stevens, "Dana," p. 116; Hadley, *Dana*, pp. 48–51.
15. Kingdon, *Dana*, p. 64; Lipton, "Dana," pp. 37–38.
16. Stevens, "Dana," p. 117; Kingdon, *Dana*, pp. 70, 79–81; Sabine, "Dana," p. 420.
17. Lipton, "Dana," pp. 34–36; Kingdon, *Dana*, pp. 82–83, 173.

18. Johnson, "Dana," pp. 57–59; Johnson and Winser, "Dana Bibliography," pp. 92–93; Hadley, *Dana*, pp. 52–59; Kingdon, *Dana*, pp. 90–91; Stevens, "Dana," p. 117; John T. Cunningham, *Newark* (Newark, N.J.: New Jersey Historical Society, 1966), p. 220.

19. Dana, "The Library as a Business Aid (March 1913)" and "The Evolution of the Special Library (January 1914)" in Dana, *Libraries*, pp. 213–214, 243–259; Stevens, "Dana," pp. 117–118; Johnson, "Dana," pp. 54, 66.

20. Stevens, "Dana," pp. 118–120; Johnson, "Dana," pp. 64–66.

21. Dana, *Libraries*, pp. 3, 24–28, 54–56, 66; Johnson, "Dana," pp. 54–55.

22. Dana, "Library Problems (1902)," "Anticipation, or What We May Expect from Libraries (1907)," and "What the Modern Library Is Doing (1911)," in Dana, *Libraries*, pp. 51–67, 147–152, 157–166; John Cotton Dana, *The New Museum*, p. 21; Kingdon, *Dana*, pp. 85–86, 92; Cunningham, *Newark*, p. 259.

23. Kingdon, *Dana*, pp. 58, 62–81, 96–97, 120–121, 158–160; Hadley, *Dana*, pp. 4, 33–51; Lipton, "Dana," pp. 55–56; Kent, *My Education*, p. 102.

24. Kingdon, *Dana*, p. 97; Newark Museum, *A Survey: Fifty Years of the Newark Museum*, pp. 7, 120–122; John Cotton Dana, "A Museum of Service," p. 582.

25. Kingdon, *Dana*, pp. 97–98; Hadley, *Dana*, pp. 67–68; Lipton, "Dana," pp. 23–26; John Cotton Dana, "A Small American Museum," pp. 144–150.

26. Dana, "Museum of Service," p. 581; Dana, "Small American Museum," pp. 144–150; Hadley, *Dana*, pp. 55–56; Newark Museum, *Fifty Years*, p. 9.

27. Dana, "Museum of Service," pp. 583–584.

28. Dana, *New Museum*, pp. 9, 11–15; Dana, *Gloom of Museum*, p. 23.

29. Dana, *New Museum*, pp. 15–19, 39; Dana, *Gloom of Museum*, pp. 24–28; Dana, *Plan for New Museum*, pp. 12–13, 23–28; Persis Motter, "The Lending Collection," *The Museum* (new series) 12 (Fall 1960): 1–12.

30. Dana, *Plan for New Museum*, p. 57.

31. Dana, *New Museum*, pp. 10, 22–52; Dana, *Gloom of Museum*, pp. 31–45; Dana, *Plan for New Museum*, pp. 9–11; Theodore L. Low, *The Museum as a Social Instrument* pp. 10–13, 16–17, 19, 27–30, 54, 67–70; Ellen C. Hicks, "The AAM (American Association of Museums) after 72 Years," pp. 44–47.

32. Dana, *Gloom of Museum*, pp. 20–23; Dana, *Plan for New Museum*, pp. 20–24; John Cotton Dana, "Libraries and Museums," pp. 455–456, 539–540, 697–699, 839–842; 47 (1922): 705–708; Richard Grove, "Pioneers in American Museums," p. 87.

33. Kingdon, *Dana*, pp. 106, 111–120; Newark Museum, *Fifty Years*, pp. 8, 11–12, 76–88; Cunningham, *Newark*, p. 220; Stephen Mark Dobbs, "Dana and Kent and Early Museum Education," p. 39.

34. Newark Museum, *Fifty Years*, pp. 11–13; Dean Freiday, "Modern Design at the Newark Museum," pp. 1–32; Lipton, "Dana," pp. 38–42; Dana, "Museum of Service," pp. 583–584; Dana, *Plan for Useful Museum*, p. 24; Pach, *Art Museum in America*, pp. 196–202; Kingdon, *Dana*, p. 104; Dana, "Small American Museum," p. 145; Edgar Kaufmann, Jr., "Museums and Industrial Design," in Royal Society of Arts, *Museums in Modern Life* (London: Royal Society of Arts, 1949), pp. 27–29; *Literary Digest* 98, September 1, 1928: 22–23.

35. Dana, "Small American Museum," pp. 144–150; Dobbs, "Dana and Kent," p. 38; Kingdon, *Dana*, pp. 44–45, 89, 104, 144–156; Newark Museum, *Fifty Years*, pp. 12–13; Holger Cahill, "John Cotton Dana and the Newark Museum," p. 25.

36. Newark Museum, *Fifty Years*, pp. 12–13; Freiday, "Modern Design," pp. 3–4; Kingdon, *Dana*, pp. 103–104; Lipton, "Dana," p. 24.

37. Dana, "Small American Museum," pp. 144–150; Dana, "Museum of Service," p. 584; Kent, *My Education*, pp. 118–120; Kingdon, *Dana*, pp. 110–111.
38. Newark Museum, *Fifty Years*, pp. 27–129; Newark Museum, *Collections and Exhibitions, 1959–1969*, pp. 1–60; Valrae Reynolds, *Tibet: A Lost World—The Newark Museum Collection of Tibetan Art and Ethnology* (Bloomington, Ind., and London: American Federation of Arts, 1978).
39. Louise Connolly, *The Educational Value of Museums;* Newark Museum, *Fifty Years,* pp. 23–25; Dana, "Small American Museum," pp. 144–150; Kingdon, *Dana,* p. 103; "Growth of the Newark Museum," *Museum Work* 3 (1920): 41–42; Winifred Eva Howe, *A History of the Metropolitan Museum of Art,* 2 vols. (New York: Metropolitan Museum of Art, 1913, 1945), 2: 204–205; *The Museum* 3 (September 1931): 171–173.
40. Lipton, "Dana," p. 28.
41. Kingdon, *Dana,* pp. 100–101, 105–106; Lipton, "Dana," pp. 45–55; Newark Museum, *Fifty Years,* p. 7; Cunningham, *Newark,* pp. 248, 272–273; Dana, *Plan for New Museum,* pp. 13–14; *The Museum* 1 (September to December 1925): 65.
42. Newark Museum, *Fifty Years,* pp. 8–9; Kingdon, *Dana,* pp. 105–106; Lipton, "Dana," pp. 34–36; Edward P. Alexander, "A Handhold on the Curatorial Ladder," *Museum News* 52 (May 1974): 23–25.
43. Newark Museum, *Fifty Years,* p. 131; *The Museum* 2 (February 1930): 104; *Museum News* 40 (October 1961): 26; 46 (June 1968): 37; 47 (September 1968): 44; 50 (June 1972): 60; *Museologist,* No. 125 (October 1972): 3.
44. Newark Museum, *Fifty Years,* pp. 13–20; Holger Cahill, "American Primitives: A Prelude to American Painting," *Studio* 101 (June 1931): 417–424; Kingdon, *Dana,* pp. 144–156; Freiday, "Modern Design," p. 7.
45. Newark Museum, *Fifty Years,* pp. 13–20; Freiday, "Modern Design," pp. 6, 10–11; *Museum News* 39 (December 1960/January 1961): 44; 40 (January 1962): 44.
46. Newark Museum, *Fifty Years,* pp. 9, 14, 16, 21–25, 130; *The Museum* 4 (June 1939): 33–36; (December 1941): 53–60; *Museum News* 38 (February 1960): 4; *Aviso: Monthly Dispatch from the AAM* (June 1977), p. 7; Robert R. Coles, "The Newark Planetarium," *The Museum* (new series) 5 (Spring 1952): 1–8.
47. Kenneth T. Jackson and Barbara B. Jackson, "The Black Experience in Newark," pp. 36–56; Clement A. Price, "The Beleaguered City as Promised Land: Blacks in Newark, 1917–1947," in *Urban New Jersey since 1970,* edited by William C. Wright (Trenton: New Jersey Historical Commission, 1975), pp. 10–45; Ralph Whitehead, "Behind the Violence in Newark: Anatomy of a Riot," *Commonweal* 86 (August 11, 1967): 492–494; Daniel Gaby, "Newark: The Promise of Survival," *Nation* 219 (December 14, 1974): 619–622.
48. *The Museum* 4 (February–March 1932): 2; "Newark: Cultural Wasteland (editorial)," *New York Times,* February 14, 1969; *Art Digest* 6 (March 15, 1932): 11; *American Magazine of Art* 26 (June 1933): 301; Russell Lynes, "How to Make Politics from Art and Vice Versa," *Harper's Magazine* 239 (August 1969): 21–22; "Crisis in Newark" (editorial) and "Newark City Council Votes to Drop Library," *Library Journal* 94 (March 15, 1969): 1081, 1083; "Victory from the Jaws of Defeat: A Tribute to the Newark Public Library," *Wilson Library Bulletin* 43 (April 1969): 740–745.
49. Samuel C. Miller, "An African Festival at the Newark Museum," pp. 25–27.
50. Newark Museum, *Fifty Years,* pp. 12–16; *The Museum* 3 (October 1931): 178; *Art Digest* 18 (April 15, 1944): 20; *Museum News* 17 (November 1968): 36, (January 1969): 40; 48 (April 1970): 42; 49 (March 1971): 37; 50 (September 1971): 52; (March 1972): 6; Newark Museum, *Black Artists: Two Generations* (Newark, N.J.: Newark Museum, 1971); Dorothy Budd Bartle,

"Black Heroes in History: Medals Honoring Black Americans," *The Museum* (new series) 23 (Fall 1971): 1–20.

51. "Newark Council Rescinds Library Budget Slash," *Library Journal* 94 (April 1, 1969): 1403–1404; "Victory from the Jaws of Defeat," pp. 740–745; James Brady, "New York Intelligencer," *New York* magazine 6 (January 22, 1973): 50; "Newark Alive, Well and Kicking," *Museum News* 51 (May 1973): 11.

52. Arthur C. Parker, *A Manual for History Museums* (New York: Columbia University Press, 1935), pp. 1, 51, 128; Alexander, *Museums in Motion*, pp. 224–227.

53. Hadley, *Dana*, pp. 77, 101–103, 172–173; Cahill, "Dana and the Newark Museum," pp. 268–275; *John Cotton Dana: The Centennial Convocation* (October 17, 1956); Lipton "Dana," p. 3; *Wilson Library Bulletin* 31 (March 1957): 542; *Special Libraries* 59 (May-June 1968): 356–361.

54. Pach, *Art Museum in America*, p. 196; the *Nation* quoted in *The Museum* 2 (October 1929): 81.

# SELECT BIBLIOGRAPHY

Cahill, Holger. "John Cotton Dana and the Newark Museum." Foreword to *A Museum in Action: Presenting the Museum's Activities . . .* , by the Newark Museum. Newark, N.J.: Newark Museum, 1969.

Coffey, Katherine. "Operation of the Individual Museum." *Museum News* 40 (October 1961): 26–29.

Connolly, Louise. *The Educational Value of Museums: Edited and with an Introduction by John Cotton Dana*. Newark, N.J.: Newark Museum Association, 1914. 73 pp.

Dana, John Cotton. *American Art: How It Can Be Made to Flourish*. Woodstock, Vt.: Elm Tree Press, 1914, 1929. 31 pp.

———. *The Gloom of the Museum (With Suggestions for Removing It)*. Woodstock, Vt.: Elm Tree Press, 1917. 45 pp.

———. "Increasing the Usefulness of Museums." American Association of Museums *Proceedings* 10 (1916): 80–87.

———. *Libraries: Addresses and Essays*. Freeport, N.Y.: Books for Libraries Press, 1916, 1966. 299 pp.

———. "Libraries and Museums." *Library Journal* 46 (1921): 455–456, 539–540, 697–699, 839–842; 47 (1922): 705–708.

———. "A Museum of Service." *Survey Graphic* 49 (February 1923): 581–585.

———. *The New Museum*. Woodstock, Vt.: Elm Tree Press, 1917. 52 pp.

———. *A Plan for a New Museum: The Kind of a Museum It Will Profit a City to Maintain*. Woodstock, Vt.: Elm Tree Press, 1920. 57 pp.

———. "A Small American Museum: Its Efforts Toward Public Utility." *Museum Work* 4 (November 1921–February 1922): 144–150.

———. "Use of Museums." *Nation* 115 (1922): 374–376.

Dobbs, Stephen Mark. "Dana and Kent and Early Museum Education." *Museum News* 50 (October 1971): 38–41.

Freiday, Dean. "Modern Design at the Newark Museum." *The Museum* (new series) 4 (Winter/Spring 1952): 1–32.

Grove, Richard. "Pioneers in American Museums: John Cotton Dana." *Museum News* 56 (May/June 1978): 32–39, 86–88.

Hadley, Chalmers. *John Cotton Dana: A Sketch*. Chicago: American Library Association, 1943. 106 pp.

Hicks, Ellen C. "The AAM (American Association of Museums) after 72 Years." *Museum News* 56 (May/June 1978): 44–48.

Jackson, Kenneth T., and Barbara B. Jackson. "The Black Experience in Newark: The Growth of the Ghetto, 1870–1970." In *New Jersey since 1860: New Findings and Interpretations*, edited by William C. Wright, pp. 36–56. Trenton: New Jersey Historical Commission, 1972.

*John Cotton Dana: The Centennial Convocation* (October 17, 1956). New Brunswick, N.J.: Rutgers University Press, 1957. 63 pp.

Johnson, Hazel A. "John Cotton Dana." *Library Quarterly* 7 (January 1937): 50–68.

Johnson, Hazel A., and Beatrice Winser. "Bibliography, John Cotton Dana." *Library Quarterly* 7 (January 1937): 68–98.

Kent, Henry Watson. *What I Am Pleased To Call My Education*. New York: Grolier Club, 1949. 208 pp.

Kingdon, Frank. *John Cotton Dana: A Life*. Newark, N.J.: Public Library and Museum, 1940. 175 pp.

Lipton, Barbara. "John Cotton Dana and the Newark Museum." *Newark Museum Quarterly* 30 (Spring/Summer 1979): 1–58.

Low, Theodore L. *The Museum as a Social Instrument*. New York: Metropolitan Museum of Art, 1942. 70 pp.

Miller, Samuel C. "An African Festival at the Newark Museum." *Museum News* 47 (May 1969): 25–27.

Newark Museum. *Collections and Exhibitions, 1959–1969: Survey 60*. Newark, N.J.: Newark Museum, 1969. 60 pp.

———. *The Museum: Science, Art, Industry*, monthly journal, 1 (March 1925)-4 (December 1941); discontinued, 1942. Followed by *The Museum, New Series*, quarterly, 1 (February 1949)-25 (Summer/Fall 1973). Name changed to *Newark Museum Quarterly*, 26 (Winter 1975) to date.

———. *A Museum in Action: Presenting the Museum's Activities* . . . Newark, N.J.: Newark Museum, 1944. 192 pp.

———. *The Newark Museum: A Chronicle of the Founding Years, 1909–1934*. Newark, N.J.: Newark Museum Association, 1934. 49 pp.

———. *A Survey: Fifty Years of the Newark Museum* . . . Newark, N.J.: Newark Museum Association, 1959. 136 pp.

Pach, Walter. *The Art Museum in America*. New York: Pantheon, 1948. 300 pp.

Sabine, Julia. "Dana, John Cotton." In *Encyclopedia of Library and Information Service*, edited by Allan Kent and Harold Lancour, vol. 6. New York: Marcel Dekker, 1971.

Stevens, Norman D. "Dana, John Cotton (1856–1929)." In *Dictionary of American Library Biography*, edited by Bohdan S. Wynar. Littleton, Colo.: Libraries Unlimited, 1978.

Winser, Beatrice, editor. *John Cotton Dana, 1856–1929*. Newark, N.J.: Newark Museum, 1930. 125 pp.

# Index

413

Lohr, Major Lenox (*con't.*)
Science and Industry (Chicago), 367
Louis XV of France and Vivant Denon, 82,
83, 84; Louis XVI of France and Denon,
83; Louis XVIII of France, 100, 101, 103,
105, 106
Louisiana Purchase Exposition (St. Louis,
Mo., 1904), 322
Louvre (Paris): home of Musée Napoleon,
world's most beautiful art museum
(1802), 5, 96, 105, 107; symbol of French
national glory, 5, 98, 105, 106–107;
standards of exhibition and conservation
set by Vivant Denon, 5–6, 103; center of
pioneer work in art preservation, 11, 94,
97; progress tied to French military
victories, 15, 100–101; opens (1793) as
Muséum Français or Muséum National,
88; artworks brought into Grand Galerie,
88, 90, 96–97; a "people's museum," 88,
105, 106; "spoils-of-war" artwork brought
in, 89–90, 92–93, 100, 107, 108; paintings
and artwork secured by Denon, 92–93;
holdings help stock French
departmental museums, 93–94, 107;
special events scheduled, 95–96, 108;
artworks commissioned for, 98–99;
makes restitution of looted artworks,
101–102, 106, 107, 108; Friends of the
Louvre, 106; Department of Oriental
Antiquities, 106. *See also* Denon,
Dominique Vivant
Lyceum of Natural History (New York), 66

Machinery Court (Great Exhibition of
1851), 149, 150
Machinery Hall (London), 11
Machinery Hall (Philadelphia Centennial
Exhibition of 1876), 279
Malaria: and cure for, 6, 23, 131
Malmaison: palace of Josephine, Empress
of France, 93, 108
Marlborough House: temporary home of
British Museum of Manufactures (1852),
159, 160, 161. *See* South Kensington
Museum/the Victoria and Albert
Museum
Massachusetts Historical Society, 64
Mastodon: in painting by Charles Willson
Peale, 45; bones found, 48, 58, 65, 70;
skeletons exhibited, 57–58; in England,
58; now in Darmstadt, West Germany,
72

Medals: series of, French, 88, 100, 103;
collections of, 436
Medical Society of the State of South
Carolina, 65
Mellon, Andrew W.: aids Smithsonian
Institution, 302
Menageries: Carl Hagenbeck's, 9; Charles
Willson Peale's, 53, 54
Meteorological stations (Smithsonian
Institution): set up, 284; turned over to
Weather Bureau, 285
Metropolitan Museum of Art (New York),
13–14, 15–16, 70, 167, 214, 218
Millennial Exhibit (Budapest, 1886):
ethnographic village, 248
Miller, Oskar von; electrical engineer, 9–10;
his father's influence, 344, 349; early life
of, 344, 346; characteristics of, 344, 347,
348, 349, 351, 366, 367; in electrical
engineering field, 346–347; with German
Edison Co., 347; as engineer-
entrepreneur and member of
Parliament, 348; plans grid to utilize
Bavarian waterpower, 347, 348–349;
death of, 349, 358, 366; his plan for
Deutsches Museum, 350; organization
and administration of, 350–353; and
teaching through exhibits, 353–356;
technical contributions to museum work
in Bavarian National Museum, 356;
library and conference center, 356–357;
publication program, 358; chairman,
engineers' unions, 358
Miller, Philip: and Chelsea Physic Garden,
28
Moated zoos, 9, 326, 328, 330, 331, 335. *See
also* Hagenbeck, Carl—Carl Hagenbeck's
Tierpark; Safari zoos; Wild animal parks
Montagu House, Bloomsbury: and the
British Museum, 36, 37
Montelius, Oscar (Swedish archaeologist),
244, 255
Mount Vernon: early operation of, 7; in
1853, 179; governance under Ann Pamela
Cunningham, 181–194; charter for
mansion's purchase and operation by
Mt. Vernon Ladies' Association of the
Union, 181; visitors to the mansion, 186,
189, 191, 198; preservation of, 187, 188;
during Civil War hostilities, 188, 189, 191,
196–197; and history of women's rights,
195–196; original pieces in mansion, 196;
as model in historical landscape, 198:

Napoleon (*con't.*)
92–93; as First Consul, 86; in Belgium and Italy, 89, 94, 95, 96, 98; triumphal parade, 89; and looting of conquered countries' art, 89, 90, 92, 107; North German and Peninsular campaigns, 92; and art distribution, 93–94; second marriage of, 95–96; Napoleonic legend, 98–100; and Russians, 100; seizes the Papal States, 100, 101, 102; abdication of, 100; on Elba and St. Helena, 100–102
Napoleon III, 105, 106
National Air and Space Museum (Smithsonian): and National Air Museum, 303
National Art Historians Association (Germany), 214
National Collection of Fine Arts (Smithsonian): and National Museum of American Art, 302
"National Collection of Curiosities" (Smithsonian), 285
National Gallery (London), 107–108, 161, 162, 165
National Gallery of Art (U.S.): Andrew W. Mellon gift to Smithsonian, 302
National Gallery of German Art, 208, 220, 230
National Library (British Museum), 38–39
National Library (Berlin's Museum Island), 231
National Museum (U.S.): and the Smithsonian, 279, 292
National Museum exhibits and Fisheries Commission (U.S.) displays, 281
National Museum of Cultural History (Smithsonian), 9
National Museum of Ethnology, Leiden, 250
National Museum of Finland, 264
National Museum of History and Technology (Smithsonian): now National Museum of American History, 301, 303
National Museum of Natural History/ National Museum of Man (Smithsonian), 294, 301–302, 304
National Portrait Gallery (Smithsonian), 302
National Register of Historic Places (U.S.), 266
National Zoological Park (Smithsonian), 292, 302
Natural history: arrangements, 5, 10; specimens, 36–37; collections, 89

Natural history museums: and habitat groups, 45; Charles Willson Peale's dream of, 47–53; and libraries, 53, 56; New-York Historical Society, 64, 66; New Panorama Building, 65; New City Tavern, 66
Natural History of Jamaica, 22, 29–30
Nazis and museums, 229–230. *See also* Berlin; Museum Island; Bode, Wilhelm
Neue Museum (Museum Island, Berlin), 208, 220, 229, 230
New American Museum (New York), 66
Newark (N.J.) Public Library: and John Cotton Dana, 10, 379, 382, 386–390; and public relations, 386; and community service, 386, 388, 390; and women in administrative posts, 386, 387; Special Libraries Association formed, 387; branch libraries, 387, 388, 397. *See also* Dana, John Cotton
Newark (N.J.) Museum: and John Cotton Dana, 10, 13, 15, 389, 390–399; branch museums, 10, 392, 397; special exhibits, 10, 383, 390, 392, 394–396, 402, 404–405, 406; Newark Museum Association, 14, 390, 396; and public service, 383, 384, 390, 393, 400, 403, 404–405, 406; public relations and publicity, 383–384, 385; and women in administrative posts, 384, 397, 400–402; funding, 390, 399, 403–405; educational programs, 391, 402–403, 404–405, 406; Memorial Building, financed by Louis Bamberger, 398–399, 401; Junior Museum, 397, 403; apprenticeship courses, 399. *See also* Dana, John Cotton
New York Botanical Garden, 136
New York City museums, 65–66
New-York Historical Society, 64, 66
New York Parthenon, 69
New York Society Library, 66
New York Zoological Society (Bronx Zoo), 316, 332
Nordiska Museet (Nordic Museum): opens, 8; administration, 13, 246; for research and scholars, 249; research library, 253; yearbook, *Fataburen* (Storehouse), 253; produces most books and papers of all European museums, 253; Association for the Promotion of, 255; Committee of Trustees, 257; exhibits, education, and lectures, 258; school kits and visits, 259; now national

*Index*